MONET
NATURE into ART

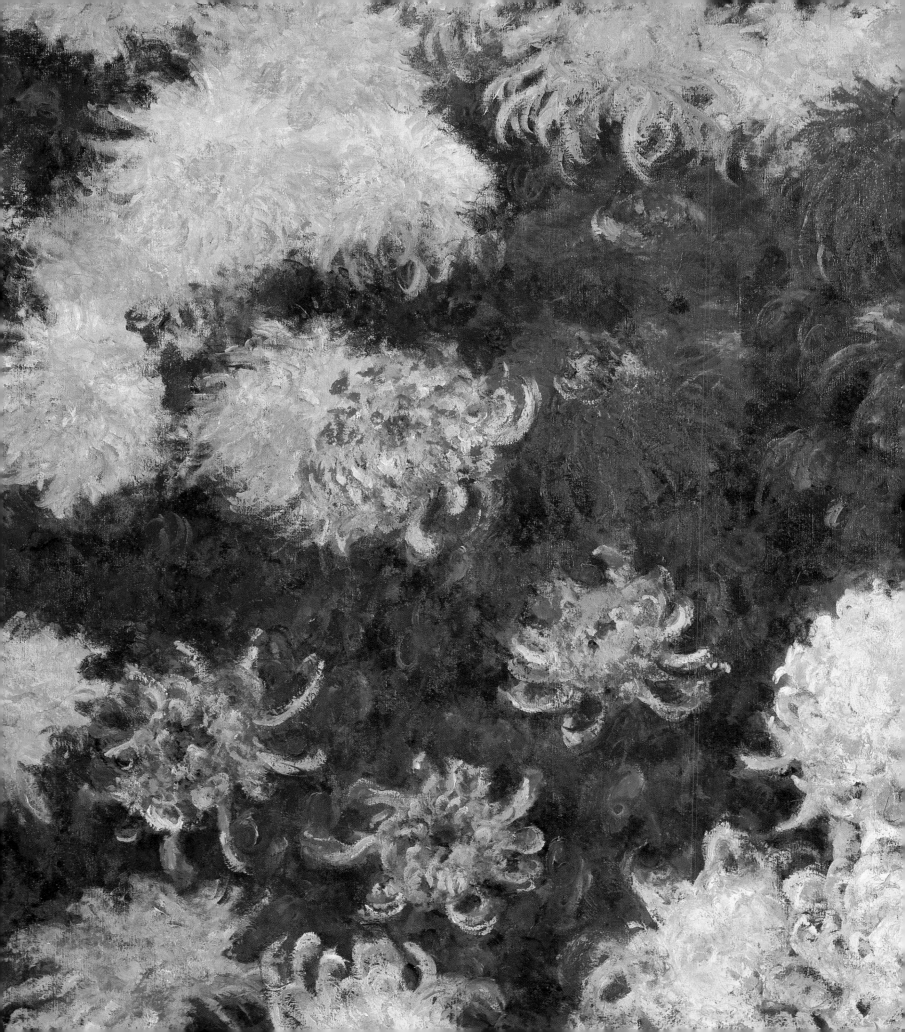

MONET
NATURE into ART

John House

YALE UNIVERSITY PRESS
NEW HAVEN AND LONDON · 1986

For Adam and Joe

Designed by Faith Brabenec Hart
Filmset in Monophoto Bembo by
Jolly & Barber Ltd, Rugby, Warwickshire
Printed in Italy by
Amilcare Pizzi, s.p.a., Milan

Library of Congress Catalog Card Number: 86–50364
ISBN: 0–300–03785–6

(frontispiece) Detail of pl. 59

(pp. vi–vii) Detail of pl. 110

ACKNOWLEDGMENTS

OVER the many years that this book has been in the making, I have received help from many people, while preparing it in its original form as a thesis for London University, and more recently, while reshaping it as a book. I am most grateful to all the friends, colleagues and students, past and present, who have in some way contributed to it – many of them in ways that they may not realise.

My primary debt is to the late Charles Durand-Ruel, for the generosity and enthusiasm which so many scholars of Impressionism will always remember, and for allowing me free access to the Archives Durand-Ruel, which are of such central importance in any study of the history of Impressionism. I am also indebted to M. Emile Gruet, Mlle France Daguet and Mme Caroline Godfroy for their patient and positive help in my consultation of the Archives Durand-Ruel. M. Gilbert Gruet generously allowed me to consult the Bernheim-Jeune archives, while M. Yves Brayer and the late Jacques Carlu kindly permitted me to study the Monet documentation at the Musée Marmottan, Paris – the artist's sketchbooks and account-books, his collection of press cuttings, and his collection of Japanese prints before their recent re-installation at Giverny; M. Claude Richebé helped me greatly in my work at the Musée Marmottan. John Rewald has also generously made documents available to me, and has most patiently answered queries.

I owe a special debt to Robert Ratcliffe for his constant insistence that all close discussion of paintings must be based on meticulous physical examination of their make-up; his example made many aspects of my research possible, though he should not be held responsible for my conclusions. I also learned much about techniques from looking at paintings with Anthea Callen. At the Museum of Fine Arts, Boston, and at the Courtauld Institute of Art I was given the chance to examine certain canvases through microscopes, which greatly enriched my understanding of Monet's methods.

The staff, past and present, of many museums and galleries have been very co-operative in answering my questions and in showing me material in their reserve collections. I would like to mention, in particular: in Paris, the staff of the Jeu de Paume, including Mme Hélène Adhémar, Mme Anne Distel and Mme Sylvie Gache-Patin; in Britain, the staff of the Courtauld Institute Galleries and the Tate Gallery, London, of the Ashmolean Museum, Oxford, and the Fitzwilliam Museum, Cambridge; and in the United States, the staff of the Museum of Fine Arts, Boston, including John Walsh, Alexandra Murphy, Elizabeth Jones, Alain Goldrach and Brigitte Smith; of the Brooklyn Museum, including Sarah Faunce; of the Art Institute of Chicago, including Richard Brettell; of the Hill-Stead Museum, Farmington, Connecticut; of the Metropolitan Museum of Art, New York, including Charles Moffett and Gary Tinterow; of the Philadelphia Museum of Art, including Joseph Rishel; of the National Gallery of Art, Washington, D.C., including Frances Smyth and Gaillard Ravenel; and of the Sterling and Francine Clark Art Institute, Williamstown, Massachusetts, including George Heard Hamilton, David Brooke and David Cass. I have also been much helped by the staff of Sotheby's and Christie's, in London and New York, and by the co-operation of many dealers, notably in New York the Acquavella Gallery, Wildenstein and Co., Stephen Hahn, Richard L. Feigen and William Beadleston; and in London the Lefevre Gallery, where Desmond Corcoran and Martin Summers have been particularly helpful and tolerant over the years.

I owe a great debt to the two people who have read and advised on my manuscript: to Sir Lawrence Gowing, who made many helpful and constructive suggestions on it at an earlier stage, and to the anonymous reader who, more recently, made many very pertinent comments which contributed much to my final revisions. At the Yale University Press, John Nicoll and Faith Hart have handled me and the manuscript with quite unwarranted sympathy, and I am indebted to Sue Adler for preparing the index.

A number of friends have at various times read parts of the book, and have offered perceptive and far-reaching commentaries which have helped me pull the arguments into shape; for undertaking this task, I must thank Kathleen Adler, Mary Beard, Christopher Green, Richard Hobbs, Jill Lloyd and Alexandra Murphy. I have learned much from them in conversation, too, as I have also from the following friends and colleagues: Juliet Bareau, Alan Bowness, Richard Brettell, David Bromfield, Lynne Cooke, Allan Ellenius, John Gage, Marc Gerstein, Robert Gordon, Anna Gruetzner, Paula Harper, Robert Herbert, Joel Isaacson, Richard Ormond, John Read, Christopher Robinson, Grace Seiberling, Virginia Spate, Robin Spencer, Mary Anne Stevens, Charles Stuckey and Linda and Jon Whitely. My friend Simon Heywood contributed much to my thinking over the years through his enthusiasm and insight; I wish he had lived to see the results. I also owe a great debt to my wife, Jill, for great support, help and forbearance, and to my children Adam and Joe; I hope that sometime they may think it was all worth while, and dedicate this book to them.

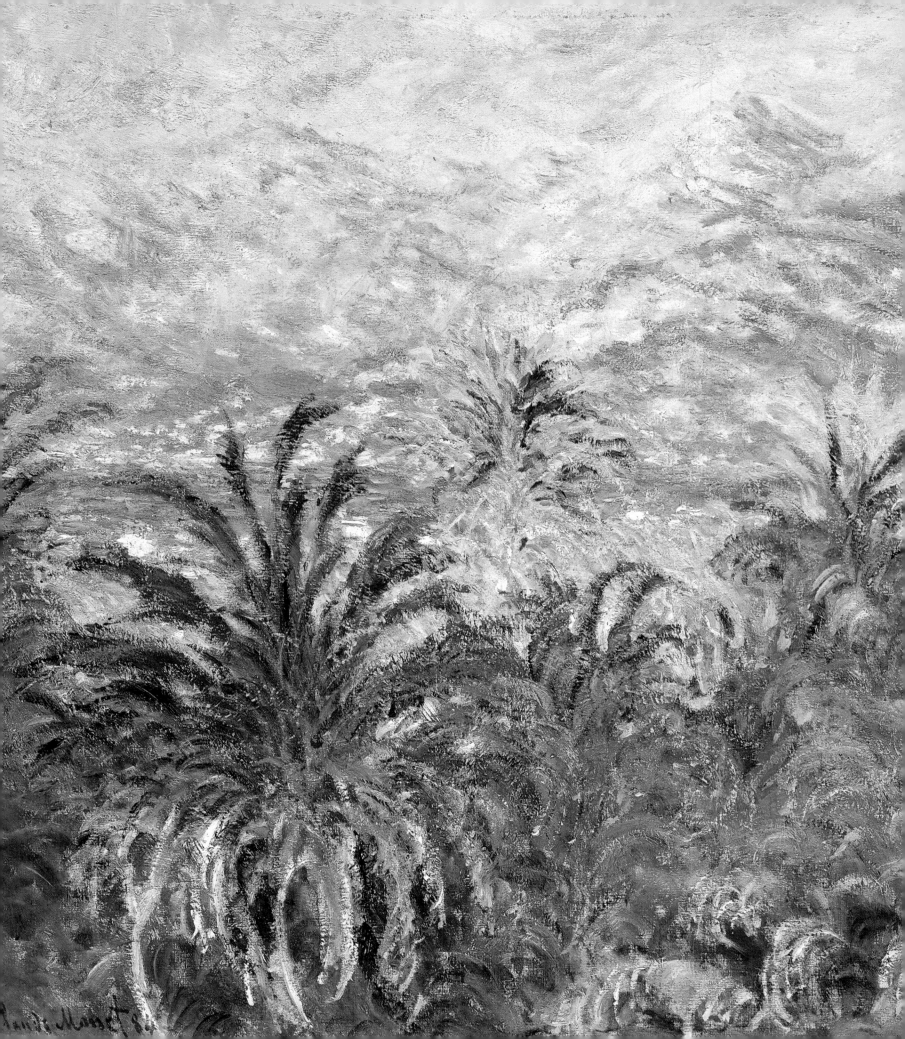

CONTENTS

Introduction 1
1 *LIFE and CAREER* 5
 PERSONAL and FAMILY 5
 FRIENDS and ASSOCIATES 6
 PATRONS and DEALERS 10
 TRAVELS 12
 MONET at HOME 12
2 *CHOICE of SUBJECTS* 15
 LANDSCAPE 15
 FIGURE PAINTING 33
 STILL LIFE 40
3 *PICTORIAL COMPOSITION*
 and CHOICE of VIEWPOINT 45
4 *BUILD-UP of the PAINT SURFACE* 63
 PRIMING of the CANVAS 63
 The 'EBAUCHE' 65
 ELABORATION of the CANVAS 69
5 *BRUSHWORK* 75
6 *COLOUR* 109
 PROVISOS 109
 AIMS and PRECEDENTS 110
 PRACTICE 114
7 *OPEN-AIR PAINTING* 135
8 *STUDIO WORK* 147
9 *MONET'S ATTITUDES to FINISH* 157
10 *MONET'S PRACTICE in FINISHING* 167
11 *PENTIMENTI* 183
12 *The EVOLUTION of MONET'S SERIES* 193
 The GENESIS of MONET'S SERIAL PROCEDURE, 1864–1889 194
 The GRAIN STACKS SERIES 197
 MONET'S MATURE SERIAL METHODS 201
13 *MONET and the PUBLIC EXHIBITION* 205
14 *CONCLUSION: NATURE into ART* 217
 Appendix A: *Monet's Drawings* 227
 Appendix B: *Outline Chronology* 231
 Notes to the Text 233
 Bibliography 247
 Index 252
 Photographic Acknowledgments 256

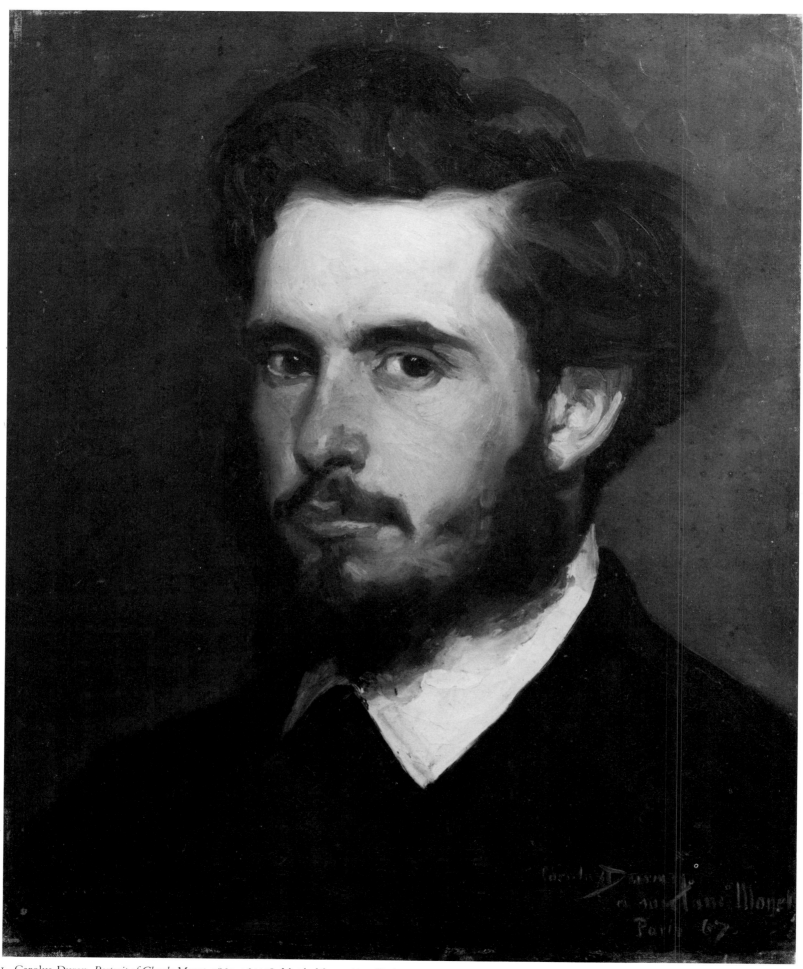

1. Carolus-Duran, *Portrait of Claude Monet*, 1867, 46 × 38, Musée Marmottan, Paris

INTRODUCTION

MONET, we are told, declared: 'I would like to paint as the bird sings.' Constable, seventy years earlier, had written of his quest for a 'natural painture'. Both artists' statements were central to their artistic programme, marking their rejection of the conventions and artifices of the exhibition painting of the day, in favour of an art rooted in direct experience of the world around them. The image of the artist going back to nature is often presented in terms of the *tabula rasa*: conventions are swept away in order to confront the external world with an innocent eye and record it on a clean slate. Monet, like many artists before him, contributed to this image, telling Lilla Cabot Perry that 'he wished he had been born blind and then had suddenly gained his sight so that he could have begun to paint . . . without knowing what the objects were that he saw before him'.

If we seek to understand their art in the contexts within which and for which it was made, we should examine such comments with care, but all too often they have been taken at face value. Subsequent discussions of Monet's art, as of Constable's, have been dogged by the notion of the 'natural painter'; there has, indeed, been a tendency to see Monet's painting as so natural that the traditional tools for analysing paintings – through iconography, composition, technique, patronage – are scarcely relevant. Any attempt to treat any type of painting as 'natural' comes up against insuperable problems, both conceptual and practical, and these problems must be clearly confronted.

All ideas of the natural are themselves historical, generated within a particular culture, and they demand historical analysis. In discussing Impressionist painting, we need to remind ourselves how unnatural the Impressionists' pictorial vision was considered by their original audiences in the 1870s; and also to recognise how closely our present-day notions of 'natural vision' are interwoven with the status that Impressionist painting has been accorded in the visual culture of twentieth-century Europe and North America. We must seek to reclaim something of the strangeness of their painting for its first viewers, and also to acknowledge the values that underlie its huge popularity today; this popularity results in part from the type of vision of the 'natural' that Impressionist painting presents, but also from the value (both commercial and cultural) accorded to the paintings themselves as cult objects.

In another sense, too, the idea of a natural painting is a contradiction in terms. Any act of formulating visual experience in terms of coloured touches on a bounded two-dimensional surface is an act of artifice, both in the selection of what to include from the myriad images that meet our eyes as we explore the visible world, and in the choice of the means of representation – of the material technique adopted. The relationship between coloured touches of oil-based colour on a rectangular surface and our binocular vision of the world is conventional and historical, not natural; only at certain moments in history has it been possible to view such images as direct visions of nature.

Attempts to treat Impressionist paintings as 'natural' also obscure the complexities of the means by which they were made. All outdoor painting, however scrupulously and dispassionately it aspires to record direct experience, involves a series of decisions which crucially determine the form it takes: the choice of subject and effect to be painted; choice of viewpoint, which (for the open-air landscapist) means establishing the composition of the picture; choice of the range of colours on the palette which are to stand for those seen in nature; and choice of the types of brush-mark which evoke what the painter seeks to express about the chosen subject. At every point, these practical decisions involve substituting wholly artificial conventions – the arrangement of coloured marks on a flat surface – for the initial perceived effect.

Further problems arise when the paintings are presented to a public and a potential market, as most of Monet's canvases were; seen in public, they will be classified and judged in relation to current debates about painting. Monet's decision to exhibit comparatively small paintings, often bright in colour and sometimes quite sketchily executed, was a calculated intervention into these debates, and a statement that pictures like these could legitimately be regarded as finished, complete works of art. His search to find outlets and markets for such canvases can only be understood in relation to the expectations of their original viewers and critics and potential buyers.

The form of the present book seeks to highlight these issues; successively, its chapters trace the stages of the production of the work of art – its conception, execution, completion and presentation. Within each chapter, the treatment is largely chronological, examining Monet's changing approaches to particular problems, and presenting them in relation to contemporary debates and practices. Each chapter stands in a sense as an independent account, but it is very misleading to view the stages which have been isolated for

discussion as distinct and separable. All are stages in a continuous material process, and they are united by certain recurring threads; to isolate one point at the expense of another distorts the whole. Two particular points about the division of the chapters need stressing at the outset: Chapter 2, on Monet's subject matter, precedes the discussion of the paintings themselves, although the content of the works is inseparable from the ways in which it was expressed; and the discussion of patrons, dealers and exhibitions (Chapter 1, pp. 10–12, and Chapter 13) frames the central and largest section of the book where such commercial concerns play a subsidiary role, although Monet's whole strategy as an artist was integrally bound up with his concern to market his work, and with the various frameworks within which he might find buyers, or they might find his paintings.

Monet's activities form the central theme throughout the book, and are analysed in detail, with brief reference to his colleagues. But the close study of a single artist's methods will also, I hope, bring into sharper focus some of the key issues in the practice of French nineteenth-century landscape painting – issues about subject matter and about methods. The question of modernity in painting is central here, whether this lay in the choice of a distinctively contemporary subject, or rather in the qualities of the painting itself – in the ways in which the painter realised the work of art. The questions about methods descend directly from traditional polarities in French painting: between drawing and colour; between colour and chiaroscuro, and, most significantly, between spontaneity and finish.

This last network of debates, between the work of art as the direct expression of the painter's feelings and inspiration, and the finished painting as a demonstration of flawless skill, went back, like the others, to the debates of the seventeenth century between the supporters of Rubens and Poussin, but the arguments gained a fresh relevance in the mid and later nineteenth century for various reasons. Contemporary philosophy, particularly among those of Positivist persuasion, was re-examining the status of sense perceptions – the relationship between seeing and knowing. These concerns raised crucial questions for the painter, about the relationship between the experience of the visible world and the work of art which claimed to recreate it: should it seek to convey the effect of the viewer's immediate perceptions, or to distil a more ordered, but synthetic, image of the world? The debate between spontaneity and finish was also closely bound up with changing patterns in the art market. The profile of the artist's production was no longer dominated by the long-standing opposition between preparatory sketch and large exhibition picture; there was a growing market for smaller pictures, complete but less elaborately finished, whose relation to the 'aesthetics of the sketch' was a question for constant exploration. These debates are the essential context for the genesis of Impressionism, and the details of Monet's practice as a painter highlight the issues involved.

Concentration of these issues has led me to focus in particular on the middle years of Monet's career, from the 1870s to the 1890s. His ambitious attempts of the 1860s to become a celebrated Salon painter form the starting point, but the history of the search for a grand modern painting during this decade is best written comparatively, treating many artists side by side; this is the subject for another book. It was only after 1870 that Monet began more consistently to explore a particular type of picture-making – the smaller-scale open-air landscape; and it was these explorations that developed from, and in turn contributed to, the debates about the relationship between nature and art. The practical problems he encountered in painting out of doors, from his ever increasing capacity to discriminate between the minutiae of natural effects, forced him to reconsider the relationship between the landscapist's visual experience and the finished work of art; but at the same time the demands of his markets and his critics were encouraging him to produce more elaborated, resolved pictures that went beyond the initial rapid notations of a natural effect. The relationship between verbal debate and pictorial practice was never one way; each informed the other, and any attempt to give consistent priority to either will misrepresent the development of Monet's art.

The changes which took place in the work of the Impressionist group from the late 1870s onwards have been characterised as the 'crisis of Impressionism'; sometimes this is located in the 1880s as a whole, sometimes in a narrower period around 1880. This 'crisis' is described as a phase when the artists came to question many of their basic assumptions – about the value of painting out of doors, about what subjects they should treat, about how to display and market their work. But this notion of a crisis is misleading: there was no single moment when all these questions simultaneously came to a head; and, more significantly, the debates about these issues were essentially continuous, involving constant discussion and disagreement, in which points of view were formulated, questioned and reformulated. The historian's task, in dealing with these questions, is to unravel the changing patterns of debate and practice. Certainly they may be studied by isolating the 'state of play' at a particular moment, but this must be seen as an abstraction from a continuous process, not as a fixed, definite point; the notion of a 'crisis' seems to enshrine just such a static point within a dynamic process.

Much of the account that follows is presented from the ostensible viewpoint of Monet himself, and is couched in terms of his purposes or intentions. By presenting the material in this way, I do not mean to suggest that Monet himself would have viewed the course of his career as a sequence of clear-cut decisions, or that he would have described the evolution of his art in the terms used here. The starting point is the paintings themselves, and what we know of the circumstances of their production and public presentation, and I aim to use this material in order to present his artistic strategy in its historical context; but the structure of the argument is, of course, my own, and inevitably the product of the concerns and debates of the late twentieth century.

At times the account is heavily supported by quotation from the artist's own words, but such material is never neutral: with his letters we must ask how far he is tailoring his account to the concerns of his correspondent (most frequently his dealer or the woman with whom he lived); with interviews, we must consider the image he wanted to project, and whether the reporting is likely to have been accurate. Such questions are vital when we read what may at first sight appear as transparent primary evidence, the 'voice of the artist'. I have tried to present Monet's own pronouncements in the context of other contemporary discussions of the same issues, seeking to establish the terms of reference then current. But sometimes the verbal framework is largely my own, when the pictorial conventions he adopted were not clearly formulated in words, either by Monet or by his contemporaries; this is particularly the case in the chapters on composition and brushwork, where many of the distinctions drawn are couched primarily in the vocabulary of the later twentieth century. And even where verbal material from the nineteenth century is extensively used, my verbal glosses on it, like the larger structure of the argument, inevitably belong to the present.

Hindsight has introduced particular problems in the study of

Impressionism. The twentieth-century apotheosis of Impressionist painting has marooned it from the art of its contemporaries, as the prime material for 'great' museums, 'great' individual collectors and blockbuster exhibitions, and no longer as just one expression of a multifarious visual culture. Moreover, the language used to discuss it reflects the status that has subsequently been bestowed on it as one of the prime sources of the modernist tradition, with its overriding concern for the pictorial qualities of the work of art, stripped of the conditions of its production and its social and economic context. Historians are now trying to reclaim this lost territory; the result of this reclamation will not be to lessen the significance of the Impressionists' paintings, but to redirect our understanding of them, so that we can see more clearly how they redefined the theory and practice of landscape and modern-life painting. But we cannot simply rid ourselves of the accretions of Impressionism's subsequent reputation, for the myths which have grown up around it inevitably condition the patterns of argument we use when we seek to demythologise it. The present book is, indeed, a further monographic study of a 'great' artist; my hope is that this detailed analysis of his practice will contribute to the reassessment of the work of the Impressionists as an integral part of the artistic activity of their time.

Finally, a word about the role of illustrations in this book. Reproductive processes have given us ever-increasing access to visual material, but the easy availability of such reproductions – particularly colour photographs, slides and films – gives an illusory sense of security. Clearly, reproductions cannot reveal every detail that can be seen in the original, but their implications may be more positively damaging, in giving a false sense of scale, texture and values, and a wholly misleading idea of the relationship of the image to its surroundings: they give no access to the physicality of the picture. Moreover, when we meet them in a book, we are asked to take them on trust, and can rarely check them against the original painting. I have seen the original of every painting discussed in detail in this book, but the illustrations which accompany the discussions can in no way replace the experience of the painting itself. I can only hope that this text, with its illustrations, will encourage its readers to return and return again to whatever originals they can see; and that the approaches to the paintings which it suggests will enrich the viewer's experience of them – not only as objects of pleasure in the present, but also as the products of a particular cultural situation in the past.

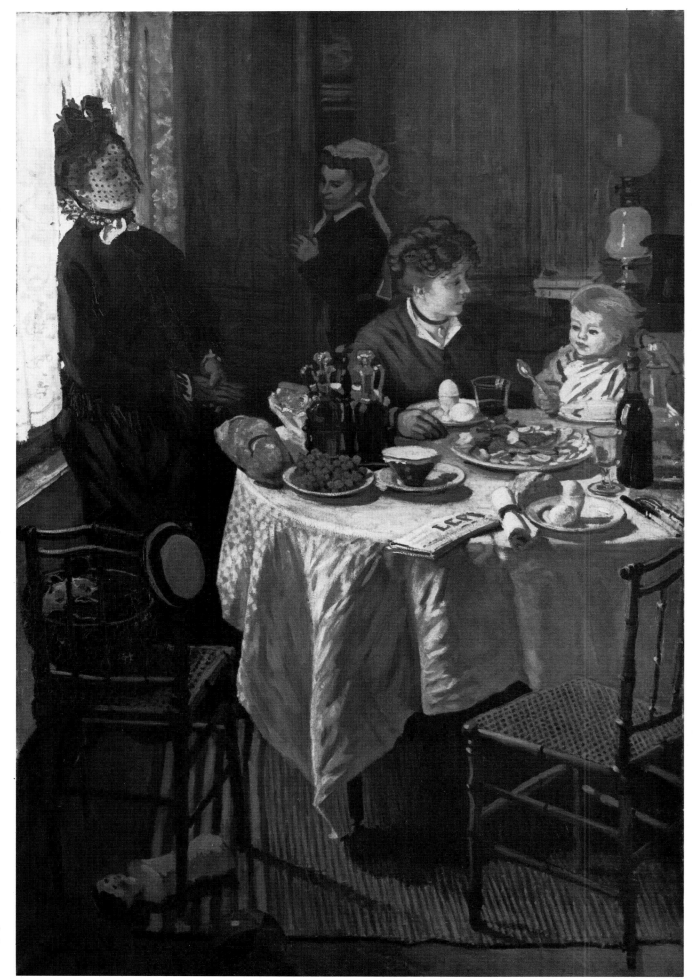

2. *Luncheon*, 1868,
230 × 150, W 132,
Städelsches
Kunstinstitut,
Frankfurt

CHAPTER ONE
LIFE and CAREER

MONET presented himself in many different guises through his long career – from his gregarious youth leading the Bohemian life in Paris to the privacy of his old age as the patriarch of his family and gardens at Giverny. All through his life, too, there were apparent contradictions in his behaviour: loyal friendship alternated with unabashed self-interest, and the perceptive conversationalist whom one interlocutor met might, soon after, appear to another as mono-syllabic, even truculent. His art much affected his moods; his letters when he was painting away from home suggest that he used an almost constant dissatisfaction as a spur to yet further efforts, and in later years his family at Giverny often felt the aftermath of an unsuccessful day's work. Monet's life revolved around his art; a brief discussion of the contexts in which he operated will set the scene for the discussion of his art.

PERSONAL and FAMILY

Monet was born in Paris in 1840, but around 1845 his family moved to Le Havre on the Seine estuary, where his father Adolphe began to work in his brother-in-law's wholesale grocery business. Monet's mother died in 1857, and thereafter he spent much time with an aunt, Marie-Jeanne Lecadre, who, unlike his father, sympathised with his artistic interests; it was doubtless her support which enabled him to spend a year in Paris in 1859–60. Monet's military service in the clear light of Algeria with the Chasseurs d'Afrique in 1861–2 seems to have encouraged his ambitions as a landscapist, and on his return it was probably his aunt, again, who persuaded his father to give him an allowance to live in Paris, on condition that he study painting with the celebrated academic teacher Charles Gleyre. Monet's reluctance to study and his wayward behaviour led his father on several occasions to withdraw his financial support, but he seems to have still been receiving money from his family as late as 1869.[1]

Probably in 1865 Monet began a relationship with Camille Doncieux, a young girl who had recently moved from Lyons to Paris with her parents. They seem to have lived together when they could afford it, but when Camille gave birth to their first child, Jean, in Paris in August 1867, Monet was penniless and back with his family in Le Havre. Sales to a local collector, Louis-Joachim Gaudibert, enabled them to set up house together at Etretat on the Channel coast in 1868–9 (see pl. 2), but by summer 1869 they were

again virtually penniless, and living together at Saint-Michel, near Bougival in the Seine valley west of Paris. They were married in Paris in summer 1870, but that autumn the Franco-Prussian War and the threat of conscription persuaded them to flee the coastal resort of Trouville, where they were honeymooning, and take refuge in London. Having returned to France via Holland, they set up house late in 1871 at Argenteuil (see pl. 3), on the Seine just downstream from Paris, a convenient base, within easy reach of Paris by train to the Gare Saint-Lazare. They were briefly prosperous while the dealer Paul Durand-Ruel bought Monet's work in 1872–3, but thereafter their finances were very uncertain, depending on Monet's piecemeal sales to private collectors. In the mid-1870s, Monet developed close relations with Ernest Hoschedé, an apparently wealthy business man who played artistic Maecenas, and his wife Alice; he stayed with them at their country house at Montgeron to the east of Paris in autumn 1876, working on an ambitious sequence of decorative canvases (including pls. 4 and 5). Hoschedé, however, went bankrupt in 1877, and in summer 1878 his family and Monet's decided to pool their meagre resources.[2]

The families moved together to Vétheuil (see pl. 188), a village on a secluded loop of the Seine over forty miles downstream from Paris. Monet kept a modest pied-à-terre in Paris until 1882, where he could show his paintings to prospective patrons, since he could no longer readily invite them to visit him at home, as he had at Argenteuil; but he often let several months pass without visiting the capital. Camille had given birth to a second son, Michel, in March 1878, shortly before the move to Vétheuil, but thereafter her health deteriorated quickly, as a result, it seems, of a longstanding disease of the womb. She died in September 1879, leaving Monet and Alice Hoschedé to look after her six children and Monet's two; Ernest Hoschedé gradually cut himself off from his family, preferring an impecunious bachelor existence in Paris. This unconventional ménage, and the rumours that grew up around it, probably contributed to Monet's comparative isolation from his former colleagues around 1880.[3] The two families moved together in 1881 to Poissy, on the Seine rather nearer Paris, and then in 1883 to Giverny, a small village overlooking water meadows a mile from the Seine about fifty miles north-west of Paris. Monet's and Alice's decision to remain together after Camille's death and Ernest's departure gave their relationship an air of permanence, though on occasion in the 1880s they still felt doubts about their future together, and they still

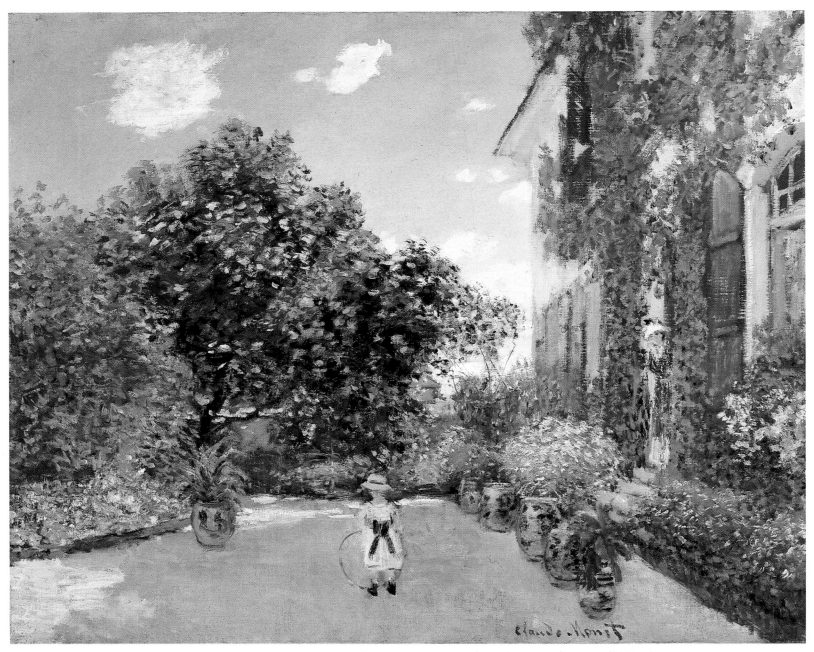

3. *Monet's House at Argenteuil*, 1873, 60.5 × 74, W 284, Art Institute of Chicago. Jean is seen standing in the garden, with Camille in the doorway.

lived, nominally at least, separate lives. Short trips together to Paris seem to have given them the freedom which the presence of their families denied them at home until, after Ernest's death in 1891, they were able to marry in 1892. During the 1880s the presence of Alice at home, willing to look after his children but not tied to him by any formal commitment, allowed Monet to make long trips the length and breadth of France in order to paint; these trips became far less frequent after their marriage. From the 1890s onwards their home life at Giverny acquired the image of a prosperous bourgeois ménage, aided by Monet's increasing wealth, which allowed them to entertain their chosen friends in considerable style. Alice died in 1911, followed in 1914 by Monet's elder son Jean; Jean had married Alice's second daughter Blanche, who in her widowhood returned to the family home to look after the ageing painter, who died in 1926.

FRIENDS and ASSOCIATES

The pattern of Monet's friendships related so closely to the artistic circles in which he operated that it is hard to draw a distinction between his personal and professional life. Most of his contacts focused on the Parisian art world, with which he remained closely in touch, until during the 1890s, with his reputation at last established, he could afford to play a less regular part in the artistic acitivities of the capital.

Monet's meeting with the local landscapist Eugène Boudin in Le Havre around 1856 first launched him into an artistic circle, opening his eyes to the possibilities of landscape painting, which supplanted his teenage activities as caricaturist of local notables.[4] Initially through Boudin, he became one of the painters who in the

1860s made the Normandy coast their prime subject – a group whose activities revolved around the Ferme Saint-Siméon at Honfleur. The most important of the others was the Dutchman Johan Barthold Jongkind, whom he met in 1862, and who, with Boudin, played an important part in popularising paintings of the Channel coast. Monet remained closely in touch with this group throughout the 1860s.[5]

At the same time he was developing contacts in Paris. On his first visit there in 1859–60, through his art-loving aunt he got to know Amand Gautier, a member of the Realist circle who had recently won Baudelaire's praise for his *Sisters of Mercy* at the 1859 Salon; he also met the animal painter Constant Troyon, a friend of Boudin, and at the Académie Suisse, a free studio, he made his first contact with Camille Pissarro, later one of his closest colleagues. At the same time he made a precocious appearance in the Parisian *vie de bohème* at the Brasserie des Martyrs. However, it was only in 1862–4, during his time in Gleyre's studio, that he first became part of a group of likeminded contemporaries; first to become his friend was Frédéric Bazille, son of a prosperous agronomist and vine-grower from the South who supported his son's artistic ambitions, followed by Pierre-Auguste Renoir, son of a tailor, and Alfred Sisley, son of a silk-merchant of English ancestry. These four built up a close comradeship, often sharing Bazille's studio at needy moments; Bazille remained Monet's closest friend as his paintings of his studio interior of 1865–6 (pl. 6) and 1867 testify; the two men's paintings hang side by side on the walls; and when Renoir painted Bazille at work in 1867, a snow scene by Monet hung beyond him. By around 1865 Monet was also on close terms with Gustave Courbet, participating eagerly, it seems, in the older artist's celebrated Bohemian life style. At times, though, Monet's importunate demands for financial support clearly got on Bazille's nerves, and Courbet, too, was asked for loans.[6]

By the end of the decade, Monet was painting on occasion with both Renoir and Pissarro, in the villages and pleasure resorts around Bougival and Louveciennes, west of Paris, notably with Renoir at La Grenouillère in 1869. However, the clearest indication of the range of his contacts in these years appears in two studio interiors of 1870 – Bazille's informal evocation of life in his airy studio (pl. 7), and Henri Fantin-Latour's ambitious group portrait, *A Studio in the Batignolles Quarter*, where Monet, Bazille, Renoir and others look on as Edouard Manet paints. Manet was initially suspicious of the similarity of their names, but by around 1868 he had become a friend and supporter of the younger man. The two studio paintings of 1870 also bear witness to Monet's presence in the circle of artists and writers who met regularly at this time in the evenings at the Café Guerbois in the Grande Rue des Batignolles. Of the writers in this circle, Emile Zola and Zacharie Astruc were already friendly with Monet.[7] But he found that the constant discussions of Parisian café life were difficult to reconcile with his developing practice as a landscapist, seeking to work directly from nature; he wrote to Bazille in December 1868 from Etretat: 'One is too preoccupied with what one sees and hears in Paris, however strong-minded one is, and what I shall do here will at least have the merit of being unlike anyone else, at least I think so, because it will simply be the expression of my own personal experiences.'[8]

We cannot, though, assume that Monet's contacts with these friends – themselves figures whose reputations have stood the test of time – give a representative picture of his associations during the 1860s. Discussion of the early careers of the artists who were to form the Impressionist group in the 1870s has been dogged by a tendency to focus primarily on their relationships with the other Impressionists-

4. *The Hunt*, 1876, 173 × 140, W 433, Private Collection. The second figure from the front is Ernest Hoschedé.

5. *The Turkeys*, 1876, 172 × 175, W 416, Musée d'Orsay, Paris. In the background is seen the Hoschedés' house, the Château de Rottembourg at Montgeron.

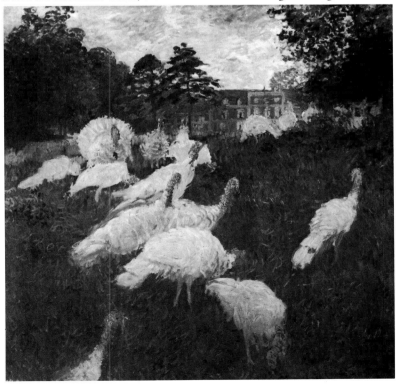

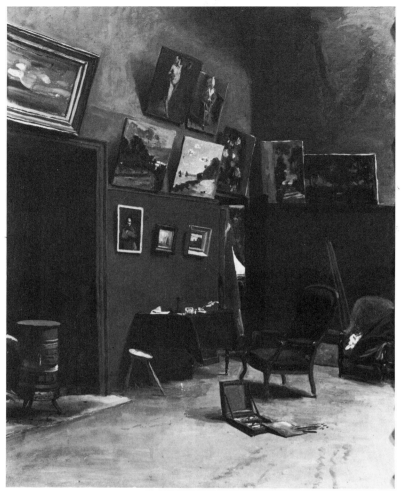

6. Bazille, *Studio in the rue Furstenberg*, 1865–6, 80 × 65, Musée Fabre, Montpellier

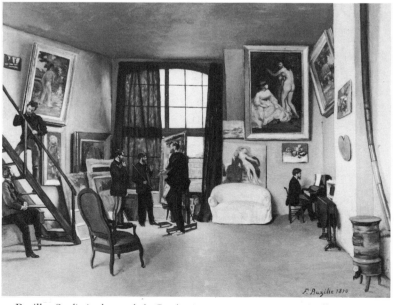

7. Bazille, *Studio in the rue de la Condamine*, 1870, 97 × 127, Musée d'Orsay, Paris

to-be, before the group as such had any existence, at the expense of their contacts with other artists who were not to become part of the later group, or whose careers have not undergone close historical scrutiny.[9] One hint that Monet's circle of friends was wider than this, and rather different in character, is the portrait of him painted

by Carolus-Duran in 1867, inscribed 'Carolus-Duran to his friend Monet, Paris 67' (pl. 1). Carolus-Duran, three years Monet's senior, was exhibiting large history paintings at this date, but was about to turn to the fashionable portraiture which made his fame in the next decades. Many other such friendships from Monet's youth may have left no visible trace; despite the mass of documentation we have from the nineteenth century, it is evidence from informal friendships like these between young artists who met often without prior arrangement that can so easily disappear into oblivion.

Bazille's death in one of the more futile engagements of the Franco-Prussian War robbed Monet of his closest comrade while he himself was in the safety of his refuge in London. His meeting with Pissarro in London must have strengthened the ties between them. For the decade that followed, we have little detailed information about his contacts; he and his friends, living in and around Paris, met regularly and thus rarely needed to write to each other. During these years he was, it seems, most closely tied to the group of painters who exhibited with him at the independently organised exhibitions which they mounted from 1874 onwards as an alternative to the annual Salon – particularly Renoir, Pissarro, Sisley and Degas; Manet too was a staunch friend, though he continued to exhibit at the Salon. At Argenteuil, Monet painted on occasion with Manet, Sisley and Renoir (pl. 8); in Paris, the group and their associates met at the Café Guerbois, and then at the Café de la Nouvelle-Athènes in Place Pigalle, which succeeded it as their main meeting place later in the decade.

Monet's move to Vétheuil in 1878 and his increasing disenchantment with the results of their independent exhibitions led him to sever his regular links with the café set. His works were only included in the 1879 group exhibition through the efforts of Gustave Caillebotte, the wealthy painter and collector who had exhibited with them since 1876; Monet abstained from their exhibitions in 1880 and 1881. This, together with his submission to the official Salon in 1880, caused considerable bitterness, since the group had instituted their exhibitions as an attempt to create a viable alternative to the Salon. These feelings were expressed in a scurrilous report, whose authorship was never admitted, in the daily paper *Le Gaulois* in January 1880, announcing Monet's demise as an Impressionist, and the appointment of Jean-François Raffaëlli, painter of the Parisian poor, as his successor. Monet voiced his own dissatisfaction with the group in an interview later in the same year: 'Only very rarely do I see my colleagues, men or women. The little church has today become a banal school which opens its doors to the first dauber who comes along.'[10]

Monet's ménage with Alice Hoschedé may also have contributed to his isolation in 1880, but this was a passing phase. His contacts with Paris became more regular from 1881 onwards, principally because the dealer Durand-Ruel began again to buy his work. It was Durand-Ruel who brought him together with his old colleagues in 1882, by organising the seventh Impressionist exhibition for the 'old guard' of the group. Thereafter Monet remained in touch with most of his past associates, though he only met them irregularly, mainly when their paths happened to cross in Paris.

He lost a close friend on Manet's death in 1883 and was the only Impressionist to be a pallbearer at his funeral. Thereafter it was Renoir who, until his death, remained Monet's closest friend, apparently the only one to call him *tu*. Monet did not find it easy to paint in proximity to Renoir, and often disagreed with him on matters of principle – about the role that nature should play in art, about the attitude that they, as self-declared independents, should take to

honours offered by the State, about the guilt of Dreyfus; but, despite Renoir's increasingly vociferous conservatism, they remained devoted comrades.[11] With Pissarro, Monet's relations were less smooth in the 1880s, initially because Pissarro insisted that his protégés Gauguin, Guillaumin and Vignon should be included in the 1882 group exhibition, and then as a result of his incessant propaganda in 1886–8 for the 'scientific' Neo-Impressionism pioneered by Georges Seurat, with its pointillist application of paint. After 1890, though, Pissarro became almost as much of a friend as Renoir.[12] Caillebotte, too, remained a close friend, partly because of a shared passion for gardening and boating.[13] Less frequent were Monet's contacts with Sisley and with Cézanne. He was close enough to Sisley in 1881 to consider moving to his neighbourhood at Moret, near the Forest of Fontainebleau, but he met him rarely thereafter, as Sisley withdrew from contact with his fellow artists; however, he played a leading part after Sisley's death in 1899 in organising a sale for the benefit of his children.[14] Monet had known Cézanne since the early 1860s, but without becoming a close associate; he visited him with Renoir in the South in 1883, and Cézanne visited Giverny in 1894, and probably also in 1885, but their meetings were few, although they remained staunch admirers of each other's work.[15]

During the 1880s Monet's dealings with Durand-Ruel and his participation in the rival dealer Georges Petit's *expositions internationales* brought him into contact with artists of more diverse backgrounds. It was at Durand-Ruel's around 1884–5 that he became friendly with John Singer Sargent, and probably also with Paul Helleu, both of whom he had first met around 1876; they were both to win their fame primarily as portraitists, but both produced outdoor figure paintings that reflected their admiration of Monet. Sargent was one of his most regular guests at Giverny in the later 1880s (pl. 9), and Helleu, along with Caillebotte, was a witness at Monet's wedding to Alice Hoschedé in 1892.[16] The number of painters whom Monet knew by the late 1880s can be seen from the list of subscribers to the fund he organised for the purchase of Manet's *Olympia* for the nation in 1889–90. Those that survive of Monet's requests for contributions and of the replies to them show that he was on

friendly terms with many of the fashionable painters who exhibited modern subjects at the Salon – many of them also fellow-exhibitors at Petit's.[17] It was in these years, too, that Monet became friends with two artists whom he had probably met many years before – Whistler and Rodin, both of them exhibitors at Petit's. Monet visited London to see Whistler in 1887, while the exhibition that he shared with Rodin in 1889 at Petit's gallery greatly enhanced both of their reputations. Less happy was a visit Rodin paid to Giverny, when his staring so disconcerted Alice Hoschedé's daughters at dinner that they all had to leave the room.[18]

From the mid-1880s Monet participated in two social rituals which kept the Impressionist group together and extended his sphere of acquaintances to include the writers of the younger generation. It was through the Thursday dinners organised by Berthe Morisot, a loyal exhibitor at the group exhibitions and Manet's sister-in-law, that Monet met Puvis de Chavannes and got to know Stéphane Mallarmé well.[19] At the same time monthly Impressionist dinners were held at the Café Riche, which included, alongside many of the original group, the writers Octave Mirbeau, Joris-Karl Huysmans and Gustave Geffroy. Monet also occasionally joined in other literary dining circles in the later 1880s, meeting such writers as Octave Uzanne, Edmond de Goncourt and Léon Daudet.[20] The journalist and art critic Geffroy, whom he first met by chance on the Breton island of Belle-Isle in 1886, became a particularly close comrade and Monet's biographer; he in turn introduced Monet to the poets Maurice Rollinat and Francis Jourdain, and reintroduced him to the politician Georges Clemenceau, who was to become the great friend and supporter of his old age. Guy de Maupassant, too, was an acquaintance of these years.[21]

After his marriage to Alice Hoschedé in 1892, Monet visited Paris less, but began more regularly to entertain his friends at home at Giverny. In his early years at Giverny, he struck up easy relations with some of the American painters who came to the village, notably Theodore Robinson and Lilla Cabot Perry; but his gates soon closed once the small group of Americans had spawned a large colony, all of them aspiring to Monet's friendship and trying to

8. Renoir, *Monet painting in his Garden at Argenteuil*, 1873, 46 × 60, Wadsworth Atheneum, Hartford

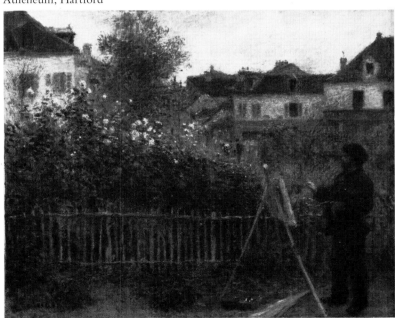

9. Sargent, *Claude Monet painting at the Edge of a Wood*, ?1885, 54 × 65, Tate Gallery, London

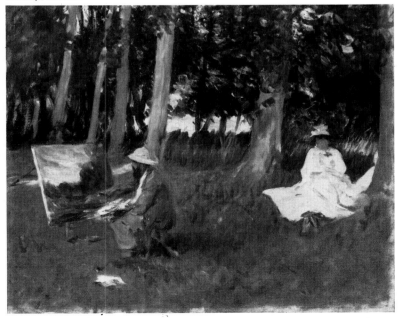

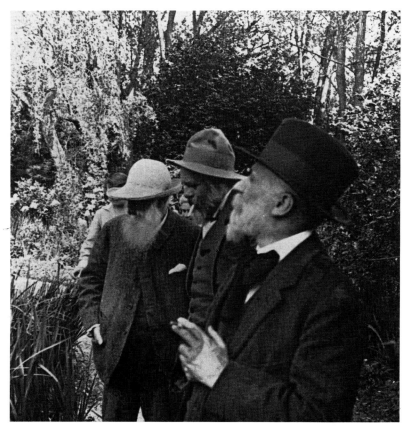

10. Photograph of Monet, Roussel and Vuillard at Giverny, 1920

watch him as he painted.[22] It was at Giverny, too, that as he grew older, young French painters tried, with more or less success, to impress the master: Pierre Bonnard, Edouard Vuillard and Ker-Xavier Roussel, in particular, won his favour (pl. 10), but Maurice Vlaminck's visit was a disaster; Monet thought him 'the biggest brute I've ever seen'.[23] In his last years, too, the pilgrimage to Giverny was made by many artists, writers and journalists; some of them gained much of Monet's time and attention, but many had to be content with a glimpse of the master and his water garden through closed gates.[24]

PATRONS and DEALERS

Like many other young artists in the 1860s, Monet found difficulty in deciding how best to advance his career within a free market structure. To win a reputation he needed success at the Salon, still by far the most significant shop window for modern painting, where only large, ambitious paintings were likely to draw attention to an unknown artist. However, it was smaller, more domestically scaled canvases that stood a greater chance of finding a buyer, among collectors who increasingly belonged to the commercial and professional urban middle classes, generally with only the limited wall space of city apartments to house their collections. It was during Monet's career that such smaller paintings first found a consistent market through the emergence of commercial picture dealers who made such canvases their stock in trade. It was during these years, indeed, that picture dealing first became an autonomous profession: in 1860 all but a very few dealers sold pictures merely as a sideline alongside other goods (such as painters' materials, frames, stationery

or ornamental goods), but by 1900 the professional art dealer played a central role in the art market, and was beginning to supplant the big annual 'shop window' exhibition as the prime means of bringing art before a public.[25]

For the first two decades of his career, Monet had no consistent outlet for his paintings. In the mid to later 1860s he tried to establish contact with likely collectors, with much help from his friend Bazille, who tried to interest the wealthy collectors of his own social circle in Monet's work, both in Paris and in the South, where Alfred Bruyas of Montpellier, Courbet's celebrated patron, could not be persuaded to buy.[26] But he made few sales – occasional canvases to a private buyer or a dealer; he did, it seems, manage to sell his first two Salon paintings to the dealer Cadart for 300 francs each in 1865, and one of his Paris views to Latouche in 1867, but such successes were rare. Only in late 1868, when Arsène Houssaye, director of the periodical L'Artiste, bought his large portrait of Camille, shown at the 1866 Salon, for 800 francs, and the Gaudibert family from Le Havre were also supporting him, can he have held even short-lived hopes that the tide was turning in his favour. However, his attempts to make further sales in Le Havre came to nothing, although he had won a silver medal at the International Maritime Exhibition there in autumn 1868; nor did Houssaye's purchase encourage other Parisian buyers.[27]

In London late in 1870 Monet met the dealer Paul Durand-Ruel, who had also taken refuge there from the Franco-Prussian War; Durand-Ruel was already buying works by the painters of the Barbizon School, and was keen to turn his attention to younger landscapists. This led to a brief period of security for Monet, when Durand-Ruel bought many paintings from him in 1872–3, as he did from Manet, Pissarro and Sisley; at the same time, Monet also sold a few canvases to other dealers. But Durand-Ruel stopped buying from the Impressionists around the end of 1873, because he had over-extended himself on purchases and had failed to find buyers.[28] Thereafter, until the end of 1880, Monet had to earn his living the hard way, by hawking his paintings around to prospective buyers. In the mid-1870s his mainstay was the celebrated operatic singer Jean-Baptiste Faure; Ernest Hoschedé bought extensively, particularly between summer 1876 and summer 1877; otherwise his most regular supporters between 1876 and 1879 were Caillebotte and the homeo-pathic doctor Georges de Bellio, while quite a number of collectors bought the occasional canvas. His attempts to sell at auction in 1875 and 1877 met with little success. Monet's earned income rose to almost 25,000 francs in 1873, when Durand-Ruel's purchases were at their height, then fell to around 10,000 francs in 1874 and 1875; from 1876 to 1879 it varied between about 12,000 and 15,000 francs.[29] Comparisons between nineteenth-century and twentieth-century financial figures are notoriously tricky, because of huge changes in the relative costs of many items in the regular budget, and changes in the significance attributed to various commodities and services; but it seems that an income of 10,000 francs or above in France in the 1870s was adequate for a reasonably comfortable bourgeois existence.[30] However, the many letters begging his friends to lend him money or to buy a painting cheaply show that he was often short of ready cash, and had to spend time touting for buyers in Paris; many more such letters were doubtless destroyed by their recipients. One of the many surviving appeals to de Bellio will give some idea of the way in which Monet presented his circumstances: 'I didn't dare say it yesterday, since I was afraid of abusing your good will; but I'm in a very difficult situation, without a sou to hand and not knowing where to find any. I had absolutely no success

yesterday. So I'm writing to you, begging you to excuse my indiscretion. Would two sketches of the type and size of your *Bridge*, for 150 francs the two, take your fancy? This would tide me over my difficulties for the moment. Forgive me not coming myself, but I don't want to take advantage of you, and I'm feeling rather ashamed; so please be so kind as to give your reply to the porter. Once again, forgive me.'[31] Monet's notebooks show that at times he accepted minimal prices for canvases – down to 25 francs for a sketch and 50 for a finished painting: in December 1877 he sold five sketches to the pastrycook–collector Eugène Murer for 125 francs the lot, and promised him four further finished paintings for 200 francs in all. The notebooks show, too, that his friends sometimes made him loans or advances of as little as a seemingly derisory five francs, or even one franc – little more than the cost of a one-way rail ticket from Paris to Argenteuil. However, the overall level of his income in these years suggests that his problems were more the result of improvidence rather than of genuine poverty.[32]

At the end of 1879 a fresh ray of hope appeared when the dealer Georges Petit first purchased a small group of paintings. Petit probably contributed to Monet's decision to submit again to the Salon in 1880, and he urged him not to go on selling at low prices to all comers; Monet promptly wrote to de Bellio, his mainstay for several years, to tell him that his supply of inexpensive paintings had come to an end.[33] Though Petit did not at the time begin to buy regularly, Monet's circle of patrons widened in 1880 as the result of his one-man show in the offices of the publisher Georges Charpentier's fashionable magazine *La Vie moderne*. However, the great change in his fortunes, which allowed him to alter the pattern of his life, took place in February 1881, when Durand-Ruel again began to buy his paintings, as a result of an injection of capital from the Union Générale bank. Durand-Ruel transformed Monet's finances: in 1881 his income from Durand-Ruel alone was almost 20,000 francs, in 1882–5 between about 25,000 and 35,000 francs each year, despite the collapse of the Union Générale which threatened Durand-Ruel's future.[34] Though Monet's letters to the dealer still on occasion show him short of ready cash, Durand-Ruel's regular payments made possible his travels of the period – both by financing them, and by sparing him the necessity of being his own salesman. Durand-Ruel now found most of his new patrons, who generally bought his paintings through the dealer. Further buyers may have come Monet's way through his brother Léon, a chemist in Rouen, who seems to have recommended his work among his own clientèle.[35]

But Durand-Ruel's purchases did not guarantee him exclusive rights to Monet's work; he never had any contract with the artist, who felt free to deal on his own if he chose. Even when Durand-Ruel had just resumed massive buying of his work in 1881, Monet, without warning the dealer, offered first choice of his latest paintings, of the coast at Fécamp, to another (unidentified) buyer. Later in the decade, he would not allow the collector Hayem to buy directly from him and thus undercut Durand-Ruel's prices, but he did sell a painting to the painter Charles Giron: 'It's between us, isn't it, the little sale of *The Church at Vernon*, for the reasons I mentioned to you, and to avoid a precedent because of Durand-Ruel.'[36] Such behaviour characterised Monet's commercial dealings at this period, and sometimes soured his relations with Durand-Ruel. During the 1880s, when at last there was some demand for his paintings, he was willing to play off prospective buyers against each other; his plans for exhibitions, like his dealings, were also dominated by self-interest, even when this led to conflict with the interests and wishes of his friends and associates.[37]

Monet broke off dealings with Durand-Ruel in 1887 because he disagreed with the dealer's policy of exporting the latest Impressionist paintings to the United States. However, this was a gesture he could now afford to make, since he had renewed his dealings with Petit in 1885, and in 1887 received 20,000 francs from another source, the fashionable dealers Boussod & Valadon (formerly Goupil), in the person of their branch manager Théo van Gogh, brother of the painter. Indeed, from summer 1888 until early 1889 Boussod & Valadon had some sort of contract with Monet – apparently the only dealers ever to do so.[38] Until late in 1890, when Monet began again to sell to Durand-Ruel, Boussod & Valadon and Petit ensured his finances. It was during these years that his work at last began to sell more quickly to collectors, and to make higher prices. The prices that Durand-Ruel paid for his landscapes had gradually increased through the decade, from around 300 francs for a normal-sized canvas in 1881 to 500–800 in 1884; Boussod & Valadon paid him 1,200–1,500 per picture in 1887, rising to 2,000–2,500 in 1889, and 3,000 upwards in 1891–2. Most of the paintings that Durand-Ruel bought up to 1886 remained in his possession into the 1890s, but Boussod & Valadon managed to sell what they bought quickly and for substantial profits. These rising prices were partly the result of Monet's appearance in Petit's fashionable *expositions internationales* in 1885–7, and partly of the big Monet–Rodin show which Petit mounted in 1889; but paradoxically his real financial breakthrough was ensured by the success of Durand-Ruel's sales campaign in the United States, at just the moment when Monet was refusing to sell to him because of it. Durand-Ruel's first New York exhibition in 1886 found several new buyers for his work, and the Paris Exposition Universelle of 1889 brought these and other American collectors to Paris; the records of Durand-Ruel's firm and of Boussod & Valadon show that it was largely American collectors who paid high prices for his work in 1889–92.[39]

This sudden transformation took place in years for which Monet seems not to have kept his own financial records. His account books give his income as 44,000 francs in 1887 and 28,000 francs in 1888; in 1891 he earned around 100,000 francs from Durand-Ruel and Boussod & Valadon alone. When the account books resume, between 1898 and 1912, we find his income fluctuating wildly: often it was around or well over 200,000 francs, but in two years, 1903 and 1908, apparently nothing at all. By then, it is clear, he could comfortably live from savings in years when no work projects came to completion. Yet, even after his fortune was assured, he continued on occasion to play dealers and collectors off against each other, seemingly putting personal profit before questions of loyalty. Durand-Ruel remained his main outlet; Boussod & Valadon continued to buy until 1902, while Bernheim Jeune, a major purchaser in later years, began to buy in 1898. Occasionally he sold to other dealers, but now only rarely to collectors, though the Japanese collector Tajiro Matsukata bought many paintings directly from Monet from around 1920 onwards.[40]

After 1890 Monet's problem was no longer one of finding buyers, but rather of keeping his many prospective patrons happy without making himself the prisoner of his popularity.[41] His freedom from immediate financial worries gave him the chance to experiment at leisure in his work; indeed, in the last decade of his life he sold virtually no newly painted canvases, financing his gigantic project of Water Lily Decorations from sales of earlier pictures which he still had by him (see pl. 183).[42] But, unlike artists with private means such as Cézanne, he remained ultimately dependent on his markets to maintain his way of life and allow him to continue painting.

TRAVELS

Paris-born but brought up on the Channel coast at Le Havre, during the first two decades of his career Monet rarely travelled beyond the Seine valley that linked the two places. He made a few ritual trips in the 1860s to the Fontainebleau forest, then famous as the cradle of modern landscape painting, through the paintings of the Barbizon School and their many followers; but otherwise his chosen sites all belonged to city, Seine, or Normandy coast. Only during his military service in Algeria in 1861–2, and his self-imposed exile in London and Holland during the Franco-Prussian War and the Commune in 1870–1, did he stray beyond these narrow limits, apart from a brief second visit to Holland whose date is unknown.[43] The choice of particular themes and precise sites for his paintings concerned him greatly, wherever he was, as will be examined in the next two chapters. But during the years up to 1880, the material circumstances of the moment largely dictated where he lived and worked; unable to travel at will in search of new locations, he chose his subjects from what lay at hand.

The 1880s were exceptional in Monet's life for the length and number of journeys he made away from home. His family situation gave him the freedom to travel, and Durand-Ruel's purchases gave him the means. As we shall see, artistic factors played a major part in his travel plans, but his choice of areas to visit was often influenced by the invitations or suggestions of family, friends or patrons. His brother Léon had a villa at Petites-Dalles on the Normandy coast, where he worked on occasion in the 1880s, and he was encouraged to visit Dieppe in 1882 by Renoir; on his first excursion prospecting for sites on the Mediterranean coast in December 1883 his companion was Renoir, who had already painted in the area.[44] He went to Holland in 1886 to paint the tulip fields on the invitation of a prospective patron, Baron d'Estournelles de Constant, Secretary in the French Embassy in The Hague, a friend of the collector Charles Deudon. His trip to Belle-Isle, off the south coast of Brittany, in 1886 was a response to an invitation from Octave Mirbeau to stay with him on nearby Noirmoutiers, where Monet stopped on his way home. In 1889 Gustave Geffroy took him on his first short visit to the valley of the Creuse in the Massif Central, where he introduced him to the poet Maurice Rollinat; Monet quickly returned there to paint.[45] Travel was essential to Monet's artistic ambitions of the 1880s, but such haphazard suggestions supplied him with the impetus to choose particular places; none of his journeys was made to an area with which he had no personal links.

He travelled less, and generally in Alice's company or to visit one of their children, after their marriage in 1892. He went to Norway in 1895 to see his stepson Jacques, and his son Michel was studying in London when he went there to paint in 1899–1901. Some excursions produced no paintings, including one, probably during the 1890s, on which he jotted down the silhouette of Mont Saint-Michel in a sketchbook, and a later trip to Switzerland in 1913. His desire to see Velásquez's paintings took him and Alice to Madrid in 1904, but in Venice in 1908 he was more concerned with painting than seeing the sights.[46] In 1901 he acquired a motor car (pl. 11), which the family used for many excursions around Giverny and to the Channel coast. Though Monet never drove himself, his taste for speed made him a keen spectator at motor races; when, though, he was charged with speeding (in lieu of his chauffeur) in the village of Freneuse, near Giverny, in 1904, he declared that he was 'completely opposed to speeding'.[47]

Monet visited Paris often during the 1880s, for business reasons

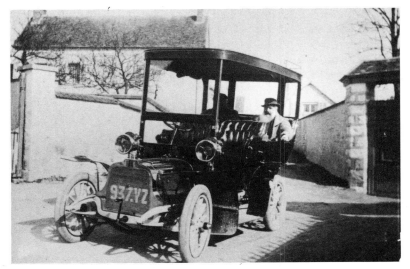

11. Photograph of Monet in his motor car, c.1906

and to see friends and he took the opportunity to keep up with the latest art exhibitions and theatrical performances, but from the 1890s onwards, such trips gradually became less frequent. Information about such short visits is very fragmentary, but we know that he saw Seurat's work, praised the van Goghs at the 1889 Indépendants, disliked the 1893 Gauguin and 1896 Bonnard exhibitions at Durand-Ruel's, and was deeply impressed by Cézanne's show at Vollard's gallery in 1895. He visited the newly formed Salon du Champ de Mars at least once in the 1890s, and in London took an active interest in the paintings of young British artists at the Royal Society of British Artists and the New English Art Club.[48] At the theatre, he mainly saw plays by friends such as Mirbeau and Zola. Later he occasionally visited the opera and the ballet, seeing *Boris Godunov* with Chaliapin and Pavlova, and the Ballets Russes; he saw Loïe Fuller dance, and accompanied Alice, apparently at her insistence, to wrestling matches.[49]

MONET at HOME

Monet gave much attention to the décor of the houses in which he lived and to the organisation of their gardens. His gardens, in particular, were always a central concern; indeed Monet himself used to claim that painting and gardening were his only two interests in life.[50] Only after he finally purchased his Giverny home in 1890 was he able to indulge his tastes fully, but these interests left their mark on his previous surroundings.

His own paintings give us occasional glimpses of these settings. Big blue and white flowerpots adorned the garden at Argenteuil in summer (pl. 3). In winter, it seems, they were moved indoors, where, with the plants in them, they created the studied decorative ensemble depicted in *A Corner of the Apartment* (pl. 13); his walls at Argenteuil were enriched by flights of Japanese fans (pl. 264). The flowerpots travelled on with him to Vétheuil, where they appear in his 1881 pictures of his garden there (pls. 188–9), and then to Giverny.[51] From Argenteuil we also have an indication of his care in arranging the flowerbeds; a note in his personal account book for 1872–5 lists the colour sequence for seven rows of hollyhocks: purple, white, red, violet, yellow, cream and pink.[52] Paintings of the Argenteuil and Vétheuil gardens show lavish multicoloured masses of flowers (pls. 118, 154).

On his arrival at Giverny in 1883 one of his first concerns was to arrange the gardens. This was initially in part to supply the materials for still life painting, but, particularly after he bought the house in 1890, the garden came to play an ever more important part in his life. To it he added in 1893 the land that he made into his first small water garden; permission was given for the construction of the pond in July, and by October the little green wooden bridge was already in place (see pl. 36). The pond was vastly enlarged after he bought further land in 1901 (see pl. 140).[53] Though these water gardens became his main focus as a painter, the flower gardens in front of the house were also the result of elaborate care and calculation, both to provide flowers for as long a season as possible, and for their aesthetic effect; The German art historian Julius Meier-Graefe concluded after seeing them: 'Monet reveals himself best . . . in the garden he has planted about his country house. He has made it on the same principle as his pictures . . . Every individual blossom contributes to the mass of colour.'[54] After their recent restoration, the gardens and house can once again be seen much as they were in Monet's last years.

The décor of the house acted as a beautifully controlled foil to the gardens, opposing fastidious taste to the rampant natural growth of the flowerbeds outside its windows. The recollections of the painter Jacques-Emile Blanche seem to be the only clue to its early appearance; from a visit around 1893 he remembered: 'Monet had lined his dining room walls with white damask cloth with Japanese designs on its silvery background.' However, when Berthe Morisot's daughter Julie Manet saw the house after recent alterations in October 1893, Monet had already established approximately its final scheme: a dining room painted in shades of yellow, and a small *salon* with panelling in shades of violet (it appears today as later accounts describe it, in shades of blue). The yellow dining room (pl. 12) was the *tour de force* of the decorations, and was described by many visitors; one of them even noted the matching bowl of lemons on the window sill.[55] In 1905 the critic Louis Vauxcelles noted the Whistlerian quality of this décor; the idea of it is very like the decorative schemes Whistler executed in the 1870s and 1880s, notably the stand that he and E.W. Godwin designed for the 1878 Paris Exposition Universelle.[56]

Through these ground-floor rooms hung Monet's collection of Japanese prints, now reinstalled there. Upstairs, in the suite of rooms occupied by Monet and Alice, was his collection of paintings by friends and contemporaries, which was particularly strong in works by Cézanne and Renoir.[57] The end room on the ground floor was originally Monet's studio, before he built a new one in the garden in

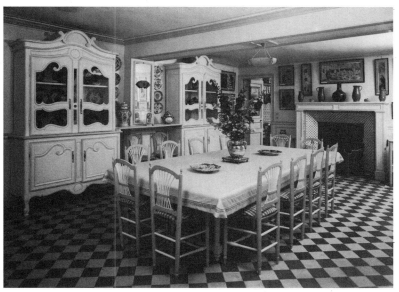

12. Photograph of Monet's dining room at Giverny, after recent restoration

1897; thereafter it became the family's sitting room, hung with several rows of Monet's own paintings (pl. 183); in it Monet used to read aloud to the family on quiet evenings.[58]

Literature played a regular part in Monet's life, at least from the 1880s. Thanking Mallarmé for sending him a copy of his translation of the poems of Edgar Allan Poe, Monet described himself as 'completely illiterate', but this was clearly modesty in face of Mallarmé's erudition. Geffroy remembered him at the Café Riche dinners in the early 1890s freely discussing literature and revealing his good judgment. On Belle-Isle in 1886 he spent the long evenings enthusiastically reading Tolstoy.[59] His later tastes seem to have been mainly for modern novels and plays, by authors such as the Goncourts, Flaubert, Zola, Balzac, Mirbeau, Maeterlinck and Ibsen. His favourite book, though, was Delacroix's *Journal*.[60]

To many interviewers Monet presented an image of himself as a solitary hermit painting in isolation face to face with nature; but this conceals the active part that he continued to play in the artistic life of his time, even when he was no longer in constant contact with fellow artists in Paris. It was from Giverny that he managed to establish himself as one of the dominant figures in the Paris art world, rather than merely a leading member of the notorious Impressionist clique. As we shall see, his relationships with artists and writers continued to have a significant effect on his painting.

CHAPTER TWO
CHOICE of SUBJECTS

LANDSCAPE

ONLY recently have historians begun to turn their attention from the technical revolution achieved by the Impressionists to their choice of subject matter;[1] but neither their techniques nor their subjects can be treated in isolation. The themes they chose were not merely the pretexts for demonstrations of technical virtuosity, nor were the methods they adopted simply a transparent shorthand for the 'real' world they depicted. The ways in which they conceived and executed their paintings were the material expression of their chosen subjects. At times, external pressures and practical concerns dictated where the painters found themselves; but, wherever they worked, their specific choice of subjects remained crucial – what they chose to depict from the manifold possibilities they saw around them, and how they formulated these subjects on canvas.

In every decade of his life except one, Monet painted primarily the areas where he lived. The exceptional decade was the 1880s, when he travelled widely in order to tackle the most varied natural subjects and effects, but even near home he could find a great diversity of potential themes.[2]

During his long career, there were great changes in the subjects he chose and the way he treated them. In his early maturity he deliberately sought out man-made landscapes, focusing on the contemporaneity of the scenes around him; but by around 1880 he had become preoccupied with raw nature – by the pictorial possibilities of foliage, flowers, waves and rocks. Effects of light and atmosphere had fascinated him from early on, but from about 1890 these became his prime concern, as the physical objects in his scenes were subordinated to the ever-changing *enveloppe* of coloured air which surrounded them and brought them to life.

These changes were crucial. He gradually moved away from a concern with the individual elements in the scene, and the relationships between them, to concentrate on its overall effect; whereas his earlier technique served to differentiate particular elements, later their specificity became absorbed into a closely integrated whole. In a sense this is a move from a modernity of content to a preoccupation with the qualities of the painting itself; but it is misleading to impose the modernist vocabulary of the 'flat painting' uncritically on to Monet's later work, for his paintings remained essentially concerned with translating the light and air of the visible world into colour on the canvas. It is the period of transition between these two approaches

to painting that will here be analysed in most detail. Though the present chapter treats Monet's subjects largely in isolation from questions of picture-making and technique, this gradual metamorphosis in his art can only be understood when his thematic interests are dovetailed with his changing pictorial methods.

Monet's first major paintings of 1864–5 reflect the popular conventions of the day: the coastal scenes he exhibited at the 1865 Salon (e.g. pl. 181) show the indigenous fishing boats and shore life of the place, while his first paintings of the Forest of Fontainebleau (e.g. pl. 258) were peopled by the local peasants, very much within the conventions of Barbizon painting.[3] However, in the summer of 1865 he plunged headlong into the current controversies about the painting of explicitly modern themes: his project for a monumental *Déjeuner sur l'herbe* (pl. 14) sought to give a scene of everyday bourgeois recreation the scale and status of a history painting.[4] His exhibition pictures of the later 1860s were a calculated attempt to produce viable modern reinterpretations of the various genres of landscape painting; their modernity gained its point from the context in which Monet intended them to be seen – in relation to the other paintings hanging on the Salon walls. The Forest of Fontainebleau was brought into the 1860s by the fashionable picnickers in the *Déjeuner sur l'herbe*; steamboats and tophatted figures invade the ports and jetties of the Channel coast (pl. 259); and quiet river banks, favoured subject of painters such as Daubigny, are animated by the bathers and pleasure seekers at the *demi-mondaine* resort of La Grenouillère (pl. 260).[5]

In some paintings not intended for the Salon, the modernity is still more overt. The sea becomes a mere backdrop to the fashionable figures relaxing in *Terrace at Sainte-Adresse* (pl. 67), while the many deftly characterised little figures dictate the mood of the Paris views which Monet painted from the galleries of the Louvre in 1867 (pls. 15, 68). At Sainte-Adresse and in Paris, the old and the new are juxtaposed – fishing boats meet steamboats out at sea, and the bustle of the city streets is set against its celebrated monuments.[6] In *Quai du Louvre* (pl. 68), the shape of the dome of the Panthéon on the horizon is precisely matched by the kiosk on the quai to the right – one silhouetted against the sky, the other placed amid the busy figures; neither is given the greater significance in the composition.

In 1868, in his review of the Salon, Zola hailed Monet as the prime figure in the group which he labelled 'Les Actualistes', basing his information on a visit to the artist's studio: 'He has sucked the

progress, and a number of young artists, at whose head I place Monet, feel that it is something that has been too much scorned till now. The peasants have their favoured painters, . . . but the bourgeois who walk on the jetty towards the sunset, don't they have the right to be fixed on canvas, to be brought out into the light?'8 Monet himself left little verbal evidence about his thematic concerns before 1880; so these two accounts, written by men who knew him, are of particular importance in showing how explicitly he presented himself as a modern life painter in the late 1860s.

In these modern scenes, Monet denies the viewer any direct access

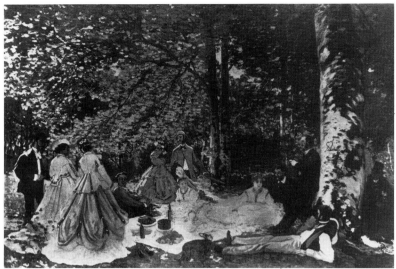

14. *Déjeuner sur l'herbe* (final study), 1865 (dated 1866), 130 × 181, W 62, Pushkin Museum, Moscow

milk of our age, his adoration of what surrounds him has grown and will grow still further. He loves the horizons of our cities, the grey and white patches (*taches*) which the houses make against the light sky; in the streets, he loves the figures who hurry about their business in their great-coats; he loves the race-courses, the aristocratic promenades with the noise of the carriages; he loves our women, with their parasols, their gloves, their chiffons, and even their wigs and their face powder – everything which makes them daughters of our civilisation.' He emphasised Monet's deliberate inclusion of the traces of man even in his country scenes: 'Nature seems to lose some of its interest for him when it does not bear the imprint of our customs.'7 The same year, Boudin wrote to the dealer Martin emphasising Monet's primacy in current attempts to paint modern subjects, and modestly underplaying the importance of his own fashionable Trouville beach scenes (e.g. pl. 62) in the development of this type of painting: 'These gentlemen congratulate me for having dared to put down on canvas the things and people of our own time, for having found the way to gain acceptance for men in great-coats and women in waterproofs . . . This attempt is making

16. Manet, *Music in the Tuileries Gardens*, 1862, 76 × 118, National Gallery, London

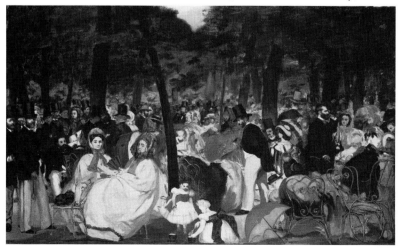

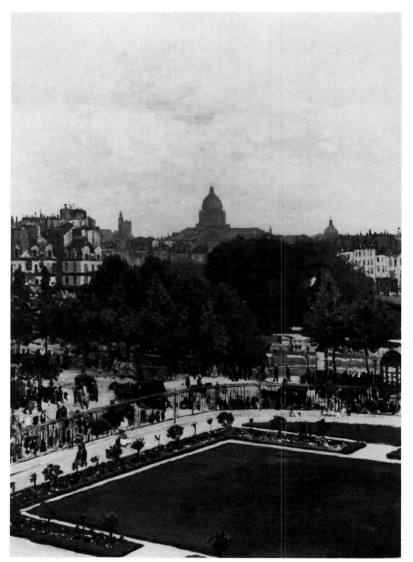

15. *The Jardin de l'Infante*, 1867, 91 × 62, W 85, Allen Memorial Art Museum, Oberlin, Ohio

to his subjects; the spectator generally views them from a distance, sometimes from above. In *Terrace at Sainte-Adresse* (pl. 67) this distancing is emphasised by the way the head of the nearest figure is wholly hidden by her parasol; we cannot even follow the direction of her gaze in order to orientate ourselves in the picture. Devices such as these suggest a parallel with the attitudes advocated in Baudelaire's essay *Le Peintre de la vie moderne*, in which he defined the aesthetic viewpoint of the *flâneur*, the man of fashion who walks through the crowd, ever observant but ever detached from what he observes; Boudin's beach scenes, and Manet's open-air subjects such

16

as *Music in the Tuileries Gardens* (pl. 16), similarly reflect Baudelaire's position.[9] This refusal to select and heroize any single element in the scenes he chose sets Monet's treatment of modern subjects – like Baudelaire's – apart from the more humanitarian celebration of the common people advocated by critics like Théophile Thoré during these years.[10]

This does not, though, mean that Monet was uninvolved with his subjects. By his very refusal to give his scenes a prime focus, he was challenging traditional hierarchies of value as well as conventions of pictorial composition. He was insisting that the significance of the

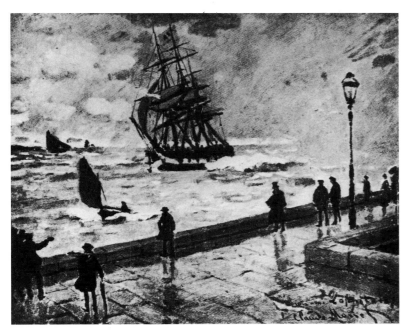

17. *The Jetty of Le Havre in Stormy Weather*, c.1868 (dated 1870), 50 × 61, W 88, Private Collection

objects he painted lay in the relationships between them, in the multifarious elements which together went to make up the modern scene, and not in any external ordering process imposed by the artist in order to elevate one aspect above the others. The subjects he chose emphasise such interrelationships – between figures and their surroundings, and also between man and the forces of nature. From the mid-1860s on, Monet often showed his fascination with nature's most extreme effects – stormy seas, winter snows – but before 1880 these are never treated as the sole theme of the canvas. They are juxtaposed with man or the traces of man: waves batter jetties with strollers on them (pl. 17); figures carry water in buckets from the frozen Seine (pl. 115); cottages nestle beside snow-clad roads (pl. 169). Always stressed is the relationship between nature and man, between elemental forces and human intervention, just as, in the urban and suburban scenes, the figures are always presented in their diverse milieus.

At Argenteuil in the early 1870s Monet continued to seek out such juxtapositions, which came readily to hand in a place that was in a state of transition: an agricultural village with encroaching factories, and a centre for the bourgeois recreation of sailing.[11] Particularly in his earlier paintings of Argenteuil, in 1872–4, Monet selected subjects that stressed its diversity. In *The Promenade at Argenteuil* (pl. 18), sails and far trees, house and factory chimneys, figures and tree trunks, create a single sequence of accents; all elements are given equal weight, with no hierarchy of significance.

Many of the same elements – sailing boats, chimneys and the same house – appear in *The Wooden Bridge* (pl. 19), and again none is given special significance. But these two pictures are very different from each other: in *The Promenade at Argenteuil* the viewer has immediate access to a welcoming, peopled foreground, with a sunlit distance beyond, while in *The Wooden Bridge* the spectator has no direct entry, barred by the open water. The *contre-jour* lighting throws the forms into silhouette, with the vista framed by the bridge – still the temporary structure put up after the bridge's destruction in the Franco-Prussian War. Out on the wide fields by the river, too, Monet focused on such juxtapositions: in *The Plaine des Colombes, Hoar Frost* (pl. 146), the scattered houses encroach on the fields, and the horizon is punctuated by poplars and factory chimneys. The mood of each of these three paintings is very different, but in each the way in which the subject is painted, in

18. *The Promenade at Argenteuil*, 1872, 50.5 × 65, W 223, National Gallery of Art, Washington, D.C.

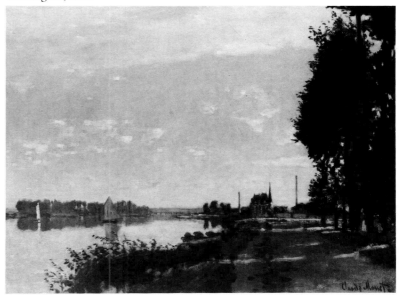

19. *The Wooden Bridge, Argenteuil*, 1872, 54 × 73, W 195, sold Christie's, London, 30 November 1971, lot 24

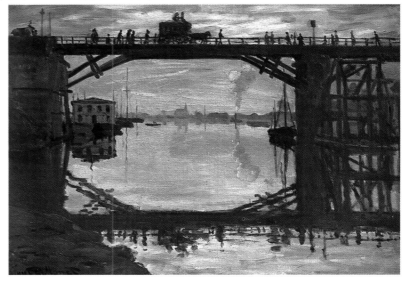

quite evenly weighted dabs and dashes of colour, further stresses the coexistence of these disparate elements in the vision of the scene which Monet presents; the scenes' significance lies in their inter-relationships.

However, in other pictures Monet focused on a single aspect of the place, occasionally on the village framed by trees, without any contemporary reference, as in *Autumn Effect at Argenteuil* (pl. 72), and more often on its sailing boats and river life – on the place as a recreational centre (pls. 20, 237) – or on the lavish display of his own garden, with his wife and child enclosed in this surburban *hortus conclusus* (pls. 3, 118). But he was attracted not only by these sunny subjects. He painted the half-developed streets of the growing village (pls. 202–3), and the railway bridge and railway station (pls. 75, 241–2), with the trains that since 1863 had linked the place to Paris, and enabled its development as a centre for industry and leisure. Indeed, whenever he showed the railway bridge, he always presented it with a train crossing it, so as to signal its function. Taken as a whole, his paintings of the Argenteuil area are very diverse in subject and effect; the area offered him an ample choice of potential themes.

Some of Monet's later paintings of Argenteuil suggest that he was becoming less interested in the specifics of the modern scene. *Poplars*

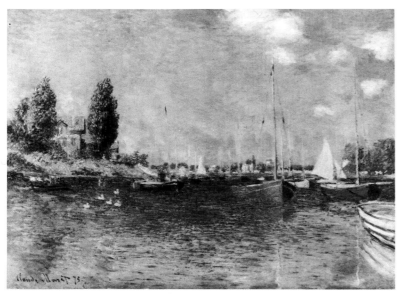

20. *The Red Boats, Argenteuil*, 1875, 60 × 81, W 369, Fogg Art Museum, Cambridge, Mass.

near Argenteuil (pl. 147) shows a view very similar to that in *The Plaine des Colombes, Hoar Frost* (pl. 146), but without the houses and chimneys; now only the summarily sketched small figure gives a hint of contemporaneity. On occasion, too, he omitted the factory chimneys from his riverscenes, as in *The Red Boats, Argenteuil* (pl. 20), presenting a recreational river untainted by industrialisation. At Argenteuil in 1876 he painted little except his own garden and a secluded backwater (pls. 118, 124); his final pictures of the place, in 1877 (e.g. pl. 21), return to the site of *The Promenade at Argenteuil* of 1872 (pl. 18), but, in place of its specificity, they absorb the whole scene into a play of colour and atmosphere, viewing it across the barrier of a lavish bank of flowers. In Paris, too, in the same years he seems to have avoided some of the more controversial aspects of his chosen scenes: the left margin of *The Tuileries* of 1876 (pl. 218) is framed by the Pavillon de Flore at the end of the south wing of the Louvre, but the viewpoint is carefully chosen so as to exclude the

ruins of the Tuileries Palace, burned under the Commune in 1871, which lay immediately to its left.[12]

It has been suggested that Monet's attitude towards Argenteuil itself changed from an enthusiastic endorsement of its modernity in 1872 to disillusion with its decay in 1877, and the physical changes in the environment during these years are sometimes cited.[13] This view ignores the diversity of Monet's 1872 pictures of the place, from the warm openness of *The Promenade at Argenteuil* (pl. 18) to the distanced silhouettes of *The Wooden Bridge* (pl. 19). But, more significantly, it views the content of the paintings simply as a dialogue between the painter and his physical subject, whereas the paintings themselves were intended to be seen in Paris, and thus to contribute to metropolitan debates about city, suburb and country, and about modernity in landscape painting.[14] Though Argenteuil was the particular site of their making, it was not there that they found their public; Argenteuil with its diversity could offer Monet the raw material for the exploration of many types of landscape, but it was in the context of the other landscape paintings on view in Paris that these types gained their meanings.

The Promenade at Argenteuil and *The Wooden Bridge*, though so different in mood, are both emphatically modern in theme, and would thus have been very topical in Paris in 1872, in a year when specifically modern landscapes attracted notice at the Salon.[15] Though later in the decade he began to steer away from certain elements in the modern scene, his subjects retained an explicitly contemporary flavour until 1878. He painted the boulevards and streets in Paris (pls. 120, 262), as well as its gardens, and only very rarely, in his paintings of the Argenteuil region, did he seek out a corner of nature unmarked by man's traces (e.g. pl. 124). *Unloading Coal* of 1875 (pl. 148), sited on the Seine at Clichy, between Argenteuil and Paris, is one of his most uncompromisingly industrial subjects; and in the third Impressionist group exhibition in 1877 he showed eight canvases of the Gare Saint-Lazare (including pls. 101, 119, 265), which viewed the train sheds and the tracks outside the station from many angles. Zola hailed these as further evidence for his concern with significant modern subjects, and in 1878 Théodore Duret, a close associate of the painter, described Monet's preoccupations in similar terms in his pamphlet *Les Peintres impressionnistes*, the first separate account published of the group: 'Monet has found little to attract him in rustic scenes . . . Above all he is drawn towards nature when it is embellished and towards urban scenes; from preference he paints flowery gardens, parks and groves.'[16]

However, Monet's paintings of the mid-1870s suggest that he was feeling the rival claims between two different types of painting – whether to concentrate on modernity of subject matter, or on translating into paint fleeting effects of natural light. In these years there was a gradual change in the way he treated his subjects. Whereas until around 1873 the separate items in his scenes were crisply, if economically, individualised, thereafter he began to subordinate them to the overall effect of the scene, to the play of textures and colours which gave the pictures their coherence. The result of this change is to play down the specificity of their social observation. In *Unloading Coal* (pl. 148), surprisingly little is made of the men's mechanical task; it is translated into rhythmic, repeated poses which are readily absorbed into the patterns of line and colour – more like a choreographed routine from the *corps de ballet* than an image of heavy labour. In the Gare Saint-Lazare paintings the figures are far less precisely characterised than in pictures of the early 1870s; instead, they are largely absorbed into the total ambience.

The details of this change in Monet's technique and in the

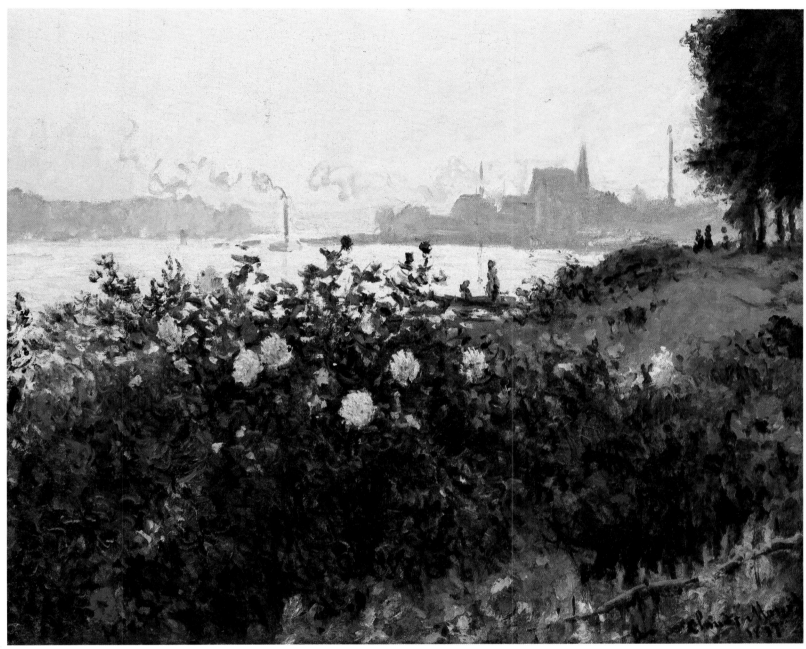

21. *Argenteuil, the Bank in Flower*, 1877, 54×65, W 453, Private Collection

qualities he sought in his finished paintings will be discussed later (see Chapter 5), but it cannot be viewed in isolation from the gradual changes in his chosen subject matter, heralded by his tendency to play down the most overtly contemporary aspects of Argenteuil. His dilemma between modern subjects and fleeting effects was resolved at a stroke in 1878, in the same year that Duret described the man-made landscape as his special province, when he moved to Vétheuil, to a landscape scarcely touched by the modern world. The initial reasons for the move were partly practical: the joint Monet and Hoschedé families needed to find a cheap and secluded home. But now he could focus on effects of light, weather and the seasons, as they played across the village and the surrounding countryside, using sky and water as the keynotes of paintings where little trace of modernity intruded into these timeless interrelationships. The village of Vétheuil, framed by hills and crowned by its church (pls. 22, 149), faces the hamlet of Lavacourt and a panorama

of open meadows (pls. 187, 270) across a sweeping bend in the river Seine – an archetype of rural France which has survived little changed to this day. Monet explored the villages and river banks from all points of view and in all seasons, rarely travelling more than a few hundred yards from home to find his subjects. Occasionally the scenes include modern elements, such as steam-tugs on the river or female figures on its banks (e.g. pl. 150), but more often they are unpeopled; in the open fields there are no labourers to be seen (pl. 23). Monet wrote to Duret from Vétheuil in 1880 that he was becoming 'more and more peasant-like',[17] but his complete omission of peasant life from his paintings shows how far this notion of the 'peasant-like' was from any actual peasant experience; his terms of reference belonged to the city, constructing an image of the rural countryside as a retreat from man's intervention, where nature itself – the weather and the seasons – dictated the rhythms of life. It was this vision of nature that became the focus of his art.

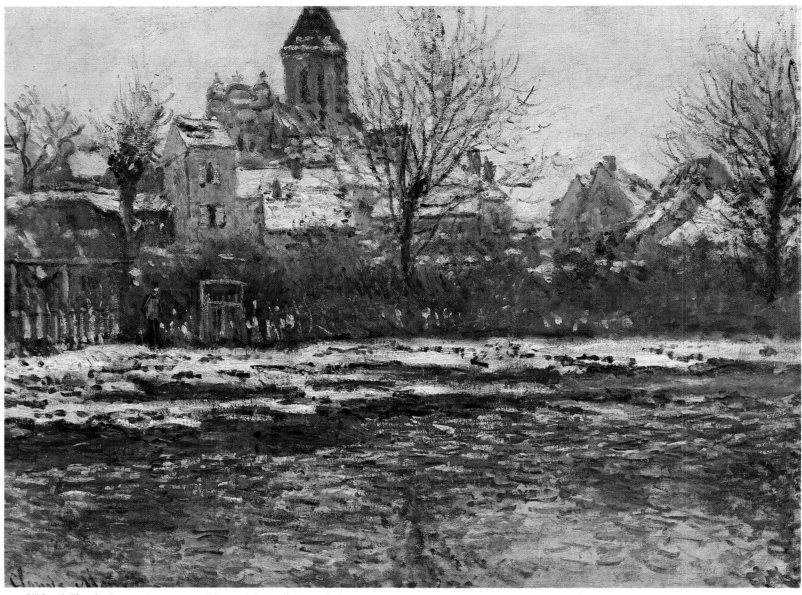

22. *Vétheuil Church, Snow*, 1879, 53×71, W 506, Musée d'Orsay, Paris

While he was at Vétheuil Monet found a subject which introduced one of his main preoccupations of the 1880s: his canvases of the great freeze and thaw of the winter of 1879–80 focus on the forces of nature at their most elemental. In contrast to the modern elements he had previously incorporated in his winter scenes, the human presence is here absent, or quite subordinate, appearing only in the occasional rowing boat or in small houses by the river. In some canvases the ice-floes, released by the thaw, float serenely in soft sunshine (pls. 185–6); in others they lie jammed together against the trees which have tried to withstand their progress (pl. 24).

Monet announced his paintings of the thaw to de Bellio in January 1880: 'We have had a dreadful (*terrible*) thaw here, and naturally I have tried to make something of it.'[18] Critics have seen a connection between the desolate mood of some of these landscapes and Monet's feelings after the death of his wife Camille in September 1879,[19] but this is a misunderstanding of the nature of the moods Monet sought to express in his art. The moods in Monet's landscapes were an integral part of their conception, but he found them within nature (see also p. 25); he was seeking to express the forces he

found in nature, to draw out as fully as possible what he saw as the essence of a particular scene, and he did not use his chosen scenes as metaphors for private, subjective states. Even the ice-floe paintings are very varied in tone and mood. His response to the challenge set by the ice and thaw seems to have renewed his faith in painting, after the desperate situation in which he found himself in autumn 1879.[20] When, later in the decade, he described his melancholy when painting Belle-Isle (see pl. 85), he made it clear that these feelings were generated by the mood of the place: 'I feel very melancholy (*triste*); besides this place cannot produce cheerful feelings, because it is sinister, even in the beautiful weather of the last few days; what will it be like in the cloud and rain?'[21]

The canvases produced in the exceptional weather conditions of winter 1879–80 were unique among Monet's paintings of the Seine valley. It was usually on his travels that he found his most dramatic subjects; at home – at Vétheuil, and from 1883 at Giverny – he came increasingly to focus on motifs with no obvious picturesque potential. His work away from home was more overtly experimental and showed a clearer break from the painting of the previous decade;

but Giverny became an important stimulus in the later 1880s, and his pictures of the place, though in many ways derived from his previous canvases of the Seine valley, were the basis for experiments which were to be crucial for his later development. From this decade onwards, we have much evidence from Monet's letters and from the accounts of people who knew him; from these we can see what types of effect particularly attracted him and how he tracked down the most suitable sites to paint. Since the problems involved are very different, the subjects he chose at home are best discussed separately from those he painted on his travels.

The reasons for Monet's travels of the 1880s and the course they took were in some sense personal: the death of Camille and the nature of his relationship with Alice Hoschedé left him free, subsidised by dealers' purchases of his paintings, to follow up invitations or suggestions from friends or patrons about places to visit.[22] But the subjects he chose to paint were chosen with great care. On an artistic level, his travels of the 1880s were an attempt to extend the range of his painting. Late in his life he described this phase to Thiébault-Sisson: 'I felt the need, in order to widen my field of observation and to refresh my vision in front of new sights, to take myself away for a while from the area where I was living, and to make some trips lasting several weeks in Normandy, Brittany and elsewhere. It was the opportunity for relaxation and renewal. I left with no preconceived itinerary, no schedule mapped out in advance. Wherever I found nature inviting, I stopped.' Monet's stepson described his reasons for these travels: 'Weary of easy subjects, of the type of nature and atmosphere he had often depicted, he sought out what was difficult, and atmospheres which he did not yet know.'[23]

This phase of travel came to an end in 1890, when Monet began to work in earnest on his series of paintings of the grain stacks near his house at Giverny (e.g. pl. 32). In his preface to the catalogue of the exhibition of this series in 1891, Geffroy summed up Monet's decade of travel, and mentioned, in a list which clearly came from Monet himself, the places he would have painted if he had not been

23. *The Wheat Field*, 1881, 65.5 × 81, W 676, Cleveland Museum of Art

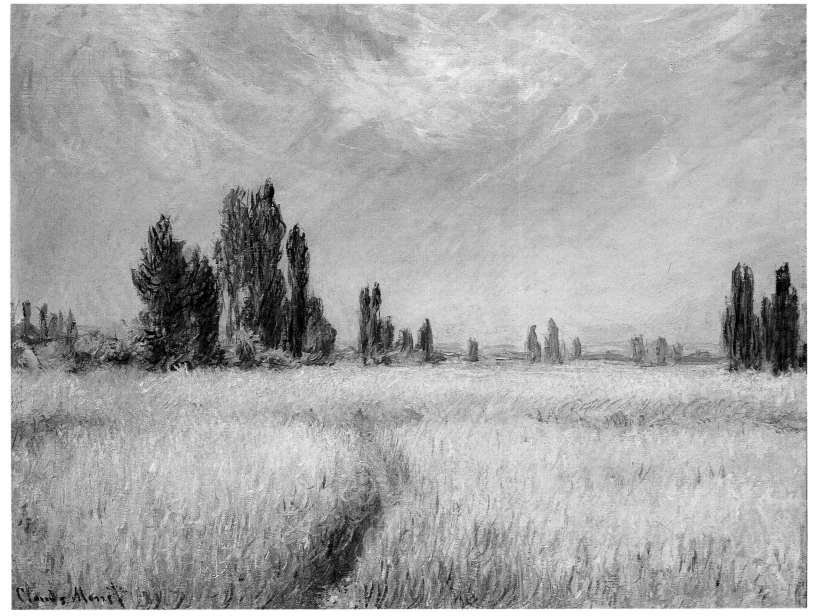

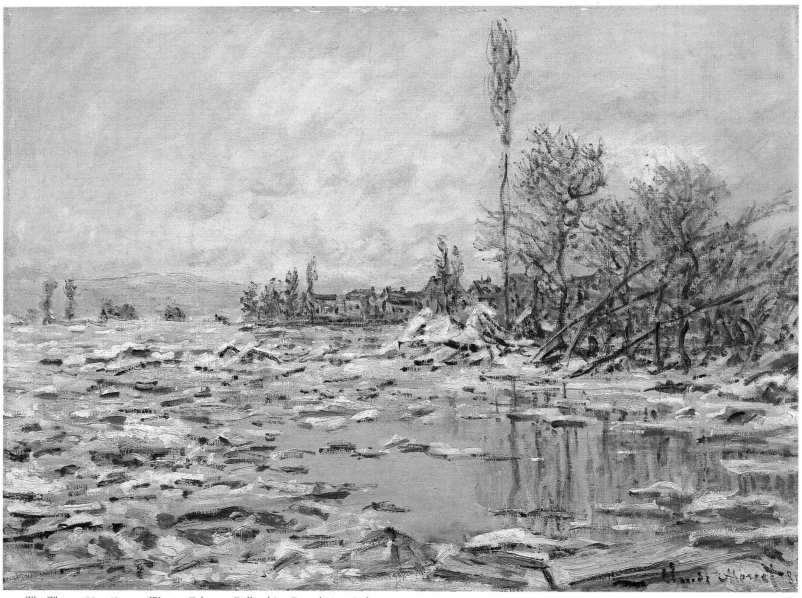

24. *The Thaw*, 1880, 68×90, W 560, Calouste Gulbenkian Foundation, Lisbon

waylaid by the *féeries* at the bottom of his garden: 'For a year the traveller has given up travelling . . . He has thought about the places he has only passed through, where he would like to return, London, Algeria, Brittany. His thoughts have gone out to vast expanses and to precise points that attract him, Switzerland, Norway, the Mont Saint-Michel, the cathedrals of France, tall and beautiful like rocky promontories.'[24] Some of these plans Monet was later to realise, and the list as a whole shows how eager he remained to expand his range as a painter. However, as we shall see, his concerns in his later travels, after 1890, were rather different from those that had guided him in the 1880s.

Monet always found that it took time to get used to a place and to see how best to paint it – problems that were particularly acute on his travels to the South, to Belle-Isle and to Norway, places whose atmosphere and effects were quite new to him.[25] At home he could explore the countryside at his leisure, but when he was away he had to begin work quickly in order to justify his trip, and to condense his process of search and selection into a short period, particularly since he rarely planned in the first instance to stay for more than a

few weeks in any one place. Wherever he went, he began by feeling that there must be a better group of subjects nearby, and he often intended to move on somewhere else. Sometimes he only began to paint in earnest after making a move, but often these further projects came to nothing.[26] Even after settling in a place, he regularly went on excursions to look for new sites when the weather prevented him from painting.[27] Despite this restiveness, though, he rarely moved his base during these spells away from home; as he got to know each place, he saw the possibilities it offered, and his real problem was usually forcing himself to leave, rather than finding somewhere he wanted to stay.[28]

Once he stopped at a particular place, Monet began to search energetically for suitable motifs. The letters he wrote home from his journeys, together with other evidence, show how he set about this first stage in the transformation of nature into art. From Dieppe in 1882, before discovering the delights of Pourville, he wrote that he had 'gone through the whole area, followed every path that ends up beneath or on top of the cliffs', without finding suitable sites; next day he visited Puys, 'and it had nothing to say to me'.[29] He began in

the same way at Bordighera in 1884: 'I climb up, go down again, then climb up once more; between all my studies, as a relaxation I explore every footpath, always curious to see something new.' He could not, though, find the subjects as he wanted them: 'The motifs are extremely difficult to get hold of, to place on the canvas; it's all so thickly wooded . . . One can walk indefinitely beneath the palms, the orange and lemon trees, and also the admirable olives, but it is very difficult when one is looking for motifs. I would love to do orange and lemon trees silhouetted against the blue sea, but I cannot find them the way I want them.' Two weeks later he was still dogged by these problems (see pl. 27): 'The broad, general views are rare. It's too thickly wooded – it's all fragments with many details, a confused mass of foliage which is terribly difficult to render, while I'm really the man for isolated trees and broad spaces.' He admired Monte Carlo (pl. 28) for its sea and 'the sweeping lines of the mountains'; there the motifs were 'more complete, more like paintings, and therefore easier to execute'.[30] When he was looking for sites in the Creuse valley in 1889 (see pl. 134), 'he would stop frequently, looking at the sky, the trees, the river, screwing up his eyes, and roaring out a "*Nom de Dieu*" which spoke volumes for his enthusiasm'.[31]

Monet's process of ransacking the countryside for subjects was just what Frédéric Henriet, Daubigny's friend and biographer, recommended in 1866 in *Le Paysagiste aux champs*, his delightful survey of the joys and tribulations of the landscapist; but Henriet warned the painter that his searches through the byways would arouse great suspicion from the local inhabitants – or, perhaps worse, misplaced offers of help.[32] Monet suffered this in 1888 at Antibes when locals and painters working in the area, including Henri Harpignies, suggested subjects to him; but, he wrote, 'all the people around here are idiots, stupidly pointing out to me all the least good places, whereas this morning, following nothing but my own instinct, I found some superb things'.[33]

However much he protested his independence, though, Monet does seem to have used help in finding subjects on his travels, drawing ideas from the work of other artists and from travel guides. Views along beaches and out to sea were common in the Salon around 1880 (e.g. pl. 80), and, more specifically, Renoir's cliff-top scenes may well have suggested possible ways of approaching the scenery of the Channel coast.[34] Some of Renoir's Mediterranean scenes, too, are very comparable with Monet's; the two men clearly discussed the problems of rendering the South on their trip together along the Côte d'Azur in December 1883.[35] Moreover, Harpignies, scornful though Monet was of his advice at Antibes in 1888, painted sites very similar to his there.[36]

It was at Etretat, though, that Monet had the greatest number of artistic precursors. Later he was to own one of Delacroix's Etretat watercolours, but it was Courbet's example that was most relevant for him while he was there. A group of Etretat seascapes from the late 1860s (e.g. pl. 26) had been one of the main successes in the Courbet retrospective exhibition at the Ecole des Beaux-Arts in 1882; when Monet arrived in 1883 he intended his own paintings of the place to feature at his forthcoming one-man show: 'I reckon on doing a big canvas of the cliff of Etretat, although it's terribly audacious of me to do that after Courbet who did it so well, but I'll try to do it differently.' Courbet's theme of waves confronting the fishing-boats and cliffs was to be echoed by Monet (e.g. pl. 25).[37]

However his choice of Etretat must be seen in the broader context of the place's status as a newly fashionable resort. The travel literature and guidebooks of the period describe how the holidaymakers then

sat where the fishermen had worked, though Monet, as a journalist noted in 1889, stayed on at Etretat alongside 'the true sea lovers who, when the Parisians have long since packed their bags, stay behind in deserted Etretat to watch the equinoctial tides pound the cliff', when the fishermen regain their terrain on the beach.[38] Nevertheless, Etretat's renown, like that of Dieppe and the Mediterranean resorts, would have given Monet's canvases of the place a context and topicality for a Parisian audience of the 1880s which the landscapes of Giverny would conspicuously have lacked, though, apart from a few fashionably dressed figures on the cliffs and beaches near Dieppe in 1882 (e.g. pl. 228), the tourist makes no appearance in his coastal scenes.

Travel guides and travel literature of various sorts probably

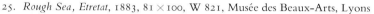

25. *Rough Sea, Etretat*, 1883, 81 × 100, W 821, Musée des Beaux-Arts, Lyons

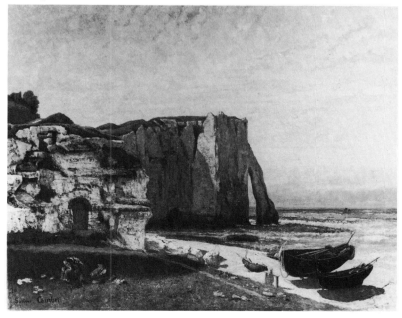

26. Courbet, *The Cliff at Etretat after the Storm*, 1869–70, 133 × 162, Musée du Louvre, Paris

27. *The Vallée de Sasso*, 1884, 65 × 92, W 859, Private Collection

played a regular part in suggesting sites and even specific subjects to Monet; a number of guides remain at Giverny. We have only one clear indication of his use of such a guide. Geffroy wrote of Monet's discovery of Belle-Isle; 'It is fortunate that an artist should have sensed this admirable place from afar, from the curves on a map and the descriptions of a "guide".' His desire to visit the place in 1886 may well also have been sharpened by the descriptions of it in an essay by one of his favourite authors, Flaubert, published earlier the same year in a book of which he owned a copy.[39]

On his travels Monet generally gravitated towards the sites which contemporary guidebooks signalled, as for instance at Bordighera and Menton in 1884. At the time of Monet's visit a guide was available in Bordighera titled *Les Motifs artistiques de Bordighera*, by the architect Charles Garnier whose villa dominated the town; this was designed for artists who could not stay long enough to explore the place fully for themselves. It picked on two sites where Monet was often to paint as the most picturesque of the area – Sig. Moreno's garden and the Sasso torrent, the former, 'the pearl of Bordighera',

28. *The Corniche de Monaco*, 1884, 74 × 92, W 890, Stedelijk Museum, Amsterdam

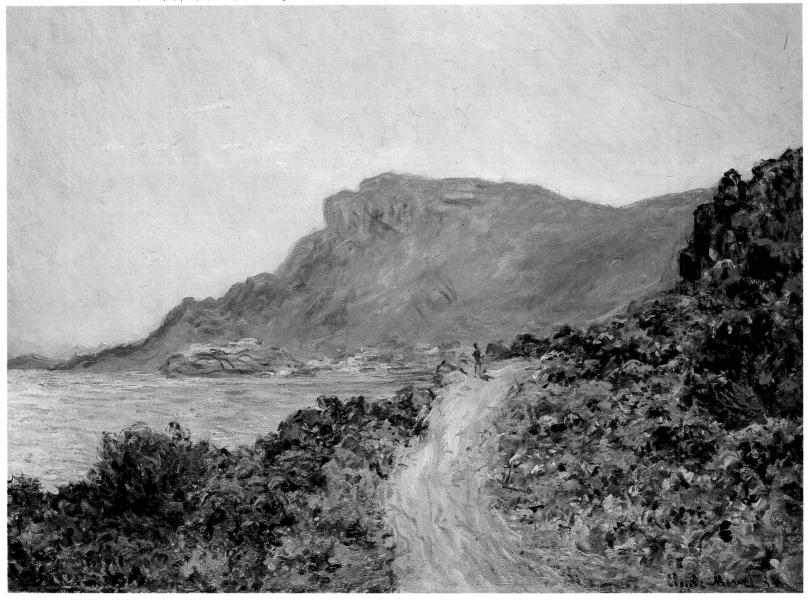

for its lavish plants and trees (see pl. 156), the latter for its scenes of wild vegetation in a rocky valley behind the town (pl. 27). Both were also warmly recommended in the winter 1883–4 edition of Joanne's guide *Les Stations d'hiver de la Méditerranée*, which praised another of his favourite spots, the valley of the Nervia and the village of Dolce Acqua (pl. 99).[40]

During his brief stay at Menton on his way home, too, Monet painted much-favoured sites, notably the view of the Corniche road towards Monte Carlo (pl. 28), which was seen from the identical viewpoint in Hugh Macmillan's *The Riviera* (pl. 29). Macmillan's illustration helps clarify Monet's relationship to such travel books. Though the book was not published until 1885, its illustrations were drawn in 1882; so they could not have influenced, or been influenced by, Monet's choice of viewpoint in 1884.[41] The relevance of such illustrations is more general: they show what were considered the most picturesque sights of a region. On his travels he could not, as he did at Giverny, take his time and find the subjects which 'required seeking';[42] instead he quickly seized on the dominant

29. *Tête du Chien, from Mentone*, illustration from H. Macmillan, *The Riviera*, London 1885, p.183

aspects of a place and sought out the most suitable subjects, presumably often with assistance from local inhabitants or guidebooks.

When beginning to paint a place, Monet always hoped to produce a varied group of canvases,[43] but as he became acclimatised he concentrated more on mastering what he saw as the prime physical features of each site – at Bordighera the palm trees and 'rather exotic aspects' (e.g. pls. 156, 245), on Belle-Isle the startling architectural forms of the rocks (e.g. pls. 30, 85).[44] Then, as he worked his way more deeply into an area, the dominant mood or atmosphere of the place took over, and his letters show a decreasing interest in the purely physical features of his surroundings. At Bordighera in 1884 and at Antibes in 1888, he became obsessed with 'this brilliance, this magical light' of the Mediterranean – all blues and pinks (e.g. pls. 119, 229). Between these two trips to the South, the Belle-Isle canvases of 1886 gave a quite different mood (see pl. 30); he saw the whole group of Antibes pictures as a contrast to Belle-Isle: 'After terrifying Belle-Isle, this will be something tender, there's nothing here but blue, pink and gold.'[45]

After Antibes, he returned, in the valley of the Creuse in 1889 (e.g. pl. 134), to scenery 'of an awesome wildness which reminds me of Belle-Isle'; to emphasise this mood he chose to paint its rocky hillsides in winter. But the onset of spring, after a spell of rain,

transformed the scene and brought out the buds on a great oak tree which appeared in several of his canvases (e.g. pl. 179). Rather than lose the starkness of his winter effect, he employed two workmen to strip it of its leaves, and finished his paintings in early May with the comment: 'Isn't it just too much to be finishing a winter landscape at this time of year?'[46] This story shows the importance of mood in the conception of Monet's landscapes; on occasion the mood which he wanted a group of paintings to express might even override the actual effects he had before him.

The idea of pursuing extreme, contrasting moods in his paintings stemmed from Monet's desire to extend the range of his work and from his reluctance to be typecast as the painter of a particular type of effect. He justified this quest for variety in 1886, when Durand-Ruel expressed his disquiet at the canvases Monet was painting on Belle-Isle: 'Although it seems to worry you, I am full of enthusiasm for this sinister place, and this is precisely because it gets me away from what I usually do; besides, I admit, I have to make a great effort and I'm having a great deal of trouble in rendering its sombre and awesome appearance. There's no point in my being the man of the sunlight, as you call it, one mustn't specialise in a single theme.'[47] The pattern of contrasting groups of paintings continued through the 1890s, with the Poplars (e.g. pls. 255–6) following the Grain Stacks (e.g. pl. 33), and, later in the decade, widely differing series under way in summer and winter.

Once he was fully accustomed to a place, Monet tended to emphasise either elemental forces or atmospheric effects. The atmosphere, as we have seen, came to dominate in his southern work, and it became the primary subject of his art from 1890, with the Grain Stacks and later series. But on his travels of the 1880s, in contrast to the quiet scenes he was painting at home, he often chose subjects which showed nature at its most elemental, particularly emphasising the opposing forces of land and sea. It was particularly on Belle-Isle that he showed his enthusiasm for such themes. He decided to prolong his stay there once the autumn storms hit the island (see pls. 30, 108): 'For three days now we've had a dreadful storm; I've never seen such a spectacle . . . I'm trying to do some quick sketches (*pochades*) of this upheaval, because it's marvellous, but it's very

30. *Storm, Coast of Belle-Isle*, 1886, 65 × 81, W 1116, Musée d'Orsay, Paris

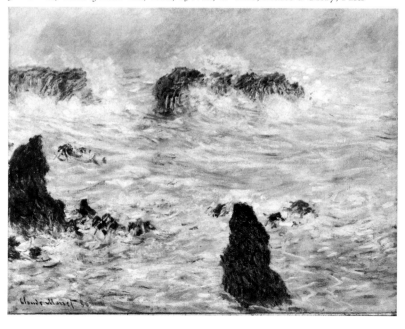

25

31. Corot, *Landscape at Coubron*, ? c.1860, 40.5 × 54.5, National Gallery of Scotland, Edinburgh

difficult . . . What I do know is that this coast really excites me.' A few days later he described his feelings for the sea: 'You know my passion for the sea, and it is so beautiful here . . . I feel that every day I'm understanding it better . . . its effect is quite terrifying . . . I'm mad about it; but I well realise that, in order to paint the sea, one has to see it every day, at every time of day at the same place in order to get to know its life at that place.'[48] Many years later, Monet's boatman on Belle-Isle, Père Poly (the lines of whose face as Monet painted it echoed the forces of the waves, see pl. 45), remembered: 'Only the sea made Monsieur Monet happy. He needed water, great quantities of it, and the more there was of it, even if it was spattering our faces with foam, the better pleased he was.'[49]

Stormy seas had fascinated Monet long before 1886. On Belle-Isle, waves and rocks alone formed his theme, but earlier he had often shown small figures facing the force of the waves – in his sea-pieces of the late 1860s (e.g. pl. 17), and again on his trips to the Normandy coast of the early 1880s (e.g. pl. 128). In 1885 he was delighted to be at Etretat at 'the high-point of the fishing', which shows how responsive he still was to the contrast between the activities of the seashore and the open expanses of the sea.[50] Observers there watched him confronting the elements on the beach on November mornings: 'With water streaming down under his cape, Monet painted the tempest while the salt water spattered him'; Maupassant saw him 'grasp in his hands a shower beating down on the sea, and fling it on his canvas' (pl. 174).[51] His flirtation with the elements nearly proved his undoing at Etretat, when a mis-reading of the tide tables led him to be swept away by a wave when he was painting the Manneporte from the base of the cliff (see pl. 83).[52] In 1882 he decided to stay on to paint near Dieppe and moved to the sea's edge at Pourville: 'The place is very beautiful and I much regret not coming here sooner instead of wasting my time at Dieppe. One couldn't be nearer the sea than I am, right on the beach, and the waves beat against the base of the house.'[53]

The most eloquent testimony to Monet's love for the sea is the accounts of his visits to the coast as an old man – not in order to paint, but just to look at the sea. He wrote from Giverny in 1917: 'Here I am back again, delighted with my little trip: I saw and dreamed about so many memories, so much toil. Honfleur, Le

Havre, Etretat, Yport, Pourville and Dieppe – it's done me good, and I'll get back to work with renewed zeal.' Jacques-Emile Blanche watched him at Dieppe on one such trip: 'It was a stormy day in November. I learned that he had wanted to gaze once again on that roadstead he had painted so often . . . He sat down on the jetty, while a bitter west wind dishevelled his beard and sprayed it with foam.' Etretat remained his favourite haunt: 'Etretat! Monet has always retained a vivid memory of its brave sailors, its agile boats and its then wild shores. And when nostalgia for the sea overtakes him again, in his peaceful Giverny, it is always to Etretat that he rushes to see again . . . the open sea under the cloudy sky.' When he died, Monet said, he wanted to be buried in a buoy.[54]

The winter also supplied him with extreme natural effects; Monet remained fascinated by nature in the grip of snow and ice. He particularly admired the countryside in winter, and continued until the mid-1890s to paint winter scenes at Giverny (e.g. pls. 157, 161) whenever the weather permitted;[55] a long freeze followed by a thaw in 1892–3 gave him the chance to return to the theme of ice floes (e.g. pl. 213), but now he focused more on atmospheric effects, in contrast to the natural drama of *The Thaw* of 1880 (pl. 24). He startled the Norwegians early in 1895 by arriving to paint their landscape in the depths of winter;[56] often in his Norwegian canvases the snowclad countryside is the sole subject (e.g. pl. 87), but some-times Monet showed the snow bearing down on the hamlet of Sandviken (e.g. pl. 100), stressing again man's relationship to the elements. This trip was his only attempt to paint truly mountainous scenery; in general, he told Marc Elder, much though he admired the mountains, he was much more deeply moved by the sea.[57]

Monet made much of braving the forces of nature when painting

32. Millet, *Autumn, the Grain Stacks*, c.1868–75, 85 × 110, Metropolitan Museum of Art, New York

out of doors, and described his activities as if he saw the act of painting itself as a sort of elemental struggle. This attitute, like the paintings in which he showed man or his creations confronting the elements, reveals Monet as an inheritor of the Romantic notion of man's insignificance before nature's power.[58] But not all Monet's coastal canvases play on this opposition. Often the sea is calm, viewed from the cliffs or the beaches, and sometimes, at Pourville in

33. *Two Grain Stacks, Close of Day, Autumn*, 1890–1, 65 × 100, **W** 1270, Art Institute of Chicago

1882, the cliffs and beaches are peopled by fashionably dressed holiday makers (e.g. pl. 228), or minuscule mussel gatherers on the rocks are silhouetted against the sunset (pl. 177). Even in the paintings of stormy waves (e.g. pls. 30, 108), Monet did not present a single wave as a heroic motif, as Courbet had in many of his seascapes, but instead allowed the waves to play with equal emphasis across the canvas, alongside the other elements in the scene. In all his paintings of the 1880s, even where there is a dominant single feature, it was the total effect of the scene that carried its expressive force; the technique of the paintings, as we shall see, treated all the elements in the picture as parts of a single, coherent whole.

Monet's canvases painted at home were always very different from his coastal scenes, in showing the enclosed perspectives and domestic scale of the Seine valley, instead of distant horizons and grand scenes. The qualities Monet found in the Seine valley can best be seen from his reactions to Giverny, where he moved in 1883. He was at once enthusiastic about the place, and its lighting would have presented few problems of acclimatisation, since it was so near Vétheuil. However, he did not at once come to terms with it pictorially. A few months after he moved there, he wrote: 'I find the countryside superb, and until now I haven't known how to take advantage of it . . . It always takes some time to familiarise oneself with a new place.'[59] At Giverny he could explore the countryside at his leisure, as he could not on his travels. His reactions to an excursion in 1892 show what he found there when he knew the

place well. The American painter Theodore Robinson recorded: 'He had been on a little trip down the Seine yesterday, and came back, as always, with an increased liking for this place . . . its variety and its charm. He agreed with me that it was not too picturesque – the motifs did not jump at you at once, but required seeking.'[60]

In some of his earlier paintings of the Giverny area, Monet concentrated on its more obvious topographical features, such as churches or clusters of old buildings (e.g. pls. 40, 157); but he soon began to focus on less obviously picturesque subjects – simple meadows with trees, backwaters of the river, folds in the hills (e.g. pls. 76, 131, 109). The views he chose were typical of the place: Giverny lies below a hilly ridge, separated from the Seine by a wide band of water meadows; the river circles these meadows in a wide arc, with a long crescent of wooded hills on its further bank (see pl. 213). Monet's chosen motifs often show how the hills on both sides form an unobtrusive backdrop to the open vistas of the fields (e.g. pls. 33, 135).

In 1888, when Monet's art would have been best known for the arresting subjects he favoured on his travels, an interviewer described a walk with him in the Giverny countryside: 'Everything interests him During a walk we took together, he stopped in front of the most dissimilar motifs, uttering words of admiration, and made me note how noble and how unexpected nature is. The enclosed meadows, smelling of wild mint, planted with willows and poplars, are as dear to him as the broad horizons.'[61] Late in his life, Monet

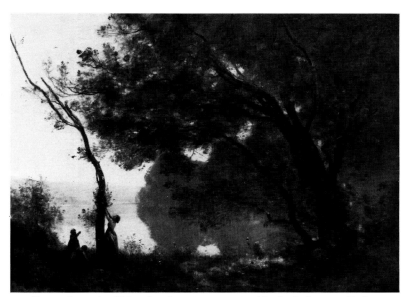

34. Corot, *Souvenir of Mortefontaine*, 1864, 65×89, Musée du Louvre, Paris

mentioned some of the things that appealed to him in this landscape – the willows on the meadows, and 'that hill that goes round beyond the Seine'.[62] His delight at the effect of this hill and the ways in which the trees punctuate the meadows shows how sensitive he remained to the area's characteristic relationships of space and scale, even at the end of his life when for the past twenty years he had painted nothing at Giverny except his own gardens.

His approach to the Seine valley landscape was not entirely novel; Corot, Daubigny and Pissarro had all chosen similar scenes. Daubigny's open river scenes of the Seine and Oise are often comparable to Monet's in their simple frontality, and on occasion, though perhaps unknowingly, Monet turned to Daubigny's actual motifs (pls. 72–3). In the later 1870s Pissarro had painted meadows with open foregrounds similar to those Monet began to paint in 1881 (e.g. pl. 125).[63] Corot had been a pioneer of the anti-picturesque landscape. The Impressionists, Renoir later recalled, had originally criticised Corot for reworking his landscapes in the studio, but the Giverny landscape itself, and particularly the willows on the meadows, helped Monet to reassess him (see pl. 31). He told Elder: 'Ever since coming face to face with these trees, I've been more and more convinced that Corot was a great painter.' Pissarro, too, felt that Corot's treatment of the Ile-de-France scenery confirmed his own approach to his subjects, writing in 1893: 'One can make such beautiful things with so little. Motifs that are too beautiful end up by seeming theatrical – think of Switzerland. What lovely little things old Corot did at Gisors: two willows, a bit of water, a bridge, like the picture at the Exposition Universelle. What a masterpiece! Happy are those who see beautiful things in unassuming places where others see nothing. Everything is beautiful, what matters is to know how to interpret it.'[64] It was the vision and interpretive power of the painter that could sense the beauties latent in nature, and could make them visible in art.

Like the Vétheuil canvases, Monet's paintings of Giverny contain no reference to the actual cultivation of the countryside. The few figures that appear on the meadows are members of Monet's own household (pls. 47–8), and even scenes that show growing crops, such as the *Field of Oats* paintings of 1890 (e.g. pl. 250), concentrate on visual effects – on light, colour and texture. Similarly, the series

of Grain Stacks of 1890–1 (e.g. pls. 33, 161–2) use the stacks as the basis for endless variations of light and colour. It has recently been pointed out that these stacks are stacks of grain or corn, rather than haystacks (as they have traditionally been translated), and that they thus represent the substance of the local farmer's livelihood.[65] Monet would of course have known exactly what they were, but nothing in his canvases hints at this. In comparison with previous depictions of such stacks, Monet's paintings conspicuously lack references to their social and agricultural function. Whereas in Millet's *Autumn, the Grain Stacks* (pl. 32, which Monet would have seen exhibited in 1887 and 1889)[66] very similar stacks are presented as the focus of the life of the community, Monet seems deliberately to have avoided making this context explicit. Monet's omission of the cultivators of the countryside is in marked contrast to the approach of his friend Pissarro, whose rural scenes gain their social meaning from the presence of the peasants who work in them (e.g. pl. 192). By 1890 the meaning of the countryside for Monet was primarily optical rather than social; like Millet and Pissarro, he was fascinated by the cycles of days and seasons, but for Monet this fascination lay in the 'weather, atmosphere and ambience' that he was struggling to paint,[67] rather than in cycles of growth, harvest and renewal. His aestheticisation of these cycles would have seemed all the more conspicuous in the pictures' original context; the cycles of agricultural labour and peasant life were the prime focus of contemporary rural painting.

On his trips to the Mediterranean in 1884 and 1888 Monet had been taxed by the problems of rendering the coloured light he saw there (e.g. pl. 229), but it was particularly at Giverny that the painting of the atmospheric *enveloppe* became of central importance for his art. At Giverny his eyes were attuned to the most minute changes of light, and it was these, rather than any spectacular natural features, that sustained his interest so fully when he painted there. Subjects veiled in mist and fog had fascinated him at least since his stay in London in 1870–1 (see pl. 144), but it was only in his paintings of the meadows at Giverny that the play of coloured light itself became the principal theme of the canvas (e.g. pl. 160). The significance of the *enveloppe* will be a central theme in the present book.

In the 1890s and later Monet picked subjects that gave free play to these atmospheric nuances: sometimes he chose light effects which veiled the local colours of the objects and imposed an overall unity on them, such as the mists on meadows and grain stacks and the dawn effects in the series of Early Mornings on the Seine (e.g. pl. 35); and sometimes he painted objects which themselves had no strong local colour, where atmospheric could dictate the whole effect, as with Rouen Cathedral or the buildings of London (e.g. pls. 138, 268). It was in this overriding search for atmosphere that his later travels differed from those of the 1880s.

As we have seen, the themes Monet chose in the 1870s and 1880s suggest that he took an active interest in their physical ingredients – in their modernity in the 1870s, in their drama on his travels of the 1880s. After 1890, though, the subjects he chose for his series are particularly diverse, ranging from poplars at Giverny to the façade of Rouen Cathedral, from early mornings of a backwater of the Seine to the busy Thames bridges of London. What they share is that all alike were absorbed into and transformed by their atmospheric cloak, and it was this that drew Monet to them. In 1891 he told a visitor to the Grain Stacks exhibition: 'For me, a landscape does not exist in its own right, since its appearance changes at every moment; but its surroundings bring it to life – the air and the light,

which vary continually . . . For me, it is only the surrounding atmosphere which gives objects their real value.'[68] He described his aims to two interviewers in Norway in 1895: 'I want to paint the air in which the bridge, the house and the boat are to be found – the beauty of the air around them, and that is nothing less than the impossible.' 'To me the motif itself is an insignificant factor; what I want to reproduce is what lies between the motif and me.' Geffroy had used the same image in writing of Monet's art in 1890: 'He does not want to represent the reality of things, he wants to fix the light that lies between him and the objects.'[69] Late in his life he told the dealer René Gimpel of his responses to London: 'I like London so much, but only in the winter. In summer, it's fine with its parks, but that's nothing beside the winter with the fog, because, without the fog, London would not be a beautiful city. It is the fog that gives it

its marvellous breadth. Its regular, massive blocks become grandiose in this mysterious cloak.'[70]

As we shall see in more detail later, his preoccupation with the *enveloppe* as the central theme of his art was accompanied by changes in his technique and in the qualities he sought in the surfaces of his finished paintings; now the textures and patterns of individual objects, and the free play of the brush, are always subordinated to the overall harmony of the picture.[71]

Monet's admiration for Turner was at its height as he focused on painting the *enveloppe*; he was looking at Turner's art with particular interest in the late 1880s and early 1890s.[72] It was at this point, not in 1870–1 when he first saw Turner's paintings, that the Englishman's rich coloured harmonies would have had a direct relevance to Monet's own concerns. Corot, too, helped him in his pursuit of the

35. *Early Morning on the Seine*, 1896–7, 81 × 92, W 1479, Private Collection

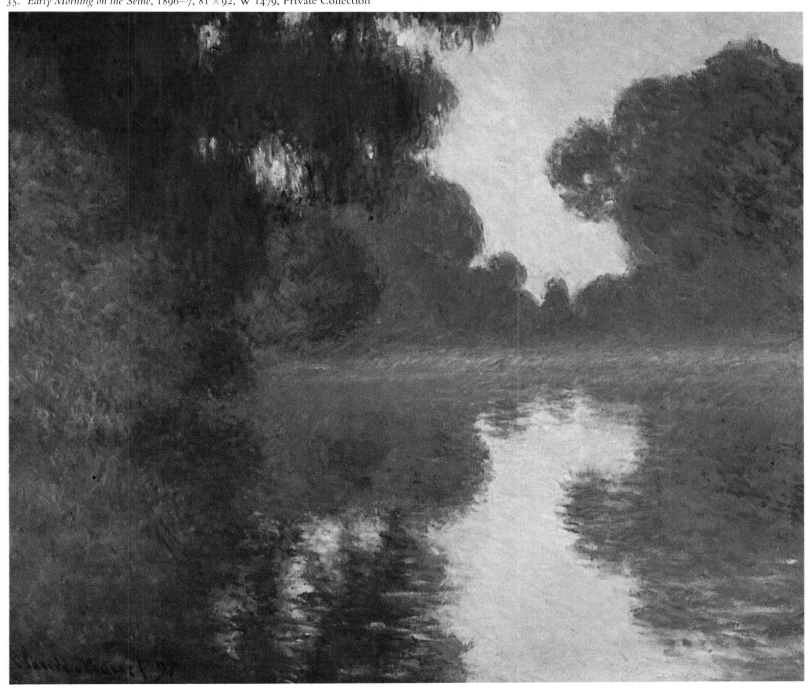

enveloppe, especially in the later 1890s when Monet spoke of him with particular enthusiasm.[73] Indeed the series of *Early Mornings on the Seine* (e.g. pl. 35) may have been meant as a tribute to Corot. They recall him in their compositions and their veiled early morning effect (compare *Souvenir of Mortefontaine* of 1864, pl. 34), and the account of the series by the American painter Lilla Cabot Perry suggests that Monet himself made such a comparison: 'They were painted from a boat, many of them before dawn, which gave them a certain Corot-like effect, Corot having been fond of painting at that hour.'[74]

During the 1890s Monet began to execute the project which would occupy the rest of his life – the creation of his water garden at Giverny, a self-designed, self-contained universe. When he moved to Giverny, one of his first concerns was to reorganise the gardens beside the house. His own gardens had been a favoured painting subject at Argenteuil and Vétheuil (e.g. pls. 3, 118, 188). He rarely

36. *The Water Lily Pond*, 1899, 89 × 93, W 1515, Musée d'Orsay, Paris

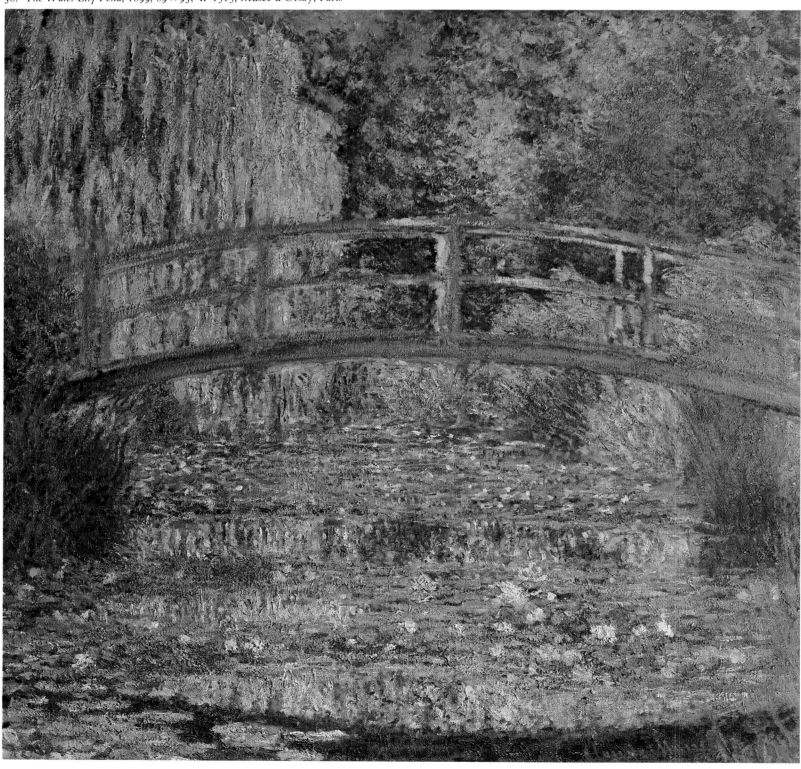

painted the gardens themselves in his first years at Giverny but his purchase of the house in 1890 allowed him to plan the gardens in the long term: he received a visit from a Japanese gardener in 1891, and spent much of 1892 at work on the garden.[75] He took the crucial step in the development of his gardens in February 1893, by buying a strip of land below his property, on the other side of the road and the local railway line, where he soon began to construct his water garden. Monet later claimed: 'It took me some time to understand

37. *Water Lilies*, 1907, 100 × 73, W 1714, Musée Marmottan, Paris

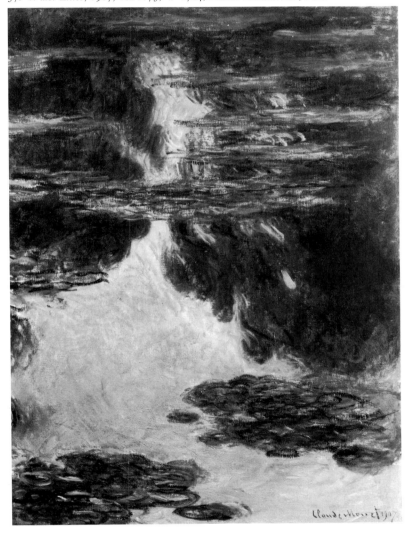

my water lilies. I had planted them for pleasure; I cultivated them without thinking of painting them . . . A landscape does not sink in to you all at once.' However, a letter of 1893 to the Préfet de l'Eure requesting permission to construct the garden shows how quickly his painting plans in fact germinated: 'It is only a question of something for amusement and for the pleasure of the eyes, and also with a view to motifs for painting.'[76] The pond, with its wooden footbridge, was originally small, as it appears in Monet's series of 1899–1900 (e.g. pl. 36). But thereafter he greatly enlarged it, to the form in which it appears in his series of Water Lilies, Water Landscapes exhibited in 1909 (e.g. pl. 37), and in the monumental Water Lily Decorations of his last years (pls. 92, 269).[77]

The water garden in a sense bypassed Monet's long searches of earlier years for suitable subjects to paint. Designed and constantly supervised by the artist himself, and tended by several gardeners, it offered him a motif which was at the same time natural and at his own command – nature redesigned by a temperament. But, once again, Monet stressed that his real subject when he painted it was the light and weather: 'The effect varies constantly, not only from one season to the next, but from one minute to the next, since the water flowers are far from being the whole scene; really, they are just the accompaniment. The essence of the motif is the mirror of water whose appearance alters at every moment, thanks to the patches of sky that are reflected in it, and which give it its light and movement.'[78] He emphasised this by giving the series exhibited in 1909 the subtitle Water Landscapes.

One other factor began to affect Monet's choice of subjects after 1880 – an interest in reworking and further exploring themes from his own previous painting. Sometimes he selected sites very similar to those he had already painted, and sometimes he returned to the same actual sites. His nostalgic visits to the coast at the end of his life are an echo of a long-cherished ambition to execute a whole sequence of paintings as résumés of his past subjects. He told Thiébault-Sisson: 'Ever since I turned sixty, I had had the idea of undertaking, for each of the types of motif which had in turn shared my attention, a sort of synthesis in which I would sum up in one canvas, sometimes two, my past impressions and sensations. I gave up this project. I would have had to travel a great deal and for a long time, to revisit one by one the staging posts of my life as a painter and to verify my past feelings.'[79]

This account suggests that these plans dated from around 1900, but they had evolved over the previous twenty years. A few of Monet's coastal subjects of the 1880s mark a precise return to subjects from the late 1860s, while, among the less direct reminiscences, the most explicit are the *Woman with a Parasol* canvases of 1886 (e.g. pl. 38) which, J.-P. Hoschedé remembered, were inspired by a memory of a painting of 1875 of Camille and Jean on a bank (pl. 39).[80] Monet took up the idea of reworking past subjects in earnest in 1894 in his series of Vernon Church (e.g. pl. 41), which repeats in foggy conditions the motif of a sunlit painting of 1883 (pl. 40); eight canvases from this new series were exhibited in 1895 alongside their solitary predecessor, a juxtaposition clearly intended to draw attention to this sort of continuity in Monet's work.[81] The series of Pourville (1896–7, pl. 165), London (1899–1901, pl. 91) and Vétheuil (1900–1, pl. 42) continue this pattern, but they are in a sense the opposite of what Monet intended, since his concentration on changing atmospheric effects led him to treat each subject in a far greater number of canvases than he had before, rather than summing them up in one or two paintings.

A subject, once he had painted it, was not a completed experience; what had attracted him once could attract him again, with the added interest that he could match his new versions against their predecessors. Both of these issues always occupied him: such relationships between new and old could reveal the continuity of his sources of inspiration, but at the same time they highlighted the changes and progress in his art.[82]

Monet's central concerns in his choice of subjects changed as his career went on, from the topicality of his scenes before 1880, through the more timeless, elemental subjects of the 1880s, to his concern for the most transitory effects of light and atmosphere from 1890 on. These phases do, of course, overlap: the elements and the atmosphere had both interested him before 1870. But his gradually changing interests illuminate the development of his ideas about the relationship between nature and art. These changes go hand in hand

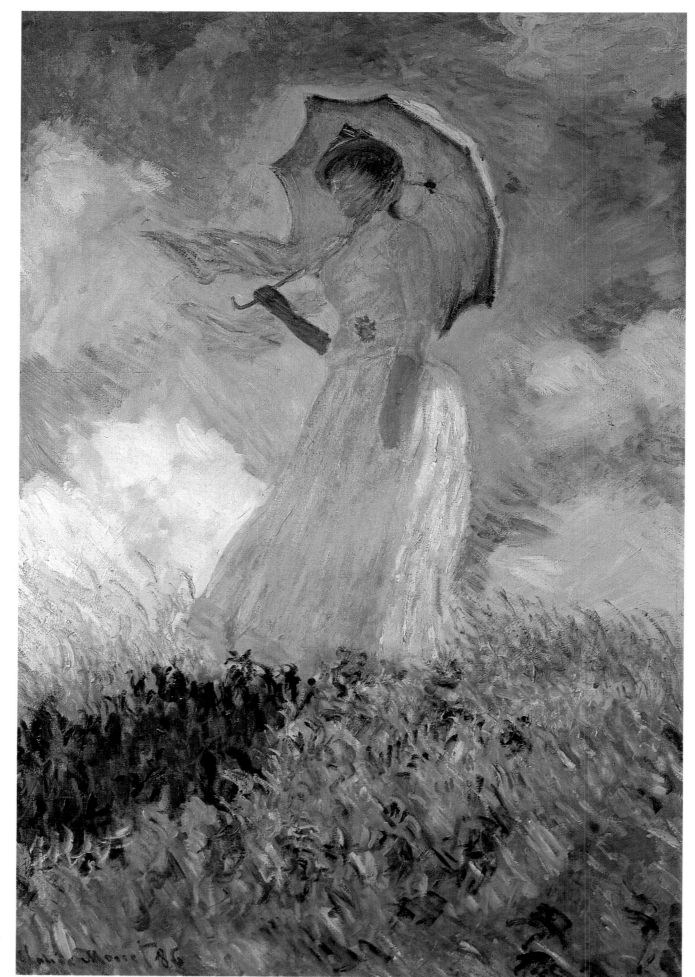

38. *Woman with a Parasol, turned to the left*, 1886, 131 × 88, W 1077, Musée d'Orsay, Paris

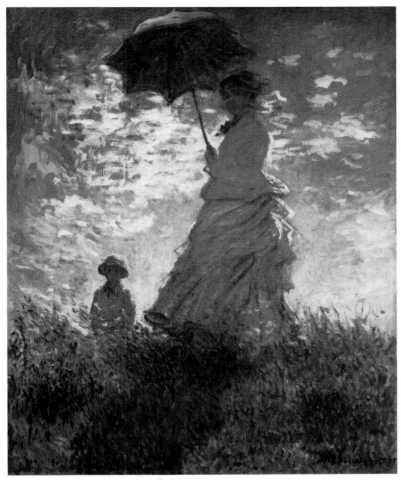

39. *The Promenade*, 1875, 100 × 81, W 381, National Gallery of Art, Washington, D.C.

40. *Vernon Church*, 1883, 65 × 81, W 843, Private Collection

41. *Vernon Church, Fog*, 1894, 65 × 92, W 1390, Shelburne Museum, Shelburne, Vt.

42. *Vétheuil, at Sunset*, 1901, 90 × 93, W 1644, Musée d'Orsay, Paris

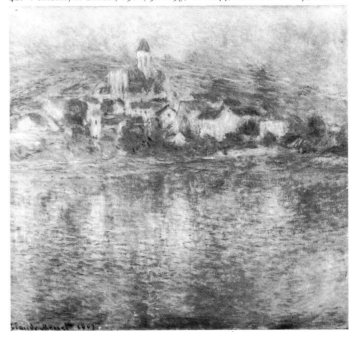

with the evolution of his technique and working methods; only by examining the means by which he transformed his raw material can we focus more fully on his evolving aims.

FIGURE PAINTING

Figures played important roles in Monet's landscapes until around 1880: they helped to define the space and scale of the scenes he depicted, and at the same time Monet characterised them closely enough for them to play their part in defining the social milieu of his subjects. But he also painted canvases where figures are dominant, sometimes appearing in isolation, sometimes within a natural setting. These fall into two groups: first, a sequence of occasional canvases up to around 1876 in which he explored several current genres of modern life figure paintings; and second, a sustained but ultimately unresolved period of experimentation in 1886–90 with the problem of 'figures treated like landscape'.

The Salon was the planned destination of his most ambitious figure subjects of the 1860s; its conventions and expectations – about subject matter and about the appropriate ways of treating it – provided the context for Monet's ventures. His *Déjeuner sur l'herbe* (study, pl. 14) was conceived as a vast modernised *fête champêtre*, but when he was unable to complete it for the 1866 Salon he submitted instead another type of modern figure in *Camille* (pl. 257) – not so much a portrait as a study of a characteristic Parisian type, with clear

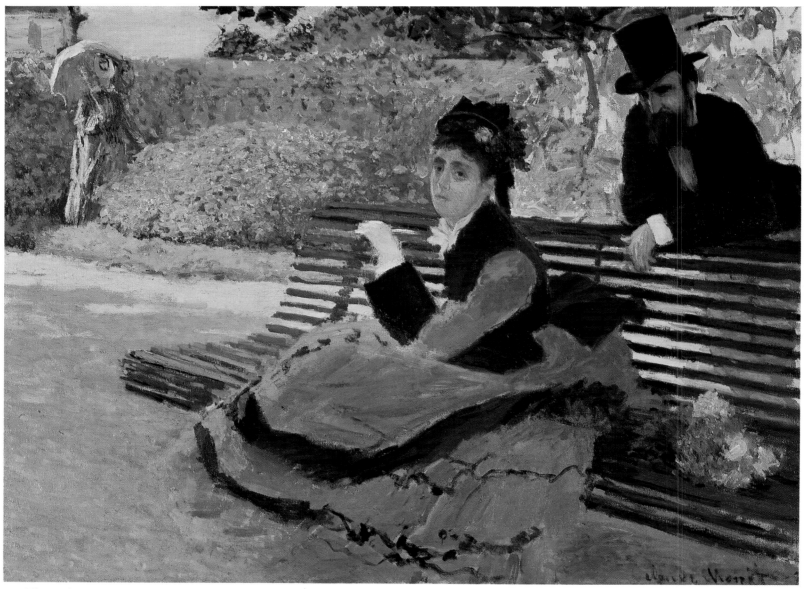

43. *The Bench*, c.1873, 60 × 80, W 281, Private Collection

echoes of recent paintings by Manet.[83] In *Women in the Garden* (pl. 64), rejected in 1867, he turned again to the open air, but its four figures do not fit into any established thematic genre. Despite its size, it has no obvious subject, and there is no clear interchange between the figures; their unfocused grouping is a deliberate rejection of conventions of thematic coherence and legibility. Later in the decade Monet's own family supplied the subject for some canvases, notably the very large *Luncheon* (pl. 2) rejected in 1870, in which the family mealtime is presented with a studied informality, with the vacant place on the near side of the table awaiting the arrival of the father of the household – the painter himself. Monet also began to paint occasional commissioned portraits in the 1860s, mostly quite small in scale, apart from the life-sized *Madame Gaudibert*, again reminiscent of Manet.

In the 1870s Monet painted a few more conventional images of modern woman, such as *Meditation*, exhibited in the London International Exhibition in 1871, which shows Camille on a sofa with a book on her knee; Monet's chosen title is an unusual concession to popular taste.[84] In other pictures the subjects are more ambiguous;

in *The Bench* (pl. 43), for instance, he omitted any clue to the relationship between the figures, as the woman on the bench leans away from her companion and turns towards the viewer. Figure subjects of the 1870s such as this and *Monet's House at Argenteuil* (pl. 3) have been viewed as somehow autobiographical, the reflection of personal alienation or marital tensions;[85] but they must be seen in relation to contemporary expectations about domestic genre scenes, which required a legible relationship or a legible narrative. The inexplicitness of the interchange between man and woman in *The Bench* and between woman and child in *Monet's House at Argenteuil* were a rejection of stereotyped images of courtship and parenthood, in favour of more open-ended, ambiguous images of human relationships. Monet's alertness to artistic traditions is shown by *Jean on his Mechanical Horse* (pl. 44), which, as Paul Tucker has suggested, is a reworking of the traditional equestrian child portrait;[86] it is not, though, an unequivocal tribute, but perhaps more a parody, as the monumental steed is transformed into a wooden horse mounted on a child's tricycle.

In Monet's few figure paintings of the mid-1870s, as in his

peopled landscapes of the same years, the figures are absorbed into more of an overall ambience, rather than crisply set off from their surroundings.[87] By far the most ambitious of these is *La Japonaise* of 1875–6 (pl. 264), a deliberately commercial venture into fashionable far eastern bric-à-brac which Monet later dismissed as 'rubbish';[88] but two other paintings of 1875 relate figures to their context in a far more interesting way. In *A Corner of the Apartment* (pl. 13) Jean appears amid the rich patterns of plants, curtains and lamp and the play of indoor light and shadow, while in *The Promenade* (pl. 39) he and Camille are as boldly sketched as the grassy bank and clouds around them. Camille often appears, too, in Monet's Argenteuil garden scenes of 1875–6, for instance *Gladioli* (pl. 118); her figure, with the patches of light playing across it, is treated as just one element in the web of coloured textures which fills the canvas. For the next decade there are rarely prominent figures in his landscapes. Only at Vétheuil in 1880–1 did he explore

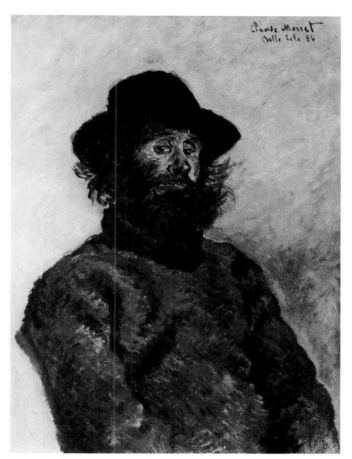

45. *Poly, Fisherman at Kervillaouen*, 1886, 74 × 53, W 1122, Musée Marmottan, Paris

46. *Camille on her Death Bed*, 1879, 90 × 68, W 543, Musée d'Orsay, Paris

44. *Jean on his Mechanical Horse*, 1872, 59.5 × 73.5, W 238, Private Collection

the borderline between landscape and figure painting in a few more canvases, among them *Woman seated under the Willows* (pl. 150), in which the woman and her setting are given roughly equal weight and are particularly closely interwoven by the patterns of the brushwork. The few figures which appear in the landscapes from his travels of the 1880s are clearly subordinated to their surroundings, as in *The Cliff Walk* of 1882 (pl. 228).

In the same years, though, Monet did continue to paint the occasional small portrait of family or friends. He rated this aspect of his work highly enough to include two of these in important exhibitions – Paul, the Pourville pâtissier, in his one-man show in 1883, and Poly, his boatman on Belle-Isle (pl. 45), at Petit's gallery in 1887; but they were only shown alongside paintings of the landscapes which had moulded these men's rugged faces. It was the human face, too, that led Monet in 1879 to one of his most extraordinary enterprises – the translation of his wife Camille, on her deathbed, into streaks and dashes of colour, so that her features seem, before our eyes, to be becoming one with the matter around her (pl. 46). The picture is a remarkable combination of the optical

48. *Meadow with Figures*, 1888, 80 × 80, W 1204, Private Collection

47. (left) *Promenade, temps gris*, 1888, 92 × 81, W 1203, Private Collection

effects Monet found in the 'coloured gradations which death was imposing on her motionless face' with the long-standing tradition of the death mask.[89]

In the late 1880s Monet returned to the problems of figure painting for the last time in his career. Durand-Ruel's son Joseph told Gimpel of this phase after Monet's death: 'Around 1889 he had as it were decided to abandon landscape; he had talked about it with Renoir and his other friends who had strongly advised him to study the figure: he had come to Paris to seek a model, he found and hired a very nice young girl who agreed to come and live at Giverny; but when he returned home his wife told him: "If a model comes into the house, I leave it." That is why we never knew Monet as a portraitist and figure painter.' Another account differs in some details: 'For marital reasons he was thenceforth to be only a portrait-ist, and then only rarely. His friends have told how between 1890 and 1900 Monet wanted to do some landscapes of the Channel beaches enlivened by nudes. His second wife agreed to this idea without enthusiasm. A young model was hired, came from Paris, and went back again without posing. Indeed, no, Madame Monet could not accept her presence.'[90] Like most good stories, these were improved in the telling; they conceal the fact that Monet was able to begin ambitious figure paintings, with Alice Hoschedé's four daughters as his models, fully clothed.

The project probably began with the two *Woman with a Parasol* canvases in 1886 (e.g. pl. 38), which Monet was encouraged to paint by memories of *The Promenade* of 1875 (pl. 39).[91] Further canvases of girls and children on the meadows and girls in boats followed, probably ending in 1890 when, with the Grain Stacks, he began to concentrate on painting landscapes in series. Few of the figure paintings were signed and dated at the time of their execution,

which suggests that he did not consider them to be fully resolved; indeed they seem to have caused him particular difficulties.[92] But he considered them important enough to exhibit several of them between 1889 and 1891, including, it seems, some unsigned canvases. In 1889 he highlighted the paintings in his retrospective exhibition at Petit's gallery by including four of them as a separate section in the catalogue, under the collective title *Essais de figures en plein air*.[93]

Until he first exhibited some of them early in 1889, Monet seems to have told only a few friends about his renewed ambitions as a figure painter. He announced the project to Duret in August 1887: 'I'm working as never before, at some new experiments, figures in the open air as I understand them, treated like landscapes. It's an old dream that constantly plagues me and which I want to realise once for all; but it's so difficult! In a word, I'm putting a great effort into it, and I'm so involved in it that it's almost making me ill.' By early 1888 Geffroy had told Mirbeau about them, but as late as November 1888 Berthe Morisot could write to Mallarmé as if they were something quite new. They formed a part of Monet's efforts to broaden the range of his art. He wrote of them to Geffroy in June 1888: 'I so want to prove that I can do something different.'[94]

In many of the paintings the Hoschedé girls appear in the garden, on the meadows or by the river. Sometimes the figures play no larger role than they had in the Vétheuil figure scenes of 1880, but in others they dominate the canvas. In two paintings dated 1888 (pls. 47–8) they are asymmetrically and loosely grouped to suggest the informality of a walk across the water meadows; the whole surface is made up of flecks and dashes of colour which give little sense of the volume of the figures – it was thus that they were 'treated like landscapes'.

The largest of these paintings – far larger than Monet's con-temporary landscapes – show the girls in boats. The two *Blue Boat*

paintings (e.g. pl. 191) show two of them in a square-sterned rowing boat in open water; the two *Pink Boat* canvases (e.g. pl. 49) show two girls in a narrow sculling boat in a shady backwater; a further two show boats in the backwater, one with three figures, one with none at all (pl. 50). Drawings in Monet's sketchbooks show that the boat in this last canvas, too, was planned to contain figures (e.g. pl. 279).[95] In all of them the boat is placed asymmetrically, in some it is cut by the margin of the canvas, in a way that is reminiscent of the placement of boats in Japanese colour prints.[96] The scale of the pictures suggests that they were planned as an ambitious commercial venture, but Monet was unable to complete any of them for sale at the time of their execution.

Monet's ambitions to treat his figures like landscapes suggests that the figure paintings were, at least in part, executed out of doors. But the size of the boating pictures, and the existence of rapid compositional drawings relating to several of them (see pls. 279–80), suggest that they involved a more complex process than Monet's landscapes. Moreover, unpeopled canvases of the meadows exist which correspond closely to the settings of some of the meadows with figures of 1888;[97] this suggests that, whatever his original intentions, all of these figure paintings may have involved some sort of additive, synthetic working process. But they were not divorced from his contemporary practice in landscape; contemporary critics commented on the close integration between figures and settings

49. *The Pink Boat*, c.1888, 133 × 145, W 1250, Museu de Arte, São Paulo

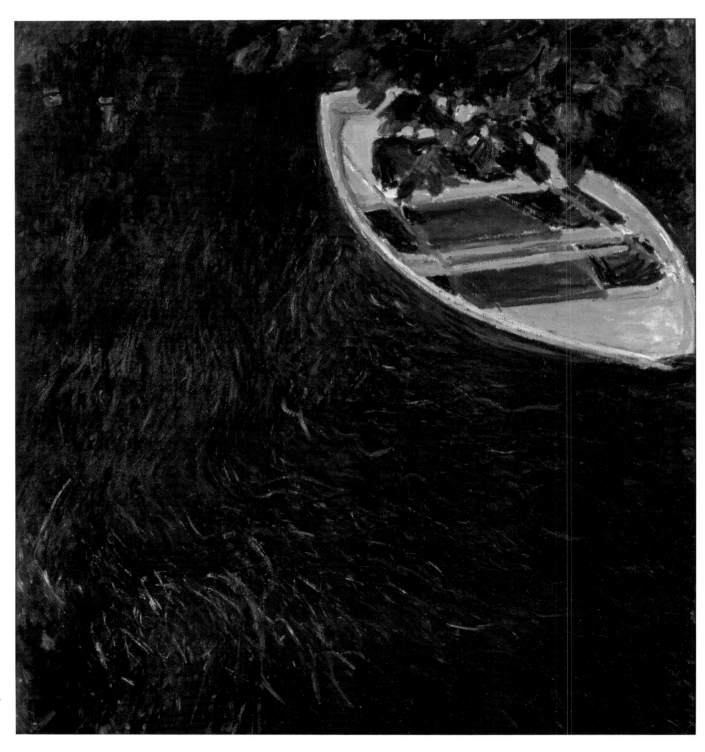

50. *The Boat*, c.1890,
146 × 133, W 1154,
Musée Marmottan,
Paris

in the meadow scenes, and noted that he was applying to the figure the preoccupation with atmospheric colour which dominated his landscapes.[98]

Gimpel's account shows that Monet's venture into figure painting was not made in isolation; it can be linked with a number of Monet's friends and associates, most significantly, as Gimpel's account suggests, with Renoir. During the 1890s Renoir largely abandoned outdoor working for his more ambitious paintings, in favour of traditional methods of studio composition from smaller studies. From this period emerged a succession of figures, mainly nudes, placed against outdoor backgrounds, some of which derived from Renoir's travels, while others were more generalised images of

unspoiled nature; in these pictures the relationship between figure and setting is left undefined, both in scale and space. Monet himself later commented when showing a visitor the Renoir *Bather* of 1892 which hung over his bed: 'Yes, the nude is beautiful, but see how sadly conventional the landscape is; it looks just like a photographer's décor.'[99]

Monet's reservations about Renoir's methods cannot have blinded him to the purpose of Renoir's enterprise – to harness broadly naturalistic aims to a version of the French Classical tradition. The two men had been arguing about the merits of figure painting at least since 1883. After their trip together along the Riviera in December 1883, Renoir spent the rest of the winter in Paris working

up studio paintings, and wrote in January 1884 to Monet, who had returned south to tackle the Mediterranean light at Bordighera: 'As for me, I am stuck in Paris where I'm getting very fed up, and I'm seeking the perfect model. But I am a figure painter.'[18] The phrasing of this comment suggests that they had discussed figure painting and had agreed to differ on it. Three years later, Monet showed his sympathy and understanding for Renoir's experimentation in his report to Durand-Ruel about Renoir's *Bathers*, on its exhibition in 1887: 'Renoir has made a superb picture out of his Bathers, not understood by all, but by many.'[100] This comment, dating from the early stages of Monet's own exploration of figure painting, shows that he had been following the progress of Renoir's manifesto picture with some care.

In the same years, other stimuli would also have encouraged Monet to reconsider figure painting. Pissarro was planning major figure compositions, and in a letter of March 1884 told his son Lucien that he was hoping to have models at Eragny; a tiny tell-tale doodle on the reverse of this letter (pl. 51) reveals the direction in which his thoughts were turning – a pair of very quick notations of reclining nudes, reminiscent of Manet's *Olympia*.[101] Degas took up the theme of the nude in earnest in the 1880s, and Monet would

51. Pissarro, drawings on reverse of letter to Lucien Pissarro, 9 March 1884

52. Sargent, *Carnation, Lily, Lily, Rose*, 1885–7, 174 × 154, Tate Gallery, London

have seen his ten pastels, *Suite of nudes of women bathing, washing, drying and wiping themselves, combing their hair or having it combed*, which were exhibited at the 1886 Impressionist group exhibition, along with Seurat's monumental outdoor figure scene, *A Sunday at the Grande-Jatte*. Cézanne was much involved with the Bather theme in this period, and figure painting may well have been a topic for discussion when Monet and Renoir visited him in the South in December 1883.[102]

However, the closest parallels for Monet's experiments are provided not by any of his French colleagues, but by John Singer Sargent, with whom he was on close terms in the later 1880s.[103] Two facets of Sargent's work must have interested him – the *plein air* procedures he used for his large canvas of girls lighting Chinese lanterns, *Carnation, Lily, Lily, Rose* (pl. 52), and his paintings of figures in boats. Sargent worked on *Carnation, Lily, Lily, Rose* in the autumns of 1885 and 1886, painting out of doors on the large canvas itself, though he had prepared the subject in a number of small studies; he had great difficulties in capturing an effect which lasted only a few minutes every evening. Monet would have seen this painting on show at the Royal Academy during his visit to London in summer 1887, and presumably discussed it with Sargent. As an attempt to harness Impressionist methods and handling to an evocative modern-dress subject, *Carnation, Lily, Lily, Rose* is much more closely related than Renoir's *Bathers* to Monet's large figure pieces; close parallels continued between the two men's work until 1890.[104]

Sargent's *By the River* of 1885 (pl. 53) is a relevant precedent for Monet's boating pictures, but Monet had so many prototypes for this subject (among them Manet, Morisot, Renoir and Japanese prints) that no one example can have played the dominant part.

Indeed, Monet's stimulus may have been literary as well as visual, for the shady backwaters of his *Pink Boat* paintings (pl. 49) strongly echo the mood and imagery of Mallarmé's 1885 prose-poem *The White Water Lily*. Monet knew this at latest by February 1889, when Mallarmé showed him Morisot's design for it, destined for a planned edition of Mallarmé's *Prose Poems* to which Monet was meant to contribute.[105] However, the relevance of Mallarmé to Monet's work of these years goes beyond a single shared motif; it will be discussed in Chapter 14.

53. Sargent, *By the River*, 1885, 51 × 69, Private Collection

Although it only lasted a few years, this experiment with figure painting played an important part in Monet's art at this period, marking a calculated, if temporary, change in direction in his work. Like his colleagues, he had come to find landscape not wholly satisfying, and, after extending the range of his landscape painting earlier in the 1880s, he finally attempted, in his own way, the course that Renoir had been advocating. However, he had great difficulties with his figure paintings of 1886–90, and found a sudden new impetus for his landscape work with the inception of the Grain Stacks series; around 1890 he abandoned once and for all the figure as a subject.

STILL LIFE

At no stage in Monet's career did still life painting form the dominant part of his production, but at certain moments it did play a significant role, which reveals much about the relationship between the artist and his potential markets.

His first three substantial paintings were still lives – ambitious and elaborately staged images of dead game and of the attributes of the artist, painted in 1861–2; but smaller still lives of the same years show his early allegiance to the Chardin tradition, and in particular to the earthy realism of Bonvin.[106] A large and lavish flowerpiece followed in 1864, seemingly painted for exhibition in Rouen; here Courbet's recent flower paintings were his most obvious model.[107] In three table-top arrangements of around 1867 (e.g. pl. 54), crisp incisive brushwork, reminiscent of Manet, is grafted onto the Chardin-like format of frontally viewed groupings of fruit, one of them with dead birds. One of these rapidly found a buyer in Manet's and Bazille's friend Lejosne, which suggests that Monet was here trying to tap the market for such pictures which Manet had already found through the dealer Cadart.[108] A single elaborate composition of fruit and flowers was painted around 1869 (Renoir painted the same vase), and two further ambitious table-top subjects in 1872 (e.g. pl. 55). These three pictures suggest that Monet was looking particularly to Fantin-Latour's delicate and refined reworking of the Chardin tradition; gentle diagonals animate them, and in the 1872 pair the brushwork is particularly fine and delicate, the subjects luxurious – a coffee service on a lacquer tray, and a rich display of fruit on oriental porcelain. Durand-Ruel quickly bought these last two paintings for 400 francs each – a higher price than he was paying Monet for similarly sized landscapes at this date.[109]

These pictures, and the few less ambitious still lives he painted in the same years, were not central to Monet's production, but each of them reveals him exploring a particular current type of still life painting; they also reveal his alertness to potential markets for such pictures. As far as we can tell, he painted no still lives in the mid-1870s, when he and his colleagues were seeking buyers through their independently organised exhibitions. But between 1878 and 1882 he executed by far the largest group of still lives of his career – around twenty substantial canvases of flowers, fruit or game, and some smaller sketches. The comparatively large number of still lives he included in his exhibitions of this period (six out of thirty-five paintings in 1882, eleven out of fifty-six in 1883) shows that he wanted to bring this aspect of his work before the public.[110]

After a few flowerpieces in 1878, Monet turned to still life in earnest in autumn 1879 after Camille's death. It has been suggested that his choice of nature morte was 'in some sense a mourning for his dead wife', and that the gravity of the resulting pictures reflects

54. *Still Life, Pears and Grapes*, c.1867, 46 × 56, W 103, Private Collection

55. *The Tea Service*, 1872, 53 × 72, W 244, Private Collection

this.[111] However, this theory, like the view that the ice floe pictures of the same winter were somehow autobiographical, seems inconsistent with the ways in which Monet sought moods in his subjects (see p. 20). Indeed, the documentary evidence suggests a quite different *raison d'être* for these comparatively sober, elaborately worked paintings: it was still lives, particularly his fruit and game pieces (pls. 56–7, 219), that Monet was able to sell for the highest prices in these years. In the winter of 1879–80, after Camille's death, Monet thoroughly rethought his commercial strategy, deciding to submit to the 1880 Salon rather than show with the Impressionist group, and actively seeking sales through dealers such as Georges Petit. He sold one still life to Petit for 500 francs, and two to Theulier for 800 francs in all; in 1880 he sold several more for similar prices, including two fruit pieces to Delius for a total of 1,400 francs, while the prices for the few landscapes he sold were significantly lower.[112] His production of still lives dropped in 1881, when Durand-Ruel began again regularly to buy his landscapes, and a few large

flower-pieces that he undertook in 1882 marked the end of this group of pictures.[113]

Still life served a further function in these years, as an occupation for days when the weather prevented him from working out of doors. When he moved to Giverny in 1883, his immediate concern was to get the garden in order 'so as to harvest a few flowers to paint when the weather is bad',[114] which suggests that flower painting may already have fulfilled this role on occasion. The only still lives he painted in his early years at Giverny were a set of decorative panels for the doors of Durand-Ruel's dining room, executed in 1883–5 (e.g. pl. 58); as commissions, these put him under unfamiliar pressures, and the project posed problems for him he had not previously faced, of thinking in terms of a decorative ensemble. In his letters to Durand-Ruel his frustration sometimes showed, and these difficulties, together with Durand-Ruel's regular purchases of

56. *Basket of Fruit, Apples and Grapes*, 1879–80, 68×90, W 545, Metropolitan Museum of Art, New York

57. *Pears and Grapes*, 1880, 65×81, W 631, Kunsthalle, Hamburg

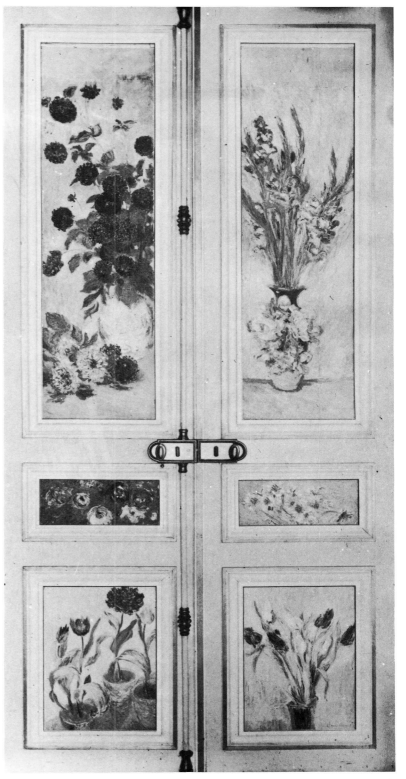

58. Six panels, decoration for Door D in Durand-Ruel's *salon*, 1883–5, two panels 128.5×37, two 16×40, two 50.5×37, W 937–42, Private Collection

his landscapes, may have discouraged him from painting further still lives.[115] However, another factor may have led him virtually to give up still life: in the mid-1880s he was spending increasing time in the studio retouching his outdoor paintings; so the wet days which had suited flower painting became instead the ideal moment for the increasingly complex business of finishing his landscapes.[116]

41

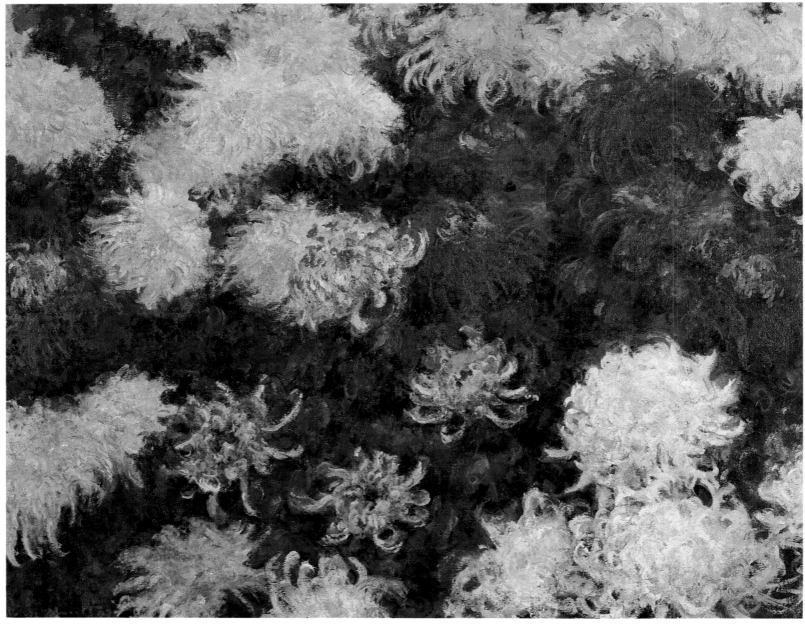

59. *Chrysanthemums*, 1897, 81 × 100, W 1496, Kunstmuseum, Basel (Dr H.C. Emile Dreyfus Foundation)

The still lives of 1878–82 fall into two groups. The game pictures and what seem to be the first of the fruit pieces (e.g. pls. 56, 219) have quite tautly structured compositions, with artfully arranged table tops seen at a gentle diagonal; their brushwork is comparatively restrained, and the colour scheme of the game pictures, in particular, quite subdued. These were very probably the canvases most directly designed for ready sale.[117] In the other paintings, he explored various ways of breaking down the traditional rigidity of the genre. Fruit is scattered far more informally across table tops which are tipped up towards the viewer (e.g. pl. 57), creating a rich weave of colour and texture which virtually fills the canvas; abundant bouquets of flowers are arranged in bold patterns which give a pretext for virtuoso displays of coloured brushwork (e.g. pl. 217). Courbet's fruit still lives of the early 1870s had rejected more conventional arrangements in order to emphasise the physical palpability of the fruit itself, and, among Monet's colleagues, Sisley had on occasion experimented with more informally viewed arrangements on table tops.[118] But it was Monet's still lives of around 1880 that more systematically undermined the conventions of the then-dominant Chardin tradition. Within that tradition, the objects in still lives were presented in clear, orderly groupings, and firmly grounded on the surfaces on which they stood. Monet played down the physicality of the objects in favour of emphasising their optical effect, with the informality of their grouping suggesting that this effect has been rapidly perceived, rather than carefully ordered. The pictures themselves, of course, are as elaborately contrived and organised as their predecessors; it was by his calculating rejection of the tradition that Monet sought to give them their sense of immediacy.

Monet painted just one further significant group of still lives, a small series of four canvases of Chrysanthemums in 1896–7, which he exhibited in 1898 (e.g. pl. 59); three of the pictures are larger than his landscapes of the period. The flowers fill the canvas, with no explicit spatial context. The blooms are arranged in clusters of varied colour and texture, placed against more shadowy foliage,

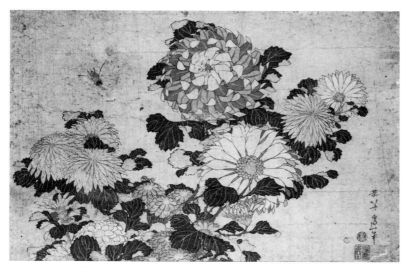

60. Hokusai, *Chrysanthemums*, from the series Large Flowers, Victoria and Albert Museum, London

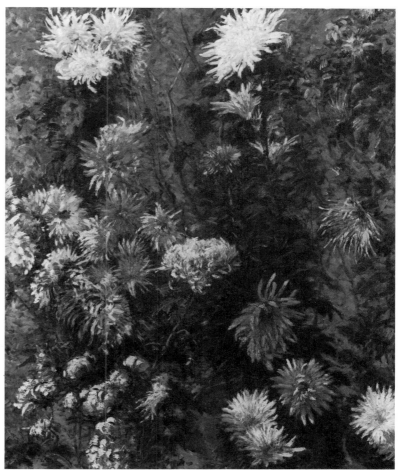

61. Caillebotte, *Chrysanthemums*, c.1893, 73 × 60, Musée Marmottan, Paris

which allows their forms to float across the whole picture surface. This format gave Monet the chance to arrange the whole picture as a colour harmony in a way he never had before; the surface is filled with subtle harmonies and contrasts, and animated by the ebullient brushwork which suggests the patterns of the petals. Monet was to explore again the spatial implications of these Chrysanthemum pictures in the later Water Lilies canvases, which are filled by the lily-covered surface of the pond.

We do not know why Monet undertook these paintings after so long without painting still lives. Hokusai's series of Large Flowers (e.g. pl. 60) may well have been a stimulus, for Monet was actively collecting them at the time. He wrote to Maurice Joyant in 1896: 'Thank you for having thought of me for the Hokusai flowers. You don't mention the poppies, and that is the important one, for I already have the iris, the chrysanthemums, the peonies and the convolvulus.'[119] The openly structured, patterned surfaces of Hokusai's prints clearly relate to Monet's paintings. But Monet's series also relates to the flower pieces of Caillebotte; indeed it may have been meant as a tribute to his recently dead friend. After Caillebotte's death in 1894, Monet bought his *Chrysanthemums* of around 1893 (pl. 61), in which he, too, had filled the whole canvas with foliage and flowers. Monet's series of 1896–7 dates from the moment when Caillebotte would have been uppermost in his mind, because of

the troubled negotiations about the acceptance of the bequest of Caillebotte's collection to the French nation. Later in his life, Monet spoke of his admiration for Caillebotte's still lives: 'In still life, he achieved pieces which are worthy of Manet's and Renoir's greatest successes.'[120]

Monet's still life painting was intermittent, and much of it closely geared to commercial concerns; nevertheless, his explorations of this subject include some of the most lavish still lives produced by the Impressionist group, and some of the most radical challenges to a long-standing still life tradition.

CHAPTER THREE

PICTORIAL COMPOSITION and CHOICE of VIEWPOINT

The hatred of composition is the characteristic sign of Impressionism; it rejects all intellectual and subjective organisation, and will accept only the free arrangements of nature.

E. Bergerat, 1877[1]

BOTH traditionalists and the younger generation criticised the Impressionists for their lack of concern with composition. Bergerat's verdict of 1877 was reiterated in 1898 by Signac: 'It was clearly their intention to seize the arrangements and harmonies of nature, as they present themselves, with no concern for organisation or combination.' Within a month of the appearance of this passage, Monet's friend Geffroy answered it in a review of Monet's latest exhibition, emphasising the care with which Monet selected his subjects: 'Very slowly and carefully Monet seeks the aspect of nature which by its arrangement, form and horizon best suits the play of light, shadow and colouring in front of him.' Signac in his critique had quoted Duret's statement of 1878: 'The Impressionist sits down on the bank of a river and paints what he has in front of him'; but Geffroy's reply shows the real implications of this statement – that it was by his choice of viewpoint, of where to sit on this river bank, that the Impressionist performed his act of composition, and that this was something over which Monet took the greatest care.[2] By selecting his viewpoint, and by deciding which direction to face and how the forms in front of him should be cut by the canvas-edge, the Impressionist could control his compositional patterns just as closely as his predecessors had in their studio compositions.

Monet's care over the precise *mise en page* of his scenes emerges from J.-P. Hoschedé's account of how he selected a viewpoint: 'If, during a walk in the countryside or in his gardens, Monet stopped, . . . screwed up his eyes, shielding his eyes with his right hand to improve his vision, then stepped back and forward, moved a little to the right and then to the left, and then continued his walk, this very often meant that he had just selected a motif.' Henriet in 1866 had described in much the same terms how the landscapist should finalise his viewpoint: 'He comes and goes, . . . quickens or slows down his pace without apparent reason . . . Next, he contemplates the panorama stretching before his eyes, by framing off with his hands the space he intends to reproduce, so as to judge it better by isolating it.'[3]

On occasion Monet used preliminary drawings to note down possible viewpoints and compositional structures. This was the function of the pencil drawings in the little-known set of sketch-books in the Musée Marmottan in Paris.[4] These include drawings from all periods of his career, which relate to many different aspects of his work; they include figure compositions, landscapes from most of his travels between 1871 and 1908, and subjects from his home countryside at Argenteuil, Vétheuil and Giverny (including the Grain Stacks and Poplars). Since the notebooks are unpublished, a fuller description of their contents is given in Appendix A (pp. 227–30).

When he first visited a place, Monet often took such a sketchbook and made quick linear drawings of potential motifs, presumably during his initial walks prospecting for sites. The drawings show the broad outlines of a scene, without detailed indication of textures or light effects; lines and contours flow with the greatest energy and vigour, without the interruption of distracting details. Some subjects, drawn in a long horizontal format, have vertical lines across them at several points, showing possible alternative ways of cutting off the composition. The drawings of grain stacks, poplars and girls in boats also set down various possible groupings of forms, in outline only, in marked contrast to the few drawings Monet made after his paintings for reproduction, which carefully reproduce in black and white the exact light effect in the canvas copied, depending primarily on tonal massing rather than contour. Many scenes in the notebooks do not appear at all in Monet's paintings, or were only painted from another viewpoint, and the majority of the subjects he painted do not appear in any drawing. This, and the nature of the drawings themselves, shows that they were not preparatory studies for individual paintings, but rather preliminary notations of possible viewpoints, a sort of repertory of potential subjects, which Monet might use in deciding which motifs to paint and how to frame a particular scene. Once this decision was taken, they would have had no further use.

His search for a promising subject completed, whether with or without the assistance of drawings, the moment of precise formulation came when Monet first confronted his bare canvas. The essential forms of a picture were generally established in the early stages of its execution, in an initial mapping out which often included elements of considerable complexity; the details of this process will be discussed in the next chapter. The immediacy with which Monet established his forms shows how closely he was able to harness his direct perception of a scene to his powers of visualising a picture, how readily he could find the pictorial form which expressed his *sensation* – his experiences of the world around him.

On a few occasions Monet spoke of his concern for composition. In 1926 he said that he had always 'attached great importance to design (*dessin*) and to the *mise en page*', and a few years earlier told another interviewer: 'One is not an artist unless one carries one's painting in one's head before executing it and unless one is sure of one's technique and one's composition.'[5] At times in the early stages of several of his travels, he found it difficult to formulate his subjects as he wished, and letters lament his problems with choice of site and *mise en toile*.[6] However, the directness with which he could lay out his compositions was the envy of his friends. Looking at the tower of Aix Cathedral, Cézanne told Borély: 'How easy it is to deform that shape. I try as hard as I can, and find it terribly difficult. Monet has that great ability, he looks, and, straightway, draws in proportion. He takes something from here, to put it down there; that's a gesture of Rubens.' Degas, too, warmly praised the intuitive accuracy of Monet's eye. He told Sickert: 'Everything he does is always vertical, straight away, while I take such trouble, and it's still not right.'[7]

Whatever subject he chose, Monet sought the compositional formulation which expressed most clearly its dominant character – the horizontality of a river bank, the vertiginous prospect from a cliff top, the arabesque of a tree against a distant horizon. Increasingly he found patterns that conveyed the particularity of a site without subjecting its forms to the conventional schemata of landscape painting, such as the winding recession into space between framing repoussoirs. This is not to say, though, that Monet – or indeed any artist – could generate pictorial form from nature alone.[8] The compositional patterns he found in nature as he selected his viewpoints were mediated by his experience of art – in part by his gradual rejection of traditional recessional schemes, but also by the positive suggestions which he found in other conventions of composition, most significantly, perhaps, in the Japanese landscape print. Speaking of Japanese prints, Monet told Trévise: 'In the West, what we have most appreciated is their bold way of cutting off their subjects: those people have taught us to compose differently, there is no doubt of that.'[9] But methods such as those of the Japanese print only gained a relevance for him as they suggested means of formulating the various landscape subjects he decided to tackle. Riversides and cliff tops demanded very different solutions, and Monet looked to different stimuli and evolved different schemata for each. The history of his developing methods of composition is the story of his search for new schemata, for patterns and relationships within the picture which could best express particular themes.

Monet rarely spoke of the positive qualities he sought in his compositions, but two indications suggest his concerns in the middle years of his career. At Bordighera in 1884, he had great trouble finding suitable viewpoints: 'Wide panoramic views (*les grands motifs d'ensemble*) are rare there. It is too thickly wooded, and the views are all fragments with masses of details, a confusion of forms terribly difficult to render – and I am really the man for isolated trees and wide open spaces.' At Monte Carlo, by contrast, 'the motifs are more complete, more like pictures, and thus easier to execute', with 'the broad lines of mountain and sea'. Around 1892 he explained his interests in more general terms to Theodore Robinson: 'One thing I remember Monet speaking of, the pleasure he took in the "pattern" often nature gives – leafage against sky, reflections, etc.' Robinson recorded this in a passage of his diary in which he was considering the lessons of Japanese prints, but without making it clear whether it was he himself or Monet who had linked Japanese art with these thoughts on 'pattern'.[10]

We must not, though, equate Monet's concern for 'pattern' with a preoccupation with the essential flatness of the painted surface. Modernist critics, most notably Clement Greenberg, have presented the all-over quality and the suppression of value contrast in Monet's later work as one of the crucial seeds of modernism, and it is all too easy for the writer today tacitly to accept this vocabulary, rather than to discuss Monet's concern for 'pattern' in its original context, in artistic discussion in Paris in the late nineteenth century. In the 1890s several writers in Monet's circle, notably Geffroy, Mirbeau and Georges Lecomte, were commenting on the ornamental and decorative quality of his work. As Robert Herbert has shown, this was a part of a contemporary redefinition of the idea of the decorative in painting; it was no longer viewed as a rejection of nature in favour of flatness, but rather as a recreation of visual experience in terms of relationships of colour and surface pattern, replacing the perspectival structures and sharp tonal contrasts of traditional landscape. In 1892 Lecomte praised the 'knowing syntheses' of recent work by the Impressionists, notably Monet and Pissarro, which transcended immediate reality and attained all the 'plastic qualities which constitute pictorial beauty', and concluded that the art of the future lay in these 'noble ornamentations realised from the authentic appearances of nature'.[11] This reconciliation between nature and decoration in the critical writing of the period is crucial for understanding Monet's evolving ideas about 'pattern', and indeed the development of his art as a whole (see Chapter 14). Although we have no clear record of the ways in which Monet himself thought about these issues, his comment on 'pattern' shows his awareness of the painting as a decorative arrangement, at the same time as being a representation of atmospheric space.

Monet's early compositional practices belong closely to a particular historical context, within the development of French Realist painting. At least since 1850, artists of the Realist camp had been looking for compositional patterns which better suited contemporary subject matter than did traditional schemes of balance and spatial recession. Courbet had on occasion looked to popular art – notably to *images d'Epinal*, popular woodblock prints – for both the form and the content of his art, an interest picked up by Manet and others.[12] By around 1863 a number of artists, inspired by what Champfleury (anticipating Bergerat's phrase) had called 'hatred of composition',[13] were composing their canvases in loose paratactic patterns strung across the picture surface, deliberately avoiding the traditional use of focal points and winding diagonal recessions. Manet's *Music in the Tuileries Gardens* (pl. 16) and Boudin's Trouville beach scenes (e.g. pl. 62) are examples of this type of composition

62. Boudin, *Beach at Trouville*, c.1864–5, 26 × 48, National Gallery of Art, Washington, D.C.

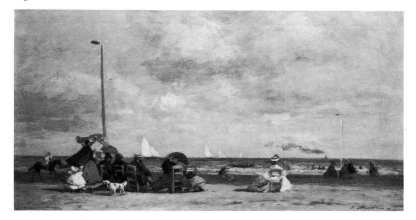

63. Daubigny, *The Studio Boat*, 1861, etching from *Voyage en bateau*, 10 × 13, Private Collection

which Monet would have known well. Daubigny, in his etching *The Studio Boat* of 1861 (pl. 63), made a joke out of the equation between Realism and such loosely structured frontal compositions by including, at bottom right, a painting of a naïvely drawn row of evenly spaced trees, with the word *réalisme* inscribed between their trunks. In this development, popular art was a sort of catalyst; it suggested alternative means of composition which overthrew academic formulae and also seemed truer to the ways in which the artists saw the world around them. Popular art did not cause this search for new forms, but it helped artists to back up their ideas with new visual conventions, by sanctioning unconventional approaches to composition.[14]

It was within this context that artists first discovered Japanese art in Paris around 1858–62; Baudelaire, for one, welcomed it explicitly as a form of popular art, describing a batch of prints which he was distributing to his friends in December 1861 as '*images d'Epinal*, from Japan'.[15] As Japanese bric-à-brac became fashionable, it appeared in many portraits and genre scenes, but artists also explored the formal lessons of Japanese art in paintings which have no overt reference to Japan. Manet and Whistler are examples of this, but for neither of them was Japanese art an isolated phenomenon; it helped them resolve problems which they were already exploring. Manet was using the lessons of Velásquez and popular art, and Whistler in particular those of the Dutch seventeenth-century interior, in their treatment of space and surface before they began to assimilate Japanese art into their experiments; these pre-existing interests conditioned what they found in the art of Japan. Indeed, both men painted canvases in the early 1860s – Manet's *The Street Singer* (Museum of Fine Arts, Boston) and Whistler's *The Music Room* (Freer Gallery of Art, Washington, D.C.) – showing characteristics which are often attributed to the influence of Japan, but can plausibly be explained within European traditions.[16] As early as 1878 Ernest Chesneau convincingly summed up the nature of the Japanese influence: he described the different things that Japanese art meant to a number of artists (Stevens, Tissot, Whistler, Manet, Monet, Astruc, Degas and Michetti, citing Monet's 'summary suppression of detail for the benefit of the impression of the ensemble'), and concluded: 'All found in it a confirmation rather than an inspiration

for their individual ways of seeing, feeling, understanding and interpreting nature. Hence a redoubling of their personal originality rather than a cowardly submissiveness to Japanese art.'[17] Though the last phrase reveals Chesneau's concern to uphold the 'originality' of modern artists, his account makes the crucial point that the artists could only make sense of Japanese art by fitting it into each of their pre-existing visual frameworks and preoccupations.

The importance of Japanese art was comparable to that of popular imagery: both were art forms alien to the western High Art tradition, and both, in simple, graphic techniques, treated modern life themes with a directness and immediacy unparalleled within that tradition, even in Dutch and Spanish art from which the Realist generation learned so much. In Monet's case, the parallel between Japanese and popular art is especially relevant, since he seems initially to have used both at the same time and for similar ends, though in the long term Japanese art was to be far more important in his development. Late in his life, he claimed to have bought his first Japanese prints in 1856.[18] This early date is not impossible, but his paintings do not reveal such an interest until the mid-1860s. Thereafter he was an enthusiastic collector of them, initially, it seems, acquiring them piecemeal, but in later years through established dealers such as Bing, whose shop he was frequenting around 1890.[19] Monet's collection of Japanese prints has survived intact or largely intact, though rarely can we tell when he acquired individual prints; much of it hangs once again on the walls of his house at Giverny, since its restoration.[20]

Monet's early landscapes adopt structures closely similar to those favoured by landscapists at the time, such as Daubigny, Corot and particularly Jongkind, with defined perspectives leading along beaches or down roads (pls. 111, 258; cf. pl. 112); for his *Déjeuner sur l'herbe* in 1865–6 (pl. 14) he looked to appropriate models, to the informally structured gatherings in the early eighteenth-century *fête champêtre*. Only in 1866–7 did he begin to experiment in earnest, in *Women in the Garden*, *Terrace at Sainte-Adresse* and his views of Paris. *Women in the Garden* (pl. 64) has been paralleled with contemporary photographs, and the calculated informality of the grouping, and the way in which the dresses are displayed, are very like fashion plates (e.g. pl. 65) – a type of popular imagery to which Monet would naturally look in seeking new forms for an image of fashionable women at leisure.[21] Its composition deliberately denies its subject the level of significance which the picture's great size would have led its original audience to expect. Instead of focusing on a central subject or motif as a monumental painting should, it presents divided focuses of attention and a complete absence of significant action or characterisation; its form, as much as its subject, must be seen as an attack on the traditions of subject-painting in the Salon.

Terrace at Sainte-Adresse (pl. 67) and the Paris views (pls. 15, 68) all have high viewpoints and compositions with scattered points of interest rather than a single focus. Monet himself in 1868–9 called *Terrace at Sainte-Adresse* his 'Chinese painting with flags in it', a phrase which can only mean that he had deliberately incorporated Japanese elements into the painting's composition (the terms Japanese and Chinese were used interchangeably at the time). The importance of the picture is confirmed by the way in which Monet spoke of it to Gimpel: 'He pointed out to us that there was a pole with a flag on each side of the composition and that at the time this composition was considered very daring.'[22] The boldness of Monet's compositions at this period, in the eyes of his contemporaries, is borne out by a letter from Boudin of 1868 about two *croquis* by Monet: 'One thing amazes me, the audacity of the composition.'[23]

47

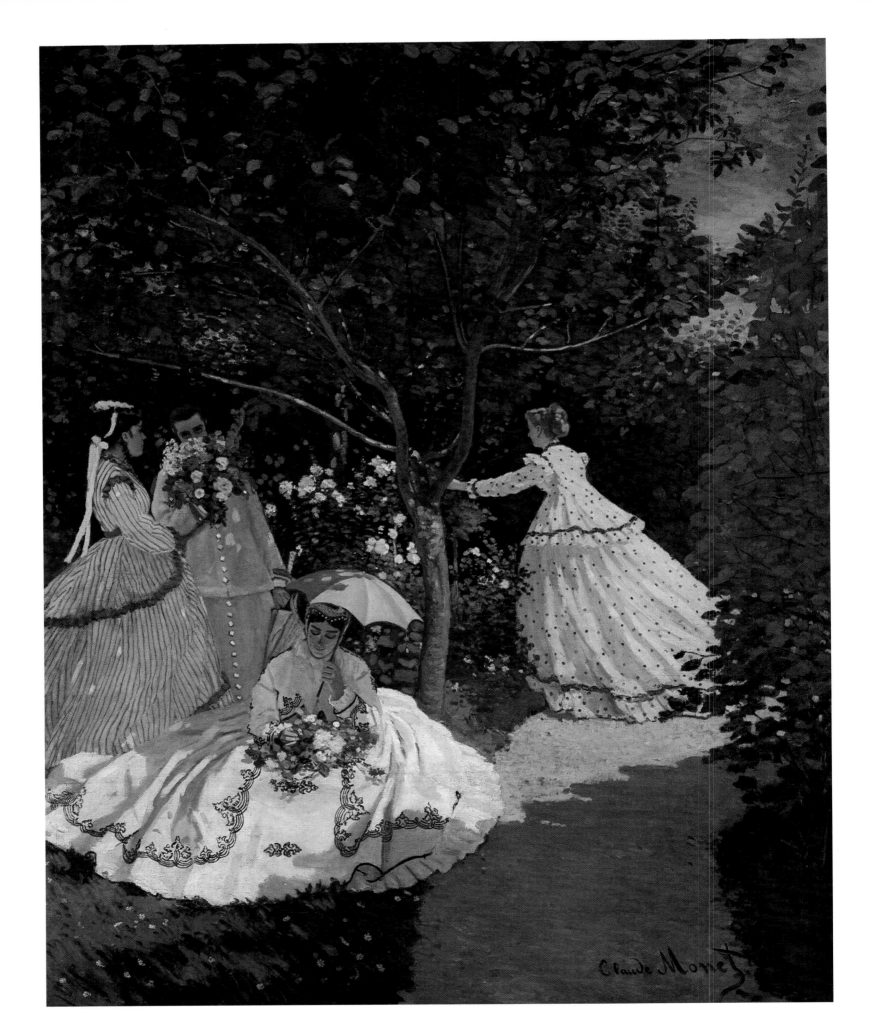

64. (facing page) *Women in the Garden*, 1866–7, 256 × 208, W 67, Musée d'Orsay, Paris

65. (middle) Fashion plate, from *Les Modes parisiennes*, c.1865

66. Hokusai, *The Sazaidō of the Gohyaku Rakan-ji Temple*, from *36 Views of Mount Fuji*, British Museum, London

67. *Terrace at Sainte-Adresse*, 1867, 98 × 130, W 95, Metropolitan Museum of Art, New York

68. *The Quai du Louvre*, 1867, 65 × 92, W 83, Gemeentemuseum, The Hague

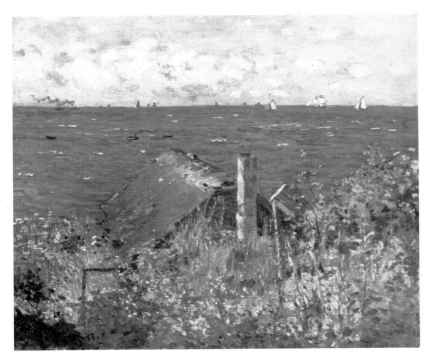

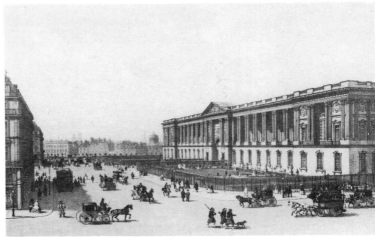

70. *Colonnade of the Louvre*, lithograph from *Paris dans sa splendeur*, 1861

69. (left) *Cabin at Sainte-Adresse*, 1867, 52 × 62, W 94, Private Collection

In *Terrace at Sainte-Adresse* the horizon is high; there are jumps in space between viewer and terrace, and terrace and sea; and the flagpoles, fences and horizon impose an emphatic grid pattern on the surface. This rectilinear grid is accentuated by the overt and surely deliberate distortion of perspective in the line of the top of the fence on the right. The fence-top is below our eye-level and runs towards us in space (as shown by the shadow cast on it by the gate); it should thus slope upwards towards a central vanishing point on the horizon, rather than being a virtual horizontal. The painting's composition has many parallels in Japanese prints, notably Hokusai's *The Sazaidō of the Gohyaku Rakan-ji Temple* (pl. 66) from the 36 Views of Mount Fuji; Monet owned a copy of this, whose damaged condition may suggest that it was one of his earliest Japanese acquisitions.[24] A contemporary French precedent may also have played a part, Millet's *The End of the Village of Gréville* (Museum of Fine Arts, Boston), shown at the 1866 Salon, which itself may owe something to Japanese prints. Millet's picture, along with Japanese prints, also bears comparison with another of Monet's canvases from summer 1867, *Cabin at Sainte-Adresse* (pl. 69), whose subject, a cliff-top cottage seen from above and silhouetted against the sea, was to become one of Monet's leitmotivs of the 1880s and 1890s. Of the Paris views, *The Jardin de l'Infante* (pl. 15) uses similar devices, with the curving garden establishing an off-centre plane floating between viewer and distance, while *The Quai du Louvre* (pl. 68), with its open-sided horizontality and figures scattered right across the foreground, adopts conventions common in topographical printmaking (e.g. pl. 70) – another of the types of popular imagery to which painters looked in their search for means of depicting the modern urban scene.[25] In the later 1860s, though, these more experimental paintings alternated with more traditional views along roads, beaches and rivers (e.g. pls. 115, 169, 238), in the lineage of Corot, Daubigny and the Dutch seventeenth-century landscapists, with no evident debts to oriental art or popular imagery.[26]

La Grenouillère (pl. 71) of 1869 introduces a type of composition which dominated Monet's work for the next decade and remained important throughout his life. A succession of horizontal planes face the spectator; forms reflected in water link foreground and distance, unifying the surface of the picture without recourse to traditional types of spatial recession; by changes of scale and emphasis, the reflected forms suggest a progression across the stretches of water;

71. *La Grenouillère*, 1869, 75 × 100, W 134, Metropolitan Museum of Art, New York

72. *Autumn Effect at Argenteuil*, 1873, 56 × 75, W 290, Courtauld Institute Galleries, London

74. (right) Renoir, *Argenteuil*, 1888, 54 × 65. Whereabouts unknown

73. Daubigny, *The Banks of the Seine*, 1851, 70 × 116, Musée des Beaux-Arts, Nantes

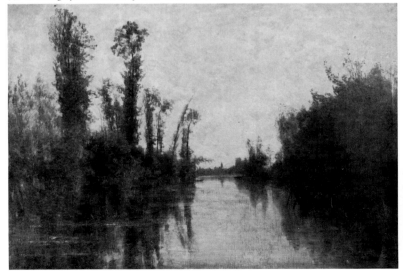

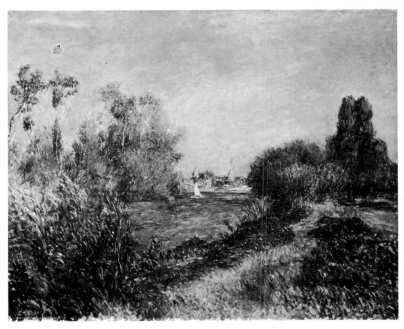

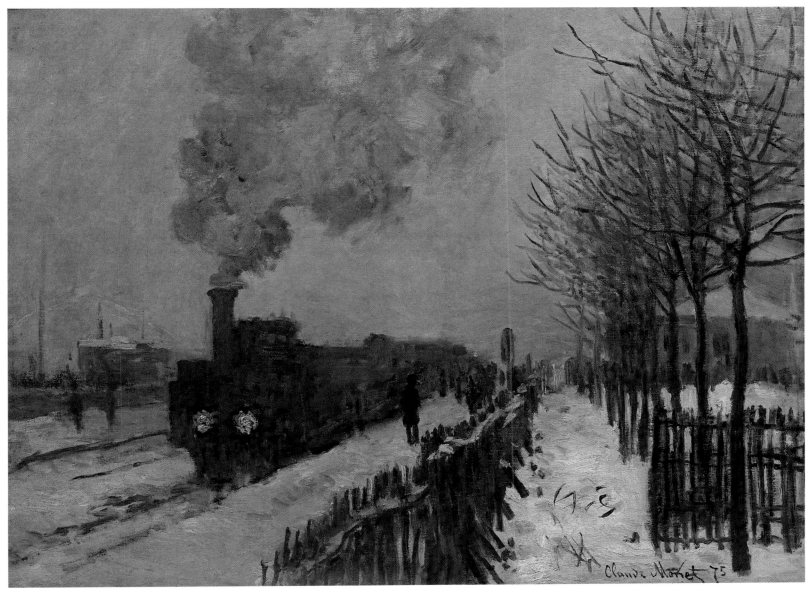

75. *The Train in the Snow*, 1875, 59×78, W 356, Musée Marmottan, Paris

the diagonals do not lead the eye into a deep space, but suggest a shallow recession by cutting in from the edges of the canvas and establishing a sequence of pointers to the islet. In Renoir's version of the scene (Nationalmuseum, Stockholm), by contrast, the boats form a bridge from viewer to islet, giving the viewer a more direct access to the scene. Renoir's canvas presents a play of soft, supple brush-marks, while composition and brushwork alike give Monet's a far more sharply articulated sense of 'pattern'. Monet's picture is an early example of another of his compositional devices, to establish two separate horizon lines (here, the islet and the far bank) which break the stability of the image and give it two alternative horizontal axes.

La Grenouillère reveals the two key factors in Monet's compositions – his desire to find ways of suggesting space and depth without resorting to traditional linear perspective, and his interest in complex surface pattern. A few examples from the 1870s will show how he explored these concerns. Often forms are viewed frontally, with perspectival diagonals subordinate or wholly absent. A screen of bushes or trees may close in the foreground, preventing a direct entry into space, as in *The Reeds* (pl. 124); here the further forms,

seen across the river, are repeated in reflection, creating rhymes between image and reflection which counterbalance the sense of recession across the water. Distant forms and their reflections sometimes form the whole subject, as in *Autumn Effect at Argenteuil* (pl. 72); here only the broken touches of the ripples differentiate water from land. This compositional type has many precedents in the work of Daubigny, such as *The Banks of the Seine* (pl. 73) of 1851 which shows the identical site. Comparison with Renoir's painting of the same scene, *Argenteuil* (pl. 74), again shows Renoir's different approach: he includes the foreground bank and a diagonal recession into the picture, while Monet, choosing a viewpoint only a few yards to the left, has a wholly open foreground and disposes the main forms frontally across the canvas, with only the ripples to act as visual stepping stones into space. Sometimes bridges and their reflections, seen head on, provide a grid-like frame for a more distant view, as in *The Wooden Bridge* (pl. 19); images like this have close parallels in Japanese prints.[27]

However, Monet did not wholly abandon receding perspectives; in many of his canvases of the 1870s there is a direct lead-in from foreground into space. But where he included such recessions he

53

tended to counteract them in some way – by a physical feature, or by the way in which he treated the immediate foreground, or by both. In *The Basin at Argenteuil* (pl. 143) the eye is arrested by the incisive horizontal bars of light and shade across the path and the grass, in *The Sheltered Path* (pl. 117) by the emphatic dabs of paint across the bottom of the picture, while in *The Train in the Snow* (pl. 75) the flow of space is interrupted both by the fence at the far right and by the signature and the vigorous accents added on the snow above it very late in the execution of the canvas.

High viewpoints, too, might distance Monet from his perspectives, as in *The Boulevard des Capucines* (pl. 262), where the cut off figures on the right (implicitly on the balcony of an invisible building) and the trees at bottom left counteract the recession. The structure of views like this has been compared with contemporary photographs of city streets; however, as Kirk Varnedoe has shown, there is nothing about the way in which Monet treated the scene that demonstrates a specific debt of photography.[28] His boulevard scenes – like the Paris views of 1867 – belong to the tradition of urban topographical views (see pl. 70), and early photographs of such subjects also formulated their images within the conventions of this tradition. Monet's interest in this theme is another example of his use of ideas from a more popular form of art as a stimulus to a specifically modern type of easel painting. The appropriateness of such high viewpoints and cut-offs to the depiction of the modern scene was signalled by Duranty in 1876, and effects like this soon became the dominant feature of Caillebotte's urban views.[29]

During the 1870s Monet's interest in Japanese art appeared most clearly in his few figure compositions and interiors, in the strongly asymmetrical compositions of some of his garden pictures (e.g. pls. 43, 263), and in the occasional inclusion of Oriental bric-à-brac. Most overtly Japanese, of course, was *La Japonaise* (pl. 264), exhibited in 1876 as *Japonnerie*; both pose and bric-à-brac details set this firmly in the tradition popularised by Whistler, Tissot and Alfred Stevens in the 1860s.[30] The pose is one common in Japanese prints, but even here other precedents must be taken into account: the pose is a virtual reversal of Monet's own *Camille* of 1866 (pl. 257), which is in turn very similar to many contemporary fashion prints (e.g. pl. 65).[31] This is not to say that fashion plates were Monet's direct

76. *The Poppies at Giverny*, 1887, 73 × 92, W 1146, Private Collection

sources, but it shows that he was working within a tradition well established by 1865, in his attempts to find a pose to convey the fleeting gestures of the fashionable woman of the time. The overtly Japanese aspects of *La Japonaise* were only fitted onto this pre-existing convention. Monet's enthusiastic espousal of the Japanese vogue is in marked contrast to Renoir's visible embarrassment, in his *Portrait of Madame Charpentier and her Children* of 1878 (Metropolitan Museum of Art, New York), at the Japanese *salon* in which his sitter insisted on being portrayed. In contrast to fashionable modern genre painters such as Stevens, Renoir played down its bric-à-brac as much as possible, and many years later remembered this Japanese décor as one of the few clouds in his relationship with the Charpentiers;[32] its self-conscious artificiality was at odds with the homespun simplicity Renoir always advocated.

At Vétheuil and Giverny Monet continued to explore the landscape of the Seine valley in informally structured compositions with emphatic horizontal axes, but at the same time he used contrasts and rhymes of shape and texture to create complex relationships between space and surface. In *The Banks of the Seine near Vétheuil* (pl. 127) the whole picture is built up of inter-woven verticals and horizontals – flowers against stems, ripples against reflections, trees against clouds. *The Thaw* (pl. 24) has more dramatic contrasts, between the tangled branches on the right and the distance beyond, and between open water and the broken textures of the ice. He reduced the structure of other paintings to virtual symmetry, as in *Poppy Field near Giverny* (pl. 109), or to simple horizontal bands, varied only by the placing of the trees, as in *The Poppies at Giverny* (pl. 76). In *The Wheat Field* (pl. 23), a path leads into the painting through the foreground grasses, but its passage into space is firmly halted by the vibrant band of wheat.

The differing structures of these paintings stress the variety of the scenes Monet chose; but each, in its own way, marks a rejection of the orderly perspectives of traditional landscape, by denying the viewer any imagined entry into the actual space depicted, and by emphasising the patterns of forms and colours within the painting itself. In canvases such as these the role of composition is increasingly taken over by brushwork and colour. The simple formal structure of the subject becomes just an armature for the elaboration of the surface; by inflexions of brushwork and gradations of colour Monet could define the space and articulate the surface while bypassing composition in its traditional sense. It becomes increasingly artificial at this point to discuss composition as distinct from execution, as Monet made the effects of surface even more integral to the initial conception of the picture.[33]

On his travels of the 1880s, though, Monet continued to experiment with varied viewpoints and compositional patterns. We have seen how the anti-picturesque subjects he chose at Giverny differed from the effects he tackled away from home – opposed natural forces and contrasts between land and sea. To convey such dramatic or exotic motifs, he sought types of composition that provided a pictorial equivalent to nature's unexpected vistas and surprising effects; to achieve this he returned to devices he had first used in the late 1860s, and to the lessons of Japanese landscape prints, notably those of Hokusai and Hiroshige. But once again he used Japanese art as a catalyst, to help him visualise in pictorial terms the natural effects he had decided to tackle.

From 1881 onwards, in his paintings from the cliff tops, Monet often set a heavy cliff mass on one side of the canvas against open sea on the other (e.g. pl. 77) – a bold asymmetry quite unlike the frontality characteristic of the Seine valley canvases. His cliff tops

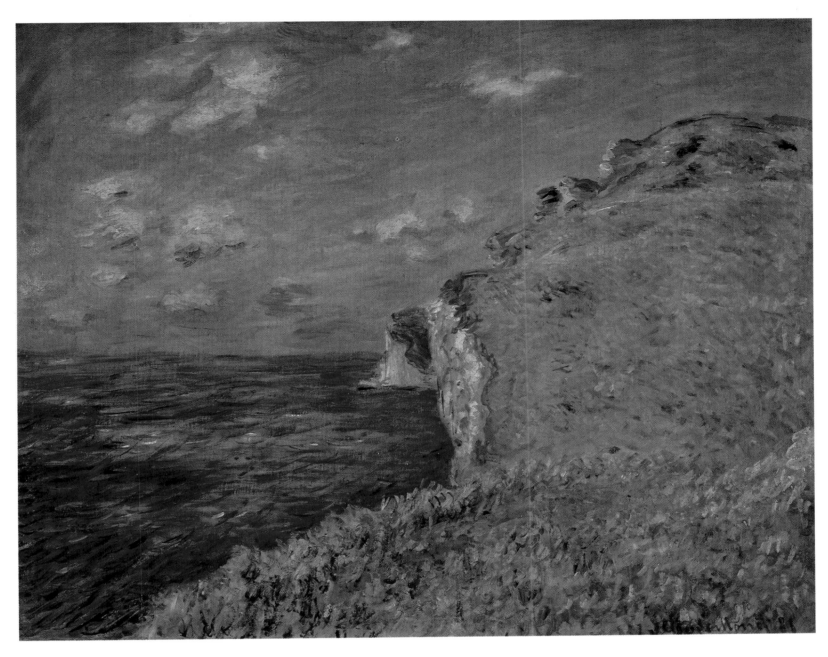

rarely show a single sweep of terrain. Instead there are breaks in space; the eye progresses into depth by a succession of jumps; distance is expressed by successive planes overlapping each other and by atmospheric rather than linear perspective – by the softening of focus and changes of colour (cf. also pls. 220, 222). Nor is the viewer securely placed in relation to the scene; Monet generally introduced a jump in space between his (and our) viewpoint and the nearest visible plane, thus preventing any direct access to the space. The view is thus presented as a spectacle, but not as a landscape that we can walk into in our imagination. Even on a rare occasion when figures appear on such a cliff top, in *The Cliff Walk, Pourville* (pl. 228), they are placed on a tipped-up plane well away from the viewer, and are closely related to other forms in the picture – to the dark areas on the cliff face and to the boats out at sea.

Monet's cliff-top viewpoints maximise the impact of the scenes – the slabs of rock, the vertiginous plunge down to the water, the vast space opening out to a high horizon. The absence of any foothold in the foreground, and the often abrupt juxtapositions of solid and

77. (above) *The Cliff at Fécamp*, 1881, 63.5 × 80, W 656, Aberdeen Art Gallery and Museum

78. *The Cliff at Dieppe*, illustration from H. Viollet de Duc, *Histoire d'un dessinateur*, Paris 1879, p.174

55

79. *Fishing Nets at Pourville*, 1882, 60×81, W 768, Gemeentemuseum, The Hague

80. Le Sénéchal de Kerdréoret, *Fishing Ground at Veules-en-Caux*, 1880, 138×200, reproduction from F.G. Dumas, *Salon illustré*, 1880

void, of cliff and open sea, heighten this sense of immediacy. As Charles Stuckey has pointed out, the architect Eugène Viollet le Duc, in his book *Histoire d'un dessinateur* (1879), had recently characterised the initial impact of a cliff-top view in very similar terms, accompanying his account with an engraving (pl. 78) showing rock formations which presents the cliff face to the viewer with a directness very comparable to Monet's. This focus on a slice of nature, presented without mediating artistic devices like repoussoirs or winding perspectival recessions, can be related back to the tradition of rapid outdoor sketches in oil, developed by landscapists all over Europe from the eighteenth century onwards – among them Valenciennes and Corot. The original purpose of studies such as these was to collect a repertory of natural elements, which could subsequently be incorporated in more elaborate compositions, but by the mid-nineteenth century some artists were finding a positive value in this sort of compositional immediacy.[34] We cannot tell how far Monet was aware of this tradition in his search for ways of heightening the impact of his scenes, but in pictures like these he elevated this type of composition from the province of the sketch and the engraved vignette like Viollet's to the status of the finished

exhibition painting, by the larger scale of his canvases and the elaboration of their execution.

Similar breaks in space and scale also occur in paintings done from the beaches, between foreground rocks and distant cliffs in *The Rocks at Pourville, Low Tide* (pl. 177), between transparent nets and cliffs in *Fishing Nets at Pourville* (pl. 79). Several Japanese prints show an effect very like these nets, with distant views seen through the sail of a boat, but it is too straightforward to see these as a simple source for Monet's nets, since the identical device had already made its appearance in French painting, in a picture shown in the 1880 Salon (where Monet exhibited), *Fishing Ground at Veules-en-Caux* by G.E. le Sénéchal de Kerdréoret (pl. 80).

Many of Monet's seascapes of the 1880s have solitary trees silhouetted against the sea, on the cliffs or by the beach – the 'isolated trees and wide open spaces' of which he wrote from Bordighera in 1884.[35] Their linear axes and broken textures are set against the opposed masses of land and sea in pictures like *Varengeville Church* (pl. 81) and *Bordighera* (pl. 245); like the fishing nets, they suggest a spatial plane but leave it insubstantial, allowing the eye to run

81. *Varengeville Church, Sunset*, 1882, 65×81, W 726, Private Collection

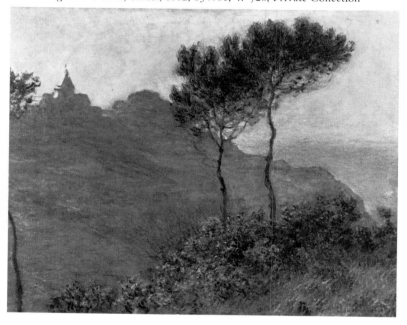

82. Kuniyoshi, *Priest in the Snow*, from *Scenes of the Life of the Holy Nichiren*, British Museum, London

56

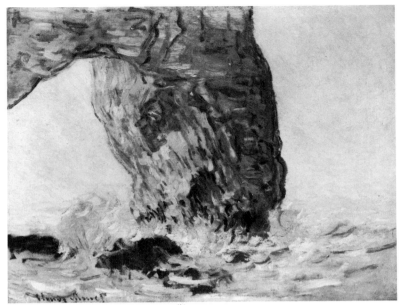

83. *The Manneporte, Etretat, c.1883, 73 × 92, W 1036, Private Collection*

84. Hiroshige, *Seashore at Izu*, from *36 Views of Mount Fuji*, Victoria and Albert Museum, London

focuses near the edges to hold the eye within them, in contrast to Millet who deliberately left his margins open in order 'to give the feeling that you are looking at a piece of nature – that the mind shall be carried on and outside the limits to that which is lying to the right and left of the picture'.[37] Monet's use of these small accents near the frame will be discussed in Chapter 10.

The extent and limitations of the influence of Japanese prints on Monet in the 1880s can be gauged from two comparisons: of Monet's views of *The Manneporte at Etretat* (pl. 83) with Hiroshige's *Seashore at Izu* (pl. 84); and his canvases of *The Pyramides at Port-Coton* on Belle-Isle (pl. 85) with Hiroshige's *Satsuma* (pl. 86). Monet owned a copy of the latter but not the former print. These visual parallels are very close, but in painting both subjects Monet was

85. (above) *The Pyramides at Port-Coton, Belle-Isle*, 1886, 65 × 81, W 1084, Pushkin Museum, Moscow

86. Hiroshige, *Twin Sword Rocks, Bō no ura, Satsuma Province*, from *Views of the 60 Odd Provinces*, Victoria and Albert Museum, London

through and round it into the background. Arabesques of trees are used in very similar ways in several Japanese prints of which Monet owned copies, for instance Kuniyoshi's *Priest in the Snow* (pl. 82), which is closely comparable to *Varengeville Church*; Kuniyoshi's print, like many others of this type, also shows the marked asymmetry and breaks of space of Monet's scenes.[36]

In some canvases with an important feature near their centre, particularly when no prominent objects frame their edges, Monet in effect reversed the traditional European system of convergent perspective, replacing it by a divergent space which spreads outwards on either side of the central feature. This type of structure is common in Japanese prints, and appears in Monet's coastal scenes and in simpler inland scenes where similarities to Japanese composition are less overt (e.g. pls. 79, 108, 127, 207, 213, 216). We feel that the space may continue beyond the visual field of the canvas, instead of being tied firmly within the frame by conventional recession. However, he rarely allowed the eye to roam without any interruption out of the sides of the pictures, but often added small

87. *Mount Kolsaas, Norway*, 1895, 65×92, W 1416, sold Christie's, London, 6 December 1968, lot 19

88. Hokusai, *Mount Fuji in Fine Weather*, from *36 Views of Mount Fuji*, Victoria and Albert Museum, London

scrupulously following the natural forms in front of him, rather than manipulating nature to fit a preconceived pattern. Japanese art helped him to see the pictorial possibilities of such forms and suggested ways of framing them on the canvas, but the final structure of each picture is the result of his direct confrontation with the motif. Japanese art may be equally relevant where no such close parallel exists, and similarities as close as these could well have arisen without Monet having known the particular prints in question, simply from his fascination with such forms in nature and his understanding of the compositional conventions of the Japanese print. Even where we can compare his paintings with particular Japanese prints which he owned, he may well have bought the print in question after he had painted the work it resembles, perhaps even because of this resemblance.

By 1895 Monet's awareness of Japanese art was inseparable from his direct experiences of nature, as he revealed in a letter from Norway, describing a fjord and its surroundings: 'It was marvellous and has given me an enormous pleasure; I have a delicious motif there of little islets almost level with the water, and a mountain in the background. One would say it was Japan, which is a common

experience in this country. I am at work on a view of Sandviken which looks like a Japanese village, and I'm also doing a mountain which one can see from anywhere here and which makes me think of Fuji-Yama.'[38] Japanese prints in his collection illustrate these comparisons: the village of Sandviken (pl. 100) echoes Hiroshige's *Tea-Water Canal*, while the views of Mount Kolsaas (pl. 87) are particularly like Hokusai's *Mount Fuji in Fine Weather* (pl. 88). His experience of Japanese art might thus have informed his appreciation of nature, just as his experiences of nature conditioned what he found to admire in Japanese prints. Pissarro, too, though less overtly indebted to Japanese art than Monet, saw it as a confirmation of his own naturalist standpoint; he wrote in 1893: 'Admirable, the Japanese exhibition. Hiroshige is a marvellous Impressionist. Monet, Rodin and I are all full of enthusiasm for it. I'm pleased to have done my snow and flood effects; these Japanese artists confirm me in our visual standpoint.'[39]

None of Monet's fellow landscapists shared his compositional interests in the 1880s. Sisley, and Renoir in his few landscapes, generally retained more straightforward recessional schemes. Pissarro, too, seems to have attached little importance to compositional experiment, and the topic is conspicuously absent from the long discussions of art in his letters to his son. Some of Cézanne's experiments in reconciling space with surface relate him to Monet, but in general his patterns of successive, overlapping spatial planes lack the dramatic contrasts of Monet's work of the 1880s, and show no explicit use of the lessons of Japanese art. Among his contemporaries, it is Degas, with his experimental viewpoints, cut-off forms and jumps in space and scale, who provides the closest parallels with Monet; both shared an interest in Japanese prints, and both, in their very different spheres, were seeking ways of formulating pictorially a vision of the world around them which was not preconditioned by traditional pictorial formulae. In landscape painting, Monet's compositional methods most resemble those of younger artists such as Caillebotte, Gauguin and some of the Nabis, all of whom probably looked to his example.

From the Grain Stacks series of 1890–1 onwards, Monet chose a single dominant compositional feature for each of his series, rather than seeking inbuilt contrasts. In the Grain Stacks he took further the simplicity of some of his previous Giverny subjects, setting one or two simple masses against the horizontals of the background hills (e.g. pls. 33, 136); the flatness of the picture is often emphasised by *contre-jour* lighting, and sometimes by the apex of a grain stack precisely meeting the horizon. The Poplars of 1891 are quite different, dominated by linear patterns (e.g. pl. 137). Here Japanese parallels can again be found, though the print from Hiroshige's Fifty-Three Stations on the Tokaido which Duret cited as a precedent for them is no more relevant than many other examples.[40] It was around the time of the Poplars that Monet spoke to Robinson of 'the pleasures he took in the "pattern" often nature gives – leafage against sky, reflections, etc.'[41] In later series the compositions are generally reduced to a few clear shapes, as Monet abandoned the structural contrasts of the 1880s in favour of a simplicity that would not distract from the varied nuances of atmospheric colour which had become his central concern. Complex silhouettes remain important – foliage against the dawn sky in the Early Mornings on the Seine (e.g. pl. 35), broken cliff edges in the Pourville series of 1896–7 (e.g. pl. 165), the fretwork of Gothic buildings in the series of Rouen Cathedral and the Houses of Parliament (e.g. pl. 89); however, these do not now create an elaborate set of spatial relationships, but rather act as patterns within the predominant structure of colour harmonies.

Of Monet's later series only the Water Lilies retain clear parallels with Japanese art. The whole conception of his water garden suggests an interest in the principles of Japanese gardening, in its irregular contours, designed to be seen from many viewpoints, and in its use of trees and plants; though Monet himself denied that Japan had been in his mind when he conceived it, he did in 1909 describe the foot bridge as a 'Japanese type bridge'.[42] The first series of paintings, of the pond and bridge, of 1899–1900 (pl. 36) echoes Hiroshige's *Wisteria at Drum Bridge*; moreover, the theme which dominates the later Water Lilies, of lily pads floating on the water surface (e.g. pl. 92), is common in Japanese prints, for instance in Hokusai's *Women gathering Water Lilies*, of which Monet owned a copy.

The way in which the lily pads materialise the immaterial water surface renews an interest which he had first shown long before, in the water-reflections in some of his canvases of the late 1860s and early 1870s (e.g. pls. 71, 142), and then again in his treatment of ice floes in 1879–80 (pls. 185–6). The exclusive concentration on the water surface in the Water Lilies from 1905 onwards (pls. 37, 140–1), with their compositions articulated by the placing of the lily pads, looks back also to Monet's series of Chrysanthemums of 1896–7 (pl. 59), whose composition is generated solely by the arrangement of the flowers which fill its surface. The Chrysanthemums are perhaps the only occasion when we can link Monet's paintings directly with his ownership of particular Japanese prints; as we have seen, he was actively collecting Hokusai's Flower prints at the time (cf. pl. 60).[43] The organisation of the Water Lilies, too, has clear general similarities with the free arrangements of Hokusai's Flowers. Japanese echoes emerge in a different way in the extended horizontals of the Water Lily Decorations (pls. 92, 269), which suggest that by now Monet was aware of traditional Japanese screen painting. In certain types of landscape screen, a single scene, too wide for the eye to take in at a single glance, is carried across all the panels, and sometimes punctuated by close-up trees, very much as Monet used willows placed on the near bank of the pond in some of the Decorations.[44]

The Water Lily Decorations, with their extended horizontality, take up another of Monet's preoccupations, with the relationship between his compositions and the format of his canvases, a concern revealed by the drawings in his notebooks of the 1880s on which he drew alternative framing lines (e.g. pl. 278). Monet normally used canvases of the standard French sizes, tending to choose the narrower *marine* proportions for motifs dominated by horizontals, and the squarer *paysage* and *portrait* formats where upright forms were more important, but this is in no way a universal pattern.[45] Sometimes he tried alternative horizontal formats for a single motif, and on occasion painted the same subject both horizontally and vertically, such as Vétheuil seen from the Ile Saint-Martin (pls. 149, 204) and the Manneporte at Etretat (pls. 129–30). The Manneporte canvases show particularly clearly the importance of the choice of format, since the inclusion or exclusion of the cliff top greatly alters the

89. *The Houses of Parliament, Fog Effect*, 1903, 81 × 92, W 1609, Metropolitan Museum of Art, New York

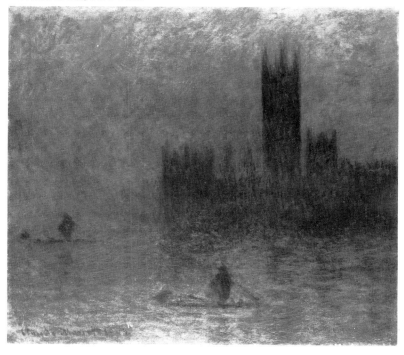

90. *Cleopatra's Needle and Charing Cross Bridge*, c.1899, 65 × 81, W 1544, Private Collection

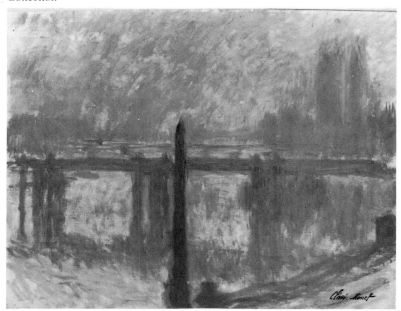

91. *Charing Cross Bridge*, 1902, 65 × 81, W 1529, National Museum of Wales, Cardiff

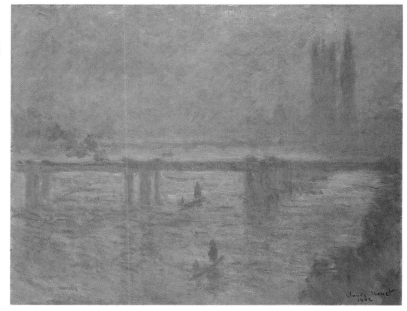

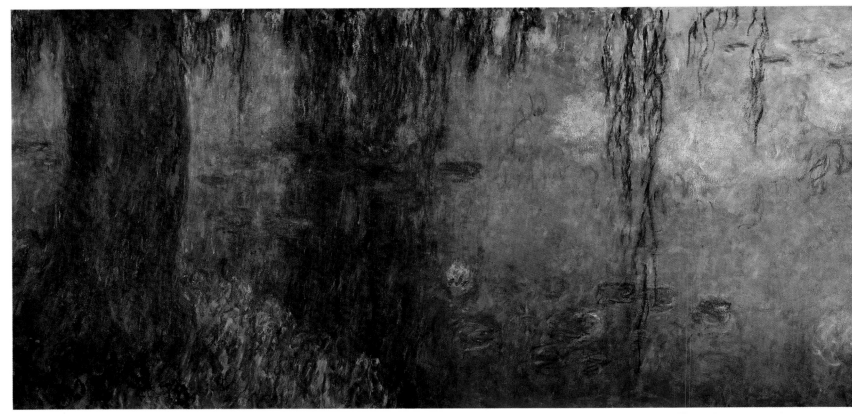

92. Water Lily Decorations, *Morning with Willows* (detail), c.1916–26, 200 × 1275 (whole), Room 2, north wall, Musée de l'Orangerie, Paris

composition. Square paintings, too, occur occasionally, sometimes of subjects also treated horizontally, such as *The Pyramides at Port-Coton* (pls. 85, 246). All these examples of varying formats seem to be canvases begun out of doors in Monet's usual way; there is no reason to suppose that such experiments were outside his normal practice of exploring possible viewpoints and *mise en page*. The question of format is an extra factor in the range of decisions facing him in his 'act of composition', as he sized up each motif before starting to paint.[46]

Most prophetic of the late Decorations are the canvases of abnormally narrow format, thus emphasising the horizontality of the motif. This occurs in occasional canvases from the late 1860s on,[47] and is particularly marked in the Poppy Field paintings of 1890 (e.g. pl. 135). Three unfinished canvases probably from the same period, of iris fields at Giverny (e.g. pl. 93), take this horizontality to an extreme, measuring about 40 by 100 cm; in their wholly unfocused compositions they look forward to the Decorations, but there is no evidence that they relate to any decorative idea. However, the possibility of applying his art to decorative purposes was in his mind during these years. In the mid-1880s he had painted Etretat's rocks on the panels of a door, and had been forced to adopt an extremely tall, narrow format for the upper panels of his flower decorations for Durand-Ruel's *salon* doors (e.g. pl. 58).[48] The first known link between Monet and a project for mural decoration dates from 1892, when Rodin abortively proposed him for a commission in the new Hôtel de Ville, but he is not known to have made any preparatory studies for this.[49] However, the first germ of the idea of the Water Lily Decorations developed soon afterwards. By 1897, even before he had started work on the first extant series of his water garden, he had made preparatory studies for a continuous horizontal decoration for a circular room 'whose dado would be entirely filled by a horizon

of water scattered with these plants [the lilies]'. The idea of such a decoration was in his mind again when he exhibited his Water Lilies series in 1909 (which included the only tondos of his career, e.g. pl. 141), but he only took up the project in earnest in 1914.[50]

For Monet, the act of composition involved choosing a viewpoint and a format which best expressed the qualities he was seeking in a particular scene. Only very rarely did this lead him to a conscious rearrangement of what he saw. The different types of pentimenti in his work and the probable reasons for them will be discussed in Chapter 11, but on a few occasions deliberate modifications in a scene can be identified, where two contemporary versions of a subject differ significantly from each other in their forms. Trees may be added, or omitted, at the edges of compositions – for instance, at bottom left of *Varengeville Church* (pls. 81, 222) and *Antibes seen from the Salis* (pls. 229–31). More substantial are the discrepancies in *Juan-les-Pins* (pls. 234–5), with a whole extra group of trees on the right of one version. In none of these cases can we tell which version is the more accurate, but such a check can be made for the most

93. *Field of Iris at Giverny*, c.1887, 45 × 100, W 1137, Musée Marmottan, Paris

significant instance – the omission of Cleopatra's Needle from all but two of Monet's known canvases of Charing Cross Bridge (pls. 90–1), when it would have cut into the centre of his composition. Presumably this sharp intrusive form in the foreground, which might have appealed to him in the 1880s, was omitted around 1900 because it disturbed the unity of colour and atmosphere which he was seeking in this series.[51]

Such a divergence from the natural scene is quite exceptional in Monet's work; in general the study of his motifs reveals his consistent care and accuracy in rendering the forms before him. Modifications, where they occur, are generally of small details in the placing of forms, such as the fringes of a tree or the contour of a hilltop. Some of these may have been the result of Monet's speed and directness of execution rather than a deliberate change of plan, but others presumably were adjustments made for aesthetic reasons.[52] In general, though, it was by his choice of subjects and viewpoints, rather than by the rearrangements of their forms, that Monet exercised his control over the arrangement and pattern of his canvases.

However, we cannot separate this interest in surface and construction from Monet's basic aim to find ways of rendering the spatial and atmospheric effects of a scene. Monet never sacrificed space to pattern, but in his compositional experiments he looked for ways of

reconciling the two. By rejecting linear perspectives and the idea of a box-like space he found greater freedom for the patterns on his canvas-surfaces, but he consistently retained the other possible means of suggesting space and depth: the overlap of successive planes; diminution and contrasts of scale; the loss of detailed focus on distant objects; and the colour modifications of aerial perspective. The flat decorative surfaces of the landscapes of Gauguin and his followers had no sense for him; indeed, he admitted his failure to understand Gauguin's work.[53]

Monet's changing compositional concerns relate closely to the overall development of his art. In the late 1860s and early 1870s he was exploring the diversity of form and texture in what he saw, the particularity of individual things, within simple, informal settings, generally viewed directly and frontally. By the 1880s he was seeing the picture as a more decorative ensemble, building compositions out of carefully orchestrated contrasts of line, form and texture, to achieve a reconciliation between space and surface. In the 1890s he came to avoid such contrasts of space and texture in favour of a more homogeneous pattern making which could best sustain the elaborations of coloured atmosphere. At each stage his chosen viewpoints supplied the natural armature for his desired effects; these effects themselves, and the material means by which he achieved them, will be examined in the following chapters.

CHAPTER FOUR
BUILD-UP of the PAINT SURFACE

WE CAN draw on two distinct bodies of material to reconstruct the ways in which Monet executed his paintings: the physical evidence of the paintings themselves, and verbal accounts, from Monet himself and from those who knew him. Both provide material essential for a full account of his methods. The verbal documents are fragmentary over some issues, but cumulatively allow us to reconstruct in some detail Monet's working habits out of doors and in the studio, and his ideas about finishing his work. However, we must first examine the paintings, and then dovetail our conclusions with the documentary evidence, to complete the description of his working methods.

The sheer quantity of Monet's surviving work supplies a mass of material for the analysis of his processes, and for two reasons his paint surfaces allow us to reach fuller conclusions about his methods than do those of most artists. First, many paintings survive which were only roughly worked and not formally finished, and some which were barely started. And secondly, Monet's handling, at least until around 1890, was essentially open in character; the superimposed layers of paint did not cover all that had gone before, and later touches and accents were intended to work in with the previous stages of the painting. One can, thus, trace the successive stages through which paintings passed, working back from their final state to the first stages of their execution. After 1890, as we shall see, he began to cover his tracks more fully, going so far as to say in 1897 that he wanted to 'prevent anyone seeing how it is done';[1] but enough unfinished canvases survive from these years to reveal his methods.

From this evidence a detailed picture emerges of the ways in which Monet executed his paintings, from start to finish. We must first examine the processes by which he built up the paint layers from the bare primed canvas, and then describe the principal factors in the appearance of the finished painting: brushwork and colour.

PRIMING of the CANVAS

We have little precise information about the materials which Monet used or about his requirements from his suppliers. He generally used canvases of standard sizes and bought them ready primed; he does not seem to have experimented, as Renoir did, with adding extra layers of priming himself. Nor was he consistent in his choice of canvas grain; his canvases were generally medium or fine grained, but variations in grain do not seem to correspond with any regularity with particular groups of paintings, or with the size of his canvases, or with the colour of their primings.[2]

It has often been assumed that Monet worked exclusively on white-primed canvases, and Monet himself in 1920 told Trévise: 'I've always insisted on painting directly on white canvases, in order to establish on them my scale of values.' He contrasted this with Courbet's use of dark primings which had led his paintings to darken.[3] As with many of Monet's published statements, this is only a half-truth. After *c.*1865, his canvas priming was always light or mid-toned; he consistently avoided, as he said, the dark base on which Courbet worked. But his statement to Trévise conceals the variety of toned primings which he used. After about 1890 he did use white grounds in most cases, but there are exceptions even after 1900; before 1890 his primings are varied and on occasion play an important part in the final effect of the paintings. Their tone and colour must have been a matter of careful planning. This is not to say that they have this importance in all of his paintings: many are so heavily worked that the priming is seen barely, if at all. But many others which Monet undoubtedly regarded as equally finished use it extensively.

All descriptions and comparisons of the colours of primings can only be approximate, for a number of reasons. A priming may be much darkened or yellowed by dirt or varnish, or both together;[4] surface abrasion may have rubbed off particles of a thin priming layer, revealing specks of the bare canvas below; the colour may be affected by the lighting in which the picture is seen; and our identification of this colour may be affected by the colours of the surrounding paint – an effect deliberately exploited on occasion by Monet and others. It is impossible to be sure that none of these factors has influenced the identification of the colour of a particular priming, but we can reconstruct, from very many examples, the general patterns of Monet's use of his grounds, and summarise the colours of priming which he chose at various periods of his career, before discussing the positive uses he made of them.

A creamy or very light beige is the most common colour of ground from around 1865 to 1890 – decisively light-toned, but slightly warm in hue. Monet's first experiments with pure white date from the late 1860s, and between 1870 and 1873 he experimented with a cool light grey, but throughout the 1870s warmer creamy

94. *The Ruisseau de Robec*, 1872, 50×65, W 206, Musée d'Orsay, Paris

primings were most frequent. From around 1880 dates a group of paintings with a light brown ground, but the lighter creamy tone remains the most common through the early 1880s. During the 1880s white or near-white primings become more frequent; both white and creamy occur in canvases from Bordighera in 1884, Belle-Isle in 1886, Antibes in 1888 and the Cruese in 1889, with occasional light grey again at Antibes. This implies that Monet took with him variously primed canvas on his painting trips. Canvases of Giverny subjects from the later 1880s show the same variation. Around 1890–1, in the Grain Stacks and the Poplars white canvases predominate for the first time; thereafter toned ones are very much the exception, though still used on occasion.[5]

From the 1860s onwards, Monet often used the light-toned ground as an ingredient in the final appearance of a painting, either leaving it bare in small areas, or allowing it to be felt through thin layers of colour, for instance in the sky (though time and the increasing transparency of paint has doubtless tended to accentuate this). In *The Thames and the Houses of Parliament* (pl. 144), for instance, the very light grey priming, showing through thin paint layers, has preserved the luminosity of the sky, whereas a dark-grounded sky would have darkened greatly, as it has in many of Courbet's more thinly painted landscapes. In *The Ruisseau de Robec* of 1872 (pl. 94), a finished painting, signed at the time of its execution, some areas of creamy priming are left bare to serve in their own right as elements in the final picture, notably the door in the far wall to the right of the figure and much of the roof at top right. The light-toned ground is also allowed to create the tone of many areas in the less highly worked versions of the Gare Saint-Lazare paintings, some of which, including pls. 101 and 265, were shown in the 1877 Impressionist exhibition. It shows through areas of smoke seen against darker backgrounds, and is only lightly worked over to provide accents and highlights.

In *Trouville Beach* of 1870 (pl. 96), one of the earliest examples of a light grey priming, Monet used the priming in a more positive way: without overpainting it acts both as a highlight in the hand of the woman on the right, surrounded by her dark dress, and as a soft mid-tone where left bare on the beach, beside the light beige paint used for the sand; this is a practical exploitation in a rapidly painted

sketch of the 'simultaneous contrast of tones' isolated by Chevreul, whereby the same tone looks lighter alongside a dark tone, and darker alongside a light one.[6]

These examples set patterns for Monet's use of his primings which did not change greatly throughout his career. Generally, more of the priming is visible in canvases that Monet did not fully finish, but the examples given here will be confined to paintings which were worked up for immediate sale, since these reveal Monet's willingness to allow the priming to play an integral part even in finished paintings.

The light brown grounds under many paintings from around 1880 must have been a deliberate experiment. Considerable areas of them are sometimes left visible, supplying important mid-tones, and they are used in very varied ways. In *Winter Sun, Lavacourt* (pl. 95), for instance, the ground acts as a mid-tone in the water, in the tree on the right and on the far bank; in *Woman seated under the Willows* (pl. 150), as the base for the whole foliage area of the trees. Monet used a light brown ground in a substantial proportion of his Vétheuil canvases, but it seems not to recur after 1881.[7]

A few examples will show how Monet used creamy toned grounds in the 1880s. In *Moored Boat at Fécamp* (pl. 221) the priming is left bare for some houses, especially on the left, and for some of the smaller clouds, such as one half way down the left edge of the sky area. In other paintings it is much seen beneath some of the principal areas of the picture, supplying a light base-tone: beneath cliff top and water in *Rising Tide at Pourville* (pl. 220), beneath snow and trees and in *Snow Effect at Falaise* (pl. 157). In *The Rocks at Pourville, Low Tide* (pl. 177), it acts like the light grey in *Trouville Beach* (pl. 96), as a light accent in the dark rocks at bottom right, but as a mid-tone in sea and sky. At times, too, these light warm primings seem to change colour according to the colour of the neighbouring paint: in *Cap Martin* (pl. 155), for example, the ground looks cooler and greyer in the orange foreground road, and warmer and beiger in the clouds, alongside the blues of the open sky.

These light-toned primings do not generally supply highlights, but establish a softly luminous underpinning to the paint layers, set off against the sharper accents of light and dark paint so characteristic of Monet's work of the 1880s.[8] White or off-white grounds are used in much the same way. Monet did not begin to use white grounds specifically to convey the high-keyed light of the South during his

95. *Winter Sun, Lavacourt*, 1879–80, 55×81, W 557, Musée des Beaux-Arts, Le Havre

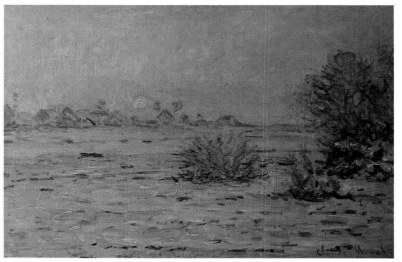

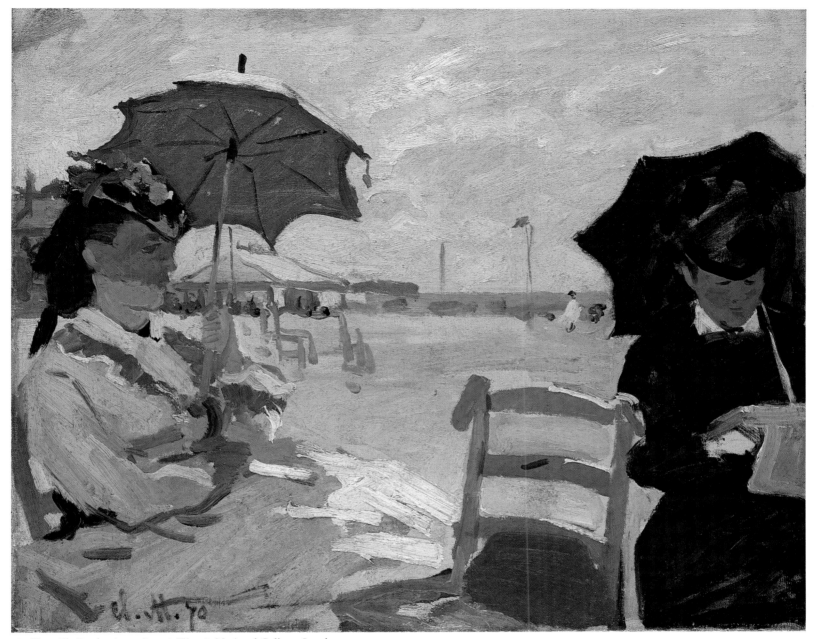

96. *Trouville Beach*, 1870, 38 × 46, W 158, National Gallery, London

travels of the 1880s; they are equally common below contemporary paintings of more muted effects. Though their overall effect is lighter than the creamy grounds, the true highlights of the canvases are still achieved by impasting, as in *The Ice-Floes* of 1893 (pl. 213), where the light tone of the priming still plays a crucial role in an overall effect of the greatest delicacy. By this date, though, as Monet's paint surfaces were generally becoming more opaque, the priming less frequently plays a major part in the final effect of fully finished paintings.[9]

Monet was not alone among the Impressionist group in exploring the possibilities offered by coloured primings; Renoir and Cézanne, in particular, used various light toned and grey grounds during the 1870s, but both seem to have turned to the exclusive use of white grounds in the 1880s,[10] while Monet continued on occasion to exploit the possibilities of the toned priming. His white or light-toned primings played an important part in the execution of his paintings even when the ground is scarcely seen in the final state of a

picture; for it gave him a light base to which he could compare and relate the tones and colours of his paintings as he worked them up. As he told Trévise, the canvas-ground served 'to establish my scale of values'.[11]

The 'EBAUCHE'

Ebauche is the standard term to describe the lay-in, the first stage of a painter's work on a *tableau*, a canvas intended for completion. The academic *ébauche* was traditionally uncoloured, an essentially tonal substructure which would establish the forms of a picture before the superaddition of colour.[12] However, by the later nineteenth century many writers had come to recommend a coloured *ébauche*. Karl Robert, the landscapist and author of teaching manuals, explained the reasons for this in 1878; after discussing various ways of treating the *ébauche*, he concluded that the best painters of the day 'make the

65

ébauche of their pictures in the required colours, that is to say in a polychromatic range which follows the definitive hues planned for the finished picture', saying that this method was best because 'it allows one to envisage the general effect of the picture with its colouring before it is completed', with the proviso that 'the *ébauche* is done in simple colours' which will be refined and modified in the final working.[13]

This practice well suited the landscapist beginning his paintings out of doors in front of their subjects, and Monet followed it closely. Around 1890 he told Lilla Cabot Perry, in the most explicit painting instructions from him that have survived, that 'the first real look at the *motif* was likely to be the truest and most unprejudiced one, and . . . the first painting should cover as much of the canvas as possible, no matter how roughly, so as to determine at the outset the tonality of the whole'. In 1888 E.M. Rashdall described this first stage in Monet's canvases: 'M. Monet's system of laying in a picture is to cover the canvas with a combination of slashes of comparatively unmixed colour, by means of long thin hog-hair brushes, with which he drags on the colour . . . After the first painting a brilliant mosaic of colour is obtained with sufficient approximation to the general effect, but absolutely devoid of small local differences of colour. The work is purposely kept extremely open, the canvas often telling freely through in places, as nothing is laid on . . . for the sake of "covering the canvas" . . . The one golden rule from which Claude Monet never departs, is to work on the whole picture together, to work all over or not at all. Neglect of this leads to loss of all harmony, to what M. Monet calls "*le triomphe de fil de fer*", the wire-drawing of nature, the attempt to represent nature as a collection of scraps instead of as a whole.'[14]

Monet's paintings themselves closely confirm these accounts. We can reconstruct this first stage of his working because he left many unfinished canvases, and because many finished ones are painted freely and openly, with areas or traces of their first working visible beneath subsequent refinements. We cannot trace any chronological development in Monet's use of the lay-in; the vast majority of lightly worked paintings date from after 1880, but what few such paintings survive from earlier years suggest that his practice did not change greatly.

Preliminary drawing on his canvases played no great part in Monet's work. A few early paintings reveal some outline drawing, as on the roof at the right of *The Ruisseau de Robec* (pl. 94), but very many do not. Two later accounts of Monet's methods, by Georges Jeanniot in 1888 and W.H. Fuller in 1899,[15] speak of him beginning his paintings with a quick charcoal sketch on the canvas, but this sketching, when it occurred, must have been very summary indeed, since no examples of it have come to light in his work after *c*.1875.

The first layer of painting in oils varied according to the textures Monet was trying to suggest. It established in a simple form the tonal structure of the scene, with muted suggestions of its colour relationships. It appears in the wholly unreworked *The Seine at Port-Villez* of *c*.1894 (pl. 97); Monet has indicated the compositional structure, of trees and hills reflected in the river, and has established a tonal contrast between the trees on the left and the far bank, but the paint areas are left flat and unaccented, with sky and water scantily covered; a few gestures of the brush begin to model the far bank of trees and hill. Slightly more worked is *The Baie des Anges, seen from the Cap d'Antibes* of 1888 (pl. 205); some paint covers most of its surface, with clear white for the snowcapped mountain tops; the nearer hills are a flat blue, the sky sparsely covered in a pinky mauve. The dull pinks and greens of the foreground foliage and trees gives a summary suggestion of patterns of light and shade, but with none of the vibrancy of most of Monet's Antibes paintings; the muted blue of the hills begins to hint at the effects of atmospheric perspective. Fully finished canvases from the South, such as *Cap Martin* of 1884 (pl. 155), have similar first layers which correspond approximately to the patterns of light and shade in the final painting, but are treated thinly and in subdued colour, before Monet reworked and keyed up the whole scene. Rather different in texture is the initial working of another unfinished southern canvas from 1888, *The Golfe Juan* (pl. 107); here the foreground rocks are treated in brisk hatchings of soft pinks and blues, which suggest not only their forms but also the effects of a windy day.

Contrasts of light and shade often appear in simplified form in the lay-in, for instance *The Manneporte, Etretat* (pl. 129) to show the fall

98. *Charing Cross Bridge*, *c*.1900, 60 × 100, W 1553, Musée Marmottan, Paris

of sunlight through the rock arch. But Monet did not indicate all important light effects so clearly in the first stages of a canvas: two versions of the valley of the Creuse of 1889, for instance, have lay-ins which show no clear sign of the dramatic sunset effects later roughly applied over them (e.g. pl. 104), and several of the Grain Stacks series (e.g. pl. 136) initially had less elaborate light effects.[16] Sometimes such apparent changes of plan may have been the results of changing weather, but from around 1890 Monet's preoccupations in his series led him on occasion to add improvised colour effects late in the execution of his canvases which bear little or no relation to their lay-in stages.[17] Many effects of sunlight in the London series

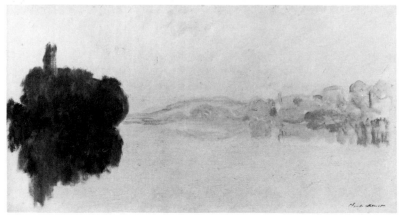

97. *The Seine at Port-Villez*, *c*.1894, 52 × 92, W 1380, Musée Marmottan, Paris

were added in this way, but another London canvas, the remarkable *Charing Cross Bridge* (pl. 98), shows that not all such sunbursts are late additions; perhaps the single least worked canvas to have survived from Monet's brush, it includes a rudimentary suggestion of sunlight reflected in the river and set off against the bridge.

The lay-ins of Monet's paintings often indicate a complex structure of planes. *Vétheuil Church* (pl. 106) includes a thin muted blue layer in the sky with some soft blue in the water, flat subdued tones for most of the buildings with a few light accents on the houses, dull green for the background foliage and soft green for the dominant foreground bush. The lay-ins of *The Golfe Juan* (pl. 107) and *The Rocks at Pourville, Low Tide* (pl. 177), both established an elaborate succession of spatial planes; in *The Rocks at Pourville* this included

water, and in lit surfaces of houses or cliffs. It was in such places that Rashdall noted 'the canvas often telling through in places, as nothing is laid on . . . for the sake of "covering the canvas"'.[18] This practice is precisely that recommended by Jules Adéline in his *Lexique des termes d'art* of 1884, in discussing the *ébauche*: 'In laying in a canvas one must also take care not to cover the parts of the picture which until the end must remain transparent, allowing the grain of the canvas to be seen.'[19] Thus the ground served as lay-in for the main parts of the rock arch in *The Manneporte, Etretat* (pl. 130); in *The Castle of Dolce Acqua* (pl. 99) the shadowed hill below the castle had to be extensively laid in with muted green, while the lit left hillside, as it was to remain light in tone, needed only scanty indications below; in *Sandviken* (pl. 100), by contrast, the unpainted priming supplied the

100. *Sandviken*, 1895, 73 × 92, W 1399, sold Christie's, London, 3 April 1979, lot 20

structure of the foreground bridge, a mid-tone alongside the impasted whites of the snow.

Other types of surface too have no opaque lay-in, notably areas of open foliage – silhouetted trees, branches and leaves with no solid mass of greenery. Robert in his treatise of 1878 distinguished between the different types of *ébauche* needed for different sorts of foliage,[20] and Monet's practice is very similar: where there are distinct accents against the sky he makes little or no preliminary notation, while opaque greenery has a more extensive lay-in. In *Path in the Ile Saint-Martin, Vétheuil* (pl. 149), the spring trees are worked in broken dabs on bare priming, and their edges touched out over the initial painting of the sky, while the bushes round their bases have some flat underpainting. He used similar methods in the Poplars series: in *Poplars on the Banks of the Epte* (pl. 214), where the lay-in is clearly seen, he began the tree tops in simple blocks of green, refining and variegating their silhouettes only in fully finished canvases like *Poplars, Overcast Weather* (pl. 209).[21]

In the Gare Saint-Lazare paintings Monet defined the station roof and other comparatively dark forms with an opaque lay-in, but omitted this beneath the principal silhouetted puffs of smoke, which are painted directly on the priming (e.g. pls. 101, 265). In reality, of course, the darker masses continued behind the smoke, but a dark lay-in would have destroyed its luminosity. This device shows how

99. *The Castle of Dolce Acqua*, 1884, 92 × 73, W 883, Musée Marmottan, Paris

soft pinks and creams in the sky, muted pink on the far cliff faces and muted green on their tops, a single off-white brushstroke for the top band of the sea, flat brown for the further band of rocks, some flat light working below the foreground sea, and a partial indication in varied sombre tones of the rocks at bottom right, in which, as we have seen, the bare priming supplies some light accents. In all three paintings the lay-in is subdued and simplified, but even after one working all must have had complex relationships of surfaces and planes. The later stages of their execution will be discussed below.

The lay-in might be virtually or wholly absent if the priming itself could supply the required base tone, as it often could in sky and

precisely even these most transitory effects were part of the initial conception of these paintings.[22] In the London series, by contrast, many areas of smoke were added as afterthoughts over the opaque paint layers characteristic of his later series (e.g. pl. 268).

As we have seen, Monet habitually omitted smaller details and accents from the *ébauche*. On occasion he seems also to have omitted rather more important elements, adding them only over an already established paint layer. In *Tulip Field in Holland* (pl. 105) the gashes of strong colour on the fields overlie more subdued and less differentiated underpainting; but in other cases, such as *Poppy Field near Giverny* (pl. 109), even the subtle variations of green in the foreground and the hill beyond are suggested in the lay-in. Structural features are also sometimes left out, such as the entire front breakwater in *The Cliffs of Petites-Dalles* (pl. 128) and the road up the hillside in *The Village of Roche-Blond* (pl. 215). In some of the London series, dense layers of dry horizontally brushed underpainting ignore the

102. *Landscape at Giverny*, c.1890, 65 × 92, W 1123, Private Collection

101. *Gare Saint-Lazare, the Normandy Train*, 1877, 59.5 × 80, W 440, Art Institute of Chicago

position of the bridges across the Thames. The reason for the presence of these dense layers will be discussed later,[23] but their opacity itself makes firm conclusions impossible: a further thin lay-in without textured impasto might well lie beneath them, and might include elements subsequently painted over in the interests of the overall effect. The very thin lay-in of Cleopatra's Needle in *Charing Cross Bridge* (pl. 90) might well have been totally obliterated in this way if the canvas had been further worked. Important linear elements of other sorts, too, were generally included in the lay-in, such as the tree, with its branches described in some detail, in *Landscape at Giverny* (pl. 102) of around 1890.

We cannot establish precisely what Monet aimed to include in the *ébauche*. Some later additions do reflect significant changes of mind on his part,[24] but not all such apparent omissions can be genuine pentimenti, and Monet probably had no fully consistent policy over what to include in his first session of work on a canvas. All that he needed from it was a framework of sorts, of forms and colours, which he could enliven and elaborate in subsequent sessions of work.

Karl Robert's discussion of the *ébauche* shows that Monet's lay-ins

were firmly within the landscape tradition to which Robert belonged. Daubigny was perhaps Robert's principal model, and his lay-in technique was particularly like Monet's, as seen in his unfinished *Tow Path* of the 1870s (pl. 103). The other landscapists in the Impressionist group began their canvases in a similar way during the 1870s, though after 1880 the methods of both Pissarro and Cézanne were to diverge on occasion, Pissarro sometimes adopting a more schematic, striped lay-in, perhaps a reflection of his dissatisfaction with outdoor sketching, while Cézanne often juxtaposed quite densely painted areas with zones of virtually unpainted canvas.[25]

Monet's general policy over the lay-in is clear. He used it to establish the dominant masses of the painting, flatly and quite roughly, with muted and unmodulated colours. When René Gimpel visited Monet's studio in 1918, he was disappointed by most of the

103. Daubigny, *The Tow Path*, ?1870s, 87 × 183, Mesdag Museum, The Hague

paintings he saw there; they were mostly 'of little interest, quite flat and colourless, they are preparatory work'.[26] This describes precisely the effect of Monet's *ébauches*, which formed the bulk of the paintings from earlier periods which Monet retained at the end of his life (e.g. pls. 102, 104–5). In themselves Monet's lay-ins have little of the *éclat* and verve of his more highly worked paintings, but this first stage was, as he told Mrs Perry, essential in 'determining at the outset the tonality of the whole'.[27] As he continued work on a picture, the *ébauche* supplied the tonal and colouristic base for his later elaborations. Monet realised the continuing influence of the lay-in

on the final appearance of his pictures when he told Trévise in 1920 how he had habitually worked them up, alternately improving them and spoiling them, 'without ever having erased the first layers'.[28]

ELABORATION of the CANVAS

When Monet was describing his methods to Mrs Perry around 1890, he first showed her a canvas on which he had worked only once, 'covered with strokes about an inch apart and a quarter of an inch thick [i.e. wide?], out to the very edge of the canvas', and then one worked twice, on which 'the strokes were nearer together and the subject began to emerge more clearly'.[29] This account suggests that some of the lay-in layers already described may have been the product of more than one session, for only *Charing Cross Bridge* (pl. 98) conforms at all closely with Mrs Perry's description of the canvas worked only once. However, Monet must often have been able to take a painting very much further than this in a first session when light and weather conditions did not change too rapidly; indeed, in March 1884 he wrote of executing 'a very successful quick sketch (*pochade*)' in a free hour,[30] and many lightly worked canvases from earlier in his career, such as *Impression, Sunrise*, may well have been the product of a single, quite brief, session of work.

We cannot tell how many sessions Monet spent on individual canvases; documentary sources suggest that the number might range from one to sixty,[31] and some canvases which he regarded as fully finished are far less heavily reworked than others. Some general factors have to be considered in discussing the build-up of his paint surfaces from the lay-in to their finished state. He painted some canvases from start to finish without the first layers of paint having had time to dry, while others were extensively reworked over one or more dry layers. We cannot use this criterion to distinguish between work done out of doors and studio repainting, since Monet often took canvases back to the motif some time after their previous working, and equally might retouch a painting in the studio very soon after finishing his outdoor work on it. The problem of determining the nature and extent of his studio reworking will be discussed in Chapter 9. Paintings reworked after a whole layer had dried might still be left in a very rough state, such as *Poplars on the Banks of the Epte* (pl. 214), while others reached a state of considerable refinement without any layer having dried during their working; an example of this is *The Ice-Floes* of 1893 (pl. 213), in which even some small contrasting touches, characteristic of Monet's last gestures on the canvas, are applied over a wet paint layer.

The drying time of layers of paint varies enormously according to their thickness, but so many other factors can affect drying – the weather, the conditions in which the paintings are kept, the composition of the paint, and the amount and nature of medium used – that the presence or absence of dry paint layers below the final surface of a painting gives no precise indication of the span of time over which it was executed.[32] Any densely impasted layer would, though, take weeks rather than days for it not to be disturbed by overpainting, while a very thin layer might dry overnight. If a layer is thick enough for its dry ridges to be felt below and through subsequent painting, a significant interval must have elapsed during the execution of the picture; the reworking may have been done in the studio, and, if it was done outdoors, the interval must often have been long enough for the season and lighting to have changed, forcing Monet into some sort of compromise with his original effect. Reworking over dry layers of paint may provide important information, particularly when the additions change the original structure or effect of a painting.[33] Parts of earlier layers may be left uncovered, to blend visually with subsequent reworkings, but even fully covered dry layers may often be detected by examining a canvas in raking light.

With these provisos about what can be deduced from individual paint surfaces, we can trace how Monet normally worked up his paintings from their initial lay-in. Théodore Duret described this process in 1880: 'He places a clean canvas on his easel, and briskly starts to cover it with slabs of colour which correspond to the coloured patches shown him by the natural scene. Often during the first session he can only make an *ébauche*. The next day, returning to the same spot, he adds to the first sketch (*esquisse*), and the details are brought out, the contours sharpened.' This account is very like the methods used by Burty's fictional painter Brissot in his novel *Grave Imprudence*, also published in 1880.[34] In 1887 Geffroy succinctly summed up the successive states of Monet process: 'Hurriedly he covers his canvas with the dominant values, studies their gradations, contrasts them, harmonises them.'[35] Pissarro, in his instructions to the young painter Louis le Bail, told him to work up all areas of his canvas together, and to 'refine his work little by little',[36] similarly, Rashdell described Monet's process as one of 'amplification', and, as we have seen, noted his insistence that the whole should be worked together.[37]

This process remained fairly consistent throughout Monet's career, as a gradual definition, articulation and emphasis of the forms and colours in the picture, and a gradual transition from the initial rapid notation of observed effects to a greater concentration on pictorial qualities in the later stages of the execution of a painting. The present section will sketch the outlines of this process, in the main using examples from the 1880s, when Monet's technique was still essentially open in character. However, his treatment of the final surface of his paintings, in terms of brushwork and colour, did undergo a clear evolution; the next two chapters will deal chronologically with the development of Monet's brushwork and colour.

Two canvases in the Musée Marmottan are only summarily reworked. *Valley of the Creuse, Evening Effect* (pl. 104) has emphatic separate strokes over the lay-in, some in quick zig-zags which break the flatness of the surface and begin to model the hillsides; rough lines are also added to define some boundaries between planes. In *Tulip Field in Holland* (pl. 105) vigorous green diagonals at lower right, over the flat green lay-in, begin to suggest the patterns of the foliage; above this, bold strokes of violent colour key up the scene quickly to match the dazzle of the tulip fields, while the sails and other details are added to the windmill.

These first reworkings are quick and rough. As he took his paintings further Monet used the brush to define the specific forms of objects, instead of merely suggesting them by masses, and the paintings gradually gained greater variety of surface. He added the broken edges of foliage over the first indications of the sky, with flecks and dabs of paint, and reworked areas of foliage to give each its characteristic rhythm. His handling never became literal, in the sense of describing every leaf and twig, but captured the patterns of many different natural textures in a form of representational shorthand.

The transition from the flatness of the lay-in and the roughness of the early reworkings to this more delicate treatment can be seen in *Vétheuil Church* (pl. 106). Much of the reworking in this is as summary as in the paintings already discussed – a few rough indications of clouds, darker drawing lines to give structure to the buildings, and darker dashes on the background buildings. But the

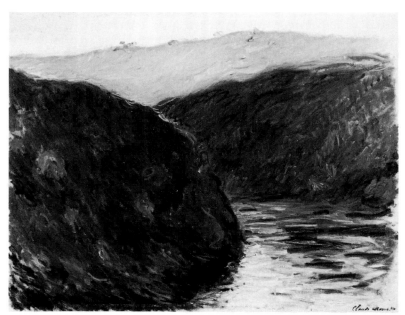

104. *Valley of the Creuse, Evening Effect*, 1889, 65 × 81, W 1225, Musée Marmottan, Paris

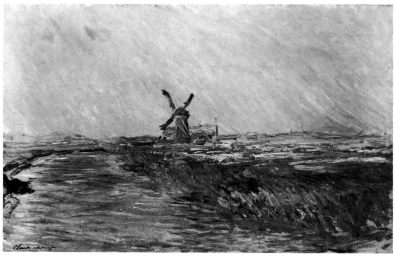

105. *Tulip Field in Holland*, 1886, 54 × 81, W 1069, Musée Marmottan, Paris

in the foreground water: above, the figures and offshore rocks were added when the painting of the sea was wet, and later the boats after it had dried; below, freeflowing strokes, only a little more carefully resolved than those in *The Golfe Juan* (pl. 107), describe the breaking waves. The small dark forms along the horizon and the vigorous handling of the sea transform a comparatively stark image into a rich fusion of forms and forces.

Monet's response to the seacoast in rough weather was taken further in *Storm on Belle-Isle* of 1886 (pl. 108). This is another very rapidly painted canvas, entirely executed, apart from a few very small accounts, while the underpainting was wet; but, as he painted it, his brush wove increasingly complex patterns. In the water, the long curving horizontals in the open sea contrast with the dynamic swirls of the breaking waves; the rocks, with free dashes of deep reds, purples and browns, are opposed to the blues and greens which predominate in sea and sky. Some of the brushwork has no literal representational purpose, such as the hooks of red-brown floating

106. *Vétheuil Church*, 1881, 58.5 × 72.5, W 697, Private Collection

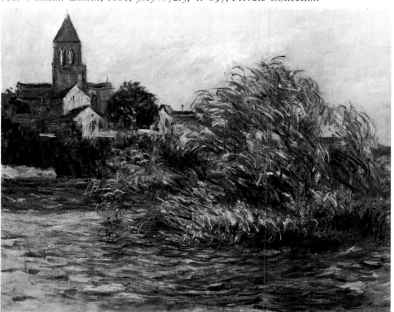

107. *The Golfe Juan*, 1888, 65 × 92, W 1180, Private Collection

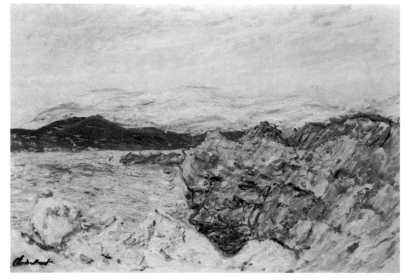

foreground bush has been reworked very fluently in long curling strokes which are echoed in the water; the bush is modelled by tonal contrasts between darker and lighter green strokes, bluer near the top. None of the underlying layers dried before the reworking. This canvas remained unfinished and unsigned in Monet's studio at his death, but the treatment of the bush, rapid though it is, approaches the richness found in the foliage of fully finished paintings of the same period. Similarly in *The Golfe Juan* (pl. 107) the water area at bottom left is enlivened with vigorous hooks of paint, suggesting the choppy sea, which are very like those in finished paintings of similar effects.

The Rocks at Pourville, Low Tide (pl. 177), is a sea effect which, though little more fully worked than the last two paintings discussed, was rapidly signed and ready for sale. Over the lay-in, which has already been described (p. 67), Monet added some darker accents in the sky, some free linear working on the far cliffs, mostly over wet paint layers, and varied dark strokes on the foreground rocks. But more important was the reworking along the horizon line and

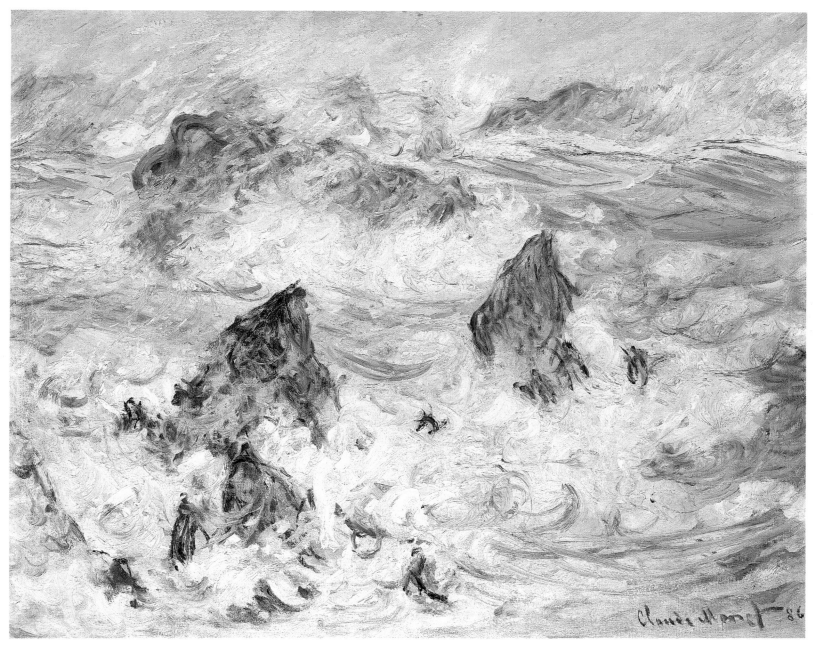

108. *Storm on Belle-Isle*, 1886, 60 × 73, W 1117, Private Collection

across the surface of the far rocks; their main purpose is to knit together the dominant colours and forms on the picture surface.

Other sorts of subject demanded wholly different responses, for instance the quiet foliage effects at Giverny which he could study and refine at his leisure. *Poppy Field near Giverny* of 1885 (pl. 109) is dominated by varied textures of grass and foliage. Over its lay-in, Monet gradually defined each area, adding late dashes of deep green and dark blue on the background bushes, soft verticals for the growing grass and greater differentiation between the foreground zones; soft blues begin to create an atmospheric unity. The painting shows another characteristic of Monet's reworking: he preserved where possible the basic colour relationships from the lay-in, but later made more complex links between areas by adding broken touches in one area which tied it in tone or colour to the area next to it; in *Poppy Field near Giverny* this appears in the late-added salmon pink strokes on the hillside, the red touches in the left field and the ·

few separate poppies at bottom right, which link these predominantly green areas to the reds of the central mass of flowers. Similar late contrasting touches may be used to link adjacent areas of light and shade, suggesting the mobile play of light through foliage as in the bushes at bottom left of *A Bend on the River Epte* of 1888 (pl. 131), or across a rough rock surface, as in the rock arch in *The Manneporte, Etretat* of 1883 (pl. 129). Comparable refinements were added across the bottom of *Cap Martin* (pl. 155), with creams and salmons broken in with the greens and blues at bottom left, and dull blues and purples added late along the base of the orange road.

In all these paintings, the principal layers of paint preserve and emphasise the patterns of light and shade established in the lay-in. These small contrasting touches are a final stage in suggesting the full variety of nature; they are presumably what Geffroy was referring to in saying that Monet 'contrasts' his dominant values.[38] The importance which Monet placed on such small local contrasts is

71

109. *Poppy Field near Giverny*, 1885, 65 × 81, W 1000, Museum of Fine Arts, Boston

shown by a criticism he made of one of Theodore Robinson's paintings in 1892, that it had 'some undecided tones . . . and values rather equal'.[39]

In working up his backgrounds Monet was faced with a different problem. Instead of working towards a fuller expression of the specific forms in front of him, he needed to suggest masses such as distant hills and cliffs without describing them in any detail, and to set them in an atmospheric space. Delacroix distinguished between these types of handling in his Journal: 'When the touch (*touche*) is used as it should be, it affirms more appropriately the different planes in which objects lie. Bold and pronounced, it brings them forward; the opposite makes them recede.'[40] Monet's problem was to find a way, whilst preserving this spatial differentiation, of weaving foreground and background together into a single pictorial effect.

Monet's southern scenes provide good examples of the different treatment of backgrounds. In *Cap Martin* (pl. 155) the main background planes were established from the start in soft oppositions of blues and salmons; these were then lightly emphasised, and later broken up to some extent by introducing soft salmony accents into the blue zones, and vice versa, but in delicate pastelly touches quite unlike the crisp contrasts of colour, tone and texture in the foreground of the picture. In painting the far hills in this and other Mediterranean canvases, Monet emphasised alternately the blue and the salmon which express shadow and light, gradually strengthening the contrast until the hills hold their own against the more defined forms in the foreground, but preserving the sense of distance by their atmospheric colour and by the softer inflections of their brushwork.

Palm Trees at Bordighera of 1884 (pl. 110) shows how Monet gradually built up his picture surface, both by refining his representation of the scene and by imposing an overall pictorial coherence

(right) Detail of pl. 109

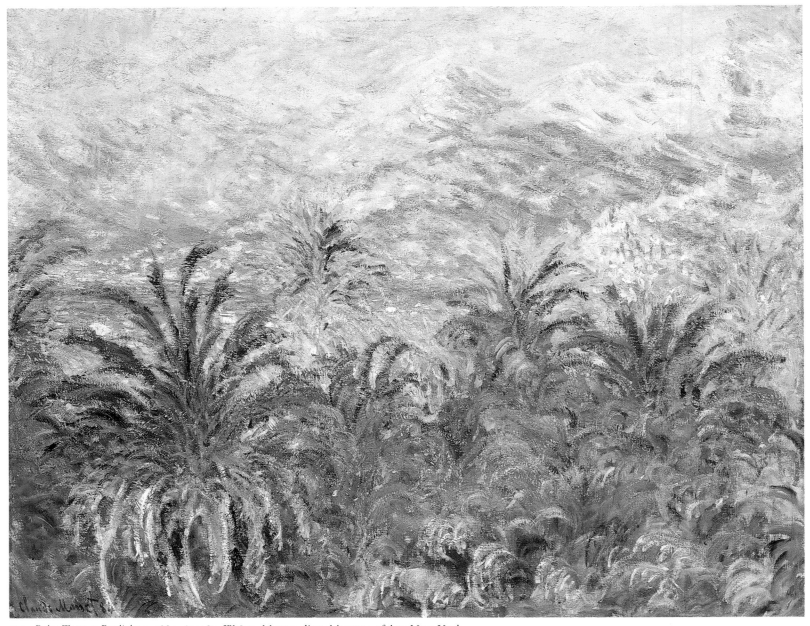

110. *Palm Trees at Bordighera*, 1884, 65 × 81, W 877, Metropolitan Museum of Art, New York

on it. Salmon and blue are emphasised alternately in the background, which acts as a luminous high-key backdrop. The foreground mass of palm fronds is in shadow and quite subdued in tone; only the tops of the further palms are caught by the sun. Monet drew the two halves of the picture together in two ways, first by extending some of the darker fronds in deep greens and blues up towards the base of the hills, thus cutting in to the luminous upper half of the canvas, and secondly by adding a variety of late touches in the foreground. The underlying layers in the foreground are quite muted and predominantly green; over this Monet added some crisp darker accents to define the forms of the trees, and some sharper greens, oranges and reds to enliven their colour; most important, he also added a sequence of pastelly pink accents in hooks and dashes across the base of the picture, with light blue touches as well particularly towards the lower right. These pinks and blues rhyme with the luminous pinks and blues of the background, across the intervening darker belt of trees, establishing a lavish harmony and continuity of colour and atmosphere which run through the whole painting.

These apparently artificial light accents suggest that, in completing his paintings, Monet variegated their surfaces not only to record the diversity of the scene, but also to extract a pictorial, two-dimensional coherence from the effects of space and pattern before him. Form and space were suggested by two principal means, by inflections of brushwork and by variations of colour and tone. But, as his career progressed, these two factors also began to play a dominant role in the two-dimensional organisation of his pictures; in his earlier years, as we have seen, composition could be discussed separately from execution, but by the 1880s the two became increasingly inseparable, as he found ways of integrating form and space into a pictorial unity which emerged as he finished his canvases. This evolving relationship between two-dimensionality and three-dimensionality, between surface and space, is the key element in the final appearance of Monet's canvases, which forms the subject of the next two chapters, on brushwork and colour.

CHAPTER FIVE
BRUSHWORK

The touch gives the painting an accent which the blending of colours cannot produce.

Delacroix, 1857[1]

THE PRIME inspiration in the development of Monet's brushwork was his own experience of working from nature, and his exploration of the ways in which his experiences of nature could be transformed into paint. His evolving handling of paint closely follows the vision of nature which he presented in his paintings, as it developed from observant responses to the life around him towards the preoccupation with nuances of effect and atmosphere of his later years. But his experiences of art also played an important part, in showing him the range of expressive possibilities which the brush offered; most important of these influences were, perhaps, Manet, Delacroix and Japanese art, but their lessons were assimilated into Monet's own evolving ways of rendering nature.

As early as 1864 Monet showed his concern with finding a personal *facture* in a letter to Bazille; he described 'a simple study (*étude*) . . . done entirely from nature. You may perhaps find in it a certain relationship with Corot, but this has come about quite without any imitation; the only reasons for this are the motif and above all the calm, misty effect. I did it as conscientiously as possible without thinking of any other painting.' That is, he claimed that his treatment of the scene simply grew out of his direct contact with nature, but the phrasing of his letter shows how inseparable in fact this process of learning from nature was from his experiences of art; it was in relation to art that he defined the naturalness of his own painting. Throughout his career, on the few occasions when he gave advice to artists, Monet always urged them to learn first and foremost from their own experience of painting directly from nature, in an effort to persuade them to shed an overriding preoccupation with style.[2]

In his first exhibition paintings, such as *The Pointe de la Hève at Low Tide* (pl. 181), shown at the 1865 Salon, and in other contemporary seascapes (e.g. pl. 111), Monet's touch is economical and flexible, suggesting the varied features and textures of the scene, with some minuteness where the subject demanded it. In its flexibility and conciseness, this handling owes much to Jongkind, who was so clearly Monet's mentor in the whole conception of these paintings (cf. pl. 112). In his next paintings, though, Manet's example comes to the fore. Monet presumably knew Manet's paintings from the 1863 Salon des Refusés, but clear traces of Manet's technique seem to appear in his work only around 1865; in 1883, in an article which clearly owed many details to Monet himself, Philippe Burty dated to the aftermath of the 1865 Salon Monet's discovery of Manet's 'bold handling which suppressed intermediate tints and sharply accentuated the highlights'.[3] Only in Monet's portraits and figure subjects is Manet's influence overt, in the crisp incisive brushmarks by which he modelled his forms; but for the Impressionist generation the importance of Manet's handling must be seen in broader terms.

In retrospect Manet can be placed in a long tradition of painterliness, but in the 1860s his brushwork, and particularly the freedom of treatment of his Salon paintings, was a controversial issue. Zola in 1867 pinpointed this as one of the principal characteristics of Manet's canvases: they were 'an ensemble of delicate, accurate *taches* [patches or touches] which, from a few steps back, give a striking relief to the picture', and Manet reduced a figure's face and clothes to simple *taches* of blue and white. For Thoré in 1868 this reduction of everything in a scene to equal-weighted *taches* was disturbing evidence of 'a sort of pantheism which gives a head no higher value than a pair of trousers'.[4] Monet echoed this idea in his instructions to Lilla Cabot Perry around 1890: 'When you go out to paint, try to forget what object you have before you, a tree, a house, a field or whatever. Merely think, here is a little square of blue, here an oblong of pink, here a streak of yellow, and paint it just as it looks to you, the exact colour and shape, until it gives your own naïve impression of the scene before you.'[5] The *tache* was also seen as a characteristic of Daubigny's paintings in the 1860s; Gautier complained in 1861 that his landscapes 'offer little more than juxtaposed *taches* of colour'. Preoccupation with the *tache* came to be seen as a feature of anti-academic painting.[6]

In 1865–6 Monet was experimenting with various means of translating natural effects into paint. In a few seascapes he modelled some surfaces with the palette knife (e.g. pl. 113), in a clear echo of the practices of Courbet, with whom he was in close contact at the time; this was the only occasion in his career, it seems, that he painted with the knife.[7] In other paintings of the period, he used the brush to give certain areas an assertive flatness comparable to the effects of palette knife work – areas where the subject itself presented simple undifferentiated planes, for instance the sky and the sunlit grass of *Jeanne-Marguerite Lecadre in the Garden* (pl. 114). But other parts of this picture are treated very differently: decisive Manet-like accents

model the figure's skirt, and varied dabs and flecks of paint define the various textures of foliage and flowers.

This picture introduces what were to be the key elements in Monet's handling of paint between the mid-1860s and the early 1870s: the use of a flexible, crisply executed notational system which could find appropriate equivalents for any observed form or texture. He gradually refined his means and extended his range of types of brush mark, but every fresh refinement was added to his basic repertory of pictorial devices for rendering what he saw. One method did not supersede another; each might be called upon when-

world and the work of art, while Monet's in these early years was analytic and closely rooted in visual experience.

In the later 1860s Monet's touch became lighter and less literal, less closely tied to details. The figures in outdoor scenes such as *Ice-Floes on the Seine at Bougival* (pl. 115), probably painted in 1867–8, are rendered in a few crisp strokes; his powers of characterisation recall his boyhood experience as a caricaturist, but the gestures so deftly captured are now typical, not personal, characteristic of particular activities, not individuals, and the mark-making more painterly than graphic. Other forms, such as the plants and grasses

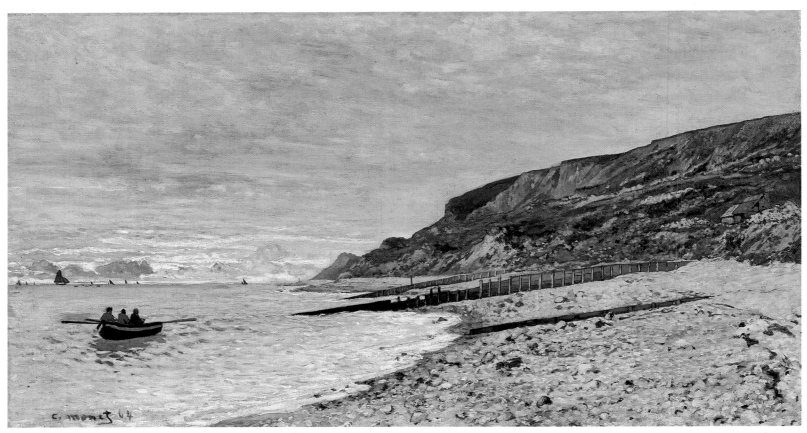

111. *The Pointe de la Hève*, 1864, 41 × 73, W 39, Private Collection

112. Jongkind, *The Coast of Sainte-Adresse*, 1862, 33 × 46, Rijksmuseum Twenthe, Enschede

ever appropriate. Their very diversity reveals Monet's fascination during these years with the endlessly differing properties of the things he saw around him, but these means have one important thing in common: the brushstrokes never establish a hierarchy of importance among the elements depicted; each is equally integral to the whole scene.

This language of mark-making was well suited to expressing the aesthetic which Baudelaire had propounded in *Le Peintre de la vie moderne* – the viewpoint of the 'passionate observer', fascinated by every nuance of what he saw, but refusing to become psychologically implicated in it.[8] In these terms, Monet's handling is comparable to Manet's; but in some ways their use of the brush differs. Monet's sums up forms in a brisk shorthand, whose variety brings out the distinctive characteristics of each element, while Manet at times created patterns of brushwork which challenge the integrity of forms and create ambiguities of space (cf. pl. 16). From the start Manet's approach was synthetic, constantly emphasising the disjunctions between the visible

113. *Seascape, Storm,* c.1866, 48.5 × 64.5, W 86, Sterling and Francine Clark Art Institute, Williamstown, Mass.

114. *Jeanne-Marguérite Lecadre in the Garden,* 1866, 80 × 99, W 68, Hermitage Museum, Leningrad

which show through the snow at bottom right in *Ice-Floes on the Seine at Bougival*, are expressed by improvised dabs and zig-zags of paint which suggest the observed forms when the painting is viewed from a distance, but without any vestige of detailed illusionism. In all the paintings of this period, though, distinct brushmarks such as these are set off against other areas treated far more flatly and simply. Again, it is possible that Manet's example played a part in this liberation of Monet's touch; by now he knew Manet, and at Manet's one-man show in 1867 he would have had his first chance to examine the ensemble of Manet's work, including paintings such as *Music in the Tuileries Gardens* (pl. 16), bolder and more summary in its use of the *tache* than Manet's Salon exhibits, and so clear an illustration of Baudelaire's ideas about modernity.

By the end of the decade, particularly in less finished works such as *La Grenouillère* (pl. 71), Monet was using the *tache* with great freedom. Here, Manet's example is only directly felt in small details such as the figures, but the treatment of the water, in bold slabs of colour, shows Monet applying the lessons of Manet's paint surfaces to a subject observed from nature. This bravura handling recurs on occasion in the early 1870s, in the boldest of his *esquisses*, *Regatta at*

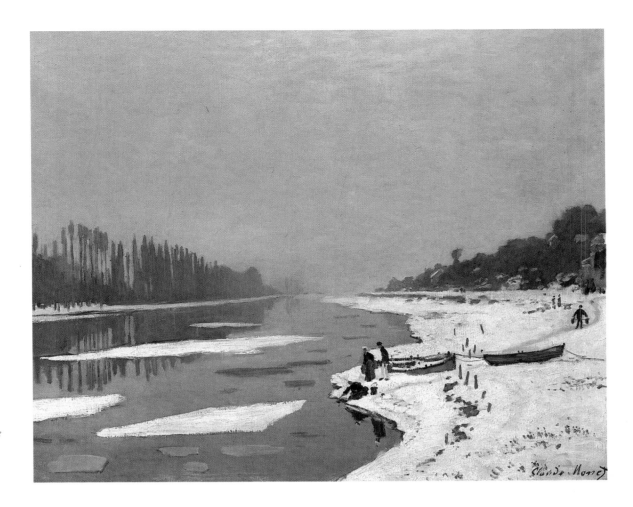

115. *Ice-Floes on the Seine at Bougival*, c.1867–8, 65 × 81, W 105, Musée du Louvre, Paris

116. *Lilacs in Sunlight*, 1872, 50 × 65, W 204, Pushkin Museum, Moscow

Argenteuil (pl. 142), and, more delicate in touch but no less startling in effect, in the *taches* of sunlight in *Lilacs in Sunlight* (pl. 116), which absorb figures and foliage alike into a single vibrant play of coloured *taches*.[9] Other subjects demanded quite different treatment: in still river and port scenes like *The Thames and the Houses of Parliament* (pl. 144) and *Impression, Sunrise* (pl. 199), water and sky alike are treated in liquid sweeps of colour which suggest that Monet may have responded to Whistler's early Nocturnes (e.g. pl. 272).[10] But some contemporary scenes are treated in far greater detail, with smaller differences of texture crisply notated, as in the later 1860s; this tighter more literal handling, seen for example in *The Basin at Argenteuil* (pl. 143), is characteristic of the paintings Monet completed for the dealer market at the period.[11]

In the mid-1870s we find the beginnings of a more general change in Monet's handling. In place of the distinct, diverse accents of previous paintings, he began to seek ways of coordinating the whole paint surface more closely, both by variegating and breaking up every surface within the picture, and by introducing echoes and rhymes of touch and texture across the surface between different areas of the picture. This did not, though, lead him to any systematisation of touch or treatment. Two early and very different examples of this change belong to autumn 1873. In *Autumn Effect at Argenteuil* (pl. 72) the encrusted surfaces of the trees and their reflections give the whole surface a density and consistency, though the paintwork in the trees, more prominently on the right, shows scratchmarks probably made with the brush handle, and presumably an attempt to lighten the effect. By contrast, the effect of *The Sheltered Path* (pl. 117) is like filigree: the touch still varies from object to object, but no surface is left unenlivened, and the small flecks of paint give the surface a constant vitality.

The Sheltered Path is a subject dominated by broken textures; soon, though, this overall variegation appeared in paintings without

117. *The Sheltered Path*, 1873, 54 × 65, W 288, Philadelphia Museum of Art

so textured a subject. As before, different subjects demanded different responses; the nature of this gradual change can best be gauged by comparing Monet's treatment of similar subjects. *Unloading Coal* of 1875 (pl. 148) shows a scene comparable to *The Wooden Bridge* of 1872 (pl. 19); as in the earlier painting the principal elements in the composition – bridge, figures and gangplanks – are sharply defined, but the surface of the whole is treated with a delicate, almost dappled touch, quite unlike the earlier broad, crisp paint zones. Two garden paintings show a similar change. In *Monet's House at Argenteuil* of 1873 (pl. 3) the foliage is treated with much finesse, but other areas are handled more flatly, and individual elements such as the figures and the vases are marked out by a more sharply focused touch. In *Gladioli* of 1876 (pl. 118), by contrast, the constant variegation of the surface overrides such distinctions: the picture's textures are all busy and animated, and there are no points of repose in the subject; the figure, like the mass of flowers, is made up of sequences of mobile brush-marks. Monet's touch is differentiated in order to suggest the varied natural textures, but the dominant effect is pulsating and immaterial, of coloured touches floating across the surface, seemingly weightless like the butterflies which flutter all through the garden.

This new type of paint surface is fully realised in the Gare Saint-Lazare paintings of early 1877. These retain an emphatic compositional framework in the train sheds and bridges; but within their central arena of space, figures, trains and signals alike are integrated into sequences of colours and tones which make no special focus on one element at the expense of any other. The open areas of ground and the puffs of smoke and steam are enlivened by variations of touch and colour while the figures too are busily flecked. In the loosely finished *The Pont de l'Europe* (pl. 265) the engine on the left and parts of the smoke are animated by bold curls of paint, but there is little to differentiate the figures from the forms beyond them. Even in the highly finished paintings of the station such as *The Gare Saint-Lazare* (pl. 119) the separate elements are absorbed into the dense encrustation of the surface; the figures lose their separateness and their faces become red accents of just the same weight as the touches on the engine and the hut in the distance.

This is a great change from the early 1870s; this gradual absorption

118. *Gladioli*, 1876, 55 × 82, W 414, Detroit Institute of Arts

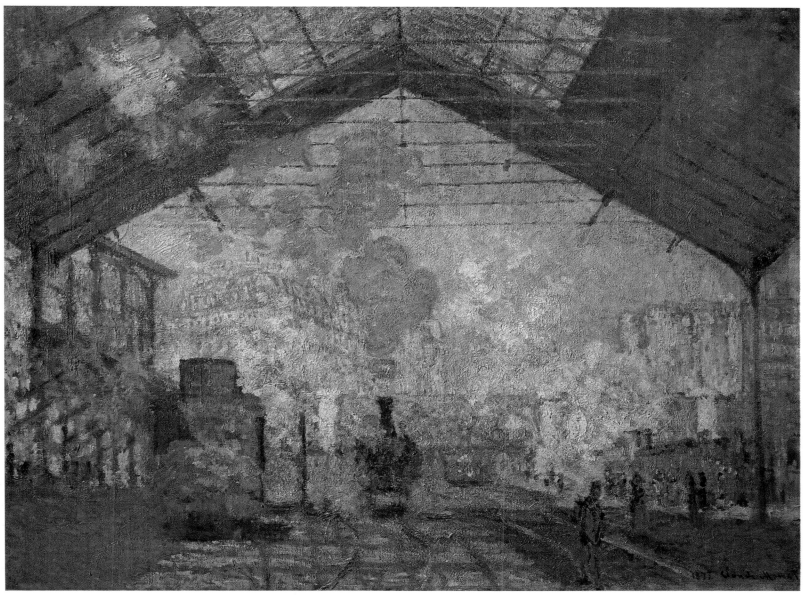

119. *The Gare Saint-Lazare*, 1877, 75 × 100, W 438, Musée d'Orsay, Paris

of the individuality of the parts of the scene marks a crucial change in Monet's attitude to his pictures as a whole. In paintings of the early 1870s, like *The Basin at Argenteuil* (pl. 143), the figures, though summarily treated, were seen as wholes, as distinct elements in the scene equivalent in weight to others such as trees, sails or chimneys. Now, by contrast, they lose their integrity, as the connections across the surface are made not from one separate element in the physical scene to the next, but from one coloured touch to the next. The point is now no longer that all the distinct ingredients of the scene are of equal value, but rather that no object has a significance in its own right; each only gains a value from the part played in the ensemble of the picture by the paint-marks which make it up. The subject of the painting is now no longer the relationships between the separate ingredients of the view depicted, but rather its overall effect; its parts are subordinated to the light and weather that play across it, and the whole is woven together by brushwork and colour. In 1887 Monet wrote of his new figure paintings (e.g. pl. 38) as 'figures in the open air as I understand them, treated like landscapes; this is an old dream which always plagues me, which I want once to realise'.[12] It was his

new treatment of the paint surface in the later 1870s which first allowed Monet to conceive of 'figures treated like landscapes'.

This integration of subject and effect reached clear realisation in the Gare Saint-Lazare paintings, Monet's last major sequence of modern-life subjects. In 1878 he took this still further in his last paintings of Paris, the two street scenes of the *Fête nationale*; in *Rue Montorgueil* (pl. 120) flags and houses fuse into an interplay of verticals and diagonals, while in the street below individual figures become indistinguishable in the flurry of light and dark paint accents. By comparison, the figures in *The Boulevard des Capucines* of 1873 (pl. 262), though very schematically indicated, do retain their independence as figures,[13] and those in the Paris scenes of 1867 (pls. 15, 68) are still more clearly defined. However, the 1878 street scenes mark the end of Monet's concern with specifically modern subject matter. His last Argenteuil paintings of 1877 (e.g. pl. 21) show less interest in the separate ingredients of the scene than their predecessors had,[14] and in 1878 he moved to Vétheuil, to an environment which represented a seemingly timeless integration between man and nature, rather than an actively evolving set of internal

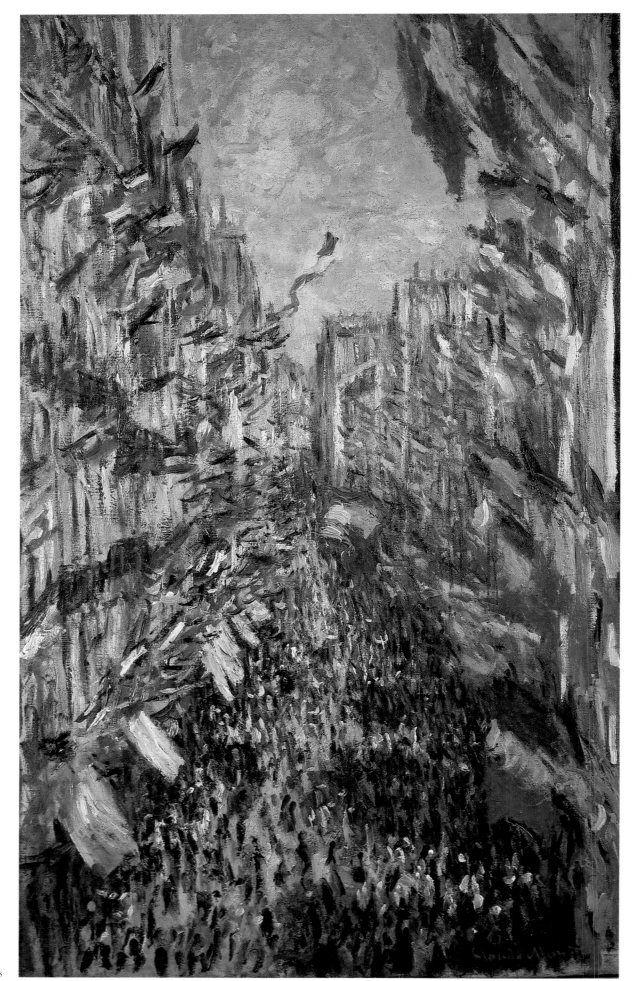

120. *The Rue Montorgueil, Fête nationale*, 1878, 80 × 48.5, W 469, Musée d'Orsay, Paris

contrasts (e.g. pls. 22, 95). Here he could concentrate exclusively on the effect, on nuances of texture, light and colour within the natural scene, and could uninterruptedly refine his perception of the changing weather and seasons; but these qualities had appeared in his paintings before he moved to Vétheuil. His changing preoccupations were presumably one of the reasons why he felt the need in 1878 to move away from specifically modern landscapes.

In the later 1870s, as earlier in the decade, Monet's boldest brushwork appears in his less highly finished paintings. Only a few lightly worked canvases from this period survive, but several of these were exhibited at the 1877 Impressionist exhibition, notably some of the Gare Saint-Lazare paintings (including *The Pont de l'Europe* pl. 265, and apparently even *The Signal*, pl. 266), and a canvas entitled *The Tuileries, esquisse*, shown together with a far more highly finished version of the same subject (pls. 195, 197).[15] The free handling of the *esquisse* is quite unlike the broad sweeps and slabs of colour which characterise Monet's lightly worked paintings from the early 1870s such as *Regatta at Argenteuil* (pl. 142); its surface is animated throughout, with loops and swirls of paint across the trees, soft pink in the sun, deep green in the shadows. The fully finished version, too, is consistently varied in surface, but its forms are far more precisely and crisply indicated.

In these views of the Tuileries and the Gare Saint-Lazare, the contrast between sketchier and more finished paintings suggests that in the later 1870s Monet's most fluent handling generally belonged to the earlier stages of the execution of his canvases. In a few fully finished paintings, such as *The Hunt* (pl. 4), flowing ribbons and hooks of paint suggest the patterns of foliage and branches, but most do not have this richness of overall patterning in their brushwork, while the most thickly worked of all, *The Gare Saint-Lazare* (pl. 119), has least surface animation in the brushwork, its subtle nuances being achieved rather by delicate coloured touches over layers of dense impasto. The finished *The Tuileries Gardens* (pl. 197) is characteristic in its surface treatment: though far more varied in touch than *The Gare Saint-Lazare*, the movement in the brushwork is confined to individual parts of the picture – here particularly in the foliage – without giving the whole surface any one dominant rhythm, or setting up integrated sequences of rhythms which lead the eye from area to area across the painting. Over the next few years, Monet was to come increasingly to seek such coordinated rhythms.

The emphatic, improvised handling and breadth of treatment of Monet and his colleagues was much discussed by critics. Hostile responses found these picture surfaces incoherent, but their supporters emphasised that the pictures needed to be viewed from a greater distance than the traditional picture. The Italian critic Diego Martelli expressed this clearly in 1879 in a letter to Giovanni Fattori, leading painter among the Italian Macchiaioli (literally '*tache*-ists'), describing the effect of Monet's paintings of the 1878 *Fête nationale* (e.g. pl. 120): 'They are painted in such a way that if one goes up close to them, one finds only scribbles of various colours . . . But, looking at these pictures from the right viewpoint, not only does one find form, but even movement, and flags flying and people strolling.' In 1883 Burty noted how Monet painted 'at a distance', and concentrated on 'the idea of colour rather than on the memory of details'; therefore one should judge his paintings 'from a distance'.[16] Monet himself left no indication of what he envisaged as the best viewing distance for his paintings, nor did any of his colleagues during the years of the Impressionist group exhibitions. He would, though, very probably have agreed with Millet, who advocated 'a considerable distance, say four or five times their greatest width or height', and with

Pissarro, who around 1888, during his experiments with Neo-Impressionism, recommended a distance of three times the diagonal of the picture; both of these were seemingly rather further than those demanded by the perspectival structure of most paintings of the Renaissance.[17]

The changes in Monet's brushwork during the 1870s can be related to the work of his friends and contemporaries, and to elements from the art of the past. Jongkind's recent paintings may have played a part (e.g. pl. 121). In place of the distinct accents which had influenced Monet's paintings of 1864–5 (see pl. 112), the Dutchman was, by around 1870, beginning to build up his entire paint surfaces from a network of more evenly weighted broken touches, which recreated the mobile effects of sunlight, and subordinating individual ingredients to overall effect. This development in Jongkind's work, fully realised by 1872, foreshadowed Monet's new conception of the paint surface in the later 1870s.

It was during the 1870s, too, that the lessons of Delacroix and of Japanese art became relevant to Monet's brushwork. Delacroix's influence was less overt than Manet's but perhaps equally far-reaching. In some of Monet's seascapes of the late 1860s there are echoes of Delacroix's small oils and watercolours painted on the Normandy coast in the early 1850s. Monet probably saw many of these in the exhibition before Delacroix's studio sale in 1864, which Bazille, at least, visited; indeed this sale, which first revealed the range and richness of Delacroix's sketching from nature, may well have played an important role in the emergence of coloristic painting from nature among the Impressionists-to-be.[18] Monet's own *Impression, Sunrise* (pl. 199) of 1872 is particularly like one of Delacroix's marine watercolours which Monet himself later owned (pl. 122), in the treatment of sun reflected in sea, and in the supple dark accents across the water surface. Though this was in the 1864 Delacroix studio sale, Monet is unlikely to have acquired it before 1872, and may well have bought it many years later because it so resembled his own celebrated canvas.

It was, though, not only Delacroix's studies from nature which were important for Monet. His finished oils carried a lesson which in the long term was to prove far more significant. On first seeing Delacroix's paintings, at the 1859 Salon, Monet had dismissed them as 'mere indications, lay-ins (*ébauches*); but as always he has verve

121. Jongkind, *Boat on a Canal in Holland*, 1872, 32.5 × 45.5, Private Collection

123. (right) Delacroix, *Jacob wrestling with the Angel*, 1856–61, 714 × 488, Saint-Sulpice, Paris

122. Delacroix, *Cliffs near Dieppe*, c.1852, watercolour, 20 × 31, Musée Marmottan, Paris

124. *The Reeds*, 1876, 54 × 65, W 430, Private Collection

and movement'.[19] Discussion of the importance of Delacroix for the Impressionists has concentrated on questions of colour, but the verve and movement which Monet noted became important for Monet's own handling. Time and again Delacroix's *Journal* (which became Monet's favourite book after its publication in 1893–5) talks of the need to preserve in the final work the freedom of the sketch,[20] and, as Monet realised in 1859, Delacroix's later works make this dichotomy clear. While Manet's lesson lay in the effect of emphatic, simple strokes on the picture surface, Delacroix used the brush in a more flowing, calligraphic way. His last great paintings, the murals in the church of Saint-Sulpice, opened to the public in 1861, show this to the full; the decorations quickly became a focus of attention for young artists.[21] In *Jacob wrestling with the Angel* (pl. 123) the treatment of the trees, and the rhyming lines and forms of trees and figures, foreshadow the way in which Monet later used the whole picture surface to generate continuous, mobile rhythms, a tendency which began to emerge in the mid-1870s.

As well as influencing his modes of pictorial composition, Japanese art made its contribution to his brushwork. A few canvases of the mid-1870s suggest the influence of Japanese brush drawing, for instance the treatment of foreground reeds in *The Reeds* (pl. 124). Monet did not talk in any interview specifically about Japanese brush drawing, focusing his attention principally on colour prints. He apparently spoke to Jeanne Baudot of his enthusiasm for the Japanese, who 'express life with a stroke of the pen', which suggests, if he has been reported correctly, that he had no great interest in Japanese technique as such, since Japanese drawing was done exclusively with the brush, not with the pen.[22] In more general terms, Monet thoroughly assimilated the lessons of the Japanese use of line, as he did those of Delacroix's brushwork; they are felt in his later work not as specific stylistic parallels, but in an awareness of the potential of certain types of arabesque and calligraphy with the brush, particularly in some seascapes of the 1880s.

The general directions of the development of Monet's brushwork during the 1870s are closely paralleled in the work of his Impressionist colleagues, notably Sisley and Pissarro. Both men shared the endlessly

flexible varied *taches* and the simple zones of open paintwork of 1872–3. Likewise Pissarro became more concerned with the homogeneity of his paint surfaces around 1874, though, unlike Monet, he returned briefly to the palette knife in 1875, doubtless in response to Cézanne, before turning in 1876 to a greater animation of surface which can, once again, be closely compared with Monet.[23] Equally Monet's greater preoccupation with the overall effect in 1877 is shared by both Pissarro and Sisley. For Pissarro, 1877 marked the beginning of a greater ordering and systematisation of touch which led him, by 1880, to paint surfaces built up of closely coordinated sequences of small hatching strokes (e.g. pl. 125), a device closer to the unity which Cézanne was seeking at the time in his 'constructive stroke'[24] than it is to Monet's freer and more intuitive handling. Sisley's development was closer to Monet's. In 1877 both men were emphasising the touch throughout the painting to suggest the animation of nature, and Sisley, like Monet, began at this moment to absorb the individual ingredients of his scenes into their total effect, instead of signposting each as a distinct element within the scene; Sisley's *The Seine at Suresnes* of 1877 (pl. 126), a canvas which caused him considerable trouble, can be closely compared with Monet's Gare Saint-Lazare paintings (e.g. pls. 119, 265).[25]

As we have seen, Monet extended the range of his subjects in the 1880s, and began to choose themes which showed natural forms or forces at their most lavish or extreme. His brushwork became correspondingly more flexible, to describe this new range of forms, and the patterns of the brush became an integral part of the structure of the painting, animating and amplifying the initial compositional framework. Georges Lecomte described this aptly in 1892: 'To this sort of understanding [of the forces of nature] corresponds a sort of grandiloquence of handling. His drawing is broad, vigorous, powerfully synthetic, his painting dazzling and resonant, his touch bold.'[26] No longer did Monet tone down this bold handling as he worked up the painting, but it became a dominant feature even in his fully finished canvases.

A new richness of brushwork appears in the treatment of foliage in Monet's Vétheuil paintings of 1880–1, as seen in sketchy form in

125. Pissarro, *Sunset, Côte des Grouettes, Pontoise*, 1879, 54 × 65, Private Collection

126. Sisley, *The Seine at Suresnes*, 1877, 60.5 × 73.5, Musée d'Orsay, Paris

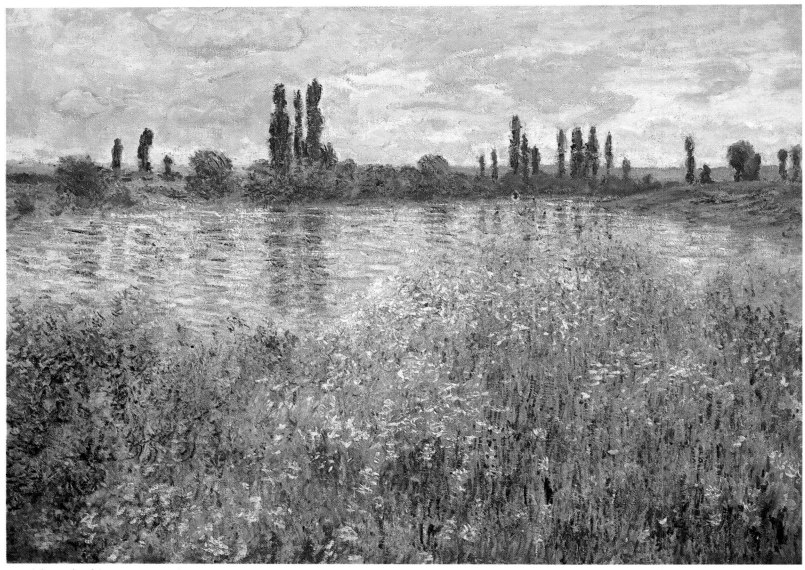

127. *The Banks of the Seine near Vétheuil*, 1880, 73 × 100, W 597, National Gallery of Art, Washington, D.C.

the bush in *Vétheuil Church* (pl. 106). In *The Banks of the Seine near Vétheuil* (pl. 127), an elaborately finished painting, the distinctive rhythms of every element in the composition are emphasised in the brushwork, with sequences of verticals and horizontals of different weight and density expressing clouds, trees, water, flowers and plant stems; in *Flower Beds at Vétheuil* (pl. 154) ebullient loops and curls describe the bank of flowers. In neither painting is there any overall coordination of the touch, any single dominant rhythm; the surface structure of the painting is established by the way in which the varied textures are played off against each other. In *Woman seated under the Willows* (pl. 150), one of the few 'figures treated like landscapes' of the early 1880s, the figure is absorbed into its surroundings in touch, treated in simple *taches* enlivened by crisp, energetic hooks and dashes of colour, thus undermining the traditional hierarchy in figure–ground relationships by wholly integrating the figure into the natural scene.

In some of Monet's seascapes from the 1880s, too, the structure of brushwork is built of contrasts, here expressing in material form the opposition between land and sea (e.g. pls. 128, 177). However, in other seascapes we find the beginnings of a greater integration between the parts of the picture, an interest in finding a dominant

rhythm running through the whole scene. We have already seen how, in *Storm on Belle-Isle* (pl. 108), Monet made the brushwork on the rocks complement the driving water; but such internal organisation of the surface was not only achieved by dramatic effects such as this, as we can see by comparing two versions of *The Manneporte, Etretat* (pls. 129–30). In the former, the waves establish a swaying horizontal rhythm to which Monet opposed the solidity of the arch; but across much of the rock mass he laid on supple horizontal strokes. These are wholly justifiable as translations of the long grooves which run across the rock face itself, but they all have a clear pictorial function, in picking up the horizontal movement of the sea below. In the other version the sea is calm, and the verticality of the arch, emphasised by the vertical format, becomes dominant. Soft broken touches unite sea and rock face, and establish a homogeneous texture without creating strong rhythms within the surfaces. The orange vertical stripes on the cliff are also justified by the natural subject: here the sandy topsoil on the cliff top has trickled down the rock face.

These examples show how impossible it is to separate descriptive elements from pictorial ones in these paintings. As he worked them up, Monet emphasised the natural patterns which could supply the

pictorial rhythms he sought, but these rhythms were themselves abstracted from his observation of nature, and the pictures remain closely observed records of the forms and effects he had in front of him. Lecomte wrote in 1892 about works like the Belle-Isle storm paintings: 'The terrible shock of these two opposing forces, the sea and the land, is rendered harmoniously, despite its savage brutality, in the Japanese manner, by ornamental arabesques.'[27] This integration of the rhythms of rocks and waves has parallels in many Japanese prints (e.g. pl. 84), but Monet has worked out the lessons of Japanese arabesques in terms of his own observation of nature, in contrast to the overtly decorative use of such prints by Gauguin and his followers. For Monet, to reduce nature simply to decorative pattern would have been to lose sight of its meaning. The rhythm and animation which give his paintings of the 1880s their decorative quality grew from his fascination with extreme natural effects, as he used his brushwork as a metaphor for the unifying forces he found in nature.

In his treatment of foliage, too, during the 1880s Monet was able to explore the widest repertory of effects – from the lavish exoticism of the Riviera to the delicate nuances of the Seine valley. Palm trees lend themselves to bold handling, but the distinctive quality of Monet's vision emerges from comparison between his palms and those in Renoir's Algerian paintings of 1881–2. Renoir gave his trees crisp and varied textures, but did not make their cursive patterns into the keynote for a whole composition as Monet did in *Palm Trees at Bordighera* (pl. 110), where the late retouches in the foreground (see p. 74) pick up and accentuate the rhythms established by the palm fronds; the distances here, though, are treated far less emphatically, to preserve a sense of atmospheric space.

At Giverny Monet concentrated on less sumptuous effects. When he reduced his compositions to horizontal bands or combinations of simple shapes, he relied on colour and brushwork to bring the painting to life. The varied accents added late in the execution of *Poppy Field near Giverny* (pl. 109) are an example of this; every area of the painting is enlivened in some way. Such movement begins to appear early in the execution of some paintings; in *Field of Iris at Giverny* (pl. 93), which is little more than a lay-in, the brushwork of

128. *The Cliffs of Petites-Dalles*, 1880, 59 × 75, W 621, Museum of Fine Arts, Boston

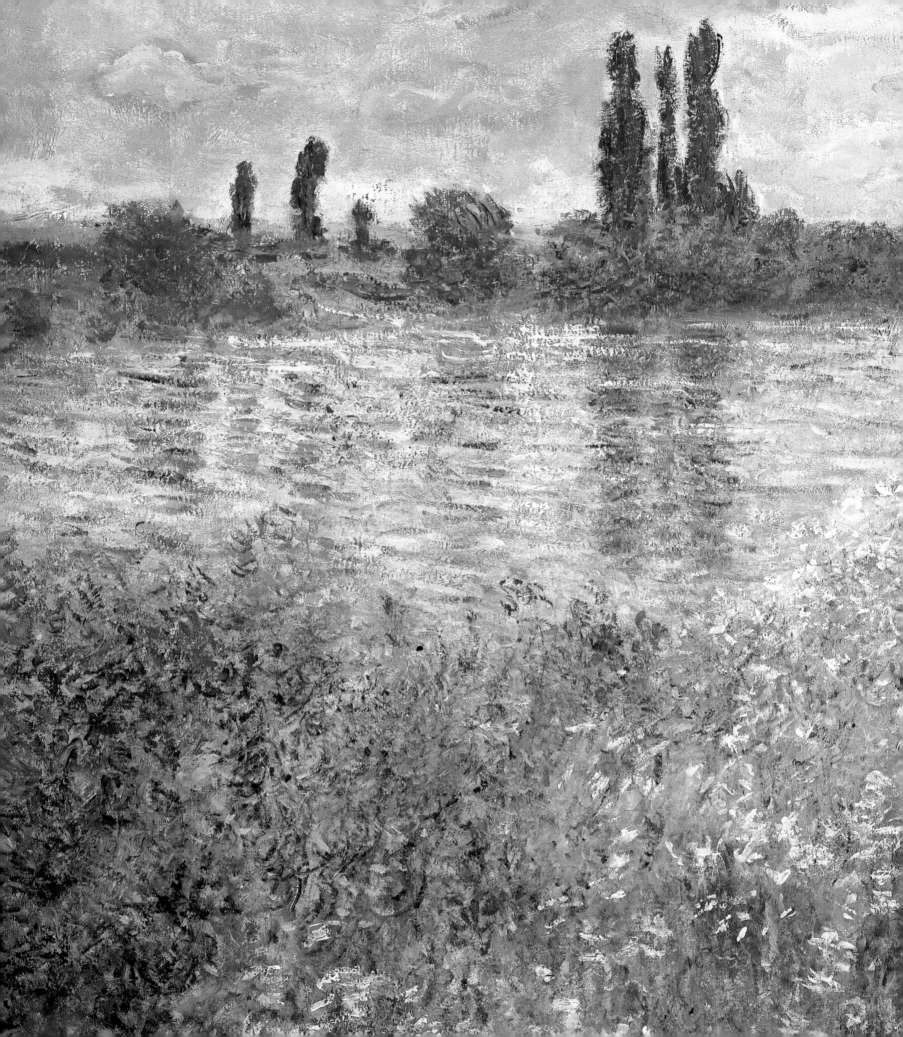

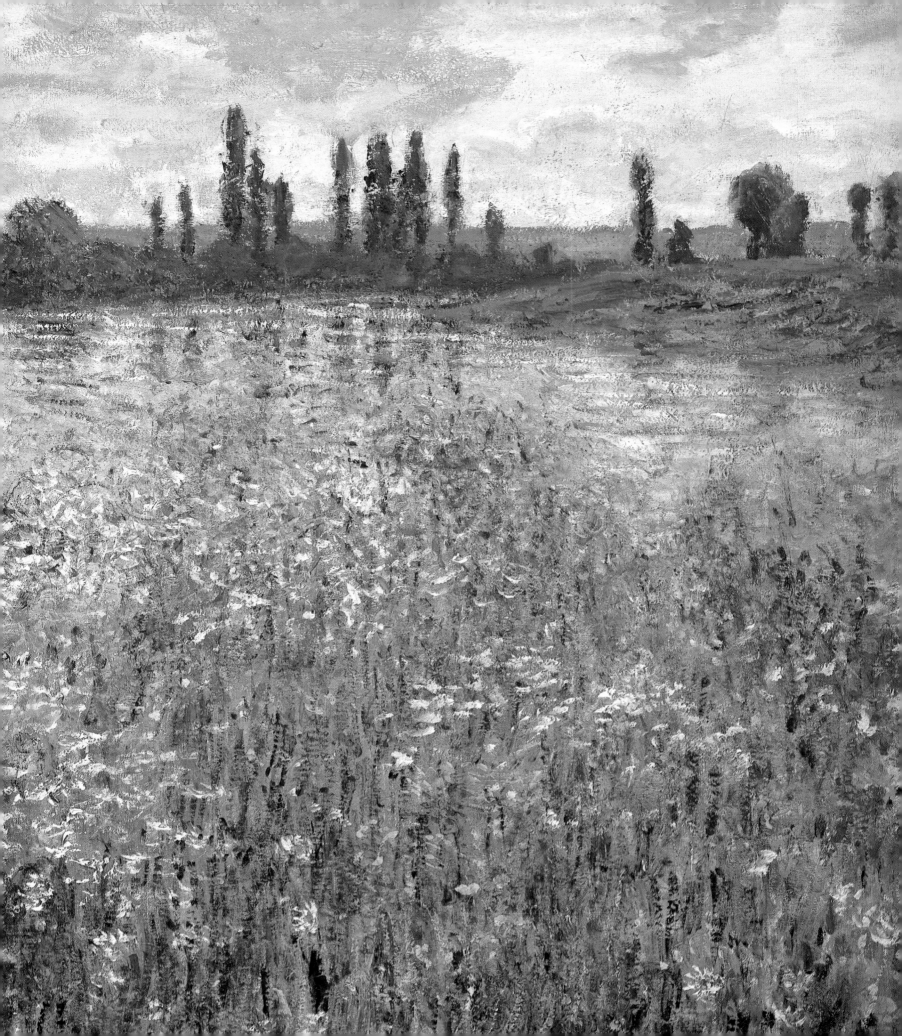

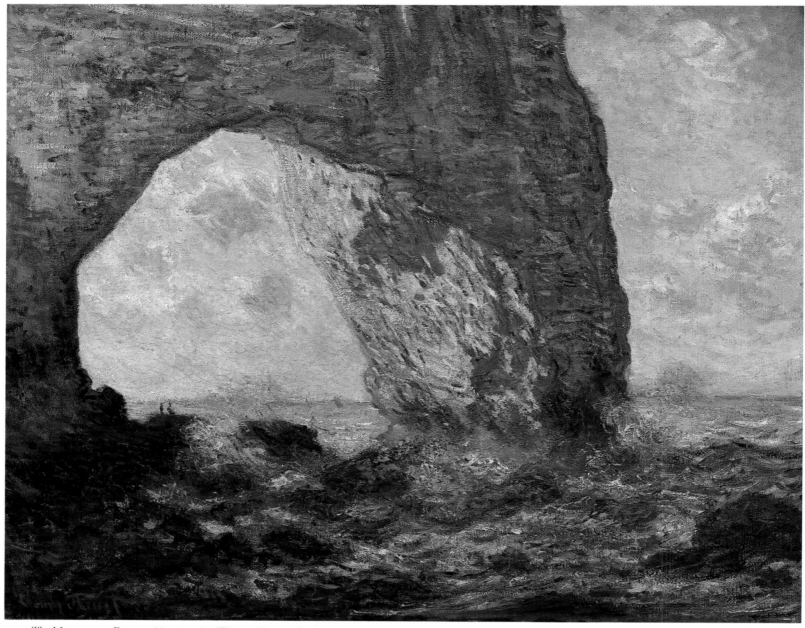

129. *The Manneporte, Etretat,* 1883, 65×81, W 832, Metropolitan Museum of Art, New York

the foreground field creates a gentle rightward movement, balanced by soft leftward touches on the background trees, while freely dabbed flowers enliven the bottom of the canvas. In finished paintings of similar subjects, such as *The Poppies at Giverny* (pl. 76), such textures are amplified and enriched; a sense of space and recession is created entirely by nuances of colour and inflections of the brush.

In a more complex composition, such as *Snow Effect at Falaise* of 1886 (pl. 157), different types of touch establish varied rhythms which link up across the painting. The verticals of the fence at bottom left are picked up in the trees on the hillside; a succession of mainly diagonal accents, on trees and bushes, leads across the centre of the painting – a link made more explicit late in the execution of the canvas by the restatement of the branches cutting in at the left edge; and the diagonals on the foreground field are quietly echoed on the hillside above. Monet may have exaggerated the verticals on the far trees to some extent in the interests of this pictorial unity, but

he always used the actual forms of his subject as the starting point for these surface relationships.

When working from motifs with very homogeneous textures, Monet used the brush to create a single overriding rhythm. An extreme example of this is *A Bend on the River Epte* (pl. 131). Within the mass of trees which dominates the picture, Monet introduced endless variations of colour and touch – creams, pinks, reds and blues set against the greens, and delicately varied touches which animate the surface and create a gentle diagonal rhythm in the sunlit trees. This canvas, painted in 1888, may well have been Monet's answer to the Neo-Impressionists; while Seurat and his colleagues reduced the variety of nature to a uniform *petit point*, he here showed that even the most *pointillé* subject varied constantly in accent and rhythm. Monet would certainly have endorsed Pissarro's later verdit on Neo-Impressionism, that, when using the *point*, it was impossible 'to follow my *sensations*, and in consequence to give

90

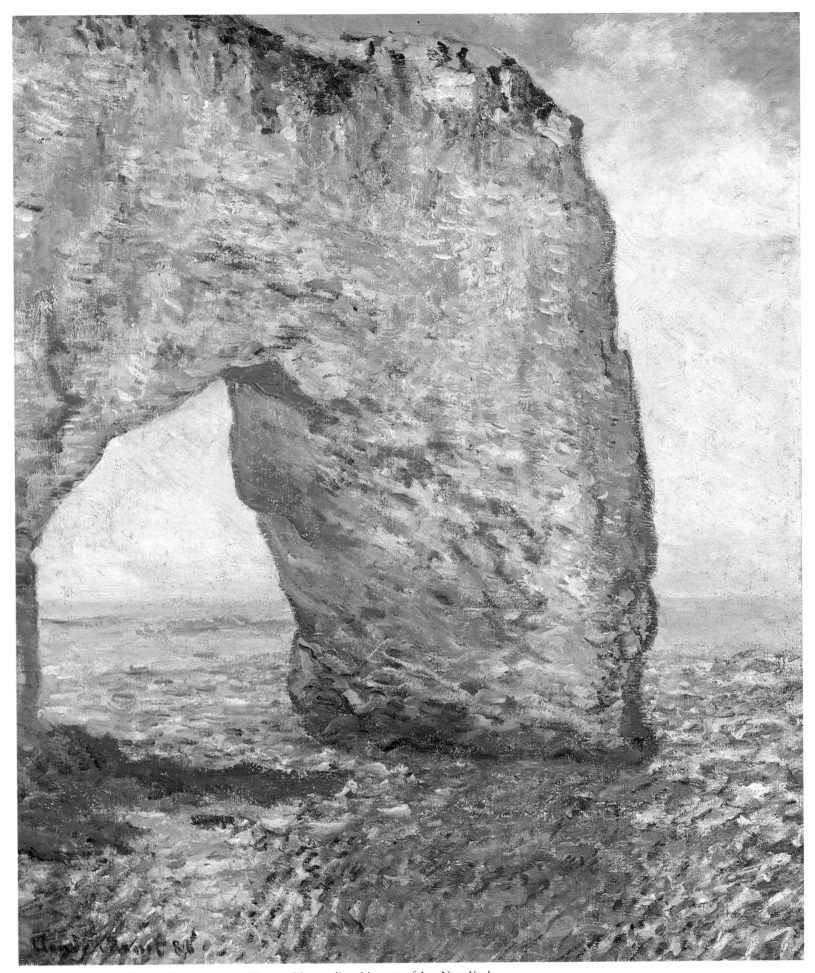

130. *The Manneporte, Etretat*, 1886, 81.5 × 65.5, W 1052, Metropolitan Museum of Art, New York

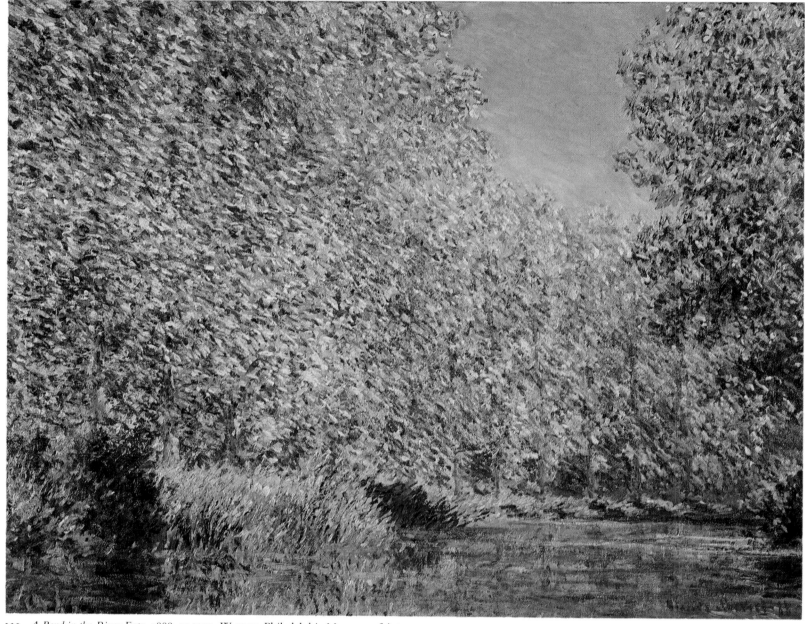

131. *A Bend in the River Epte*, 1888, 73 × 92, W 1209, Philadelphia Museum of Art

life and movement . . . to pursue those so fleeting and marvellous effects of nature . . . to give an individual character to my drawings'. Monet himself commented tersely to the American painter Cecilia Beaux in 1896, when he was painting the Early Mornings on the Seine (e.g. pl. 139): 'Nature does not have *points*.'[28]

Analysis of these paintings reveals the deliberation with which Monet built up the surfaces of his fully finished paintings, and the delicacy with which their final effect was achieved. The degree of calculation in Monet's brushwork has been emphasised by Robert Herbert.[29] Herbert identifies a number of different types of brush-stroke which Monet habitually used in building up his surfaces, particularly from the 1880s onwards. He distinguishes between 'texture strokes', the 'thick strokes of paint which were allowed to dry before surface colours were added', and the generally less thick surface strokes; most important of these is the 'skip stroke', where a loaded brush is drawn 'very lightly across the canvas so that it skips, depositing paint when it touches', allowing the colours below to

show clearly through these superimposed accents, and thus creating an active interplay between the successive paint layers.

Herbert sees the underlying 'texture strokes', even when their actual colour is obscured by surface colours, as having as 'their main purpose . . . to give a texture of apparent spontaneity', and as being 'the principal carrier of the feeling of immediacy of sensation'. This raises questions both about Monet's intentions in his working methods, and about the ways in which the viewer experiences the paintings. The 'texture strokes' establish the main body of impasto on the picture surface, during the processes described here in the previous chapter (pp. 69–74). However, their role in the appearance of the final picture may vary greatly. At times, especially in the boldest *esquisses* of the early 1870s, such as *Regatta at Argenteuil* (pl. 142), they may remain quite unadorned as the final paint surface. In rapidly executed paintings from the 1880s such as *Storm on Belle-Isle* (pl. 108), the quickly added reworking acts merely as a refinement, allowing these main layers to express the immediacy of the storm,

(right) Detail of pl. 131

and in many of his more dramatic subjects from this period, such as those from Belle-Isle and the Creuse, the later reworking merely augments and emphasises the dynamic rhythms of the texture strokes. In other paintings, such as *Stone Pine at Antibes* (pl. 133) which Herbert describes, the 'texture strokes', felt through surface reworking, serve to differentiate the various planes of the composition by their differing rhythms (here to distinguish foliage from sea from distance), though their effect is not particularly dynamic. However, elsewhere the animation of the final picture belongs far more to the final reworking; in *The Cliff Walk, Pourville* of 1882 (pl. 228), for instance, the layers below do not play a prominent part in the final effect: its freshness and breeziness are generated by the rich weave of hooks and dashes of colour added across the surface, which draw out the rhythms and patterns of waves and grasses.

The diversity of these examples suggests that the role of the 'texture strokes' is not a constant one, but varies according to many factors – the subject and effect chosen, and the degree to which the painting is worked up. Some paintings owe more of their sense of immediacy to dynamic 'texture strokes', others more to their surface elaboration. Sometimes these two types of elaboration, from within and from without, both play an important part, as in *Meadow with Haystacks near Giverny* (pl. 132), where the mobile 'skip strokes' across the surface and the broader strokes beneath combine to produce an ensemble almost bewildering in its density and complexity. By the early 1890s, as we shall see, Monet resolved this potential conflict emphatically in favour of surface enrichment; even where underlying textures are seen clearly in the final picture, they are comparatively even and regular, rather than expressions of an idea of spontaneity.

Herbert concentrates his detailed discussions on the variety of small-scale strokes and touches with which Monet overlaid his main paint layers, touches which refine the effects of colour and light. His main examples are from the recently cleaned paintings in the Museum of Fine Arts in Boston. In each of his three examples from

132. *Meadow with Haystacks near Giverny*, 1885, 73.5 × 93.5, W 995, Museum of Fine Arts, Boston

(right) Detail of pl. 132

133. *Stone Pine at Antibes*, 1888, 65 × 81, W 1172, Museum of Fine Arts, Boston

1885–9, *Meadow with Haystacks near Giverny* (pl. 132), *Stone Pine at Antibes* (pl. 133) and *Ravine of the Creuse* (pl. 134), he finds minute, even hairline brushstrokes, designed to simulate the effects of larger, more broadly swept strokes, and at times even adding a tiny factitious shadow beneath an impasted brushstroke. However, microscopic examination of the areas in question does not support such analyses. The marks described are the product of causes other than single, minute touches of the brush: variously, they are parts of very delicately flicked 'skip strokes', or small areas of earlier paint layers seen through subsequent touches, or the result of accidents on the paint surface such as deposited brush bristles or subsequent abrasion.[30]

This does not invalidate the general conclusion that Monet's technique was utterly deliberate and his pictures were often the results of many successive stages of elaboration; the freshness and spontaneity of his initial encounter with nature had, in his most highly finished paintings, to be recreated in complex acts of pictorial manipulation. However, as far as can be seen, this artfulness did not involve him in considered dissimulation. The apparent fluency of his picture surfaces was the product of an utterly knowing mind and hand, as well as a remarkable eye, but the actual physical effects he achieved were gained by movements of the brush which were both delicate and fluent; this appears particularly in the extraordinary lightness of touch with which Monet applied many of his 'skip strokes', and also in the small, crisp dabs and dashes by which he articulated many parts of his paintings very late in their execution.[31] The interweave of coloured touches which make up his most highly finished paint surfaces was not the result of a miniaturist's control over the microstructure of the surface, nor was every minute effect individually predetermined; but the effect of the picture was the product of a consumate overall control, and a sure sense of how the intricacies of its parts could contribute to the whole.

(right) Detail of pl. 133

134. *Ravine of the Creuse*, 1889, 65 × 92, W 1219, Museum of Fine Arts, Boston

There is a marked change in the treatment of Monet's paint surfaces around 1890. The varied, emphatic brushwork of the 1880s gives way to more uniform surfaces, more opaque and sometimes very dense in texture. The change is connected with Monet's growing preoccupation with the atmospheric *enveloppe*, in place of the dramatic effects he had favoured in the 1880s. The first hints of a new approach to the picture surface appears in some canvases of the later 1880s: in *Stone Pine at Antibes* (pl.133), for instance, the free play of the brush is replaced by softer, less directional dabs which evoke texture rather than movement; in a subtle atmospheric effect like *Morning Haze* (pl. 160) of 1888, the underlying layers are simple and unemphatic, and in the final surface of the painting the visible *touche* is virtually suppressed. At this point, though, such pictures alternate with richly accented surfaces such as those in many of the Creuse paintings (e.g. pl. 134). Monet's Giverny paintings of 1890 develop further these comparatively inert surfaces. In the Field of Poppies paintings (pls. 135, 251), soft touches, quite evenly weighted and rarely directional, and often quite broad, make up the whole surface of field and trees, over thick yet not dynamic layers of impasto. Even where natural textures are more conspicuous, as in *Spring Effect at Giverny* (pl. 159), the surface is coordinated by

texture more than by pattern; the slight directional movements felt in the trees are subordinated to this new homogeneity of touch.

In the Grain Stacks series, atmospheric effects become predominant. To convey such effects Monet had to introduce the constantly varying coloured nuances by which he conveyed the *enveloppe* without disrupting the unity of the effect by accentuated patterns of brushwork (e.g. pls. 33, 161–2). With this in view, he resorted to a delicate animation of the paint surface which never threatens to read as a representational shorthand for actual textures within the natural scene. These touches are added across broader paint areas, less active and generally opaque, and normally dry before the reworking. The added accents are varied in shape and generally lightly dabbed onto the surface, animating the picture without creating any distinctive surface rhythm. The touch is generally crisper on the near side of the stacks, which hints at the texture of the stems that made them up; spatial recession is suggested by the softening focus of the touch from foreground to background, as well as by changes in colour. Occasionally Monet did still give free rein to his calligraphy, for instance in *Grain Stacks at Sunset, Winter* (pl. 136), in which a remarkable orange-red doodle animates the roof on the far right of the picture. In no way can this gesture be read representationally; it

(right) Detail of pl. 134

135. *Field of Poppies*, 1890, 60.5 × 100, W 1252, Museum of Fine Arts, Boston

is an act of pictorial improvisation, intended to enhance an effect of coloured light, whereas the free ribbons of paint of the 1880s derive far more directly from observed natural forms.

The Grain Stacks were a subject without strong contrasts of natural texture; the Poplars of 1891, by contrast, were dominated by a fretwork of foliage silhouetted against the sky. Yet Monet made far less of this than he had even in such recent canvases as *A Bend on the River Epte* of 1888 (pl. 131). In comparison with this earlier picture, the foliage on the trees and bank in *The Poplars, the Three Trees, Autumn* (pl. 137) is treated less crisply and less literally; a rightward diagonal movement in the bank is answered by a soft leftward movement in the crowns of the background trees, but these rhythms are not closely tied to the actual textures of trees or grasses, belonging rather to an interplay of coloured accents on the picture surface. Likewise, in *The Ice-Floes* of 1893 (pl. 213), the trees on the far bank to the left of the islet are animated by the most delicate yet fluent interlacing loops which bear no direct relationship to the actual textures of the trees, but enhance the delicacy of the overall effect.

The nuanced, atmospheric subjects which he now favoured demanded a handling quite different from the bravura brushwork of his most dramatic scenes of the 1880s. Monet himself sensed the challenge that these subjects set him; he wrote to Berthe Morisot in 1888, while he was trying to capture the southern light at Antibes: 'It is so difficult, so tender and so delicate, while I am so inclined to brutality.'[32] The new type of paint surface which he evolved in these years was his response to these demands; but it also marked a decisive

shift, with the decorative taking precedence over the descriptive in the surface effect of his finished paintings.

In the Rouen Cathedral paintings of 1892–4 (e.g. pl. 138) the chosen subject presented Monet with particular problems. He told Theodore Robinson that in them he wanted 'to do architecture without using lines or contours'; when Whistler criticised him for 'never delimiting his forms, whereas nature often delimits', Monet replied: 'Yes, doubtless nature does, but light never does.'[33] Yet the rigid scaffold of the façade of Rouen Cathedral offered him no alternative rhythmic pattern as a starting point. His solution was to soften his touch still further, giving it no crisp focus, and cloaking the final surface with full-bodied layers of paint, dragged across the dense textures below and filling all but their deepest crevices. These added strokes are generally quite broad, and lack any distinctive shape of their own; by avoiding sharp contours on the building and crisp accents in the brushwork, Monet directed attention away from the details of the architecture to the nuances of the atmosphere which cloaked it. As Monet's letters show, this series caused him particular problems, and by the end of his second stay at Rouen in 1893 he described his paintings as an 'obstinate encrusting of colours'.[34] The final effect of these paint surfaces has often been compared with the texture of actual stonework, but the most thickly painted areas of the sky are similarly treated. The antecedents of surfaces like these appear in a few of Monet's earlier paintings of non-architectural subjects – in the most highly worked version of the Gare Saint-Lazare (pl. 119), in some Antibes canvases (e.g. pl. 133), and in the 1890 Field of Poppies paintings (pl. 135). All

(right) Detail of pl. 135

of these acquired their encrusted surfaces after a protracted process of revision and elaboration; likewise the surface quality of the Rouen paintings seems to be a by-product of the difficulties they caused Monet and the time they took to paint, rather than a conscious attempt to simulate stone.

His next major series, the Early Mornings on the Seine of 1896–7 (e.g. pl. 139), marks a clear rejection of the loaded impasto of the Rouen paintings; surfaces like theirs would have been quite inappropriate to convey the mists of dawn on the Seine, and Monet sought a far more economical solution. Though they are reworked over layers of dry paint, these layers are generally thin and unobtrusive, and the final surfaces of the paintings are smooth and liquid, their fluency not the result of individual gestures with the brush, but of the manipulation of soft veils of colour. Across these veils Monet added soft inflections of the brush just emphatic enough to establish the successive planes of the scene, and to hint at the textures of the foreground foliage; these touches focus particularly on points of demarcation – a few light accents where sky is seen through trees, a few darker ones where foliage is silhouetted against sky, and soft ribbons of light to suggest the further edges of the water surface. This surface animation, unlike that of the 1880s, is not closely tied to objective description, nor does it develop directly from any scheme of representational notation; it evokes in pictorial terms the play of light and colour across the subject, instilling a sense of freshness into the scene at the end of the working process. While painting the Early Mornings, Monet told Guillemot: 'I should like to prevent anyone seeing how it is done.'[35] This statement, and the opacity of the surfaces themselves, show how far his handling had changed from the open surfaces of the 1880s when every successive layer entered into an active relationship with its predecessor.

The London series of 1899–1904 and the Water Lilies of 1904–9 are similarly treated; surface animation is added over less accentuated opaque layers. In some of the London paintings smoke or clouds are indicated by free calligraphic strokes (e.g. pl. 268), and in the Water Lilies the lily pads are at times redefined in bold loops of paint (e.g. pls. 37, 141) which foreshadow the way in which the lilies float across the paint surfaces in the Water Lily Decorations (pls. 92, 269). The surface activity in these pictures bears no close relationship to the paint layers below. However, in some canvases from both series the underlying dry layers are densely impasted, and their textures play a significant part in the picture's final appearance, acting in a sort of counterpoint to the animation on the surface. Often these underlying textures are sweeps of dry impasto, generally brushed horizontally; but, as Robert Herbert has shown, they

136. *Grain Stack at Sunset, Winter*, 1891, 65 × 92, W 1282, Private Collection

137. (right) *The Poplars, the Three Trees, Autumn*, 1891, 92 × 73, W 1307, Philadelphia Museum of Art

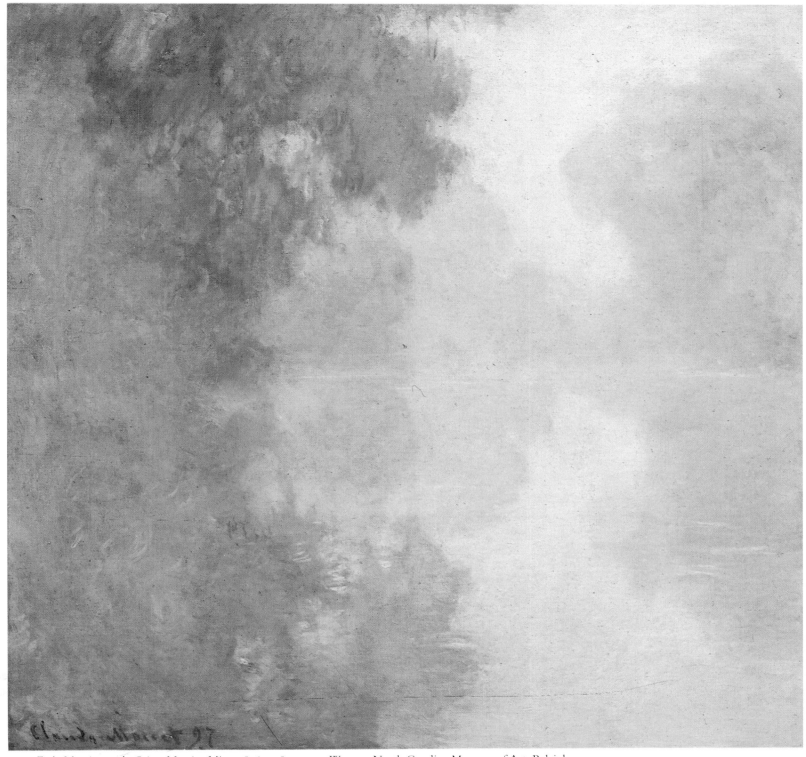

139. *Early Morning on the Seine, Morning Mists*, 1896–7, 89 × 91.5, W 1474, North Carolina Museum of Art, Raleigh

derive at times from the build-up of paint as successive sweeps of paint are brushed across the weave of the canvas and adhere to its ridges, leading to a sort of corrugation.[36]

In the Water Lilies such layers are most common in paintings dated 1905 and 1906 (e.g. pl. 140), while those dated 1907 are generally less impasted (e.g. pl. 37), and those dated 1908 very thin and liquid in surface (e.g. pl. 141). The dates on this series were presumably added as the canvases were completed for exhibition in 1909, but they seem likely to relate to the year in which the

particular painting was begun.[37] Thus only those reworked over a period of years show these textures. Even in these the textures do not underlie the whole surface; in Herbert's example, the 1905 canvas in Boston (pl. 140), parts of the areas of open water at right of centre and bottom right are far less impasted. Many paintings from this series were altered during their execution, particularly in the positions of the lily pads, and the most densely textured areas seem to be those in which some revision has been made.

But did Monet actively seek such textures and value their effect,

138. (left) *Rouen Cathedral, the Portal and the Tour d'Albane, Grey Weather*, 1892–4, 100 × 73, W 1345, Musée des Beaux-Arts, Rouen

105

or were they a by-product of his working method? An indication of his attitude to this series appears in an account published in 1908, after he had for a second time cancelled a planned exhibition of them: 'All those who saw the pictures in February and March considered them "overworked", that is, they showed too plainly how long they had stood on the easel. One of M. Monet's friends even went so far as to say that there were four or five different pictures on each canvas. M. Monet admitted this himself, and stated how dissatisfied he was with his work.'[38] On this account the paintings which best reflected Monet's ambitions were those which lack these underlying textural layers, particularly those dated 1908, executed from start to finish with great finesse, and reminiscent of the delicate surfaces of the Early Mornings on the Seine. As Herbert

shows, this textural substructure does give a sense of depth to some of Monet's water surfaces, but we must doubt whether this was a deliberate device.

Similar textures lie below many of the monumental paintings executed for the Water Lily Decorations over a period of years after 1916 (e.g. pls. 92, 269). These are generally veiled by more fluid layers which carry rich nuances of colour, and across these Monet's surface brushwork reached a new graphic freedom in suggesting the lily pads and flowers, as he sought a *facture* suitable to the vast size of the canvases. Here again, it is this late-added surface activation which gives the paintings their freshness of effect. In the Decorations, hand and eye come together on a vast scale; scumbled veils of colour and calligraphic gestures fuse to produce an ensemble

140. *Water Lilies*, 1905–8 (dated 1905), 89 × 100, W 1671, Museum of Fine Arts, Boston

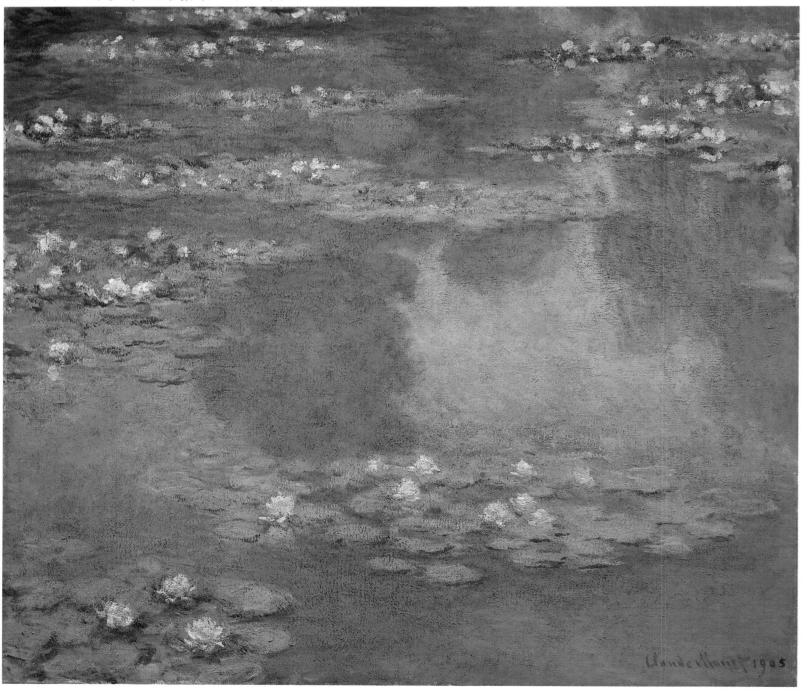

(right) Detail of pl. 140

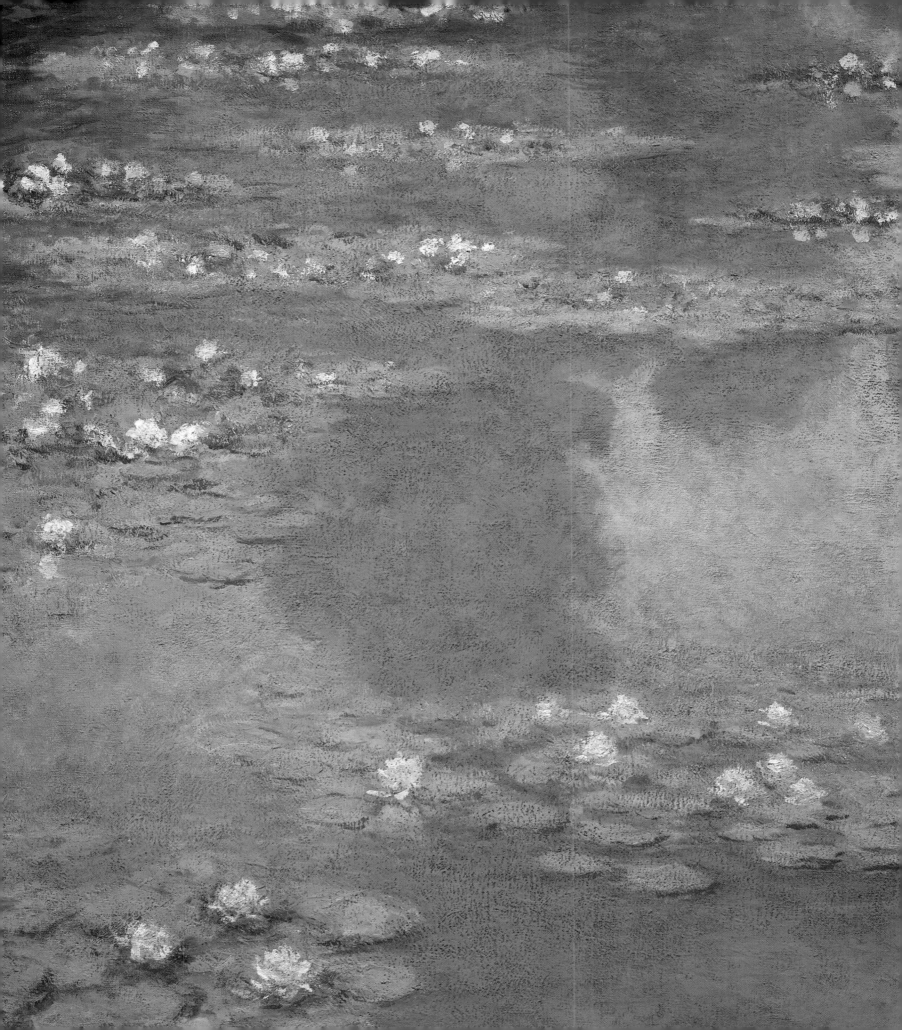

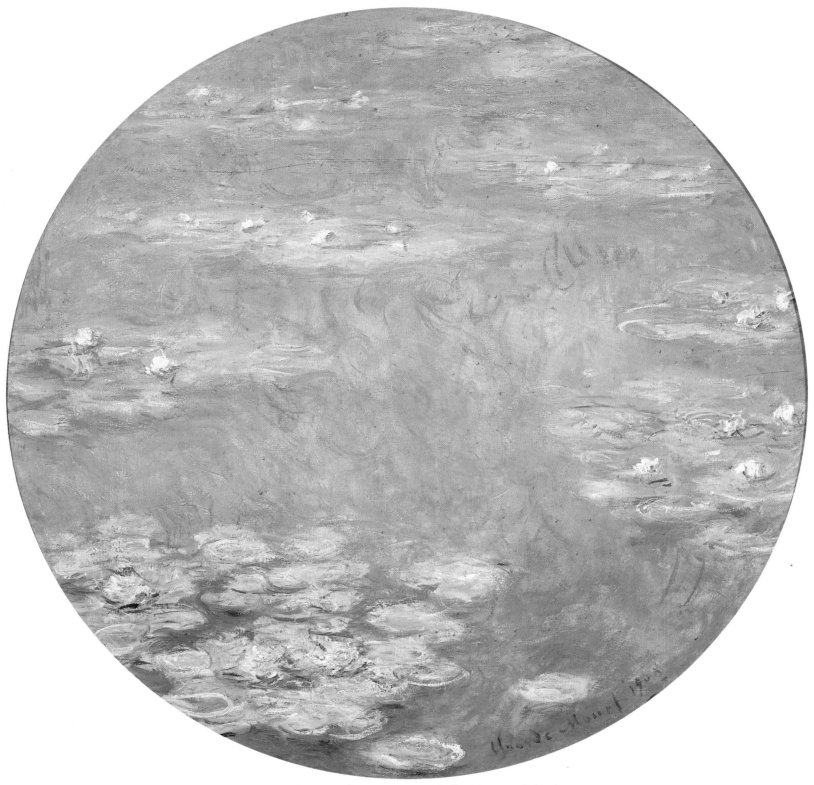

141. *Water Lilies*, 1908, diam. 80, W 1729, Dallas Museum of Fine Arts

which is decorative whilst still suggesting the pads as they float across the shimmering surface of the pond.

In 1910 Sickert noted that most Impressionist landscapes were 'on a small scale, and not for nothing are they so. Theirs is an art closely conditioned by an incessant readjustment and restatement of the message sent from the eye to the hand'; it would, he added, be very risky to 'do Impressionism on the scale of the exhibition picture'.

Seventeen years later, when he had seen the Water Lily Decorations, Sickert commented that Monet had 'yielded to a fatal enlargement of scale in a method that called for the strictest limitation of area'.[39] The subsequent history of painting has helped us to revise this verdict; we can now appreciate the power of the brushstroke itself as a means of lyrical expression on a grand scale.

CHAPTER SIX
COLOUR

PROVISOS

THE discussion of colour in painting is dogged by four problems: the material condition of paintings, the conditions in which they are seen, the limitations of colour reproduction, and the absence of an objective and sophisticated language for describing colour.[2]

The appearance of paintings is much affected by variations in lighting (natural, or artificial of various types), by the colour and brightness of their frames, and by the colour and tonality of surrounding wall coverings and floors. Given the current tendency to hang Impressionist paintings on very light-toned or even white walls, it should be remembered that darker, generally warm-toned walls were the standard practice in the nineteenth century; the painters would thus have anticipated their open-air scenes being the lightest things in the exhibition room; their luminosity would have opened out the atmospheric space within the pictures, whereas, on the light walls still generally favoured in exhibitions today, even the most high-key painting is significantly darker than its surroundings.[3]

Many Impressionist paintings are dirty, and many affected by varnishing. Rarely can we assess the full extent of such changes, unless an unaffected portion of a painting or of its priming is visible along a margin. As an indication of the degree of such changes, the photographs of half-cleaned paintings in *Monet Unveiled*, published by the Boston Museum of Fine Arts to celebrate the cleaning of its Monets, come as a salutary warning. More recent varnishing layers may be nearly colourless, though we cannot be sure of this, while earlier layers of varnish often transform the tonality and colours of a painting, and the relationships within it.[4] Monet did not, as far as we know, ever varnish his own paintings, but many, it seems, were varnished in order to help them sell. Monet told Gimpel in 1920 that he and his friends could not afford to object when Durand-Ruel told them, in the early days: 'Collectors find your canvases too plastery. To sell them, I have to varnish them with bitumen.'[5]

Even if clean and unvarnished, a surface may have changed greatly since its execution. Monet told Trévise in 1920 that he had often used suspect materials, notably 'a dreadful chrome which has faded badly; and then, the *blanc d'argent*', and that he had not taken enough care over his materials and the way he used them, 'so that my most heavily worked canvases are in danger of deteriorating, while the successful sketches remain stable'. In 1918, though, he presented a different image to Gimpel, who recorded that 'Monet is like Renoir, much preoccupied with the chemical changes of colours, and he insists that he is constantly aware of this when painting'.[6] Around 1900 Monet showed Lilla Cabot Perry, clearly with regret, two Rouen Cathedral canvases, one that had always been kept in a case and one that had been hanging on a wall; the latter seemed very smooth in comparison with the encrusted impasto of the former, of which he seemed very proud. Such issues recur in his comments on past painting. He told Mrs Perry that he was sure that Rembrandt's work had originally been much more thickly impasted, and lamented to Gimpel the effects of varnish on Rembrandt. He also noted how the dark grounds used by Delacroix and Courbet had transformed their paintings beyond recognition.[7] But Monet never had the obsessive concern with such problems which beset Renoir from the 1880s onwards.[8]

The language of colour presents intractable difficulties. Since there are no objective criteria for describing colour, any term used to characterise a colour in a painting can only be approximate and subjective;[9] moreover, comparisons between paintings may be affected by the different conditions in which they have been seen. There are various solutions to the problems of writing about colour in art. Ideally one might try to describe colours by the precise pigments used, but for a number of reasons this cannot be done with the necessary precision: because of the variations between paints bearing the same name; because many colours are obtained by the mixing of paints; and because of the changes of appearance in a painting since its completion. Besides, our information about the composition of Monet's palette at various periods is very incomplete; what lists we have are best presented in a footnote.[10] For these reasons I have not attempted such a method of colour labelling. Equally I have not tried to match Monet's colours with any modern colour chart; distortions would again arise from the changes in appearance of the paintings, and the viewing conditions in most galleries would prevent this method being used with any accuracy. I have reverted to a simpler policy. My colour vocabulary is confined to basic terms which may include a great variety of tints, but whose general meaning is agreed: red, yellow, green, blue; also pink, orange, mauve, purple and brown; and a few more specific terms whose meaning is fairly precise, such as salmon, carmine, emerald and

vermilion. The use of these terms is of course subject to all the above provisos; my observations can only be checked from the paintings themselves, and even such direct observations cannot claim objectivity.

It is, though, essential to treat Monet's colour in concrete terms. As we shall see, his colour had no systematic theoretical basis; it evolved from his direct observation of nature, combined with his study of the paintings of his mentors and friends, building increasingly on his own past experience of coloration, rather than on any preconceived ideas about the theory of colour.

AIMS and PRECEDENTS

Discussions of Monet's colour from the 1880s onwards have insisted on its empirical basis. Alfred de Lostalot's account of 1883 needs little revision: 'To achieve his goal he puts into practice the law of contrasts, the law of complementaries, the law of irradiation, in a word, all the secrets of nature which Veronese and Rubens . . . had discovered and put into practice long before science thought of laying down the rules.' A letter from Pissarro in 1887 confirms that this was Monet's position; writing to Lucien, he anticipated the objections of the collector de Bellio to the Neo-Impressionists' claims to be scientific in their use of colour: 'Yes, but – he will say – people have always known that, look at Monet.' If Monet had been interested in recent scientific discoveries about colour, Pissarro would have been the first to know of it. Seurat, too, realised Monet's position vis-à-vis colour theory, when he cited among the formative influences on his own early career the 'intuition' of Monet and Pissarro.[11] Monet greeted Pissarro's passionate advocacy of colour-science in 1886–8 with a combination of charity and exasperation, and his later friends insisted that he was not interested in the theory of colour.[12]

On one level Monet's teacher as a colorist was his own study of nature. In 1889 Mirbeau quoted his instructions to a young painter: '"But I don't teach painting. I just do it . . . there has been and will be only one teacher . . . that, out there." And he showed him the sky . . . "Go and consult it, and listen well to what it tells you. If it says nothing, well then, enter a notary's office and copy out registers."'[13] Very similar was Cézanne's regular refrain at the end of his life, when Emile Bernard was coaxing him to put his theory of art into words: 'The painter must consecrate himself entirely to the study of nature, and try to produce pictures which may be a lesson. Talks about art are virtually useless.' When, exceptionally, he agreed to instruct Lilla Cabot Perry around 1890, Monet simply told her: 'Paint it just as it looks to you, the exact colour and shape, until it gives your own naïve impression of the scene before you.'[14]

However, the idea of naturalism in colour has had many varied interpretations.[15] The Impressionists' mature ideas on colour were rooted in one particular approach to the relationship between nature and colour: forms should not be modelled primarily by tonal gradations, from dark to light, but form and space should instead be suggested by contrasts and variations of colour. Two letters from Cézanne to Pissarro show that this was the basis of the Impressionists' colour in the 1870s. In 1874 he told Pissarro of his recent attempt to explain their art to the director of the Aix museum: 'I told him . . . that you replaced modelling with the study of colours, and I tried to make him understand this in front of nature.' Two years later, Cézanne described the coloured silhouettes which he observed on the Mediterranean coast: 'I may be wrong, but this seems to me to

be the antithesis of modelling.'[16] This belief, that the study of natural effects justified the suggestion of objects by contrasts and variations of colour (or modulations, in Cézanne's word), formed the basis of their mature colour practice. That Monet pursued this modelling by colour is confirmed by an interview of 1888: 'The theory underlying Claude Monet's practice is in the main the old and simple one, that colour owes its brightness to force of contrast, rather than to its inherent qualities; that primary colours look brightest when they are brought into contrast with their complementaries.'[17]

This is not to say that the Impressionists' use of colour was entirely self-taught and learned from nature. The development of their colour practice fits closely into contemporary debates about colour. Monet's own use of colour will be described in the next section, but his experiments must be related to the framework within which he worked and the influences that helped him to crystallise his ideas. Richard Shiff, in his important study of Impressionist colour, has isolated three distinct coloristic conventions current at the time: first, chiaroscuro, based on the modelling of forms by gradations from dark to light tones, to which coloration was secondary; second, *peinture claire*, expressing light by a predominantly luminous, blond tonality; and third, coloristic painting, suggesting forms by contrasts and relationships of colour rather than oppositions of dark and light. By the mid-century, colour painting was closely associated with Delacroix. The art of the Impressionists, as Shiff suggests, was not simply a development of colour painting, but a fusion of this with *peinture claire*.[18] Monet's own colour practice was central to this fusion.

Shiff's discussions of *peinture claire* focus on the 1870s, but by the 1850s such blond tonalities were used by a significant group of painters of contemporary subjects, among them Cals, Tassaert, Amand Gautier and Boudin, in contrast to the emphatic chiaroscuro of artists such as Ribot.[19] Corot too was associated with *peinture claire*. Monet's beginnings as a landscapist belonged specifically to this tradition of *peinture claire*, as he made clear in an autobiographical letter to Geffroy in 1920. Describing his initiation into landscape painting by Boudin in the later 1850s, he added: 'It was thus that I became interested in *peinture claire*, which Boudin practised' (see pl. 62).[20] The example of Jongkind would have confirmed Monet in this path in the early 1860s (see pl. 112), leading him to use predominantly light tones, without particularly strong effects of colour, in his efforts to catch the luminosity of the outdoor world to which Boudin had opened his eyes.

It was in his development as a colorist that Delacroix's example was important, as also, for Monet more than for any other of the Impressionists, were the lessons of the colour in Japanese prints. Delacroix's theory and practice of colour were widely discussed after his death in 1863, in the writings of Baudelaire, Charles Blanc, Théophile Silvestre and Achille Piron. Piron's book, though it contained Delacroix's notes on light and colour made at Dieppe in the 1850s, probably attracted little attention,[21] but Silvestre's account of 1864 is likely to have become widely known; it is all the more interesting for the discussion of Impressionism because it compares Delacroix with Turner. Turner, he wrote, felt that all past artists 'had remained well beneath the pure and joyful brilliance of nature, on the one hand through a conventional darkening of their shadows, on the other by not daring to tackle honestly all the different lights which creation revealed to them . . . Delacroix did not venture so far, but, like the English artist, climbed imperceptibly from a sombre harmony to a luminous (*claire*) one . . . After a series of

experiments he evolved an absolute colour system . . . Instead of simplifying local colours by generalising them, he multiplied the different hues to infinity and contrasted one with another, to give each a double intensity . . . In Delacroix the picturesque effect results from these complex contrasts.' Silvestre went on to describe Delacroix's practice of giving his shadows colours complementary to the lights, and described a sort of colour circle which Delacroix used to show neighbouring and contrasting colours.[22]

Even if Monet did not read such accounts as this, he must have picked up the gist of them from his friends, notably his fellow Delacroix enthusiasts Bazille and Renoir – perhaps more dedicated readers than Monet.[23] There is no hint that Monet ever used any sort of colour indicator like Delacroix's, but from the mid-1860s onwards he began to use contrasts of complementary or near-complementary colours, and to subdivide his colours into many closely related but varied tints – in both respects following Delacroix's methods as reported by Silvestre. In Delacroix's Saint-Sulpice murals (pl. 123) and elsewhere he would, of course, have been able to see these ideas put into practice.[24]

Monet later spoke of his innovations in colour of the mid to late 1860s. About *Women in the Garden* (pl. 64) he said in 1900: 'I was still far from having adopted the principle of the division of colours which turned so many people against me, but I was beginning to experiment with it in part, and I was working at effects of light and colour which ran counter to accepted conventions.' He said else-

where of the same period that he 'fell in love with the ray of light (*rayon*) and the reflection (*reflet*)', and, describing it to Marc Elder, he apparently used the phrase 'an obstinate, methodical quest'.[25] These comments show that he was consciously pursuing unconventional ways of translating his visual experiences into colour. His interest in the *rayon* and the *reflet* echoes Delacroix's Dieppe notes, and the 'principle of the division of colours' is what Silvestre had described in Delacroix's works. Delacroix expressed this even more clearly in one of his notebooks: 'Constable says that the superiority of the green in his fields derives from the fact that it is made up of a multitude of different greens. The reason why the greenery of most landscapists lacks intensity and life is that they usually treat it in one single tint. What he says here about the green of meadows can be applied to all other hues.'[26]

Delacroix's example in the 1860s should be seen not so much as a direct influence on Monet, but as a catalyst which helped him to see nature for himself in terms of variations and contrasts of colour, and to escape from the dominantly tonal vision of the Barbizon landscapists. Delacroix's role in this development was stressed in 1880 by Duret, in a passage which shows how the lessons of colour painting and *peinture claire* might be combined: 'It is to a few gifted men, particularly to Delacroix, that we owe the first return to the *peinture claire et colorée* which is the true delight of the eyes. In the Saint-Sulpice murals one can see what a degree of luminosity (*clarté*) he finally attained.'[27]

142. *Regatta at Argenteuil*, 1872, 48 × 75, W 233, Musée d'Orsay, Paris

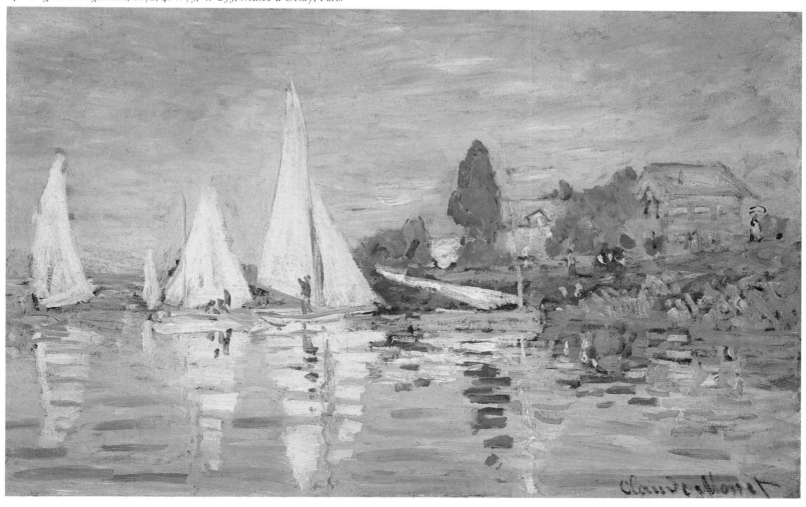

In the same passage Duret went on to discuss the importance for Monet of Japanese colour. Discussion of the lessons of Japanese prints has emphasised their undoubted influence on the Impressionists' pictorial composition, but early writers thought that their colour was equally important; particularly relevant is the rich colour of Hiroshige's prints, of which Monet owned many.[28] As early as 1873 Armand Silvestre suggested that the luminous, blond tonality of the new landscape was inspired by Japanese prints; Louis Gonse, too, felt that Japanese prints had influenced 'practice of clear colours (*tons clairs*)' of the Impressionists, as well as their compositional methods. Gonse used to describe how he had taken a Japanese visitor directly from the official Salon to the first Impressionist exhibition; the Japanese told him: 'Over there I was in an exhibition of oil pictures, here I feel as if I were entering a flowery garden.'[29]

The fullest account of the importance of Japanese colour appeared in Duret's 1878 pamphlet *Les Peintres impressionnistes*: 'We needed the arrival of Japanese albums in our midst before anyone dared to sit down on a river bank, and juxtapose on a canvas a roof which was bright red, a wall which was white, a green poplar, a yellow road and blue water. Before the example given by the Japanese this was impossible, the painter always lied. Nature with its bold colours blinded him; all one ever saw on a canvas were subdued colours, drowning in a general half-tone.' Duret pointed out the extreme naturalism of Japanese prints, evident to those who, like himself, had visited the country, and continued: 'Japanese art rendered particular aspects of nature by means of bold and new methods of colouring; enquiring artists could not fail to be struck by it, and so it strongly influenced the Impressionists.' He concluded that Japanese art was a catalyst, which they studied 'in order to develop their own originality and to surrender themselves to their own personal *sensations*'. Duret stated in 1880 that Monet was the pioneer of this new Japanese-inspired colour, and in his 1878 account may well have had in mind a striking example from Caillebotte's collection, Monet's *Regatta at Argenteuil* of c.1872 (pl. 142), painted in bold slabs of unmodulated colour.[30] The colour of Japanese prints is more relevant to Monet's simpler, flatter paint surfaces of the later 1860s and early 1870s than it is to the more variegated textures and colours of his

143. *The Basin at Argenteuil*, 1872, 60 × 80.5, W 225, Musée d'Orsay, Paris

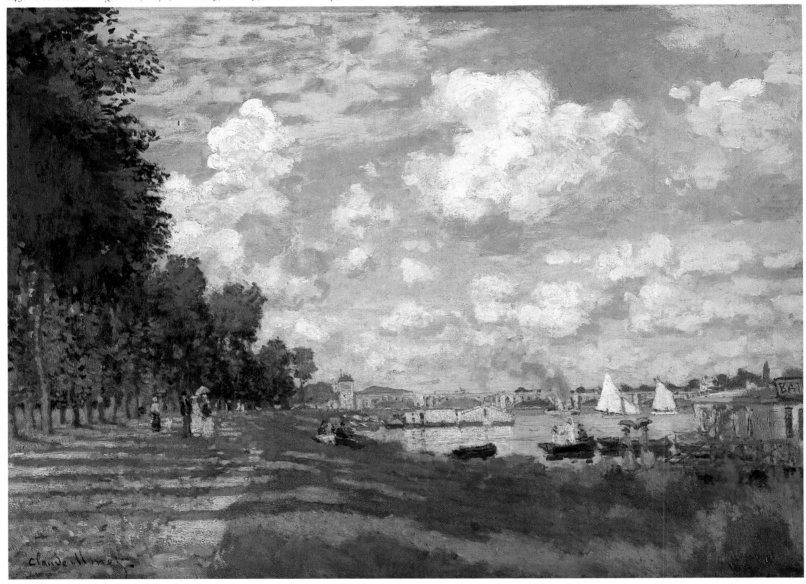

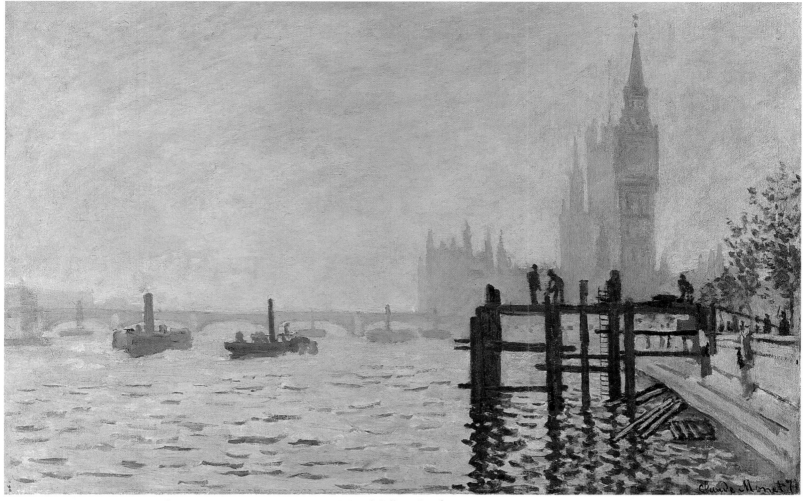

144. *The Thames and the Houses of Parliament*, 1871, 47 × 73, W 166, National Gallery, London

work from the mid-1870s onwards, by when he had fully assimilated its influence.

Théophile Silvestre's comparison of Delacroix and Turner raises the much discussed issue of Turner's influence on Monet's colour. We have a few rather contradictory hints about Monet's attitude to Turner. To Raymond Koechlin, Monet denied his influence: 'It has often been said that Turner was important in Monet's development; he has always denied it, and indeed his development had begun long before he knew Turner's work at the National Gallery; besides, as he never tried to deny in conversation, he was out of sympathy with this work because of its exuberantly romantic imagination.' He presented a rather different view to René Gimpel in 1918: 'Once I liked Turner very much, but now I like him less – he did not lay out his colour carefully enough, and he used too much of it. I have studied him well.'[31] We can date this period of admiration, not to the aftermath of Monet's first stay in London in 1870–1, but to the late 1880s and early 1890s.

Critics occasionally compared Monet's art with Turner's during the 1870s,[32] but his paintings of this decade show little sign of his influence. The motif of the sun setting over water, in *Impression, Sunrise* (pl. 199) and many later paintings, may echo Turner, but his handling and colour at this period are quite unlike Turner's, and, as Koechlin's comment suggests, continue a development begun before he knew Turner's work. Turner became important for him in the later 1880s when he was visiting London regularly. In 1888 an

interviewer spoke of his 'enthusiastic admiration' for Turner 'as a master from whom he has learnt much in [his] struggle after qualities of colour', and in 1892 to Theodore Robinson he 'spoke of Turner with admiration – the railway one – and many of the w.c. studies from nature'.[33] This fresh interest coincided with Monet's increasing concern in his own work for the atmospheric *enveloppe* and for richly integrated harmonies of colour. It was at this time, too, that the importance of his discovery of Turner in 1870–1 first began to be stressed, initially, it seems, by his friend Geffroy. At the same date Pissarro (himself now preoccupied by questions of colour) told an interviewer: 'It seems to me that we are all descended from the Englishman Turner. He was perhaps the first who could make colours blaze with a natural brilliance.' Like Monet, Pissarro later revised this verdict, and their comments are more relevant to their concerns around 1890, when they admired Turner most, than they are, applied retrospectively, to the 1870s.[34] Later in the 1890s, Monet turned back to Corot (cf. pl. 34), as he became increasingly concerned with the most delicately nuanced harmonies of colour in series such as the Early Mornings on the Seine (e.g. pl. 35).[35] As with Turner, it was the changing patterns of his own work which allowed Monet to rediscover Corot, whose use of colour had been so antithetical to his robust colour contrasts of the 1870s.

We can only gauge the importance of precedents for the Impressionists' colour by examining the ways in which they used colour in their paintings. These mentors only became relevant as

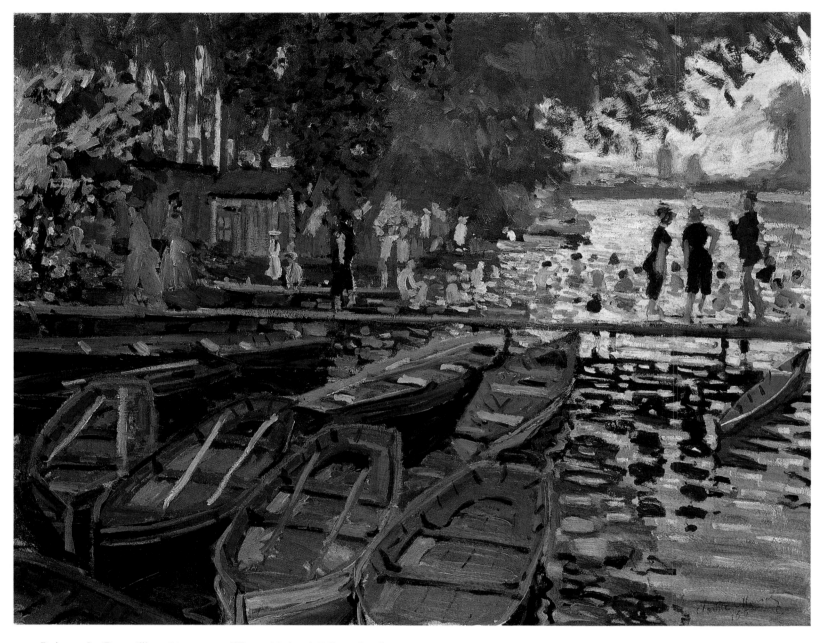

145. *Bathers at La Grenouillère*, 1869, 73 × 92, W 135, National Gallery, London

they helped them to evolve their own means of realising in paint their sensations of nature. Practice gave relevance to precept, rather than precept determining practice. The development of Monet's colour was essentially empirical, and must be charted from the paintings themselves.

PRACTICE

Monet's colour and brushwork developed along broadly parallel courses. In the late 1860s and early 1870s different paintings are treated in very different ways, depending on the type of effect being shown; the greater coordination and richer pattern-making which develop in his brushwork between the mid-1870s and late 1880s are accompanied by more organised colour schemes, while with the very integrated paint surfaces of the 1890s come the highly unified colour harmonies of the series.

Monet's first ambitious paintings belong closely to the *peinture claire* of Boudin and Jongkind. In his coastal scenes (e.g. pl. 111) individual objects are generally quite softly coloured, sometimes crisp and dark in tone, but the overall tonality is clear and light, the effects of water and sky conveyed by subtle variations of light blues, greens, beiges and greys. Brighter colours may appear in some sunlit foliage (e.g. pl. 258).

As Monet said, his new approach to colour began around 1866, when he began to interest himself in the 'division of colours' and in 'rays of light and reflections'. In *Women in the Garden* (pl. 64) the light in the foliage is expressed by many variations of green – light and sometimes yellowish in the highlights, subdued but without blue nuances in the shadows. But the cast shadow across the foreground path is clearly tinged with blue; Monet well remembered in later years 'the outcry which that blue shadow precipitated'.[36] More dramatic is the colour in *Terrace at Sainte-Adresse* of 1867 (pl. 67). In this open sunlit effect, the reds of the flowers, picked up in the flags,

are played off against the greens of grass and foliage; rhymes and contrasts of colour dominate the surface, and the foreground shadows, though predominantly tonal, include tinges of blue.

However, different effects produced very different responses. *The Quai du Louvre* of spring 1867 (pl. 68) is luminous rather than highly coloured, structured around sequences of crisp tonal accents across the foreground and the interplay of soft greens and pinks along the central band of the picture; by contrast, *Ice-Floes on the Seine at Bougival* (pl. 115), probably of 1867–8, is an exercise in virtually monochromatic greys, with the space in the picture suggested by the passage from crisp light–dark contrasts in the figures and posts on the near river bank to the soft nuances and virtually colourless mid-tones of the distance.

These paintings, in the different colour conventions they adopt, establish the patterns for Monet's use of colour over the next six years; he explored them with increasing subtlety, as his growing experience of translating nature into paint allowed him to refine the pictorial effects he achieved. Occasional subjects were dominated by effects of strong colour, like *Regatta at Argenteuil* (pl. 142), frontally lit and without visible shadows, where even the darkest hues are a strongly coloured mid-tone, without trace of a more conventional tonal substructure. However, a fully finished side-lit view of a sunny river bank such as *The Basin at Argenteuil* (pl. 143), also of 1872, still depends on a tonal structure to establish the play of light and shade on the bank and in the trees; the shadows in the foliage are suggested by quite deep greens, though the open areas of sky and river are conveyed in a fresh and luminous tonality. Even where effects of colour dominate the subject in a more finished painting, as in *Monet's House at Argenteuil* of 1873 (pl. 3), dark tonal values model the far trees, and the highly coloured flower masses are organised around the open foreground of the path, its shadow only softly nuanced with blue.

Monet's sensitivity to greys reaches great finesse in *The Thames and the Houses of Parliament* (pl. 144) where soft pinks suffuse the misty sky on the right. In a similarly atmospheric effect in *Impression Sunrise* (pl. 199), the greys are tinged with blues and set against the sharp orange of the sun and its reflection; even here, though, the placing of the boats and the signature give the composition a crisp tonal underpinning. More complex is *Bathers at La Grenouillère* (pl. 145). The boats and overhanging trees here are an exercise in subtly coloured mid-tones, a muted nuanced *peinture claire*; but beside them the view down the river and the stabs of sunlight on the left give the composition an axis of bright contrasting colour, thus throwing two quite different types of coloristic organisation up against one another.

Until 1872, at least, Monet on occasion used black paint, as did his Impressionist colleagues. He used it sparingly, to colour individual dark points, notably details of figures' clothing, such as those in *The Basin at Argenteuil* (pl. 143). Unequivocal identification of blacks in the paintings of this period, seen in normal viewing conditions, is particularly difficult, since other very dark tones, if dirty or varnished, may look like true blacks. From examination of their paintings, it seems to have been in 1873–4 that the rejection of black became an issue of principle for the Impressionists, as they began in earnest to implement the dictum that there are no blacks in nature. Once Monet had accepted this dictum, probably around 1873, it played virtually no part in his palette, though slight traces of it have been found in a canvas of 1877; it is very likely that he wholly abandoned it soon after this.[37] The abandonment of black did not, though, mean that Monet rejected the use of emphatic tonal contrasts. As we shall see, compositions structured around dominant light–dark contrasts continued into the 1890s; but Monet came increasingly to think of his dark values in coloristic terms, rather than just as an absence of light. Shadowed tree trunks and small dark accents on figures had to be rendered in the colour which best drew out their form and best fitted the overall composition.

The rejection of black coincides with the beginnings of a more general change in Monet's colour practice, a change which corresponds closely with the developments in his brushwork during the mid-1870s. In outline, he became more concerned with the overall coordination of his colour and with the problem of rendering atmospheric space by colour – of finding consistent schemes of atmospheric perspective. These general concerns appear in paintings of many different types of effect.

Monet's developing use of colour can be seen in three paintings of 1873. In *The Sheltered Path* (pl. 117), an autumn subject, the shadow under the bush on the right is dark in tone, but contains rich deep greens and dull reds and blues; the nearest trees on the left again have dark shadows in their foliage, in dull greens, blues and browns, but at the far end of this row of trees, in the centre of the picture, their shadows are a soft clear blue, coloured by atmospheric distance. The sunlit areas are all variegated in colour, animated largely by an interplay of pinks and greens, with some quite sharp points of colour. In *The Plaine de Colombes, Hoar Frost* (pl. 146), painted early in 1873, there are no such dark shadows to create a tonal repoussoir; the distance supplies a luminous, coloured backdrop to an open foreground where the still frosty shadows create a clear blue contrast to the rich oranges and pinks in the sunlight. *Autumn Effect at Argenteuil* (pl. 72) is dominated by the contrast between the blues of water and sky and the bank of sunlit trees – a rich orange with soft pastelly nuances; tonal contrast is reduced still further than in *The Plaine des Colombes*, with just a little duller blue modelling the shadows in the right tree and bushes.

This increasing use of colour shows that Monet was, as Cézanne put it at the time, 'replacing modelling by the study of colours'; but Monet's treatment varied greatly according to the type of effect he was depicting, and even in sunlit scenes he did not immediately abandon tonal modelling. In *Poplars near Argenteuil* (pl. 147) the shadows in the nearest tree are treated in subdued deep green, while the further trees have clear blue shadows, creating a jump from tonal to coloured modelling as the eye moves into space; the open spaces on the right are expressed entirely by colour.[38]

In these years blue was coming to play an increasingly important part in Monet's compositions. It expressed atmospheric distance, as in the far hills in *Poplars near Argenteuil*, as well as suggesting the shadowed side of forms in the middle distance. It was used to suggest atmospheric effects, such as the smoke in the paintings of the Gare Saint-Lazare (e.g. pl. 119), and to show the subdued light of an interior on a sunny day in *A Corner of the Apartment* (pl. 13); Monet listed this picture as *Intérieur (tableau bleu)* in his *carnet* when he sold it Caillebotte in 1876. Lastly, blue still evoked cast shadows in the foregrounds of paintings, though often these blues were added over a duller tonal base, as at bottom left of *Gladioli* (pl. 118). This addition of colour over a tonal shadow shows how far the translation of light and shade into colour was a deliberate decision on Monet's part, rather than simply an immediate record of observed effects; the Impressionists' pursuit of a coloured rendering of nature was a conscious rejection of one system of conventions in favour of another.

For two years or so in the mid-1870s, Monet frequently used

146. *The Plaine des
Colombes, Hoar Frost,*
1873, 55 × 73, W 256,
Private Collection

147. *Poplars near
Argenteuil,c.*1875,
54.5 × 65.5, W 378,
Museum of Fine Arts,
Boston

crimson or carmine hues to establish warm dark tones in his canvases, notably for tree trunks and branches, but also for accents of other sorts, particularly where he could set them off against the greens of foliage. They were used in the lower parts of the flower mass in *Gladioli* (pl. 118), where they help to anchor the lavish display of colour around them; in *The Tuileries* (pl. 218) they suggest the branches of the trees at the bottom, and appear, together with blues, in the shadows of the central bushes. These carmines are particularly prominent in paintings of around 1875–6; they recur at times in the following years, but more subdued in colour, as in the tree on the right of *Path in the Ile Saint-Martin, Vétheuil* of 1880 (pl. 149). Sisley also used this colour extensively to model forms, particularly around 1876–8. Its occurrence in both men's work illustrates a phase in their gradual rejection of chiaroscuro, offering them a type of drawing in colour which could give forms a clear tonal definition and at the same time play an active part in a colour composition.

His treatment of overcast weather also began to change at this date, as *Unloading Coal* (pl. 148) shows. The subject itself led Monet to adopt a dominant tonal structure, of bridge, barges, figures and gang-planks; but the *temps gris* effect is no longer treated in actual greys, but in soft and constantly varying nuances of colour, notably yellows, yellow-greens and blue-greens. Again, Monet is seeking a coloristic alternative to a purely tonal chiaroscuro. A similarly subdued effect with crisp tonal contrasts in *Vétheuil Church, Snow* of 1879 (pl. 22) is enlivened throughout by soft greens and blues which revolve around the blue jacket of the single figure.[39]

Monet developed these tendencies further in the early 1880s. A sunny summer day became the basis for a complex network of colour in *Path in the Ile Saint-Martin, Vétheuil* of 1880 (pl. 149). There is still a clear core of tonal modelling: the shadows in the nearer bushes and those cast on the foreground fields are predominantly deep green; by contrast, rich blues are used in the distance and where the shadowed foliage is silhouetted against the sky. But these blues are only part of a sequence of blues which runs through the whole

148. *Unloading Coal*, 1875, 55 × 66, W 364, Private Collection

149. *Path in the Ile Saint-Martin, Vétheuil*, 1880, 80×60, W 592, Metropolitan Museum of Art, New York

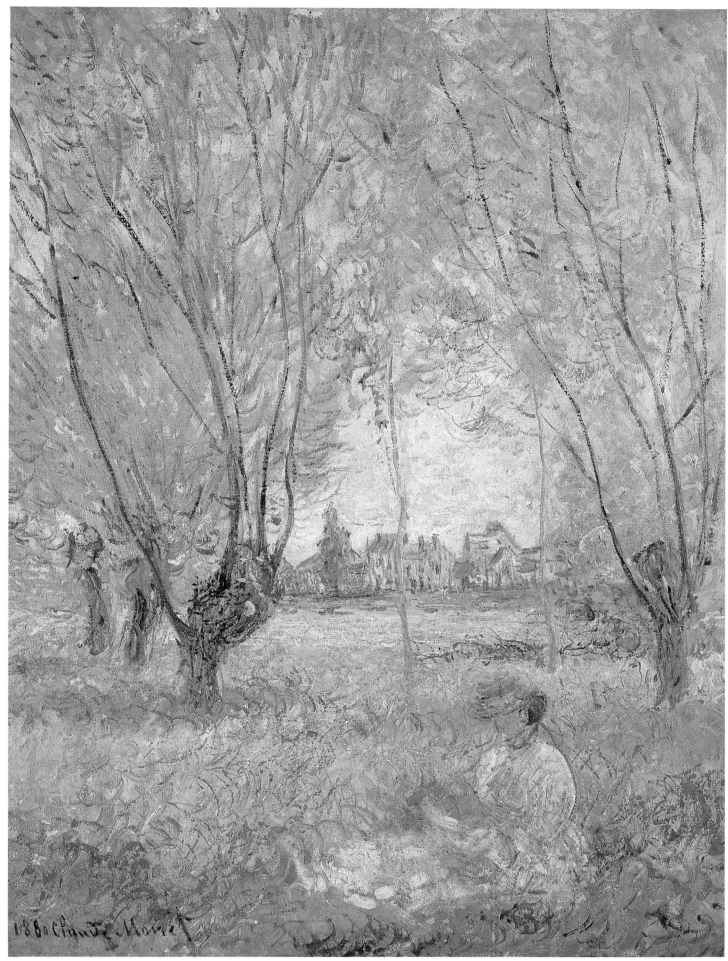

150. *Woman seated under the Willows*, 1880, 81×60, W 613, National Gallery of Art, Washington, D.C.

canvas – sky, far hills, buildings, foliage and even, in soft touches, the foreground field. Alongside these blues is a comparable sequence of soft pinks, seen in the sky, hills and buildings and on the open field, but not in the main bushes and trees; these pinks link up with the stronger red of the foreground poppies, set off against the green field. The soft atmospheric harmony of blues and pinks, emphasised late in the painting's execution, acts as a sort of counterpoint to the basically descriptive colours of the main elements in the scene. *Woman seated under the Willows*, also of 1880 (pl. 150), shows how, from a basis of descriptive colours, Monet was willing to improvise in order to enhance the pictorial effect: free hooks of blue are added over the more subdued greens of the foreground shadows, and, chamelion-like, the branches of the trees change colour according to their position, not, though, for camouflage, but in order to bring out their form; the left stem of the left tree, for instance, varies along its length from dull green to dull red-brown to dull blue.

Monet's cliff scenes of the early 1880s show an increasingly complex atmospheric weave, as he gave more emphasis to soft salmon pink touches across open grass and greenery. In the grasses on the right of *The Cliff at Fécamp* (pl. 77) pinks were included from the early stages of the painting's execution, and link the cliff top to the rocky cliff faces and the clouds.

They are not, though, a purely arbitrary pictorial device. On the Channel coast as at Vétheuil, they suggest long dry grass stems; but they also break the uniformity of the green areas, and by slightly exaggerating their pinkness Monet could introduce delicate colour contrasts to his foregrounds, which complemented their free handling and picked up the more atmospheric colours of the backgrounds. In *The Coastguard's Cottage at Pourville* (pl. 151) he added such pinks across the central bushes, setting off the stronger colour contrasts created by the red flowers at the base and by the cottage against the sea, and the tonal opposition between lit and shadowed foliage. This canvas has an overall colour scheme of greens and blues set against reds, pinks and oranges, but never is this a simple opposition: in every area nuances and shifts of colour and tone establish successions of smaller rhymes and contrasts which complement the principal scheme. Even scenes in overcast weather were treated throughout in a knit of subtly varied colour, as in *Cliffs near Dieppe* (pl. 152), where the stony beach is expressed by a soft interplay of pinks and blues; this whole picture is an exercise in coloured greys.

151. *The Coastguard's Cottage at Pourville*, 1882, 60.5 × 81.5, W 805, Museum of Fine Arts, Boston

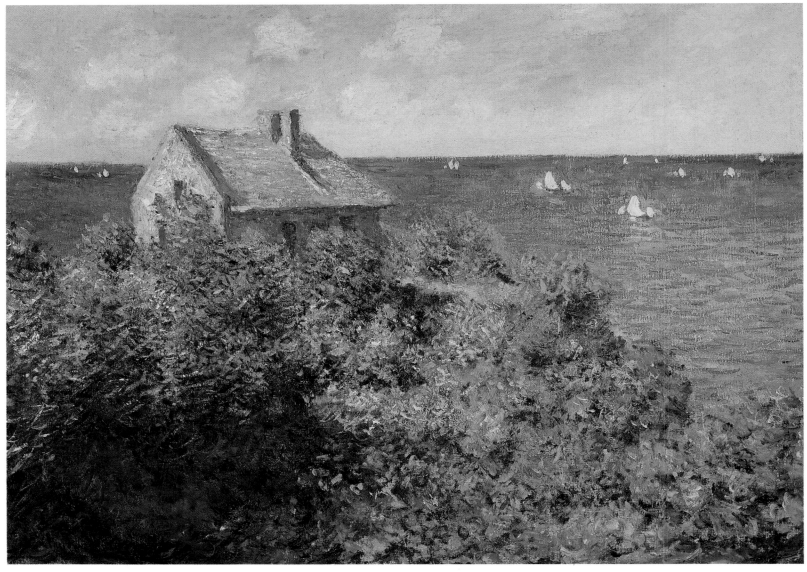

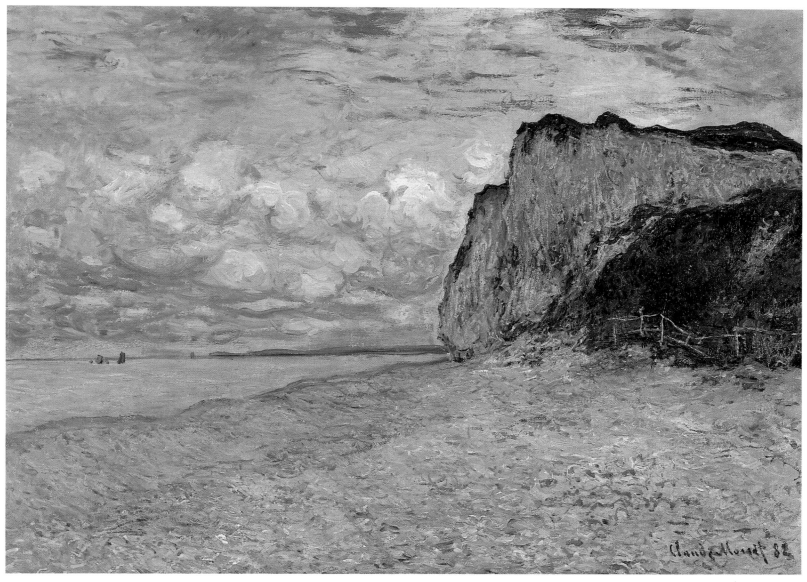

152. *Cliffs near Dieppe*, 1882, 60 × 81, W 719, Museum of Art, Carnegie Institute, Pittsburgh

Monet's colour schemes appear at their most coordinated in these years where atmospheric effects dominate the subject. Blue and salmon nuances at their most delicate convey the morning mists in *Vétheuil in the Fog* (pl. 201), while the same contrast is at its boldest in showing sunlight and shadow across snow in *Snow Effect at Lavacourt* (pl. 153). He returned in 1880 to a subject very reminiscent of *Impression, Sunrise* in *Sunset on the Seine, Winter* (pl. 187), originally intended for the Salon;[40] again he set the orange sun and its reflections against the atmospheric blues, but here he elaborated the idea by the treatment of the islets and foliage in the water, using soft deep blues and red-browns to pick up the central contrast.

The richest colour schemes of the early 1880s represent summer sunsets. In *Flower Beds at Vétheuil* (pl. 154) pastelly pinks and greens in the background pick up the stronger reds and greens in the foreground flowerbeds, with clear blue accents woven in both halves, while in *Varengeville Church* (pl. 222) Monet added rich oranges and pinks late in its execution, to emphasise the sunset effect and to unite the whole picture by a strong orange-green contrast; the pink hooks on hilltop, trees and bushes and the pink diagonal strokes added half way down the left margin link the softer hues of

153. *Snow Effect at Lavacourt*, 1881, 60 × 81, W 511, National Gallery, London

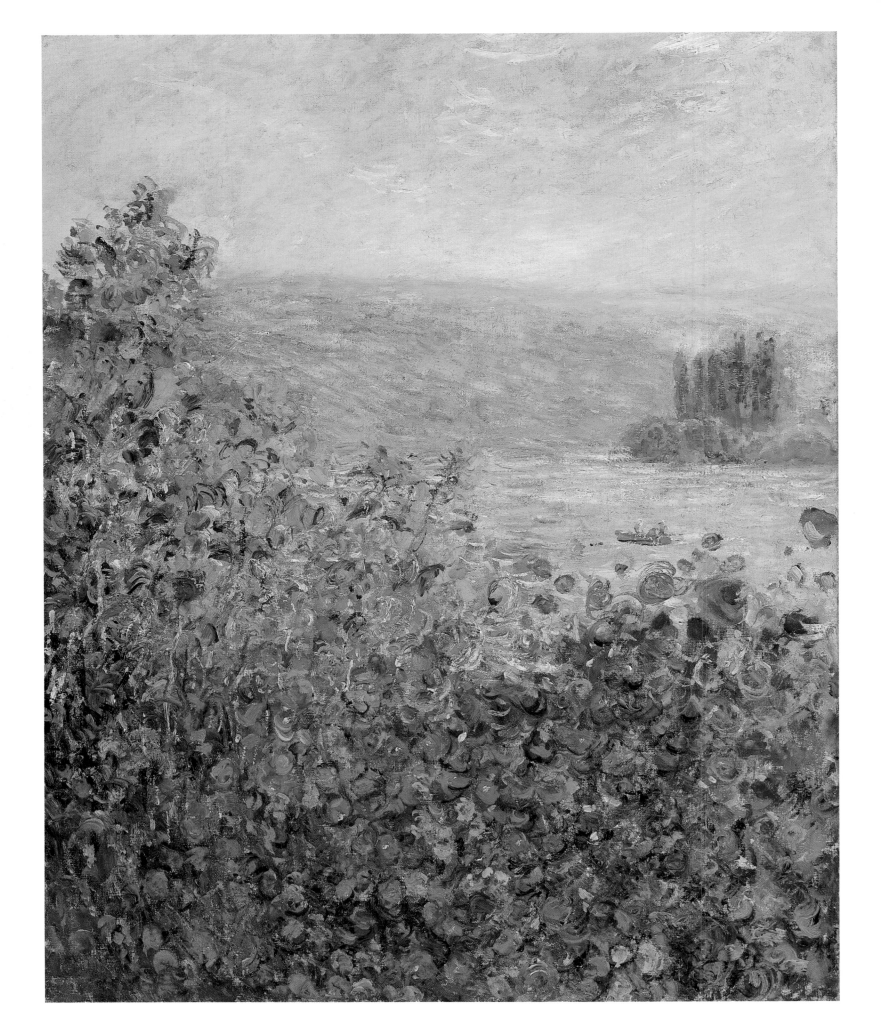

the distance with the crisper tonal contrasts of the foreground. Paintings such as these, in their accentuated colour, compensate for the impossibility of reproducing the full effects of natural light in paint.

The increasing elaboration of Monet's colour effects in the early 1880s may be compared with the very different ways in which Pissarro came to organise his colour during the same years. Pissarro favoured subjects dominated by natural greens, making these the keynote of his compositions, and bringing them into focus by occasional accentuated emerald touches. Against the greens he set sequences of small touches of blue and soft red, often focusing the blues, and sometimes the reds, on a particular feature such as the hat or the smock of a peasant figure. Like Monet's, Pissarro's surfaces retain tonal contrasts within their primarily coloristic organisation. But Pissarro exercised his control over quite a restricted range of hues, carefully interwoven, while Monet introduced more varied nuances into individual colours, and pursued far more varied effects.

The implications of Monet's experiments in the early 1880s were highlighted by his experience of painting the light of the Mediterranean in 1884 and 1888. The South accentuated his problems: he had to find ways of conveying the dazzle of the light and the intensity of colours observed in clear conditions. He made both his visits early in the year, when the distant views were at their clearest and least obscured by heat haze. His letters from Bordighera in 1884 often discuss colour, which his letters from the Channel coast never did, and show the problems he had in adjusting his palette to the conditions. He described to Durand-Ruel the effect the light was having on his work: 'It may well make the enemies of blue and pink complain, since it is precisely that brilliance, that magical light that I am trying to render, and those who have never seen this countryside, or who haven't looked at it properly, will protest, I'm sure, that it's unrealistic, although I'm well below the tone: everything is pigeon's breast and punch flame.' Elsewhere he spoke of the 'delicious harmonies' he found in the mixture of fruit trees; this is the first

155. *Cap Martin*, 1884, 66 × 81, W 897, Museum of Fine Arts, Boston

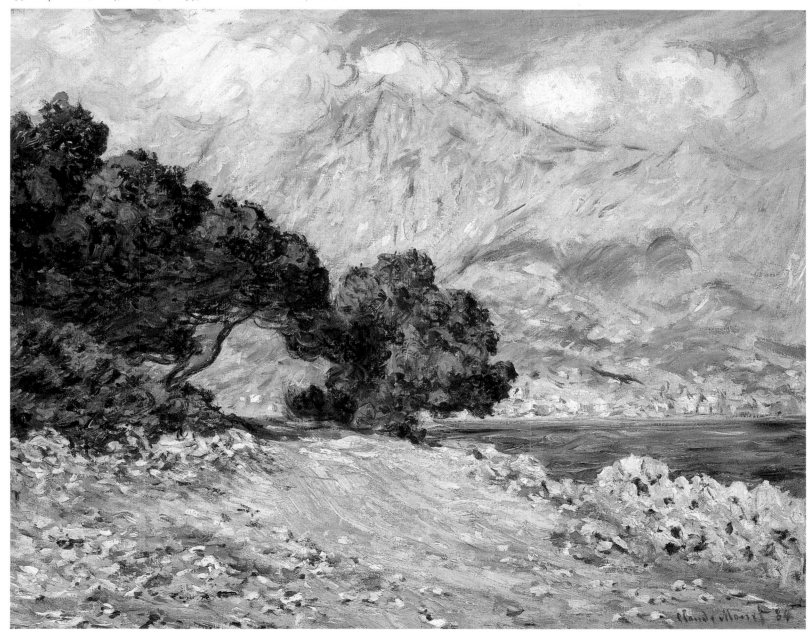

traced occasion on which he described natural effects in terms of harmonies.[41] His letters show that, after initially feeling that he would have to key up all his colours, and would need 'a palette of diamonds and precious stones', he gradually came to see the landscape in terms of dominant oppositions of blue and rose.[42] Four years later he described Antibes in just the same way: 'What I bring back from here will be sweetness itself, white, pink and blue, all enveloped in this magical air.' At the end of his stay, he left Antibes not knowing what to think of his work 'by dint of struggling with the admirable sun'.[43]

These spells in the South led Monet to see the full implications of his experiences while doing military service in Algeria in 1861–2. He said in 1900: 'The impressions of light and colour which I received there were only sorted out later; but the germ of my future researches was there.' An earlier account of 1889, clearly based on Monet's own words, shows how he remembered Algeria in the immediate aftermath of his southern trips of 1884 and 1888: 'Africa completed his education as a colorist. It taught him to "look in the shadows", to follow the brilliant decomposition of light there, to make float around objects that shimmering atmosphere which encircles them like a halo.' Monet's renewed interest in his memories of North Africa is confirmed by the presence of Algeria in Geffroy's 1891 list of the places where Monet hoped to paint.[44] The way in which he stressed the importance of these early experiences at this point in his career is very comparable to the way in which, at the same date, he came to attribute great significance to his first exposure to the art of Turner in 1870–1 (see p. 113); in both cases, it was his recent experiences, during the mid to later 1880s, which led him to find a new relevance in these early coloristic discoveries, which had originally had little immediate impact on the appearance of his paintings.

Two other indications show how Monet thought about the light of the South. Late in his life he discovered that a work by Marquet which he had recently bought was a southern scene: 'Ever since I was told it was the South, it has really put me off. I had taken that tender *grisaille* to be Brittany.' This suggestion that Monet regarded the Midi as highly coloured is confirmed by his comment, recorded by Theodore Robinson, about the Rouen Cathedral paintings early in their execution: 'The sunshine ones are handsome, but, as he says, make one think of the South, Venice or Sicily' (see pl. 163).[45] The chief characteristic of the sunlit Rouen paintings is their dependence on simple contrasts of colour, clear blue against yellows, oranges and pinks; it was presumably this type of colour scheme which Monet associated with the South, and felt a little unhappy at having applied to the façade of Rouen Cathedral.

His paintings themselves reveal the problems he found in painting the South. As he worked them up, he emphasised their colour contrasts, notably the oppositions of blue and pink which he mentioned in his letters. *Palm Trees at Bordighera* (pl. 110, see pp. 72–4) and *Cap Martin* (pl. 155) show the devices he evolved. In *Cap Martin* he treated the far hillside from the start in soft blues and salmons; the salmons are picked up in the bright yellows and oranges of the foreground road, the blues in the rich blue sea. Strong greens, too, appear in the sea, and make a link with the greens in the trees and the foreground, while the orange-reds in the road are echoed by touches on the bush and the ground at lower left. The whole canvas is based on this contrast of salmons, oranges and reds against blues and greens, a scheme present from the start of its execution, but much emphasised in its late retouches. At the same time Monet suggested space by defining the foreground forms far more crisply, and by the transition from the basically descriptive colours and tonal con-

trasts of the foreground to the atmospheric pinks and blues beyond.

Monet achieved the luminosity of this canvas, painted at the end of his 1884 trip, not by keying up individual colours, but by the organisation of its entire colour scheme. In the more highly worked *Palm Trees at Bordighera* (pl. 110) some at least of its surface coherence may have been the result of studio reworking, when, back at Giverny, he was able to apply the lessons of the whole trip to the revision of paintings begun earlier in the stay (see p. 150). The initial difficulties Monet had in the South may be illustrated by *The Palms, Bordighera* (pl. 156), probably painted in February 1884, and a canvas which he did not complete for early sale. This too has strong colour, but its yellows, greens, roses and blues, despite their intensity, remain separate colours which detract from each other rather than work together. Only when he realised that he had to render the South by accentuating and simplifying his colour relationships did he discover how to go beyond the luminosity of his sunlit northern scenes of the previous few years. Also during the 1884 trip he returned on occasion to the device he had used when trying to enrich his colour in the mid-1870s, the use of deep red or carmine, particularly in tree trunks, which creates a rich warm coloration in areas of shadow, for instance beneath the trees on the left of *Cap Martin* (pl. 155).

These problems of painting the southern light had taxed many French painters of the previous generation, notably Delacroix and the other Orientalists. Delacroix's use of colour oppositions devel-

156. *The Palms, Bordighera*, 1884, 92 × 73, W 875, Private Collection

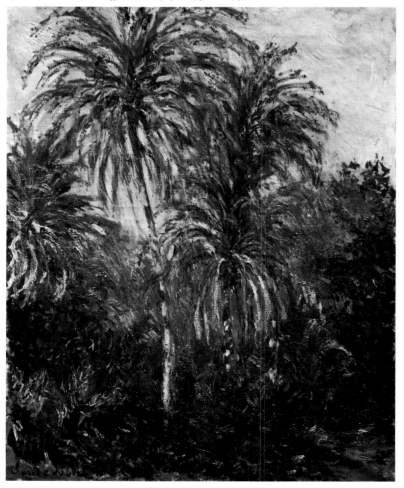

oped in part at least from his experiences in Algeria in 1832, though clearly his study of painters like Veronese also played a crucial role in this. In 1859 Eugène Fromentin discussed the various ways of rendering the Orient in *Une Année dans le Sahel*, contrasting the tonal chiaroscuro of Decamps with the rich overall coloration of Delacroix, and emphasising from his own experience the problems of transposition which faced the painter.[46] By the 1880s the bright

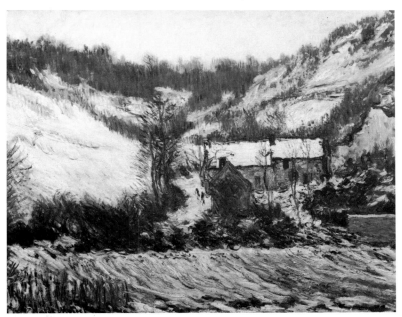

157. *Snow Effect at Falaise*, 1886, 66 × 81, W 1054, Private Collection

exotic colour of the South had become a commonplace in French painting.

Most significant for Monet would have been the recent experiences of Cézanne and Renoir in the South. In 1876 Cézanne wrote of a view of L'Estaque: 'It's like a playing card. Red roofs against the blue sea . . . The sunlight is so fearsome there that the objects seem to be silhouetted not just in black and white, but in blue, red, brown and violet.' In the views that Cézanne was describing in this letter and in his southern paintings of the early 1880s, which Monet would have seen when he visited Cézanne with Renoir in December 1883, Cézanne used contrasts very similar to those Monet evolved in 1884 – oranges and reds opposed to greens and blues, though Cézanne rarely in his oils adopted the pastelly tonality and the delicate pinks that Monet favoured. Monet would have agreed with Cézanne's later conclusion that 'sunlight cannot be *reproduced*, but has to be *represented* by something else, by colour'.[47]

When Monet started to paint at Bordighera in 1884, Renoir would have been in the front of his mind. During their holiday together on the Riviera in December 1883, when they visited Cézanne, both men had painted a little; one motif, indeed, they may have painted side by side.[48] Faced with Monet's inexperience, Renoir would doubtless have recalled his own recent experiences of painting in the South, with Cézanne in 1882, and in Algeria in 1881 and 1882. Renoir had admired Algeria for its exotic life and for its light and colour; he told Rivière how the light transformed everything he saw there, and his son Jean remembered him saying that it was there that he had discovered the value of white.[49] Renoir did not give his southern scenes colour schemes as integrated as Monet's; he was more interested in opposing rich varied descriptive colours

and atmospheric blues to pivotal areas of white. Monet did, though, testify to his interest in Renoir's Algerian paintings in the clearest way in 1900, by buying *The Mosque, Arab Festival*, Renoir's boldest study of the life and light of Algiers.[50]

It is difficult to assess precisely the importance of Monet's southern expeditions in the evolution of his colour. His Mediterranean canvases have a new intensity of colour and brilliance of effect, but in their organisation they develop tendencies established by 1883, for instance in *Varengeville Church* (pl. 222) and *The Coastguard's Cottage at Pourville* (pl. 151). Some indication of the effect of the South may be seen in the comparison of two views of the Manneporte at Etretat which sometimes hang together in the Metropolitan Museum of Art in New York, one painted before, one after, the trip (pls. 129–30). In the latter the colour scheme seems slightly more synthetic, with rather more use of pinks; but the difference is only one of degree, since these ingredients appear in the earlier version. Paintings of other types from the mid to later 1880s also show a more evident organisation of colour, even in a subdued winter effect such as *Snow Effect at Falaise* of 1886 (pl. 157). Here blues, mauves and greens in the darker areas pick up the pastelly nuances of blue, green and salmon pink in the snow, while the blue in the background trees emphasises one of the principal elements in the colour scheme as well as suggesting spatial recession. The complexities of the colour in this painting complement its rich and varied brushwork (see p. 90). Similarly calculated is the colour in an overcast scene of a quite different type, *Storm, Coast of Belle-Isle* (pl. 30), in which the reds and browns of the rocks are overworked with soft blues, while the dominant light grey-blue of the sea contains muted touches of pink and red. When painting Belle-Isle, Monet needed, he wrote, 'to make a great effort to paint sombrely, to convey its sinister, tragic appearance, I who am more inclined to gentle, tender tints'.[51]

It is in Monet's sunlit scenes of the period that a new richness of colour is most evident. Sometimes tonal contrasts are reduced to a minimum, but they often retain an important part in the composition, alongside the relationships of colour. They are used very sparingly in *Spring at Giverny* of 1886 (pl. 158), simply to give some modelling to the tree trunks, the foreground foliage and the windows of the cottage. Otherwise it is all very pastelly: soft pinks, mauves, blues, greens, yellows and oranges establish two principal contrasts, between the blue of shadows and sky and the salmon in clouds and cottage walls, and between the greens of the foliage and the orange-red of the roofs; but these oppositions are knitted together to create a play of soft contrast and transitions all across the surface. Still more limited in tonal range is *Morning Haze* (pl. 160) of 1888, where the forms of the trees as the sun begins to penetrate the morning mist are treated in the softest nuances of light-toned colour. By contrast, tonal oppositions are at their most marked in dramatic *contre-jour* effects such as *Varengeville Church* of 1882 (pl. 222) and *Juan-les-Pins* of 1888 (pl. 234), though even here varied rich colours are broken into the darker areas, setting up relationships with the high-key colour of the backgrounds.

A Bend on the River Epte of 1888 (pl. 131) shows how tone and colour are brought together in a simpler subject from Giverny. Deep greens are used for the blocks of shadow along the river bank and for the shadowed core of the tree on the right; by contrast, clear blues appear where the shadowed foliage of this tree is silhouetted against the sky, and in the further bank of trees beyond this. Light yellow-greens and pale creamy touches, sometimes tinged with pink, convey the sunlit foliage on the left, while the shadows in their foliage are suggested by crisp darker greens and also by occasional

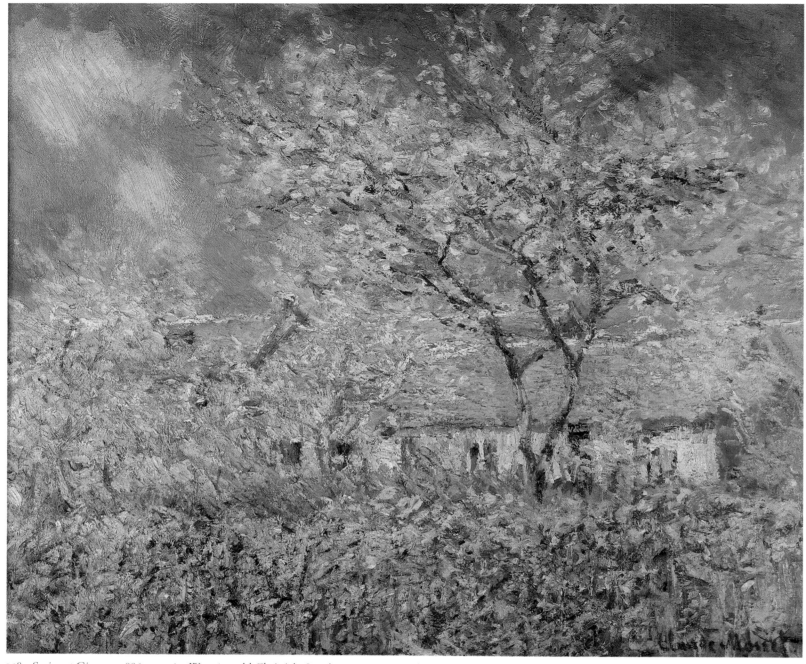

158. *Spring at Giverny*, 1886, 54×65, W 1062, sold Christie's, London, 30 June 1970, lot 37

159. *Spring Effect at Giverny*, 1890, 60×100, W 1245, Private Collection

blues, which hint at leaves silhouetted against the sky beyond; their trunks and branches are treated in soft pinks, mauves and carmines, which pick up the light salmony hues that appear on the left bank, in the water and across the top left foliage. The larger dark areas create a tonal structure across the lower part of the canvas and a spatial repoussoir on the right, while the small darker accents animate and redefine the foliage. The play of colour, though, predominates in the interplay of greens, blues, pinks and creams which runs throughout the canvas, their proportions varying according to the dominant observed colour of each zone. Similarly, in *Spring Effect at Giverny* of 1890 (pl. 159) the shadows in the foliage are only a clear blue where the foliage is seen against the sky; deep greens predominate in the core of the trees and in the cast shadow across the field, which has some added blue touches, while full deep reds model the shadowed side of the nearer haystack.

The complexities of the colour-weave in these paintings well illustrate Monet's colour practice as an interviewer described it in 1888, presumably closely following Monet's own words: 'One of his great points is to use the same colours on every part of the canvas. Thus the sky would be slashed with strokes of blue, lake, green and yellow, with a preponderance of blue; a green field would be worked with the same colours with a preponderance of green, while a piece of rock would be treated in the same way, with a preponderance of red. By working in this way, the same colour appearing all over the canvas, the subtle harmony of nature, that middle tint or base, in which nature puts her accents, is successfully obtained without the loss of colour which was necessary by reducing the whole to a base of brown or grey. To get brilliant colour, . . . which is not merely surface colour, but with solidity and envelopment besides, is M. Monet's aim.' This account and the pictures themselves show how far Monet was still working within the tradition of Delacroix; he was reapplying to the direct observation of natural subjects Delacroix's principles of colour composition, as described by Charles Blanc: 'It is not in isolation, but in sequences that the painter opposes and interlaces his colours, making them penetrate each other, answer each other, mitigate each other, sustain each other.'[52]

It was in the series, from the Grain Stacks onwards, as the atmospheric *enveloppe* became his dominant preoccupation, that Monet's interest in overall colour harmonies became paramount, and his colour gained an increasing autonomy. Descriptive, local colours still play an important part in some of the summer effects (e.g. pl. 252), but in the scenes of sunset, mist, snow and frost, where the varied greens of nature did not dictate his starting point, he recreated the effect in networks of rich colour. As their much repainted surfaces show, he worked the pictures up over a considerable period, adding their final enrichment long after the passing of the transitory effect that was their initial subject, and presumably in the studio. In *Two Grain Stacks, Close of Day, Autumn* (pl. 33) the afterglow of the sunset is suggested by subdued but endlessly varied

160. *Morning Haze*, 1888, 73 ×92, W 1196, National Gallery of Art, Washington, D.C.

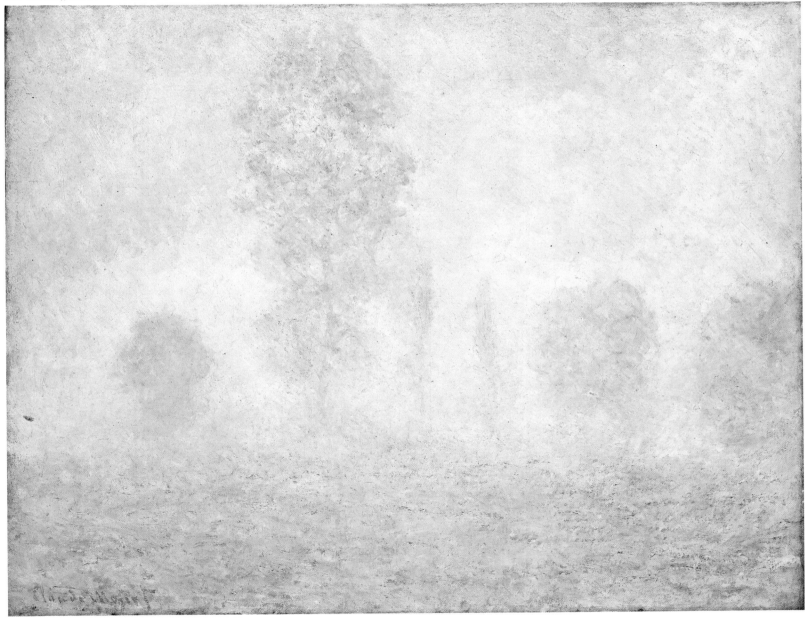

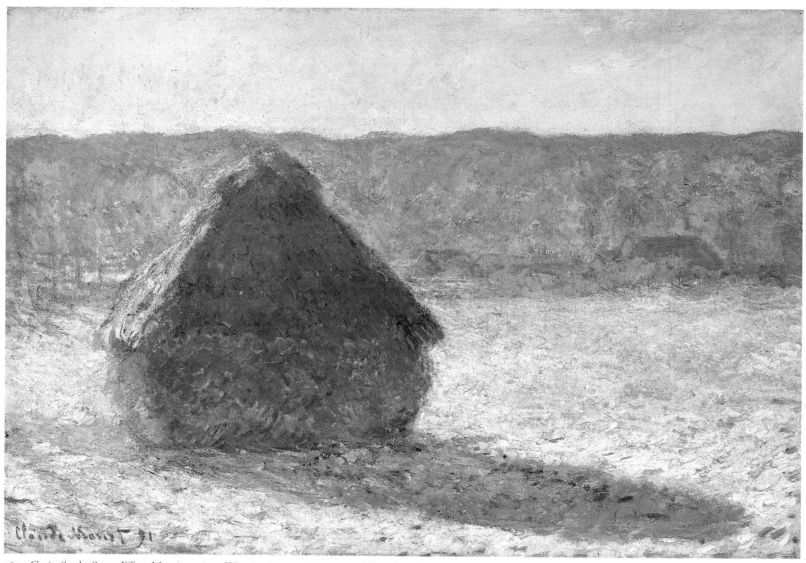

161. *Grain Stack, Snow Effect, Morning*, 1891, W 1280, 65×92, Museum of Fine Arts, Boston

hues, of very consistent tonal value – greens, blues, orange-pinks and mauves. The freedom of Monet's coloration is seen in the silhouetting of the left sides of the crowns of the stacks, mauve on the left one, a bluish green on the right; in each case the colour is chosen so as best to draw the stack forward from what lies beyond, whilst preserving the cohesion of the colour scheme. The snow effects in the Stacks series retain a strong tonal structure, the darker stacks, often with their shadows, standing out from the background. These canvases are mostly dominated by blues opposed to orange or salmon pink, comparable to the simple complementary contrast used a decade earlier in *Snow Effect at Lavacourt* (pl. 153); now, though, a far wider range of subsidiary colour nuances is added, particularly in the shadowed sides of the stacks – mauves and greens, for example, in *Grain Stack, Snow Effect, Morning* (pl. 161). This elaboration, by its varied colour and its more broken surface texture, makes the stacks the focus of the composition, set against the more integrated textures and colour schemes of the rest of the canvas. In *Grain Stack at Sunset, Winter* (pl. 136) and *Grain Stack at Sunset* (pl. 162) the variety is extended to the whole surface. In both paintings, blues are opposed to warm atmospheric colours; but these warm hues are rich and varied, ranging from clear yellows to intense reds, while greens and purples play an important part in

both, animating their shadowed areas and diversifying their overall effect. In *Grain Stack at Sunset* intense brick reds give the shadowed side of the stack an incandescent core, while the light of the sunset haloes the stack with vermilion and yellow, and scatters the lit parts of the field with particles of pink, orange and mauve. But, for all their complexities and despite the obvious liberties they take with observed colour, the colour schemes of these pictures are so subtly interwoven that the viewer can suspend disbelief at the actual colours used, and can see the pictures as a recreation of experience.

Some of the Poplars series of 1891, such as *The Four Trees* (pl. 256), retain emphatic tonal structures, but in a picture like *The Three Trees, Autumn* (pl. 137), even the darkest values, here the greens and blues on the bank, are clear mid tones. In other canvases of the period value contrasts are still more completely suppressed: in *The Ice-Floes* of 1893 (pl. 213), where the whole is treated in the softest whites and pale blues, with tinges of mauve, and in many of the Rouen Cathedral paintings. Rouen Cathedral had no dominant natural colour which could dictate Monet's palette, and it became the groundwork for sequences of colour variations as complex as those in the Grain Stacks. Occasionally the effect is grey and overcast (e.g. pl. 138), but most of the series are concerned with the play of sunlight and shadow across the façade at different times of

day (e.g. pls. 163–4). Monet consistently used clear light blues in the shadows in this series, in contrast to the sunlit surfaces, but added rich schemes of reflected colour in the areas of deep shadow such as the portals, as he had in the shadowed sides of the stacks, to add variety and to mediate between the most extreme colour contrasts.

Similarly integrated effects of atmospheric colour predominate in the series of Pourville and the Early Mornings on the Seine, both of 1896–7, and in the paintings of London (1899–1904) and Venice (1908–12). Particular colour schemes emerge as the keynote of each series. The Early Mornings (e.g. pls. 35, 139, 211) show the soft hues of dawn, blue and mauve mists veiling the greens of the trees, the sky tinged by the first sunlight, in one of the most consistently delicate and nuanced of all Monet's series. The Pourville paintings (e.g. pl. 165), by contrast, show stronger pinks, blues and greens, quite light in tonality but intense in colour, making an interesting comparison with Monet's first paintings of the place of 1882 (e.g. pl. 151), in which the textures are far crisper, the colour more

directly observed. In 1901 Monet described the varied colours he saw in London's fogs: 'There are black, brown, yellow, green, purple fogs and the interest in painting is to get the objects as seen through all these fogs.'[53] In the London paintings the nuances change from picture to picture (e.g. pls. 223, 268), but the keynotes of the series as a whole are blues and mauves, with touches of green, often punctuated by the orange of a sunburst. Venice, a climate which Monet did not know well and later felt he had never mastered,[54] is translated primarily into oranges and blues (e.g. pl. 166), with varied nuances in the shadowed sides of the palaces, rather synthetic arrangements that threaten to make his Venice as unconvincing as that of Félix Ziem, creator of the orange-blue Venetian stereotype of the later nineteenth century.

Only in his first paintings of his water garden of 1899–1900 (e.g. pl. 36) did Monet return to a subject in which the contrasts of natural textures and colours regained the importance they had held before 1890. The second series of the pond of 1904–9, though, is far

162. *Grain Stack at Sunset*, 1891, 73 × 92, W 1289, Museum of Fine Arts, Boston

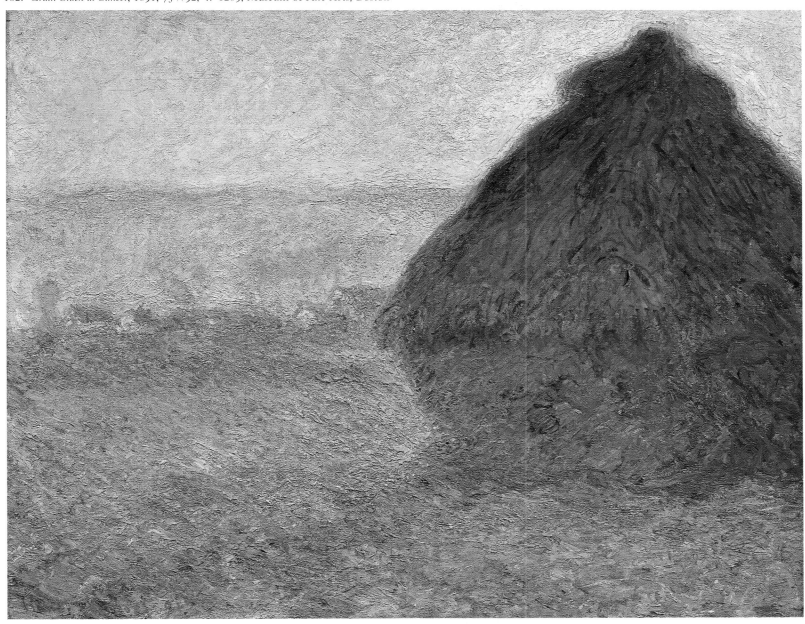

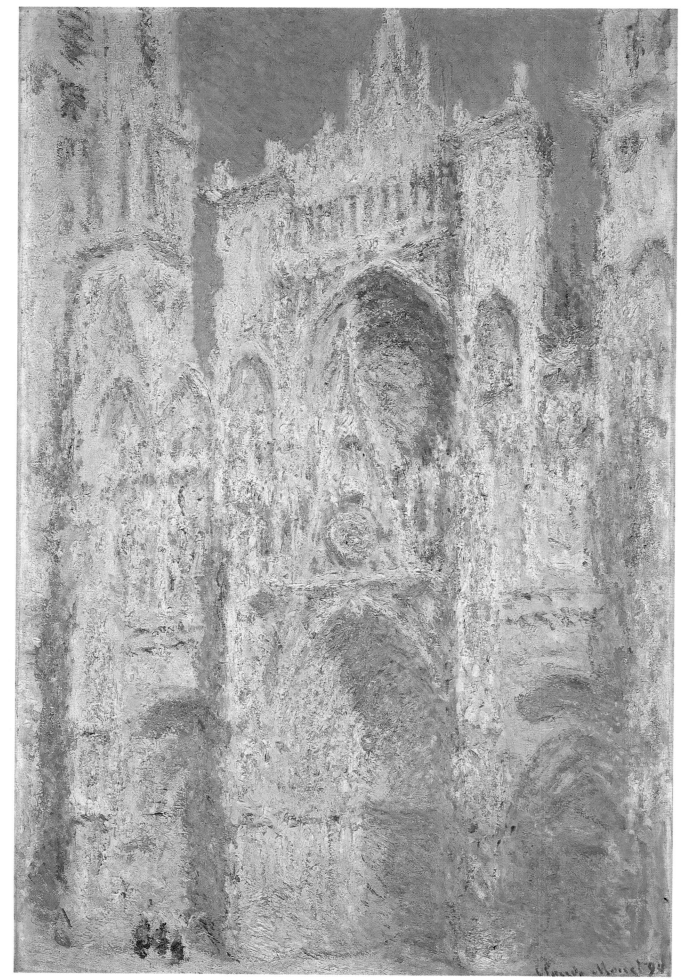

163. *Rouen Cathedral, the Portal, Sunlight*, 1892–4, 100 × 65, W 1324, National Gallery of Art, Washington, D.C.

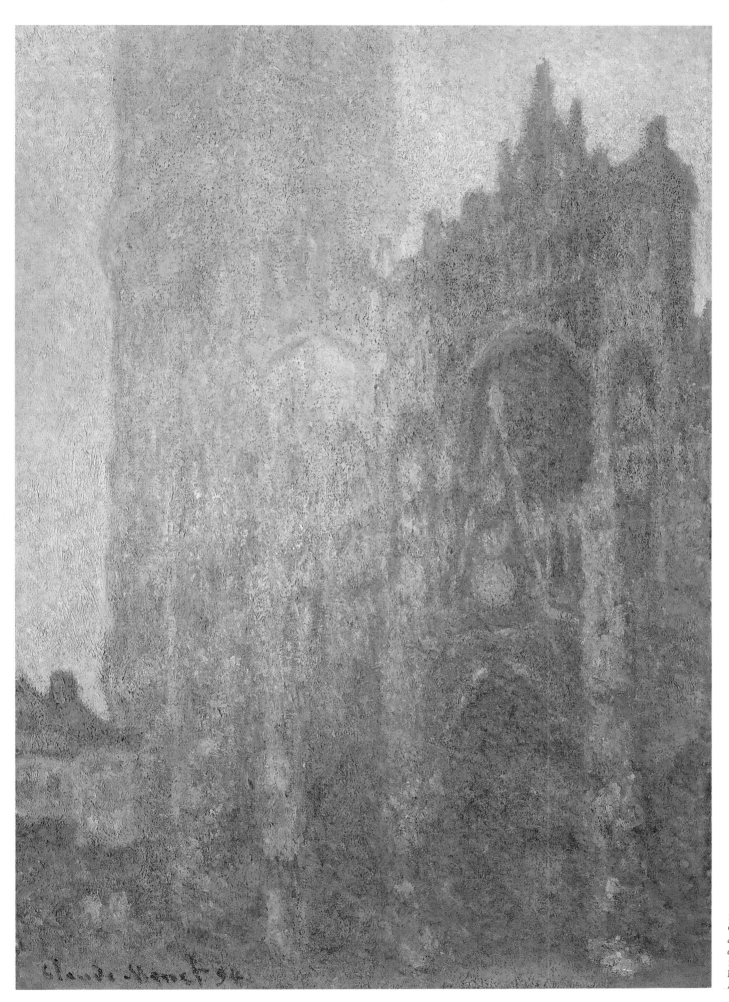

Claude Monet 94

164. *Rouen Cathedral, the Portal and the Tour d'Albane, Dawn,* 1892–4, 106 × 74, Museum of Fine Arts, Boston

165. *The Coastguard's Cottage at Pourville, Full Sunlight*, 1897, 65 × 92, W 1450, Musée des Beaux-Arts, Le Havre

166. *Venice, the Ducal Palace*, 1908–12, 81 × 100, W 1743, Brooklyn Museum

132

more unified (e.g. pls. 140–1). By focusing on the water surface itself, Monet had a subject with its own inbuilt unity, its colour changing according to the play of light and reflections; across this he set the lily pads, sometimes darker, sometimes lighter than the water below them, creating an endlessly varied interplay between their colours and the surface of the pond.

For this writer, the most successful of Monet's series are those from Giverny, particularly the Grain Stacks, the Early Mornings on the Seine and the Water Lilies of 1904–9. At Giverny he knew the light so well that the harmonic unity he sought in the paintings could evolve naturally from the long hours he had spent, year in and year out, looking at and painting the scene. Elsewhere he had more deliberately to seek a keynote, a characteristic harmony for each place; as a result such effects can seem more synthetic, superimposed on to a subject rather than growing out of it as they did at Giverny.

Such effects, monumentalised, became overtly decorative in intent in the Water Lily Decorations (pls. 92, 269). But this did not involve Monet in a real change of direction or purpose. Since the 1880s his paintings had become increasingly harmonised in their colour, and from 1891 onwards, over and above the carefully coordinated effects of individual paintings, he had intended them to be seen as integrated groups in the exhibitions of his series.[55] The huge surfaces of the decorations were thus an extension of his previous work, making explicit in a permanent form his belief that his paintings could be transformed into a decorative ensemble without sacrificing a sense of his direct contact with nature.

The decorative qualities of Monet's later works, and the ease with which they lent themselves to actual decorations, are the result in part of his interest in 'pattern', but to a great extent also of his subordination of tonal contrast to colour relationships. As we have seen, this was a gradual process, tonal modelling long retaining a significant part in the structure of many paintings, alongside their increasingly lavish colour effects. But, in the context of the expectations of the Impressionists' first critics, even in the 1870s their art was conspicuous for its suppression of value contrasts in favour of the play of colour, resulting in what seemed to contemporary eyes a startling sense of flatness. This flatness, which denied an easel painting its expected sense of relief and three-dimensionality, was, by contrast, the prerequisite of decorative painting. Hence Monet's work was regularly described as decorative from the 1870s on; and hence in 1892 the quality which Lecomte pinpointed as fundamental to Impressionism was its 'concern for decorative beauty'.[56]

Monet's carefully harmonised surfaces of the 1890s are without parallel in the work of the other Impressionist landscapists. Pissarro, under the influence of Neo-Impressionism, had created elaborately woven networks of colour in his finished paintings of 1886–1893, and on occasion reflected his interest in Turner, as in the sunset effects in some of his Rouen canvases of 1896–8; but his later work is more concerned with the observed colours of particular objects. Sisley came to introduce varied colour even to the subdued areas of his canvases, but remained concerned with variations of local colour and specific effects of weather, rather than with the unifying atmospheric *enveloppe*. In Renoir's last works, the particularities of observed colour are absorbed into his idealised vision of an all-embracing sunlit fusion between figures and nature. Only Cézanne's later paintings, though quite unlike Monet's in the effects represented, so deliberately translate direct experience into colour compositions.

Monet's colour of the 1890s is a far cry from the basically descriptive colour of his work of the 1870s, and at first sight this is a move away from any idea of 'naturalism' in colour. Certainly the iridescent portals of Rouen Cathedral bear far less resemblance to our everyday experience than do the reflections on the river at Argenteuil, and they can be discussed as colour compositions in their own right, without reference to nature. In 1894 Paul Signac wrote in his diary: 'But no, M. Monet, you are not a naturalist . . . Bastien-Lepage is much closer to nature than you! Trees in nature are not blue, people are not violet . . . and your great merit is precisely that you painted them like this, as you feel them (*comme vous les sentez*), and not just as they are.'[57] That Signac could reach this verdict at all is important, because it shows that in the 1890s Monet was felt to belong much more closely than is usually realised to the prevailing tendency in the avant-garde, Nabi and Neo-Impressionist, towards autonomous colour composition. But Signac's judgment reflects only the end product of Monet's colour as it appeared in the 1890s, and disregards the process by which these solutions had evolved. It was through his experience of nature and his exploration of ways of realising this experience in paint that Monet had reached this point.

We have seen the gradual development of his use of coloured shadows and his increasing preoccupation with the coloured *enveloppe*; seen in this light, his colour schemes of the 1890s were a direct outcome of his concerns over the previous twenty years, about reconciling the need to describe what he saw with an increasing interest in the overall coherence of his paintings. The *enveloppe* gave him a pretext for coloured improvisations which were based on his experiences, but could be integrated into a tightly knit pictorial unity. He said in 1912: 'I know only that I do what I think best in order to express what I experience (*ce que j'éprouve*) in front of nature', and that his aim was to 'fix my *sensations*':[58] but he also realised that there was nothing objectively true about these *sensations*. The way he saw nature, as well as the way he painted it, was basically personal and subjective. A story told of him by Theodore Robinson shows this: 'A young man shows him a landscape done much in his manner – too much, in fact. Monet asks – "And do you really see Nature like that?" "Certainly, Sir." "Impossible, my dear friend, that is the way I see it."'[59] So Signac's anti-naturalistic Monet can still, in his own terms, be painting his *sensations*; the development of his colour is not a rejection of nature, but an evolution in the ways in which he experienced nature and reconciled these experiences with the demands of picture-making.

Claude Monet

CHAPTER SEVEN
OPEN-AIR PAINTING

One day, at Varengeville, I saw a little car arriving in a cloud of dust. Monet gets out of it, looks at the sun, and consults his watch: 'I'm half an hour late,' he says, 'I'll come back tomorrow.'

Ambroise Vollard[1]

NORMALLY, all Monet's standard-sized canvases of outdoor subjects were begun on the spot, and many must have reached an advanced stage of working there.[2] However, at least from the 1880s the studio came to play an increasingly important part in his methods. Discussion of his paint surfaces has shown the stages through which he took his paintings during their execution, but this alone cannot determine the nature and likely extent of his studio reworkings. To assess the respective roles of outdoor and studio work, we must correlate the evidence from the paintings themselves with the mass of documentation which allows us to reconstruct Monet's patterns of working from around 1880 onwards; for his earlier years, the information is far more fragmentary.

Boudin's quick sketches fascinated Monet in the late 1850s, encouraging him to study the variations of light and atmosphere and to paint out of doors,[3] but Boudin's own commitment to outdoor work has been overstated: though he produced the pastel studies which Baudelaire described in his 'Salon of 1859', inscribed with details of date, time and weather, his more elaborate oils are unlikely to have been painted outside.[4] Jongkind, when Monet was in closest contact with him between 1862 and 1865, on occasion worked outside in oils, albeit on a small scale, though his outdoor work was normally confined to watercolour.[5] In this context the 'simple étude . . . done entirely from nature', which Monet proudly described to Bazille in 1864, seems unexceptional.[6] Late in his life he told Trévise: 'When I began, I was like the others; I thought that two canvases were enough, one for dull weather, one for sunshine.'[7] His early coastal scenes confirm this account, lacking for the most part any very specific effects of light and shade (e.g. pl. 111), though some of his other landscapes of 1864–5 do include quite specific effects of sunlight and shadow (e.g. pl. 258).

As Boudin's pastels show, an interest in more subtle variations of light was by no means unknown at this date. Valenciennes's small oil studies are the earliest surviving examples of an artist's quick notations of particular effects of light and atmosphere, and of different effects on one and the same subject. Valenciennes's teacher Joseph Vernet advised scrupulous attention to such factors in a letter to a pupil, urging him to ensure fidelity to nature by constantly comparing the colours of the objects in his view: 'The time of day chosen to paint a picture must make itself felt throughout, and every object must participate in the general tonality offered by nature.'[8] In England, Constable's oil studies, like Boudin's pastels often inscribed with details of the conditions recorded, supply another precedent; some French artists knew of these at least by the 1870s, though they were not widely known until the late 1880s.[9]

These examples are all of studies, not of exhibition pictures. Corot's Italian oil sketches of the 1820s fall into the same class, though one of them was later upgraded by being exhibited at the 1849 Salon.[10] Outdoor work on paintings intended for exhibition was far less common. In his first Salon submissions in 1865 Monet adopted the traditional method of making studio enlargements from smaller paintings, which may themselves have been partly painted out of doors. His vast and abortive *Déjeuner sur l'herbe*, planned for the 1866 Salon, was also a studio composition worked up from studies (e.g. pl. 14), though it includes specific effects of raking sunlight which are clearly the result of close observation, in contrast to the schematic studio lighting in Manet's *Déjeuner sur l'herbe*, which Monet was seeking to outdo.[11]

Monet's first radical gesture towards the open air was *Women in the Garden* (pl. 64), rejected at the 1867 Salon. Monet told Trévise that it was 'painted on the spot and from nature, something which wasn't done at the time', and described the ditch which he had had to dig to hold the base of the canvas as he worked on the top of its eight feet ($2\frac{1}{2}$ metres); Courbet, he said, had mocked him for working on it only when the sun was shining. In 1900 he described how at this time 'I threw myself body and soul into the *plein air*. It was a dangerous innovation. No-one had done it before.'[12]

These accounts date from long after the event; the truth was not as simple as this. *Women in the Garden*, though certainly begun out of doors at Ville d'Avray in the summer of 1866, was completed indoors at Honfleur early in 1867.[13] Nor were Salon paintings executed outside quite as unprecedented as Monet suggested. Rousseau and Corot had both painted occasional exhibition pictures outside,[14] but Monet's most important predecessor in this was Daubigny. From the 1850s onwards many of Daubigny's Salon pieces were at least begun out of doors, and in 1864 he exhibited a large canvas, *Villerville-sur-Mer* (pl. 167), which was apparently entirely executed outside. Henriet's account of it reveals the prob-

167. Daubigny, *Villerville-sur-mer*, 1864 (reworked 1872), 100 × 200, Mesdag Museum, The Hague

lems of the open-air painter: 'The *Villerville-sur-mer*, from the 1864 Salon, was, among others, entirely executed on the spot. Daubigny had fixed his canvas to some posts firmly driven into the ground, and there it remained, continually exposed to the horns of cattle and the pranks of young rascals until it was completely finished. The painter had specifically chosen a turbulent grey sky with big clouds chased by an angry wind. He kept watch for the favourable moment and ran out to work there as soon as the weather promised to

correspond to the effect of the picture.' The grey weather allowed Daubigny to work on the painting for longer without the effect greatly altering.[15] Monet's problem with *Women in the Garden* were far more acute, because of its vast scale and because he had chosen to paint a very specific effect of sunlight.

For all Monet's claims about the breakthrough which *Women in the Garden* represented in his working methods, he seems to have executed few, if any, large paintings out of doors until around 1914.[16] His Salon submissions of the late 1860s show all the signs of being studio compositions, and, as we shall see, his few large outdoor scenes of the 1870s and 1880s were probably executed in the studio, with the possible exception of the paintings of girls in boats of 1887–90.[17]

In the later 1860s, though, he painted increasing numbers of smaller outdoor scenes which tackle a very wide range of natural effects. Some of the boldest of these, like his views of La Grenouillère of 1869 (pls. 71, 145), were sketches for larger canvases, but others were complete paintings in their own right. We cannot tell whether the most ambitious of these, three size 60 canvases (130 cm across), were painted on the spot. *Terrace at Sainte-Adresse* (pl. 67) was presumably begun, at least, from an upstairs vantage point, and probably extensively worked in front of the natural subject, while the deep snows depicted in *The Magpie* (pl. 168) might well have made it impossible to work out of doors on a canvas of this size;

168. *The Magpie*, c.1868–9, 89 × 130, W 133, Musée d'Orsay, Paris

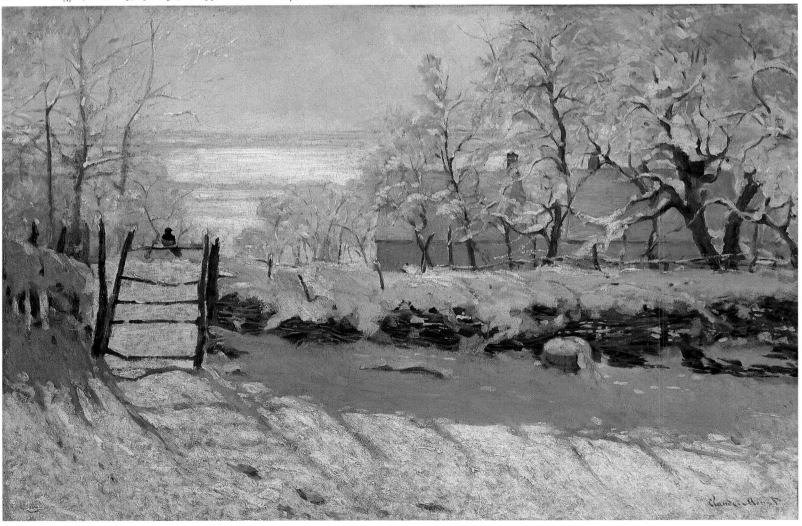

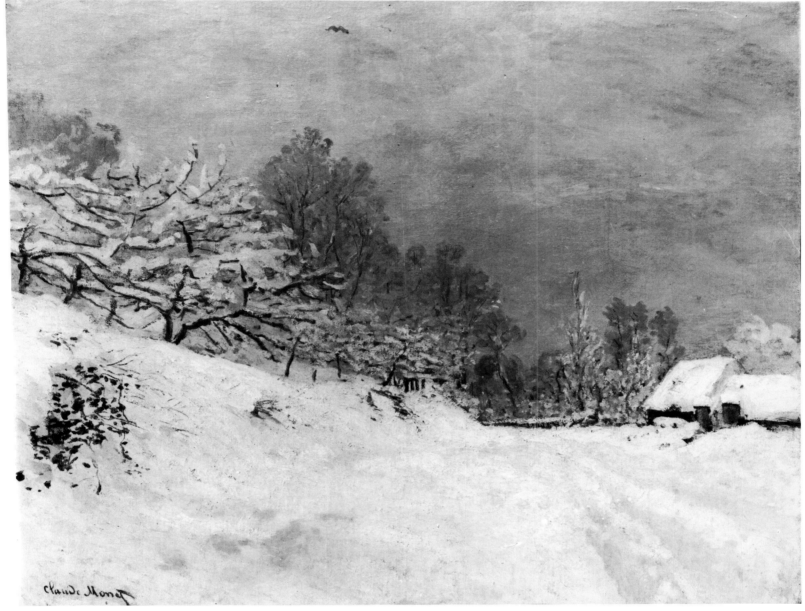

169. *The Road in front of the Ferme Saint-Siméon, Winter*, 1867, 81 × 100, W 79, Musée du Louvre, Paris

smaller outdoor studies survive for *Fishing Boats at Sea* (pl. 182), which strongly suggests that it was painted in the studio.[18]

However, Monet did undoubtedly work out of doors on his smaller paintings, even in very severe conditions. His reputation as the intrepid documenter of nature at its harshest was lauched by a local journalist in 1868, who described him painting in the deep snow at Honfleur (see pl. 169), probably in winter 1866–7: 'We have only seen him once. It was in the winter, during several days of snow, when communications were virtually at a standstill. It was cold enough to split stones. We noticed a foot-warmer, then an easel, then a man, swathed in three coats, his hands in gloves, his face half frozen. It was M. Monet, studying a snow effect.'[19] Until the mid-1890s Monet was often to brave such conditions in his fascination for subjects of snow and ice.

After 1870 the open air came to dominate Monet's work, as he largely abandoned the big exhibition picture in favour of the smaller, less ambitious canvases which formed the bulk of his exhibits at the Impressionist group exhibitions from 1874 onwards. We have little evidence of Monet's procedures in the 1870s, though we must assume that much of his work was done out of doors. One account describes him 'perched with his easel on a pile of packing cases' in the Gare Saint-Lazare,[20] and a number of paintings by his friends show him at work out of doors, one by Renoir of him painting in his Argenteuil garden (pl. 8), and two by Manet of him at work in his studio boat. Manet titled the more complete of these (pl. 170) *Claude Monet in his Studio*, with the comment 'Monet? his studio in his boat',[21]

Monet's studio boat, launched probably in 1873 as the result of 'a fruitful sale',[22] is the clearest testament to his outdoor work of this decade, but equally it pays tribute to Daubigny's almost identical boat, launched in 1857; when Monet had his boat built, he was on close terms with Daubigny, after their association in London in 1870–1.[23] Daubigny seems to have been more ambitious in the use of his boat than Monet; as he depicted in his *Voyage en bateau*

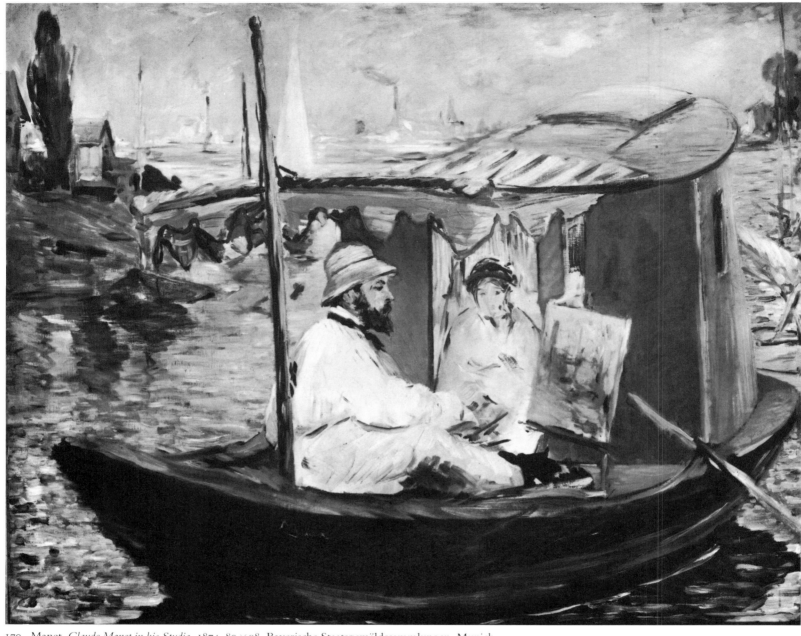

170. Manet, *Claude Monet in his Studio*, 1874, 80×98, Bayerische Staatsgemäldesammlungen, Munich

etchings (e.g. pls. 63, 171; published in 1862), Daubigny made it his home for days at a time, as he travelled painting on the Seine and the Oise, while Monet seems to have moored his where he was living, using it only within a short radius of home. Daubigny's boat, in his own etchings and in paintings by his friends, appears on the river in open countryside, while Monet's, in Manet's and his own paintings, is always seen close to home, at Argenteuil and later at Vétheuil.[24] Manet's painting of Monet in his boat has been seen as a tribute to one of Daubigny's etchings (pl. 171), but the resemblance does not seem unequivocal;[25] Monet's own painting of himself at work in the boat (pl. 172) can more plausibly be seen as a homage to Daubigny (see pl. 63).

The original studio boat survived the ice-floes of January 1880, and presumably accompanied Monet to Giverny; it does not appear in any of his own paintings after 1881, but the boat in which Sargent depicted him painting in the later 1880s (pl. 173) looks very like the original one. In 1891, though, Monet asked Caillebotte for the loan

171. Daubigny, *Gulping it Down (Luncheon on the Boat)*, 1861, etching from *Voyage en bateau*, 10.5×16, Private Collection

138

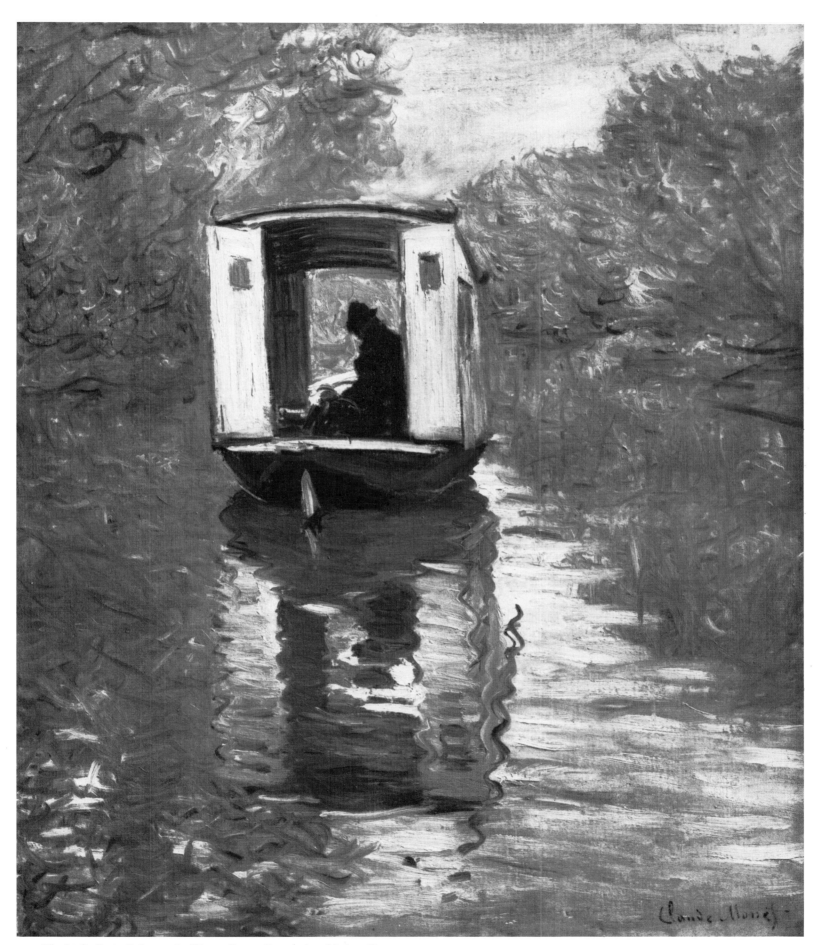

172. *The Studio Boat*, 1876, 72 × 60, W 390, Barnes Foundation, Merion, Pa.

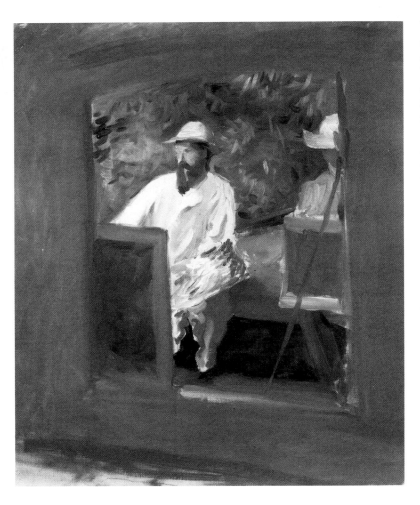

173. Sargent, *Claude Monet painting in his Bateau-Atelier*, *c*.1885–90, 60 × 49, National Gallery of Art, Washington, D.C.

of a boat, because he was at work on a quantity of canvases on the Epte (presumably the Poplars series), and felt 'very uncomfortable in the *norvégienne*'; Monet's mention of the *norvégienne* (a sort of round-stemmed rowing boat) implies that he was no longer using the original studio boat.[26] Descriptions of the boat he used after 1890 confirm that he replaced it with something larger; he himself described the first boat as having 'a cabin made out of planks where I had just enough room to set up my easel', while the boat he used for the Poplars and the Early Mornings on the Seine series was described as 'a broad-bottomed boat fitted with grooves to hold a number of canvases', 'quite a large sort of barge-cabin; one could sleep there', and 'the great wherry at anchor which is his studio'.[27]

By 1880 the Impressionists were known as a group whose methods were rooted in the principle of outdoor painting. The propaganda of their supporters emphasised this,[28] creating a public image which has lasted ever since. This image was confirmed in 1880 on the occasion of Monet's first one-man exhibition. Duret, in his preface to the exhibition catalogue, described Monet's work as 'oil painting started and completed in its entirety in front of the natural scene', and in an interview Monet declared: 'I have never had a studio, and I don't understand shutting oneself away in a room.'[29] This statement was a simple untruth, as we shall see, but it was an image Monet continued to propagate sedulously throughout his career. His determined propaganda about his own outdoor work testifies not only to the importance he attached to it, but also to his belief that the open air was one of Impressionism's primary justifications. The idea that Monet only painted out of doors was upheld even by those who visited Monet at Giverny after 1890, such as W.H. Fuller, Wynford Dewhurst and Maurice Guillemot.[30] Only after 1900 did mentions of Monet's use of the studio begin to creep into some accounts of his work, though the studio had played an integral part in his methods for more than a decade.

The blueprint for most accounts of Monet's outdoor methods appeared in 1889, in his friend Mirbeau's essay in the catalogue of the Monet–Rodin retrospective. This description, as far as it relates to his procedures out of doors, is an eloquent and undoubtedly authentic account which deserves to be quoted at length: 'M. Claude Monet realised that it was the time of day chosen which characterises the landscape; this is instantaneity. He noticed that, on a settled day, an effect lasts for barely thirty minutes. Thus he had to record the history of these thirty minutes . . . He made it a strict rule to cover the canvas in that short space of a half hour . . . Every day at the same hour, for the same number of minutes, in the same light, sometimes through sixty sessions, he would come back to his *motif* . . . stopping ruthlessly, and running to a different *motif*, if, during that short session, the light changed. Never . . . never did M. Claude Monet let himself succumb to the temptation, strong though it was, to slave on at a canvas beyond the time he had fixed. This integrity in his work . . . enabled him to have ten studies under way at a time, almost as many studies as there are hours in a day.' Mirbeau concluded: 'The open air is his only studio.'[31]

Mirbeau here describes Monet's methods as they would be in ideal conditions of unchanging weather. As Fuller said in 1891: 'When we stand before one of his highly finished paintings, we know at once that Nature has been very kind to him.'[32] Evidence about Monet's use of the studio shows that things were not as simple as he had led Fuller to believe, but equally a mass of evidence shows the lengths to which Monet went on occasion to work in the open.

He loved to tell his friends of the hardships he underwent in painting out of doors. 'The painter goes to his work as if going into battle', wrote Geffroy after watching him on Belle-Isle in 1886, dressed in oilskins like the fishermen of the coasts, with his easel tied to the rocks and with gusts of wind blowing brushes and palette from his hands. At Pourville in 1896 he lamented that 'the wind blew away my canvases, I put my palette down to pick them up, and off it went in its turn'; in 1888 at Antibes he fastened both easel and canvases, but the wind covered his painting with sand.[33] Sand can still seen embedded in the paint surface of a canvas of 1870, *Trouville Beach* (pl. 96). We find Monet pinioned to the ice floes at Giverny in 1889 with a hot water bottle for his fingers, and in Norway in 1895 he returned from a day's work in a blizzard 'white all over, with my beard covered with "stalactited" icicles'; a week later he had to give up work, because he could find no shelter and no umbrella was strong enough to hold the weight of the snow.[34]

Rain, too, often hindered his work. At times he went on working in it, obviously with an adequate umbrella, but wherever possible, and clearly when assaulted by wind and rain together, he had to find some sort of shelter. In 1882 at Pourville he lamented: 'I cannot work in all weathers here as I did at Fécamp. There are no shelters, no hollows in the cliff where I can install myself while it is raining.' In 1896 the same problem at Pourville made him send for a spade and build a shelter, and to arrange for the use of a cabin on his return the following year, which allowed him to work in all weathers; he also had to have a shelter built on another site in 1897.[35] Only rarely did Monet paint falling rain. A view of Etretat, though dated 1886

(pl. 174), is presumably the 'shower beating down on the sea' which Maupassant described Monet grasping in his hands and flinging on the canvas in 1885. That year he worked from various windows along Etretat's sea front in bad weather; the rain canvas, showing the bay from below the eastern cliffs, was presumably painted from one of these.[36]

Etretat was the scene of some of Monet's greatest heroics. In the storms of November people saw on the beach 'Claude Monet, water streaming down under his cape, painting the tempest while spattered with salt water'. In November 1885 he met with his most serious accident there while working on a view of the Manneporte. He had consulted the wrong day's tide table before going down to the beach, and was swept away by a freak wave when he thought the tide was already receding. He lost canvas, easel and *sac*; his palette was plastered to his face, but he managed to crawl from the waves.[37]

Monet obviously gained great satisfaction from working under such extreme conditions; in this he must be seen as the direct descendent of Turner's and Joseph Vernet's self-exposure to storms at sea. Such physical confrontations were the material expression of the excitement he felt in the forces of nature at their most elemental.[38] In his choice of viewpoints, too, he often put himself to great discomfort. The story of his near-drowning while painting the Manneporte shows that he must have descended a perilous cliff path with all his equipment to reach the beach around high tide.[39] Similarly the remarkable subject of the Needle at Etretat viewed through the Porte d'Amont, which he painted around 1868/9 (pl. 175) and again in 1885, was painted from a beach only accessible by a steep rock path, and from a rock platform reached across wide shoals and only exposed at low tide (see pl. 176). Some of his Pourville sites, too, are only accessible at low tide (pls. 177–8).

Not all of Monet's outdoor work was so like an outward-bound

174. *Etretat, Rainy Weather*, 1885 (dated 1886), 60 × 74, W 1044, Nasjonalgalleriet, Oslo

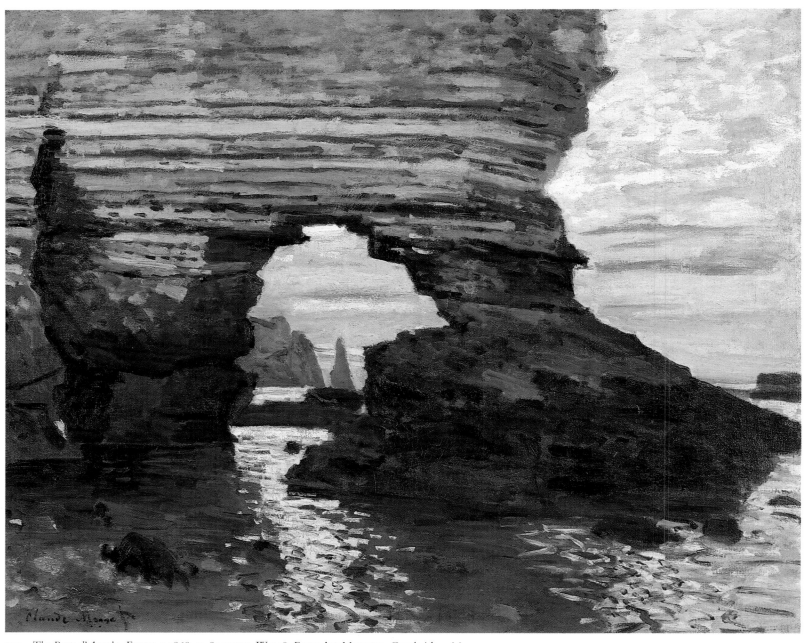

175. *The Porte d'Amont, Etretat*, c.1868–9, 81 × 100, W 258, Fogg Art Museum, Cambridge, Mass.

course, but even when conditions were less extreme he faced taxing problems in order to paint a scene before the weather or the angle of lighting changed. He quickly became dissatisfied with the 'two canvases, one for dull weather, one for sunshine', which he had used at the beginning of his career, as his experience of working out of doors made him more and more aware of the minutest changes of lighting. Valenciennes had advised the outdoor sketcher to confine his sessions to two hours, warning him that he was unlikely to find the same effect on another occasion. Monet's perceptions became so acute that by the 1880s the half hour period which Mirbeau mentioned in 1889 seems comparatively long. In 1883 Jules Laforgue had spoken of a quarter hour as the natural time span for an Impressionist painting, while Monet himself mentioned seven minutes as the limit for one of his Poplars series, 'until the sunlight left a certain leaf', and in 1918 talked of effects which lasted 'sometimes three or four minutes at the most'.[40] Little wonder that he had to employ a barber to cut his hair as he worked in the Creuse in 1889, or that he

176. Photograph of the subject of pl. 175, taken by the author 1972

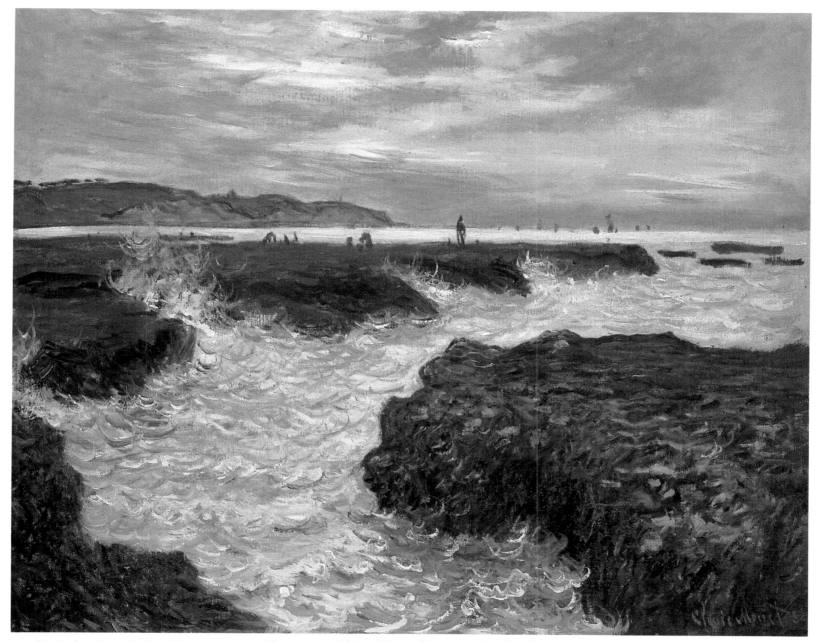

177. *The Rocks at Pourville, Low Tide*, 1882, 63 ×77, W 767, Memorial Art Gallery of the University of Rochester, N.Y.

might arrive too late for a particular effect, as Vollard witnessed at Varengeville: however, on occasion Monet took the precaution of writing the time of day on the back of his canvases.[41] It was to counteract problems such as these that, for the Early Mornings on the Seine series, he chose to paint at and before dawn, which made it 'an easier subject and simpler lighting than usual', because at this time of day the effects did not change so rapidly; however, this involved him getting up at 3.30 a.m., which seems to have been unprecedented even for so inveterate an early riser as Monet.[42]

Though Monet rejected the oversimplification of the traditional 'two canvases, one for dull weather, one for sunshine', his working habits in later years clearly evolved from this practice. He found it necessary to begin separate sequences of canvases of sunlit and overcast effects, so as to have suitable pictures to paint whatever the weather, as he explained from Pourville in 1896: 'I must decide to begin canvases in all sorts of weather, all types of wind; it is impossible for me to do only a few and to wait with my arms

178. Photograph of the subject of pl. 177, taken by the author 1972

folded when the right effect is not there.' Equally, particular subjects suited pa ticular times of day, presumably because of the angle and quality of lighting. These factors were part of his planned strategy in the Creuse in 1889: 'I'm well organised and things are under way, with my motifs chosen for the morning and the afternoon, sunlight and grey weather.' Even with such precautions, though, the weather might change too quickly for him, as in 1884 at Bordighera, when one morning he took grey weather canvases out with him and the sun came out, and then the reverse happened the same afternoon.[43]

Monet prided himself on the number of different canvases on which, in favourable circumstances, he was able to work in a single day. Proudly he described in 1882 working in one day on 'eight studies, and supposing I work on each *une petite heure*, you can see I'm not wasting my time, without counting the journey from one motif to another'. Two years later he worked on seven in a day, and, forgetting the previous occasion, declared this a record.[44] Days when he worked on seven are noted at times in the later 1880s, followed by a new record, of eleven in a day, in May 1889. This in turn was exceeded at Rouen in March 1893, with fourteen in a day.[45] Here, though, his task was simpler, since all his canvases would be at hand in the room where he was working on the single subject of the cathedral façade, rather than needing to be taken to various outdoor sites in anticipation of the return of the hoped-for effects.

More common, before he began to work in strict series, would have been days such as those he described at Etretat in November 1885. The 19th of November was 'a splendid day . . . I used it well, I assure you, the morning at La Passée where I'm in the process of turning a bad thing into something good, I think. An early lunch, and at midday I was at the Manneporte where I worked well, and then I painted the departure of the boats near the Maison Perrin, and a sunset.' The 23rd was not so easy: 'Today has not been too bad, but the weather has been very variable, with even a little rain, so I have walked around and moved my site a lot, in order to do very little work at a time on six canvases.'[46]

Ideally Monet hoped to be able to return to a motif at the same time over a period of days, in order to work up his canvas to a considerable degree of finish. Mirbeau spoke of him spending up to sixty sessions on a single canvas, Trévise of twenty or thirty; Monet recalled his great luck, when painting the tulip fields of Holland (see pl. 216), that 'for twelve days in succession I had practically the same weather';[47] by the end of his stay at Pourville early in 1882, he had worked on some canvases twenty times.[48] His letters from Bordighera in 1884 show how his normal processes evolved: by 29 January, when he had been at work for little more than a week, some canvases had already been worked on six times; by mid-February some had received ten or twelve sessions of work; and late in March near the end of his stay he mentioned paintings 'over which I have laboured for fifteen sessions'. On Belle-Isle he wrecked a canvas on which he had worked at least twenty times by reworking it.[49] These very large numbers of sessions were probably exceptional, at least in the 1880s, but most paintings, if nature allowed, would have seen several sessions of work in front of the natural subject.

At home Monet could freely return to his subjects when the right conditions returned, continuing them the following year if necessary. His letters suggest that he had less trouble in completing his Giverny paintings than those he brought back from his travels. Occasionally canvases left unfinished on one of his expeditions were taken back to the site the following year. This became his regular practice in the

1890s, with visits to Rouen in 1892 and 1893, to Pourville in 1896 and 1897, and to London in 1899, 1900 and 1901, but he began to revisit sites with unfinished paintings in the 1880s, with his spells of work at Etretat each year from 1883 to 1886. He intended a further visit in September 1886, to 'finish one or two of my Etretat seascapes', but this trip never took place, leaving him with a number of incomplete paintings on his hands.[50] It was presumably one of these that Lilla Cabot Perry bought in 1889: 'Monet said he had to do something to the sky before delivering it as the clouds did not quite suit him, and, characteristically, to do that he must needs go down to Etretat for a day with as near as possible the same sky and atmosphere, so it was some little time before I could take possession of the picture.'[51] Puzzlingly his stay at Etretat in February 1886 is his last recorded spell of work there, and no visit in 1889 is documented; a short outing might have passed unnoticed, but one must suspect that he never visited Etretat to correct the clouds, instead reworking them at home. This would have been in line with his practice at this date, as we shall see, and he may have been reluctant to tell Perry the whole truth.

Many of his sites, though, he only painted during one visit: Bordighera and Menton in 1884, Holland and Belle-Isle in 1886, Antibes in 1888, the Creuse in 1889 and Norway in 1895. Finishing paintings from these trips presented him with quite different problems, particularly when, in his first weeks at the place, he had needed to habituate himself to novel effects of light. On these occasions any painting not completed in its essentials on the spot had to be pulled into shape in the studio or abandoned.

When working out of doors Monet was at the mercy of the transitoriness of the elements. Many witnesses described him nervously waiting for the return of a desired effect: 'The painter lay in wait for each of his effects, slave to the disappearing and returning light, halting his brush when the scene before him changed, placing the uncompleted canvas at his feet, watching out for the return of the vanished impression so that he could continue his original work.'[52] Monet's letters reveal his repeated problems in trying to find the same weather conditions over again. He held that 'the first real look at the *motif* was likely to be the truest and most unprejudiced one', and feared that reworking would spoil the 'purity of accent' of his paintings;[53] and any number of factors might prevent him from ever finding the initial effect again. Even in continuing bright weather the wind might vary, 'which makes a great difference to the state of the atmosphere, and especially the sea'. On another occasion he complained that 'the light's wrong, and that cloud oughtn't to be up there'.[54] Winter presented still greater problems, for snow might fall, or thaw, too soon: late in 1885 he waited in worry at Giverny on hearing that snow was spreading up from Paris, while in January 1893 the thaw caught him in mid-painting; fresh snow transformed the distant mountains at Antibes in 1888; in Norway an hour's sunshine or a breath of wind would make snow fall from the laden pine forests, and the ice floes, theme of his famous sequence of 1880, lasted only about four days.[55]

Work on the coast brought its own recurrent problems. Even in settled weather, every day the tide levels became increasingly out of step with the angles of sunlight he was painting. In 1885 at Etretat he lamented that 'so many things have to be right, finding the same effects again at high tide or low, the sea calm or rough', in 1896 at Pourville that 'I often have the weather I need, but the tide is low when I need it to be high'.[56] On Belle-Isle in 1886 he was delighted to find that, with the deep waters off the island, 'the tides scarcely make any difference, as the sea is so deep here at the edge of the

179. *Old Tree at Fresselines*, 1889, 81 × 100, W 1229, Whereabouts unknown

coast'. Even inland water levels might change greatly, as on the Creuse in 1889: 'And then there's this river which falls, then rises again; one day it's green, then it's yellow; just recently it was dried up, but it will be a torrent again tomorrow after the dreadful amount of rain falling at the moment.'[57]

Even seasons might change too quickly for him, particularly if bad weather prevented him from working for any length of time. Often the angle and quality of sunlight changed so much that his subjects were no longer lit in the same way.[58] Spring and autumn caused him particular problems year after year. In 1894 he had 'a number of spring canvases which I have had to start again with the greenery further advanced', and on the cliffs of Pourville in 1896 and 1897 he found that, late in March, 'those beautiful dried grasses which gave me such pleasure have been invaded by the new green growth . . . it's a funny business being a landscapist'.[59] Monet's problems with changing seasons came to a head in the Creuse in 1889. He intended to paint a group of winter canvases, some of them dominated by a great oak tree (e.g. pl. 179). However, bad weather kept him from work, and, by the time he could resume, the tree was covered with spring buds. Rather than lose his winter effect, he got permission for two workmen to strip the tree of its leaves, so that he could finish his paintings with its branches bare, in the second week of May. Happily the tree recovered.[60]

Man, as well as nature, might thwart his attempts to finish his pictures. In 1880 he returned to an apple orchard which he had started to paint, only to find its crop picked; at Etretat the fishing boats on the beach were constantly moved as he sought to paint them; in the Creuse he once found his trees felled and a pile of logs on his actual viewpoint; in 1890 his attempts to paint reeds growing in a river bed (e.g. pl. 50) were interrupted by the raking of the river; and on his return to Pourville in 1897 he found that a large part of the cliff top in one of his subjects from the previous year had been shut off for the construction of a shooting range, and he had to work against time before the grass was burnt, and 'all those beautiful movements of the land' were dug up.[61]

In 1887 Geffroy summed up the difficulties Monet faced: 'Today he hastens to the place where he was installed yesterday, he asks himself if he will find nearly identical the combination of light, shadows, reflections, water and sky in front of which he passed his time the previous day.'[62] Geffroy did not, though, acknowledge the practical alternatives which Monet so often faced in practice. If he could not recover the original effect of a painting, he had, in essence, three choices: to work on at the original effect on the basis of the preliminary notation on the canvas; to alter the canvas to conform to the new effect he had before him; and, in the unique case of the Creuse oak, to alter nature itself to bring it back into line with his effect. Between the first two of these options Monet constantly found himself wavering. Though his supporters, such as Mirbeau and Lilla Cabot Perry, insisted that he always managed to stop work when an effect changed, he admitted to Perry that at times this was difficult.[63] At times he was forced to change the effects represented, either because he could not stop in time, or in despair at ever finding again his original effect. He acknowledged this in 1886 at the end of an eloquent description of the problems of the outdoor landscapist: 'I am having more and more difficulties, because I want to finish, and for that one must find one's effect again quite precisely, which is often impossible, because every day the sun's path becomes shorter and it no longer lights things the same way; also the weather is so variable that I would need to be followed by a cart with all my canvases, because I often take out those which I think I can work at according to the weather, and often, like today, for example, the weather changes while I'm on my way to the spot . . . I'm obliged to transform some canvases.'[64] He wrote from Norway in 1895 of 'a certain subject which I have done a dozen times, and I have the greatest trouble in finding one of these effects repeated; so I change them, and the next day the effect I was waiting for returns'. Two years later he wrote from Pourville: 'It would be best not to touch some canvases again, and, if the weather improves, to start some new ones, which I ought already to have done, instead of transforming my pictures and only succeeding in making them bastard and imprecise.'[65] As he came to paint still larger numbers of canvases at a time of a single motif, the problem acquired a new dimension, as he discovered in London around 1900: 'I had up to a hundred canvases under way – of a single subject. By searching feverishly among these *ébauches*, I would choose one which wasn't too far away from what I could see; in spite of everything, I would change it completely. When I'd stopped work, shuffling through my canvases I would notice that I had overlooked precisely the one which would have suited me best and which was at my fingertips.'[66]

Not surprisingly Monet's paintings themselves reflect the multifarious problems of painting out of doors. Pentimenti can often be found in his canvases. Some of these seem to be the result of changes in his plans for a picture rather than changes in the scene which he had before him, but many bear witness to the transience of natural effects. Water levels may be raised or lowered; the state of wind or waves may change; snow may be added or erased; the angle or quality of lighting may be transformed; and the seasons themselves may be altered. A later chapter will describe some examples of this, in the context of a general discussion of Monet's pentimenti: only by considering the various reasons for the changes he made in his pictures can we gauge the degree of deliberation involved in their final appearance.[67]

Direct painting from nature was Monet's indispensable stimulus, and his basic aim throughout his career remained a form of naturalism. In 1926 he wrote to Charteris in terms that he could have used at any time in his career: 'My only virtue is to have painted directly in

front of nature, while trying to render my impressions in front of the most fugitive effects.'[68] He sedulously maintained the image of an artist whose work was both begun and finished in front of the subject, but the various problems he faced in completing his paintings forced him to adopt methods rather different from those he professed. Pissarro and Renoir were willing to confess more openly than Monet their growing dissatisfaction in the 1880s with open-air painting as an ideal. Their changing methods and the ways in which they resolved these problems will be discussed in the next chapter, in relation to Monet's own use of the studio.

In the 1870s and early 1880s it seems that Monet aimed, whenever he could, to complete his work on the spot. In 1878–80, we find bad weather preventing him from completing paintings, which implies that, weather permitting, they could have been finished out of doors.[69] In 1882, too, he thought that he would be able to send Durand-Ruel some paintings direct from Pourville. Six weeks later he wrote from Pourville that he had five finished canvases, but he introduced an important proviso: 'If it's all the same to you, I would rather show you the whole series of my studies at the same time, as I am keen to see them all together at home.'[70] Though he did not say that he intended to retouch these paintings, the letter is the earliest surviving indication that, even when his outdoor work had been completed to his satisfaction, Monet felt the need to look over his work away from the motif, and that artistic considerations, as well as the exigencies of nature, might delay the final completion of his pictures.

He continued to hold hopes of finishing paintings on the spot. He went to Etretat in January 1883 to complete something quickly for the exhibition Durand-Ruel was mounting in March, but again the weather took a hand; he was able to deliver only one Etretat painting to the dealer within a week of leaving Etretat, and clearly decided against including it in the exhibition, as it was returned to him the day after the show opened.[71] At Bordighera in 1884 he described a few canvases as finished, but soon qualified this: 'When I decide, not that a canvas is finished, but that I will not touch it any more, I jam it in a case so as not to see it again until I'm at Giverny.'[72] In the event, he delivered no southern canvases to Durand-Ruel until six weeks after his return home.

Later in the 1880s he still spoke of his attempts to finish paintings on the spot,[73] but he became increasingly committed to the policy of looking over his canvases at home before declaring them finished. This final stage came, more and more, to involve actual reworking. In a crucial letter from Belle-Isle in 1886 he made his position clear to Durand-Ruel: 'You ask me to send what I have that is finished; I have nothing finished, and you know that I can only really judge what I have done when I see it at home, and I always need a moment of peace and quiet before I can put the final touches to my canvases . . . For many of the motifs I have much trouble in finding the same effect again, and I'll have a lot to do once I get back to Giverny . . . Above all I have to complete, or nearly complete, my canvases here.'[74] So, even if the weather allowed him to complete some canvases on the spot, an additional stage was needed in the studio at home. To assess the nature and purposes of Monet's studio work we must first examine the documentary evidence for his use of the studio, and then relate this to the indications supplied by the paintings themselves.

CHAPTER EIGHT
STUDIO WORK

My studio! But I have never had a studio!
 Monet, 1880[1]

WITH the exception of his outdoor heroics with *Women in the Garden* (pl. 64) in 1866, Monet executed his large exhibition pictures of the 1860s in the studio, from smaller studies. At times this involved little more than an enlargement of a smaller painting (e.g. pls. 180–1) at times an elaboration of a single effect (e.g. pls. 17, 259), and at times a more complex act of composition, combining elements from several smaller canvases (e.g. pls. 71, 145, 260).[2] During these years he also executed some smaller paintings in the studio. At Sainte-Adresse in autumn 1864 he made copies of some *études*, which were presumably studio versions of outdoor paintings, but quickly realised that he preferred the original *études*. The identification of these pictures raises many problems.[3] Two years later, he is reported to have painted a group of seascapes at Ville d'Avray in the presence of Astruc, 'making use of the palette knife in imitation of Courbet'. Speaking of them, Monet apparently wrote: 'It was like a conversation painted in obedience to memories of my youth spent in Le Havre, as they rose before me.' Again, these paintings cannot be identified with confidence, but *Fishing Boats at Sea* (pl. 182) was apparently one of them.[4] It was not only in technique that these paintings were an emulation of Courbet (who visited Monet at Ville d'Avray while he was working on *Women in the Garden*): Courbet, too, made a habit of painting rapid palette knife landscapes in his studio in front of admiring friends, as demonstrations of his virtuosity.[5]

Such work from memory seems to have been quite exceptional; in later years it would have been anathema to Monet.[6] By around 1870 he seems to have been firmly committed to open-air painting. As we shall see, though, he continued to paint occasional large canvases in the studio, and, more significantly, even his outdoor paintings sometimes needed a degree of studio reworking.

Whatever public image he propagated, Monet seems never to have been without a studio of some sort, even in the 1870s. As soon as he returned from Holland in 1871 he took over Amand Gautier's studio in Rue d'Isly near the Gare Saint-Lazare; when he moved to Argenteuil soon afterwards, his first house there, previously occupied by the painter Ribot, had a large studio with views of the Seine (once Monet had stripped the windows of the black paper which Ribot had stuck over them), but he still maintained the Rue d'Isly studio. He abandoned this base in Paris in 1874, and moved in

Argenteuil to 'a nice little house where I could work so well'.[7] In January 1877, while still based at Argenteuil, he took an apartment in Paris at 17 Rue Moncey, initially perhaps for convenience as he started work on his Gare Saint-Lazare paintings; but he kept it on, and in February 1878 called it 'my studio' to distinguish from 'our residence' at 26 Rue d'Edimbourg, to which he moved after leaving Argenteuil in January 1878.[8] After he moved to Vétheuil in August 1878 he took a different studio in Paris, at 20 Rue Vintimille, which he kept until 1882. Here, an acquaintance remembered fifty years later, Monet 'stacked his canvases against the wall in dozens'; it must have served more as a showroom to prospective buyers than as a working studio, since Camille's ill-health in 1878–9 prevented Monet from paying frequent visits to Paris. However, Monet also had facilities for painting indoors at Vétheuil, where he executed his three large studio paintings for the 1880 Salon. After leaving Rue Vintimille in 1882, he never again had a pied-à-terre in Paris.[9]

We know little of his arrangements at Poissy, where he lived from December 1881 until April 1883, but his house there had room for him to work, and, while staying at Pourville in February 1882, he was able to borrow a studio in Dieppe to use as he pleased.[10] At Giverny, on his arrival in April 1883, he was at once in a position to work indoors, and made successive enlargements to his studios there. The first was originally 'a barn with a floor of beaten soil', which Monet, soon after his arrival, knocked into the house, adding a large new window. The exact dates of these alterations are not clear, but in 1885–6 he was enlarging his '*atelier*', and in 1891, after buying the house, he 'remade his studio'.[11] In 1899 he built a large separate studio in the garden beside the house, with big windows in the north wall and the north side of the roof. Finally in 1916 the vast studio constructed for the Water Lily Decorations was completed. The first studio, in the house, became the family's *salon* on the construction of the second, though it was hung from floor to ceiling with past paintings which Monet might be persuaded to sell (pl. 183). The second, from its creation until Monet's death, was where he normally signed and sold his paintings (pl. 184); the third was reserved exclusively for work on the Decorations.[12]

Detailed information about Monet's use of the studio dates only from 1881, when Durand-Ruel established a regular relationship with Monet. In his letters to the dealer there are repeated mentions of retouches to his paintings and frequent excuses for his inability to deliver paintings that Durand-Ruel had already purchased. On

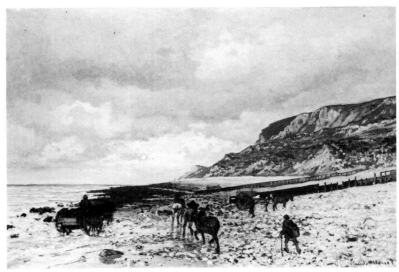

180. *The Pointe de la Hève at Low Tide*, 1864, 51.5 × 73, W 40, Private Collection

181. *The Pointe de la Hève at Low Tide*, 1865, 90 × 150, W 52, Kimbell Art Museum, Fort Worth

182. *Fishing Boats at Sea*, ?*c.*1868, 96 × 130, W 126, Hill-Stead Museum, Farmington, Conn.

2 October 1881, sending five canvases, Monet added: 'At the last moment I wanted to sign them and to retouch them here and there, but I didn't have enough time. So I'll do it when I get to Paris.' On 17 December, just after his move from Vétheuil to Poissy, he wrote of another group of paintings: 'I have worked at the few canvases I owe you; as soon as they are finished, I shall bring them to you.' The paintings delivered in December comprised one coast scene from Monet's stay at Fécamp that spring and five Vétheuil paintings, which shows that he was already willing to retouch his canvases away from their subjects.[13]

Further evidence for retouching in 1880–1 lies in the group of paintings delivered to Durand-Ruel on 19 February 1881, which included a summer subject and a painting of ice-floes, both of which are dated 1881 though the outdoor work on both must have been done in 1880. At least two other canvases dated 1881 also show the melting ice-floes, though all three presumably derive from the short-lived thaw of early January 1880.[14] In the 1880s Monet normally dated his paintings with the year in which he had begun them, though signature and date were added on the picture's completion for sale or exhibition, which was sometimes considerably later. The few examples of postdating on paintings which Monet finished in the 1880s may perhaps show that these canvases were more extensively reworked before their sale. This demonstrably became Monet's habit in the 1890s, but cannot be firmly established for the 1880s.[15]

Some writers have assumed that this retouching was a new development in the early 1880s, but this conclusion seems unwarranted: documentary evidence of any sort about Monet's methods in the 1870s is fragmentary in the extreme, and he spoke of retouching in 1881 as if it were a routine matter; nor do the paintings themselves suggest any marked change in his methods around 1880. Indeed such retouches were, it seems, equally normal in December 1877, when he wrote to de Bellio of a painting which he had just sold him: 'I told you that I wanted to retouch it before giving it to you, and since then I've been bothered by so many things that I have not found a moment's quiet to do this little task.'[16] Presumably Monet made studio retouches throughout the 1870s, primarily when practical problems prevented him from finishing out of doors. A hint of such problems emerges from Le Roux's description of him 'hindered by the manoeuvres of the trains' while painting the Gare Saint-Lazare. The carefully planned arrangement of the smoke in these paintings (e.g. pl. 101) shows that they were the result of a more complex process than usual. However, the reworked surfaces of some other paintings of the 1870s (e.g. pl. 143) suggest that they had to be elaborated or revised; this must often have been done in the studio.[17]

During the 1880s, paintings done on his travels put more pressures on Monet than those done at home. Problems of acclimatisation, uncongenial living conditions, the realisation that he could not easily return later to his motifs, and the desire to justify his travels by bringing back a large body of work, all made him very dissatisfied with many of the paintings he brought back from his expeditions. As each trip drew to a close he lamented the incompleteness of his work and the pressures he had suffered. From 1881 to 1886, when Durand-Ruel was buying the bulk of Monet's work as soon as he could lay his hands on it, we can trace the difficulties Monet had in completing and parting with the paintings from his travels. Monet's financial situation made him keen to keep the dealer happy, but his letters and Durand-Ruel's stock books show that increasingly long intervals began to elapse between his return from a trip and the delivery of the paintings, as the studio came to play a larger and more central role in his methods.

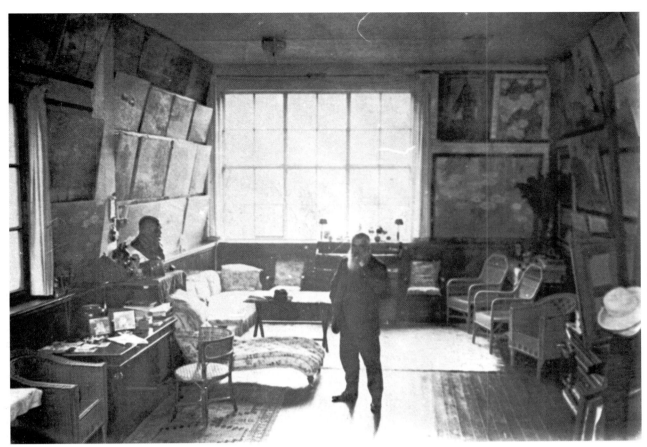

183. Photograph of Monet in his *salon atelier* at Giverny, c.1915

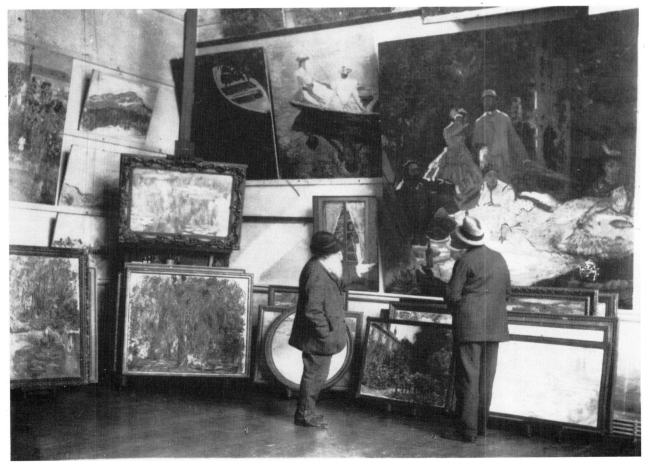

184. Photograph of Monet in his second studio at Giverny, with the Duc de Trévise, 1920

In the early 1880s Monet still found no great difficulties in making his pictures ready for sale. On his first trip to Pourville, early in 1882, he insisted on seeing all his canvases together after he got home, but was still able to deliver twenty-three paintings within a fortnight of his return. At Pourville that autumn bad weather thwarted him, and shortly after returning home to Poissy he announced that he had nothing finished; however, twenty-five paintings followed within three weeks. Further paintings from the Pourville area did, though, emerge during 1883, including five in December, when he had not visited the place for over a year.

After his three weeks at Etretat in February 1883 he had greater problems, partly because his stay had been so short. As we have seen, he failed to finish any Etretat paintings in time for Durand-Ruel's exhibition in March, and, partly because of the interruption of his move to Giverny, he had still delivered none by 22 July, when he wrote that the bad weather was allowing him to 'work indoors and finish as many canvases as possible for you; but it is not as easy as you think'. As he despatched the first five Etretats on 27 July he added: 'I have made you wait a bit, but I will tell you that those retouches which seem to do nothing are much more difficult than you would think, and I've had a lot of trouble . . . I have followed your advice and have been able to make some quite good things from canvases I had considered lost.' Even then there was a last-minute hitch, because, Monet wrote on 29 July, 'just as I was signing one of the pictures I did a clumsy retouch on it which I had to repair . . . one or two canvases will still be wet'. The next Etretats did not reach Durand-Ruel until November, and five followed in December, ten months after his return from the coast.[18]

Less clear conclusions can be reached from later deliveries of Etretat paintings, since Monet stayed there in 1884, 1885 and 1886, and the paintings delivered cannot be linked to specific visits. He told Durand-Ruel that the weather and social pressures had prevented him from working on his 1884 visit, but five Etretats survive dated 1884. Four of these were signed and dated late in his life, when his dating was often inaccurate, but one was in circulation by the 1890s, and may, exceptionally, bear the date of its completion. The 1886 date on the one known canvas of the bay in the rain (pl. 174) may well also be a misdating, if this is indeed the picture which Guy de Maupassant watched Monet painting in October 1885.[19]

Another Etretat canvas, a view of the Manneporte, caused Monet great trouble. He exhibited it at Petit's *exposition internationale* in summer 1886 and afterwards offered it to Durand-Ruel, who was not wholly satisfied with it and asked him to retouch it. At first Monet refused to do this, but relented, sending it to him in January 1887. It is impossible to tell which of two versions of the subject is the painting in question; if it is pl. 130, the very extensive revision of its whole composition, which will be described later, is eloquent testimony to the problems it caused Monet.[20] At the time Durand-Ruel was asking him to rework it, in August and September 1886, Monet was planning to revisit Etretat to finish some paintings, but changed his mind and left for Belle-Isle. He apparently never worked there again, and so was left with a large number of incomplete Etretat canvases; this explains the high proportion of his paintings of the place which were either signed and sold in a rough state late in his life (e.g. pl. 198), or left unfinished on his death.[21]

Easier to disentangle are the details of paintings of places Monet only visited once, notably Bordighera and Menton (1884) and Belle-Isle (1886). The problems such canvases caused emerge from a letter he wrote to Durand-Ruel on his return from the South in 1884: 'I haven't a single canvas which doesn't need to be looked at again and carefully retouched, and that cannot be done in a day. I need to see all my work peacefully, in the right conditions. I have worked for three months in front of nature, taking great pains and never feeling satisfied, and it's only here during the last few days that I can see what to make of a certain number of paintings. You must realise that among the large number of *études* I have made, not all can be delivered to the trade; some could be very good, I think, and others, even though a bit vague, could turn into good things if they are carefully retouched, but, I repeat, this cannot be done from one day to the next.'[22]

As he returned home from the South in mid-April 1884, he told Alice Hoschedé that he had 'very nearly fifty canvases' of which 'half are not saleable'; once at Giverny, he spent the whole of the next month working in the studio, presumably on his southern canvases.[23] He started deliveries of them six weeks after his return, sending thirteen in late May, and nine in mid-June; four more followed in the first half of 1885. These purchases total twenty-six, slightly over the half he had expected to be saleable of the total of almost fifty, but the dates of the sales suggest that even on these Monet had much to do in the studio. At least forty landscapes survive from this trip; some of those Monet abandoned in the 1880s were signed and sold late in his life (e.g. pl. 156), and others remained uncompleted at his death.

From his two months on Belle-Isle he brought back in December 1886 'nearly forty canvases, but there are at best five or six good ones'; he told Durand-Ruel that he could not complete any until he had seen them in the quiet of his Giverny studio.[24] How long these retouches took is not clear, since the pattern of his sales was more complex in 1887 as a result of his disagreements with Durand-Ruel and his sales to Boussod & Valadon and Georges Petit.[25] The greatest puzzle over the Belle-Isle paintings is the existence of five dated 1887; these are not late misdatings, since they were quickly sold. Since Monet did not return to Belle-Isle in 1887, we must assume that they were given the date of their completion, though this would at first sight be strange, because the bulk of the Belle-Isles are dated 1886 and it seems unlikely that these were all completed between his homecoming around 2 December and the end of the year. The alternative is that the canvases dated 1887 were wholly executed in the studio. On very rare occasions, as we shall see, Monet made studio versions of his landscapes, but there is no clear evidence for this, except for large paintings, between the 1860s and the 1890s; moreover only one of the 1887 canvases corresponds closely with a known version of the same subject dated 1886.[26] It seems more probable that the 1887 paintings reached Giverny in a particularly sketchy state and involved more reworking than those Monet dated 1886.

From his three months at Antibes, Monet returned home at the beginning of May 1888 'in despair, as I have some canvases which have improved, but are inadequate in their present state'.[27] Ten were ready for the exhibition which Théo van Gogh mounted for Boussod & Valadon in June, and others were bought by Petit, Boussod & Valadon and Durand-Ruel in 1889 and 1890. Giverny paintings, too, might need studio reworking, such as a group of spring and summer subjects of 1890 which Monet had to retain for retouching through October 1890 (e.g. pls. 135, 159).[28]

However, by this date time lags such as these do not necessarily indicate Monet's difficulties in finishing the pictures. Now that several dealers, as well as individual collectors, were competing for his work, he began to keep paintings in reserve for prospective

customers, instead of selling all that he could to Durand-Ruel, as he had in the earlier 1880s when Durand-Ruel was the only willing buyer. Monet had begun to retain paintings in this way by 1889, as is shown by the large number of recent pictures in the catalogue of his exhibition at Petit's gallery for which no owner is listed; some of these seem to have been lent anonymously by Boussod & Valadon, but most were clearly Monet's own.[29] In March 1892 he made this new position explicit to Durand-Ruel, who still expected to have his pick of Monet's work: 'As for your regrets about Messrs. Montaignac, Boussod, etc., you know that I'll do my best to give you preferential treatment, but I cannot and will not send people away, since I find it absolutely wrong and ill-advised for an artist to sell exclusively to one dealer. Moreover, for the future I do not want to sell my canvases in advance, I want to finish them first, without hurrying, and to choose after a certain time which ones I want to sell.'[30]

During the 1880s retouching was always a second best, a chore which he would use any excuse to defer, though it became increasingly central to his procedure. Ideally it could be done on rainy days, and in the earlier 1880s Monet did his best to confine it to these. Indeed on his arrival at Giverny in 1883 he seems not to have expected retouching even to fill the periods of bad weather, since he spent time gardening 'in order to gather some flowers to paint on bad days'. When Durand-Ruel commissioned a sequence of decorative still life panels in 1883, he hoped to paint them on rainy days, but soon found that the combined claims of the decorations and his retouching were keeping him from outdoor work for long periods; thereafter he virtually abandoned still life.[31] In 1890 he again deferred retouching until a period of bad weather, as he began work on the Grain Stacks series.[32]

Retouching did, though, begin to keep him from painting outside. It was over a month after his return from the South in April 1884 before he was able to resume work out of doors.[33] The problems of an accumulated backlog only came to a head in 1891–2, when Monet, still clearly unused to the implications of being so much in demand, committed himself to sales of many paintings he had not finished. His declaration to Durand-Ruel in March 1892, that he planned only to sell his work after completing it, was a case of shutting the stable door after the horse had gone. Only in December 1892 was he able to declare in triumph: 'At last I have finished everything I had to deliver. What a relief! Now I'll be able to work out of doors again.'[34]

Though the evidence of his sales becomes more ambiguous after around 1890, Monet's problems in finishing his work can still be amply charted. His letters from Giverny reflect the increasing rivalry between his desire to work out of doors and the demands of finishing his paintings. Regularly he deferred his most important exhibitions because he could not bring the canvases to a satisfactory state. So the Rouen Cathedral series was not shown until May 1895, over two years since his last stay in Rouen, alongside eight pictures from his recent trip to Norway. This juxtaposition, of works completed under the fresh inspiration of working from nature and paintings worked up and pondered over a period of years, shows the conflict Monet had come to feel between making direct records of his experiences and evolving ambitious, calculated tours-de-force. The London series was exhibited only in 1904, over three years since he had last been in London. On his final visit to London in 1901, he had written that it was 'not a place where one can finish on the spot; one never finds one's effects over again', and when he got back to Giverny he invited Geffroy to come and see 'the mass of studies, quick sketches and attempts of all sorts that I've brought back with me'. Two years later he wrote again to Geffroy in quite a different vein: 'My mistake has been to want to retouch them; one so quickly loses a good impression . . . those attempts and lay-ins could have been shown; but now that I have retouched *all* of them, I must at all costs go through to the end.'[35] A year later they were ready for exhibition. Then he twice deferred the exhibition of his Water Lilies, in 1907 and 1908; with this series, his letters show that the crucial phase in his attempts to finish took place early in the year, outside the flowering season of the lilies, and thus in the studio. He was finally able to declare them complete in 1909 because 'my trip to Venice has had the advantage of making me see my canvases with a clearer eye.'[36]

It was only after 1900 that writers began to comment publicly on Monet's use of the studio, particularly in relation to the London series; Monet himself seems to have been prepared at this point to admit that the paintings had not been completed on the spot. Maurice Kahn quoted him at the time of their exhibition in 1904: 'After four years of work and retouching on the spot, I have had to resign myself to only taking notes, and completing here, in the studio.' Desmond Fitzgerald and Arsène Alexandre, too, spoke of the Londons as in a sense a studio series.[37] With the Venice series, Marthe de Fels quoted him lamenting that he had finished the paintings in the studio: 'It is detestable . . . I finished from memory, and nature has had her revenge.' His letters confirm that much studio work went in to this series, too, between his return from Venice in 1908 with 'some attempts, some beginnings' which would 'merely be souvenirs for me', and the exhibition of the pictures in 1912, when he quickly regretted working the pictures up for show (e.g. pl. 166). Nevertheless, his stepdaughter Blanche, defending to the last his reputation as a plein-airist, insisted that the Venice paintings were 'not at all painted in the studio'.[38]

Monet denied that he had any use for photographs of his subjects, although he did own several photographs of Rouen Cathedral and of London. He replied testily when news of the latter leaked out in 1905: 'I do not know Mr Rothenstein, still less Mr Alexander, but only Mr Harrison, whom Sargent asked to make me a little photograph of the Houses of Parliament which I have never been able to use. But that is of no great significance, and whether my Cathedrals, my Londons and other canvases are painted from nature or not, that is nobody's business and is of no importance. I know so many painters who paint from nature and create nothing but horrors.' A black and white photograph can have helped little when Monet was surrounded by his own paintings of a subject, except as a reminder of some detail, but this letter shows how, even after 1900, Monet was reluctant to admit to the extent of his studio work.[39]

Some of his later paintings bear seemingly anomalous dates. The single Creuse painting dated 1888 must be a simple error, since Monet did not go there until 1889, though the handwriting of this signature is of around 1890. During the 1890s he began regularly to date paintings with the year of their completion, starting with the Grain Stacks: the fifteen canvases exhibited in May 1891 were all dated 1891, though the summer effects among them were begun the previous year.[40] Similarly, the Rouen Cathedral paintings, begun of Monet's visits to Rouen in 1892 and 1893, are all dated 1894, and the majority of the London series are dated 1902, 1903 or 1904, although Monet only worked in London in 1899, 1900 and 1901. Here the dates may refer to the year in which Monet did the principal body of work on each canvas. However, with the Water Lilies exhibited in 1909, the dates, ranging from 1903 to 1908, probably refer to the year in which particular pictures were begun, although he continued to work at them until their exhibition.[41]

185. *The Ice-Floes*, 1880, 61 × 100, W 567, Musée d'Orsay, Paris

specifically treating them as an ensemble as he finished them; and whether any individual canvases were entirely painted in the studio.

After 1900 his letters make it clear that paintings were completed by reference to each other, as he explained about the Londons from Giverny in 1903: 'For the work I'm doing it is indispensable to have them all before my eyes, and, to tell the truth, not one is definitively finished. I'm bringing them all along together, or at least a certain number of them . . . What I'm doing is extremely delicate.' He had begun to work in this way by 1901 and continued to do so.[43] Grace Seiberling has argued that this procedure began with the Grain Stacks, citing Guillemot's 1898 description of the execution of the Early Mornings on the Seine: 'The working procedure which we have noted above dates from the Stacks.' The method 'noted above' is, though, simply that of working in series. Only later in his account does Guillemot describe the Early Mornings displayed as a series on easels in Monet's studio, and then without suggesting that they are being reworked there.[44] Some degree of simultaneous retouching probably did begin with the earlier series, but it seems likely that this only became extensive with the London series, when Monet worked for long periods on very large numbers of canvases in the studio.

Alexandre described Monet's process in the London series rather more precisely: 'His work [was] partially recommenced in the studio, and more than that, several paintings contributed to recompose a single one, or a smaller number. Thus he repainted the views of the Thames in his studio, keeping them for almost two years, reshaping them and combining them.'[42] This account raises two questions: how far Monet worked up his series in the studio as a group,

One letter about the Londons raises the possibility that some canvases were executed entirely in the studio. In 1905 he delayed sending Durand-Ruel a view of Waterloo Bridge because, he wrote, 'it is useful to me to keep it in order to make another one with smoke,

186. *The Ice-Floes*, 1880, 97 × 150.5, W 568, Shelburne Museum, Shelburne, Vt.

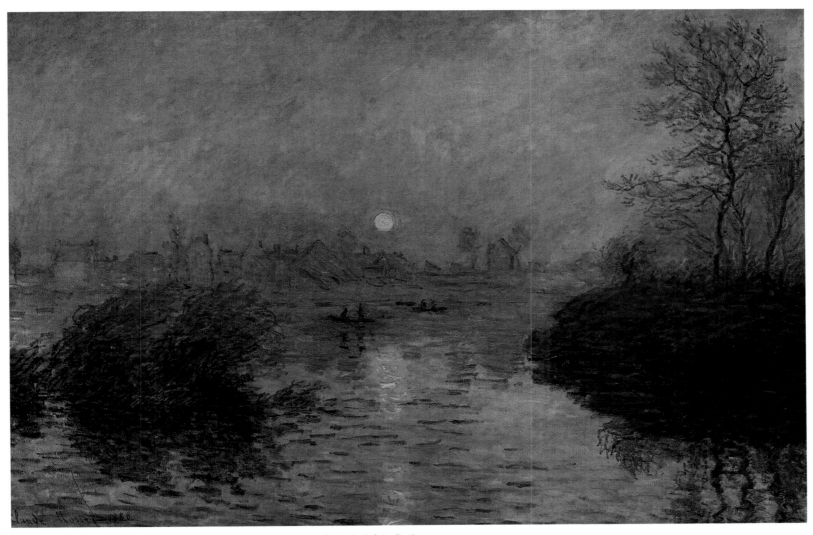

187. *Sunset on the Seine, Winter*, 1880, 100 × 152, W 576, Musée du Petit Palais, Paris

as you have requested'.[45] This shows how Monet might work to order, but it may relate to adding a specific effect to a canvas already laid in, rather than to starting a fresh canvas; many London paintings had smoke added to them late in their execution (e.g. pl. 268). There is, though, some evidence that Monet may have painted extra canvases of Rouen Cathedral at Giverny. In 1905 Fitzgerald wrote: 'There were originally about twenty-five of the "Cathedral Series", but as the artist added several afterwards, there are now possibly thirty-five in existence.' It seems possible to verify this. Monet painted at Rouen early in 1892 and early in 1893, but not thereafter; on 30 October 1893 Julie Manet visited Giverny with Berthe Morisot, and specified in her diary that there were, then, twenty-six Cathedral paintings. Thirty of the series exist today; only twenty-six of these in fact show the west façade seen from the south-west (e.g. pls. 138, 163–4), but one of the two views from due west (pl. 240), and both of those of the Cour d'Albane (e.g. pl. 267), were included in the 1895 exhibition, which shows that Monet did, then at least, regard these canvases as part of the series proper.[46] Thus it seems likely that Monet did add to the series in the studio.

With these possible exceptions, Monet began all his standard-sized subjects on the spot. However, even in the 1870s and 1880s when his outdoor work was at its height, he used the studio for the execution of some large paintings, that is, larger than size 40 (1 metre

for their longer side); this was a continuation of his normal practice in the 1860s. The few large canvases of the 1870s and 1880s were painted for exceptional reasons, either as decorations or as important paintings for exhibition. Those of the 1870s were, it seems, all conceived as decorations. No preparatory studies exist for *Luncheon* of 1873 (pl. 263), originally titled *Decorative Panel*, or for *The Turkeys*, painted for Hoschedé in 1876 (pl. 5), and we cannot tell how they were executed; but smaller canvases very probably served as studies for the other three large decorations made for Hoschedé (such as pl. 4), which were presumably painted indoors.[47]

When in 1880 he decided again to submit to the Salon, he sent two size 80 (*c.* 100 × 150 cm) canvases, *Lavacourt* (pl. 270) and *The Ice-Floes* (pl. 186), of which only the former was accepted. A third canvas exists of the same size and like the other two dated 1880, *Sunset on the Seine, Winter* (pl. 187). Monet described these three paintings in a letter to Duret on 8 March 1880: 'I am working hard on three large canvases, of which two only are for the Salon, because one of the three is too much to my personal taste to send it. It would be refused, and instead I have had to do something more judicious, more bourgeois.'[48] *Lavacourt* (pl. 270) answers the last description best. It is a summer effect, though painted early in 1880, and must have been painted from outdoor canvases of the previous years; though identical to no single one of these, all its features are found in

153

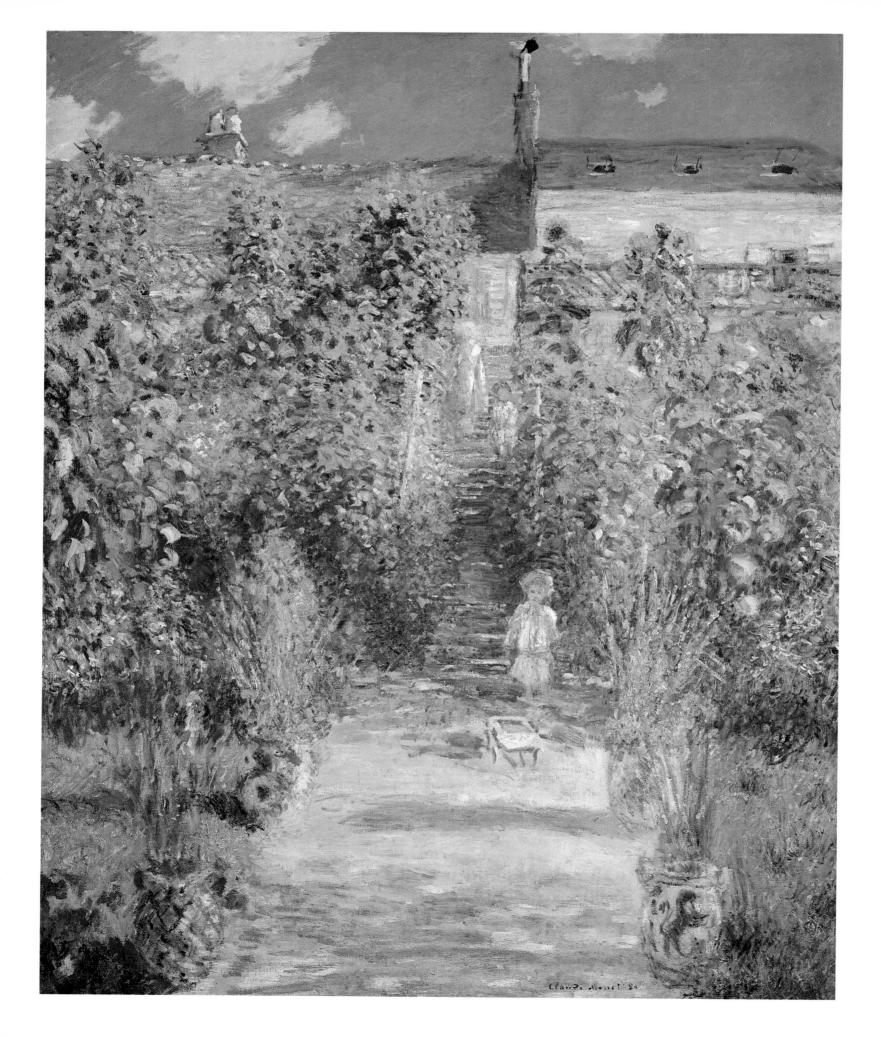

189. *Monet's Garden at Vétheuil*, 1881, 100 × 81, W 683, sold Christie's, London, 15 April 1975, lot 31

other versions of the subject.[49] The rejected painting, *The Ice-Floes* (pl.186), showing the melting ice of January 1880, corresponds precisely, ice floe for ice floe, with a smaller canvas (pl. 185), of which it is a direct copy. The canvas 'too much to my personal taste' must be *Sunset on the Seine* (pl. 187); its similarity to the notorious *Impression, Sunrise* (pl. 199) explains Monet's pessimism about its chances with the jury. Monet valued this painting highly, as he showed when telling Durand-Ruel what large paintings to include alongside *The Ice-Floes* in the 1882 Impressionist group exhibition: 'Above all do not put in the big Lavacourt, which was in the Salon, but rather the big winter landscape with sunset.' Though no smaller painting corresponds precisely with this, it is very probably a variant on a similar version of the scene.[50]

Another size 80 canvas exists from Vétheuil, *Monet's Garden at Vétheuil*, dated 1880 (pl. 188); the subject also appears in three smaller canvases, all dated 1881. The date of the large one does not, though, prove that it antedates the others, since it is in the handwriting of Monet's old age, and the canvas appears, apparently unsigned, in photographs of his studio around 1920 (e.g. in pl. 184). The disposition of its clouds is identical to those in pl. 189, from which it differs only in the addition of figures on the stairs and two further vases in the foreground. These additions are probably part of the process of monumentalisation which Monet applied to the subject when he repainted it in the studio from the smaller outdoor canvas.[51]

At Etretat in 1883 he planned to 'bring back masses of documents in order to paint some large things at home', presumably with exhi-

bition in view, but he had to abandon these plans.[52] From his southern trip of 1884, though, two large canvases did emerge, both direct enlargements of outdoor landscapes, one a very large (139 × 180 cm) canvas of the Corniche de Monaco seen from Cap Martin (pl. 190, enlarged from pl. 28), the other a view of Bordighera painted as a decoration for the *salon* of Berthe Morisot's new house. Monet had promised a decoration before leaving for Bordighera, initially hoping to paint a scene at L'Estaque for this purpose, presumably a subject he had seen on his visit to see Cézanne with Renoir in December 1883. However, he failed to do this on the trip, and invited Berthe Morisot to Giverny to see if they could choose together, from his southern canvases, 'something which lends itself to a decoration'. This letter shows that he had decided that the decoration should be a direct enlargement of an outdoor canvas; it corresponds in all its essentials to a normal-sized canvas of the scene. We cannot tell whether the initial plan of a L'Estaque subject would have similarly involved a studio enlargement, or whether Monet was initially thinking of tackling the large canvas out of doors.[53]

Further plans for large studio paintings may be indicated by two letters of December 1885, saying that he wanted 'to get back to big paintings' and that he was planning to enlarge his studio.[54] Though Monet may here be referring to canvases no larger than size 40 (81 × 100 cm), these plans may represent the germ of the projects for large figure paintings which Monet undertook in 1886–90. We know little of the execution of the figure paintings; the preoccupations which led Monet to paint them suggest that they may, in part, have been a rare instance of Monet undertaking large canvases out of doors, but the existing drawings for them (see pls. 191, 280) show that their compositions were carefully worked out in advance.[55]

190. *The Corniche de Monaco*, 1884, 139 × 180, W 891, Private Collection

Monet painted no large canvases between 1890 and around 1914, when he began work on his last monumental paintings, the Water Lily Decorations (pls. 92, 269). These were entirely painted in the studio which Monet built for them, but many smaller paintings of the pond exist, some of them undoubtedly painted in the open, which Monet used as studies and *aides-mémoire* for the decorations. The exact processes of transformation involved have yet to be

188. (left) *Monet's Garden at Vétheuil*, 1881 (dated 1880), 150 × 120, W 685, National Gallery of Art, Washington, D.C.

191. *The Blue Boat*, c.1887, 109 × 129, W 1153, Private Collection

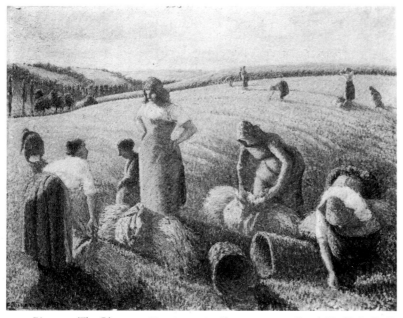

192. Pissarro, *The Gleaners*, 1889, 65.5 × 81, Kunstmuseum, Basel (Dr H.C. Emile Dreyfus Foundation)

studied in any detail, but the large paintings seem to be lyrical improvisations based both on memory and on the smaller canvases.[56] In a sense they are both the culmination and the resolution of the conflict in Monet's methods between the open air and the studio.

The concerns which led Monet gradually to change his procedures in the 1880s and 1890s were not his alone. Both Pissarro and Renoir were at the same time working out their own solutions to much the same problems. On one level this happened as they, like Monet, often found themselves thwarted in their attempts to capture nature's most transitory effects, but they each, at a certain point, came to give studio work a much more positive value, as a mirror to the inadequacies of the whole open-air aesthetic.

In 1882, after his trip to Italy, Renoir wrote that 'Raphael never worked out of doors but he had nonetheless studied sunlight, for his frescoes are full of it', and said that he himself was seeking 'broad harmonies, without any longer preoccupying myself with small details which extinguish the sunlight instead of making it blaze'. To achieve this, he adopted on Guernsey in 1883 the method of painting 'documents for making pictures in Paris'; these would supply him with 'a source of real and pleasing motifs which I will be able to make use of'.[57] Through most of the 1880s Renoir worked in the traditional way, building up studio compositions in the winter, from drawings and from his outdoor notations of the previous summers. However, by around 1890, he came to find this dependence on the studio restricting. He commented when working out of doors in Brittany in 1891 that 'these three months will have got me further than a year in the studio', and wrote from La Rochelle, perhaps in 1890: 'I have lost a lot of time by working within my four square metres of studio. I would have gained ten years by doing a little of what Monet has done.'[58] Open-air painting, though, always remained a fair weather pursuit for Renoir.

Pissarro came by about 1890 to regard his studio work (e.g. pl. 192) as entirely different from open-air painting. He made his most unequivocal declaration in favour of the studio in an 1892 interview: 'I do not paint my *tableaux* directly from nature: I only do that with my *études*; but the unity which the human spirit gives to vision can only be found in the studio. It is there that our impressions, previously scattered, are co-ordinated and enhance each other's value to create the true poem of the countryside. Outside, one can seize the beautiful harmonies which immediately spring to the eyes: but one cannot sufficiently examine oneself, so as to express in the work one's intimate feelings. It is in search for this intellectual unity that all my efforts are directed.'[59] However, Pissarro later began again to execute his final canvases in front of their subject. While he was working on his last group of paintings, of the port of Le Havre in 1903, he was seeking, above all, to establish 'the accord between sky, land and sea'; this is a continuation of his 1892 demand for 'unity', but the unity now depended on specific atmospheric effects, in a way far closer to the preoccupations of Monet's series.[60]

In the normal patterns of Monet's work, the studio was used for the retouching and completion of paintings which had been begun out of doors. His studio enlargements of outdoor works were occasional and exceptional. The evidence about his increasing difficulties in finishing his canvases must be correlated with his more general ideas about finish, and with a discussion of the appearance of his fully finished paintings, in order to suggest the likely nature of his studio retouching, as it became more integral to his working processes.

CHAPTER NINE
MONET'S ATTITUDES to FINISH

Anyone who says he has finished a canvas is terribly arrogant.
Monet, 1893[1]

WITH very few exceptions Monet's paintings were in part executed in front of their subject, but he became increasingly aware of the factors involved in transforming an outdoor painting into a finished picture. Even though the final work was one and the same canvas that he had begun out of doors, it had to meet certain criteria before he could regard it as finished. The evidence of documents and of the paintings themselves shows that Monet valued both spontaneity and finish, and struggled to reconcile their conflicting claims.

In working up for exhibition the same canvases that he had begun out of doors, Monet was breaking with conventional landscape practice, but in his letters and recorded comments he conformed to the traditional vocabulary of the French artist, in the terminology he used to distinguish between various sorts of preparatory work, and complete paintings of different types: *étude*, *esquisse*, *pochade*, *impression*, *ébauche* and *croquis*. His view of the status of these varied types of work provides a key to his attitudes to finish. The use of these terms in French artistic theory underwent many changes – changes which reflect basic questions about picture-making; a summary of the ways in which the meanings of these terms became modified or blurred during the nineteenth century will provide a context for the discussion of Monet's own ideas.[2]

The conventional definitions are given in the Dictionary volume of Paillot de Montabert's *Traité complet de la peinture* (1829): 'The *croquis* is the first outline on the paper or canvas of the first idea of the composer, the *esquisse* is a trial work on a small scale, in which the composer combines the principal relationships, and even makes some changes from the *croquis*; the *ébauche* is the first work which the painter does on the *tableau* itself. So the *croquis* is only a rough draft; the *esquisse* is only a small-scale trial for the *tableau*, and the *ébauche* is the beginning of the *tableau* itself, or the first work on the *tableau*.' '*Pochade*. This word is much used by painters, because they need it to express, in relation to a first coloured *esquisse*, what one means by draft in the art of writing. One does need a word for these efforts which are free or boldly dashed off (*pochés*), sometimes quickly dabbed . . . This work, coarse, abrupt and slapdash though it is, often produces a very precious attempt; it is different from the normal working of the *esquisse*, which is treated with greater restraint and less indecision.' '*Études*. Certain preparatory

works . . . certain trial fragments in painting', as opposed to 'whole and complete works'.[3] For Valenciennes in 1800 the aim of the painter in making '*études* from nature' was to 'make *études* which can help him in due course compose *tableaux*'. However, Paillot makes it clear that even by 1829 artists were presenting to the public as *études* the paintings which they had been unable to finish. He warned students against this habit, which allowed them to ignore 'that unity of propriety, style, character and execution which it is so important to possess, in order to attain the goal of the art'.[4]

Several of these terms acquired different, or modified, interpretations later in the century. The two whose meanings remained constant were *ébauche*, the lay-in, which, as we have seen, consistently refers to the first session of work on the final canvas,[5] and *croquis*, a preparatory graphic notation of an effect or detail for a composition; *croquis* does not normally refer to work in oils.

Étude is the term with the widest range of meanings, as Paillot's account suggests. Throughout the century it retained its meaning as an exclusively preparatory work, as documentation for composing a painting. It appears thus in Jules Adéline's *Lexique des termes d'art* of 1884, and even after 1900 Ernest Hareux insisted that the *étude* was only 'the fragment executed, elaborated in its smallest details, without concern for the ensemble'.[6] However, its wider meaning was acknowledged alongside its traditional sense in the *Dictionnaire de l'Académie des Beaux-Arts* in 1896, which says that the *étude* may be treated as a work in its own right, and that 'in the domain of landscape painting one can equally give the name *étude* to a *tableau* painted directly from nature and, in a sense, in the form of a portrait'. The *Dictionnaire* still, though, maintains that the function of the *étude* remains essentially preparatory for a true painting.[7] To find an unequivocal defence of the values of the *étude* we must look to the informal sources, the letters of artists. Thomas Couture, for instance, wrote to a collector refusing to retouch an *étude* because 'productions of this sort have a logic of spontaneity to which reasoning can add nothing'.[8]

The traditional role of the *esquisse* was quite distinct from that of the *étude*. It was a quick mapping out, on a small scale, of a painting's composition. Its particular characteristics were freedom and boldness of handling, which might be seen either as virtues or as snares for the unwary. In 1833 Louis-Charles Arsenne, in a widely circulated manual, quoted Diderot's view of this dichotomy: Diderot had written that '*esquisses* often have a fire which the *tableau* lacks', but

elsewhere cited a contemporary comment that 'it needs thirty years of craftsmanship to learn how to preserve one's *esquisse*'. This warning was echoed by Hector Allemand in 1877: 'An *esquisse* often beguiles you too much, if it is not supported by great knowledge.'[9] Adéline's *Lexique* reiterates both sides of the argument: 'The *esquisse* must be executed quickly, with vigour and dash . . . The *esquisse* has the heat of improvisation . . . When a *tableau* is insufficiently studied, its execution insufficiently detailed, one characterises it by saying: "It's only an *esquisse*."' Under the heading 'painted *esquisse*', Adéline adds that it should have 'indications of colouring and modelling, applied with a broad, free touch. Some painted *esquisses* sometimes have the value of true *tableaux*.'[10] The *Dictionnaire* in 1896 put its merits more forcefully: 'An *esquisse* interests the spirit and the gaze of the spectator by the very freedom with which it is treated, by the air of frankness it expresses, by the boldness of the indications of which it is made up, and even by its quality of incompleteness, with respect to the material resemblance of the bodies or objects represented.' Delacroix in his *Journal* harped on the problem of retaining the qualities of the *esquisse* in his finished works.[11]

The landscape *esquisse* seems to have become acceptable rather earlier as a painting in its own right. The French edition (1835) of John Burnet's *Practical Hints on Colour in Painting* (which Delacroix read) made its values clear: 'In painting a landscape *esquisse* from nature, and when one has time only to seize the principal features, detailing only the objects which are particularly striking or interesting, one often satisfies the spectator the more, because he experiences a sensation which corresponds to the truth of the *impression* he has received', in contrast to the finished work, which loses the general effect in favour of details.[12]

If we compare Burnet's discussion of the landscape *esquisse* with the *Dictionnaire*'s treatment of the landscape *étude*, quoted above, we see that in the field of landscape there might be no clear distinction between the two, although the original meaning of the two words was widely different. The landscape *esquisse* was particularly important in Daubigny's methods. His friend Frédéric Henriet described the 'prodigious multitude of *esquisses*' around his studio, and his pupil D. W. Tryon commented: 'The number of sketches which he brought back after a few days' journey were surprising, and many of the smaller paintings which are today found in various collections are the results of a few hours' work, and were rarely touched the second time.'[13]

The meaning of *pochade* was generally agreed to be that which Paillot gave it, a quick *esquisse*. Artists were regularly warned not to be led astray by it, for instance by Allemand in 1877: 'If, neglecting serious studies, you abandon yourself to begin with to the charm of the *pochade*, you will not learn enough and you will not be able to express anything precise in a large-scale canvas.'[14] Karl Robert in 1878 defined the *pochade* both as 'an *ébauche* executed with a certain care' and as 'necessarily an incomplete *étude*', since it concentrated on a simple notation of values: 'Many artists and particularly amateurs are content to paint *pochades* and not *études*, and that is a great mistake, because, if the *pochade* is often useful, it accustoms the artist to be easily satisfied, and it is to this mistake that we owe the school called the Impressionists.'[15] In the 1891 edition of his *Traité*, Robert gave his chapter 'About the *Pochade*' the new title 'The *Impression* from Nature, the *Pochade*', which shows how closely linked the two terms were.

Impression had many precedents before Monet used it in the title of *Impression, Sunrise* in 1874. At first it referred to the initial effect which a natural scene made on the painter, and to the effect which a painting had on the viewer. The earliest traced example of these uses is in the passage from the French edition of Burnet's treatise (1835), quoted above; they were common among artists in the 1850s and 1860s, being used, among others, by Corot, Millet, Manet, Boudin and Delacroix. By the 1860s *impression* began to be used by transference to describe the painting which recorded such a natural effect. Gautier, for instance, used it in a particularly prophetic context in 1861, in criticising Daubigny because he 'contents himself with an *impression* and so neglects the details. His *tableaux* are only *ébauches*, and *ébauches* which have not been taken far . . . they offer only juxtaposed patches (*taches*) of colour.'[16]

In this context we can examine Monet's use of these terms. He consistently described as *études* his paintings from nature which were in an incomplete state, as in a letter to Bazille in 1864: 'I am quite content with my stay here, although my *études* are far from being as I should like. It really is appallingly difficult to do something that is complete in every respect.' He was presumably trying at this time to follow a course of study such as that which Troyon had urged on him in 1859: 'From time to time, go to the country to make *études*, above all take them as far as you can.'[17] In the 1860s many of his small *études* were preparatory for large Salon pieces, but he might finish them as independent paintings in their own right; in 1864 he sent Bazille, as complete works, three of the outdoor *études* he had mentioned to him.[18] However, from the 1870s onwards he consistently used *étude* to describe incomplete canvases, while he was working on them, paintings which would themselves become *tableaux* or *toiles* when finished. In 1882 he described as *études* paintings on which he had spent up to twenty sessions without completing them, and in 1884 made explicit the disctinction between *toiles* and *études*: 'I have eight finished *toiles* . . . Today I worked at seven *études*.'[19] Clemenceau later described the role of the studio in Monet's methods when 'the moment comes for him to move on from the *étude* to the *tableau*'. When, in the Water Lily Decorations, he returned to the traditional method of executing the final canvases in the studio from preparatory outdoor studies, these were again classified as *études*.[20]

Only very occasionally does Monet seem to have used *etude* to characterise a painting that was in some sense complete. In May 1881 he sold Durand-Ruel a canvas with the title *Etude de mer vue des*

193. *Study (étude) of the Sea from the Cliff-tops*, 1881, 60 × 81, W 649, Private Collection

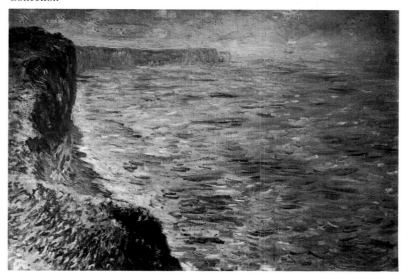

hauteurs (pl. 193); it was exhibited with the same title in the seventh group exhibition in 1882. Quite sketchy in execution, it is also the only traced example of a painting Monet sold to Durand-Ruel unsigned, which indicates its unusual status. Once later he exhibited a painting similarly titled. In 1891, with the Grain Stacks, he included *Etude de rochers, Creuse*, lent by Clemenceau; the identification of this presents great problems.[21]

An odd use of *étude* occurs in a story told by Durand-Ruel to Gimpel: 'Before beginning his series, he made of each a good seventy *études* before finding its definitive form, *études* which he all destroyed.'[22] Many accounts speak of Monet destroying incomplete abortive paintings; with the London series and the Water Lilies of 1903–9 the destructions seem to have been very extensive. Rarely have we any idea of what these destroyed paintings were like, but, with the Water Lilies of 1903–9 one canvas evaded the flames. In 1907, when deferring his exhibition of Water Lilies, he told Durand-Ruel that he had destroyed 'at least thirty of them, to my great satisfaction', and added: 'You remind me, it is true, that I have sold one of these canvases to Mr Sutton. I'm the first to regret this, because if I still had it, I should destroy it, and in any case I would not want it to appear in the planned exhibition.' This canvas can be identified (pl. 194): dated 1903, it is clearly a painting in which

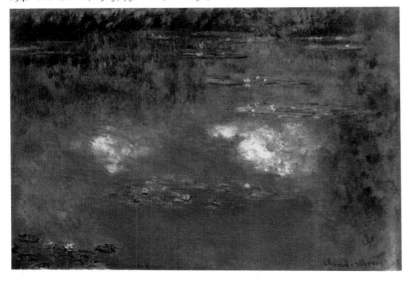

194. *The Clouds*, 1903, 73 × 100, W 1656, Private Collection

Monet has not yet found the 'definitive form' for this series; in its own right it seems to be finished, but in it Monet has not yet begun to interweave the lily pads with the reflections of trees and clouds to create a single complex pattern, as he did in the exhibited paintings.[23] A few other canvases survive which probably belong to the same preliminary stage of searching for the definitive form of a series: one of Rouen Cathedral from the west, and the two of Charing Cross Bridge (e.g. pl. 90) before Monet decided to omit Cleopatra's Needle from the subject.[24] It seems unlikely, though, that such experiments existed in anything like the numbers mentioned by Gimpel. The majority of the canvases Monet destroyed were probably versions of a subject which went wrong in some way during their execution. Monet would have called these *études*, since they were left incomplete, but without implying that all were part of the initial process of formulating the subject.

His use of *esquisse* and *pochade* is regularly different from the

meaning he gave to *étude*. *Esquisse* regularly characterises canvases on which he had finished work, but which were left in a sketchy state, not as highly finished as the paintings he normally sold; a *pochade* refers to a rapid *esquisse*. On several occasions in his letters Monet distinguished between *esquisses* and *tableaux*. In 1878 he told the collector May, 'I owe you a *tableau* and an *esquisse*'; when considering giving a painting to be sold for the benefit of flood-victims in 1910, he thought he could give 'a good *esquisse* and not a real *tableau*'; and in 1920, when Durand-Ruel asked his opinion of a suspected fake view of Etretat, he replied: 'I know I did several of this type, some of them in the state of *esquisse*, and it's quite possible that someone might have found them incomplete and might have finished them.'[25] This implies that Monet had himself regarded such *esquisses* as in a sense complete. He made the same distinction to Trévise in 1920: 'My most highly worked canvases run the risk of darkening, while the happy *esquisses* do not change.'[26]

He defined the status of these *esquisses* in a letter to Durand-Ruel in 1891: 'Sometimes I sell certain *esquisses* a little more cheaply, but only to artists or friends.' He similarly implied a dual standard of finish in a letter of 1886, saying that among his work to hand 'there are no doubt some interesting things, but too incomplete for the collector (*amateur*)'.[27] Monet felt that such paintings had qualities which made them particularly suitable for fellow artists and for the converted, but that they would do his reputation no good if put on the open market. Duranty drew much the same distinction in *La Nouvelle Peinture* in 1876, defending the Impressionists' lack of finish: 'It matters little that the public does not understand; what matters is that artists should understand, and in front of them one can exhibit *esquisses*, preparations, underpaintings (*dessous*), in which the thought, intention and drawing of the painter are often expressed with more rapidity and concentration.' This idea belonged to a long tradition. In the sale catalogue of the collection of Varanchan de St. Geniès in 1777, Paillet wrote: 'This collection would appear to be that of a rich artist with good taste rather than of a collector . . . Though finished paintings are more generally popular, a certain class of collector rejoices particularly in a single sketch; he looks for the soul and thoughts of the man of genius whom he can see and recognise.'[28]

However, Monet's *carnets* show that, at just the time of Duranty's pamphlet, he was frequently selling paintings which he classified as *esquisses* and *pochades*, and not only to fellow artists; for these he received prices consistently lower than he received for the (presumably fully finished) canvases which are listed without indication of their status. It was these sales, particularly frequent in 1876, 1877 and 1878, and made under great financial pressure, which so damaged Monet's reputation in these years. The *carnets* show how accurate Zola was in 1880 in accusing Monet of habitually selling '*esquisses* that are scarcely dry'. Such comments, far from reflecting Zola's failure to understand Monet's art, were a pointed response to Monet's recent selling habits – habits which, as we shall see, quickly changed around 1880.[29] However, even after this, as his 1891 letter shows, he continued on occasion to sell or give such *esquisses* to artists or friends.

We can identify a number of canvases which Monet described as *esquisses*. In the 1877 group exhibition he showed two canvases with the subtitle *esquisse*, *The Grand Quai at Le Havre* and *The Tuileries* (pl. 195); the latter he sold during the exhibition to Caillebotte as *esquisse Tuileries*. Both are freely and openly painted. In the same show he exhibited another version of the same Tuileries subject without a subtitle (pl. 197); George Rivière described the two

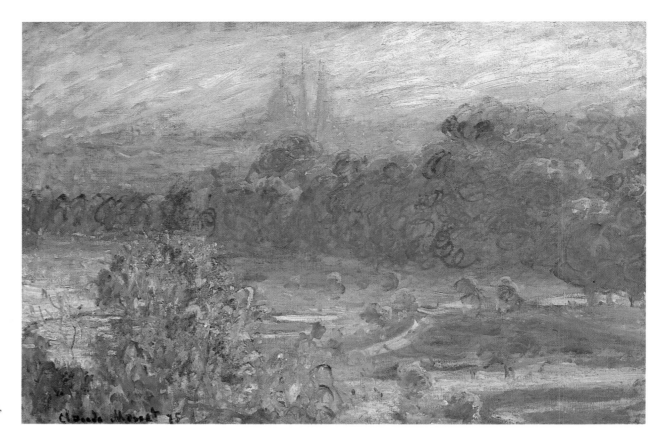

195. *The Tuileries,*
esquisse, 1876 (dated
1875), 50 × 74, W 403,
Musée d'Orsay, Paris

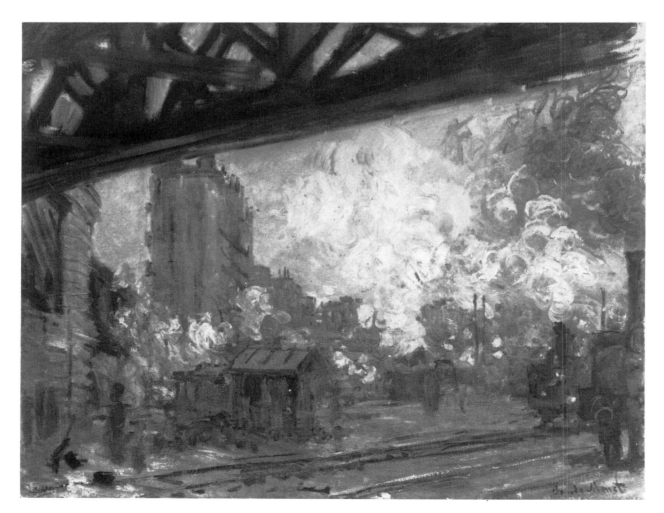

196. *The Gare Saint-*
Lazare, Exterior View,
1877, 65 × 81, W 447,
Private Collection

canvases in *L'Impressionniste*: 'The Garden of the Tuileries with Paris flooded by the golden dust of sunset is very remarkable; the *esquisse* of the same *tableau* has a charm all its own in its self-effacement.'[30] As it stands, Rivière's account suggests that one canvas is the *esquisse* for the other, a preparation for it, but this is presumably a misinterpretation of Monet's methods: the two differ slightly in *mise en page*

197. *The Tuileries Gardens*, 1876, 60 × 80, W 402, Private Collection

and angle of lighting, and they seem to be independent works, the *tableau* taken to a considerable degree of finish, the *esquisse* complete in a sense but lightly worked. A few more *esquisses* can be identified. In 1878 Monet sold Caillebotte three canvases of the Gare Saint-Lazare, listed thus in his *carnets*: '2 *esquisses* (chemin de fer) 300f . . . Gare St Lazare 685f.' The difference of designation and price reflect the marked contrast between the paintings: *Gare St Lazare* is the largest and most elaborately finished of the whole series (pl. 119), while the two *esquisses* (pls. 196, 266) are both far looser and bolder in execution, one of them startingly abbreviated.[31] He sold one canvas as an *esquisse* to Durand-Ruel in 1890, a view of Vernon Church; some paintings owned by fellow artists and friends would very probably have come into the same category, such as *La Manneporte, Etretat* (pl. 83), in the collection of John Singer Sargent.[32] These canvases, and those explicitly called *esquisses*, are lightly worked and summarily treated. Free paint accents are left visible on the paint surface, without the more thorough, overall reworking characteristic of the paintings Monet completed for sale at this period.

Two uses of *esquisse* in Monet's letters to Durand-Ruel raise doubts about the definition of his *esquisses* as lightly worked but complete canvases. In both instances he seems at first sight to be using the word as a synonym for *étude*. He wrote from Menton in April 1884 that 'to try to complete the *esquisses* which I have attempted to do here would get me too deeply involved', and, the next year, after a spell at Etretat, he wrote: 'I am hardly bringing any finished pictures (*toiles faites*), but mainly *esquisses* which are getting in my way here. I'm bringing also some *toiles* (which I will take back again) solely in order to see them elsewhere and in frames.'[33] Both of these comments can, though, be understood within the suggested sense of *esquisse*. Monet had always planned his stay at Menton to be brief: before going there he said that he was planning to paint *pochades* there, and he realised that, in the time

available, he could not produce highly worked paintings in front of nature.[34] Therefore he was willing from the start to see the Menton paintings as *esquisses*, in contrast to the more heavily worked paintings he was bringing back at the same time from Bordighera. The letter about the Etretat pictures incorporates some distinction between *esquisses* and *toiles*. The *toiles* were presumably paintings which he had almost finished, or was planning to finish, formally; the *esquisses* must be the same 'interesting things, but too incomplete for the *amateur*' that he mentioned two months later, and his letter about the supposed fake Etretat in 1920 confirms the existence of such paintings of this site (e.g. pl. 198).[35] Many of the less highly finished canvases, mostly dating from the 1880s and 1890s, that Monet signed and sold late in his life were probably originally kept as *esquisses*, paintings which were a comparative success in Monet's own terms, but which he did not regard as sufficiently finished for him to put on the market at the date of their execution (e.g. pls. 156, 198, 204–5, 214, 233). This is confirmed by Geffroy's 1922 description of Monet's first, indoor, studio: 'The walls are covered with finished pictures and *esquisses*.'[36]

Monet also used the term *pochade* frequently to characterise his rapid sketches. Though he never makes a clear distinction between *pochade* and *esquisse*, he tended to use *pochade* to describe sketches of particularly fleeting effects, sometimes painted on smaller canvases than normal, and thus conceived from the start as *pochades*. But on

198. *Etretat, the Cliff and Porte d'Aval in Stormy Weather*, c.1883, 73 × 100, W 820, Private Collection

occasion the *pochade* seems indistinguishable from the *esquisse*: for instance, the 1882 portrait of Paul, the Pourville *pâtissier*, was called an *esquisse*, the very comparable one of Poly, his Belle-Isle boatman in 1886 (pl. 45), a *pochade*.[37] His earliest recorded use of *pochade* refers to his paintings of La Grenouillère: 'I have a dream, a *tableau* of the bathing place of La Grenouillère, for which I've done some bad *pochades*, but it is a dream.' These *pochades* are very probably the famous and comparatively large paintings in New York and London (pls. 71, 145); they are not taken to exhibition finish, as their surfaces are left very rough, and even more boldly handled than the lost version of the subject (pl. 260), which was probably the planned *tableau*.[38] Many canvases sold in the 1870s are listed as *pochades* in the *carnets*. On only one occasion does one of these seem, by

implication, to be distinguished from an *esquisse*: in two separate but successively listed transactions in January 1879 he sold to de Bellio 'one *pochade* 60f' and '*esquisse* Lavacourt 150f'; the differing prices may indicate that the *pochade* was a slight work. A few of the *pochades* of the 1870s can be identified. *Pochade Argenteuil*, sold to Caillebotte in April 1876, is very probably the startling *Regatta at Argenteuil* (pl. 142); *Pochade Marine*, sold to Chocquet in January 1878, is a small sketchy open sea view of the later 1860s; one of the two *Pochades Argenteuil* that Monet sold Durand-Ruel in 1872 is *View of the Plain of Argenteuil*.[39] In 1892 Theodore Robinson saw a Monet at Goupil's, and commented, clearly after mentioning it to the artist, that 'the snow thing I saw at Goupil's was a *pochade* . . . it was at Argenteuil, done in a sitting'; one at least of the Argenteuil snow scenes which Boussod & Valadon (Goupil's) had in stock at the time (pl. 202) is very summarily treated.[40]

Several times in his letters of the 1880s he described particular paintings as *pochades*. At Etretat in 1883 and again in the Creuse in 1889 he painted what he called 'large *pochades*' of subjects which he did not expect to be able to finish fully.[41] The distinction between *pochades* and his normal canvases emerges most clearly in his letters from Belle-Isle in 1886. In mid-October the storms prevented him from working on his '*études* begun a long time ago'; instead he had to paint 'attempts at *pochades*', for which he needed fresh canvases, in order to capture 'this upheaval . . . it is admirable, but so difficult'.[42] The *pochades* were thus clearly distinct from his *études*, which he characterised also as his 'serious *toiles*'; moreover, the *pochades* could not easily be retouched, because the effects they showed were so fleeting. By 23 October he had 'thirty-eight canvases covered; I must say that there are seven or eight *pochades* and the same number of very mediocre canvases, but there are a good twenty-five to complete together'.[43] These letters show that the pochades were begun as such, and could not be converted into *toiles*; indeed these *pochades* were, it seems, executed on smaller canvases (e.g. pl. 108) than the *toiles*.[44] However, during his brief stop on the island of Noirmoutier on his return journey from Belle-Isle, he wrote: 'I have undertaken two *pochades*, which will remain in the state of *pochades* unless tomorrow and the day after I have the same weather, and it is in this case alone, if it is necessary, in order to make something of these two *toiles*, that will delay our return for a day.' On this one occasion Monet described as *pochades* works that he could envisage turning into finished paintings; we must assume that he continued to regard them as *pochades* so long as he did not have the chance to rework them. The Noirmoutier canvases seem not to have survived, but as he prolonged his stay at Menton in 1884 the results of his stop became complete works, rather than the 'two *pochades*' he had originally planned to execute there.[45]

Consistently, though, Monet's *pochades*, like his *esquisses*, were paintings that did not reach the finish expected of *tableaux*; and, like the *esquisses*, they were suitable for a personal friend, but not for the open market. Octave Mirbeau very probably acquired the boldest of the Belle-Isle storm *pochades* (pl. 108) when Monet visited him on Noirmoutier on his way home from Belle-Isle, and in 1889 Monet chose to give to Mallarmé what he described as a *pochade* of a Seine subject of which there exist several more highly finished versions.[46]

In 1897, speaking of his early work, Monet said that 'in the old days, we all did *pochades*'; after mentioning Corot's and Jongkind's methods, he went on to describe the christening of *Impression, Sunrise* (pl. 199) at the 1874 exhibition, though without specifically calling it a *pochade*. He called it *Impression*, he said, because 'it really couldn't pass as a view of Le Havre'.[47] This emphasises its summari-

ness, and distinguishes it from finished works which could be described as views, such as *Le Havre, Fishing Boats leaving the Port* (pl. 200), shown with this title at the same exhibition.

Much though he disliked the label 'Impressionist',[48] Monet did on occasion continue to subtitle paintings as *Impression* after *Impression, Sunrise* had given the movement its name in 1874. He showed the same picture again several times – as *Effet de brouillard, impression* in 1879, as *L'Impression* in 1883, and as *Impression* in 1889; in 1886 he showed *Temps de pluie (impression)* (pl. 174) and *Marine (impression)*, in 1887 *Vétheuil dans le brouillard (impression)* (pl. 201), and in the 1904 exhibition of the London series *Fumées dans le brouillard, impression*.[49] In reusing the term, Monet obviously intended to evoke memories of 1874, but the paintings so labelled have more in common than just their titles: all those that can be identified are quite summary and economical in handling, and depict particularly hazy or misty effects. Occasionally he used *impression* in the same sense as *pochade*: he wrote from Norway in 1895 of 'these poor *toiles* which make no progress [because of the changing weather], which will be neither *impressions*, nor more highly worked canvases (*toiles un peu poussées*)'; in London in 1901, the effects of light were so fleeting that he felt that he should only have tried to paint '*pochades*, true *impressions*'.[50]

The technical meaning of the term *ébauche* and Monet's use of the lay-in layer have already been discussed. Only very rarely did Monet use the word to describe his own work – in his surviving letters, only in 1900 to describe paintings which the changing light effects had forced him to leave in a particularly unresolved state. However, many critics had used *ébauche* as a term of criticism against the Impressionists during the 1870s.[51] Where he used the word *croquis*, he normally meant some form of small graphic work; for instance, he gave to the photographer Nadar *fils* in 1900 'a *croquis* in pastel . . . it's a mere *croquis*, done some time ago'. Once, though, he described a work in oils as a *croquis*, sending Burty in 1883 a 'little canvas . . . it's nothing much, like a sort of *croquis* in oils'. The apologetic tone of the letter shows that Monet was giving the picture this paradoxical label so that Burty should not expect too much of it.[52]

In the context of Monet's use of these traditional terms, we must ask what he meant by the idea of finish, and what qualities he wanted to bring out in finishing his paintings. On one level he set great store by spontaneity. He wrote in 1884 from Bordighera: 'I am very proud of myself, because, in a free hour, I did a very successful *pochade*, better than many of the things on which I've toiled for fifteen sessions.' He clearly had a particular feeling for the 'happy *esquisses*' he mentioned to Trévise, adding that 'what comes out successfully at a single stroke . . . lasts best'. His stepson emphasised this enthusiasm: 'He considered that many *esquisses* which only involved a session or two of work – first *impression*, first attempt – were better than some of his "overworked" canvases, "spoiled", he dared add.'[53]

He showed his loyalty to his quickest and most direct notations of nature by exhibiting canvases with the subtitle *impression* or *esquisse*, in order to show his art at its most spontaneous. In 1889 he explained his reasons for exhibiting such works, describing a painting titled *Un brouillard* then on show at Boussod & Valadon: he included it because 'he thought that it would inform people about his working methods, that it would tell much about its author and his dream', and described how he had been unable to finish the painting, because its subject, a village with a church appearing through the fog, seen from the river, had so quickly disappeared.[54] This painting

199. *Impression, Sunrise*, 1872, 48 × 63, W 263, Musée Marmottan, Paris

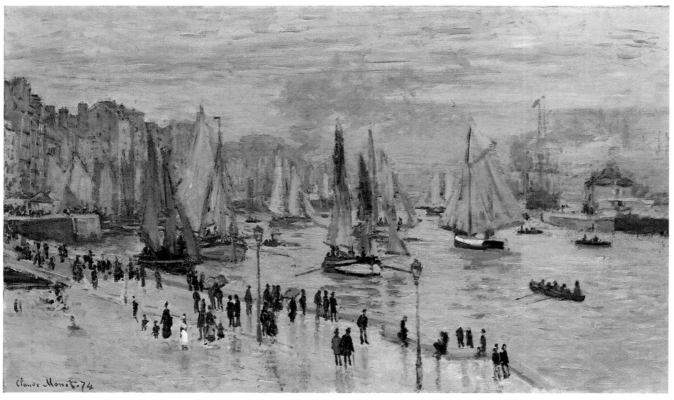

200. *Le Havre, Fishing Boats leaving the Port*, 1874, 60 × 101, W 296, Bayerische Staatsgemäldesammlungen, Munich, on loan

163

201. *Vétheuil in the Fog*, 1879, 60 × 71, W 518, Musée Marmottan, Paris

must be *Vétheuil in the Fog* (pl. 201), which had been shown with the subtitle *impression* in 1887. The same painting took on a legendary role in Monet's later years, as he repeatedly retold its story: the singer Faure had rejected it because it was 'all white' and had 'not enough painting' on it, and Monet would never afterwards sell it, though he received vast offers for it, keeping it on an easel in his first studio as a symbol of the misunderstanding which his earlier work had met.[55] Criticisms such as Faure's affected Monet greatly. He spoke to Robinson in 1892 'of stupid people saying, "you are going to finish that, you are not going to leave that *comme ca?*" "*Mais pourquoi pas?*" Why not indeed? and who is the judge when to stop, if not the painter?'[56]

Alongside his enthusiasm for the successful sketch, Monet sometimes expressed his aversion, which his stepson mentioned, to paintings he felt he had reworked too much. He lamented to Durand-Ruel in 1885: 'I have been unable to make a success of the canvases which have been under way for so long and which I would have done much better to abandon weeks ago; I should have had the time to do some others. Instead all I've done is to do them and undo them.' On Belle-Isle he found that reworking his paintings comprised their 'purity of accent'. To Perry, Monet admitted that it was difficult, when the light changed, 'to stop in time because one got carried away'.[57] Clearly it was sometimes difficult to stop reworking paintings beyond their needs. Buyers, too, might find it hard to prise paintings from Monet's grasp. When the American collector Desmond Fitzgerald bought *Fishing Boats at Etretat* from him, Monet 'with his normal reluctance to part with a canvas refused to let it go out of the studio. Mr. Fitzgerald, though, was persistent, as he did not want another particle of paint put on the canvas, and at last he was successful in obtaining the picture.'[58] At his most

despairing moments in later years Monet felt that he could never reach the resolution of which he dreamed. He wrote from Rouen in 1893: 'I tell myself that anyone who says he has finished a canvas is terribly arrogant. Finished means complete, perfect, and I toil away without making any progress, searching, fumbling around, without achieving anything much.'[59]

These problems show that by the 1890s Monet's love for his most spontaneous paintings often became a lost cause, and explain why the very few canvases which came out right on their first working had such significance for him. But his increasingly obsessive need to rework his paintings arose not simply because he felt that he was losing the ability to capture the essence of a subject at a single sitting. During the 1880s he came to feel an equally strong, and ultimately stronger, pull in the opposite direction: the dissatisfaction he voiced in 1893 is a symptom of his attempts to go beyond the quick sketch. A feeling of spontaneity might be desirable in a painting, but increasingly the final pictorial effect had to be the result of careful consideration, and often reworking, over a period of time. Monet's descriptions of this change reveal the underlying reasons behind the growing time-lag between the commencement of a painting in front of nature and its completion for sale. Monet explained his position most clearly to Robinson in 1892: 'He said that he had quite lost the power of doing a thing at once and letting it go at that – as he did 25 years ago – now he wants to feel that he has time to keep at a thing for a certain space of time.' In 1899 Fuller recorded: 'In his early days, as he once remarked to me, he often completed a canvas at a single sitting; "but now," he modestly added, "I am more exacting, and it takes a long time for me to finish a picture."' As he was starting the Grain Stacks series in 1890, he told Geffroy that 'more than ever easy things which come at one go disgust me'.[60]

Rapid, direct notation was presumably his ambition in his smaller, outdoor pictures of the later 1860s and early 1870s, but the increasing complexity which we have noted emerging in some of his paint surfaces of the later 1870s suggests that the beginnings of this change should be placed in these years, though its progress can only be charted with any clarity from the 1880s onwards as his surviving letters begin to supply a regular commentary on his work. In September 1882 the changing natural effects at Pourville prevented him from finishing his work, but he could add: 'I'm not saying that all these difficulties may not have made me make certain efforts and perhaps some progress, but this isn't leading to anything at the moment.'[61] Soon his expressed desire to be 'demanding on myself (difficile pour moi)' became almost a watchword by which he could reassure himself that the problems he was facing were not simply caused by the failure of his powers. He voiced this predicament in 1883: 'I'm having more and more difficulty satisfying myself, and I sometimes wonder whether I'm going mad, or even whether what I'm doing is neither better nor worse than before, but simply that I'm finding it harder today to do what I used to do easily. However, I believe I'm right to be more demanding.'[62] He lamented in 1884 that 'the futher I go, the harder I find it to bring an étude to a successful conclusion', but soon afterwards made it clear to Durand-Ruel that these problems were caused by his new efforts to finish his work thoroughly: 'You know that for a long time now it has been my ambition to give you only finished canvases with which I am completely satisfied. You yourself, in one of your latest letters, urged me to work them up, to finish them as highly as possible, telling me that lack of finish was the principal reason for their lack of success . . . As for finish, or rather polish (léché), for that is what the public wants, I shall never agree to it.' Monet's mention of léché

reveals what at all costs he wanted to avoid. In the same year Adéline defined léché: 'It refers to an overfinished execution, of a work of art whose smallest details are executed with too much minuteness, whose handling is too precise, too laboured.'[63] We have seen Monet setting increasing store by his 'moment of peace and quiet before being able to put the final touches to my canvases'; he insisted in 1888 that he could not finish his work properly under pressure: 'I can finish nothing; I only have some canvases finished with a struggle, and as a result incomplete.'[64] It was to avoid this that he changed his selling policy around 1892, after his financial security was assured, trying to sell only paintings which he had finished at his leisure. In an interview around 1900 he made a virtue of his slowness: 'Most of the people think I paint fast. I paint very slowly. I am never contented with my work. I let a picture go because I would work on it for ever if I did not. When I was young I used to expedite matters much more than I do now. I am getting harder and harder to please.'[65] However, the ways in which Monet came to finish his paintings in a way belied this long process of maturation.[66]

Monet's struggle to reconcile spontaneity with finish was nothing new in French nineteenth-century painting. Delacroix and Couture were prime examples of artists haunted by this delemma throughout their careers. Couture advised the painter to limit his retouches to a minimum, in order to preserve the freshness of the initial working while avoiding the imperfections of painting 'at the first attempt', while Delacroix asked himself 'how to preserve, while adding details, that overall impression which results from very simple masses'. Delacroix enlarged on the problem of finish in 1852: 'One must always spoil a painting a little in order to finish it. The final touches intended to establish some accord between its parts remove some of its freshness. One must appear before the public after removing all the happy negligences which so delight the artist . . . Retouches are not, though, as fatal to the picture as one might think, when the picture is well thought out and has been executed with deep feeling.' In 1895 Pissarro lamented the difficulty of finding the right note for the final touches on his latest figure paintings: 'Finished? That means that I leave them to wait around a bit in my studio in order to find, at a given moment, the final sensation which must give the ensemble its life. Alas! so long as I haven't found this final stage, nothing will be completed!'[67]

Monet's changing ideas about finish, as they evolved over two decades, from the 1870s to the 1890s, involved a radical revision of the values he sought in the finished painting. Some of the reasons for this were internal to his practice as a painter. We have examined his growing dissatisfaction from the 1880s onwards with the comparatively casual way in which he had picked his subjects in the 1870s, and with their restricted range of forms and effects; to this he responded in the 1880s by a search for variety and for particularly taxing challenges, and, in his paintings, by an increasing concern for patterns of brushwork and integrated schemes of colour. Robinson recorded his dissatisfaction with painting 'anything that pleased him, no matter how transitory' and his search for the 'important motif', a quest which led him to work in series.[68]

However, external factors also played a central part in his reorientation, both as a stimulus to him to redirect his efforts, and in supplying the material security which allowed him to go beyond the transitory sketch. These involved Monet's responses to the critics of his painting and pressures from his prospective buyers – two factors which have tended to be disregarded, in favour of a view which presents his development as essentially self-contained and somehow organic.

From the 1874 exhibition onwards, even such comparatively sympathetic critics as Chesneau and Castagnary criticised the unfinished nature of Impressionist painting; indeed the label 'Impressionist' itself carried this implication. Such comments, as we have seen, picked up an important thread in previous criticism of modern landscape painting, notably of Daubigny.[69] In a sense Monet acknowledged the force of such criticisms by always exhibiting his *esquisses* and *impressions* alongside more highly worked canvases, but his repeated sales of such sketches in the later 1870s, perhaps more than his exhibits at the group shows, contributed to his reputation as a casual and incomplete artist. His decision in 1880 to submit again to the Salon, and his submission of *Lavacourt* (pl. 270), a painting which was 'more judicious, more bourgeois',[70] shows how far, at this moment, he felt the need to respond to his critics. It was in his review of this exhibition that Zola voiced his pointed criticisms of Monet's recent selling habits, hoping perhaps to encourage him to continue with more ambitious works like *Lavacourt*: 'M. Monet has given in too much to his facility of production. Many *ébauches* have left his studio in difficult times, and that is worth nothing; that pushes a painter down the slippery slope. When one is too easily satisfied, when one delivers *esquisses* that are scarcely dry, one loses the taste for bits of work which have been studied for a long time; it is study which makes solid works. M. Monet is today paying the penalty for his haste, for his need to sell . . . He must resolutely devote himself to important *toiles*, studied through several seasons, with the sole concern of expressing himself and his temperament completely.'[71]

By the time of Zola's criticisms Monet had already begun to reconsider his ideas about finish, not only in *Lavacourt*, but also in his normal-sized canvases; no longer was he flooding the market with *pochades*. He could not accept at face value Zola's formula of 'important *toiles*, studied through several seasons', with its implied rejection of the open air as a necessary and constant stimulus. His solution, as we have seen, was to refine and elaborate his outdoor canvases, in order to make them more than mere *esquisses*. The results of this change could first clearly be seen in the paintings Monet showed at the 1882 group exhibition; among the first to welcome this was a member of Zola's Médan set, Huysmans. In his note on the 1882 show, Huysmans congratulated Monet for abandoning his 'brief improvisations' and 'fragments of landscapes' in favour of painting 'very beautiful and very complete landscapes'. Huysmans's comments have been seen as a reflection of his own evolving taste, but they must be recognised as a response to Monet's changing practice. Burty made a similar reassessment in a long and sympathetic article on Monet's one-man show in 1883. One passage of this seems directly to reflect Zola's criticism of 1880: 'No longer is he the slave of a hasty production caused by the need to sell from day to day . . . By selling at higher prices, he can work on a canvas for longer, can realise his intentions more precisely, and can even

rest on days when reverie or exhaustion got the better of him.' In 1884 Monet implicitly acknowledged that his and Renoir's current concerns resulted in part from the barrage of criticism they had met: 'We are definitely becoming very demanding (*difficiles*), and yet people always reproach us for making no effort.'[72]

But this change was more than a dialogue between artist and critics. As Zola's and Burty's comments show, financial concerns played a crucial part. The small-scale easel painting had emerged as Monet's stock-in-trade in response to a potential market through dealers, most notably when Durand-Ruel was buying much of his work in 1872–3. After Durand-Ruel had been forced to withdraw his support in 1874, Monet had to become his own salesman; always improvident, he often thus had to raise sums of money at short notice, at times in the late 1870s becoming little more than an itinerant peddlar of his latest rapid sketch. But by the end of 1879 it became clear to him that his policy of selling *esquisses* and *pochades* was getting him nowhere. In December 1879 he sold three paintings to the dealer Georges Petit, who, as Monet quickly explained to de Bellio, urged him 'not to sell cheaply any more'; in 1880 his prices increased steadily, and he entirely ceased to sell *pochades* and *esquisses*.[73]

In effect, then, Monet had decided before Zola published his 1880 Salon review to pursue a policy similar to that which he advised. Petit did not, in the event, become a regular buyer in the early 1880s, but from early in 1881 onwards Monet had a regular and relatively secure outlet with another dealer, Durand-Ruel; never again did he need to sell anything he could, irrespective of the price. As we have seen, Durand-Ruel encouraged Monet to finish his canvases more fully, and the financial security he offered allowed the artist a degree of leisure to complete his work which he had never had before. Monet's final commercial breakthrough, around 1889, was followed at once by a further slowing down of his painting processes. In later interviews he attributed his ability to be 'demanding on myself' directly to his commercial success. He told Trévise: 'When I had nothing to live off, I used to sell what I did as soon as my *étude* was finished; either it came out well, or it didn't. But since I've no longer needed to sell, I've been able to work. Now, I think I'm as demanding on myself as I can possibly be.'[74] This sounds like an acceptance, albeit in 1920, of the validity of criticisms such as Zola's.

Clearly none of these factors can be taken in isolation. Monet's financial security allowed him to travel and to finish paintings in his own time, but money was only the catalyst which gave him the chance to develop his ideas without too many material constraints; it gave him the freedom without dictating the use he made of it. To see the ways in which he realised his broadening ambitions, we must return to his paintings, and trace the new practices in finishing which evolved as he dwelt on his canvases for longer in the studio before declaring them complete.

CHAPTER TEN
MONET'S PRACTICE in FINISHING

EXAMINATION of the build-up of Monet's paint surfaces has revealed the gradual process of definition and refinement that his canvases underwent as he worked them up. In discussing the development of his brushwork and colour we have traced the changing qualities he sought in his finished paintings. We must now focus on the final stages of their execution, in order to isolate the particular characteristics which distinguished his fully realised *tableaux* from his incomplete *études* and his *esquisses* and *pochades*. We must then consider what kind of work Monet habitually did in the studio.

In 1887 Geffroy summed up Monet's working process: 'Rapidly he covers his canvas with the dominant values, studies their gradations (*dégradations*), contrasts them, harmonises them.' As we have seen, this is a very fair summary of the stages of execution of Monet's paintings.[1] It is the last two of these stages which particularly concern us here: the establishment of contrasts or oppositions between the principal elements in the picture, and the attempt to bring them into an overall harmony. These provide two essential keys to what Monet particularly sought in finishing his paintings.

What this involved in practice may best be seen by comparing fully finished paintings with canvases of similar type and date which never became *tableaux*. The qualities of the finished painting emerge particularly clearly when paintings completed for sale soon after their initial execution are compared with the lightly worked canvases from the 1880s and 1890s that Monet left unfinished on his death or sold late in his life; but similar contrasts can be made between his *tableaux* and the *esquisses* he sold in the 1870s and 1880s. A sequence of such comparisons reveals Monet's changing priorities in finishing his paintings.

Monet's *esquisses* of the early 1870s might be treated in fluid washes of paint, as in *Impression, Sunrise* (pl. 199), or in distinct dashes and slabs of more opaque colour, as in *Regatta at Argenteuil* (pl. 142); their treatment varied according to the effect depicted – liquid for a vaporous atmosphere, very solid and physical for sharp sunlight. In *tableaux* of the period, such as *The Basin at Argenteuil* (pl. 143), the forms are generally far more crisply defined, with the various textures and features of the scene much more clearly differentiated. In the fully finished version of *Snow at Argenteuil* of 1874 (pl. 203), the touch is endlessly varied, sometimes very delicate as in the floating snowflakes, sometimes in rather larger dabs (on the bank) or brisk fine dashes (in the trees), the details of forms are far less crisply defined than in *The Basin at Argenteuil*, but the touch

activates the whole surface except the sky. In the *pochade* of the same scene (pl. 202; see p. 162), the bank on the right is treated in broader broken touches and the forms of the trees are only very summarily indicated – on the left by a few darker dashes on a flat dull lay-in, in the freestanding tree on the right by freer squiggles of paint. The play of light and shade is crisply caught, but the surface has been given no refinement or redefinition, and the flat working of the wall at far left and the trees at far right do not fully succeed in suggesting forms in space. By 1876, *esquisses* such as *The Tuileries* (pl. 195) show free loops of paint in the trees; in the *tableau* of the same subject (pl. 197) this dynamic handling is replaced by a more complex and finely wrought overall variegation, in successions of touches, varied in shape and direction yet consistently small and mobile, which run throughout the painting.

Landscape at Vétheuil (pl. 204) is a lightly worked version of the subject of *Path in the Ile Saint-Martin, Vétheuil* of 1880 (pl. 149). In the former, the principal elements are quickly laid in, with summary differentiations of texture, with the poppies across the foreground hinted at by vigorous curls of red. In the latter the foliage textures are suggested far more fully; small contrasting touches, of deep greens on light areas and light yellow greens on darker areas, enliven the surface and express the passage of the light through the foliage; the poppy flowers are individually dabbed on. Soft pinks and blues are threaded through the whole composition, and the brushwork takes on gentle directional rhythms. The small contrasting touches here act as the oppositions of which Geffroy spoke, while the blues and pinks serve to harmonise the scene.

A similar process distinguishes *The Manneporte, Etretat* of 1883 (pl. 129) from the *esquisse* of the arch which Sargent owned (pl. 83). In the *esquisse*, emphatic ribbons of paint suggest the furrows of the cliff face in a rapid, wholly non-illusionistic notational shorthand, while broad sweeps of the brush convey the breaking waves. The finished *tableau* represents a very similar effect of waves and sunlight, but treats them with a much finer touch; seen from a normal viewing distance, the brushwork gives a far more precise idea of the furrows on the cliff and the breaking waves, but, from close to, they become a delicate weave of cursive patterns across the picture surface.

Three Antibes paintings of 1888 illustrate different degrees of finish. *The Baie des Anges* (pl. 205) is little more than a simple lay-in, with flat surfaces and muted colours, which Monet sold only in

these final touches the whole surface becomes a closely controlled weave of interrelated colours and textures, in which local contrasts are emphasised, but now perhaps more subordinated to an overall harmony than they had been in the early 1880s.

A further comparison may be made between *Poplars on the Banks of the Epte* (pl. 214) and *Poplars, Overcast Weather* (pl. 209). In the former, the surface has never been articulated or refined, though it has been worked over on two separate occasions; the second stage intensified the blue of the sky and added more definition to the foliage, but the whole remains rapidly and summarily brushed. By contrast, the latter treats the foliage and light effects more minutely; its colour scheme, elaborated at a late stage in its execution, opposes rich deep blues and greens to the soft mauve-pinks of the sky and the deeper warm browns of the tree trunks. The brushwork on the final surface is less strongly accented than in *Antibes* (pl. 207), creating a

202. *Snow at Argenteuil*, 1874, 50 × 65.5, W 349, Private Collection

203. *Snow at Argenteuil*, 1874, 55 × 74, W 348, Museum of Fine Arts, Boston

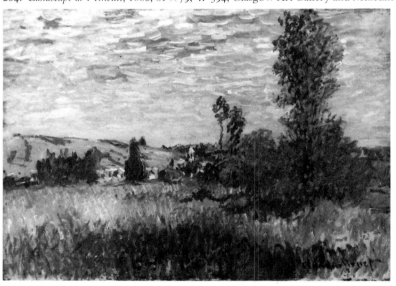

204. *Landscape at Vétheuil*, 1880, 61 × 79, W 594, Glasgow Art Gallery and Museum

205. *The Baie des Anges, seen from the Cap d'Antibes*, 1888, 65 × 81, W 1178, Private Collection

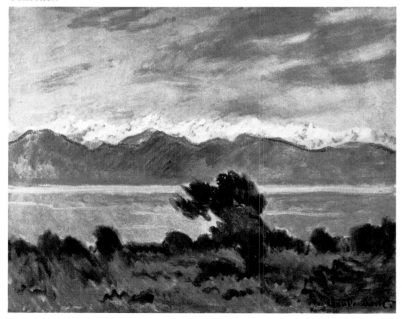

1920. By contrast, *Cap d'Antibes, Mistral* (pl. 206) and *Antibes* (pl. 207), both completed for sale in 1888, are more elaborated, but markedly different in their surfaces. *Cap d'Antibes, Mistral* remains quickly and freely handled. Discussion of this painting is complicated by the beginnings of another picture below its surface (probably a different view of the bay of Antibes), but the whole surface of the painting in its present form was taken to a state far beyond *The Baie des Anges*, before its main paint layer had time to dry, with only a few accents added once it had dried. Though vigorously brushed, so as to express the effects of the mistral, it is a fully finished canvas, with all its forms and relationships clearly defined. *Antibes* is far more precise in finish. X-rays (pl. 208) reveal a freely applied, animated dry paint layer beneath the present surface (comparable perhaps to the final state of *Cap d'Antibes, Mistral*), but the final painting, particularly in the water and the foliage, is far less dynamic, enlivened by dashes and hooks of colour of considerable finesse which establish small-scale colour accents and contrasts of tone. By

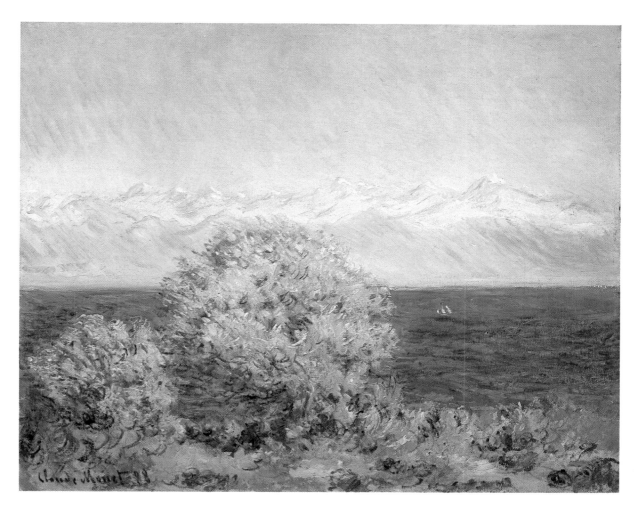

206. *Cap d'Antibes, Mistral*, 1888, 65 × 81, W 1176, Museum of Fine Arts, Boston

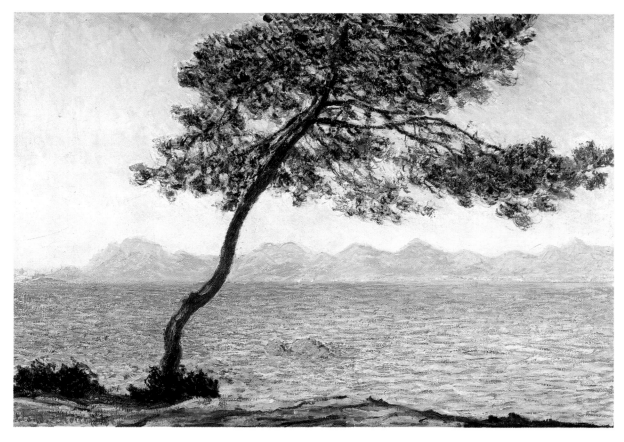

207. *Antibes*, 1888, 65 × 92, W 1192, Courtauld Institute Galleries, London

far more homogeneous effect, and suggesting the play of light by delicate shifts of colour and texture, rather than by distinct, contrasting touches. At this point harmonisation because the central concern, as Monet abandoned the surface contrasts which he had sought in the 1880s.

By the later 1890s, in the Early Mornings on the Seine (e.g. pl. 211) for instance, the surfaces of the finished paintings become thinner and still less accented, animated primarily by delicate surface strokes. In *The Flood* (pl. 210), an unfinished painting of a similar subject from the same period, the branches of the trees are defined in fine rapid strokes, yet the overall effect of the canvas, laid in with fluid sweeps of soft colour, creates, even at this early stage, an overall harmony which suggests in embryo the extremely integrated effects of the finished Early Mornings on the Seine. Similarly the unfinished paintings from the London series (e.g. pls. 90, 98) show from the start simplified versions of the atmospheric harmonies that characterise the finished London canvases (e.g. pls. 91, 268), though these effects were often revised during the execution of a painting.[2]

We can, then, see a gradual change in the qualities Monet sought in his finished canvases, from a crisp, descriptive diversity, through types of surface animation in the 1880s which became increasingly concerned with pattern and harmony as well as articulation and contrast, to a dominant concern, in the 1890s, with such internal harmony; there seems also to be a corresponding evolution in his treatment of the earlier stages of his canvases. Geffroy's description of 1887, which emphasises both contrasts and harmonisation, belongs

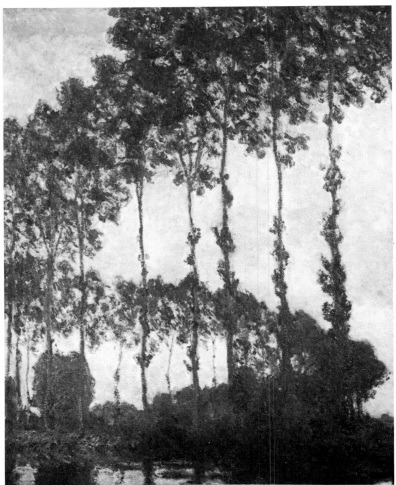

209. *Poplars, Overcast Weather*, 1891, 92 × 73, W 1291, sold Christie's, London, 2 December 1975, lot 24

208. (left) X-ray of pl. 207

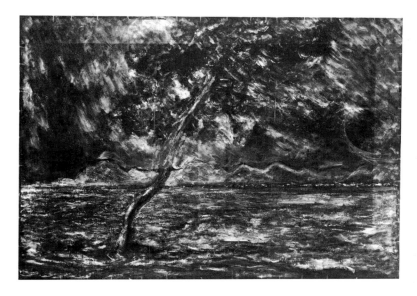

210. *The Flood*, c.1896, 73 × 92, W 1439, National Gallery, London

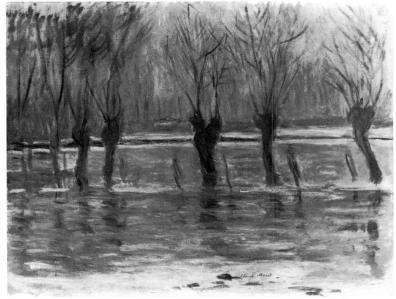

to the moment when these two aspects were both important, as Monet was trying to reconcile them, before harmony became his prime concern.

We cannot, though, conclude that the differences between *tableaux* and unfinished paintings reveal the normal extent of Monet's studio reworking, or that the present appearance of the unfinished paintings is typical of the state of the pictures which he took back to the studio for retouching. For the paintings he chose to sell quickly must generally have been those he had been able to take furthest in the open air, while those on which less work had been done would tend to have been set aside. However, the types of retouch which Monet habitually added as final accents to his *tableaux* presumably reflect the normal nature of his studio work.

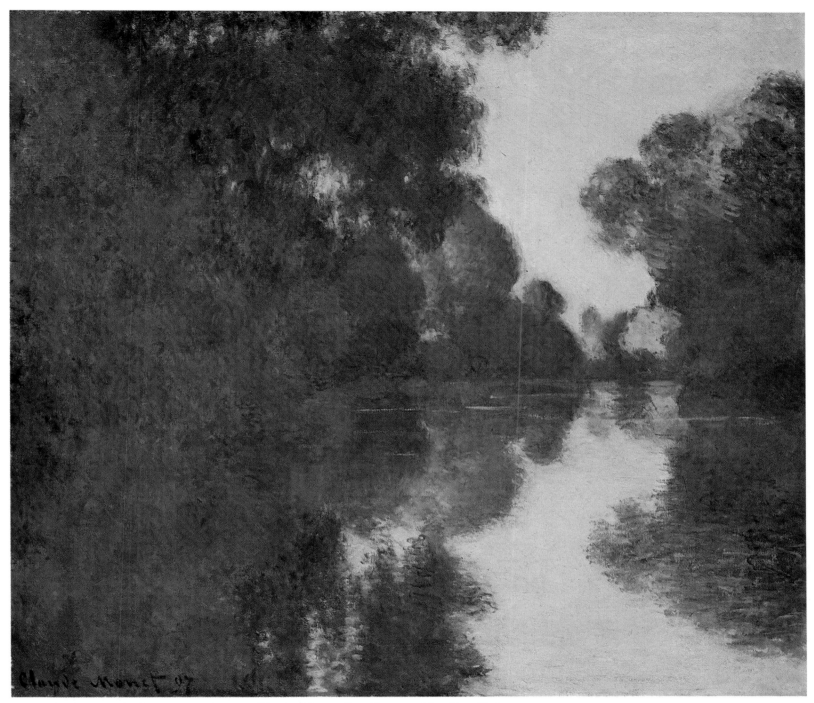

211. *Early Morning on the Seine*, 1896–7, 81.5 × 93, W 1482, Metropolitan Museum of Art, New York

We have few documentary indications of the nature of Monet's work in the studio. What there are refer principally to the later part of his career, and cannot be taken as unequivocal evidence of his practice in earlier years. They do, though, offer valuable hints about the general patterns of his activity in the studio. Several witnesses describe Monet sitting in front of his work in the evenings to 'ponder on the canvases under way'.[3] According to Goulinat, his studio work consisted in 'filling in the blanks which he had to leave on the canvas in his haste to fix the relationship between a cloud and the sky it was crossing',[4] while Monet's stepson J.-P. Hoschedé, the staunchest upholder of Monet's image of always working out of doors, insisted on several occasions that, in the studio, 'he signed his pictures and painted the edges of his canvases which he tended not to

paint right up to their margins', though elsewhere he allowed that Monet added 'sometimes, but not always, a touch of the brush here and there'. Hoschedé reproduces a photograph of Monet at work in his studio around 1913 (pl. 212), painting, he claims, 'the edges of a canvas'; in the photograph, though, the artist is working on an area not far from the centre of the picture.[5] Clemenceau, though insisting that Monet 'was only himself in the open air', admitted that the studio played an essential part 'when the moment came for him to pass from the *étude* to the *tableau*'. Geffroy, though also maintaining the primacy of his outdoor work, gave a valuable clue to what his studio activities involved, stating that it was in his first studio, in the house at Giverny, 'that he cleans up, that he completes, that he harmonises'.[6]

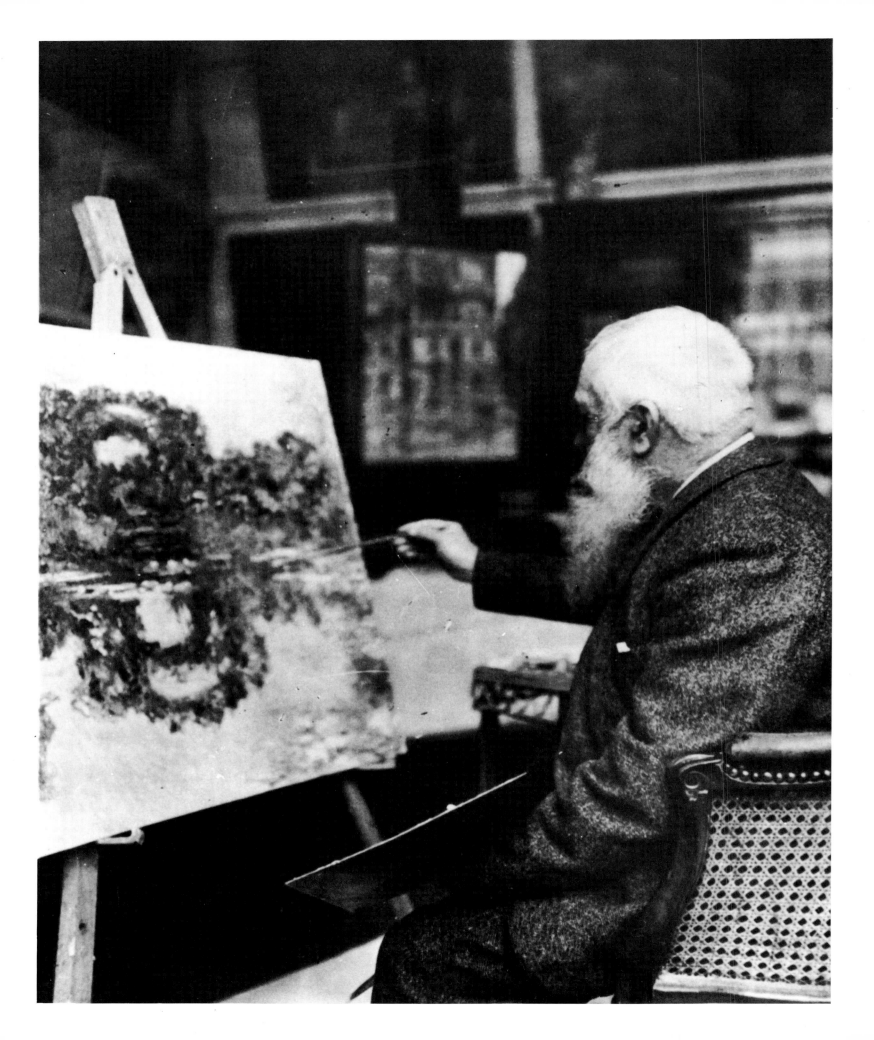

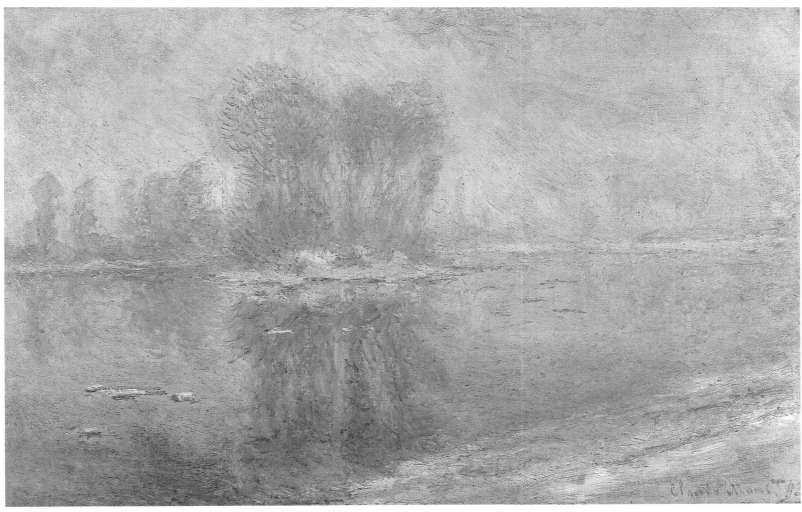

213. *The Ice-Floes*, 1893, 65 × 100, W 1335, Metropolitan Museum of Art, New York

A further indication of what Monet did in the studio emerges from his letter describing the state of the paintings he brought back from the South in 1884: 'Some could be very good, I think, and others, even though a little vague, may turn into good things if they are carefully retouched, but, I repeat, it cannot be done from one day to the next.'[7] The retouching of these 'vague' canvases must have involved defining and re-emphasising their forms. A last clue is in an account of Monet's problems in reworking his canvases from Norway: 'Since the whites were not luminous enough, Monet wanted to renew work on certain *études*, but, as he always liked to put it, "nature was missing", and, in fury, he destroyed everything which dissatisfied him.'[8] So, on occasion whole groups of paintings might lack something when Monet saw them at home, and he might try to restore what was missing. This is not surprising in the Norway paintings, painted as they were in deep snow which would have cast dazzling reflections on the canvases, making it impossible for him to judge how to pitch his whites (e.g. pls. 87, 100, both left unfinished). Similar problems were one of the main reasons for Renoir's mistrust of open-air painting.[9]

On occasion, then, the studio might be needed for a number of purposes, over and above tidying up and filling in the accidental infelicities and omissions in paintings executed in haste in front of the subject. Its main functions were for redefining forms, for keying up colours in an attempt to match the effects of nature, and to impose an internal, pictorial harmony onto his pictures. These closely reflect the qualities we have just described in analysing the appearance of his finished paintings. The definition of forms may be emphasised by accented brushwork (to bring out the forms of trees or waves, for instance), by more linear treatment (as on tree trunks or the edges of objects), or by touches of contrasting tone or accentuated colour. Oppositions, too, may be set up by such small touches, to draw attention to particular features in a painting, or to differentiate one form from another. Compensation for a failure to match nature can be seen particularly in the reworking of some southern canvases, where dominant colour contrasts are emphasised in an attempt to capture the *éclat* of the light. Harmonisation is achieved, late in the execution of the paintings, by emphasising formal patterns or relationships of colour, to give their surfaces a marked decorative unity.

Rarely, though, is it easy to tell what Monet added to a particular picture in the studio. As we have seen, he might often rework canvases out of doors months, or even a year, after their initial working, often modifying their effect; thus refinements or revisions over dry paint layers are not in themselves evidence of studio reworking. In *Antibes* (pl. 207; cf. pl. 208), for instance, much of the final layer over the initial animated sketch may very probably have been added out of doors after the wind dropped,[10] while the rapidly executed *Cap d'Antibes, Mistral* (pl. 206) was presumably largely completed while the wind blew. With one series, the Early Mornings on the Seine (e.g. pl. 211), he deliberately chose 'an easier subject

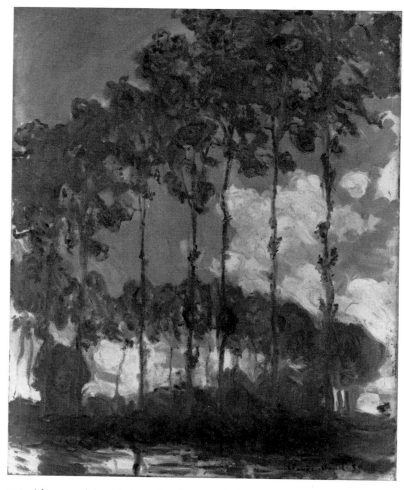

and simpler lighting than usual . . . therefore he had been able to take it further';[11] even despite these precautions, though, he devoted two summers, 1896 and 1897, to these pictures.

On occasion he must have been able to complete many of the late stages of articulation and definition out of doors. However, we cannot assume that all retouches added while the main paint layers were still wet were necessarily done outside; some canvases, particularly of subjects around Giverny, were probably given their final touches in the studio soon after their initial execution. A likely example of this is *The Ice-Floes* of 1893 (pl. 213). Though no paint layers had time to dry before it reached its present very delicate finish, the melting ice floes which form its subject may well have lasted such a short time that the final refinements had to be added in the studio very soon afterwards.

Poplars on the Banks of the Epte (pl. 214) illustrates the difficulty of distinguishing between outdoor and indoor working. The second layer of paint was added when the first was dry, and alters the original effect in two ways: first, by intensifying the blue of the sky, and second, by moving three tree trunks (the second, third and fourth from the right) about half an inch to the right. However, the main cloud mass was left in its original position; so, if this reworking was done out of doors, it was not simply a response to a new natural effect. One detail shows how carefully planned the reworking was. Originally the top left edge of the main cloud mass stopped precisely at the original line of the third tree trunk from the right; when shifted to the right, this tree trunk ran across the dried painting of the cloud edge. Monet then added a single dash of paint to the left of the new line of the trunk, across the original trunk, to extend the cloud very slightly to the left, thus establishing a contrast between the lines of the trunks and the mass of the clouds, instead of the unnaturally precise meeting of their edges in the original version.

Even in a painting such as this, which has not been worked up to exhibition finish, Monet might still make careful calculations and adjustments of forms. The second working of the picture may well have taken place out of doors, since its freedom suggests a response to a natural effect rather than a rethinking done in the leisure of the studio. But, if it was done outside, the adjustments to the clouds

214. (above, and detail below taken in raking light) *Poplars on the Banks of the Epte,* 1891 (dated 1890), 92 × 73, W 1300, Tate Gallery, London

215. *The Village of Roche-Blond at Sunset,* 1889, 73 × 92, W 1237, sold Christie's, London, 2 December 1975, lot 15

216. *Tulip Fields in Holland*, 1886, 65.5 × 81.5, W 1067, Musée d'Orsay, Paris

show how far even outdoor work might involve purely aesthetic considerations. This shows the impossibility of establishing any firm criteria for distinguishing between indoor and outdoor working, since there was no radical break in the procedures involved, no single point, coinciding with his taking the canvas into the studio, when art, so to speak, took over from nature.

The extent of studio reworking may more easily be assessed in paintings from sites where Monet only stopped briefly, notably Menton (1884) and the tulip fields of Holland (1886). During the few working days he had at each place (seven at Menton, eight near The Hague) there would not have been time for impasted paint layers to dry fully; so one must assume that additions over thick dry brushstrokes were made in the studio at Giverny. The Menton paintings, executed after Monet had spent three months at Bordighera acclimatising himself to the Mediterranean light, are not extensively reworked; in paintings such as *The Corniche de Monaco* (pl. 28) and *Cap Martin* (pl. 155), retouches are confined to a few light-toned and blue accents which sharpen the contrasts between zones of the

picture. In Holland, though, he had little chance to acclimatise himself to the 'vast fields of open flowers', lamenting that it was 'admirable but enough to drive the poor painter mad, for it cannot be rendered with our poor colours'. Though a spell of consistent weather allowed him to do much work outside,[12] at least one of his Dutch canvases, *Tulip Fields in Holland* (pl. 216), was reworked over dry layers: the blue in the sky has been intensified and some clouds adjusted; ridges of dry impasto underlie the freely dabbed bright colour in the foreground field; and on the horizon the tiny vertical to the left of the windmill has been added, together with the bold blue stroke along the horizon just left of it. All of these additions must have sharpened the definition of the scene and heightened its *éclat*.

The Village of Roche-Blond at Sunset (pl. 215) contains a clue of a different sort about its studio reworking. While some of its paint was wet, the canvas was leant against some sort of bar (probably in a packing case), which left a vertical groove in the paint about two inches in from the right margin. This cut through the thick main

layers of paint when they were wet, but the final reworking was added over this mark, when the paint was dry. If the damage was done during Monet's stay in the Creuse, the final touches might have been added out of doors, but it probably happened during the painting's journey back to Giverny. The retouches which overlie the groove are very much what one might expect from a studio reworking: they conform to the disposition of light and shade in the previous stages, but add blues and mauves into the dominantly yellow sky, dark purple and green on the shadowed hillside, and the sparkling reflections in the foreground stream. Identical reworking occurs in many other parts of the picture; overall, this accentuates the oppositions within the canvas, and enriches and amplifies its colour scheme, in much the same way as in some of the Grain Stacks series.

Less informative is the studio reworking added at the time of their sale to some of the paintings of the 1880s and 1890s that Monet sold only near the the end of his life. Such canvases were signed when they were sold, and in a few cases their signatures cut through wet paint layers, which must thus have been added at the same time. Examples of this are *Landscape at Vétheuil* (pl. 204) and *Etretat, the Cliff and Porte d'Aval in Stormy Weather* (pl. 198). However, Monet seems only to have quickly tidied up the margins of the painting, which, as we have seen, were often initially left unpainted; *The Castle of Dolce Acqua* (pl. 99), a painting of the same period which was never tidied up for sale, still shows unpainted bottom corners. Such late retouches are certainly not characteristic of his patterns of work in the studio before 1900, when his fully finished paintings had to satisfy far more exacting standards of finish.

Though one can rarely trace the precise scope of studio work in individual paintings, its general functions seem clear. He drew out and accentuated the natural forms of the subject and enriched the patterns and colour schemes of the picture surface, not by turning away from the initial stimulus of nature, but by articulating the surface in such a way that it became a pictorial equivalent of the way he saw the forms and colours of the scene. In some cases, such as his paintings from Bordighera or from Norway, considerable adjustment might be needed to compensate for his problems in capturing extreme and unfamiliar effects. But even paintings done in areas with which he was thoroughly familiar must on occasion have needed significant reworking, not merely to refine the rendering of their forms, but also to organise their colour schemes. *Snow Effect at Falaise* (pl. 157) and *Spring at Giverny* (pl. 158), two complex canvases of very different types from the mid-1880s,[13] may illustrate this, though neither has heavy underlying layers of dry paint. When working in a familiar area, though, he may well have been able to visualise such canvases, in pictorial terms, as they would appear indoors, while he was working on them outside, thus avoiding the radical break between outdoor work and studio retouching which he must often have felt on his return to Giverny from distant parts.

With the Grain Stacks series of 1890–1 Monet's problems in finishing were greatly aggravated (e.g. pls. 33, 162), as he pursued the most transitory atmospheric effects ('the sun sets so quickly that I can't keep up with it'), and at the same time was determined to go beyond 'things which come easily, at the first attempt'.[14] His conflicting concerns, with the ephemeral and with pictorial richness, forced him to use the studio more than before, and the final complex surfaces of most of the exhibited series must have owed much to their studio retouching. Again, any precise definition of the role of the studio in individual paintings is difficult, but many of the Grain Stacks series have colour schemes which were substantially

amplified or altered late in the paintings' execution; *Grain Stack at Sunset, Winter* (pl. 136) is a particularly elaborate example, presumably much enhanced in the studio. With Monet's later series, notably the Rouen Cathedral and London paintings, the documentary evidence of the long periods he spent working on them at home makes it all the more certain that their final appearance emerged only in the studio.[15] Studio retouching, in the series, becomes a form of lyrical improvisation, increasingly self-sufficient in pictorial terms. At the same time, Monet became more willing to make substantial alterations in his pictures, not merely in their colour but also in their formal structure; in these series such changes must generally have been a task for the studio.[16] However, even in the most extreme examples where very considerable transformations were made indoors, and the final result went far beyond the original outdoor work, it seems probable that Monet's alterations were always extensions of the spirit of the original, amplifying and enriching the initial stimulus from the natural scene.

So far we have focused on the ways in which Monet's late retouches contribute to the overall effect of his paintings, and on the qualities he sought in a finished picture as a whole. We can, though, approach his retouching from a different point of view, by isolating particular types of accent which he habitually added very late in the process of completing his canvases. We have already noted his

217. *Vase of Flowers*, 1880, 100 × 73, W 629, National Gallery of Art, Washington, D.C.

176

218. *The Tuileries*, 1876, 54×73, W 401, Musée Marmottan, Paris

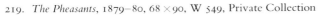

219. *The Pheasants*, 1879–80, 68×90, W 549, Private Collection

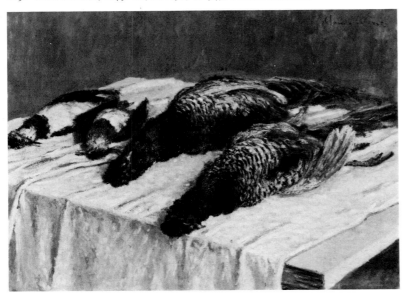

tendency, particularly during the 1880s, to add crisp light or dark strokes which sharpen the tonal oppositions within the picture. During the same period he often used to add small features or colour accents to activate open spaces in the composition. Sometimes these are representational – such as small figures or boats – but often such touches have no obvious representational purpose. Moreover, a comparable role is played by another feature which appears on all his finished paintings – his signature. The development of his signature coincided closely with Monet's changing approach to finishing his canvases.

Monet consistently signed his paintings when they were ready for sale or exhibition, though the act of signing might be accompanied by further retouching.[17] Canvases from earlier periods which he sold late in his life were signed on sale; only in very exceptional circumstances did he part with an unsigned painting.[18] In its placing and in its colour, the signature might play its part in the structure of a painting. Monet generally signed his name in one or other bottom corner, where it best suited the forms of the scene, but he was willing to place it at other points along the base of the canvas if necessary; very occasionally he placed it vertically up the canvas, or

on an object within the picture space, thus creating an ambiguity between space and surface.[19] His concern with the placing of his signature is shown by three paintings in which he altered its initial position: he moved it from bottom right to bottom left in *The House of Parliament, Fog Effect* (pl. 89), and from just left of bottom centre to top left in *Old Tree at Fresselines* (pl. 179); in *Vase of Flowers* (pl. 217) he began to sign above the table on the left, before deciding to place his name on the right. Once, too, he made an active play with spatial ambiguity in the placing of his signature: in *The Water Lily Pond* of 1899 (pl. 36) he deliberately made the crossing of the final 't' of his name, in red, appear to lie behind a prominent foreground reed by the pond.[20] Of Monet's friends, Manet was particularly playful in placing his signature; in *Music in the Tuileries Gardens* (pl. 16), for instance, it appears to lie on the ground beyond a child's hoop.

However, it was the colouring, not the placing, of his signature that was most important for Monet after around 1875. This was first pointed out by Paul Gsell in 1927, in discussing the colour schemes of his later paintings: 'He pushes this principle as far as an imperceptible detail, which no-one has yet noticed. He does not want his signature to be in opposition with the coloration of the work, and he always writes it precisely in the principal tone of the picture.'[21] This was the practice Monet had evolved by around 1890, but it was the result of about fifteen years of experiment.

Monet's early signatures are dark and colourless, often standing out boldly, as in *Women in the Garden* (pl. 64), so as best to advertise the artist's name. Around 1876 he began to relate the colour of his signature to the rest of the painting. Several early examples of this are in the carmine which, at this date, he was using to enliven the darker areas of some canvases;[22] in *The Tuileries* (pl. 218), for instance, the colour of the signature is picked up in retouches in the foreground bushes and on the quay at upper left. Colourless signatures become less frequent in the later 1870s; by the early 1880s varied reds were the most common colour for signing. These generally stand in opposition to the dominant greens of his canvases, but they may also pick up the various red accents set off against the greens in other parts of the picture. Red signatures on dominantly green areas were nothing new (Courbet and Cézanne were perhaps Monet's most relevant precedents), but around 1880 Monet's concern with the colour of his signature began to go further than this. *The Pheasants* (pl. 219) shows his awareness of its role in the whole picture: the signature, originally clear red, was later written over in a dull brown, presumably because the red did not suit the painting's comparatively sombre tone. From the same period, too, there are three paintings in which different parts of the signature are coloured differently; in one of these, *Vétheuil Church, Snow* (pl. 22), its colour changes in relation to the colours below it: it is bluish where it crosses light blue, reddish across soft green.[23]

Monet began in the later 1880s to gear the signature more to the overall colour scheme of his canvases. Often it picks up the warm end of the colour range, as for instance the rich orange-red in *Antibes* (pl. 207), but sometimes, even in brightly lit scenes, the signature may echo the cool values; in *Spring at Giverny* (pl. 158) it is a muted blue. Generally, too, the signature's colour echoes the overall mood of the group of paintings to which it belongs: muted deep reds, or dull greens and blues, predominate in the Belle-Isle canvases, stronger reds in those from Antibes. In the series, from the Grain Stacks onwards, the signature becomes even more integral to the colour harmonies of the paintings; it came to serve, in a sense, as the keynote to the whole picture, guiding the eye to the colour that

Monet wanted to predominate, or, on occasion, strengthening some other strand in its harmonic structure. Most of the Grain Stacks are signed in some sort of red, but the great variety of these reds shows that they were chosen to suit each picture (e.g. pls. 33, 136, 161–2, 252); one canvas from the series exhibited in May 1891, a subdued snow effect, is signed in a dull blue. The signatures on the Poplars are more varied: in *The Poplars, the Four Trees* (pl. 256), for instance, a rich blue signature picks up the cool end of the colour range. In the Rouen Cathedral paintings a wide variety of pastelly hues is used, in the London canvases generally cool atmospheric blues, all closely integrated into each painting's colour scheme. In two paintings of 1905–6 from the Water Lilies series, Monet signed with two colours together on his brush, creating an overlay of colours which gives the signature the effect of shallow relief, standing out from the surface of the pond.[24]

One question is crucial to the discussion of Monet's signature: was it consistently added in the same colour as that used for the final retouches on the painting? If this were so, and paintings were signed simply with the last colour that happened to be on Monet's brush, the colour of the signature might matter little. Sometimes the signature is identical in colour to other late touches, but more often it is not; though closely related to the painting's colour scheme, its colour is often not used elsewhere, or may match a colour only used earlier in the execution of the canvas. We must conclude that the colour of the signature was carefully planned in its own right. On occasion it might suit his plans to retouch and sign it in one and the same colour, but he was very willing to use a fresh colour for signing if a colour scheme demanded it.[25]

Monet was not the only artist to experiment with his signatures during the 1880s. Seurat and Signac, too, began to integrate signatures, along with coloured borders, closely into their pictures. Fénéon wrote in 1890 of Signac's signatures and opus-numbers that they were 'harmonised with their backgrounds – harmonies of related colours for a light background, of contraries for a dark background'. Pissarro in the later 1880s was experimenting with signatures in two overlapping colours, applied separately.[26] However, these experiments postdate the beginnings of Monet's use of

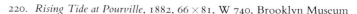

220. *Rising Tide at Pourville*, 1882, 66 × 81, W 740, Brooklyn Museum

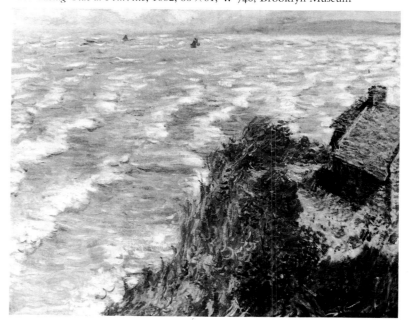

the coloured signature, and their semi-theoretical character is unlike the more intuitive way in which Monet came to incorporate signature and image into a single unity.

Monet's coloured signature provides a gauge of how he saw his paintings as he was applying their final touches: he integrated it more into overall colour schemes as these schemes themselves became more carefully worked out. In the earlier 1880s the signature generally supplied surface contrasts, which later in the decade came to relate more closely to the whole structure of the painting. After 1890, as his paint surfaces became less broken in texture and atmospheric nuances took over from local colour as their dominant feature, he used the signature as a means of tying his colour relationships firmly to the picture surface, and of introducing the viewer to them. Though the development of the signature relates closely to these general changes in his art, it is perhaps no coincidence that his move away from prominent, boldly contrasting signatures took place at the point when his name had become well known and his markets assured. No longer did he need to advertise the brand name; the product was now its own advertisement.[27]

While after 1880 the interest of the signature lies primarily in its colour, the other common types of late accents in Monet's paintings may function in terms of colour or of tonal contrast. Some such touches are clearly representational, such as small boats or figures, while others serve principally to emphasise certain relationships on the picture surface. As we have seen in examining Monet's compositional methods, he consistently avoided compositions that have either a continuous transition from foreground to background, or a spatial structure which is dependent on and defined by the format and frame. He abandoned any appearance of a stage set, in favour of compositions which seem to be extendable sideways beyond the picture's visual field. However, to compensate for this open type of structure, he often used late retouches to hold a picture within its frame, by adding accents near the edges, but without resorting to the traditional *repoussoir* to frame the picture space. In this way the space could remain open and fluid, but the image could at the same time be held within its format. Similarly, late retouches often link planes of space within the painting, to make a pictorial connection between zones joined by no direct perspectival link.

Small boats and figures were common in Monet's inland scenes of the 1870s, where country roads and urban parks are generally peopled, and the Seine often enlivened by a passing boat. They recur in some of the coastal scenes of the 1880s. Generally they were added late in the execution of a painting, sometimes with the retouches when the whole of the principal reworking was dry, sometimes at the end of this main working but while its layers were wet. One canvas, *The Rocks at Pourville, Low Tide* (pl. 177), illustrates both possibilities: the figures on the rocks and the boats on the horizon are all added over a single impasted strip of paint; but this was wet when the figures were added, and dry below the boats. Both play an important part in the painting, in defining its space and in breaking the strong horizontality of the far sea; the figures may well have been added out of doors (the rocks are still used for gathering mussels; see pl. 178), the boats in the studio. The boats in *Rising Tide at Pourville* (pl. 220) were added very late in the picture's execution, but while the final layers of paint in the sea were still wet. Their placing seems very deliberate; they punctuate the wide horizon, and provide a focus for the cottage looking out to sea. By contrast, the paint layers were dry below the figures in *The Manneporte, Etretat* (pl. 129). The figures give an important vertical emphasis, as well as defining the vast scale of the arch and providing a

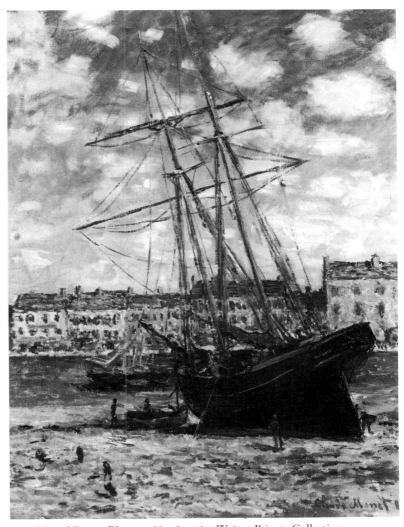

221. *Moored Boat at Fécamp*, 1881, 80 × 60, W 644, Private Collection

butt for the force of the waves. In *La Corniche de Monaco* (pl. 28) the single figure on the road was brushed onto the wet principal paint layer. As with *The Manneporte, Etretat*, the human presence gives a sense of space and scale which is missing in the unpeopled versions of the subjects. However, such small figures virtually disappear from Monet's landscapes after the mid-1880s.

Small objects of other types, such as rocks at sea, may play similar roles. Two examples, both added at a late stage but in wet paint, are the tiny touch placed centrally between the two main rock needles in *Storm on Belle-Isle* (pl. 108), and the four dark dashes on the right of the far rocks in *The Rocks at Pourville, Low Tide* (pl. 177); the former is a focus around which the larger dynamic forms revolve, while the latter links the main masses of the middle ground to the right margin.

The nature of Monet's retouches can best be illustrated by the touches whose function is less literally representational; sometimes these involve giving an unexpected emphasis to a particular element in the composition, such as part of an area of foliage or open water, but sometimes they seem to have no starting point at all in observed reality, serving simply to establish the relationship between image and format, or as visual passages between elements in the painting. Two examples occur in *Flower Beds at Vétheuil* (pl. 154): a few red touches, on the hillside just to the right of the upper area of flowers, link the pinks of the hillside to the stronger reds of the flowers; on

the right of the painting a sequence of dark green dabs floats above the main block of flowers, with a particularly prominent one at the right edge half way between flowers and far bank, exactly half way up the margin. Like the red touches these link foreground and background, but they also tie in the right margin, preventing the horizontal of the river from flowing uninterrupted out of the picture. The green accents belong, in form and colour, with the treatment of the main mass of flowers, but Monet has allowed them to float independent of it on the picture surface.

Monet added retouches of varied sorts near the margins of his paintings. Near the bottom left corner of *Moored Boat at Fécamp* (pl. 221), three dark dabs, perhaps meant as mooring posts, were added when the main paint layer was dry, to give some visual accent to this part of the picture; in *The Sheltered Path* (pl. 117) the open area across the base of the painting is given some focus by a scatter of darker dabs near the centre, which serve no obvious representational function. In several pictures, emphases were added near their right margins. At the extreme right of *Autumn Effect at Argenteuil* (pl. 72) the dull blue shadow by the water's edge – the darkest area in the whole of this very luminous painting – anchors and holds in the composition. Comparable is the dramatic string of scarlet dashes in *The Wheat Field* (pl. 23), which runs across the right third of the painting on the near edge of the standing wheat; it holds in the right margin of the picture, and its accentuated colour balances the heavier forms on the left of the canvas. These scarlet dashes were added particularly late in the painting's execution, probably at the same time that Monet dated it; the date '81' is the only other use of the colour in it, and was clearly added after he had signed his name in a dull red brown. Accents such as these may all have had some basis in observed reality; but the emphasis he gave them was a response to the demands of picture-making.

In discussing late retouches near the edges of Monet's paintings, it is relevant that he habitually applied the final touches to his canvases when they were in frames. We find him insisting on finishing

222. *Varengeville Church*, 1882, 65 × 81, W 727, Barber Institute of Fine Arts, University of Birmingham

223. *Waterloo Bridge, Overcast Weather*, 1902, 66 × 100, W 1560, Kunsthalle, Hamburg

paintings in frames in 1868, and this was his regular practice in the 1880s and presumably afterwards. For example, he wrote to Durand-Ruel from Etretat in 1883: 'I'll need a size 40 frame at Poissy for my return in order to see and finish as I need the things that I've done of that size.' Later he accumulated his own stock of frames of various sizes at Giverny.[28] Millet described his own reasons for completing paintings in their frames, when he was finishing *Shepherdess seated on a Rock*: 'A picture . . . ought always to be finished in its frame. One could never know beforehand what effect the gold border would have; the picture might have to be painted up to it, and a picture should always be in harmony with its frame, as well as with itself. He did, in this case, lighten the whole sky, besides making other changes, after the frame arrived.'[29] Many of the small touches which Monet made near the edges of his paintings are likely to have been added in the frame. The fact that such touches are perhaps more common at the right edge of the canvas may show that he instinctively 'read' his paintings from left to right, and particularly felt the need to prevent their space and forms from continuing wholly uninterrupted out of the right margin.

Similar late retouches may also help to bring out certain relationships within the picture. In *Varengeville Church* (pl. 222) two diagonal red dashes, half way down the land mass near the left margin, hold in the left edge and provide a link, both in colour and in the direction they run, between the sunset above them and the bushes at bottom right of the canvas. They were added at the end of the second main working of the picture, which gave it its strong pinks and oranges. Retouches may also establish spatial transitions in the middle of paintings. In *Storm, Coast of Belle-Isle* (pl. 30) four crisp blue dashes in the spray above the top centre rocks, and others on these rocks, tie the background to the blue accents in the foreground rocks and water; in *Cap d'Antibes, Mistral* (pl. 206) a long sequence of about twenty very pale pink touches, stretching across the mountain tops, and added at the end of the main working of the painting, link the mountains more firmly to the stronger pinks of the foreground.

The varied small accents that have been described are particularly characteristic of Monet's work in the 1880s, when he was exploring the contrasts he found in nature, and translating them into vigorous patterns of brushwork and colour. However, after 1890, as he became more and more preoccupied with the unifying effects of the atmospheric *enveloppe*, such contrasting features disappeared from his work. The three tiny figures in the portal of *Rouen Cathedral, the Portal, Sunlight* (pl. 163) are quite exceptional for their date and in the context of the homogeneity of the rest of the series (e.g. pl. 164); they may perhaps reflect a fear that nothing in the twenty pictures of the cathedral that Monet exhibited in 1895 would give a sense of the monumental scale of the building in front of which he had worked for so many months. Generally, though, in his later paint-

ings, as their spatial structures became simpler and the effects depicted became more unified, late retouching served either to redefine one of the main forms of the painting or to emphasise a colour scheme. Such points of emphasis may still be placed near the margins of a canvas in order to coordinate the whole image; the strong blue touches at bottom right of *Grain Stack, Snow Effect, Morning* (pl. 161) have no clear representational purpose, but balance the signature and connect the sunlit area to the patch of shadow. However, in later series the accents become less dynamic and more completely subordinated to the overall effects of the whole canvas. We have already described the soft accents that animate the surfaces of the Early Mornings on the Seine (e.g. pls. 139, 211), delicately accenting in particular the margins between sky and trees; in paintings such as these it is no longer relevant to isolate particular points of emphasis which fulfil separate functions within the picture.[30] Even in *Waterloo Bridge, Overcast Weather* (pl. 223), where many crisp touches of paint are added late to emphasise the bridge and the traffic on it, this band of more broken working across the canvas is integral to the patterns of the whole picture, rather than an attempt to emphasise a contrast or articulate a relationship in any one part of it. In the Water Lily Decorations (pls. 92, 269) the protracted process of reworking and elaboration produced surfaces which, from close to, create a complex and free-flowing interplay of patterns and colours. But when the canvases are seen as a whole, this surface activity does not assert itself too much or disturb the overall coherence of their huge spaces.[31]

Monet's most typical late retouches, then, are small accents of varied types, often with a representational function, but also closely related to the two-dimensional structure of the picture, articulating certain areas of the painting or linking one area to another. In the 1870s and into the 1880s they most often set up contrasts of tone, and increasingly contrasts of colour, whereas later they became woven into the coordinated harmonies of his finished paintings, serving to emphasise their essential hues and rhythms. In all the different forms they took, they added to the canvas what Delacroix called *liaison*. Delacroix defined this as the 'art of tying together the parts of the picture by means of the effect, by colour, by line, by reflections, etc.', and described it in terms that explain the natural basis which he felt to lie behind this pictorial unity: 'When we cast our eyes on the objects which surround us . . . we notice between the objects a sort of *liaison* produced by the atmosphere which envelops them and by the reflections of all sorts which make every object participate in some way in a sort of general harmony; . . . most painters seem not even to have noticed in nature this necessary harmony which gives a work of painting a unity which lines on their own cannot create, however ingeniously they are arranged.'[32] It was in the last stages of finishing his paintings that Monet was able to recreate the web of harmonies which he too felt connecting all parts of the natural scene.

Rarely can we tell whether Monet's late retouches were added out of doors or in the studio. On occasion they were doubtless done outside, but more often they must have been part of the studio revision which became increasingly indispensable for him during the 1880s and 1890s. Whereas in the earlier 1880s, definition and contrast were the keynotes of his retouching, thereafter the increasing use of the studio for an 'act of harmonisation' provides the clearest indication of his evolving ideas about finish. However, in the successive stages of executing a painting which Geffroy defined – establishing the dominant values, studying their gradations, contrasting them and harmonising them[33] – there was no basic distinction between the types of working done out of doors and in the studio. The business of working up and completing his canvases always remained one continuous process of doing 'what I think best in order to express what I experience in front of nature . . . to fix my sensations'.[34]

CHAPTER ELEVEN
PENTIMENTI

IN MANY fields of the history of art, the examination of pentimenti, the changes made during the execution of a painting, is a well established tool of analysis. However, of the Impressionist landscapists, only Cézanne has been closely examined from this point of view;[1] with the other landscapists of the group, it has, it seems, been assumed that problems of this sort do not occur in paintings as direct and spontaneous as theirs have generally been considered to be. In examining Monet's paint surfaces and their execution in the previous chapters, we have seen the calculation which went into their final effect and the factors involved in transforming the initial experience of nature into a finished canvas. On occasion, these processes went wrong, and the execution of the canvas was not one continuous progression from the discovery of an interesting effect to its final pictorial realisation. Difficulties might arise at any stage, and the variety of things that might go wrong helps to highlight the particular points in Monet's working process where decisions had to be taken. The frequency and extent of the pentimenti to be found in his paintings increase during the 1880s and 1890s – a further indication of the growing complexity of his methods during these years.

The study of Monet's pentimenti is hampered by the fact that very few of his paintings have been X-rayed,[2] perhaps on the assumption that his methods were straightforward. For the moment, then, conclusions must be based on examination of his paint surfaces, but in this Monet's techniques of paintings are a great help. At least between around 1874 and 1895 he consistently worked in a full impasto, and, when corrections had to be made, he generally left his previous working intact below the new layers. Sometimes he did scrape out failed beginnings, and a few canvases show partly scraped zones left unreworked, presumably when the removal of some paint by itself achieved the desired effect.[3] But for the most part he left the original layers undisturbed, to keep his reworking to a minimum, allowing as much as possible of the previous working to play a part in the painting's revised appearance. He told Trévise of the changes he had been forced to make: 'There are some things of mine which were good to start with, then got spoiled, and then became good again as a result of corrections, but without my ever having erased the first layers.'[4] The results of keeping the underpainting are clear in many canvases, allowing one to reconstruct their forms and effects as originally planned. In the 1880s his comparatively open brushwork often leaves elements from previous workings uncovered, while the more uniformly covered surfaces of the 1890s still often allow the shapes of previous forms to be detected, as impasted ridges which can be seen in raking light.

Some visible underworking has no connection with the final painting. This is when Monet reused a canvas for a different subject without erasing all or any of his first start. He frequently did this until around 1880, when he could not afford to waste a canvas, but much less thereafter, presumably because Durand-Ruel's regular purchases meant that he could afford to discard failed beginnings. The few traced examples of reused canvases after 1880 were all executed on Monet's travels, when he would have been more reluctant to scrap abortive starts for fear of being unable to obtain fresh materials.[5] However, the many reused canvases of earlier years pose considerable problems for the examination of his methods, for many apparent changes in his paintings may in fact be the ghosts of previous pictures on the same surface; so it is more difficult, in discussing his paintings from before 1880, to isolate changes made during the execution of a particular image, though these do certainly occur then, as later.

On occasion, enough is visible of an underlying different picture for its subject to be roughly reconstructed. Beneath one of the Gare Saint-Lazare *esquisses* that Monet sold to Caillebotte, the *Exterior View* (pl. 196), one can trace what seems to be a brightly coloured river scene: two red-roofed houses stand on a riverbank, seemingly with a tree between them, with a grassy bank in front of them and water across the foreground, probably with boats moored by the bank. This can scarcely be sensed on a photograph, but it can be traced from traces of colour seen between the rapidly applied layers of the final painting, and from some dried ridges of paint below opaque layers; in *Impression, Sunrise* (pl. 199), by contrast, the final painting is laid on very thinly, and traces of a previous subject have become visible through the later layers, which have presumably become more translucent with age: even in a photograph, dark shapes can be seen around the signature and vertically above its right part, extending down again into the area between and below the two boats; these could be a river scene or a quite different subject from the port of Le Havre, but clearly have nothing to do with the present subject. The underlying picture in *Gare Saint-Lazare, Exterior View* was quite densely painted and covered most of the canvas, whereas that below *Impression, Sunrise* may well have been confined to a few dark indications, mapping out a possible arrangement, since there are no substantial opaque layers below the surface.

Far more frequently, though, we cannot trace the underlying painting at all; it just makes its presence felt by otherwise inexplicable thick dry brushstrokes beneath the surface, or traces of unexpected colour seen between later layers – things that bear no relationship at all to the image on the final surface.

On other occasions the first working, though different in some lines from the final one, is still recognisably of the same subject. Sometimes the original state cannot be clearly traced beneath the present surface,[6] but three examples may be described in some detail. Their original forms are best shown in diagrams: an off-centre shed in *The Gare Saint-Lazare* (pl. 119; cf. pl. 224), probably originally not unlike the main forms in plate 101, was replaced by a precisely symmetrical structure; the lines of the rock arch were completely changed in *The Manneporte, Etretat* (pl. 130; cf. pl. 225); and in *Antibes seen from the Jardins de la Salis* the positions of trees and town were shifted (pl. 226; cf. pl. 227). The changes were slight enough for the original working of each canvas to supply a good part of its final surface, particularly in the main areas of the Etretat

226. *Antibes seen from the Jardins de la Salis*, 1888, 73 × 92, W 1164, sold Christie's, London, 27 March 1973, lot 57

227. Diagram of *Antibes seen from the Jardins de la Salis* (pl. 226); dotted lines indicate original disposition of forms

224. (above) Diagram of *The Gare Saint-Lazare* (pl. 119); dotted lines indicate original disposition of forms

225. Diagram of *The Manneporte, Etretat* (pl. 130); dotted lines indicate original disposition of forms

rock arch, which are little reworked. Their first working served as a form of lay-in and a basis for their colour schemes, before their compositional structure was modified.

All three examples can be explained by a change in Monet's physical viewpoint, but he must have had positive reasons for making such changes. Sometimes the quest may have been for variety; at Antibes he was worried about repeating himself, and the original form of *Antibes seen from the Jardins de la Salis* (pl. 226) was close to another painting.[7] But sometimes his reasons involved questions of taste: at Pourville in 1896 he was, he wrote, 'always hesitant, dissatisfied with the *mise en toile*, with the choice of my site, which leads me to make changes'.[8] Some Pourville paintings of this date show extensive alterations to their contours, which amount to an

184

effective recomposition of the painting during its execution; in *The Coastguard's Cottage at Pourville, Full Sunlight* (pl. 165) the cottage was enlarged and the cliff edge to the right substantially shifted. Monet's first step in making such changes may well have been to move his easel, but his motives were presumably a dissatisfaction with the way in which he had originally formulated his subject on the picture surface, indicating his concern for compositional pattern.

Other changes cannot be ascribed to changes in his actual viewpoint. On occasion he left the basic forms of a painting undisturbed, while significantly changing a form or an outline in one part of it; again, his reasons may well have been primarily aesthetic. In *The Cliff at Fécamp* (pl. 77) the bottom cliff edge originally ran almost horizontally to the left edge of the canvas, about three inches from its base, following, it seems, the forms of the natural subject; the extension of the sea downwards into the bottom left corner breaks the uniformity of the bottom edge. *The Cliff Walk, Pourville* (pl. 228) included, in its original form, only one shadowed area of cliff face, in the centre

of the picture; at upper right there was originally only a simple boundary between the lit cliff top and the sea. The second shadow mass, with its complex contours, is an emendation, giving a balancing dark accent on the right, so that the two figures (which were part of the original plan) are framed between two equally weighted features.[9] In a further coastal scene of 1882, *The Coastguard's Cottage at Pourville* (pl. 151), the dominant cottage was originally much smaller than it is now, ending below the horizon.

The alterations in *The Cliff Walk, Pourville* (pl. 228) relate to the concern for defining the edges of a picture, which we examined in the last chapter. Forms near the edges of pictures may be manipulated in many other ways. In *Vase of Flowers* (pl. 217) a curving red stroke extends the table edge virtually to the right margin, and tightens up the pattern of shapes in the bottom right corner. Three canvases of a single Antibes subject, *Antibes seen from the Salis*, reveal similar anxieties about edges and corners. There are minor discrepancies between the versions. In two of them (pls. 229–30) the intrusive

228. *The Cliff Walk, Pourville*, 1882, 65 × 81, W 758, Art Institute of Chicago

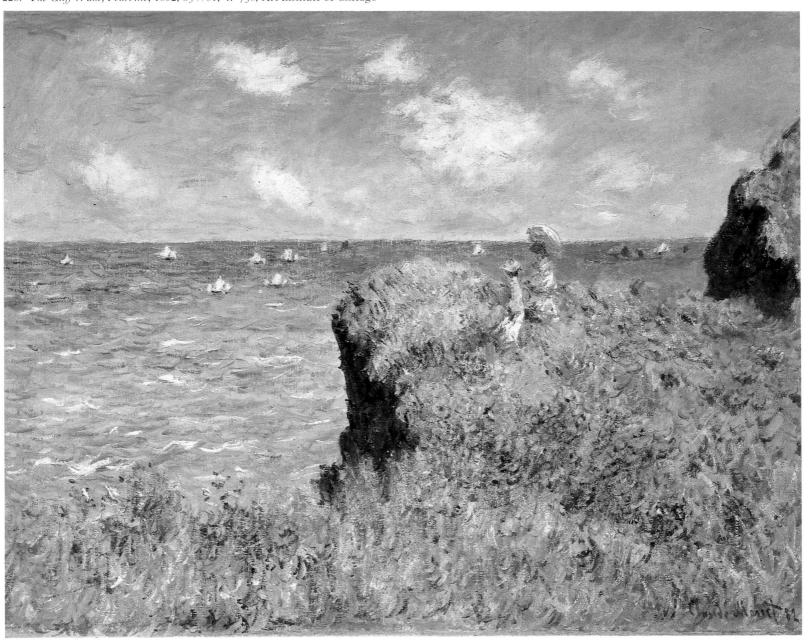

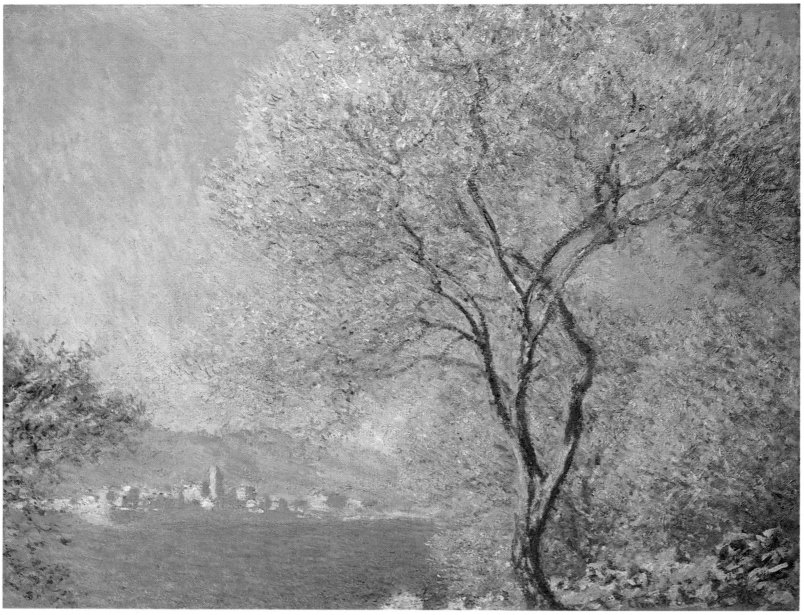

229. *Antibes seen from the Salis*, 1888, 73 × 92, W 1168, Toledo Museum of Art

foliage at the left is extended down over the sea in the bottom corner, but in one (pl. 231) this area is left open; where the foliage cuts over the water, it seems to have been added at a very late stage. The branches of the main tree on the right also differ between the versions: in two (pls. 230–1) the right-hand trunk continues vertically above the foliage beyond it, and a branch extends from it to the right near the top of this further foliage; one version, though (pl. 229), has neither the continuing vertical nor the rightward branch. Even these two differences in this tree arose in different ways: the right branch, where it appears, was added very late; the version without it seems never to have included a branch at this point; however, the same version shows clear signs that it, too, originally had a continuing vertical trunk like the other two. So it seems likely that, originally, all three had the vertical trunk but no branch to the right at that point; perhaps this emphatic vertical seemed to contrast too much with the rather amorphous area to its right, but Monet tried two different expedients for correcting this: either adding the branch to

the right, or, in one case (pl. 229), breaking the vertical. Though comparatively slight in themselves, details such as these reveal the painter's concern with such small-scale relationships as parts of the whole, and his willingness to manipulate the forms in front of him in unobtrusive ways where the effect he sought demanded it.

Alterations of many kinds appear in Monet's treatment of trees and foliage. Sometimes even large trunks are moved or removed. In *Poplars on the Banks of the Epte, seen from the Marshes* (pl. 232) a tree trunk originally ran all the way up alongside the left margin – a precise correspondence of verticals between tree and margin which he presumably disliked, since he painted over the trunk in this version and did not include it at all in his only other painting from the same viewpoint (pl. 233).[10] In *Juan-le-Pins* (pl. 234) the lines of the trunks at the right have been much altered, but in their final positions they are the same as those in the other painting of the same subject (pl. 235); however, this second version includes a group of three extra trees at far right, which do not correspond with any of

230. *Antibes seen from the Salis*, 1888, 65 × 81, W 1170, Philadelphia Museum of Art

231. *Antibes seen from the Salis*, 1888, 65 × 92, W 1167, Private Collection

where quite substantial features of the final picture did not appear in the lay-in, we cannot assume that they reflect changes in his plans; such additions can only confidently be identified as pentimenti when the original placing of the objects is visible, or when the objects are so substantial that, if they had been planned from the start, they would have appeared in even the most summary lay-in.

232. *Poplars on the Banks of the Epte, seen from the Marshes*, 1891, 88 × 93, W 1312, Private Collection

233. *Poplars*, 1891, 90 × 93, W 1313, Fitzwilliam Museum, Cambridge

the original tree lines in the first and were a late addition. The trunk of the single tree in *Antibes* (pl. 207) was shifted slightly to the left during the execution of the painting, presumably to emphasise its sinuosity. Even so lightly worked a painting as *Landscape at Vétheuil* (pl. 204) shows a shifted tree: the fir which cuts the horizon to the left of the church tower has been moved to the left, but the original position of its crown had not yet been erased from the sky when Monet left off work on the canvas.

These are only a small sample of the paintings in which Monet adjusted the lines and forms of his trees. One must, though, distinguish between such deliberate changes and Monet's normal process of working from the initial lay-in to the finished picture.[11] As we have seen, the open fretwork of the edges of foliage and small vertical tree accents do not generally appear in the lay-in, but are added later over the initial working of the sky. This involved quite substantial additions at times, as in the foreground foliage in *Antibes* (pl. 207) and the background trees in *The Banks of the Seine near Vétheuil* (pl. 127). Even

234. *Juan-les-Pins*, 1888, 73 ×92, W 1189, Private Collection

The pentimenti discussed so far are mainly alterations whose main purpose seems to have been the adjustment of certain surface patterns and of the relationships between forms on the picture surface, often with a particular concern for the framing of forms within the margins of the canvas. These changes must be seen as part of Monet's processes of retouching and finishing his paintings, described in the last chapter. There is, though, another class of pentimenti which are the direct result of Monet's difficulties in working out of doors, caused by nature's refusal to remain still and unchanging. In some heavily worked paintings it is difficult to determine the reasons for particular changes, but certain types of pentimento can be directly attributed to material changes in the scene before him; they are a direct reflection of the problems Monet encountered in his efforts to work up his paintings as far as possible in front of their subject, problems which, as we have seen, are ceaselessly reiterated in his letters.[12]

Some of the changes in Monet's subjects were the results of man's agency. He wrote of his troubles with the constant moving of boats on the beach at Etretat in the rough weather of February 1883, and the altered positions of the boats in *Rough Sea, Etretat* (pl. 25) may well be a direct result of this. Again in autumn 1885 similar problems presumably led to the rearrangement of the masts in *Boats on the Beach at Etretat* (pl. 236), whose original positions can be seen where they are not fully covered by the rapid reworking of the picture.[13] But we cannot assume that all moved boats represent changes in their actual positions; others were shifted because Monet was dissatisfied with their original placing. In *Terrace at Sainte-Adresse* (pl. 67) there was originally a boat with a single large sail just to the left of the left flagpole (perhaps a recreational sailboat, in contrast to the fishing boat to the right of this pole), while beneath the right pole, just below the little paddle steamer on the horizon, was another three-sailed fishing boat, travelling in the opposite direction to the one on the left. The small boats in his seascapes of the 1880s sometimes met a similar fate: in *Cap d'Antibes, Mistral* (pl. 206) one has been covered in the foreground sea area and replaced by one further out to sea. The alteration in *Oarsmen at Argenteuil* (pl. 237)

cannot be attributed to natural causes: Monet narrowed the apex of the large sail, so that it is now less than one centimetre across where it meets the canvas edge, whereas it had originally been considerably wider at the top of the picture.

Most often, though, it was nature's changefulness, not the works of man, which caused Monet's problems. His difficulties in matching tide level with light effect can be seen in several paintings, for instance in *The Manneporte, Etretat* (pl. 129), where the tide level was originally higher, and broken waves reached about a quarter of the way up the left margin; the rocks which now appear in the foreground were all added over a dry layer of sea-painting. Conditions might also change out at sea. Both *Antibes* (pl. 207) and *The Pyramides at Port-Coton, Belle-Isle* (pl. 246) originally showed far more agitated waves, more like *Cap d'Antibes, Mistral* (pl. 206) and *Storm on Belle-Isle* (pl. 108), paintings from the same trips whose animation was never tempered. Several of Monet's Creuse paintings testify to the changing water levels he found in the river, for instance *Ravine of the Creuse* (pl. 134), where the original level was substantially higher than the one we see now.[14]

236. *Boats on the Beach at Etretat*, 1885, 65.5 × 81, W 1024, Art Institute of Chicago

now with an effect of heavy hoar-frost, originally had a dense light layer, perhaps representing snow, below its main areas.

Changing seasons also left their mark on paintings. At Giverny Monet could generally return to a painting the following year, but, with the Poplars series in 1891, he had to complete the series in one summer and autumn, before the trees were felled. In at least one case he had to convert a summer painting into an autumnal effect: *The Poplars, Autumn* (pl. 255) has an initial in-lay not unlike that still seen on the surface of *Poplars on the Banks of the Epte* (pl. 214) – clearly in a summer colour range, but it has been consistently worked over in a rich autumnal colour scheme. This was not Monet's normal procedure for the autumnal Poplars, as *The Three Trees, Autumn* (pl. 137) shows: the final effect here is close to the other autumnal picture, but its lay-in, too, is fully autumnal in colour.

Changes of lighting are less easy to identify with confidence. As

235. *Juan-les-Pins*, 1888, 73 × 92, W 1188, Private Collection

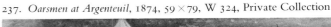
237. *Oarsmen at Argenteuil*, 1874, 59 × 79, W 324, Private Collection

The movements of clouds are so rapid that even the most rapid attempt to capture them on canvas must involve some degree of compromise with any particular momentary grouping in nature. When their placing is altered during the execution of a painting, one can draw no clear distinction between modifications forced by nature's metamorphoses and those which reflect questions of aesthetic placement; we have already examined the reworking of the clouds in *Poplars on the Banks of the Epte* (pl. 214). Most obviously the result of pictorial rather than natural concerns are individual changes in canvases where most of the clouds are left in their original positions – for example the two small clouds added just below and to the left of the crown of the tallest tree in *Spring Effect at Giverny* (pl. 159).

As Monet's letters lead one to expect, some paintings show changes in snow effects. An early example, *The Seine at Bougival* (pl. 238), now has thick snow and ice, which seem to have been absent in its original state. The comings and goings of snow are reflected, too, in the Grain Stacks series, as in his letters written while he painted them:[15] *Grain Stack at Sunset, Winter* (pl. 136),

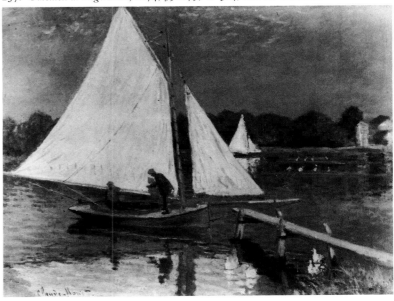

The sky, too, was originally different, with clouds just above and to the left of the cliff face, now an area of clear sky – a change which might be attributed to the changing weather. However, at far right Monet also moved the line of the cliff top downwards, by adding a strip of blue paint over the top part of the original lay-in of the hill. Moreover a group of vertical accents has been erased in the sea to the left of the main cliffs; these may have originally represented poles for hanging out fishing nets (see pl. 79). Though this number of

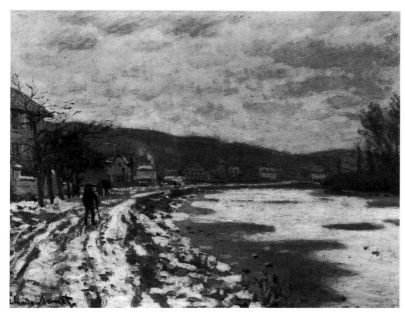

238. *The Seine at Bougival*, 1869–70, 51 × 65, W 143, sold Christie's, London, 28 November 1972, lot 15

we have seen, Monet's lay-ins were generally in comparatively simple, broad planes of muted colour, without detailed indications of the fall of light or of atmospheric colour. Dramatic lighting is often added or accentuated in reworking a canvas, but its absence in the lay-in does not necessarily indicate a change of plan; the lavish sunset in *Varengeville Church* (pl. 222) is an example. In paintings of effects of mist, too, the initial layers often represent the forms more distinctly, with more local colours, before the addition of the nuanced atmospheric skin, for instance in *Morning Haze* (pl. 160).

Low Tide at Pourville (pl. 239) shows a number of the factors already discussed appearing in a single painting. As it stands the wide sand flats off Pourville are shown covered with shallow water, though the colour of the lay-in below this area suggests that it originally represented uncovered sand; a tide change here is not surprising, since the sands are quickly covered by the incoming tide.

239. *Low Tide at Pourville*, 1882, 60 × 81, W 716, Cleveland Museum of Art

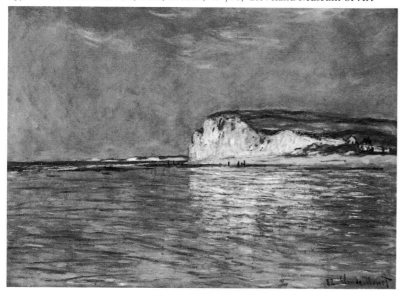

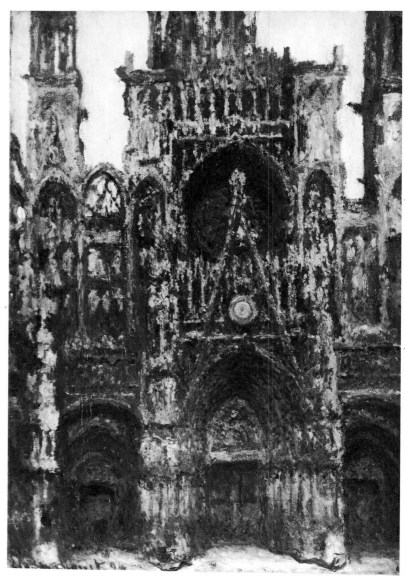

240. *Rouen Cathedral, the Portal, Front View*, 1892–4, 107 × 73, W 1319, Musée d'Orsay, Paris

changes is unusual in a canvas which is not particularly heavily worked, the variety of pentimenti here shows the difficulties that Monet might face, both from changing natural effects and from his own adjustments of compositional features, even when he was working in a comparatively straightforward way from nature.

These problems were all accentuated in the series from the 1890s onwards. Some alterations in the Grain Stacks and the Poplars have already been mentioned – snow, seasons and tree tunks. However, the Grain Stacks in particular, and after them the Rouen Cathedral, London and Water Lilies series, show more frequent and more

extensive pentimenti than any of Monet's previous work – not surprisingly, given the transitoriness of the effects depicted and the time Monet spent on them. These pentimenti show how calculated the series were, in both colour and form.

Grain Stack at Sunset, Winter (pl. 136), perhaps, as we have seen, originally a snow effect, also shows considerable alterations in its colour scheme, particularly in the sky, where rich orange and blue was added over an original quite uniform yellow layer. In isolation this change might be attributed simply to a fresh natural effect, but the complexity of the whole surface makes it likely that the modification of the sky was part of the elaboration and harmonisation of the whole surface. The painting also includes a major pentimento of a different sort: the stack has been moved several inches to the left; an identical change was made in two other versions of the same composition, including *Grain Stack, Snow Effect, Morning* (pl. 161). *Grain Stacks, Snow Effect, Sunlight* (pl. 254) was also much altered: the right stack was enlarged to the right, and the shape of the left-hand shadow modified; the effect of the changed shadow is to give the field a rhythm of alternating blue and salmon zones, and to clarify the painting's formal structure.

In the Rouen Cathedral series, too, Monet on occasion emended his effects radically. Signs of a different, much brighter colour scheme can be seen below the surface of *The Portal and the Tour d'Albane, Grey Weather* (pl. 138). In *The Portal, Front View* (pl. 240), the only finished version that views the façade from due west, the original working placed the whole façade quite differently, further down and to the right, and perhaps viewed from the south-west, like the vast majority of the series.[16] This shows that, far from being a first attempt, as Wildenstein assumes, this west view, in its present formulation, was a matured decision which reveals his concern to lend variety to the group of paintings he exhibited in May 1895.[17]

Many of the London series have colour schemes that were greatly enriched or altered late in the execution of the painting; in others, the position of plumes of smoke is altered (e.g. pl. 268). Moreover, in some canvases he made wholesale alterations in the placing of the forms; there are examples of this in paintings of each of the three subjects which make up the series.[18] Such problems were not confined to paintings executed away from Giverny. One of the Japanese Bridge series had the whole composition, with the bridge, shifted; in the 1903–9 series of the lily pond, many canvases reveal evidence of shifted lily pads (e.g pl. 140). About this last series, commentators at the time pointed out that Monet himself admitted that 'there were four or five different pictures on each canvas', and that this caused him great dissatisfaction.[19] Finally, in the Water Lily Decorations and the other monumental canvases of the painter's last years, there are many instances of altered colour schemes, of shifted lily pads, and, in the Orangerie decorations, of moved tree trunks.[20]

Constant emendations and reworkings did not always improve the paintings for Monet. On occasion his obsessive overpainting and his refusal to stop working led him to spoil what he had started. On one side, he could advise Louis Le Bail: 'One ought . . . never [to] be afraid . . . of doing over the work with which one is not satisfied, even if it means ruining it.' But on the other, he told Lilla Perry that 'it was difficult to stop in time because one got carried away'.[21] His pentimenti bear witness both to his perfectionism and to his dissatisfaction with himself. He was willing to alter his paintings extensively, particularly in later years, but the more he changed them, the more uncertain he became that his emendations were improving them. His pentimenti reveal the problems created by his open-air methods, and also the increasingly complex ways in which he structured and unified his picture surfaces.

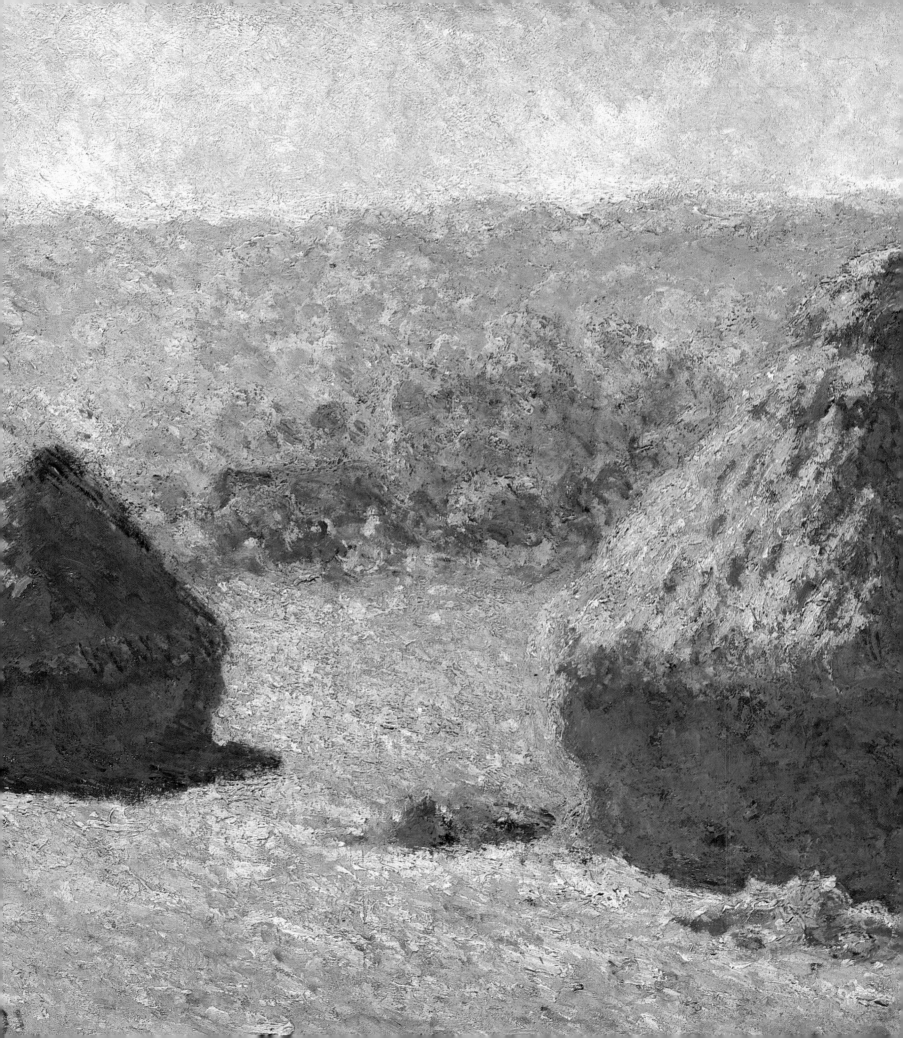

CHAPTER TWELVE
The EVOLUTION of MONET'S SERIES

IN DISCUSSING Monet's work, the term 'series' is generally used to describe the homogeneous groups of paintings of identical or near-identical subjects which he exhibited from 1891 onwards. There is, though, nothing in the word itself to suggest such a specialised meaning: *série* was widely used to refer to any group of studies or paintings either seen together or of related themes, even if they lack the close links that characterise Monet's series after 1890. From the 1860s onwards groups of Monet's paintings were described by critics as series, and Monet was using the word to describe his own work by 1876, when he described a group of new paintings of Argenteuil as 'a whole series of new things'.[1] The term occurs regularly in his letters thereafter. Rarely can we identify the precise paintings that Monet characterises as series, but we can determine what he meant by it from the ways in which he used it, in the context of the general patterns of his work.

Monet used the term to describe a group of canvases under way at the same time. These may form a coherent group in terms of the type of effect depicted, but he also used the word to describe groups of paintings which were only loosely interconnected. A 'series of studies' of 1880 seems to mean little more than all the work he had under way at the time, clearly including a lot of paintings besides the two canvases of apple trees which are the only ones specified in the letter. Similarly loose in reference is the 'series of new things' he promised Durand-Ruel to bring back from Bordighera in 1884; while at Bordighera, though, he also used the word to describe smaller, more coherent groups of paintings, classing the canvases he was planning of M. Moreno's garden in February 1884 as a separate series from the Bordighera pictures he had already started.[2] He was again referring to comparatively small groups of paintings when he wrote in January 1885 of a series of snow scenes, and in April 1885 of a 'series of spring subjects', though these groups had no overall coherence.[3] The word became Monet's standard term after 1890 for his more tightly integrated groups of paintings, but his quite casual previous uses of it, and its common usage by critics and other artists, show that his use of the term in itself has no great significance in the genesis of his serial procedure.

Monet's series after 1890 have two prime characteristics: whole sequences of paintings of near-identical subjects were worked up together as a group; and such groups were exhibited together as an artistic unit. Both of these practices had some precedents, but Monet pursued the policy more consistently and on a far larger scale than any previous painter. It was nothing new for an artist to treat a single motif on many occasions. This might be done for several reasons, some of them directly relevant to the evolution of Monet's procedures. Replicas, or repetitions with minor modifications, had been part of the artist's stock in trade for centuries, to satisfy patrons or the market. But on occasion artists returned to a theme seemingly because of some more personal significance it held for them: Rembrandt's self-portraits and Turner's variations on subjects such as Norham Castle are examples of this, the former a constant re-exploration of an ever-present subject, the latter a reinterpretation of the artist's own past versions of the theme, rather than simply a renewed direct encounter with the subject itself.[4]

An artist might also return to the same subject as a means of refining his observation of natural effects. The sources of this idea in France lie in the precepts and practice of Valenciennes, who in 1800 instructed the artist: 'It is good to paint the same view at different hours of the day, to study the differences which light makes on forms. The changes are so clear and so astonishing that one can scarcely recognise the same objects.' Valenciennes's own small Italian oil studies of the 1780s show the idea in practice. But for Valenciennes the works so produced had no claim to be independent works of art; they were simply notations of natural effects for use in composing pictures.[5] This interest in observing meteorological variations on a single subject was maintained by French landscapists: Paul Huet's sequence of nine watercolours of a single sunset of the mid-1860s are an extreme example, paralleled by Turner's colour notations of different light effects on the Rigi above Lucerne.[6]

There were precedents, too, for exhibiting such interrelated works together. In 1809 Turner showed at the Royal Academy two views of Tabley House at different times of the day and from slightly different viewpoints, and he included at least three finished watercolours of different effects on the Rigi in his set of Swiss views of 1841–2.[7] In France the first traced instance of paintings of the same subject in different light exhibited together is the pair of views of the Fontainebleau forest, in morning and evening, which Théodore Rousseau showed in 1855. Both, like the Turners, were studio works, improvised from outdoor studies or drawings, but Rousseau was fascinated by how light changed the appearance of nature; he showed Burty a similar pair of paintings as proof that a different lighting 'changed the physiognomy of a site so as to make it almost unrecognisable'.[8]

The artists at the time in France who worked most consistently

on groups of paintings of related subjects were Daubigny, Jongkind and Courbet. Daubigny repeated the same scene on many occasions at intervals of up to twenty years, but some of the later versions may have been replicas or studio variants rather than the result of fresh study of the natural subject, and the variations in natural effects between versions may often have been synthetic additions.[9] Jongkind concentrated intensively on single subjects over shorter periods, particularly during the 1860s, when on several occasions he painted a single scene in different lights – for example three versions of *Notre-Dame de Paris*; highly finished scenes such as these were not, though, themselves painted out of doors, and there is no evidence that he intended such paintings to be exhibited together.[10] Courbet's attitude to series is more complex: fascinated by the idea of series, he saw some of his Salon paintings as belonging to series of related themes; but more relevant for Monet was Courbet's one-man show of 1867, in which he included a group of no fewer than thirteen *Paysages de mer*, recently painted on the Normandy coast.[11]

Japanese prints supply a final precedent. In the cycles of views of Mount Fuji by Hokusai (e.g. pls. 66, 88) the chosen views vary greatly, but the mountain is a single thematic focus. Other series such as Hokusai's Large Flowers (e.g. pl. 60) and Waterfalls are devoted to a single theme, though the individual subjects differ. Such series were well represented in Monet's own collection. Equally suggestive in this context would have been a pair of prints which Monet owned by Hiroshige of the same scene from the Famous Places of Edo, *The Isle of Tsukuda*; printed from one and the same block, but using different inking, these create images of the scene by night and by day.[12]

The GENESIS of MONET'S SERIAL PROCEDURE, 1864–1889

The genesis of Monet's serial procedure can best be analysed by correlating the evidence of his paintings with his letters and the surviving accounts which claim to record his own account of its origins. The evidence of the paintings is primarily statistical – the increasing numbers of canvases that treat one and the same subject. But the particular characteristics of the series are not simply a matter of the number of versions of any subject; they involve the way Monet saw these paintings, whether he worked them up and exhibited them as a single unit. The present section will examine paintings and written evidence from before 1890; the following one will examine in detail the Grain Stacks series, which Monet himself regarded as a turning point in his work, and will ask how far it is foreshadowed in his previous practices.

In summer 1864 Monet adopted Jongkind's practice of making more than one painting of equal status of the same subject; several such pairs survive from this year. In some of these one canvas is the study for the other, but in one case, views of the beach at Sainte-Adresse at high and low tides (pls. 111, 180), the two are independent works of equal status.[13] Some similar pairs recur in the later 1860s and early 1870s (e.g. pls. 241–2). However, it is rarely possible to tell whether paintings of a single subject were undertaken simultaneously and intended as a pair, or whether one represents a subsequent return to the subject; the dating of Monet's paintings from the mid-1860s until the mid-1870s remains very uncertain, particularly at Argenteuil in the early 1870s, when he seems to have returned almost annually to certain favoured spots.[14] Of Monet's companions,

Sisley, in particular, was producing similar pairs from 1870 onwards.[15]

Monet's work of the later 1870s reveals a greater interest in focusing on single themes. Instead of occasional related pairs, he began to work on certain subjects in groups of three or four canvases,[16] but there is no indication that he thought of exhibiting such groups together. The Gare Saint-Lazare paintings of 1877 are not unified in the same way; eight of Monet's twelve canvases of the place were shown at the 1877 group exhibition (including pls. 101, 119, 265–6), but no more than two of the sequence are treated from any one viewpoint. Their importance as a thematic focus in this exhibition will be discussed later (see pp. 206–8), but with their varied forms they do not represent an important stage in Monet's multiplication of canvases of single viewpoints.

Like the Argenteuil paintings, Monet's work at Vétheuil presents

241. *The Railway Bridge, Argenteuil*, 1874, 55 × 72, W 319, Musée d'Orsay, Paris

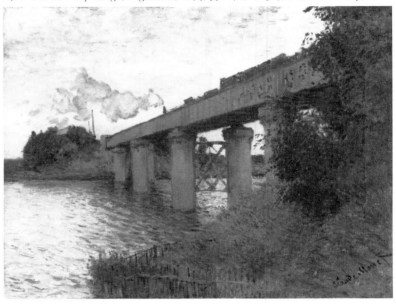

242. *The Railway Bridge, Argenteuil*, 1874, 54.5 × 73.5, W 318, John G. Johnson Collection, Philadelphia

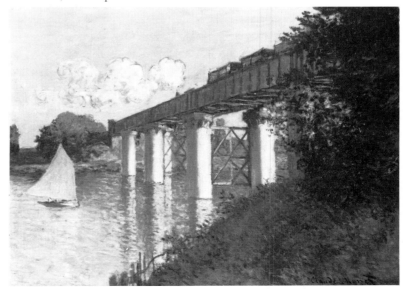

243. *Low Tide at Pourville*, 1882, 60 × 81, W 712, Private Collection

244. *Low Tide at Pourville, Hazy Weather*, 1882, 60 × 81, W 779, Private Collection

dating problems; some subjects recur many times, but these paintings probably belong to different campaigns of work. Many closely related pairs exist, but the cumulative effect of the paintings of the riverbanks around Vétheuil is to give a very full image of the area, seen from many viewpoints and in every season and type of weather. Even in his most unified group of paintings from Vétheuil, those of the frozen river and the ice floes of 1879–80 (e.g. pls. 24, 95, 185–6), there are not more than two canvases of any precise subject.[17]

Monet's working patterns are clearer and a development more visible in the paintings from his travels of the 1880s; moreover, letters and eyewitness accounts begin to give an idea of how he set about painting particular groups of pictures. The first long sequence of canvases from his travels are those of the coast west of Dieppe of 1882, but the fact that Monet spent two spells there during the year makes it impossible to tell precisely which canvases belong to which visit. Many subjects are found in pairs, and three more frequently: Varengeville Church, with three from the identical viewpoint (including pls. 81, 222); the Douanier's cottage, which appears, seen

from all angles, in seventeen canvases, but with no more than three from any one viewpoint (including pls. 151, 220); and the view westwards along the beach from Pourville. This last scene appears, with only minor changes of viewpoint, sixteen times in canvases which must date from 1882 (including pls. 243–4). The paintings vary considerably in finish, size, weather, lighting, tide level, boats and staffage, and cumulatively present a varied impression of the life of the beach, set against the recurring backdrop of the cliffs. There is no evidence, though, that Monet saw these paintings as a group apart among his Pourville work; they were part and parcel of the total of about a hundred canvases which he brought back from his two visits to Pourville in 1882.[18]

The first two eyewitness accounts of Monet painting groups of canvases relate to his stays at Etretat between 1883 and 1886. Guy de Maupassant, who saw him there in 1885, wrote in 1886: 'Off he went, followed by children carrying his canvases, five or six canvases representing the same subject at different times of day and with different light effects. He picked them up and put them down in turn, according to the changing weather.' The second account, published by Hugues le Roux in 1889, describes Monet working on Etretat beach: 'Between his knees he had two or three canvases, which took their turn on his easel for a few minutes each. On the same stormy sea, framed by the same cliffs, they were different effects of light.'[19] The importance of these two passages is the greater because they were published before 1891, when Monet made his serial procedure explicit in exhibiting the Grain Stacks; they are not the result of hindsight. Letters from Etretat in 1885 suggest that his reasons for working in this way were essentially practical – so that he could have canvases under way on which he could work whatever the weather.[20]

The paintings from Etretat show no great change from Monet's previous practices. He viewed the rock arches from a great variety of angles. The largest number of views from a single viewpoint is six, of the Manneporte from the east, but they do not belong to a single campaign: one is dated 1883 (pl. 129), one 1885, two 1886 (including pl. 130) and two are undated (including pl. 83). As at Vétheuil and Pourville, Monet's canvases collectively give a full impression of Etretat's beaches, rocks and boats, but there is no sign that he thought of grouping together the few painted from identical viewpoints.

We can analyse Monet's paintings of Bordighera, Belle-Isle, Antibes and the Creuse more precisely, because each group is the product of a single trip. The Bordighera paintings fall into certain clear divisions, which presumably correspond to the 'series' he distinguished in his letters, such as his views of the town (e.g. pl. 245), of the *Jardin Moreno* (e.g. pl. 156) and of the Vallée de Sasso (e.g. pl. 27).[21] But not more than two canvases were painted from any one precise viewpoint. On Belle-Isle in 1886, most motifs were treated at least twice, and one, *The Pyramides at Port-Coton*, six times (including pls. 85, 246). Writing in 1887, Geffroy described Monet at work on Belle-Isle, 'so active that he begins during a single afternoon ten *études* of a single view'; when he reprinted this passage, Geffroy emended its exaggerated claim to 'several *études*'.[22] As at Etretat, Monet's letters show that this was initially an expedient to cope with the changeable weather,[23] but later in his stay on Belle-Isle he for the first time gave a positive justification for his re-exploration of a single subject: 'I well realise that, in order really to paint the sea, one must see it every day, at every time of day and in the same place in order to get to know its life at that particular place; so I am redoing the same motifs as many as four or even six times.'[24] The constant scrutiny and depiction of a single site now seemed

245. *Bordighera*, 1884, 65 × 81, W 854, Art Institute of Chicago

to him to be the means of understanding it more fully; it was this cumulative understanding, gained by juxtaposing successive instants, that five years later became the *raison d'être* of the exhibitions of the series.

However, this realisation produced no sudden change in his practices. At Antibes, as on Belle-Isle, most of his sites were treated twice or more (see pls. 229–31), and one six times;[25] in the Creuse he made nine versions of the ravine with only minor changes of viewpoint (including pls. 104, 134). But on all these journeys a number of subjects were only painted once and many only twice; on each occasion he painted a large total number of sites – sixteen on Belle-Isle, eighteen at Antibes, nine on the Creuse. Arriving at Antibes, he declared with pleasure that he had 'five or six superb motifs to do', and voiced the worry about Agay, where he also planned to paint during this trip, that it was 'not very varied, and I must beware of giving way to repetitions'.[26]

The number of versions of some subjects shows that during the

1880s Monet was becoming increasingly interested in the varied effects that could be found on a single group of natural forms, but his letter about repetitions, together with the variety of his paintings from his travels and his policy in exhibiting these pictures, reveal that such groups of canvases from single viewpoints were not of central importance in this decade. This is confirmed by Octave Mirbeau's lengthy account of his methods published in 1889, where Monet is described 'stopping relentlessly, and going on to another motif, if, during this rapid session, the light changes'.[27] By the groups of paintings he brought back from his travels, Monet remained intent on suggesting the overall effect of the places he visited: the variety of their natural forms as well as their lighting. Even after he had embarked on his more integrated series, he still wanted, when he visited a new place, to convey its general characteristics; he wrote from Norway in 1895 that he wanted his paintings to give 'an idea of Norway', and, as on his travels of the 1880s, he did his best to vary the subjects he chose there.[28]

196

Two of Monet's companions, Degas and Sisley, pursued the idea of unified groups of canvases further than he did during the 1880s. At the last group exhibition of 1886, Degas showed his *Suite of nudes of women bathing, washing, drying and wiping themselves, combing their hair or having it combed*, ten pastels which, though varied in composition, were meant as a closely integrated sequence. Of Monet's fellow landscapists, Sisley most often treated individual subjects many times over. Like Monet's, Sisley's pairs of related canvases of the 1870s gave way on occasion by around 1880 to threes and fours, and in the mid-1880s Sisley began to treat some subjects in the area around his home at Moret (on the River Loing near the Fontainebleau Forest) much more often than this. Though his work is not always easy to date, some groups clearly belong together, notably at least ten of the Canal du Loing from around 1885. Several further groups followed in 1888–9, of Moret church seen from various angles from the river.[29] Some of these were included in an exhibition at Petit's gallery in December 1888, where Félix Fénéon commented on them in a way which suggests that they presented a more unified group than anything previously exhibited by Monet: 'The not very attractive spectacle of the banks of the Loing, at Moret (the bridge, the mill, the dirty water), he has painted it twenty times, these last few years. His vision, . . . in his obstinacy to go on painting a single site, seems like an admission of his continuing failure to bring out its character clearly.'[30] Monet was in close touch with Petit at this period and very probably saw this exhibition.

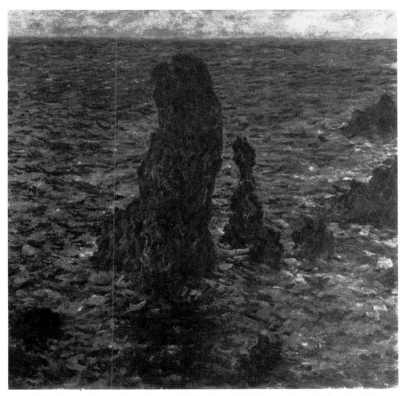

246. *The Pyramides at Port-Coton, Belle-Isle*, 1886, 65.5×65.5, W 1087, Private Collection

The GRAIN STACKS SERIES

In later years Monet often described the Grain Stacks series as a new departure, in the methods that he had used to paint them; certainly their exhibition in May 1891 marked a change in his exhibiting policy (see pp. 213–16). But the germs of the ideas that led to this series can be traced in his earlier work. A close examination of Monet's activities in 1890–1, and of his own accounts of the origins of the series, will set these experiments in their context.

Several apparently independent sources record Monet's own descriptions of the beginnings of the series. All of these accounts mention some specific experience, a particular occasion on which Monet needed to start one new canvas after another as the light changed. One version places the experience in the summer sun, another in the mists of autumn; two speak of him painting a single stack, one a group of stacks; one says that the experience took place on his first day of work on the subject, while another suggests that he was already painting it.[31] There is some truth in all these versions. Combined with the evidence of letters and of the paintings themselves, they allow us to reconstruct the genesis of this series.

Several times in the mid-1880s Monet had painted *meules de foin*, or haystacks, though using them more as part of the décor of the Giverny landscape than as the prime subject of the painting. As we have seen, other artists had previously made *meules de blé*, or grain stacks, into the focus of canvases, for instance Pissarro and Millet, whose *Autumn, the Grain Stacks* (pl. 32) was exhibited in Paris in 1887 and 1889.[32] *Meules de blé* first appear as a dominant feature in Monet's work in three canvases dated 1889; two of these, including pl. 247, were shown in Monet's exhibition at Petit's gallery in summer 1889.[33] These three canvases all show the identical pair of stacks, with the larger one on the left, in a grouping that appears in none of the other Grain Stacks paintings; Monet never regarded them as belonging to the series proper.

The field in which they stand seems to be the one shown in the later series, with houses, trees and a line of hills beyond it. This is the *clos Morin*, the field lying immediately west of Monet's house at Giverny, seen looking to the west or the south-west, with as backdrop the range of hills on the far bank of the Seine about a mile away; these hills form a continuous horizontal when looking south-west, but, as one looks west, they begin to get lower to the right as they approach Vernon. The field appears in a canvas by Theodore Robinson of 1890, probably painted around the time Monet began the series proper, this time looking north-east (pl. 248); the group of buildings in the background of this painting very probably includes Monet's house (before additions). A photograph of the field, looking south-west from the window of the studio Monet built himself in 1899, was published in 1905 (pl. 249); it suggests that Monet's viewpoints for the series were near the boundary wall of his own garden. Robinson's painting confirms that in 1890 a large stack stood close to this wall, which would explain in naturalistic terms the viewpoint of a canvas such as *Grain Stack at Sunset* (pl. 162).

Monet began work in earnest on the Grain Stacks theme sometime in the late summer or early autumn of 1890. However, during this summer he had been working on two other projects to which he attached considerable importance, one of which might have led his art in a quite different direction; it was his work on the Grain Stacks which finally showed him the course to take. The first of these projects was his last attempt at open-air figure painting, to which he was referring when he told Geffroy on 22 June that he was working on 'things impossible to do: water with grass undulating in its depths'; work on this theme (see pl. 50) continued into July.[34] The second major undertaking of the summer was a number of canvases of meadows with flowers, which fall into three distinct groups, or short series (e.g. pls. 135, 159, 250–1); it was in these canvases, as we

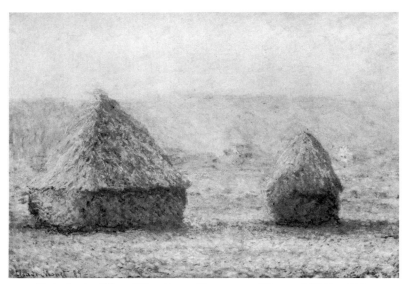

247. *Grain Stacks, Effect of Hoar Frost*, 1889, 65 × 92, W 1215, Hill-Stead Museum, Farmington, Conn.

248. Robinson, *Scene at Giverny*, 1890, 41 × 65, Detroit Institute of Arts

249. Photograph of the view from Monet's second studio, *c.*1905, from *L'Art et les artistes*, December 1905, p. 90

have seen, that Monet achieved a new homogeneity of touch and texture.[35] On many occasions Georges Clemenceau emphasised the importance of one of these groups (pls. 135, 251) in Monet's evolution, describing in 1895 how he had seen Monet 'with his four canvases in front of his poppy field, changing his palette as fast as the sun pursued its course'. Clemenceau emphasised the fact that this predated the Grain Stacks. In later versions of the story Clemenceau described Monet working 'with four easels, on which, in turn, he gave a vigorous stroke of the brush, as the light changed'.[36] The details of this account are thrown into some doubt by Jean-Pierre Hoschedé's indignant denial that Monet ever used more than one easel: 'Monet's easel (one only) was always, necessarily, set up in a single place. It was canvases alone that followed each other on this sole easel.' Admittedly, a single easel must have been the norm, but in 1890 Hoschedé was only thirteen years old, and might have forgotten, or never have seen, a brief experimental stage such as this, in which Monet was using several easels to speed up his pursuit of the changing light. On occasion later he had more than one easel set up around the lily pond.[37]

The importance of the Poppy Fields was as the immediate prelude to the Grain Stacks. The first clear evidence that Monet was at work on the Grain Stacks appears in his letter to Geffroy of 7 October: 'I'm working away at a series of different effects (of stacks), but at this time of year, the sun sets so quickly that I can't keep up with it . . . I'm becoming so slow in my work that it makes me despair, but the further I go, the better I see that it takes a great deal of work to succeed in rendering what I want to render: "instantaneity", above all the *enveloppe*, the same light diffused over everything, and I'm more than ever disgusted at things that come easily, at the first attempt.'[38] Two elements in this letter suggest that it dates from shortly after the revelatory experience about the Grain Stacks: first, that he speaks of the new canvases as something which will be news to Geffroy, with whom he was in regular contact; and second, that these new paintings have forced him to reformulate his basic aims as a painter in terms of the most fleeting and transitory atmospheric effects.

It is in this context that we must examine the accounts which Monet himself later gave of this experience. Despite their variations over details, they are united in saying that it was a sequence of especially transitory effects on one particular day which provided Monet with the stimulus to make a closely knit sequence of paintings of stacks, by forcing him to start several canvases in quick succession in an attempt to keep pace with the changing light. Arsène Alexandre described the context of this occasion most clearly: 'Monet felt that his cycle of Grain Stacks was due to a chance circumstance. He tells how one day, beguiled by the opulence of a beautiful stack in the plain of Giverny . . . he had come with his step-daughter . . . to make an *étude* of it, with no intention of multiplying his observations of this theme.'[39]

One other account, that of Thiébault-Sisson, describes the germ of the idea in Monet's earlier work, but its chronological confusions create many problems. The 'starting point' of the series, according to Thiébault-Sisson, was an experience that took place when Monet was painting the church at Vernon in mist with the sun coming through: 'I felt that it would not be trivial to study a single motif at different hours of the day and to note the effects of light which, from one hour to the next, modified so noticeably the appearance and the colouring of the building. For the moment I did not put the idea into effect, but it germinated in my mind gradually.' Then, after several chronological inaccuracies, Monet describes the Grain Stacks

as his first attempt to put this idea into practice. The importance of this account of the germ of the idea of the series is that it does not link it with the gradual multiplication of canvases of identical subjects which took place in the 1880s. Instead, it traces it back to a single experience which did not itself lead to any sort of series, but forced Monet to realise the particular problems of trying to paint sun in mist. Only with the Grain Stacks in 1890–1 did this become a dominant theme in Monet's work. This account, then, confirms the suggestion in the other versions of the story that his experience when painting the stacks led to something new in his art which was not just a continuation of his interests of the 1880s. A further problem with Thiébault-Sisson's account is to identify the canvas, ostensibly of Vernon Church, which Monet was painting when he had the initial idea. The only feasible solution is to identify this with *Vétheuil in the Fog* of 1879 (pl. 201), the canvas which, as we have seen, acquired an almost emblematic significance for Monet after Faure refused to buy it because it was insufficiently finished.[40]

Confirmation that Monet's plans for the future changed radically in the autumn of 1890 is found in Maurice Rollinat's letters to him of 1890–1. These show that Monet, probably in summer 1890, had promised to revisit Rollinat in the Creuse the following spring; but this promise was swept aside, presumably in the excitement of work on the Grain Stacks. The fact that the Grain Stacks put an end to Monet's decade of travels was noted by Geffroy in his catalogue preface for the Grain Stacks exhibition of May 1891.[41]

The revelatory experience and the first canvases of the group presumably date from late September or early October 1890.[42] There are several late summer canvases in the final sequence of paintings, one of which, *Grain Stacks, End of Summer* (pl. 252), has across the background hills a delicate veil of soft light blue, added over a dry layer of clearer greens, as if an early autumn mist came down while Monet was at work on the painting. He continued to paint the stacks through the winter of 1890–1, as his letters show. By 5 December they had already become a definable group of canvases which he wanted to keep together: 'M. Valadon has been to see me very recently . . . it was with great difficulty that I have able to hold on to the Grain Stacks. But if the snow comes back, you will find some good ones among them.' On 21 January 1891 he was still at work on 'these splendid winter effects'.[43] So, unlike the paintings Monet brought back from his travels, and unlike most of his later series, the Grain Stacks became some sort of cycle of the seasons, though without any hint of the traditional agricultural associations of such cycles (see above, p. 28).

Monet did not, though, keep the whole series until he was ready to exhibit them. He sold two to Boussod & Valadon on 5 February 1891, one of them dated '90', a late summer effect of the same grouping of stacks as *Grain Stacks, End of Summer*, which is dated '91', the other a more recent snow scene; he sold them a further snow scene on 26 March.[44] In March, Monet's publicity machine began to introduce the series to the public: in his article on Monet in *L'Art dans les deux mondes* on 7 March, Mirbeau spoke of the 'extraordinary *meules* which he completed this winter', and reproduced a drawing by Monet made after the canvas dated 1890 which he had sold to Boussod & Valadon in February.[45] Neither this painting, nor the other two that Boussod & Valadon had bought, figured at the Grain Stacks exhibition which Durand-Ruel mounted in May. By April, word about the series had spread, and Pissarro lamented that dealers were all asking for Grain Stacks at Sunset; a week later Pissarro had heard that Monet was planning an exhibition of 'nothing but Grain Stacks'. The exhibition opened on 4 May, but

Monet had second thoughts about including Grain Stacks alone, and seven other canvases were added to the fifteen Grain Stacks exhibited.[46]

At least thirty canvases of Grain Stacks survive, including the group of 1889. Four in all are dated 1889, three 1890, twenty-two 1891, and one is undated.[47] All of those exhibited in May 1891 were, it seems, dated 1891, including those that represented effects from

250. *Field of Oats*, 1890, 51 × 76, W 1260, Private Collection

251. *Field of Poppies*, 1890, 61 × 93, W 1253, Art Institute of Chicago

the late summer and autumn of the previous year (e.g. pl. 252). Those dated 1890 and 1891 – the series proper – do not all show the same grouping of stacks. Nine, including most of the late summer ones, show a pair of stacks with the larger one on the right (a reversal of the pairing of the first three of 1889); this suggests that Trévise may have been right to record the initial revelatory experience in terms of a group of stacks rather than a single stack. The other canvases, mostly of effects of snow and frost, show variously placed single stacks or stacks in pairs (e.g. pls. 136, 161, 254). The three paintings that show a single stack from close by, cut by the frame, including pls. 162, 253, are particularly adventurous in

252. *Grain Stacks, End of Summer*, 1890–1, 60 × 100, W 1266, Musée d'Orsay, Paris

composition, and may well, as Wildenstein suggests, belong to the end of the series.

With their variety of groupings, the Grain Stacks go little further, simply in terms of numbers of canvases executed from identical viewpoints, than some of the groups of paintings Monet brought back from Belle-Isle and the Creuse. For a number of reasons, though, they are radically different from his work of the 1880s. One crucial factor is the way they were exhibited, which will be discussed in the next chapter; but the subject chosen and the methods used to paint them were also in some ways novel. For the first time Monet consistently subordinated topographical interest to variations of colour and light. Whereas in the Creuse the most-painted scene, showing the ravine (pls. 104, 134), is scenically dramatic, and the ensemble of Creuse pictures presented this scenery from a variety of viewpoints (cf. pls. 179, 216), the Grain Stacks, though variously placed in their field, are strikingly homogeneous as an ensemble, and totally without picturesque qualities in the traditional sense, since they tell us virtually nothing about Giverny as a place. Their pictorial qualities derive from their translation of atmospheric effects into a play of colour and forms. Kandinsky's initial failure to recognise the subject of one of the more unusual compositions in the series, *Grain Stack in Sunlight* (pl. 253), would have been an inconceivable response to any of Monet's previous paintings.[48]

Monet himself felt that there was something new about the methods he had employed on the Grain Stacks, as the late accounts already quoted suggest. This is confirmed by Maurice Guillemot's

253. *Grain Stack in Sunlight*, 1891, 60 × 100, W 1288, Kunsthaus, Zürich

interview with Monet published in 1898. Guillemot describes Monet's methods of work on the Early Mornings on the Seine (e.g. pls. 35, 139, 211): 'There are fourteen canvases begun at the same time . . . translating one and the same motif whose effect is modified by the time of day, the sun and the clouds:' he adds later that 'the method of work which we have indicated dates from the Grain Stacks'.[49] The descriptions of his methods at Etretat and on Belle-Isle, quoted above, suggest that he had begun on occasion to work in this way before 1890, but the general pattern of his work of the

1880s show that this was exceptional, and that he placed no special value on such groups as an independent ensemble. With the Grain Stacks the internal unity and coherence of the group because the dominant concern. Though he wrote from Belle-Isle in 1886 that 'I can only really judge what I have done when I see it again at home, and I always need a moment of peace and quiet before I can put the final touches to my canvases',[50] this does not imply that he was seeking any particular internal coherence within the group as a whole. About the Grain Stacks, however, he said in 1891 that the individual canvases of the series 'only acquire their value by the comparison and succession of the entire series'.[51] Moreover, the canvases themselves, as we have seen, bear ample witness to a considerable period of reworking, alteration and elaboration, which presumably took place in the studio between February and April 1891, though Monet continued to retouch canvases from the series after their exhibition.[52] Monet immediately realised that the Grain Stacks involved some sort of basic reassessment of his aims as a painter: he told Theodore Robinson in 1892 that he could no longer paint 'anything that pleased him, no matter how transitory . . . regardless of the inability to go further than one painting', but was instead looking for 'more serious qualities' in his latest work. What these serious qualities were will be discussed below.[53]

MONET'S MATURE SERIAL METHODS

After 1891 Monet increasingly systematised the procedures he had used for the Grain Stacks, in a succession of series each intended to be seen as an integrated, organic whole. However, not all of them were pre-planned, or strictly homogeneous in treating precisely the same subject. The variety of Monet's work of the 1880s did not give way to an immediate unity.

The Poplars, which followed the Grain Stacks, likewise owed something to chance. He found the trees by the river Epte marked for felling (whether before or after he had begun to paint them is not clear), and paid their purchaser to leave them standing long enough for him to paint them.[54] He started work on them in summer 1891; on 28 July he wrote to Mallarmé of 'quantities of new canvases which I must finish', which can only refer to the Poplars; he was still painting them, though, in October, haunted by 'this appalling weather which makes me despair for my trees', presumably threatening to strip them of their leaves before he could finish work.[55] As we have seen, the change from summer to autumn during their execution left its mark on *The Poplars, Autumn* (pl. 255; see p. 189). The Poplars are varied in composition, with two basic types of arrangement, one with an accentuated zig-zagging per-

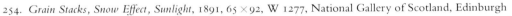
254. *Grain Stacks, Snow Effect, Sunlight*, 1891, 65×92, W 1277, National Gallery of Scotland, Edinburgh

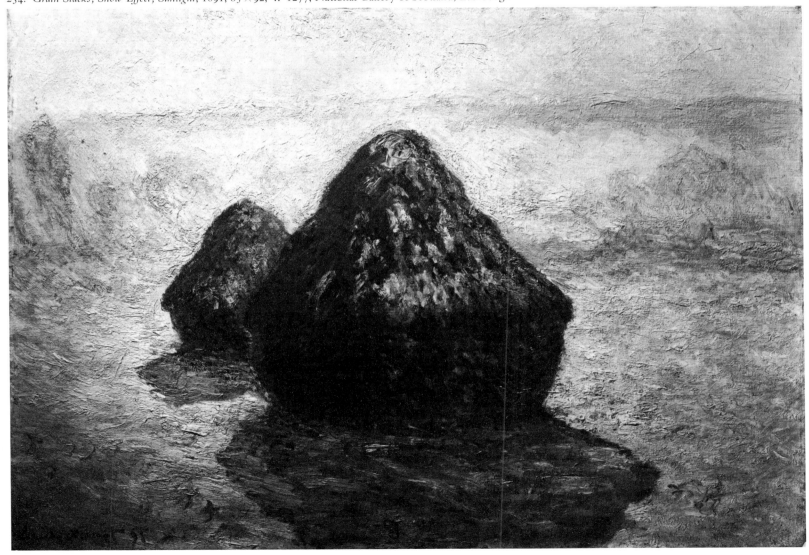

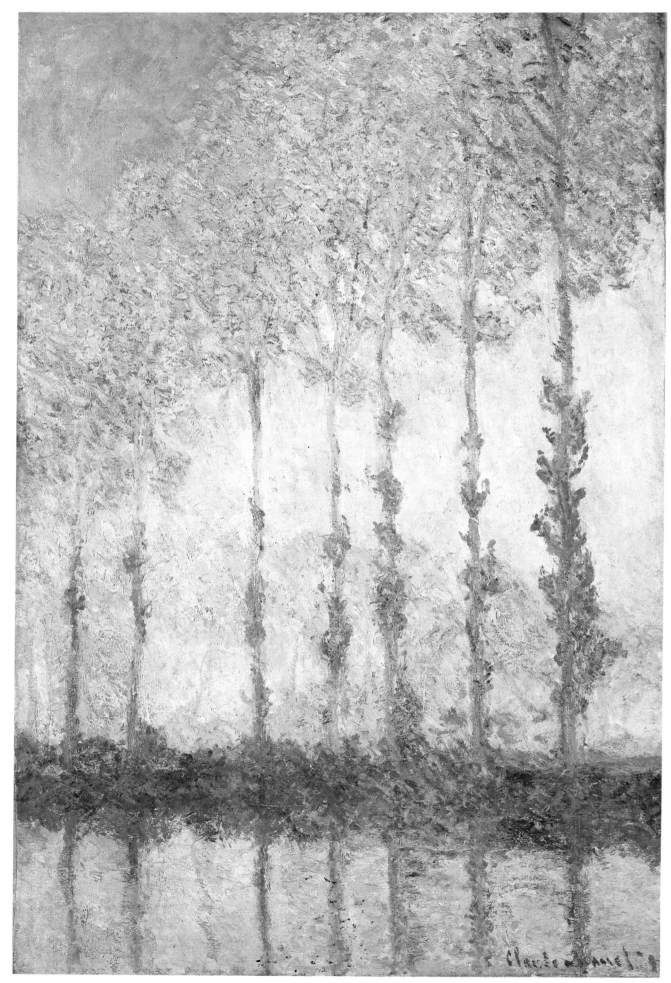

255. *The Poplars,*
Autumn, 1891, 100 × 65,
W 1298, Philadelphia
Museum of Art

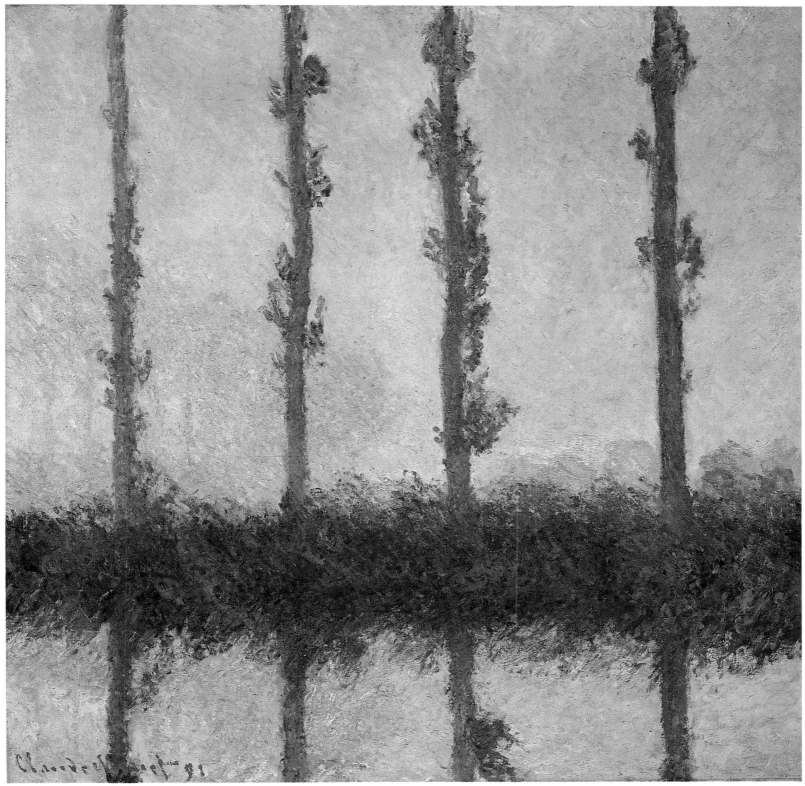

256. *The Poplars, the Four Trees*, 1891, 82 × 81.5, W 1309, Metropolitan Museum of Art, New York

spective (e.g. pl. 255), the other using the trunks of the nearest trees as a dominant foreground grid (e.g. pl. 256); but a few canvases conform to neither pattern (e.g. pls. 232, 233). As a whole, the series presents a set of variations on a linear framework, as do the Grain Stacks on their massive solid forms; and like the Grain Stacks, the Poplars are entirely devoid of topographical content.

This variety of viewpoints continues in the groups of paintings Monet executed on some of his later trips away from home – to Norway (1895), to the coast of Pourville (1896–7) and to Venice (1908).[56] Other series, though, show fewer variations, focusing on a single dominant compositional format, such as those of Rouen Cathedral, the Early Mornings on the Seine, the Japanese Bridge, and the three subjects which make up the London series. The Water Lilies of 1903–9, though all concentrate on the water surface,

present varied formats and groups of lilies and reflections (e.g. pls. 37, 140–1).

During the 1890s Monet came to treat his serial methods as a matter for pride, sometimes even assessing the progress of the work in hand by the number of paintings he had under way. However, at the same time he came to realise that the more he started, the harder they would be to finish. These rival concerns emerge in his letters. He wrote to Blanche Hoschedé from Norway complaining that the changing weather meant that 'I cannot get quantities of canvases under way', but when he continued the letter the next day, after the weather had relented and allowed him a day's work, he lamented: 'I have had to begin six canvases of this last subject [Mount Kolsaas; e.g. pl. 87] because the effects are so variable, but will I be able to finish them?' The constantly varying weather, rather than any idea of a final pictorial ensemble, remained his initial reason for endlessly multiplying his canvases. He wrote from Pourville in 1896: 'I must decide to begin canvases in all sorts of weather, all types of wind; it is impossible for me to do only a few and to wait with my arms folded when the right effect is not there.'[57] On well-established subjects he might work on twelve or fourteen canvases at a time, or more. This process of multiplication reached its height in London: in March 1900 he told Blanche that he had just begun his fiftieth canvas (presumably of two subjects together, Charing Cross Bridge and Waterloo Bridge), and according to one, probably exaggerated, account he was finally working in London on a hundred canvases of a single subject. Not surprisingly, this proliferation of canvases committed him to an ever-increasing amount of studio reworking, in order to be able to finish any paintings at all.[58]

The Grain Stacks, as they evolved from late summer through winter, became a sort of cycle of the seasons; the Poplars, too, express a progression, though only from summer to autumn. After this, though, Monet generally treated each subject during a single season, and chose his themes in part for their suitability for a particular time of year. Even in 1892–4 his subjects divide up naturally, with ice floes (when the weather allowed) and Rouen Cathedral (unaffected by foliage) reserved for the winter, and country subjects round Giverny for the other seasons. By 1897 this division had become more systematised, with summer and winter series under way simultaneously. This remained so until about 1906 when the Water Lilies came to absorb his whole attention, and he continued to paint them in his studio out of season, when the lily pond had no inspiration to offer him. His trip to Venice late in 1908 produced a further stock of canvases for winter reworking, but after their exhibition in 1912 he undertook only summer subjects, all within the confines of his own garden.[59]

Monet also began to favour certain times of the day for some subjects, feeling that they appeared at their best with the sun at a particular angle. The Grain Stacks and the Rouen Cathedrals present a sequence from morning to sunset; in the Grain Stacks the varied lighting sometimes emphasises the solidity of the stacks (e.g. pl. 252), and sometimes reduces them to *contre-jour* silhouettes, with the sun setting behind them (e.g. pl. 136). The Poplars series is dominated by afternoon and evening effects, with the light coming from the right. Later in the 1890s Monet came to plan the lighting of his subjects more precisely. He wrote from Norway in 1895, probably about the view of Mount Kolsaas (e.g. pl. 87): 'I am working almost exclusively in the afternoon on a single motif that I have done a dozen times.' This afternoon lighting, from behind Monet's back, picks out the features of the mountain. Monet's Early Morning on the Seine (e.g. pl. 211), by contrast, were specifically chosen as a dawn subject, because this type of lighting suited the subject best.[60] The London series, with their predominantly misty effects, are mostly treated *contre-jour*, with the sun seen through the mist, filling the atmosphere with colour and reducing the forms to silhouettes; thus the view of Waterloo Bridge, looking eastwards, was for the most part painted in the morning, Charing Cross Bridge, looking south, in the middle of the day (e.g. pl. 91), and the Houses of Parliament, looking west, in the afternoon (e.g. pl. 89).

Monet's series had an immediate impact on his fellow Impressionists, notably Pissarro and Sisley. Sisley's views of Moret Church of 1893–4 must owe a debt to Monet's Rouen Cathedrals, even if only by hearsay, and Pissarro seems to have found in Monet's series the sanction to restrict his subjects. He wrote to Mirbeau in spring 1892 that, being unable to work out of doors, 'I am doing over again the same subjects from my window; it's all so different, and what does the frame, the motif matter, if the effect is varied?' His response to the Rouen Cathedral series was to see in it 'a superb unity which I have sought so hard', and in his urban views from 1896 onwards he worked more than before in series.[61]

In one respect, Monet's series differ from those of his contemporaries: in his preoccupation with the *enveloppe*. Alongside his multiplication of canvases of a single motif, Monet continued to seek almost tangible overall effects of atmosphere, which, he felt, gave his paintings a unity – singly and in groups – that could not be achieved in paintings conceived simply as a form of topographical notation. It was by this route that he worked towards the 'more serious qualities' he sought in his art.[62]

CHAPTER THIRTEEN
MONET and the PUBLIC EXHIBITION

THROUGHOUT his career Monet was much concerned about how his work was presented to the public. Between the first appearance of his work in Paris, at the 1865 Salon, and his final exhibition, the Water Lily Decorations in the Orangerie which opened in May 1927, five months after his death, his ideas about exhibiting changed in many ways. But he always felt that a public showing was the essential outlet for his work, and explored the various possibilities of the art exhibition more fully than any of his fellow Impressionists. The purpose of this chapter is to trace his evolving ideas about the composition of the groups of paintings he presented to the public; for this the principal evidence is the contents of the shows themselves.[1]

One crucial distinction must be made at the start: between the exhibition as a shop window to attract buyers, and the exhibition as an art work in its own right. In the simplest terms, Monet changed from the former to the latter attitude at the point at which he reached financial security, around 1890, and at last found himself able to paint and exhibit what he wanted, when he wanted and how he wanted. But the story is not as straightforward as this.

During the 1860s the focus of his aspirations was the annual Salon, to which he submitted his largest and most ambitious completed paintings from 1865 to 1870. These Salon submissions were clearly designed to win him a quick reputation. His plans each year allow us to chart his evolving artistic allegiances and his changing ideas about the sort of modern painting which might best establish his name and gain success. His first venture, two seascapes in 1865 (e.g. pl. 181), was an attempt to cash in on the growing taste for such Channel coast subjects; in everything except their ambitious scale, they looked to Jongkind as a mentor (see pl. 112). But the centrepieces Monet planned for the next two years were experiments in the quite different genre of modern-life open-air figure painting: *Déjeuner sur l'herbe*, which he failed to complete for the 1866 exhibition (see pl. 14), and *Women in the Garden*, rejected the following year (pl. 64). Manet was the obvious starting point for *Déjeuner sur l'herbe*, but Monet translated the theme of Manet's notorious *Déjeuner sur l'herbe* of the 1863 Salon des Refusés into a modernised version of an eighteenth-century *fête galante*. His allegiance to Manet was, though, clearly endorsed by *Camille* (pl. 257), the full-length fashionable figure he submitted in place of the *Déjeuner* in 1866; many years later he wrote that this picture should be seen not as a portrait, but as 'a figure of a Parisian woman of that

epoch', which shows that he was seeking a reputation as a painter of modern urban life.[2] His other exhibit of 1866, though, was an exercise in a different mode; *Forest of Fontainebleau* (pl. 258) avoided such overt contemporaneity, and presented his credentials as a painter of the popular theme of the forest as rural retreat, populated only by peasant figures and a cart.

After the comparative success of the 1865 seascapes and of *Camille* in 1866, Monet committed himself to ambitious modern subjects for his Salon pictures, but in the next four years all his submissions were rejected apart from one port scene in 1868, admitted thanks to Daubigny's intervention. The vast *Women in the Garden* (pl. 64), with its complete lack of a significant subject, was more like a monumentalised fashion plate than an exhibition picture, while his coastal scenes (e.g. pl. 259), unlike those shown in 1865, included overtly modern elements which stressed Le Havre's role as international port and bourgeois leisure centre.[3] It was these paintings that Zola hailed in 1868 as evidence of Monet's emergence as one of the leading young painters of modern subjects, but the occasional appearance of Monet's rejected canvases in the windows of dealers' shops was scant compensation for their rejection by the Salon jury.[4]

After their rejection in 1867, he and Bazille conceived a first project for an independent group exhibition, presumably inspired by Courbet's and Manet's one-man shows of the same year, but they could not raise the necessary money, and realised that there was, for the moment, no alternative to the Salon.[5] Monet's continuing dedication to the Salon is of particular importance in understanding his and Renoir's paintings of La Grenouillère of 1869. Monet described to Bazille in September 1869 his hopes for the next year's Salon: 'Alas! Once again I will not appear there, since I won't have anything finished. I do have a dream, a *tableau* of the bathing place of La Grenouillère, for which I've done some bad *pochades*, but it is a dream. Renoir, who has just spent a couple of months here, also wants to paint this subject.' In the event Monet submitted two works in 1870, *Luncheon* (pl. 2) and a landscape; both were rejected. The landscape may well have been the planned *tableau* of La Grenouillère, as there is good reason for thinking that Monet was able to complete this; it was probably the lost pl. 260. The other versions (pls. 71, 145), despite the importance subsequently attributed to them, must be identified as the 'bad *pochades*'.[6] This pairing of canvases submitted in 1870, of a very informal bourgeois interior with a panorama of a notorious fashionable pleasure place, re-

emphasises Monet's ambitions as a painter of modern life. Renoir's riverside subject, *Bather with a Griffon* (pl. 261), was accepted at the same Salon; though modern in context and trappings, it was explicitly a modern Venus, with its overt reference to the *Venus of Cnidos*, whereas Monet's paintings, with their very informal structure, reject any such traditional underpinning.

After 1870 Monet did not submit to the Salon again for a decade. In 1872–3 he had a ready outlet for his paintings in sales to Durand-Ruel, and in 1874, 1876, 1877 and 1879 his work appeared in the first four Impressionist group exhibitions. At the same time he painted far fewer large exhibition paintings, and began to exhibit smaller, less ambitious works in the group shows. In concentrating on such smaller paintings, he may well have hoped that they would, initially through Durand-Ruel, find a market with private collectors, since such canvases, though rarely shown at the Salon, were standard dealers' merchandise at the time.[7] Smaller canvases were also, as we have seen, better suited for painting out of doors. When he and his companions turned to independently organised exhibitions, after Durand-Ruel had been forced to stop buying, they were taking a calculated gamble, in the hope that they might find a reliable market for their work without seeking the patronage which success at the official Salon could bring.[8] Their final success, in the later 1880s and 1890s, stemmed more from the efforts of dealers to promote their work than from these group exhibitions, though the shows gave the artists a public reputation, albeit hardly a favourable one.

In the 1874 exhibition Monet showed works of three very different types: seven pastels, four small or medium-sized oil paintings, and one large figure scene, *Luncheon* (pl. 2), the canvas rejected at the 1870 Salon. In part the reason for this variety was the hanging policy of the show, to separate large works from small, and to hang small below large; thus the artist had the incentive to include both large and small.[9] However, even Monet's smaller oils were conspicuously dissimilar; rapid notations such as *Impression, Sunrise*

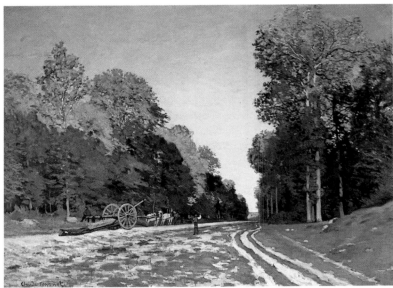

258. *Forest of Fontainebleau, c.*1865, 98 × 130, W 19, Private Collection

(pl. 199) hung beside more fully finished canvases (e.g. pls. 200, 262). This exhibit must have emphasised Monet's versatility; his colleagues, likewise, showed very varied paintings. Thus the labelling of the whole group as 'Impressionists' on the basis of the title of this one canvas gave the group a misleading image of homogeneity, highlighting just one facet of their work. This has conditioned the public image of the painters to this day.

In the 1876 and 1877 shows, as in 1874, Monet included at least one large *tour de force*: in 1876 *Luncheon* (pl. 263), a garden scene painted around 1873 and shown under the title *Panneau décoratif*, *La Japonaise* (pl. 264, shown as *Japonnerie*), and perhaps the final version of *La Grenouillère*; in 1877 *The Turkeys* (pl. 5, exhibited with the subtitle *décoration non terminée*) and perhaps others of the decorative canvases he had painted for Ernest Hoschedé. In 1876 each artist's works were hung together, but Monet's exhibits were very varied; in 1877 his works were spread out in several rooms, and again included a wide range of subjects.[10]

However, the 1877 exhibit was exceptional in two ways: he showed two views of the same subject of the Tuileries Gardens, one subtitled *esquisse* (pls. 195, 197); and he included eight views of the Gare Saint-Lazare. The Tuileries paintings, as we have seen, were probably independent versions of the same subject, one fully finished and one only lightly worked, exhibited to demonstrate his skills and to reveal his working methods.[11] Contrasting degrees of finish can likewise be seen in the Gare Saint-Lazare paintings; we

257. *Camille*, 1866, 231 × 151, W 65, Kunsthalle, Bremen

259. *The Jetty of Le Havre*, 1868, 147 × 226, W 109, Private Collection, Japan

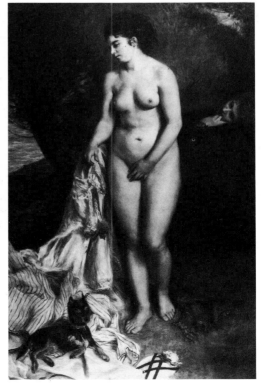

260. (far left) *The Bathing Place at La Grenouillère*, 1869, ?60 × 100, W 136, destroyed

261. Renoir, *Bather with a Griffon*, 1870, Museu de Arte, São Paulo

cannot identify precisely all the canvases shown, but some which were certainly included are very freely handled (e.g. pls. 265–6; cf. pl. 119).[12] They are not all listed together in the catalogue, and the reviews of the exhibition do not tell us whether they were hung together. But, however they were hung, the Gare Saint-Lazare paintings were the first group exhibited by Monet whose effect was in some sense cumulative. The sense of movement they create is much stronger when the canvases are seen together (alas, only in photographs today) – movement which stems largely from the

262. *The Boulevard des Capucines*, 1873, 61 × 80, W 292, Pushkin Museum, Moscow

variety of their viewpoints and staffage, and from the movements of the trains. The paintings belong to the world of the *tableau* of modern Paris, rather than to the self-contained universe of Monet's later series. In their 1877 context they must, though, be considered together with the other paintings Monet showed – more than twenty canvases revealing the full range of his work: scenes of rivers, meadows, gardens and parks; seascapes, portraits and one still life.

Monet had little to do with the selection of his paintings Caillebotte assembled for the 1879 group exhibition,[13] and he did not participate in the collective shows of 1880 and 1881. In 1880 he made one last attempt to gain success at the Salon, explicitly in a spirit of compromise, since the only one of his submissions to be accepted, *Lavacourt* (pl. 270), was designed to be 'more judicious, more bourgeois' than the more personal work he had originally planned to submit. In the traditional way, his submissions were substantial studio enlargements

263. *Luncheon (Panneau décoratif)*, 1873, 162 × 203, W 285, Musée d'Orsay, Paris

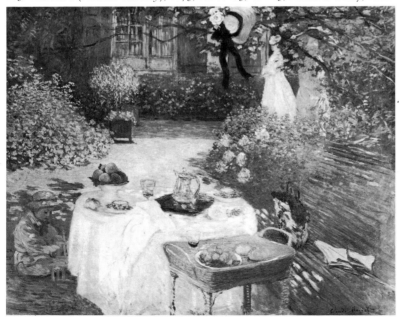

of outdoor canvases, in marked contrast to the smaller, mainly outdoor works he had generally shown in the group exhibitions.[14] Various factors led him to return to the Salon. Renoir had gained considerable success at the previous Salon with his *Portrait of Madame Charpentier and her Children*, and in 1879 Sisley, too, had considered submitting; friends such as Zola and Duret would also have urged such a course.[15] Most importantly, one suspects, the dealer Petit led Monet to expect further support if he showed at the Salon,[16] a great incentive when Monet had received no sustained support from any dealer over the past six years. However, the refusal of *The Ice-Floes* (pl. 186) and the poor hanging and reception of *Lavacourt* persuaded him never again to submit his work to the jury.

While the Salon was on, his first one-man show opened, in June 1880, as one of a sequence of small single-artist exhibitions at the offices of Georges Charpentier's periodical *La Vie moderne*. The picture rejected at the Salon, *The Ice-Floes*, was the focal point of the show; it was quickly bought by Charpentier's wife. Only eighteen pictures were exhibited in all, mostly recent works and of very diverse subjects, including landscapes of different seasons and types of subjects, cityscapes, still lives, one marine and one genre scene.

The 1880s was a decade of constant disagreements among the members of the original Impressionist group about plans for exhibitions. There was a sequence of abortive projects, thwarted by the rival ambitions of the artists, by the claims made on them by dealers, and by conflicting ideas of how to win over the public. Monet pursued a consistent course of self-interest; he was willing to exploit both collectors and dealers and to play them off against each other for his own ends, irrespective of their interests and the past favours they had done him. Group exhibitions, which classed all alike as 'independents', clearly became less appealing to those who, like Monet and Renoir, began to win commercial success before less fortunate colleagues such as Pissarro and Sisley. The rift in Monet's relationship with Durand-Ruel between 1886 and 1890 was a price he had to pay for the course he took, but it was in these same years that he at last found a ready market for his paintings through other dealers and through Durand-Ruel's efforts with his existing stock. When he resumed dealings with Durand-Ruel in 1890, it was very much on his own terms.[17]

Monet's ideas about exhibiting can, though, best be gauged from the exhibitions that did take place – from the contents of his shows of the 1880s, together with the letters he wrote about them. For the last time, in 1882 the nucleus of the original Impressionist group, except Cézanne, came together in a group exhibition under the auspices of Durand-Ruel; on this occasion, unlike in 1879, Monet took great care over his exhibits. He explained his requirements in detail to Durand-Ruel: 'I find it very difficult to give you a list of pictures to exhibit . . . In deciding, I want to make it as complete as possible, and to do it well I would need to see the canvases, for the titles tell me nothing. For preference, though, choose from among the canvases I did at Fécamp. Then some ice effects, the poppies, some cornfields, several still lives, and for the catalogue put vague titles (landscape, marine) so that one can change as one needs. Above all do not include the large Lavacourt which was at the Salon, but do put in the big winter landscape, at sunset. If you would like to ask Mme Charpentier if she would agree to lend the large picture of Ice Floes which she bought from me . . . I'd be pleased; though it has already been exhibited, it is one of my good things, and since you have nothing at all large, that would be a good thing.'[18]

In the end Monet presumably went to Paris to make the final

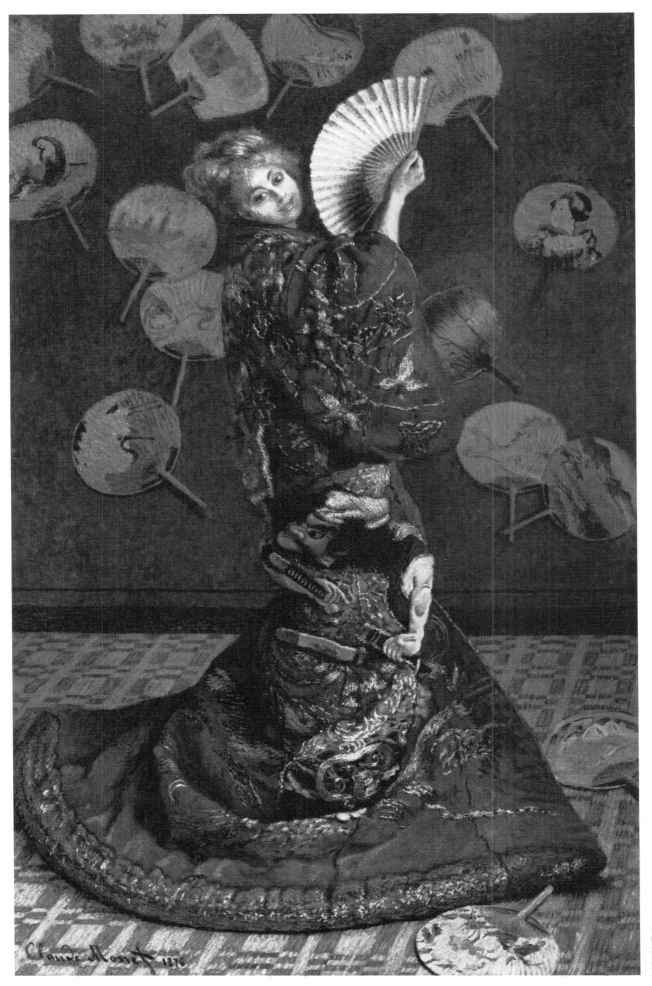

264. *La Japonaise*
(*Japonnerie*), 1875–6,
231.5 × 142, W 387,
Museum of Fine Arts,
Boston

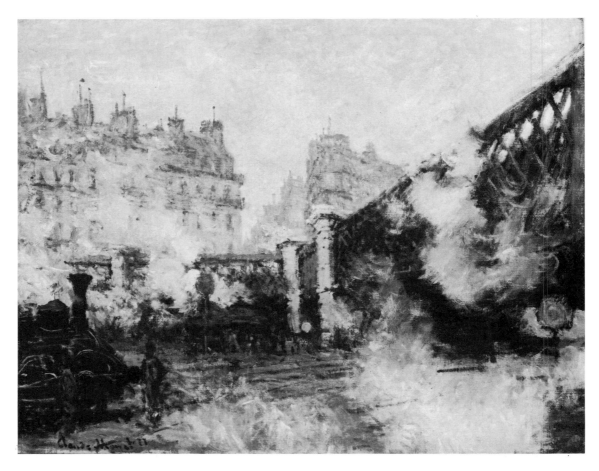

265. *The Pont de l'Europe*, 1877, 64 × 81, W 442, Musée Marmottan, Paris

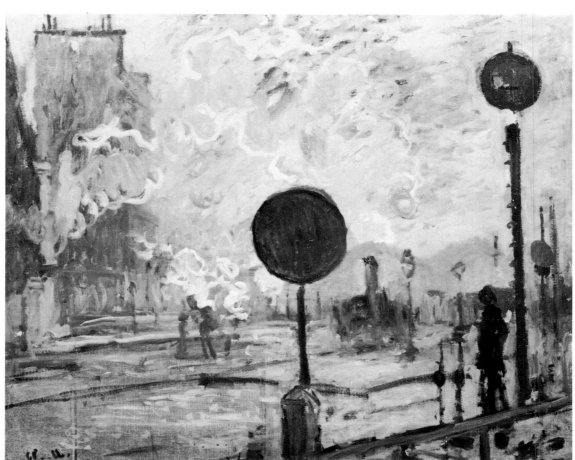

266. *The Gare Saint-Lazare, the Signal*, 1877, 65 × 81, W 448, Private Collection

selection, and the titles in the catalogue are fairly specific. The great majority of the pictures shown were already in Durand-Ruel's stock, so Monet's exhibit, at least, was more a trade show than an independent display. The general lines of what he showed are very much as suggested in the letter, though of the thirty-five pictures listed in the catalogue, only thirty were finally hung – we do not know exactly which.[19] *The Ice Floes* (pl. 186) and the large sunset (pl. 187; the painting Monet decided not to send to the 1880 Salon because it was too personal) were the two large paintings in the show; the rest were a miscellany of his recent work, varied coastal and inland scenes, and still lives. Thus the exhibition presented Monet's recent work in all its moods, without any inner unity as an ensemble; it served very much as a shop window.

Monet was working at Pourville while this exhibition was on, and wrote from there to Durand-Ruel about his newest paintings: 'I've got five that are finished, but if it is all the same to you, I would rather show you the whole series of my studies at the same time, as I am keen to see them all together at home.'[20] Though this use of the term 'series' is nothing new, as we have seen, this letter is the first surviving indication that Monet was interested in seeing his paintings together as a group away from their subject. But it is a long step from this to his later practice of completing them together as a unit and making an exhibition out of such a group.

Late in 1882 he made a suggestion to Durand-Ruel which prefigured an important development in the Impressionists' ideas on exhibiting: that, instead of over-frequent group exhibitions, the artists should take it in turns to have one-man shows.[21] Durand-Ruel took the idea up, and mounted in turn exhibitions of Boudin, Monet, Renoir, Pissarro and Sisley, one a month from February to June 1883. Some one-man shows of living artists had, of course, taken place before, among them Charpentier's little displays at *La Vie moderne*,[22] but Durand-Ruel's sequence in 1883 seems to be the first concerted attempt by a dealer to present his artists to the public by carefully planned one-man exhibitions, a practice that became frequent in Paris from around 1890 onwards.

It was in his exhibition in March 1883 that Monet had the chance to show a number of his Pourville works together, both those done early in 1882 and paintings from his return visit that summer. Of around sixty exhibits, there were about twenty-four from the Pourville area and eleven still lives; the remainder were very diverse, with a substantial retrospective element, going back to *The Pointe de la Hève* (pl. 111) of 1864, and including *Impression, Sunrise* (pl. 199). As far as one can tell from the catalogue, the show included no large paintings – that is, nothing above size 40 (100 cm the longer side). Until shortly before the show, though, Monet planned to include a new large canvas. When he began to work at Etretat in February his first intention was to produce something large for the show; he quickly abandoned the plan for shortage of time, and in the end was unable to include any new Etretat paintings, even of normal size.[23] The presence of twenty-four Pourville paintings does not mean that they formed a unified group or that they were hung together; they were varied in subject and effect, but this number of recent coastal scenes must have given parts of the display a certain coherence.

From 1882 onwards Durand-Ruel tried to find markets for Impressionist paintings outside France, since he felt that he was making little headway at home. Monet disagreed strongly with this policy. The catalyst for his split with Durand-Ruel in 1886 was the dealer's decision to ship many of their latest paintings to New York.[24] Monet could, though, afford this rupture with Durand-Ruel, for he had, since 1885, been participating in the *expositions internationales* mounted by Durand-Ruel's rival Georges Petit. Petit initially invited Monet to participate, it seems, on the suggestion of J.-C. Cazin. Gauguin hoped that Monet's presence in Petit's shows might mark the beginning of salvation for the Impressionists as a whole.[25] Renoir was to show there in 1886 and 1887, Pissarro and Sisley in 1887. It was Petit who ensured that Monet did not exhibit in the eighth and last Impressionist group show; he made his invitation for the 1886 *exposition internationale* conditional on Monet not exhibiting elsewhere.[26] Monet's experiences with Petit were not always smooth, as Mary Cassatt reported in 1886: 'Degas insisted on my going to see the exhibition at Petit's Gallery *at once* as he wanted me to judge of the Monets. They have managed to nearly kill him. They were up until three in the morning the day before the opening and every time Monet's pictures were hung the painters next took theirs away. Finally they separated all his pictures and put them in different corners.'[27] Despite this treatment all Monet's pictures at this show were apparently sold,[28] and the following year he was on the hanging committee.

In 1885 and 1886 he showed a variety of recent work at Petit's, and aimed for a similar variety when he was for the first time invited to show with Les Vingt in Brussels in 1886.[29] In Petit's 1887 exhibition, though, we find the beginnings of a change in his approach to exhibiting: ten of the fifteen or sixteen paintings he showed were of Belle-Isle, where he had spent the previous autumn; they must have made a strong collective impression. In discussing the genesis of his series, we have seen that it was on Belle-Isle that he first declared the positive value of studying a single subject in different conditions; but this repetition found no echo in Petit's show, for the exhibited Belle-Isle canvases seem all to have represented different sites. In the letters he wrote to Petit and his assistant before the exhibition, we find him working against time to finish new Giverny landscapes for the show, and then planning to borrow varied earlier paintings when unable to finish what he had hoped. He asked de Bellio to lend one of his Gare Saint-Lazare paintings (pl. 101), because 'I would like to show a note very different from my marines'.[30] So, after establishing the nucleus of Belle-Isle seascapes, comparatively homogeneous in tonality and mood, Monet felt the need to inject great diversity into the remainder of his exhibits.

Further disagreements with dealers in 1888 led Monet to make a contract with Boussod & Valadon, in the person of their branch manager Théo van Gogh, who in June 1888 mounted a small exhibition of Monet's recent Antibes paintings. This was the first time that Monet showed exclusively paintings of one place and one date. No catalogue of the exhibition has been found, and probably none was printed; but the contents of the show can be reconstructed by combining the evidence of the stock books of the firm with Geffroy's review, which describes all ten canvases, possibly in the order in which they were hung.[31]

All of those shown were of similar size, size 25 or 30 (81 or 92 cm for their longer side); all are views from the promontory between Antibes and Juan-les-Pins, but they reflect the full range of Monet's Antibes work. He made more than one version of almost all his subjects there, and four of some; but the ten exhibited paintings represented nine different sites (including pls. 207, 231), with only one pair of paintings of the identical scene in different effects of light. We should not, perhaps, make too much of the choice of pictures in this show, since it appears that the decision to exhibit them resulted from van Gogh's purchase of the ten pictures in question; thus the choice was presumably van Gogh's rather than Monet's.[32] The effect of the display would have been a real variety

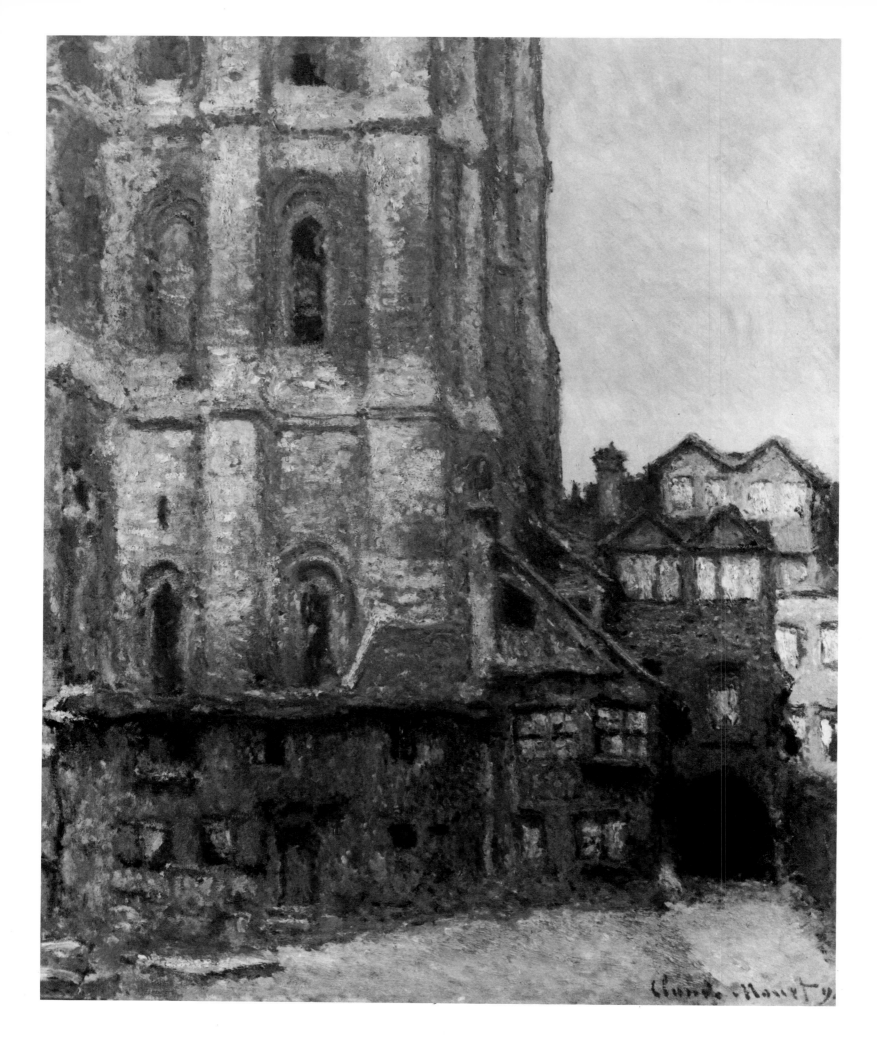

in the individual exhibits, within an overall unity of colour and atmospheric effect which would have given a real coherence to the ensemble.

However, small exhibitions in small galleries such as Théo van Gogh's branch of Boussod & Valadon could not bring Monet the commercial breakthrough for which he had waited so long. This came in the wake of the large Monet–Rodin retrospective that Georges Petit mounted in the summer of 1889, to coincide with the Exposition Universelle; it was this show which opened the eyes of American collectors, in particular, to Monet's art. It included one hundred and forty-five paintings, with an extensive retrospective section of fifty canvases up to 1880; half of the exhibition, though, was of very recent work, from 1886–9, including twelve paintings from Belle-Isle, seventeen from Antibes and fourteen done in the Creuse early in 1889. Five of the Creuse paintings represented a single subject (including pl. 134), and three another.[33] Such groups certainly foreshadow Monet's later exhibitions, but they formed only a very small element in this show. Also included, in marked contrast to the Creuse pictures, were four of his recent *Essais de figures en plein air* (probably including pl. 49; see pp. 36–40), whose importance he signalled by listing them separately under this heading at the end of the catalogue.

Monet also figured at the Exposition Universelle itself, though only in the retrospective Exposition Centennale, and with three not very recent works (including pls. 40, 218). The poet Gustave Kahn, reviewing the exhibition, commented that it would have been easy to show his 'poem of Antibes, spread out in a series of canvases, whose juxtaposition would have revealed an artist's will studying, from different viewpoints, a single landscape'.[34] This shows that Monet was known by this date to be limiting his subjects to a sequence of variations on a particular place. But Kahn's phrase 'from different viewpoints', and the Antibes paintings themselves, show that there was great variety in the precise viewpoints and compositions he adopted.

For nearly two years after the summer of 1889 Monet showed nothing in Paris. This was, as we have seen, a period of reflection and reassessment in his art; at the same time he reconsidered his policy about exhibiting. While at work on the *Grain Stacks* in December 1890, he wrote to Durand-Ruel about this: 'For my part I am wholly obstinate about anything to do with the re-establishment of the exhibitions of the old group. You have in your gallery paintings by all of us, which constitutes a sort of permanent exhibition; I think that is enough and that it would arouse far more interest to put on from time to time a small exhibition of a choice of recent works by one of us, but to revive our old exhibitions would seem to me useless and perhaps damaging.'[35] Monet was here advising Durand-Ruel to build on the example of Théo van Gogh's small one-man shows – in a sense to upgrade them from the *petit boulevard* to the *grand boulevard*. Durand-Ruel took his advice.

Rumours began to spread in April 1891 about Monet's latest paintings; de Bellio told Pissarro that Monet was going to exhibit '*nothing but Grain Stacks*'. Pissarro commented with uncharacteristic asperity: 'I don't understand how Monet is not bothered by tying himself down to this repetition – such are the terrible results of success!'[36] When the show opened on 4 May, it included fifteen Grain Stacks and seven miscellaneous works which had been added, perhaps at a late stage, to give some variety – very much in the way that Monet had added to his display at Petit's in 1887. The Grain Stacks themselves presented an ensemble quite different from any that Monet had included in previous exhibitions. Not all the paint-

ings exhibited can be precisely identified, but the fifteen Grain Stacks were all from the twenty-two which exist dated 1891; they included pls. 136, 161–2, 252, 254. They were also comparatively homogeneous in size – all size 30 or 40 (92 or 100 cm for their longer side).

The genesis of the Grain Stacks, and the ways in which their conception and execution differed from Monet's previous work, have been discussed in the last chapter. As exhibited, too, they must have seemed a real departure from groups such as the Antibes paintings, in their lack of scenic or topographical interest, in their simple, massive forms, and in their concentration on atmospheric effects. The importance of the specific atmospheric effects represented in this and the subsequent exhibitions of his series was highlighted in the catalogue by the inclusion of precise descriptive titles for each picture. Monet told a visitor to the exhibition that the paintings 'only acquire their full value by the comparison and the succession of the whole series',[37] which suggests that the coherence of the exhibition itself had been the end in view as Monet finished work on the paintings. The exhibition itself, as much as the individual canvases which made it up, had become the work of art – though a work of art doomed to be broken up. Pissarro's great regret that his son Lucien would not see the Rouen Cathedral paintings before they were dispersed shows that the collective significance of such exhibitions was quickly realised.[38] It is this which is hardest to recreate today, when only the Water Lily Decorations in the Orangerie (see pls. 92, 269) survive in a grouping that Monet planned for them.[39]

Monet's new financial security must have been a factor in allowing him to work with such concentration on the Grain Stacks, and his sudden popularity with collectors must have encouraged Durand-Ruel to agree to an exhibition which at first sight must have seemed to have so little immediate appeal, with its utterly unpicturesque theme. Aspects of the idea were foreshadowed, as we have seen, in the Gare Saint-Lazare paintings and in some of the groups of canvases he brought back from his travels of the 1880s. But in artistic terms the exhibition of the Grain Stacks was not merely a continuation of trends in his earlier work which his financial situation now enabled him to realise in full. Prosperity may have been the catalyst that allowed him to experiment, but his experiments gave his work a new impetus and direction, which was thereafter to be

268. *Charing Cross Bridge*, 1902, 65 × 92, W 1533, Private Collection

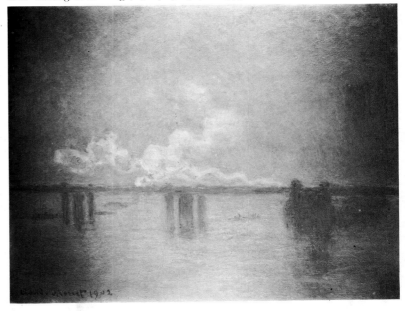

267. (left) *Rouen Cathedral, the Cour d'Albane*, 1892–4, 92 × 73, W 1317, Smith College Museum of Art, Northampton, Mass.

213

269. Water Lily Decorations, *Green Reflections*, (detail) c.1916–26, 200 × 850 (whole), Musée de l'Orangerie, Paris

focused on the succession of exhibitions of his series, each one designed as an artistic entity, which Monet mounted between 1891 and 1912.

However, not all the earlier shows were completely unified: seven other paintings were shown with the Grain Stacks; with the Rouen Cathedrals in 1895 he included two shorter series (Vernon Church and Norway) and a miscellaneous group of thirteen other canvases. One of the reasons Monet gave for deferring the exhibition of the Rouens was that, by combining the Cathedrals with other work he was doing in the interim, he would have 'a more varied and more complete exhibition';[40] he still felt the need to prove his versatility. The paintings shown together with the Grain Stacks were themselves a planned group: four of the Giverny meadow scenes from summer 1890, one *tour de force* from the Creuse, and the two *Woman with a Parasol* paintings of 1886 (including pl. 38), shown as *Essais de figure en plein air* and clearly meant as a follow-up to the four canvases he had shown under the same collective title at Petit's in 1889. The Poplars exhibition of February 1892 was the first to be devoted solely to a single series. From 1898 onwards, all the shows which Monet himself planned comprised only one or more series, though Durand-Ruel, in particular, often mounted separate shows of more miscellaneous paintings by Monet from his own stock.

The greatest problem in determining the original effect of Monet's series is to find out how they were hung. The ways in which each series was grouped on the gallery walls would have been crucial, but our evidence about this is extremely fragmentary; alas, no installation photographs have come to light. Ever since the first group exhibition in 1874, simple uncluttered hanging, in one or at the most two rows, had been a major consideration for the Impressionists; their smaller paintings continued in general to be hung in two rows.[41] In 1889 Geffroy noted with pleasure that the paintings in the Monet–Rodin exhibition at Petit's were hung 'in a thoughtful and harmonious arrangement, not too close together and well spaced, in only two rows of pictures.' For Monet, though, the virtues of this hanging were blotted out by the installation of Rodin's sculptures in their midst.[42]

News of Whistler's experiments in the hanging, framing and décor of his exhibitions reached Paris at least by 1883, when Pissarro claimed that Whistler's decorative schemes for his shows derived from experiments of Pissarro's own.[43] No evidence survives of a concern on Monet's part about the environment and décor of the rooms where his paintings were shown, beyond a practical concern for lighting conditions that best allowed them to be seen.[44] We must assume that Monet generally expected his paintings to be installed on walls of comparatively deep, warm hues – generally reds – which was normal in exhibition galleries, including Durand-Ruel's, at the time. Thus they would originally have appeared as luminous framed windows in a darker surround. Nor does he seem to have shared Pissarro's interest in coloured frames and borders; he apparently used white frames for some of the Grain Stacks and Poplars, but generally favoured gold frames. In 1899 Signac spoke of 'Monet's handsome gold frame' as if this was a particular characteristic of his exhibitions; in 1897 Monet sent three Rouen Cathedral paintings to La Libre Esthétique in Brussels in 'antique frames which I value particularly highly'.[45]

We have only two indications about the hanging of the Grain Stacks: one of the late summer effects, which Monet regarded as the best painting of the series, was placed 'in the middle of the others', and the *Essais de figure en plein air* (including pl. 38) were hung above the Grain Stacks.[46] The fact that a summer effect was in the middle shows that they were not hung in the order in which they appear in the catalogue, where the summer canvases are listed first, and also that they were not hung as a simple cycle from summer to winter. The fact that the figure paintings, although they are vertical and

quite large, hung above the Grain Stacks suggests that the other extraneous paintings, too, hung in the upper row – presumably with the Grain Stacks in a single row below. But there seems no means of telling how the Grain Stacks themselves were grouped, a task which Monet himself presumably performed at the last minute in the gallery.[47]

Little is known about the installation of the later series. The Poplars were hung in two small rooms, and two rooms, presumably larger, were used for the Rouen Cathedral exhibition, with the Vernon Church series in the outer one, the Cathedrals in the inner.[48] This would suggest that the Poplars and the Cathedrals, both painted on vertical canvases, had their spaces to themselves, and were hung in one single row. In retrospect, one might have expected the Rouen Cathedrals to be hung sequentially, either from dawn to dusk or as a set of colour variations; but Clemenceau's long review makes it clear that no such overall pattern emerged from their installation in 1895: 'Hung as they are, the twenty canvases are twenty marvellous revelations, but the close relationship that connects them will, I fear, elude the rapid viewer . . . Imagine them arranged on the four walls as a series of transitions of light: the great dark mass at the beginning of the *grey series* continually getting lighter, the *white series* passing from soft lighting to the dazzling crispness which continues to its fulfilment in the *rainbow series*, which become quiet in the calm of the *blue series* and fade away in the divine mists as the light dims.'[49] The catalogue, once again, is in no particular order; the two exhibited versions of *The Cour de la Maîtrise* (the Cour d'Albane, e.g. pl. 267), which show a different part of the cathedral, are numbers 3 and 10 in the sequence of twenty. The presence of these two paintings means that the series as exhibited was not totally unified; this continuing desire to vary his viewpoints even within a series is highlighted by the inclusion, as well, of *The Portal, Front View*, number 9 in the catalogue (pl. 240), alongside the seventeen which view the façade from the south-west; as we have seen, this was a much reworked canvas, not simply a first idea.[50] Size may have been a factor in the hanging of the Rouen Cathedrals, since some are slightly larger than others. When sending three of the series to La Libre Esthétique in 1897, he instructed Maus to hang them with the largest one as a pivot, flanked by the smaller ones, with the one subtitled 'sunset' on the right.[51]

If Monet avoided too great a unity in the Rouen Cathedral series, in two ways he adjusted the London paintings shown in 1904 to make them more homogeneous. By omitting Cleopatra's Needle from all the exhibited versions of *Charing Cross Bridge* he allowed unified atmospheric effects to dominate this series; and in two of the canvases (including pl. 268) he showed of this subject he emended the placing of the smoke from the trains, so that finally it was in the same position in both, whereas originally it had been in different positions.[52] Again the catalogue provides no clue to the hanging, listing the canvases chronologically within each of the three Thames series exhibited, with subtitles describing the particular effects shown.

Still less informative is the catalogue of *The Water Lilies, Water Landscapes* exhibited in 1909, in which the forty-eight paintings are listed baldly by date with no subtitles (including pls. 37, 140–1). Within this series there are changes in viewpoint and format between the canvases of different years, but we have no clues about the arrangement of the exhibition, the largest group of paintings from a single series that Monet ever exhibited, though probably it was

hung roughly chronologically with smaller more closely knit groups, rather than by successions of contrasts. This seems the more likely because, even before he exhibited the 1909 series, he had in mind the idea of turning this subject into the theme for a unified decorative scheme, designed to run right round the viewer with minimal interruptions.[53] The Water Lily Decorations (pls. 92, 269), whose arrangement was carefully considered and reconsidered as the plans for their installation changed,[54] achieve a different sort of homogeneity from the earlier series; their long continuous sweeps of canvas virtually dissolve the solidity of the walls of the oval halls in the Orangerie in which they are installed. Different panels, on different sides of the rooms, represent different effects of lighting; but the viewer cannot see these breaks without moving or turning. The single gaze now embraces a wholly integrated, self-contained experience.

In exhibiting his series, Monet explored the possibilities of large pictorial ensembles, with the individual canvas an integral part of a larger entity. The changes in his working methods during the 1880s, in particular his gradually increasing use of the studio, led him to work out more fully the relationships of form and colour on his picture surfaces; in exhibiting his series from 1891 onwards, he was able to extend these relationships beyond the boundaries of the single canvas. To achieve this, he began to work up his paintings in the studio by reference to the other canvases of their group;[55] thus the cumulative effect he sought in his exhibitions began to affect the ways in which he executed his canvases, whereas before he had finished them piecemeal and without thought of establishing such an inner coherence. As much as the individual paintings themselves, the ensembles of his exhibitions became the end product towards which he worked.

The form of these later exhibitions expressed a rejection of his previous exhibiting policy; no longer was the exhibition a shop window for the diversity of his merchandise. But this does not mean that the series and their public presentation were not commercial as well as artistic ventures. Each series was part of a carefully considered strategy of salesmanship, by which Monet demanded for his canvases the highest prices he thought the market could bear. With the Rouen Cathedrals, his prices seem, initially at least, to have scared off his regular buyers.[56] Moreover, the form of his exhibitions quickly became a central part of Monet's public image. By 1908 his exhibition plans were a matter of such public interest that the postponement of his Water Lilies show, and his rumoured destruction of many of the canvases, was networked in a report from Paris to newspapers all across the United States.[57] That the later series were regarded as 'blue chip' investments is suggested by the fact that the Davies sisters, Welsh heiresses to a coal and rail fortune, in 1912–13 added seven recent Monets, their first truly contemporary acquisitions, to their collection, until then dominated by work from the 1850s, 1860s and 1870s.[58]

We have no way of telling how Monet would have responded if the first of his series exhibitions, the Grain Stacks in 1891, had not succeeded commercially. It was at this moment, and this alone, that his new type of exhibition involved some degree of risk. At this date, though, as his letters show, he had so much other work either reserved by or promised to various collectors and dealers that such an experiment was viable.[59] The success of this show allowed him to pursue with confidence the idea of working and exhibiting in series.

CHAPTER FOURTEEN
CONCLUSION: NATURE into ART

THE integrated harmonies of Monet's series are a far cry from the crisply sketched forms in his work of the late 1860s. As we have seen, this transformation in the appearance of his finished paintings was the result of a protracted process of evolution and change, both in the subjects he chose and in the ways in which he treated them: a gradual move in the 1870s away from specifically modern subjects to a concentration on the widest range of natural forms and effects, leading by 1890 to a preoccupation with light and atmosphere; and in his technique, a move from crisply individuated forms to a more fragmented, all-over touch by the later 1870s, through a richer surface patterning in the 1880s to the homogeneous textures and rhythms of his later work. Clearly there are correspondences between subject and technique – between the abandonment of modern subjects and the adoption of a less descriptive touch, between his focus on atmosphere and the very harmonised surfaces he produced.

His process of painting, founded on the close study of the natural subject, translated his experiences of nature into art; we have examined the successive stages this involved. In another sense, too, the evolution of his painting was a gradual transformation from nature towards art – from a technique that subordinated the material *facture* of the painting to the natural subject, the elements depicted, towards a treatment that emphasised the decorative qualities of the painting itself; we have traced this change as it emerged in his working methods and in the appearance of his finished pictures. But we must also set these material developments in a more conceptual framework, and ask what status he attributed to these experiences of nature – the starting point or raw material of his art – and how far his ideas changed about the relationship between these experiences and the finished work of art; these questions will relate his art to the broader patterns of intellectual and cultural history of his time.

Today, we inevitably approach Monet's development with the hindsight of a century during which an emphasis on the primacy of the painted surface has crystallised into the ostensibly natural language of modernist criticism, whose presuppositions have more recently been subjected to critical and historical reassessment. Monet's evolution is a crucial part of the emergence of this conception of the painting, but we cannot simply impose on it the vocabulary that the modernist movement later deployed to sustain its position as the dominant critical discourse. The present day historian cannot bypass these debates, and indeed must learn from them; but these structures of hindsight must be dovetailed with an exami-nation of the ways in which Monet himself presented his artistic aims and development, and with the ways in which his art was discussed by his contemporaries – friends and critics.

Monet's declarations of his aims take varied forms. Some, particularly the few fragments we have from his early career, reflect his hopes and ambitions and project the image of bold independence. Others, mainly from his middle years, are the voice of an artist at last sure of his success, reassuring his audience and himself that he is still searching, still extending and enriching his art, not resting on his new-won laurels. Lastly we hear the voice of old age, asserting the continuity of his whole career, the unity of his vision.

Can statements such as these be used to illuminate our understanding of Monet's paintings, or do they belong to a world of public image, and self-image, which is largely independent of his practice as a painter? We can only gauge this by analysing them in relation to the development of his art; Monet's evolution was so closely tied to the material circumstances of his art – to questions of technique and working methods, and to the market for his paintings – that it can make no sense to isolate precept from practice. But this is not only a function of Monet's particularly pragmatic approach to painting. More generally, artists' declarations of their aims and intentions, like the works of art they produce, cannot be detached from the contexts within which and for which they were made. Precept and practice must be discussed together, whatever the relationship between them, since it is from a combination of the two that the artist's image is constructed.

In general terms Monet's declared aims remained consistent throughout his career. In 1868 he wrote to Bazille of his latest work: 'It will simply be the expression of my own personal experience (*l'expression de ce que j'aurai ressenti*).' He wrote to Geffroy in 1912: 'I only know that I do what I think best to express what I experience in front of nature (*pour exprimer ce que j'éprouve devant la nature*).'[1] Many similar quotations are recorded from Monet's last years.[2] He generally used verbs such as *sentir* and *éprouver* to convey the nature of the experience he was trying to record; only rarely did he use *voir*, the simple verb of sight.

In its context, the 1868 letter to Bazille is a sort of declaration of independence, of Monet's need to find his own path, away from the distractions of Paris: 'One is too preoccupied with what one sees and what one hears in Paris, however, strong one is, and what I do here will at least have the merit of resembling no-one – at least that's

what I think – because it will simply be the expression of my own personal experience . . . The further I go, the more I realise that one never dares to express frankly what one experiences (*exprimer franchement ce que l'on éprouve*).' Cézanne used very similar vocabulary in his defiant statement to the journalist Stock in 1870: 'I paint as I see, as I feel (*comme je vois, comme je sens*) – and I have very strong feelings (*les sensations très fortes*) – they too feel and see as I do, but they do not dare . . . they make Salon painting . . . But I am daring, M. Stock, I am daring . . . I have the courage of my opinions.'[3] 'Feeling' is quite inadequate as a translation of *sensation*, the term used by Cézanne and Camille Pissarro throughout their careers to describe what they were trying to render in their art; the word *sensation* itself encompasses both seeing and feeling, both perceptual experience and personal response.

By 1900 Monet's tone of determined individualism had given way to the assurance of the established sage. To an American who asked him what advice he gave to students, he replied: 'Paint as you see nature yourself. If you don't see nature right with an individual feeling, you will never be a painter, and all the teaching cannot make you one. A painter must work out his own problem in his art, as everyone must work out his own problem in life.'[4] He gave similar advice to Lucien Pissarro in 1919, as the letter Lucien wrote to him after his visit shows: 'After seeing you I am more and more certain than ever that "the sensation" is the foundation of everything, a noble thing as long as it comes from a real feeling . . . It doesn't really matter if sensation arises from work painted in front of nature, or not, so long as the sensation is there.' Lucien cited Cézanne, van Gogh, Gauguin, Seurat and Signac, and ended: 'All the same there was something in their art which was alive – the sensation.' Monet clearly gave Lucien the same moral support and reassurance of the validity of his own *sensation* that he had given Cézanne on his visit to Giverny in 1894.[5]

As Cézanne's interview with Stock and Lucien's letter show, the *sensation* was essentially personal. Camille Pissarro made the same point in 1895, noting the similarly between some of Cézanne's Auvers and Pontoise landscapes and his own: 'But what is certain, each of us preserved the only thing that counts, his own *sensation*.'[6] Likewise the quotations from Monet, and the vocabulary he adopted – the verbs *sentir* and *éprouver* – suggest that he too regarded the experiences he was trying to record as essentially subjective. However, other comments suggest that he was pursuing a more objective sort of truthfulness. He wrote to Alice Hoschedé from Bordighera in 1884: 'Every subject . . . I choose, I tell myself that I must render it well so that you can see where I have been and what it is like.' In 1891 he declared categorically about his attempts to paint light and atmosphere in the Grain Stacks: 'Above all I have wanted to be truthful and exact.'[7]

How can we reconcile the apparent objectivity implied in statements like these with his essentially subjective descriptions of his experiences? Richard Shiff has shown that the distinction between subjective and objective was more apparent than real in contemporary discussions of perception. The artists' comments, and the ways in which many contemporary critics described their work, adopt the terms of reference of contemporary positivist philosophers and perceptual psychologists, notably Taine, Ribot and Littré.[8] For them, there was no independent objective criterion for judging reality; the only access to it was through the individual's experience, which was necessarily personal. The terms *sensation* and *impression* were among those widely used to characterise these experiences. The criterion for judgment of a work of art based on such *sensations*

was the sincerity with which it recorded them, not an appeal to any objective standard of truthfulness. This is the central justification that Edouard Manet gave in his exhibition catalogue preface of 1867 for his position, in opposition to the artificial formulae of Salon art: 'The artist does not say today: come and see faultless works, but: come and see sincere works. The result of this sincerity is to make these works seem like a protest, though the painter has thought only to render his *impression*.'[9]

A passage from Zola's discussion of Jongkind in his 1868 Salon review shows how effortlessly the critic could switch from the subjective to the objective in characterising Jongkind's vision: 'He sees a landscape at a stroke, in the reality of its ensemble, and he translates it in his own way, presenting its truthfulness while communicating to it the emotion that he has felt. It is this that makes the landscape live on the canvas, no longer only as it lives in nature, but as it has lived for several hours in a rare and exquisite personality . . . Here, everything is original, the handling, the *impression*, and everything is truthful, because the whole landscape has been grasped in reality before it has been lived in by a man.'[10] The same fusion lies behind Zola's famous definition of the work of art as 'a corner of nature seen through a temperament'. Thus the *sensation* and the *impression* could be both truthful and essentially personal.

The few surviving comments from Monet's earlier years cannot, of course, be taken to reflect the range of his aims. We have no word from the artist himself of his ambitions as a painter of specifically modern subjects, to which associates such as Zola, Boudin and Duret testify in their writings of the period. Nor do we have any contemporary descriptions in his own words of his technical experiments of the 1860s and 1870s, which became the subject of much debate in the reviews of the first three Impressionist group exhibitions; his few recorded comments about these questions date from many years later.[11] There are several reasons for this silence. During these years he had little reason to write to colleagues whom he was seeing regularly, nor was his art treated seriously enough by the press for his opinions to be sought by journalists.[12] But, more significantly, he may have felt that his position needed little verbal explanation within his circle of colleagues and associates. His ambition to express his *sensation* of the world around him may have seemed to him, in the later 1860s and 1870s, to be relatively unproblematic. Never a man of theoretical bent, he would have been largely unconcerned by academic debate over the status of these *sensations*. The subsequent historian needs to draw out into the open the unspoken presuppositions which lay behind his position, and to examine how these affect our understanding of his practice. But we cannot assume that he, or most of his colleagues at this period, were actively aware of these more abstract philosophical issues. Monet's public platform was his practice as a painter, concerned to bring his canvases before an audience and a potential market.

Nor do we have any indication of the ways in which Monet himself viewed the crucial changes in his art in the mid to later 1870s – the changes in his painting technique and his rejection of the modern scene as a subject – nor did contemporary critics focus on these issues with any clarity. However, Zola's review of the 1880 Salon, 'Le Naturalisme au Salon', gives some hint of this change, from an obviously partisan viewpoint. In 1868, as we have seen, Zola had hailed Monet as a truly modern painter, and had enumerated the facets he loved in the modern scene; but in 1880, after his critical comments about Monet's technique, Zola had little to say about his exhibited canvas, *Lavacourt* (pl. 270), 'a stretch of the

270. *Lavacourt*, 1880, 100 × 150, W 578, Dallas Museum of Fine Arts

271. Guillemet, *The Old Quai de Bercy*, 1880, 150 × 240, Private Collection

Seine, with an island in the middle, and the white houses of a village on the bank on the right . . . an exquisite note of light and open air'. The enthusiasm that he had felt for Monet's modernity in 1868 was in 1880 reserved for Antoine Guillemet's *The Old Quai de Bercy* (pl. 271) with which he ended his review, enthusiastically enumerating its contents: 'Nothing gayer or more lively than those thousand details, this swarming *faubourg*, this gash of light on the great city, whose smell and noise one senses. The picture arrests you like a window suddenly opened on to a well known horizon.'[13]

There was little to interest Zola in *Lavacourt*; understandably, his enumerative description of its subject made it sound very banal, whereas Monet's earlier paintings, like Guillemet's exhibit, responded readily to such an itemisation of their contents. Monet's art had, by 1880, firmly turned its back on the aesthetics of Zola's Naturalism, with its ostensible presentation of a 'slice of life' by cumulative, additive descriptions of environments; he had rejected, too, the diversity of his own previous subjects, in favour of simpler, more unified themes which would not distract from the overall effect of light and atmosphere across them. Routine comment though it was, Zola's phrase 'an exquisite note of light and open air' did contain the embryo of what Monet was pursuing; Huysmans acknowledged this more positively two years later: he regretted the scarcity of modern urban subjects at the seventh group exhibition, but hailed Monet's new mastery of the 'so difficult problems of light in painting'.[14] It was this issue, the painting of light, that became the central element in the critical discussions that grew up around Monet's art in the late 1880s, and in his own later statements of his aims.

Around 1890 he began to explain his ideas more fully – partly, one assumes, to clarify his own perspectives on the changes in his art, and partly because his new-won success now made his ideas a matter of more public interest. In this process, too, he gave some clues to the ideas that had lain behind his previous work, ideas which he was now questioning. This coincides with the beginning of his integrated series, with the Grain Stacks; but it coincides too with a more general shift in the aesthetic attitudes current in the Parisian avant-garde, with the emergence of Symbolism as a challenge to the dominant currents of Naturalist thinking. The general aims of his earlier years, to express his *sensations*, clearly lay within this Naturalist orbit; we must see how far his ambitions, as he redefined them around 1890, relate to these larger shifts in the cultural climate.

Richard Shiff has challenged the assumption that Impressionism and Symbolism were categorically distinct movements, operating within categorically different conceptual frameworks. He has emphasised that much critical vocabulary is common to the two movements, treating the subjectivity of the Impressionist *sensation* as a bridge to the inner world which Symbolism sought to reveal.[15] However, one must emphasise that the Symbolist programme, as presented for instance in the classic formulations of Gustave Kahn in 1886 or Albert Aurier in 1891, involved a basic rejection of the Impressionist position, repudiating its continued dependence on direct visual experience of the outside world as a starting point. It was the adherents of Naturalism whom Kahn castigated for 'subjectifying the objective (nature seen through a temperament)' – a formulation wholly in line with the notion of experience which underlies early Impressionism. By contrast, the Symbolist aim to 'objectify the subjective (the externalisation of the Idea)' transforms the notion both of art and of its raw material.[16] Its subjects become internal, subjective (imagination, or the dream), while the work of art seeks to abstract their essence, or the Idea, and to achieve a level of generality which transcends the individual experience. Certainly the vocabulary in which these ideas are couched is linked to the vocabularly of Positivism and Naturalism. But it is this verbal continuity that gives the focus and force to Kahn's reversal of the Naturalist distinction between subjective and objective, thus allowing him to stand the Naturalist position on its head so effectively.

Overemphasis on the continuities between Naturalist and Symbolism also obscures the changes that took place in Monet's work. As we have seen, Monet himself saw a basic continuity running through his career on some level, but consideration of the distinctive qualities of the Symbolist position allows us to focus more closely on the nature of the changes in his art around 1890: How far do the changes of practice which we have already analysed reflect broader changes in Monet's conceptual framework and in his idea of the relationship between his *sensation* and the final work of art?

Monet indicated the general direction of his change in a conversation with Theodore Robinson in 1892: 'He said he regretted he could not work in the same spirit as once, speaking of the sea sketch Sargent liked so much [probably pl. 83]. At that time anything that pleased him, no matter how transitory, he painted, regardless of the inability to go further than one painting. Now it is only a long continued effort that satisfied him, and it muse be an important motif, that is sufficiently absorbing – "Obviously one loses on one side if one gains on another, one can't have everything. If what I do no longer has the charm of youth, I hope it has some more serious qualities, that one might live for longer with one of these canvases".'[17] Robinson's account shows that Monet connected this change with the beginning of the series, but on this occasion he went no futher towards defining these 'more serious qualities'. To see what he meant by this, we must look at his other statements of intent from this period.

Monet summed up his aims in the letter to Geffroy of October 1890 in which he announced the beginning of the Grain Stacks series: 'The further I go, the better I see that it takes a great deal of work to succeed in rendering what I want to render: "instantaneity" ("*l'instantanéité*"), above all the *enveloppe*, the same light spread over everything, and I'm more than ever disgusted at things that come easily, at the first attempt.'[18] The key elements in this are his search for instantaneity, his concentration on the *enveloppe*, and his rejection of the quick sketch, which he echoed in his conversation with Robinson. The 'more serious qualities' did not derive from any one of these factors on its own, but from a resolution of the apparent conflict between them – between his pursuit of the most ephemeral of natural effects and his concern to work up his paintings at leisure.

Instantaneity is on one level simply the result of the progressive refinement of Monet's vision, of his perception of changing nuances of light. We have seen the problems this raised in his efforts to paint out of doors, in front of his subject.[19] As Steven Levine has shown, discussions of the instantaneous quality of Impressionism had been current since the 1870s; it was generally associated pejoratively with the qualities of the photograph, but without, it seems, the use of the noun *instantanéité*.[20] Indeed Degas used it in 1872 in criticising landscapists who began to paint as soon as they came to a new place: 'The instantaneous (*l'instantané*) is photography, nothing more.'[21] However, around 1890 instantaneity took on a sort of talismatic significance for Monet, as he suggested by placing the word *l'instantanéité* in inverted commas in his letter to Geffroy. It was first used in connection with his work, Levine suggests, by Félix Fénéon in 1886, and was then taken up as a central element by Mirbeau in his

introduction to Monet's 1889 exhibition catalogue. Monet reflected his own special claim to the use of the word many years later, in 1920, when he wrote to Geffroy mentioning Boudin's *pochades*, 'progeny of what I call instantaneity'.[22]

The idea of instantaneity, as Monet confronted it around 1890, reflects the ultimate paradox of the painter's practice, the point at which painting is forced to acknowledge its categorical disjunction from the perceived world: the work of art, produced over a period of time and viewed in time, transcends the instant which ostensibly it claims to capture. In his 1890 letter to Geffroy, Monet showed that it was at this point in his career that he fully acknowledged this paradox, in coupling his search for instantaneity with his rejection of the quick sketch.

As his letter shows, in 1890 the *enveloppe* seemed to Monet the ideal raw material for his pursuit of instantaneity. The term *enveloppe* and the verb *envelopper* became widely used by artists in the nineteenth century to describe the tangible, unifying atmosphere which surrounds objects. Adéline in his *Lexique des termes d'art* of 1884, defined the verb: 'To veil, to soften the modelling of certain bits of painting. One says that a figure needs to be more *enveloppée*, to indicate that it should be modelled less drily, that it contours should be merged into the ensemble, should appear surrounded by atmosphere.'[23] The noun *enveloppe* was used by both Corot and Boudin in the way Monet meant it, to describe the unity which the artist was seeking to give his paintings of such atmospheric effects.[24] By the late 1880s the term had become a critical commonplace.

A critic wrote in 1883 of Monet's 'study of the luminous *enveloppe*', but the word only became widely used of his art later in the 1880s. The first traced example of his own use of this terminology is in 1888, in describing the colour of his Antibes paintings, 'all enveloped with this enchanting air'.[25] In 1889 two important articles on Monet, both based on his own ideas, use the *enveloppe* as a central idea. Hugues le Roux described Monet's studies of 'what, in studio slang, one calls the atmosphere, the *enveloppe*', describing his work as 'the painting of the *enveloppe*, of the movement of the ether, of the vibrating light that pulsates around objects'. Octave Mirbeau, in his introduction to the catalogue of the Monet–Rodin exhibition later in the year, enlarged on the role of the air in our perception of the world around us: 'Between our eye and the appearance of figures, seas, flowers and fields, the air intervenes in a real sense. The air *visibly* bathes every object, endows it with mystery, envelops it with all the colours, muted or dazzling, that it has picked up before reaching our eyes.'[26] Monet himself told Geffroy in July 1890 that he was trying to 'render the weather, the atmosphere, the ambience', and enlarged on this to a visitor to the Grain Stacks exhibition: 'For me, a landscape does not exist in its own right, since its appearance changes at every moment; but its surroundings bring it to life – the air and the light, which vary continually . . . For me, it is only the surrounding atmosphere which gives objects their real value.'[27] He described his aims to two interviewers in Norway in 1895: 'I want to paint the air in which the bridge, the house and the boat are to be found – the beauty of the air around them, and that is nothing less than the impossible.' 'To me the motif itself is an insignificant factor; what I want to reproduce is what lies between the motif and me.' Geffroy had used the same image in writing of Monet's art in 1890: 'He does not want to represent the reality of things, he wants to fix the light which lies between him and the objects.'[28]

In trying to paint the *enveloppe* Monet was pursuing natural effects at their most ephemeral. In this respect this concern around 1890 picks up one of the *leitmotivs* of his earlier career – reflections in water. In his treatment of reflections in the 1870s the fragmented reflection is juxtaposed with the solid forms of the objects reflected; only the water surface is the vehicle for transitory effects, and, beside it, the actual objects appear solid and unchanging. Michel Butor has seen Monet's interest in reflections as an expression of his fascination with the idea of fragmentation and reversal of images as such, which 'corresponds to the activity of the painter', the water becoming 'a metaphor for painting'.[29] However, Monet never expressed an interest in reflections as distortions of the material world or as a mirror of some other sort of 'reality'; such metaphysical questions were alien to his essentially perceptual approach to nature. Instead, as with the *enveloppe*, it was the transitoriness of reflections which fascinated and challenged him. He made this clear in his one substantial recoded statement about reflections – a description of his aims in his Water Lilies paintings: 'The water flowers are far from being the whole scene; really, they are just the accompaniment. The essence of the motif is the mirror of water whose appearance alters at every moment, thanks to the patches of sky which are reflected in it, and which give it its light and movement.' Monet went on to describe how the changing breeze and light endlessly transformed the water surface, saying how fascinating it was to trace the changing light and colour as it fell 'on this mobile, constantly changing stuff that water is . . . which renews itself and shows itself in an important light at every moment.'[30]

The Water Lilies take the theme of reflections further than his paintings of the 1870s had. The water surface has taken over the whole painting, and its fluid forms are no longer set beside the objects they reflect. The whole painting is unified by the water surface; it is the fleeting effects of light and colour across it which dictate the rhythms and colours of the entire canvas. In this respect the Water Lilies take up one of the lessons Monet had learned from his study of the *enveloppe*: that the most transitory effects could give a painting an overall unity to which all the objects in it were subordinated. A water surface, as well as the enveloping effect of coloured atmosphere, could be the means to this unity.

In 1926 Monet told Charteris that his basic aim was to 'render my impressions in front of the most fugitive effects'; it was their fugitive quality which formed the essential link between his twin obsessions, with reflections and with the *enveloppe*. This continuity was emphasised just before Monet's death in an article by Georges Grappe which probably reflects Monet's own words: 'He has always felt the aesthetic *vertige* of water. The sea, rivers, canals, ponds had fascinated him.' Grappe described Monet's pursuit of the effects of light on water, 'this mysterious and elusive spectre. Thus, gradually, it was light which took pride of place in his work, and which made out of the implaccable realist . . . a metaphysician, a lyricist, an idealist.'[31]

Though it was around 1890 that the *enveloppe* came to play a central role in Monet's pictorial experiments, this was not the first occasion that he had explored the theme. Thiébault-Sisson, in his account of the origin of the series published in 1927, attributed the immediate stimulus to start the Grain Stacks series to an effect of the sun appearing through fog, but traced the germ of the idea back to a previous experience, of painting a church in the morning mist, which gave it 'an ideally misty *enveloppe*'. This painting, as we have seen, was very probably *Vétheuil in the Fog* of 1879 (pl. 201).[32] Monet included this in his exhibition at Boussod & Valadon's gallery early in 1889 expressly, he told le Roux, to illustrate his methods – his problems in trying to record the most fleeting natural

effects.[33] It was as he became more preoccupied by the *enveloppe* in the late 1880s that the significance of this past experience grew for him; his inclusion of the painting in one exhibition in 1887 and two in 1889 emphasises the relevance he felt the painting had for his current concerns.

But *Vétheuil in the Fog* was not Monet's first attempt to paint mist and fog; indeed, his most famous single painting, *Impression, Sunrise* (pl.199), had already treated the subject. He had first painted mist and fog in London in 1870–1 (pl. 144); before he returned to paint there in 1899 it was for its fog that he remembered the place, and when in 1887 he planned to work there again, he intended to paint 'several effects of fog on the Thames'.[34] Such effects follow fairly regularly in the 1870s. After his experience at Vétheuil in 1879, it was a different type of scene that drew Monet back to the problems of painting the atmosphere – the light and colour of the Mediterranean coast. The rich colour schemes which he worked out to translate the 'admirable rose-coloured light' of Bordighera, and the white, rose and blue, 'all enveloped with this enchanting air', at Antibes, led him to think again about the ways in which the air could unify a scene.[35]

In 1888–9 he began to paint mist effects at Giverny, in a sequence of canvases of meadows and fields, some with stacks in them. Their delicate pastel hues are quite unlike the more vibrant colour schemes of the southern paintings, but they too are unified by the coloured *enveloppe*. Mirbeau's emphasis on the *enveloppe* is 1889 in his preface to the Monet–Rodin catalogue was thus immediately relevant to Monet's concerns of the moment. Its significance was re-emphasised by the choice of paintings for the exhibition itself, which included a set of paintings of mist effects spanning the past two decades, including *Impression, Sunrise*, *Vétheuil in the Fog* and several of his very recent paintings of effects of mist. Small groups of paintings of single subjects were, as we have seen, one aspect of this show, but more prominent, in its overall effect, must have been Monet's interest in the *enveloppe*.[36]

At the period that the atmosphere came to predominate in his own painting, Monet renewed his contact with the work and ideas of three artists who shared this interest: Whistler, Turner and Corot. Monet stayed with Whistler in London in 1887, returning to France deeply impressed with the man and his work. That winter he introduced Whistler to Mallarmé, who promptly translated Whistler's *Ten O'Clock* into French. In a famous passage in the *Ten O'Clock* Whistler described the rare occasions when nature succeeded in 'producing a picture' (see pl. 272): 'And when the evening mist clothes the riverside with poetry, as with a veil, and the poor buildings lose themselves in the dim sky, and the tall chimneys become campanili, and the warehouses are palaces in the night, and the whole city hangs in the heavens, and fairyland is before us . . . Nature, who, for once, has sung in tune, sings her exquisite song to the artist alone . . . To him her secrets are unfolded, to him her lessons have become gradually clear.'[37] Monet would not have endorsed Whistler's disparaging remarks about Nature, but he would have agreed with his belief that the unifying effects of mist could transform an everyday scene into something artistic.

Whistler's subtle tonal harmonies, though, are a far cry from Monet's colour schemes of the period. It was his search for an overall coloured unity which led him to a new enthusiasm for Turner's work at this time; the 'tinted steam, so evanescent and so airy' of Turner's later work must have shown him the potential of the sunlit *enveloppe* as a vehicle for this unity.[38] Monet's admiration for Corot was at its height in the later 1890s. His desire to make

paintings with which 'one could live for longer' out of his studies of the *enveloppe* echoes one of Corot's comments about the veil of mist in his paintings (see pl. 34): 'To enter fully into one of my landscapes, one must have the patience to allow the mists to clear; one only penetrates it gradually, and, when one has, one should enjoy oneself there.'[39]

Monet's clearest statements about the qualities of subjects veiled in mist and fog refer to his London series of 1899–1901 (e.g. pls. 223, 268). In 1901 he described to the American journalist Emma Bullet the many varied colours of London's fogs: 'My practised eye has found that objects change in appearance in a London fog more and quicker than in any other atmosphere, and the difficulty is to get every change down on canvas.' Late in his life he spoke to René Gimpel about London: 'I adore London, it is a mass, an ensemble, and it is so simple. What I like most of all in London is the fog. How could the English painters of the nineteenth century have painted its houses brick by brick? Those fellows painted bricks which they didn't see, they couldn't see.' Later he expanded on London's unity as an ensemble: 'I like London so much, but I only like it in the winter. In summer, it's fine with its parks, but that's nothing beside the winter with the fog, because, without the fog, London would not be a beautiful city. It is the fog which gives it its marvellous breadth. Its regular, massive blocks become grandiose in this mysterious cloak.'[40] This last description in particular echoes Whistler's evocation of the Thames. It was the coloured atmospheric cloak which led Monet to all his later subjects except the Water Lilies; it allowed him to give his paintings, both singly and when exhibited in groups, the internal coherence and unity he sought.

The *enveloppe* was the theme that allowed Monet to achieve the 'more serious qualities' he mentioned to Robinson. But those qualities were not simply the product of his chosen subject, but rather of the way in which it was translated into paint. This quest coincided, as he stressed to Robinson and to Geffroy, with the rejection of the quick sketch: such qualities could only emerge out of the process of elaboration and improvisation by which he transformed the ephemeral into fully resolved works of art. Moreover, this experi-

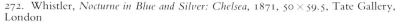

272. Whistler, *Nocturne in Blue and Silver: Chelsea*, 1871, 50 × 59.5, Tate Gallery, London

ence was not confined to single paintings; as he said of the Grain Stacks in 1891, the canvases 'only acquire their full value by the comparison and the succession of the whole series'.[41] The effects he achieved in the series depended not only on the methods by which he painted individual canvases, but also on the processes of adjustment and integration by which he produced the ensembles of his exhibitions. By working them up in the studio, he produced paintings which, in groups as well as singly, allow the viewer to 'live for longer' with them. They do not operate simply as views, but keep something back, since they depend on pictorial relationships that can only be fully experienced as we explore the paintings at our leisure.

On two occasions in 1892 Theodore Robinson recorded in his diary the quality which Monet said he was seeking in his paintings: this was 'mystery'.[42] At first sight this seems a far cry from his declared intention to record his experiences of nature. His comment can be located in two distinct contexts. The mists of sunrise and sunset had traditionally been described as mysterious by writers on landscape. Deperthes spoke in 1818 of the 'sort of mysterious veil with which nature is enveloped' at sunrise; Henriet enlarged on a similar experience in 1866: '[at sunset, a motif] derives its charm from the veil with which the dusk envelops it . . . In the evening, nature is infinitely beautiful because it has mystery; and for the human spirit, which always desires its dose of the unknown, mystery is emotion, it is the dream, it is poetry.'[43] Clearly the association of mystery with the *enveloppe* was already something of a cliché. It was a similar quality that Corot sought in his landscapes once the mists rose a little – a suggestiveness and poetry which transcended the mere description of the scene.

However, in the early 1890s there was a more immediate context for Monet's demand for a mystery emerging from the image of the natural world, in the ideas of the Symbolist poets – not the poets of the occult and visionary, but specifically Stéphane Mallarmé and his circle. This was the period of Monet's closest association with Mallarmé. For the poet, it was 'mystery' which separated the world of poetry and art from the world around us. Mallarmés views were most straightforwardly expressed in his interview with Jules Huret in 1891. He criticised the Parnassian poets for presenting their ideas directly: 'I think, on the contrary, that there should only be allusion. The contemplation of objects, the image emanating from the dreams they excite, this is poetry. The Parnassians take a thing whole and reveal it; by doing this they lack mystery: they deny the human spirit the delicious joy of believing that it is creating. To *name* an object is to suppress three-quarters of the enjoyment of the poem, which is created by the pleasures of gradually apprehending it. To *suggest*, that is the dream. That is the perfect use of mystery which constitutes symbol: to evoke an object little by little in order to reveal a state of mind, or, inversely, to choose an object and to derive from it a state of mind, by a series of decipherments.'[44]

Monet's recent paintings were discussed in very much these terms by several of the writers in Mallarmé's circle. Mirbeau, who knew Monet well, in 1889 linked mystery with the *enveloppe*: 'The air *visibly* bathes every object, endows it with mystery, envelops it with all the colours'; in 1891, after further consultation with Monet, he enlarged on the qualities of his latest work. He described Monet, 'who knows how to touch the intangible, express the inexpressible, who enchants our dream with the whole dream mysteriously enclosed within nature, with the whole dream mysteriously scattered in the divine light'; he emphasised the appeal of his work to the poets, ending by discussing the Mallarméan quality of one of his

273. *Portrait of Suzanne Hoschedé with Sunflowers*, c.1890, 162 × 107, W 1261, sold Christie's, London, 2 December 1985, lot 8

latest figure paintings, showing a girl seated by a table with a vase of sunflowers on it (pl. 273).[45] Both Mirbeau and Maurice Rollinat, of his friends among Symbolist writers, emphasised the mystery of their natural surroundings when they were inviting Monet to visit them in their solitary retreats, as if this quality might lure the painter in their direction.[46] In 1892 Georges Lecomte, in *L'Art impressionniste*, the first monograph on the group, concluded his account by insisting that 'the great mystery of nature', which Monet and Pissarro were pursuing, was just as valid a path to Thought (*la Pensée*) and the Dream as the philosophical intellectualism of many young Symbolist painters; in the final analysis the inspiration of nature, rather than mysticism, could best supply the '*sensation* of mystery' and the decorative qualities of the art of the future.[47] Lecomte's distinction between a suggestiveness based on nature and a mysticism derived from the imagination is a crucial one, but both of these approaches belong within the broad orbit of Symbolism within its historical context.

Mallarmé's ideas share with Monet the belief that the work of art should go beyond the mere description of objects. The poet's

emphasis on suggestion and gradual apprehension may be related to Monet's desire that the viewer should be able to live for longer with one of his canvases. Monet would never himself have described his art in such metaphysical terms as Mirbeau and Lecomte did, but in general terms his 'mystery' can be compared with the mystery that Mallarmé and his circle saw as the defining characteristic of the true work of art. The road Monet took to achieve his mystery was the intensive observation of the most ephemeral natural effects; the suggestive power of nature itself was his stimulus. But the finished work of art, refined and elaborated at his leisure and presented for the viewer to explore at leisure, transcended its starting point in the external world. It was thus that, as Robert Goldwater wrote, in Monet's series, 'by a most unexpected route the extremity of Impressionist analysis, so sharp that it retained no trace of usual, pedestrian vision, has arrived at the Mallarméan (Symbolist) principle of suggestion by infinite nuance alone'.[48]

The elaboration and the insistent physicality of Monet's paint surfaces of around 1890 suggest a further parallel with Mallarmé's ideas. Mallarmé distinguished between *reportage*, or journalism, and literature: the purpose of reportage was simply to convey information, while literature was crucially concerned with language as its medium and absolutely self-conscious about its means; it declared, rather than disguised, the materials out of which it was made – revealing the formal structure of the piece and drawing attention to the words out of which it was formed. For Mallarmé, Zola had done the opposite, minimising the purely literary elements in his novels in his concern to give a sense of reality.[49] The analogy with Monet lies in the painter's increasing emphasis on purely pictorial qualities: colour, touch, pattern. Monet's earlier paintings give at first sight the illusion of reality; we are not at once conscious of the artifice of the making. But with the later paintings the qualities of the painted surface are immediately evident, in their rich harmonic effects; these internal relationships became still more evident when the paintings were exhibited in series.

Exhibiting his canvases in series further complicated the questions about time which they raised. At first sight the succession of paintings around the walls re-enacted the successive instants in nature which were their starting point. But, just as the painter, as he reworked them at his leisure in his studio, could turn at will from one canvas to another and back again, so the viewers of the exhibition could create and recreate the series in whatever sequence and whatever time they chose.

Described in these terms, the effect of the series invites comparison with the ideas that the philosopher Henri Bergson first elaborated in his *Essai sur les données immédiates de la conscience*, published in 1889. Bergson used the concept of duration (*la durée*) to describe the flux of interpenetrating experiences and memories within the consciousness of the individual, distinguishing it from the notional objectivity of time as measured by clocks; for Bergson, study of *la durée* was the key to the understanding of human experience. As early as 1892, one critic, C. Janin, used the idea of *la durée* to describe the effect of Monet's series;[50] but to say that the experience of the series invites a Bergsonian analysis is not to suggest that Monet himself would have enunciated his intentions in such terms, or could have espoused such an interpretation. The only indication we have which shows that he considered his new work to involve a new kind of looking, extended in time, is his remark to Robinson that he hoped that 'one might live for longer with one of these canvases'.[51]

The problem of Monet's relationship with Symbolism is aggravated by the Rouen Cathedral series (pls. 138, 163–4). Begun early

in 1892, this was the latest project when he told Robinson that he was seeking 'more serious qualities'. As an emblem, cathedrals had great potency for Symbolist writers, both for their mystical overtones and as a symbol of permanence and continuity in a changing world.[52] One critic even saw Monet's portals, with their closed doors, as symbols for man's exclusion from the Unknown.[53] Interpretations of this type are, though, quite out of tune with the way Monet conceived his paintings. In 1926 he voiced his criticisms of literary painters: 'They want to explain what is inexplicable, since painting is a spontaneous, unreflective impulse. I paint what I experience in front of nature.'[54] His insistence here on the spontaneity of his art clearly echoes the image he wished to project rather than the complexities of his actual procedures, but his disavowal of the literary rings true. In these terms, and also because of the breadth with which he handled the façade of Rouen Cathedral, such details as his omission of the cross on the gable can have no significance.[55] However, there is one indication that cathedrals had a powerful effect on Monet, as Jacques-Emile Blanche recorded: 'Dusk, night and the dark naves of cathedrals had always terrified him, so I was told by Edmond Maître, a friend of his youth.'[56] Such associations must have been relevant to Monet's choice of this theme for one of his most important series.

The current popularity of the theme with writers must also have played a part, but in this context the most relevant parallel was probably not a strictly Symbolist one, but a novel by Monet's old associate Zola. In most of his later novels Zola made an inanimate object into one of the principal 'characters' of the plot, such as the mine in *Germinal*, the train in *La Bête humaine*; in *Le Rêve*, published in 1888, this role is played by a cathedral, whose presence and power dominate the life of the heroine Angélique. In places Zola described the cathedral in terms that could equally well describe Monet's paintings: 'The sun brought it to life, with its moving play of light, from the morning, which rejuvenated it with a luminous gaiety, to the evening which, with its slowly lengthening shadows, bathed it with the unknown.'[57] But the relevance of the book should be seen in more general terms: within a nominally Naturalist framework Zola had used the cathedral to give his novel a spiritual dimension. Though the role of the cathedral in Zola's plot was quite alien to Monet's ideas, the fact that Zola used it all may well have provided Monet with the sanction he needed to make so suggestive a subject the theme for a series in which he was pursuing 'mystery' and 'more serious qualities'.

Whatever the reasons that lay behind them, the Rouen Cathedral series attracted notice as much for their suggestiveness as for their formal values when they were exhibited in 1895. Henri Eon noted their 'new and very curious air of mystery'; it was their mistiness and suggestions of mystery that Camille Pissarro, too, remembered as the dominant characteristic of the series, as he began work on his own very different canvases of Rouen: 'Monet's cathedrals were all executed with a very veiled effect which gave the monument a certain mysterious charm.'[58] Again, it was the *enveloppe* that gave it its mystery. Monet himself may have felt in the long run that the overtones of the cathedral as a theme distracted from the primary purpose of the series, to make the paintings themselves into something more than mere views. Never again did he paint so loaded a subject.

By all accounts Monet was an atheist. In a generalised way, though, he seems to have felt some sort of force in nature; close friends, at least, attributed to him a form of pantheism.[59] The most explicit statement of such ideas was put into Monet's mouth by

Georges Clemenceau: 'I simply direct my efforts towards a maximum of different appearances, in close correlation with the unknown realities. When one is on the plane of concordant appearances, one cannot be far from reality, or at least from what we can know of it.' Doubts about the literal authenticity of this quotation are given substance by the declared aim of Clemenceau's book, to 'bring out the philosophy of Monet's painting', while Clemenceau himself elsewhere emphasised that Monet was not interested in theorising.[60] Indeed, with this one exception the comments attributed to Monet are conspicuous by the absence of such a metaphysical dimension. Monet's disavowal of such interpretations of his work is borne out by Léon Daudet, who knew him best around 1890: 'He was seeking something further, though he denied this with a laugh . . . I hasten to add that Claude Monet was extremely scornful of the baroque judgments made of his canvases and of his unrestrained love for light.' However, Daudet also records a story which reveals the emotional force Monet felt in nature. When he saw van Gogh's *Allée d'iris*, presumably in 1889, Monet asked Mirbeau: 'How could a man who has so loved flowers and light and has rendered them so well, how could he have managed to be so unhappy?'[61]

In 1892 Georges Lecomte summed up the recent changes in Monet's art: 'M. Claude Monet's vigorous talent, which has for a long time limited itself to rendering rapid natural effects in their fleeting intensity, seems more and more to abstract the lasting character of things from their complex appearances, to accentuate their meaning and their decorative beauty by a more synthetic, more considered treatment.[62] As we have seen, Lecomte was determined to distinguish Monet's nature-inspired 'sensation of mystery' from the world of the imagination cherished by the mystical Symbolists; but his comments show how readily Monet's latest work could be assimilated into a particular current of Symbolist thought. From the viewpoint of Kahn's 1886 definition of Symbolism, Monet's process of beginning his canvases from nature, in an effort to capture his *sensations*, firmly placed him in the naturalist camp; he was 'subjectifying the objective (nature seen through a temperament)'. But the extent and nature of his studio revisions by 1890, as he converted his *études* into *tableaux* and transformed a group of separate paintings into an integrated series, involved a process of a quite different kind. In Lecomte's formulation, at least, this search 'to abstract the lasting character of things' would seem to satisfy Kahn's definition of the Symbolist aim, 'to objectify the subjective (the externalisation of the Idea)'; but, for Aurier, Monet's lasting fascination with the light of the sun irrevocably excluded him from the realm of 'ideas' and 'dream'.[63] Our detailed analysis of Monet's working methods and finished paintings has shown how impossible it is to distinguish between open-air and studio work; the process of working up a canvas from lay-in to completion cannot be subdivided into categorically different stages. To talk of a 'Symbolist' approach replacing an 'Impressionist' one is greatly to oversimplify the changes in his art, and ignores the complexity of his methods throughout his career.

The results Monet achieved are an amalgam of his experiences of working from nature with his awareness of what was involved in making a picture. In many ways the Grain Stacks and the later series mark a break with his work of the 1880s – in their subjects, their brushwork, their colour, and the way they were exhibited. But the course Monet's work took in the 1890s depended in an essential way on his experiments of the 1880s. During the 1880s, his self-criticism and the increasing desire he felt to finish his canvases at home, led him to a new concern with the qualities of the painted surface. At the same time he greatly extended the range of his work, pursuing new and extreme types of subject and natural effect, and investigating different ways of achieving pictorial coherence – by carefully worked out colour schemes, by richly patterned brushwork, and by complex compositional patterns. The keynote of these experiments of the 1880s was his use of contrasts – of colour, tone, texture, form and mood. He came to master a very wide pictorial vocabulary, and then, in the Grain Stacks, felt able to apply all that he had learned to a deceptively simple subject. But, by making the endlessly changing atmospheric cloak into the focus of the paintings, he posed himself a problem more taxing than any which he had faced in tackling the extremes of nature in the 1880s.

His concentration on the *enveloppe* was a return to the theme of *Impression, Sunrise* and *Vétheuil in the Fog*. But in an essential way it was different. For those paintings had been quick notations, while the series were worked up over a long period. As he told Robinson in 1892, 'he had quite lost the power of doing a thing at once and letting it go at that – as he did 25 years ago – now he wants to feel that he has time to keep at a thing for a certain space of time'.[64] So, at one and the same time, he returned to the *enveloppe*, the most transitory of subjects, and deliberately began to slow down his working methods. He did this partly in order to satisfy his own high standards, but more specifically to achieve these 'more serious qualities'; these had to emerge from the paintings themselves, and were the product of this process of leisured revision and harmonisation.

By his new methods he found a way of bypassing the standard criticism of the Impressionists – that they neglected finish in the interests of capturing the ephemeral. Monet, from the Grain Stacks onwards, could convey the most ephemeral effects in paintings which he considered fully realised. This involved him with a progressive compromise with his original principles of painting out of doors in front of the subject, as he worked increasingly towards a type of internal pictorial unity, of colour and texture, which amplified and elaborated his original experiences of nature. This in turn led him to a different conception of the status of the work of art in relation to its external subject. Monet's methods, in developing his initial notations of nature into the complex ensembles he exhibited in the 1890s, were his way of achieving this unity, and of transforming nature's fleeting effects into complete and lasting works of art.

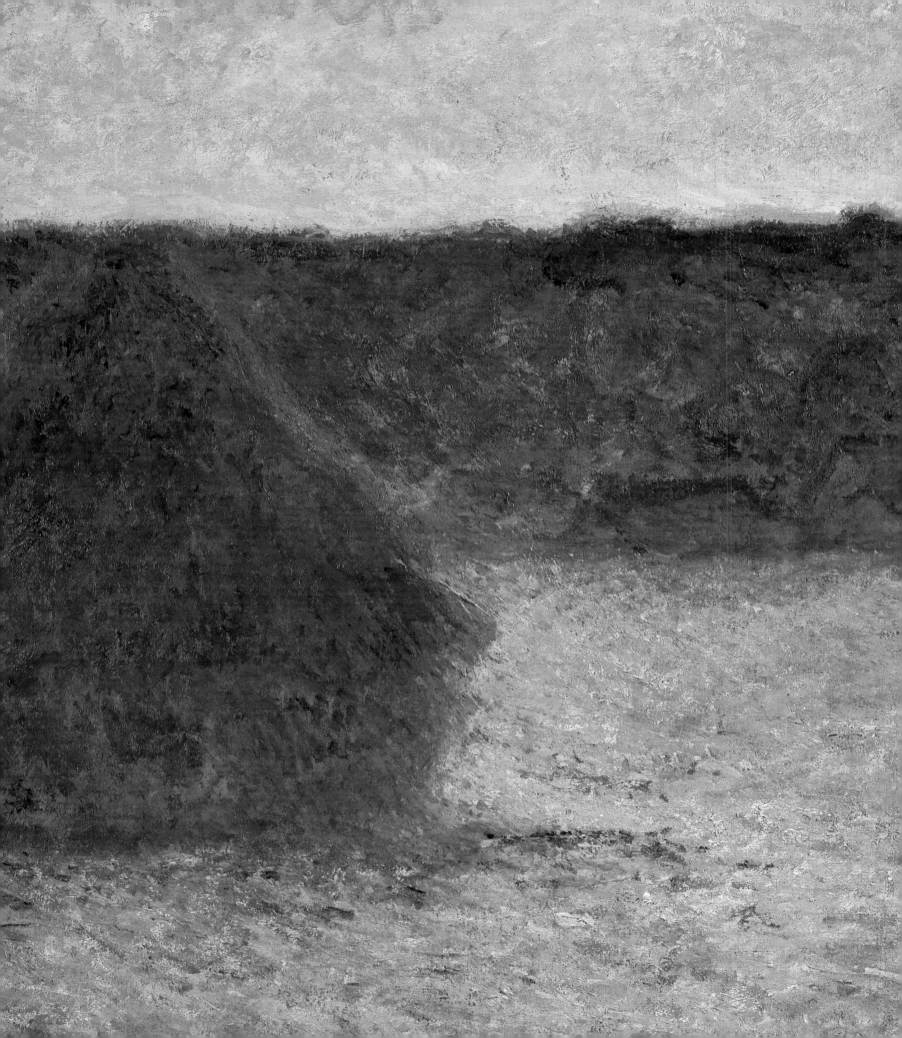

APPENDIX A

MONET'S DRAWINGS

Two completely different types of drawing by Monet survive from his maturity – a small group of copies of his oil paintings, designed for publication, and a considerable number of rough sketches of landscape sites and other possible subjects in sketchbooks, which were in a sense preparatory to his work in oils. These two classes, besides serving quite different purposes, are wholly dissimilar in style. The status of Monet's drawings has never been made clear, both because the aims of the former class of drawings have not been adequately documented, and because the latter group, the sketchbooks, have been little discussed and are largely unpublished.

Monet regarded only the former type of drawing as in any way a finished work of art; all, it seems, were signed. They were attempts to translate into black and white, for reproduction, the effects of a particular oil painting. Monet explained his attitude to drawing to Trévise in 1920: 'Drawing . . . What do you mean by that? Drawings in black on white? Yes, I had to do some like everyone else, when I was young! Since then, some magazines have asked me for sketches of my pictures, but I have never liked to isolate drawing from colour' (Trévise 1927, p. 48). Monet's first drawing for reproduction was a copy of W 51, one of his seascapes exhibited at the 1865 Salon, executed for the 1865 *L'Autographe au Salon*; all the other drawings of this type belong to the period 1880–92, from the moment when magazines again sought to reproduce his work, until the moment when developments in photographic reproduction made such drawings unnecessary. The idea of his doing drawings of this type was raised by Duranty in 1879 (see letter from Caillebotte to Monet, 1879, in Geffroy 1924, II, p. 39), but Monet only undertook such work when asked to supply a drawing for *La Vie moderne*, to accompany his exhibition at the offices of the magazine in June 1880, and then only after an initial protest that he did not have the suitable materials (see letter to Bergerat, April 1880, W letter 176). This drawing, and those he made in 1883 for *La Vie moderne* and the *Gazette des Beaux-Arts*, were designed to be reproduced by the process of *gillotage*, a technique which involved making the initial drawing on grooved paper, and creating highlights by scraping the paper surface (on this, see letter from Pissarro to Lucien, 10 February 1884, in Pissarro 1980, p. 282, and also p. 289, note 2, quoting Adéline 1884, p. 220). To see how photography made such reproductive drawings unnecessary, we must look to the reproductions of Monet's paintings published in Durand-Ruel's short-lived magazine *L'Art dans les deux mondes* in 1891. It published three reproductions of drawings by Monet on 7 March 1891 (accompanying Mirbeau 1891), but while Monet was preparing these, he urged Durand-Ruel to find some automatic method of reproducing his paintings; Durand-Ruel had begun to photograph the paintings in his stock in 1890, and on 11 July 1891 the magazine was able to publish a photographic reproduction of W 540, a painting of Lavacourt of *c.*1880 (see letters to Durand-Ruel, 3, 21 December 1890 and 4 January 1891, W letters 1082, 1088, 1093).

The following list includes all Monet's published reproductive drawings:

L'Autographe au Salon, 1865, drawing after W 51, repr. Werth 1928, pl. 61.

La Vie moderne, 19 June 1880, *Landscape*, drawing after pl. 68 (W 94), repr. Isaacson 1978, fig. 18, on 'papier Gillot', for *gillotage* (the drawing is of 1880, although the painting reproduced is of 1867).

La Vie moderne, 17 March 1883, *A Windmill at Zaandam*, drawing of 1883 after W 177 of 1871, for *gillotage*.

Gazette des Beaux-Arts, April 1883 (accompanying Lostalot 1883), p. 344, *View of Rouen*, pl. 274, drawing after W 217 of *c.*1872; p. 347, *Varengeville Church, at*

Sunset, drawing after W 726 of 1882; both drawings of 1883, subtitled 'drawing by the artist after his painting', both for *gillotage*.

L'Art dans les deux mondes, 7 March 1891 (accompanying Mirbeau 1891), p. 181, drawing, repr. Seitz, *Monet*, 1960, fig. 82, after *The Rocks of Belle-Isle* (W 1100); p. 183, drawing, repr. Seitz, *Monet*, 1960, fig. 84, after *Grain Stacks* (W 1267); p. 184, drawing, pl. 275, after *Woman with a Parasol* (pl. 38, W 1077).

Hamerton 1892, p. 25, repr. from *The Portfolio*, 1891, *A Coastguardman's Hut*, after W 742 of 1882; the drawing on p. 24, *A Village by the Seine*, is unsigned and does not seem to be by Monet; it reproduces W 540, the view of Lavacourt photographically reproduced in *L'Art dans les deux mondes* on 11 July 1891, and this drawing may have been made from that source.

Theodore Robinson hoped that drawings by Monet would be reproduced in his article on the artist in *Century Magazine*, September 1892, and presumably sent some to the United States for this purpose; he wrote in his Diary on 8 September: 'They have not used one of Monet's sketches – much to my disgust.' These may well have been the same drawings as those published in *L'Art dans les deux mondes* in March 1891. Two drawings not published at the time were presumably executed for one of the above-mentioned publications: *Fishing at Poissy* (repr. Seitz, *Monet*, 1960, fig. 78, after W 749 of 1882) was presumably made in 1883 for *La Vie moderne* or the *Gazette des Beaux-Arts*, since it is on Gillot paper; the other (repr. Seitz 1960, fig. 79) reproduces W 734, another 1882 painting of the Coastguard's cottage, and was probably made for *L'Art dans les deux mondes* in 1891, since it is very like those published there, and Monet mentioned having done four for the magazine, although only three were published (letter to Durand-Ruel, 17 July 1891, W letter 1118).

The drawings that Monet executed for publication were meant to translate in

274. *View of Rouen*, 1883, drawing on papier Gillot, after W 217, 31 × 47, Sterling and Francine Clark Art Institute, Williamstown, Mass.

black and white the effect of completed oil paintings. They suggest complex effects of lighting and textures, and evoke the gestures of the brush by vigorous graphic strokes of charcoal or crayon, designed to echo, in rough and in miniature, the copied painting; free linear contours play some part in them, but their effect is achieved primarily by the massing of gradated tonal values, standing for the coloured nuances of the painting. Though they often succeed well in this aim, they have no independent status in Monet's creative process, and were simply the result of the demands of their prospective publishers. Indeed, Monet was willing to sanction graphic copies of his paintings even when he had not drawn them himself; around 1890 he signed every copy of each lithograph in the limited edition of twenty-five copies of W. Thornley's *20 Lithographies d'après Claude Monet*; the effects obtained in Thornley's lithographs are not unlike those in Monet's own drawings for *L'Art dans les deux mondes* in 1891.

Only once did he undertake to execute an independent drawing for publication; this was his projected illustration to Mallarmé's prose poem *Plainte d'automne* in 1888–9 (on this project, see also above, p. 39 and note 105 there). Monet finally renounced his promise on 12 October 1889, telling Mallarmé: 'I feel myself incapable of doing anything worthwhile for you; perhaps I have too much *amour propre*, but truly, as soon as I try to do the slightest thing with crayons, the result is absurd and without interest, and therefore unworthy to accompany your exquisite poems' (letter to Mallarmé, 12 October 1889, W letter 1007).

In the early and later parts of his career, Monet did produce a number of groups of pastels which he regarded as complete works in their own right. We have virtually no evidence about the early ones, but Monet regarded them as sufficiently important (or perhaps sufficiently saleable) to include seven in the first group exhibition of 1874. These have not been firmly identified, and most of the surviving early pastels – mainly seascapes, with the occasional river scene – seem likely to date from the later 1860s, rather than the early 1870s (for good colour reproductions of two, see Boston, Museum of Fine Arts, 1977, nos. 3–4). They focus on nuances of light and colour in sky and sea, and bear a clear general relationship with Boudin's notations of weather effects on the Channel (on which, see above, p. 135). After this period, Monet seems not to have used pastel (with only very rare exceptions, see p. 229) until a short spell in London in January–February 1901. He began to do pastels of Waterloo Bridge from his balcony in the Savoy Hotel because his cases of paintings had not arrived, and quickly found that they 'much amused' him, and might prove useful. The medium well suited his attempts to capture atmospheric nuances because it could be applied so much more quickly than oils: 'It is thanks to my pastels, executed rapidly, that I've been able to see how to do it' (letters to Alice Monet, 26–8 January and 1 February 1901, W letters 1588–92). However, there is no evidence that he continued to use pastel after this date. Monet never worked in watercolour in his maturity; he wrote in 1924 that he had never used the medium, when declaring that a watercolour version of one of

276. Marmottan Sketchbook inv. no. 5128, p. 1, drawing of two women at a window, ?c.1865, 26 × 34, Musée Marmottan, Paris

his canvases was not from his hand (letter to unknown correspondent, 5 September 1924, W letter 2574; despite this, the watercolour entered the von Hirsch collection, and is reproduced in Seitz, *Monet*, 1960, fig. 76). However, in another late letter he admitted that he had used watercolour during his military service in Algeria (1861–2): 'At that period I considered watercolour an excellent and rapid means of rendering the "instantaneity" of light' (letter to Geffroy, 8 May 1920, W letter 2348). One of his Algerian watercolours is reproduced in Seitz, *Monet*, 1960, fig. 72. Pastel and watercolour, using colour, can more appropriately be classed with painting than drawing, but neither played a significant part in his work.

The other class of works that Monet executed in black and white served a quite different function from his drawings for reproduction; these were his rapid pencil sketches executed in notebooks as preliminary notations of possible sites or compositions for paintings. Eight sketchbooks survive at the Musée Marmottan, Paris; a ninth including drawings from the late 1850s existed, but its present whereabouts are unknown (see Isaacson 1978, figs. 1, 5; Seitz, *Monet*, 1960, figs. 66–8). This ninth book included his first, very derivative, landscape studies, dating from the late 1850s, and contemporary with the caricature drawings of local figures with which Monet won a precocious reputation in Le Havre. The eight books at the Musée Marmottan span Monet's career from c.1865 until the 1920s. Since there are no marked gaps in the sequence, they may well have been the only such books he used during this period. Pages have been removed from several of them, and some or all of the detached drawings which survive doubtless came from these books (e.g. pl. 280, given by Monet to Theodore Robinson, and inscribed 'Leaf from Monet's sk.book'; many of the missing sheets may have been removed by Michel Monet after Monet's death).

The drawings in these books throw considerable light on Monet's processes of visualising his subjects; since they have been little discussed, a brief indication of their contents is necessary, in order to assess their likely functions. They are listed below in order of the earliest drawing to be found in each, though Monet reused some old books around 1920, and on occasion seems to have had two in use concurrently. It is sometimes difficult to establish the starting date of a book, because Monet seems to have chosen at random the pages he used, rather than working consecutively through a book, and at times used the reverse sides of sheets at the same time as the facing page, but at other times seems to have worked in an approximate reverse sequence, starting from the back. The listing here indicates the range of contents of each book, without itemising the drawings on each page; where page numbers are quoted they are the numbers inscribed on the pages. The books in their entirety are to be published in a later volume of W. Sizes given are approximate.

275. *Woman with a Parasol*, 1891, drawing after pl. 38, 53.5 × 41, Whereabouts unknown

(1) Inventory no. 5128; 26 × 34 cm, begun *c*.1865. Women at a window looking out over houses and the sea (pl. 276; p. 1); study for composition of *Déjeuner sur l'herbe* (p. 2, presumably of 1865; on this, see Isaacson 1972, p. 24 and note 18); the placing of the drawing on p. 1, very similar in style to the *Déjeuner* study, suggests that it is close to it in date, but perhaps predates it; p. 1 is an interesting comparison with Whistler's *The Balcony*, largely painted in 1865; various drawings of coastal scenes,

277. (middle) Marmottan Sketchbook inv. no. 5130, p. 7, drawing of the view downstream from the Argenteuil road-bridge, c.1874, 24.5 × 31.5, Musée Marmottan, Paris

279. Marmottan Sketchbook inv. no. 5129, p. 9 recto, drawing related to *The Boat* (pl. 50), with indication of figure, and superimposed drawing of Lily pads?, c.1890 and ? c.1920, 23.5 × 31.5, Musée Marmottan, Paris

278. (right) Marmottan Sketchbook inv. no. 5131, p. 25 recto, drawing of the Porte d'Aval, Etretat, c.1883, 11.5 × 19.5, Musée Marmottan, Paris

including Etretat and probably Fécamp, perhaps all of c.1868/9 (the drawing of Fécamp reproduced in Seitz 1960, fig. 75, may well have belonged with these; many pages in this book have been torn out); four Dutch scenes of canals and windmills, presumably from Zaandam in 1871 (one repr. Tucker 1982, pl. 34; the presence of Dutch subjects suggests that the book also accompanied Monet to London in 1870–1); one drawing of the Gare Saint-Lazare (p. 23 verso; this is most like pl. 119 of the paintings of the station, but dissimilar in many details; it is treated in crisp strokes of hard pencil, unlike the drawings of the station in Inv. no. 5130); a group of drawings of children reading and drawing, possibly of c.1878/80; many rough notations of iris and lily pads, of c.1914 or later.

(2) Inventory no. 5130; 24.5 × 31.5 cm, c.1874–80 only. Miscellaneous drawings of the river and its banks at Argenteuil (e.g. pl. 277), some with more prominent figures than in Monet's contemporary river paintings (e.g. pp. 1, 9; p. 9 repr. Tucker 1982, pl. 85; p. 8 repr. Isaacson 1978, pl. 43); five drawings of the Gare Saint-Lazare (free outline sketches in soft pencil, very unlike the drawing of the station in Inv. no. 5128); two, pl. 277 (p. 7) and p. 14, have a vertical line drawn down them a short way in from their margins, presumably to help Monet visualise alternative points at which to frame the scene; some, but not all, subjects very similar to paintings; p. 11, repr. Isaacson 1978, pl. 56, is close, but not identical in viewpoint, to *The Signal*, pl. 266 here; two views of Vétheuil and Lavacourt (one similar to a painting, W 580, the other not); many pages torn out, many blank.

(3) Inventory no. 5131; 11.5 × 19.5 cm, begun in 1881 or 1882, probably not used after 1883/4. Many coastal motifs, principally from the area around Dieppe (1882, one repr. Isaacson 1978, pl. 79), and from Etretat (probably from Monet's visit of 1883, including pl. 278; another repr. Isaacson 1978, pl. 77); other coastal subjects might derive from Monet's spells on the Channel coast in 1881 or 1883; also river scenes, probably of the Giverny area, and perhaps done soon after his arrival there in 1883. Some drawings have more than one alternative margin lines drawn down them (e.g. pl. 278, p. 25 recto), and others treat one and the same motif in different formats; many of the subjects included were not painted in oils.

(4) Inventory no. 5132; 11.5 × 19.5 cm, begun in 1883/4, probably not used after 1885/6, except p. 30, an isolated highly coloured pastel of Antibes (1888), almost

certainly a copy after pl. 207 (in medium and technique this is entirely unlike anything else in the sketchbooks); drawings of Bordighera (1884), and of Rouen seen from the river; the village of Giverny (these seem to be an attempt to come to terms with the place pictorially, but very few of the motifs here were treated in paintings); the fact that the Bordighera drawings come first here may suggest that it was started early in 1884; Monet's only recorded stay at Rouen in this period was in 1883, but he may well have stopped there in 1884–5; also miscellaneous drawings of ducks and turkeys.

(5) Inventory no. 5129; 23.5 × 31.5 cm, possibly begun in 1887, or at least by 1888. Several drawings of girls in boats (some correspond quite closely to paintings, e.g. to pl. 191, but others are quite different in composition; three show versions of pl. 50, *The Boat*, one in a vertical format (pl. 279), two horizontal, and all three with figures lightly indicated, which shows that Monet planned to add figures to the painting; pl. 280, the drawing Monet gave Robinson, presumably came from this book and was later somewhat trimmed; miscellaneous subjects of landscape and village at Giverny; several drawings related to the Poplars series; one Antibes subject (1888) and a few probably from the Creuse (1889); many pages (e.g. pl. 281) have roughly drawn lily pads added across other drawings. The Poplars drawings (e.g. pl. 281) show Monet thoroughly exploring possible alternative formats and groupings for the trees, trying out the compositions of pls. 137 and 209 in both vertical and horizontal formats. One of the drawings of the Giverny area shows the

280. *The Blue Boat*, c.1887, drawing, 21.5 × 26, study for pl. 191, sold Christie's, London, 2 July 1974, lot 14

281. Marmottan
Sketchbook inv.no.
5129, pp. 10 verso
and 11 recto, both
sheets with drawings
of poplars, in faint
pencil, upside down
on left sheet, with
superimposed
drawing of lily pads,
c.1891 and ? c.1920,
each 23.5 × 31.5,
Musée Marmottan,
Paris

church of Bennecourt with precisely the same disposition of light and shade as in two oils (W 989–90; the presence of this drawing in this book suggests that the paintings were painted c.1888/90, not 1885 as W proposes), and the inscription 'Midi à 1 hre extraordinaire de gris lumineux'; this is one of the very rare occasions when Monet recorded a specific effect of light in a sketchbook, which he then made into the subject of a painting. Dating of the book is complicated by the presence in it of Poplars (summer–autumn 1891), but no Grain Stacks, when the next book, Inv. no. 5134, included Grain Stacks (1890–early 1891), but no Poplars.

(6) Inventory no. 5134; 11.5 × 19.5 cm, begun 1890, with grain stacks, or possibly 1892, with Rouen. Various motifs of Rouen, both river and cathedral (those of the cathedral view the building from several angles besides the view from south-west which Monet painted, and those of this view try out different ways of cutting off the composition); various groupings of grain stacks; miscellaneous riverbanks and seacoasts, including the Seine near Giverny, and the coast at Pourville (?1896); two simple silhouettes of the Mont Saint-Michel (pp. 37 verso, 38 verso), and a single silhouette of the Houses of Parliament in London, seen from the Savoy Hotel (p. 18 verso). This London drawing, in a book in which all the other subjects seem to date from c.1896/7 or before, raises the possibility that Monet had discovered this subject – identical in viewpoint to his series of Charing Cross Bridge – before he began to paint from the Savoy Hotel in 1899. It seems likely that the grain stacks here are of the same date as the series of 1890–1, since their positions are similar to those in the paintings; the presence of the drawings related to the later Poplars series in the earlier book, Inv. no. 5129, may suggest that he returned to the larger format of the earlier book in order to work out the more complex lines of the Poplars compositions; it seems unlikely, though conceivable, that the grain stacks here are a later return to the theme (their placing after the Rouen drawings in the book might suggest this). The Mont Saint-Michel silhouettes may derive from a visit to Brittany of 1893; Mont Saint-Michel was on the list published by Geffroy in 1891 of places Monet hoped to paint (repr. Geffroy 1892, p. 23), and these drawings are the only indication that Monet went any of the way towards realising this ambition.

(7) Inventory no. 5133; 11.5 × 19.5 cm, Norway 1895. All of Norwegian subjects, some painted, some not.

(8) Inventory no.5135; 9 × 14.5 cm, Venice 1908, with supplier's label: Emilio Aickelin, Via 22 Marzo. One solitary drawing of a Venetian palace.

In technique, the drawings in the Musée Marmottan sketchbooks are quite unlike those Monet executed for reproduction during the same years. They do not suggest the textures of natural forms – foliage, water, and so on – nor, in general, do they record specific effects of lighting; instead, they render the placing of forms in very fluent and free outline. Darker zones may be suggested by the repetition of lines, but this is done to give each element the desired weight in the composition, and not to describe the textures of objects. Monet stressed the importance of this sort of drawing in an interview in 1920, describing how he would instruct a young artist: 'You must begin by drawing . . . Draw simply and directly, with charcoal, crayon or whatever, above all observing the contours, because you can never be too sure of holding on to them, once you start to paint' (Trévise 1927, pp. 48–9).

Some of the drawings do record precise viewpoints that Monet painted, but, perhaps more often, the subjects he drew were never treated in oils, or were only painted from a different angle. This shows that the drawings served as preliminary notations of possible motifs, and of possible ways of setting particular subjects

within a rectangular format. Monet presumably took a sketchbook with him on his preliminary walks prospecting for sites in each place he visited (see above, Chapter 2, pp. 22–3), and used the drawings to help visualise the pictorial possibilities offered by various sites. The alternative vertical edges drawn over some of them reveal his care in establishing the margins and the balance of masses in his compositions (see Chapter 3 passim).

The nature of the drawings, and the fact that many of them correspond to no painting, show that they were not studies, in the traditional sense, for individual pictures. Rarely, if ever, can they have been used during the execution of a painting; they served as notations of possible themes which Monet might then choose to treat in oils. Once he fixed on the viewpoint for a painting, the drawings would have no further use; the drawings, exclusively concerned with the disposition of forms within the format, would have been irrelevant to the qualities that Monet emphasised increasingly as he worked up his paintings – the nuances of coloured brushwork which form the physical fabric of his finished works. Moreover, the very small number of drawings which he made at certain sites (e.g. Antibes, the Creuse) shows that they were not indispensable to him in conceiving his landscapes, and that, particularly from the late 1880s onwards, he could normally visualise a motif for a painting without any preliminary jotting. The drawings seem to have been most relevant when he was investigating new types of scenery, and playing with possible viewpoints and configurations of forms; the seeming absence of any drawings from Belle-Isle (1886) may have two causes: first, that his experience in recent years of working on the Channel coast made it easier to visualise possible subjects there; and second, that the island's structure – granite crags below a flat plateau – much limited his potential viewpoints. At Argenteuil and Vétheuil, too, he made only very sporadic use of drawings in formulating subjects from the familiar scenery of the Seine valley.

Only two groups of drawings may have related more closely to the creation of the related canvas – those in Inv. no. 5129 of poplars and of girls in boats. The boat drawings must have helped Monet decide how to pose his models for the paintings, though, once they had posed again, the drawings would have had no further function. The drawings of poplars show how carefully the forms of these subjects were worked out; again, he must have worked up the paintings from nature, but the drawings confirm what the pentimenti in pl. 214 and 232 suggest – that Monet felt free to rearrange the positions of his tree trunks, to suit his desired composition (see pp. 174, 185–7).

Two canvases from the 1880s survive which Monet abandoned after making only a preliminary notation of their subject in charcoal; both are portraits of his and Alice Hoschedé's children (e.g. repr. Seitz, *Monet*, 1960, fig. 80). By having this preliminary drawn framework, they are wholly contrary to Monet's procedures in his landscapes at this period, where preparatory drawing is wholly absent (see above, p. 66); nor has any underdrawing been traced beneath his other figure paintings of the period – the girls in boats, for example. These two drawn but unpainted canvases may well have been an isolated experiment.

The drawings in Monet's sketchbooks belong to the first stage of his creative process – the discovery of potential motifs, and their visualisation in pictorial forms. They show his concern for format and *mise en page*, and for the pattern of forms on the canvas (see Chapter 3), but they are wholly unrelated to the qualities of surface, light and colour which emerged as he worked up his oil paintings. By contrast, it was just these surface qualities which the other type of drawing, those made for publication, sought to recreate in black and white.

APPENDIX B

OUTLINE CHRONOLOGY

1840	Oct: Born in Paris, son of a wholesale grocer.
*c.*1845	Monet's family move to Le Havre, on the estuary of the river Seine.
*c.*1855	By now, Monet is gaining a reputation in Le Havre for his caricatures of local figures.
*c.*1856	Boudin, a landscape painter working locally, introduces him to open-air painting.
1859–60	First visit to Paris; meets Troyon and other painters in the Realist circle; meets Pissarro.
1861–2	Military service; visits Algeria with the Chasseurs d'Afrique.
1862	Autumn: Meets Jongkind on the Normandy coast; enters the studio of Gleyre in Paris, where he probably stays until spring 1864; there he meets Bazille, Renoir and Sisley.
?1863	Summer: First trip to the Forest of Fontainebleau.
1864	Painting in the Forest of Fontainebleau and on the Channel coast, around Le Havre and Honfleur.
1865	Spring: Two seascapes accepted at the Paris Salon.
	Summer: Painting in the Forest of Fontainebleau; begins his project for a vast *Déjeuner sur l'herbe*.
1866	Spring: Fails to complete his *Déjeuner sur l'herbe* for the Salon; *Camille* (a life-size figure) and a landscape are accepted at the Salon.
	Summer: Working outdoors at Ville d'Avray on *Women in the Garden*; later, staying at Le Havre.
1867	Spring: *Women in the Garden* refused at the Salon.
	Aug: Monet's son Jean born to Camille Doncieux in Paris; financial difficulties force him to stay with his family in Le Havre.
1868	Spring: One seascape accepted, one rejected at the Salon.
	Oct: Gains silver medal at an exhibition in Le Havre.
	Winter: Living with Camille and Jean at Etretat.
1869	Spring: Submissions rejected at Salon.
	Summer–winter: Living and working around Bougival; on occasion both Renoir and Pissarro work with him.
1870	Spring: Submissions rejected at Salon.
	Summer: Marries Camille Doncieux; they are on honeymoon at Trouville at outbreak of Franco–Prussian War in July.
	Autumn: takes refuge with Camille in London.
	Winter: Meets Pissarro and the dealer Durand-Ruel in London.
1871	Spring: Work rejected at the Royal Academy in London.
	Summer: Leaves London for Holland; paints at Zaandam, near Amsterdam.
	Winter: Returns to Paris; settles at Argenteuil, which is his main base until early 1878.
1872–3	Durand-Ruel buys many paintings from Monet; purchases cease in 1874.
*c.*1872/5	Paints on occasion on the Normandy coast, and pays a visit to Amsterdam, but mainly working at Argenteuil.
1874	Spring: Exhibits in first exhibition of *Société anonyme . . .*; the title of his *Impression, Sunrise* leads to the group being christened Impressionists.
1875	Mar: With Morisot, Renoir and Sisley, mounts auction of their paintings in Paris, which gains very low prices.
1876	Spring: Exhibits in the second group exhibition.

	Autumn–winter? At Montgeron, painting decorations for the financier Hoschedé.
1877	Early: Working in Paris on paintings of the Gare Saint-Lazare.
	Spring: Exhibits in the third group exhibition.
1878	Jan: Leaves Argenteuil, moves to Paris.
	Mar: Birth of Monet's second son, Michel.
	Aug: Monet and his family move to Vétheuil with the family of Hoschedé, who is bankrupt.
1879	Spring: Exhibits in fourth group exhibition.
	Sept: Death of Monet's wife Camille.
	Winter: Painting frozen river Seine at Vétheuil.
1880	Spring: One painting accepted, one rejected at the Salon; does not show at the fifth group exhibition.
	June: One-man show at offices of *La Vie moderne*, a weekly magazine run by the publisher Charpentier.
	Sept: Working on Normandy coast at Petites-Dalles.
1881	Feb: Durand-Ruel resumes regular purchases of Monet's work.
	Mar–Apr: Painting on coast at Fécamp.
	Spring: Does not show at the sixth group exhibition.
	Aug–Sept: Painting on coast, probably around Trouville.
	Dec: Moves from Vétheuil to Poissy, with Alice Hoschedé and her children.
1882	Feb–Apr: Painting on coast, around Pourville to west of Dieppe.
	Spring: Exhibits at seventh group exhibition, organised by Durand-Ruel.
	June–Oct: Again painting at Pourville.
1883	Jan–Feb: Painting at Etretat on the Normandy coast.
	Mar: One-man show at gallery of Durand-Ruel.
	Apr: Moves house from Poissy to Giverny.
	Summer: First paintings of Giverny region concentrate on views of the Seine.
1884	Jan–Apr: Painting on Mediterranean coast, at Bordighera, then briefly at Menton.
1885	May: Exhibits in Georges Petit's fourth *exposition internationale*.
	Sept–Dec: Painting at Etretat.
1886	Feb–Mar: Painting at Etretat.
	Apr–May: Two weeks painting tulip fields near The Hague in Holland.
	May: Exhibits in Petit's fifth *exposition internationale*, but not in the eighth and last Impressionist group exhibition.
	Sept–Nov: Painting on Belle-Isle, a rocky island off the south-west coast of Brittany.
1887	Apr: Makes first sales to Boussod & Valadon, through their branch manager Theo van Gogh.
	May: Exhibits in Petit's sixth *exposition internationale*.
1888	Jan–Apr: Painting at Antibes on Mediterranean coast.
	June: Ten Antibes paintings exhibited at Boussod & Valadon.
	July: Refuses Légion d'Honneur.
1889	Feb: One-man show at Boussod & Valadon.
	Mar–May: Painting at Fresselines on River Creuse in Massif Central.

June–July: Major retrospective exhibition at Georges Petit's gallery, which encourages sales of his work.

Autumn: Begins to organise subscription to buy Manet's *Olympia* for the State.

1890 Autumn: Begins work on series of Grain Stacks, continued through winter 1890–1.

Nov: Purchases house at Giverny.

1891 May: One-man exhibition at Durand-Ruel's gallery, includes fifteen paintings of Grain Stacks.

Summer–autumn: Paints series of Poplars.

1892 Feb: Exhibition of Poplars at Durand-Ruel's gallery.

Feb–Apr: Painting Rouen Cathedral.

July: Marries Alice Hoschedé.

1893 Feb–Apr: Painting Rouen Cathedral.

Summer: Begins construction of water garden at Giverny.

1895 Jan–Apr: Painting in Norway.

May: Exhibition at Durand-Ruel's gallery includes twenty paintings of Rouen Cathedral.

1896 Feb–Apr: Painting on Normandy coast at Pourville, near Dieppe.

Summer: Begins series of Early Mornings on the Seine.

1897 Jan–Apr: Painting at Pourville.

Summer: Continues Early Mornings on the Seine.

1898 June: Exhibition at Petit's gallery includes series of Pourville and Early Mornings on the Seine.

1899 Summer: Begins first series of his water garden, with the footbridge.

Sept–Oct: Painting in London, from the Savoy Hotel.

1900 Feb–Apr: Painting in London.

Nov: Exhibition at Durand-Ruel's gallery includes first series of water garden.

1901 Feb–Apr: Painting in London.

1901–2 Considerable alterations and enlargements to water garden.

1903 Summer: Begins second series of water garden, which continues until 1908.

1904 May: Exhibition of London series at Durand-Ruel's gallery.

Oct: Visits Madrid to see the work of Velásquez.

1908 Sept–Dec: Painting in Venice.

1909 May: Exhibition of forty-eight of the water garden, at Durand-Ruel's gallery.

1911 May: Death of Alice Monet.

1912 May: Exhibition of Venice paintings at the Bernheim Jeune gallery.

Summer: Cataracts in both eyes diagnosed; these slowly worsen over the next decade.

1914 Aug: Begins construction of new studio in his garden for execution of monumental Water Lily Decorations.

1916 New studio finished.

1917 Abortive project to paint war-damaged Rheims Cathedral, at invitation of the State.

1918 First plans to present Water Lily Decorations to the State.

1920 Negotiations with the State about proposed donation of Decorations; plans to instal them in the grounds of the Hôtel Biron (Musée Rodin).

1922 Apr: Decorations presented to the State, for installation in the Orangerie.

1923 Feb: Operation on cataract in one eye partly successful.

1923–6 Reworking Decorations when health and sight permit.

1926 Dec: Dies at Giverny.

NOTES TO THE TEXT

A perfect work should require no notes.

Delacroix, *Journal*, 1854, quoting Mérimée

REFERENCES in the notes are generally given in an abbreviated form. Books and articles are referred to by author and date (e.g. Trévise 1927), exhibition catalogues by location and date (e.g. Paris, Grand Palais, 1980), with extra indications in cases of possible ambiguity; full references will be found in the bibliography. The only works cited in full in the notes are those that establish a particular point but have no more general relevance to the study of Monet.

Where a number of references follow each other in quick succession in the text, their sources may be given in a single footnote.

Abbreviation: W refers to D. Wildenstein, *Claude Monet: Biographie et catalogue raisonné*, Lausanne and Paris, I (1840–1881), 1974; II (1882–1886) and III (1887–1898), 1979; IV (1899–1926), 1985. 'W 796' refers to the painting numbered 796 in the relevant volume of W; 'W letter 796' refers to the letter numbered 796 in the compilation of Monet's letters at the end of the relevant volume of W.

Monet's letters, even when first published elsewhere, are cited for convenience as they appear in W; all letters quoted were written by Monet, unless otherwise stated.

NOTES TO CHAPTER I

1. By far the most detailed account of Monet's life and career is in W; its aims are exclusively biographical. In the present chapter, source references will not be given for basic biographical information, but only for points where reference to specific information is needed, and where other sources supplement the information in W. For the activities of the Impressionist group up to 1886, Rewald 1973 remains indispensable. For Monet's wayward behaviour, see W I, pp. 23–4 and note 127 (letter from Marie-Jeanne Lecadre to Amand Gautier, 20 March 1863), p. 37 and note 260 (letter from Adolphe Monet to Bazille, 11 April 1867); for his allowance being withheld in 1869, see W I, p. 42 and note 318 (letter from Boudin to Martin, 25 April 1869).

2. Details of Monet's relations with the Hoschedés, based on Hoschedé family documents, are in W; see also H. Adhémar, 'Ernest Hoschedé', in Rewald and Weitzenhoffer 1984, and Paris, Grand Palais, 1980, pp. 169–83.

3. A scurrilous anonymous article in January 1880 ([Anon.], *Le Gaulois*, 1880) described his defection from the Impressionist group and hinted at his unusual relationship with the Hoschedés; see also W I, pp. 107–8.

4. For the proposed date *c.*1856 for his meeting with Boudin, rather than after 1858 as stated in W I, p. 5, see House, 'Catalogue', 1978, p. 678–9; this is supported by letter to Geffroy, 8 May 1920, W letter 2348.

5. For this group, see Northampton, Smith College Museum of Art, 1976; for Monet's contracts with them, see also Jean-Aubry 1922.

6. Bazille's studio interiors are Daulte 1952, nos. 16 and 21 (Chicago, Art Institute, 1978, nos. 18, 23); Renoir's portrait is Daulte 1971, no. 28 (London, Arts Council, 1985, no. 6). For the results of Monet's café gossip with Courbet, see W I, p. 35 and letter 27; in an unpublished letter to Courbet of 19 June 1866 (MS Institut Néerlandais, Fondation Custodia, Paris), Monet wrote in a tone of flattering intimacy from Ville d'Avray to plead with Courbet to lend him some money: 'my family won't give me anything and right now I have absolutely no money, not even enough to stamp this letter. Forgive me. You who know, my dear friend, what it is to be a painter, you can understand my predicament better than anyone.'

7. In Bazille's 1870 picture, Monet has variously been identified as the man on the stairs and as the left-hand standing figure. Zola's 1868 Salon review shows that he was already friendly with Monet (reprinted in Zola 1970, pp. 152–5); Astruc seems to have visited Monet at Ville d'Avray in 1866 (see here, p. 147, and La Farge and Jaccaci 1907, p. 341). For the Café Guerbois, see especially Crouzet 1964, pp. 239ff.

8. W letter 44.

9. These problems arise particularly in Rewald, *Impressionism*, 1973, and also, for instance, in Champa 1973.

10. [Anon.], *Le Gaulois*, 1880 (see note 3 above); Taboureux 1880, p. 380.

11. On calling each other *tu*, see Hoschedé 1960, I, p. 119 note; on nature and art, see here, pp. 38, 156; for their disagreement over Renoir's acceptance of the Légion d'Honneur in 1900, see Geffroy 1924, pp. 25–6, and W letter 1565, in which Monet told Geffroy why he regretted Renoir's decision; for Monet's support of Dreyfus and of Zola's campaign for him, see W III, pp. 80–3. Monet showed his feelings about Renoir most clearly in a letter to the *Bulletin de la vie artistique* (1 January 1920, p. 87) after his death: 'You can imagine my sorrow at Renoir's death; he carries with him a part of my life. For the last three days I have been constantly reliving our youthful years of struggles and hopes' (W letter 2329).

12. For the 1882 exhibition, see letters to Durand-Ruel, 23 and 24 February 1882, W letters 249–50; for Pissarro's propaganda about Neo-Impressionism, see letters from Pissarro to Lucien, 7 and 9 January 1887, in Pissarro 1950, pp. 123–4; for Monet's reactions to this, see Tabarant 1924, p. 52 (Monet was angry and threatened to break off relations), and Elder 1924, p. 68 ('he ceaselessly spoke up for its advantages, but I did not take the bait'); for Monet's friendship for Pissarro in 1891, see letter to Pissarro, 7 February 1891, W letter 1099; Monet lent Pissarro money in 1892 to help him to buy his house, and after Pissarro's death greatly helped his widow and family (see Meadmore 1962, pp. 100ff).

13. Caillebotte used to sail down the Seine from his home near Argenteuil to see Monet at Giverny, see Tabarant 1921, p. 406, and W letters 508, 570 (trips of 1884 and 1885); on flowers, and Caillebotte's advice to Monet about his garden, see Hoschedé 1960, I, p. 162, and Gwynn 1934, p. 43.

14. See letter from Sisley to Monet, 31 August 1881, describing facilities at Moret, in Paris, Braun, 1933, p. 7.

15. For the 1883 visit, see letter from Cézanne to Zola, 23 February 1884, in Cézanne 1978, p. 214; for Cézanne's 1894 visit, see W III, pp. 59–60, and Philadelphia Museum of Art, 1983, pp. 38–9, which reproduces the register of the Hôtel Baudy, Giverny (the correct dates of the visit, though, should be read as 7 to 30 November [9bre] 1894); the suggestion that Cézanne visited Giverny in 1885 is based on a story that Monet told Elder (Elder 1924, pp. 47–8) of Cézanne visiting Zola at Médan from Giverny, and returning upstaged by Zola's friend Busnach; the most likely occasion for such a visit would have been at the time of Cézanne's spell at La Roche-Guyon and Vernon in 1885 (see Cézanne 1978, pp. 218–22); for Cézanne's admiration of Monet, see Geffroy 1924, II, p. 68, Pissarro 1950, p. 381 (in 1895), and E. Bernard, *Souvenirs sur Paul Cézanne*, 1924, p. 38; for Monet's admiration of Cézanne, see Vollard 1937, p. 178, Pissarro 1950, p. 390 (in 1895), and Vauxcelles 1905, p. 89.

16. Charteris 1927, pp. 69, 130; Hoopes 1966; Sargent's paintings of Monet are the clearest evidence of his visits to Giverny; the painting of Monet in his studio with W 891 behind him can probably be dated *c.*1885 (repr. W II, p. 31); Robert Herbert has suggested that *Claude Monet painting at the Edge of a Wood* (pl. 9) shows Monet at work on *Meadow with Haystacks at Giverny* of 1885 (pl. 132) – again suggesting an 1885 visit; Sargent's canvas of Monet at work on his studio boat (pl. 173) probably belongs to the later 1880s.

17. Monet's surviving requests for contributions are in W III, pp. 250–2, the surviving responses in Geffroy 1924, I, pp. 242ff; these show that Monet was on informal, friendly terms with the following: Paul-Albert Besnard, Félix Bracquemond, Carolus-Duran, Jean-Charles Cazin, Jules Chéret, Ernest Duez, Fantin-Latour, Henri Gervex, Puvis de Chavannes, Félicien Rops and Antoine Vollon.

18. For Rodin at Giverny, see Goncourt Journal for 3 July 1889, recording a story heard from Mirbeau (Goncourt 1956, III, p. 1001).

19. Rouart 1950, p. 124, shows that Monet had not met Puvis by June 1885; Puvis showed his affection for Monet in 1889 by addressing him 'Mon cher Maître' in sending his subscription for *Olympia* (Geffroy 1924, I, p. 246); Rouart 1950, pp. 130, 132–4, suggests that Monet knew Mallarmé quite well by 1886; for further details of their friendship, see here, p. 223, and Mallarmé 1969 and 1973.

20. On the idea of establishing Impressionist dinners, see letters to Pissarro, November 1884, W letters 531, 534; on the dinners and the Café Riche, see W II, p. 39 and note 398, Geffroy 1924, II, pp. 1–2 (dates the dinners *c.*1890–4), and Hoschedé 1960, I, pp. 103–4; Pissarro described one such dinner in a letter to Lucien *c.*12 May 1886 (Pissarro 1950, p. 99 and note; this letter is here misdated to March 1886). On the Dîner des Bons Cosaques (1886–7), see W letters 756, 771, 774, and W III, p. 1 and note 603, p. 4 and note 644; on the Dîner de la Banlieue (1888–9), see W letters 896, 993, and W III, p. 21; on Monet's visit to a 'dîner occulte', see Mallarmé 1973, IV (1), pp. 93–4.

21. He met Maupassant at Etretat in 1885 (see W letters 590, 604, and Maupassant 1886) and at Antibes in 1888 (see W letters 859, 862).

22. See Phoenix Art Museum 1982; Perry (in Perry 1927) and Robinson (in his Diary, Frick Art Reference Library, New York, extracts published in Lewison 1963, and Chicago, Art Institute, 1975) recorded their impressions of Monet at Giverny; on the American invasion, see also Toulgouat 1952, and Low 1908, pp. 446ff; the extent of the American takeover, as early as 1892, can be gauged from a letter from Lucien to Esther Pissarro (Meadmore 1962, p. 67), describing the hoards of landscapists in the meadows: 'the fields look as if they were covered with mushrooms'.

23. For Monet's younger friends, see Geffroy 1924, II, p. 182, and Hoschedé 1960, I, p. 102; for one of Vuillard's visits, see Salomon 1951 and 1971; for Vlaminck's visit, see Gimpel 1963, p. 296.

24. The Duc de Trévise (Trévise 1927) and Marc Elder (Elder 1924) based their accounts of Monet's old age on extended conversations; for closed gates at Giverny, see Blanche 1928, pp. 30–4.

25. No detailed study of the rise of the art dealer in France has been completed. The most significant existing accounts are: Durand-Ruel's reminiscences, in Venturi 1939, II; Rewald, *Gazette des Beaux-Arts*, 1973; Lethève 1972; and White and White 1965. White and White 1965 is still the only work to study the economics of Impressionist painting in the overall context of the contemporary art market.

26. For Bruyas, see letter to Bazille, 14 October 1864, W letter 11; for Bazille's efforts, see Chicago, Art Institute, 1978, letters 27 (1864), 49 (1865), 65 (1868).

27. Monet mentioned these sales to Cadart (not noted in W I) in a letter to Alexandre, 6 December 1920, W letter 2391; for the sale of a Paris view and a small Marine to the dealer Latouche, see letter to Bazille, 25 June 1867, W letter 33; Monet also executed the small version of *Camille*, his 1866 Salon success, for Cadart and Luquet later in 1866 (see W 66, and W letters 29, 30). For his sales and hopes late in 1868, see W I, pp. 40–1, and W letters 43, 45–8.

28. The surviving stock-records of Durand-Ruel provide the basic evidence, though there are gaps in the records in the mid to late 1870s; for Durand-Ruel's own account of this period, see Venturi 1939, II, pp. 179ff. This information is complemented by Monet's own account books (*carnets*) which survive for the years 1872–88 and 1898–1912 (Musée Marmottan, Paris, inv. nos. M.M. 5160 (1, 2, 3)). In addition to the paintings he sold to Durand-Ruel in 1872–3, Monet sold to two other dealers – four canvases to Latouche in 1872, three to Dubourg in 1873.

29. Details from Monet's *carnets*: for the auctions, see Bodelsen 1968.

30. W I, p. 63 and note 436, p. 87 and note 612; Paris, Grand Palais, 1980, p. 109 and note 8.

31. Letter to de Bellio, ? summer 1876, W letter 94.

32. Monet several times in 1877–8 received sums of 5 francs from Caillebotte and Astruc, and once in September 1877 one franc only from Astruc.

33. Letter to de Bellio, 8 January 1880, W letter 170; see letter to Duret, 8 March 1880, W letter 173.

34. For Durand-Ruel's account of this phase, see Venturi 1939, II, pp. 210–14. Durand-Ruel resumed his purchases from Monet by buying fifteen canvases on 17–19 February 1881, for a total of 5,700 francs; W I, p. 117 and note 884, states that Durand-Ruel bought two paintings from Monet in October 1880, but the Durand-Ruel day-book (*brouillard*) makes it clear that these paintings were bought from Dubourg.

35. Gauguin, who was in Rouen in 1884, believed that Monet's brother had helped him find patrons (letter from Gauguin to Mette Gauguin, March 1892, in Gauguin 1946, pp. 223–4).

36. Letters to Durand-Ruel and to an unknown correspondent, 28 April 1881, W letters 215–16; letter to Alice Hoschedé, 13 April 1884, about Hayem, W letter 485; letter to Giron, 17 February 1885, W letter 549.

37. For Monet's exhibitions and exhibiting plans, see Chapter 13.

38. For Monet's reasons for turning to Petit in 1885, see letter to Durand-Ruel, 10 December 1885, W letter 638; for Boussod & Valadon, and the contract, see Rewald, *Gazette des Beaux-Arts*, 1973, which publishes the records of Boussod & Valadon's dealings with Monet, 1887–92.

39. For Durand-Ruel's account of his American venture, see Venturi 1939, II, pp. 214ff; see also F. Weitzenhoffer, 'The Earliest American Collectors of Monet', in Rewald and Weitzenhoffer 1984.

40. René Gimpel, who as a young dealer bought a few paintings from Monet in his last years, left an eloquent record of his negotiations with Monet in his Journal (Gimpel 1963); for Matsukata, see Tabarant 1922, and W IV, p. 108 and note 1003. For Monet's commercial manipulations, see W letters 1580–1 (1900), 1844–50 (1908), 1872–2a (1908).

41. For his worries about the demands of buyers, see letter to Durand-Ruel, 9 March 1892, W letter 1138.

42. For discussion of these left-over paintings from earlier periods, see pp. 68, 161, 167–70, and also pl. 183 for a photograph of this 'stock'.

43. W I, pp. 70–1, suggests that this second visit, during which Monet painted in Amsterdam, took place in the early months of 1874; this date is compatible with the appearance of the pictures, but it seems unlikely that Monet left Paris for so long during the preparation of the group's first exhibition.

44. On Léon's villa, see Hoschedé 1960, I, p. 119; on Dieppe, see Blanche 1937, p. 40; Renoir regularly stayed near Dieppe with his friend and patron Paul Berard, who may himself have persuaded Monet to visit the place; Berard quickly bought two of Monet's paintings of the region (W 712, 730). On the 1883 Mediterranean trip with Renoir, see letters from Renoir to Durand-Ruel (Venturi 1939, I, pp. 226–7) and to Berard (sold Paris, Hôtel Drouot, 16 February 1979, lot 76).

45. Rollinat urged Geffroy to bring Monet to the Creuse (see letter from Rollinat to Geffroy, 16 June 1888, in Rollinat 1919, pp. 272–3): 'I should be so happy to make the acquaintance of the master painter whom I admire profoundly.'

46. Norway, Switzerland and Mont Saint-Michel were all on Geffroy's 1891 list of places that Monet hoped to paint (Geffroy 1892, p. 23); for his enthusiastic response to Switzerland in 1913, see W letter 2057; for trip to Madrid, see Alice Hoschedé's letters to Germaine Salerou (Paris, Centre Culturel du Marais, 1983, pp. 267–9); for Venice, see Paris, Centre Culturel du Marais, 1983, pp. 139–40, 302–4.

47. For the car, see Joyes 1975, p. 32 and photographs on p. 69; for Monet (or presumably his chauffeur) speeding, see letter to the local justice of the peace, 30 June 1904, W letter 1736.

48. On Seurat, see Elder 1924, p. 68; on van Gogh, see Daudet 1927, p. 154; on Gauguin in 1893, see Pissarro

1950, p. 317 (apparently Monet had praised Gauguin's *Jacob wrestling with the Angel* and his ceramics in 1891, see Pissarro 1950, p. 247, note 1); on Bonnard, see Pissarro 1950, p. 398; see note 15 above; on the Salon du Champ de Mars, see Perry 1927, p. 123. Ludovici (1926, p. 172) says that Monet congratulated him on his *Dancing Girl*, shown at the Royal Society of British Artists in 1886, but this is probably an error for 1887 when Monet was in London for the RSBA show, since Ludovici showed a very similar painting then. For Monet's rather general comments on paintings in New English Art Club, see Gsell 1892, pp. 404–5, and *Sunday Times*, 3 January 1892 ('He thinks more seriously of English art than do the majority of his nation').

49. Hoschedé 1960, I, p. 88; for Zola in 1885, see W letters 552, 554, asking for tickets for *Henriette Maréchal*; for Ballets Russes, see Stravinsky's reminiscences in Craft 1962, p. 100 (*c.*1922/3: 'Old Monet, hoary and near blind, couldn't have impressed me more if he had been Homer himself'); on the wrestling matches, see Hoschedé 1960, I, pp. 85–6, and Joyes 1975, p. 23.

50. Bang 1895 (reprinted in Hoschedé 1960, II, p. 111), and M. Kahn 1904.

51. The Japanese fans at Argenteuil appear in *La Japonaise* of 1875–6 (W 387, Museum of Fine Arts, Boston), and in Renoir's canvas of Camille reading of *c.*1874 (Daulte 1971, no. 73, Sterling and Francine Clark Art Institute, Williamstown); on these, see Pickvance 1980. On the vases, see Paris, Grand Palais, 1980, p. 227; for a photograph of them installed at Giverny, see Joyes 1975, pp. 50–1.

52. This note in Monet's *carnet* is quite exceptional; they are otherwise devoted to accounts, with one address list of *c.*1880.

53. For still-life painting, see pp. 40–3; Julie Manet saw the bridge in October 1893 (Manet 1979, p. 23); for the enlargements of the garden, see Gordon 1973, and Joyes 1975, pp. 94–7 (photographs).

54. Meier-Graefe 1908, I, p. 306; for the flower gardens, see also Hoschedé 1960, I, pp. 57–70, and Joyes 1975, pp. 34–8.

55. Blanche 1928, p. 32; Manet 1979, p. 23; on the lemons, see Bernheim de Villers 1949, p. 68.

56. Vauxcelles 1905, p. 90; for the Whistler–Godwin 1878 exhibit, see the contemporary description quoted by D. Sutton, *Nocturne: The Art of James McNeill Whistler*, London 1963, p. 86; a photograph of it is in D. Sutton, *Whistler*, London 1966, p. 17.

57. Most of the finest works in Monet's private collection (including all the Cézannes and most of the Renoirs) were sold by Michel Monet before he made his bequest to the Musée Marmottan, Paris, of the residue of Monet's possessions. For descriptions of the collection, see Gimpel 1963, p. 155, Georges-Michel 1954, p. 23, Elder 1924, pp. 67–72, Geffroy 1924, II, pp. 187–8 and Howard-Johnson 1969, pp. 32, 76. No attempt has yet been made to identify all the contents of this collection.

58. On reading aloud, see Hoschedé 1960, I, p. 88, and Fels 1929, p. 198.

59. Letter to Mallarmé, 15 February 1889, W letter 911, which shows that Monet already knew Poe's prose works; Geffroy 1924, II, p. 2; for Tolstoy, see W letters 712, 726, 740, 749, 757 from Belle-Isle.

60. On reading tastes, see Hoschedé 1960, I, p. 76, Joyes 1975, pp. 25, 31, and M. Kahn 1904; Fels 1929, p. 198, adds the information about Delacroix's *Journal*. Monet's library survives in his house at Giverny.

NOTES TO CHAPTER 2

1. Such research has been launched in particular by Robert L. Herbert and his students; for Monet, see Herbert 1979 and 1982, Tucker 1982, and Los Angeles County Museum of Art 1984.

2. For an outline chronology of his life and travels, see Appendix B.

3. The second painting exhibited in 1865 is W 51; pl. 258,

Forest of Fontainebleau, was exhibited at the 1866 Salon; the dating of it and other forest paintings still raises major problems: the refinement of execution of *Forest of Fontainebleau* suggests a date of 1865 rather than 1864 which W proposes (W 19), while two other large forest scenes (W 57, 60), placed by W in 1865, are rather more crudely executed and may well belong to 1864.

4. See especially Isaacson 1972.

5. For steamboats, see W 77 (rejected in 1867) and W 89 (exhibited in 1868 and now known only from caricatures); pl. 259 was rejected in 1868; for a discussion of the La Grenouillère paintings and the likelihood that pl. 260 was rejected in 1870, see pp. 161, 205.

6. On *Terrace at Sainte-Adresse*, see Herbert 1979, p. 104; on the views of Paris, see Isaacson 1966.

7. Zola 1868, reprinted in Zola 1970, pp. 152–5.

8. Letter from Boudin to Martin, 3 September 1868, in Jean-Aubry 1922, p. 70.

9. Baudelaire's essay was first published in *Le Figaro* in November-December 1863, but had been written in January 1860; both Boudin and Manet were in contact with him at the time that he was working on these ideas.

10. See Thoré 1870, II, pp. 176–7, 185–90, 305–8 (Salon reviews of 1865 and 1866); the art of the peasant painter Jules Breton satisfied Thoré's requirements, in contrast to the unselective recording of nature for which he criticised 'naturalist' painting.

11. See Tucker 1982 for a richly documented study of Argenteuil in the 1870s.

12. Tucker 1982, p. 163, makes this point; see also photograph there, p. 173.

13. Tucker 1982, pp. 171–85 and passim.

14. T. J. Clark (Clark 1985, pp. 147–204) has related his discussions of Argenteuil more directly to metropolitan debates about leisure, industry and the margins between city and country.

15. Shiff 1978, pp. 344–5 and note 20.

16. Duret 1878, reprinted in Duret 1885, pp. 71–2.

17. Letter to Duret, 9 December 1880, W letter 203.

18. Letter to de Bellio, 8 January 1880, W letter 170.

19. For instance Cooper in London, Arts Council, 1957, p. 50.

20. See Chapter 1; he was left, without reliable source of income, as the sole breadwinner for both his and Alice Hoschedé's children, after Camille's death and Ernest Hoschedé's effective abandonment of his family.

21. Letter to Alice Hoschedé, 16 September 1886, W letter 687.

22. See Chapter 1, p. 12.

23. Thiébault-Sisson, *Le Temps*, 1927; Hoschedé 1960, I, p. 117.

24. Geffroy 1891, reprinted in Geffroy 1892, p. 23.

25. Monet told Walter Pach (Pach 1908, p. 765): 'One must always know a place thoroughly before one can paint it.' For his problems of acclimatisation, see letter to Durand-Ruel, 3 April 1884, W letter 472, and letter to de Bellio, 1 March 1884, not in W, publ. [Anon.], *Arts-Documents*, March 1953, p. 3 (for Bordighera); letter to Durand-Ruel, 1 October 1886, W letter 701 (for Belle-Isle); letter to Durand-Ruel, 9 March 1895, W letter 1280 (for Norway).

26. In 1882 he began to paint at Dieppe and considered moving on to Fécamp and Yport before discovering Pourville (see letters to Alice Hoschedé, 7, 8, 14 and 15 February 1882, W letters 235–6, 241–2); in 1883 he began at Le Havre before moving to Etretat (see letters to Alice Hoschedé, 25 and 31 January 1883, W letters 307, 310). He planned to paint at Marseilles after leaving Bordighera in 1884, but in the event stopped only at Menton (see letter to Berthe Morisot, 30 March 1884, W letter 467; for his first plans to stop in Menton, see letter to Alice Hoschedé, 3 March 1884, W letter 436); he planned to move along the coast from Belle-Isle (see letter to Alice Hoschedé, 21 September 1886, W letter 690), and to move on from Antibes to Agay (see letters to Alice Hoschedé, 15, 21 and 24 January 1888, W letters 807, 812, 816).

27. For instance, at Bordighera he discovered Dolce Acqua on such an excursion (see letters to Alice Hoschedé, 18 and 19 February 1884, W letters 422, 424).

28. For delayed returns home, see letters to Durand-Ruel, 23 March 1881, W letters 212 (from Fécamp), to Alice Hoschedé, 13 April 1884, W letter 485 (from Menton), and 15, 16 and 17 April 1889, W letters 951, 953–4 (from the Creuse).

29. Letters to Alice Hoschedé, 7 and 8 February 1882, W letters 235–6.

30. Letters to Alice Hoschedé, 24, 26 January and 11 February 1884, W letters 392, 394, 415.

31. Jourdain 1953, p. 48.

32. Henriet 1866, pp. 12ff etc.

33. Letters to Alice Hoschedé, 15 and 19 January 1888, W letters 807, 810.

34. Artists such as Lansyer, Vernier and Yon were regularly exhibiting pictures of such subjects (see F. G. Dumas, *Salon illustré*, Paris 1879, and following volumes). Comparable Renoirs are *The Cliffs of Pourville*, 1879 (Nathan Collection, Zürich), and *Varengeville Church and the Cliffs*, c.1879 (sold London, Sotheby, 16 April 1975, lot 63).

35. Canvases such as *Palm Trees at Bordighera* (pl. 110) can be compared with Renoir's *Mountains of the Esterel* (Corcoran Gallery of Art, Washington, D.C.), which was possibly painted while Renoir was with Monet on the Côte d'Azur in December 1883; the clearest indication of their discussions during this trip comes from a letter from Renoir to Berard, December 1883 (sold Paris, Hôtel Drouot, 16 February 1979, lot 76): 'The delicacy of the colours is extraordinary. Monet, who left home convinced that he would not like the Midi, contemplates it from morning to evening. Unfortunately our poor palettes cannot match it.'

36. Few of Harpignies's paintings from Antibes are dated, but he had often worked there before 1888, and thus very probably found some of the subjects which he shared with Monet before Monet did.

37. We do not know when Monet acquired his Delacroix watercolour *Etretat, la roche percée* (Musée Marmottan, Paris, inv. no. 5053); on the painters of Etretat, see Maupassant 1886, and Lindon 1958; for the reception of Courbet's Etretat paintings in 1882, see Riat 1906, pp. 267ff; for Monet's plans in 1883, see his letter to Alice Hoschedé, 1 February 1883, W letter 312; the subject of pl. 25 can be compared with Courbet's *Cliff of Etretat after the Storm* of 1870 (pl. 26).

38. Le Roux 1889; on Etretat at the time, see for instance Henry James, 'A French Watering Place' (reprinted in James 1958); Bertall, *La Vie hors de chez soi*, Paris 1876, pp. 515ff; K.S. Macquoid, *Through Normandy*, 1874, pp. 138ff.

39. Geffroy 1897, pp. 253–4; a copy of G. Flaubert and M. du Camp, *Par les champs et par les grèves*, first published in book form in 1885, survives in Monet's library at Giverny.

40. Garnier's pamphlet is reprinted in F.F. Hamilton, *Bordighera and the Western Riviera*, London, 1883, on Moreno's garden pp. 343–4, on the Sasso torrent pp. 350–6, one passage of which (p. 355) seems to describe Monet's subject quite closely: 'a picture which will fairly captivate you with its harmonious composition, colour and character: a little house close to a broken-down terrace… whilst a palm-tree laden with dates towers beside them… below us the valley which presents the whole of its left bank to our view, and at the bottom of everything the bed of the torrent, wild and stony and desolate.' For the possible relevance of Garnier's pamphlet, see also Walter and Bessone 1977. P. Joanne, *Les Stations d'hiver de la Mediterranée*, Paris, 1883, on Moreno's garden pp. 350–1, on Sasso p. 352, on the Nervia and Dolce Acqua pp. 340–3.

41. H. Macmillan, *The Riviera*, London, 1885, p. 183; only a few illustrations in Macmillan's books are dated (e.g. pp. 57, 185, 295); much of it was first published in *Art Journal* in the second half of 1884, including the Corniche illustration (November 1884, p. 321).

42. See p. 27 and note 60.

43. For instance, letter to Durand-Ruel, 31 January 1883, W

letter 311 (from Etretat), and letter to Alice Hoschedé, 17 January 1888, W letter 808 (from Antibes); in the later letter, he described a prospective site as 'beautiful, but not very varied, and I must be wary of letting myself slip into repetitions' – on the implications of this for the genesis of his series, see here, p. 196.

44. Letters to Durand-Ruel, 23 January 1884, and to Alice Hoschedé, 18 September 1886, W letters 391, 688.

45. Letter to Durand-Ruel, 11 March 1884, W letter 442; on the 'sombre and terrible aspect' of Belle-Isle, see letter to Durand-Ruel, 28 October 1886, W letter 727; on Antibes, see letter to Duret, 10 March 1888, W letter 855.

46. On wildness, see letter to Berthe Morisot, 8 April 1889, W letter 943; on the oak, see letters to Alice Hoschedé, 8 and 9 May 1889, W letters 975–6, and Geffroy 1924, I, pp. 202–3, 208.

47. Letter to Durand-Ruel, 28 October 1886, W letter 727.

48. Letters to Durand-Ruel, 17 October 1886, and to Alice Hoschedé, 30 October 1886, W letters 715, 730.

49. Le Braz 1935, p. 49.

50. Letter to Durand-Ruel, 22 October 1885, W letter 596; see also W letters 592, 594.

51. Le Roux 1889; Maupassant 1886.

52. Letter to Alice Hoschedé, 27 November 1885, W letter 631; see also Thiébault-Sisson, *Le Temps*, 1927. The similarity of Thiébault-Sisson's account to Monet's letter lends credence to this interview, many of whose other statements cannot be cross-checked.

53. Letter to Alice Hoschedé, 15 February 1882, W letter 242.

54. Letter to Durand-Ruel, 29 October 1917, W letter 2247; Blanche 1928, pp. 34–5; Geffroy 1924, I, pp. 115–6.

55. For comments on winter, see letters to Duret, 7 November 1887, and to Durand-Ruel, 25 December 1891, W letters 799, 1126, and Howard-Johnson 1969, p. 31.

56. Letter to Alice Monet, 9 February 1895, W letter 1266.

57. Elder 1924, p. 30.

58. Among more recent French precedents for Monet's vision of the sea, the seascapes with waves of Courbet and Paul Huet are probably the most relevant; this tradition can be traced back in France to Joseph Vernet's self-exposure to a storm, tied to a mast; on this, see G. Levitine, '*Vernet Tied to a Mast in a Storm*: The Evolution of an Episode of Art Historical Romantic Folklore', *Art Bulletin*, June 1967.

59. Letter to Durand-Ruel, 3 July 1883, W letter 362.

60. Diary of Theodore Robinson, 21 June 1892, MS Frick Art Reference Library, New York.

61. Jeanniot 1888, p. 2.

62. On the willows, see Elder 1920, p. 305; on the hill, see Delange 1927.

63. Daubigny's *The Banks of the Seine* (pl. 73), showing the same motif as pl. 72, was shown in the 1852 Salon; he had also painted one of Monet's Lavacourt subjects (see W I, p. 103); for meadows by Pissarro, see Pissarro and Venturi 1939, no. 490 (1879).

64. Renoir, in Vollard 1938, p. 214; Elder 1920, p. 305; letter from Pissarro to Lucien, 26 July 1893, in Pissarro 1950, p. 305.

65. Herbert 1979, p. 106; see also W III, p. 13, and Los Angeles County Museum of Art, 1984, p. 262.

66. The picture was shown both in the Millet retrospective at the Ecole des Beaux-Arts in 1887 and in the 1889 Exposition Universelle.

67. Letter to Geffroy, 21 July 1890, W letter 1066.

68. Bijvanck 1892, p. 177.

69. Hoschedé 1960, II, pp. 110–12, quoting H. Johsen and H. Bang; Geffroy, 'Salon de 1890', in Geffroy 1892, p. 186.

70. Gimpel 1963, p. 156 (diary for 1 February 1920).

71. See pp. 98–102.

72. See p. 113.

73. Koechlin 1927, p. 47, described Monet's great enthusiasm for the Corots he saw, along with paintings by himself, at the Véver sale at Petit's gallery in Paris, 1–2 February 1897.

74. Perry 1927, p. 120; though Lilla Cabot Perry does not directly attribute the comparison with Corot to Monet himself, her article mostly records his comments in the

third person, with little extraneous comment of her own.

75. Letter to Helleu, 4 June 1891, W letter 1111 bis, mentions the Japanese gardener (see also Paris, Grand Palais, 1980, p. 17); Theodore Robinson watched him reconstructing his garden in 1891–2; he wrote to Mr Perry on 9 June 1891: 'The master is … much occupied in his garden where he is planting flowers and things from all over the world' (MS Boston Museum of Fine Arts); on 3 October 1892 Robinson noted in his Diary: 'His greenhouse most completed – the garden very lovely in colour – the little sunflowers especially. He had commenced a canvas the other day and scraped it out – sunflowers and green grass.'

76. Later reminiscences, Elder 1924, p. 13; letter to the Préfet de l'Eure, 17 July 1893, W letter 1219.

77. For the development of the water garden, see Gordon 1973, and W IV; for the Giverny flower gardens, see especially Hoschedé 1960, I, pp. 57–70, and Joyes 1975, pp. 33–8.

78. Thiébault-Sisson, Revue de l'art, 1927, p. 44.

79. Thiébault-Sisson, Revue de l'art, 1927, p. 48.

80. Hoschedé 1960, II, p. 126. Among direct returns, Moored Boat at Fécamp (pl. 221) treats the same scene as a canvas of 1868/9 (W 117), and in 1885 Monet painted again the Porte d'Amont at Etretat (W 1040) from the same viewpoint as in his painting of 1868/9 (pl. 175); among other less direct reminiscences, the subject of the coastguard's cottage which he painted often in 1882 and again in 1896–7 (pl. 151, 220, 165 etc.) echoes Cabin at Sainte-Adresse of 1867 (pl. 68).

81. Though the 1883 version is not in the catalogue of the 1895 exhibition, Natanson (Revue blanche, 1 June 1895, p. 521) mentioned 'this old picture of Vernon' in his review of the show.

82. Throughout his career, Monet reiterated his wish to be demanding on himself (difficile pour moi) and to feel that he was making progress; see e.g. W letters 13 (1864) and 577 (1885), and his interview with Trévise in 1920 (Trévise 1927, p. 134).

83. For further discussion of these and Monet's other Salon figure paintings of the 1860s, see Chapter 13, pp. 205–6.

84. See House, 'New Material', 1978, p. 642.

85. Los Angeles County Museum of Art, 1984, p. 220; see also Tucker 1982, pp. 138–9, and Isaacson 1978, p. 206.

86. Tucker 1982, pp. 131, 134–5.

87. For further discussion of this change, see Chapter 5, pp. 79–83.

88. Monet described La Japonaise to Gimpel as 'une saleté', which he had painted to cash in on the success of Camille (pl. 257) ten years earlier (Gimpel 1963, p. 68); on the execution of the painting and its lucrative sale, see W I, pp. 73, 80, and W letter 84.

89. Clemenceau 1928, pp. 19–20, records Monet's memories of the compulsion he had felt to undertake this picture.

90. Gimpel 1963, p. 348; Zürich, Kunsthaus, 1952, p. 10 (introduction by G. Besson).

91. Hoschedé 1960, II, p. 126.

92. Early in 1888 Mirbeau wrote to Monet: '[Geffroy] tells me that he is furious with you, because he has seen your figures from last autumn and finds them superb… Can't you repair them?' (Mirbeau, Cahiers d'aujourd'hui, 1922; this letter can be dated to January or February 1888 from references to Mirbeau's own work in it); both of the Woman with a Parasol canvases and also Promenade, Grey Weather (pl. 47) show repaired tears in their canvas. When Trévise saw the Pink Boat paintings in 1920, Monet told him: 'Take no notice of that, it doesn't satisfy me' (Trévise 1927, p. 121).

93. Identification of the exhibited figure paintings presents particular problems. Three were shown among the nine canvases displayed by Theo van Gogh at Boussod & Valadon in February–March 1889; no catalogue was issued, but Geffroy described all nine pictures in his review (Geffroy 28 February 1889, reprinted in Geffroy 1924, I, pp. 196–8); they included two canvases of figures on a meadow, identifiable from his descriptions as pl. 47 and

48, and one in which, among the reeds on the river Epte, 'a light boat carries two young girls dressed in pink, one at the rudder, the other at the sculls' – probably pl. 49 or, less plausibly, W 1249, the other and less finished version of this subject. These two versions of The Pink Boat have previously been associated with Monet's letter to Geffroy of 22 June 1890 (W letter 1060): 'I have taken up once again things that are impossible to do: water with grasses undulating at the bottom.' However, the phrase 'once again' may imply that he had tackled this subject before, in which case the two Pink Boat canvases may well be the first attempt, dating from 1887 or 1888, with one exhibited early in 1889, and the later attempt may be The Boat (for which, see note 95). In the exhibition at the Petit gallery in summer 1889, both of the meadows with figures, pl. 47 and 48, were included, but not among the pictures listed as Essais de figures en plein air (they are nos. 106 and 111 in the catalogue). The four essais de figures include one boating subject, En Norvégienne, which is probably the canvas now in the Musée d'Orsay, Paris (W 1151), or perhaps a version of The Blue Boat (pl. 191); a norvégienne is a round-bottomed boat, with raised, rounded bows; the other three essais were La Promeneuse, probably W 1133, a girl standing among trees with a parasol, and two canvases entitled Under the Poplars, one in sunlight, one in overcast weather. W's proposed identification of these with W 1135 and 1136 is puzzling, since the figures on the meadows in these canvases are much smaller than those in pl. 47 and 48, which were not listed among the essais, but there is no other obvious identification for these paintings. Finally, in 1891 with the Grain Stacks at Durand-Ruel's gallery he included two paintings as Essai de figure en plein air; these can be identified as the two Woman with a Parasol canvases (pl. 38 and W 1076) from a contemporary description (Bijvanck 1892, p. 177).

94. Letter to Duret, 13 August 1887, W letter 794; letter from Mirbeau to Monet, early 1888, about Geffroy's comments, quoted above, note 92; letter from Morisot to Mallarmé, November 1888, in Rouart 1950, p. 141; letter to Geffroy, 20 June 1888, W letter 1425.

95. For these drawings (in sketchbook inv. no. 5129 in the Musée Marmottan, Paris) see p. 229; the suggestion in note 93 above, that The Boat dates from summer 1890 and is thus the last of these figure paintings, is perhaps confirmed by Monet's report to Morisot (W letter 1064) on 11 July 1890 that his pretty models had been ill, shortly after his letter of 22 June about painting underwater grasses (quoted note 93); their illness may well explain the absence of the planned figures in The Boat.

96. For discussion of the lessons Monet learned from Japanese prints, see Chapter 3.

97. W 1202 and 1205, showing meadows without figures, relate quite closely to pl. 47 (W 1203) and W 1206 respectively.

98. For instance, Geffroy 1889 (reprinted in Geffroy 1924, I, pp. 196–7); Bérenger, 'Un prince de la lumière', review of the 1889 exhibition at Petit's, unidentified press-cutting in Paris, Bibliothèque d'Art et d'Archéologie, fonds Louis Vauxcelles.

99. Dauberville 1967, p. 202; for discussion of Renoir's methods in these figure paintings, see London, Arts Council, 1985, pp. 239–40, and p. 259, where the painting Monet owned is reproduced (Metropolitan Museum of Art, New York, Lehman Collection).

100. Letter from Renoir to Monet, January 1884, in Geffroy 1924, II, p. 25; letter to Durand-Ruel, 13 May 1887, W letter 788; Renoir's Bathers is the canvas in the Philadelphia Museum of Art, Mr and Mrs Carroll S. Tyson collection.

101. Letter from Pissarro to Lucien, 9 March 1884, MS Ashmolean Museum, Oxford, unpublished.

102. Letter from Cézanne to Zola, 23 February 1884, in Cézanne 1978, p. 214, mentions their visit.

103. For Monet's relationship with Sargent, see p. 9 and note 16 there.

104. For Sargent's methods in Carnation, Lily, Lily, Rose, see Charteris 1927, pp. 74–7, and Ormond 1970, pp. 34–9, 242–3; for his boating pictures, see Hoopes 1966.

105. Letter from Mallarmé to Morisot, 17 February 1889 (Rouart 1950, p. 145), says that Monet has seen Morisot's design and is to contribute to the book; for this project, and Monet's failure to complete his planned illustration to Plainte d'automne, see Mallarmé III, 1969, pp. 162, 363.

106. The ambitious pieces are W 6, 7 and 10; their construction and subjects are markedly different from the smaller canvases, showing humble things like meat, bread and eggs, knives, bottles and carafes (W 9, 13, 14).

107. As W suggests, Spring Flowers (W 20) was very probably the flowerpiece Monet sent for exhibition in Rouen in summer 1864 (see W letter 9); it bears close comparison to Courbet's Bouquet of Flowers in a Vase of 1862 (Fernier 1977, no. 302).

108. For Lejosne's purchase of W 103, see W I, p. 444 (pièce justificative 16); for the comparison with Manet, see Paris, Grand Palais, 1983, pp. 212–13; for Chesneau's purchase of a Manet still life which was on display chez Cadart, see letter from Manet to Baudelaire, early 1865, in 'Baudelairiana', Bulletin du bibliophile, 1940, no. 3, p. 89.

109. He was generally paying 300 francs for landscapes in 1872, and more only for occasional larger pictures; in 1873 he paid between 300 and 500 francs for landscapes.

110. On these exhibitions, see pp. 208–11.

111. Ann Arbor, University of Michigan Museum of Art, 1979–80, p. 130.

112. Details from Monet's carnets (Musée Marmottan, Paris); the only larger sum he received was 1,500 francs from Charpentier for the large version of The Ice-Floes (pl. 186).

113. Monet mentioned these paintings in letters to Durand-Ruel in September and November 1882 (W letters 288–90, 301–2); they were probably W 634 (dated 1882 by Monet, but placed without explanation in 1880 by W), and a pair of paintings of the same size (100 × 81) which Monet only signed and sold late in his life, W 625, 809; these two paintings can be seen on Monet's studio wall in a photograph of c. 1915 (pl. 183; they are on the right wall, at the far end of the top row, with a Poplars canvas between them).

114. Letter to Durand-Ruel, 5 June 1883, W letter 356.

115. On the decorations, see letters to Durand-Ruel, 1883–5 (W letters 373, 377, 381, 383, 557).

116. On Monet's studio reworking, see Chapter 8.

117. See W for the early provenances (some of them putative) of these paintings.

118. Courbet, see e.g. Fernier 1978, no. 780 (of 1871); Sisley, see Daulte 1959, nos. 233–4.

119. Letter to Joyant, 8 February 1896, W letter 1322; letter to Durand-Ruel, 23 November 1896, shows that work on the Chrysanthemum paintings began in 1896. In the event, he did not acquire Hokusai's Poppies, nor does his Iris appear among the surviving prints from his collection (see Aitken and Delafond 1983, pp. 76–8).

120. Thiébault-Sisson 1926.

NOTES TO CHAPTER 3

1. E. Bergerat, Journal Officiel, 17 April 1877, quoted in E. Littré, Dictionnaire de la langue française (Supplément), Paris 1877, p. 196, s.v. Impressionnisme.

2. Signac 1964, p. 92, quoting Duret 1878 (reprinted in Duret 1885, p. 68); Geffroy 1898 (reprinted in Geffroy 1900, pp. 170–1; Geffroy 1924, II, p. 89).

3. Hoschedé 1960, I, p. 107; Henriet 1866, pp. 14–15.

4. For a more detailed discussion of the contents of these sketchbooks, see Appendix A.

5. Salomon 1951 (reprinted with variations in Salomon 1971); Pays 1921.

6. See letters to Alice Hoschedé, 9 March 1889, and to Alice Monet, 29 February 1896, W letters 914, 1328.

7. Cézanne, in Borély 1926, p. 491 (reprinted in Doran 1978, p. 19); Degas, in Sickert 1947, pp. 117 and 348 n. 87.

8. My discussion of compositional patterns is much indebted to Gombrich 1960, especially 1962 edn, pp. 73–8, 148–52.

9. Trévise 1927, p. 132.

10. Letter to Alice Hoschedé, 11 February 1884, W letter 415; Robinson, Diary, 17 February 1894, remembering a conversation with Monet which probably took place in 1892 (the year of Monet's Poplars exhibition).

11. Greenberg 1957, and see his 'The Crisis of the Easel Picture' (1948) and '"American-Type" Painting' (1955), all reprinted in Greenberg 1961; Herbert 1984; Lecomte, *L'Art impressionniste*, 1892, pp. 260–2.

12. For Courbet, see M. Schapiro, 'Courbet and Popular Imagery', *Journal of the Warburg and Courtauld Institutes*, 1941, and L. Nochlin, 'Gustave Courbet's *Meeting*', *Art Bulletin*, September 1967; for Manet, see A.C. Hanson, 'Popular Imagery and the Work of Edouard Manet', in Finke 1972.

13. Champfleury, describing Courbet's work in the 1849 Salon (reprinted in Champfleury, 1973, p. 155).

14. The most important contemporary texts for understanding these attitudes to composition are by Champfleury, 'Nouvelles recherches sur la vie et l'oeuvre des frères le Nain', *Gazette des Beaux-Arts*, 1860 (IV), and *Histoire de l'imagerie populaire*, Paris 1869, and by Baudelaire, 'Le Peintre de la vie moderne', translated in Baudelaire 1964 (for its composition, see above, Chapter 2, note 9).

15. Letter from Baudelaire to Houssaye, December 1861, in *Correspondance générale*, IV, Paris 1948, p. 34; Crépet mentions Fantin-Latour as one of the recipients of the lot of prints which Baudelaire was sending to his friends, and it is very likely that Manet was another. For the most recent research on the discovery of Japanese prints in Paris, see Champfleury 1973, pp. 140–5, and Eidelberg 1981. Eidelberg's evidence, that in 1859 Delâtre, Bracquemond's and Whistler's printer, published a lavish volume containing reproductions from several Japanese books, including Hokusai's *Manga* and *100 Views of Mount Fuji*, lends substantial credence to the traditional story of their discovery by Bracquemond, first proposed, it seems, by L. Bénédite ('Felix Bracquemond, l'animalier', *Art et décoration*, February 1905, and 'Whistler', 3rd article, *Gazette des Beaux-Arts*, 1905, vol. 34), though Bénédite's proposed date of 1856 is probably a year or two too early.

16. Manet made some sort of relationship between Japanese art and Velásquez explicit in the juxtaposed prints in the background of his *Portrait of Emile Zola* of 1868 (Musée d'Orsay, Paris).

17. Chesneau 1878, p. 406.

18. Elder 1924, p. 64; though 1856 is a very early date for his discovery, it is made marginally more plausible by the circumstances he described, 'at le Havre, in a shop where they sold off the curios brought back by the ocean liners'; Chesneau mentioned that Japanese prints had first been discovered by artists in Paris 'in a recent arrival from Le Havre' (1878, p. 397), and thus Monet may have come on some prints there at a very early date.

19. Edmond Goncourt noted in his Journal on 17 February 1892 that he often met Monet 'at Bing's, in the little store-room of Japanese prints where Lévy works' (Goncourt 1956, IV, p. 195); otherwise, we have virtually no evidence of where or when Monet bought his prints, apart from a clearly mistaken story that he first discovered them in Holland in 1871 (first reported, it seems, by Mirbeau 1907, pp. 207–10). In an unpublished article ('Monet and the Reception of Far Eastern Art in Europe, 1860–1900'), David Bromfield has suggested approximate dates for his acquisition of some of his collection; many of Monet's earlier prints bear the seals of Wakai and Hayashi, and were thus bought in the 1880s and 1890s when they were dealing in Paris, whereas many of Monet's more recent prints may well have been acquired before 1880. I am most grateful to David Bromfield for showing me a copy of his article. Bromfield's unpublished PhD thesis ('The Art of Japan in Later 19th Century Europe', Leeds University, 1977) established that the first prints to arrive in Europe were the most recent (and the most highly coloured), while the work of Utamaro and other eighteenth-century printmakers only appeared in circulation in Europe from the late 1870s onwards.

20. For a catalogue of Monet's collection of Japanese prints,

see Aitken and Delafond 1983.

21. For photographs, see Poulain 1937; for fashion prints, see Roskill, 'Early Impressionism', 1970. The photographs that Poulain cites have no special claim to have been Monet's inspiration; they, and other informal outdoor photographs of their type from the period, are themselves composed according to the conventions of contemporary popular prints and fashion plates.

22. Letter to Bazille, December 1868/January 1869, W letter 45; for an argument that this phrase must relate to *Terrace at Saint-Adresse*, and not to another lost canvas as W supposes (W 107), see House, 'Catalogue', 1978, p. 681; for the interchangeability of 'Japanese' and 'Chinese' in the 1860s, see Chesneau 1878, p. 387; Gimpel 1963, p. 178 (Diary for 9 October 1920).

23. Letter from Boudin to Martin, 18 February 1868, in Jean-Aubry 1922, p. 68.

24. Aitken and Delafond 1983, no. 59; in his article (see note 19) David Bromfield notes the condition of Monet's prints as a possible indication of their acquisition date, and, by verbal communication, has agreed that this may well have been one of Monet's early acquisitions, because of its worn and tattered condition and because it has no dealer stamp.

25. On the views of Paris, see Isaacson 1966. Shortly before Monet's paintings, Charles Soulier had photographed the Quai du Louvre from virtually the identical viewpoint (Paris, Bibliothèque Nationale, *Regards sur la photographie en France au XIXe siècle*, 1980, n. 142), but this photograph, like Monet's painting, belongs to a shared tradition of topographical imagery.

26. Gerald Needham has associated such perspectives, too, with Japanese prints (Cleveland Museum of Art, 1975–6, pp. 117, 133), but there is nothing about their treatment which differentiates them from the long-established tradition of such subjects in the European tradition.

27. For instance Hiroshige's *Twilight Moon at Ryōgoku*, repr. Dufwa 1981, p. 140.

28. Varnedoe 1980, especially p. 71.

29. Duranty 1876, reprinted in Duranty 1946, pp. 46–7.

30. On Monet's use of bric-à-brac, see Paris, Grand Palais, 1980, pp. 153–4, and Pickvance 1980, pp. 157–65; oriental decorative objects first appear in Monet's work in *Meditation*, painted in London in 1870–1 (W 163, Musée d'Orsay, Paris; on this, see House, 'New Material', 1980, p. 642).

31. In 1918, Monet told Gimpel that *La Japonaise* was 'a sort of pendant' to *Camille* (Gimpel 1963, p. 68).

32. Vollard 1938, p. 196.

33. See especially Chapters 5 and 6, for discussion of the role of brushwork and colour in the structure of Monet's paintings.

34. Stuckey, 'Monet's Art and the Act of Vision', in Rewald and Weitzenhoffer 1984, p. 114; on the sketching tradition, see London, Arts Council, *Painting from Nature*, 1980–1, and New York, Museum of Modern Art, 1981.

35. See note 10.

36. Aitken and Delafond 1983, no. 101; see also nos. 66, 75 (Hokusai), 116, 128 (Hiroshige).

37. W. Eaton, 'Jean-François Millet', in Van Dyke 1896, p. 183.

38. Letter to Blanche Hoschedé, 1 March 1895, W letter 1276.

39. Letter from Pissarro to Lucien, 3 February 1893, in Pissarro 1950, p. 298.

40. Duret 1910, p. 144; Monet did not own a copy of this print, *Numazu, Yellow Dusk*.

41. See note 10.

42. On the bridge, letter to Roger Manx, 1 June 1909, W letter 1893; for discussion of the Japanese aspects of the design of the water garden, see House 1983, p. 152.

43. Letter to Joyant, 8 February 1896, W letter 1322; see above, p. 43.

44. Screens of this type had been exhibited in Paris, at least since 1883, when several were included in the pioneering *Exposition rétrospectif de l'art japonais* at Georges Petit's gallery.

45. For a list of these sizes, see Callen 1982, p. 59; as an example, a size 40 *portrait* measured 100 × 81 cm, a 40 *paysage* 100 × 73 cm, and a 40 *marine* 100 × 65 cm.

46. Though there is no firm evidence that Monet took canvases of varied formats with him as he set out on his travels, the number of different formats and sizes he used on his travels shows that he must have kept various options to hand – perhaps in the form of rolls of un-stretched canvas.

47. For instance, *Stormy Sea at Etretat* of 1868/9 (W 127, 66 × 131 cm) and *Green Park* of 1870/1 (W 165, 34 × 72 cm).

48. The Etretat panels are W 1041 and 1043; for the Durand-Ruel decorations, see above, p. 41; the top panels measure around 128 × 37 cm.

49. See Geffroy, 'Quatre voix à Claude Monet', *La Justice*, 8 November 1892 (largely reprinted in Geffroy 1924, II, pp. 49–50); unfortunately, no documentation about this proposed commission seems to survive at the Archives Nationales, whose record of the case is confined to a press-cutting of Geffroy's 1892 article.

50. Guillemot 1898, p. [3]; Alexandre 1909; Marx 1909, p. 529; for the 1914 beginnings, see W IV, pp. 78ff. W's identification of eight canvases (W 1501–8) as survivors of the water lily project of 1897–8 must be regarded as hypothetical.

51. For a photograph of the scene, with the Needle, see Seitz, *Monet*, 1960, p. 41, fig. 53; W's suggestion that the two canvases with the Needle (W 1543–4) were painted from a different window is quite implausible, since the relationships between all the other elements in the scene are just the same as in the versions which omit the Needle.

52. For a discussion of elements omitted in rapidly executed canvases, see p. 68; for the pentimenti in Monet's canvases, see Chapter 11.

53. Vauxcelles 1905, p. 88.

NOTES TO CHAPTER 4

1. Guillemot 1898, p. [1].

2. For the availability of different types of canvas and priming, see Callen 1982, pp. 59–61; for Renoir's experimental primings, see A. Callen, *Renoir*, London 1978, pp. 19–20, 86–7.

3. Trévise 1927, p. 49; Monet's reasoning, that luminosity can be better preserved by working from light to darker values, can be contrasted with the reasons Courbet gave for adopting dark grounds: 'Nature, without sunlight, is dark and dull; I do what the light does, and illuminate the projecting points, and the picture is done' (Riat 1906, pp. 218–19).

4. For photographs of paintings by Monet during their cleaning, see Boston, Museum of Fine Arts, 1977, pp. 8–9; occasionally, unvarnished strips may be seen down the margin of a canvas otherwise much discoloured, as for instance down the right side of *Rough Sea, Etretat* of 1883 (pl. 25). I am indebted to Robert Ratcliffe for his emphasis on the primings of paintings, and on problems in their material condition; I have learned much from his example.

5. These generalisations are based on a sample of around 800 canvases, a large enough proportion of Monet's oeuvre to allow an assessment of the general patterns in his use of primings.

6. I owe this observation to Robert Ratcliffe. Though this idea suggests an awareness of Chevreul's *De la loi du contraste simultané des couleurs* of 1839, there is no evidence that Monet used Chevreul's prescriptions directly, either here or in his colour practice. He would certainly have become aware of their general import, probably in the 1860s and undoubtedly in the 1880s when Pissarro began to preach Chevreul's theories, but the devices he used seem most likely to have been primarily the result of practical experimentation rather than of verbal precept; for his use of colour, see Chapter 6.

7. Like the grey grounds of the early 1870s, the light brown primings of around 1880 were clearly a deliberate exper-

iment, made over a period of two or three years, and appearing in around a quarter of the canvases to have been examined from these years. The fact that these brown grounds appear on canvases of both fine and coarser grain suggests that they are not simply the result of a single batch of canvas; many seem to be on canvases finer than those Monet generally used at this period (e.g. pl. 150).

8. See pp. 71–2 and Chapter 10, pp. 167–8, 179–81.

9. As late as 1901, he used a light beige beneath *Vétheuil* (W 1639) which remains visible in the picture's final effect. One later canvas, *Water Lilies, Sunset* (W 1719), is, quite exceptionally, primed with crimson; though placed by W in 1907, this painting is very closely related to the *Sunset* panel in the first room of the Water Lily Decorations in the Orangerie, and very probably served as a study for it; its priming was presumably an isolated experiment, perhaps related to the lavish coloration of the planned large canvas.

10. For Cézanne's primings, see Ratcliffe 1961, pp. 61ff.

11. See note 3.

12. See Boime 1971, pp. 37ff.

13. Robert 1878, pp. 53–4; Théodore Rousseau's lay-ins, essentially colourless over initial drawing, exemplify the older approach, while Daubigny's are coloured (see here, p. 68).

14. Perry 1927, p. 120; Rashdall 1888, p. 196.

15. Jeanniot 1888, p. 2; Fuller 1899, p. 13.

16. Creuse: pl. 104 and W 1226; Grain Stacks: pl. 136.

17. See pp. 127–8, 178.

18. Rashdall 1888, p. 196.

19. Adéline 1884, p. 159.

20. Robert 1878, p. 77.

21. See Chapter 10, pp. 168–70, 174.

22. The surviving drawings related to the Gare Saint-Lazare paintings (e.g. Isaacson 1978, pl. 56) show that these paintings were carefully planned, but the drawings do not correspond to the paintings in details such as the placing of the smoke, and so cannot have served as detailed preparatory studies for individual canvases. For these drawings, see Appendix A; for Monet's problems with open-air painting, see Chapter 7.

23. See Chapter 5, pp. 102–6.

24. See Chapter 11 for Monet's pentimenti, and the probable reasons for them.

25. See for instance Pissarro's *Landscape at Osny* of c.1884 (Columbus Gallery of Fine Arts; Pissarro and Venturi 1939, no. 629) and Cézanne's *Gardanne* of 1885 (Brooklyn Museum; Venturi 1936, no. 431), in contrast to the more all-over lay-in in two paintings of c.1878–80, Pissarro's *Landscape at Valhermeil* (Pissarro and Venturi 1939, no. 439) and Cézanne's *Landscape* (Venturi 1936, no. 299).

26. Gimpel 1963, p. 67.

27. See note 14.

28. Trévise 1927, p. 50.

29. Perry 1927, p. 120.

30. Letter to Alice Hoschedé, 27 March 1884, W letter 464; for the value he attached to such quick sketches, see Chapter 9, pp. 162–5.

31. For a single session, see the just-mentioned *pochade* and note 30; Mirbeau 1889, p. 14, mentioned sixty sessions as the maximum.

32. No evidence has survived about what medium Monet used, or how he used it, before c.1915; in the Water Lily Decorations, he seems to have been cultivating a dry-looking final surface, and apparently put the paint from his tubes onto absorbent paper, to remove the excess oil, before using it (Salomon 1971); however, the surfaces of his earlier paintings suggest that he did not do this previously, and probably worked straight from the tube, adding medium when necessary. For discussion of the composition of later nineteenth-century French tube paints, see Callen 1982, pp. 22–5.

33. See pp. 183–91.

34. Duret 1880 (reprinted in Duret 1885, pp. 100–1); Burty 1880, p. 59 (this passage quoted in Venturi 1939, II, pp. 294–5).

35. Geffroy 2 June 1887, p. 2 (reprinted in Geffroy 1924, I, p. 189).

36. Quoted in Rewald 1973, pp. 456–8.

37. Rashdall 1888, p. 196.

38. See note 35.

39. Robinson, Diary, 15 September 1892.

40. Delacroix 1980, p. 612 (Journal for 13 January 1857).

NOTES TO CHAPTER 5

1. Delacroix 1980, p. 612 (Journal for 13 January 1857).

2. Letter to Bazille, 14 October 1864, W letter 11; for his instructions to artists, see especially Perry 1927, p. 120; Mirbeau 1889, p. 5; Bullet 1901.

3. Burty 1883.

4. Zola, 'Manet', 1867 (reprinted in Zola 1970, pp. 100–1); Thoré 1870, II, p. 531.

5. Perry 1927, p. 120.

6. Gautier, quoted in Moreau-Nélaton 1925, p. 81. On the *tache*, see e.g. Bracquemond 1885, pp. 42–3 (where he comments: 'The greater the importance which the *tache* takes on in itself, the more the modelling disappears'); H. Taine, *Philosophie de l'art dans les Pays-Bas*, Paris 1869, pp. 162–3 on Rembrandt ('Every object in the visual field is only a *tache* modified by other *taches*'); Boime 1971, pp. 152 and 215, note 13. The term *tache* was sometimes used by critics in their comments on the free handling of the paintings exhibited by the Impressionists in the 1870s (e.g. Leroy, *Le Charivari*, 25 April 1874, quoted in Paris, Grand Palais, 1974, p. 260).

7. I have found evidence of palette knife work in only three canvases by Monet, all seascapes from around 1866: W 71, 73, 86; W places the first two of these in 1866, the third in 1867, but all seem to belong together; the increasing delicacy of Monet's touch in 1867 (see below pp. 76–7) makes an earlier date more likely – most plausibly perhaps 1866, since Monet does not seem to have worked on the coast in 1865. Monet was in close touch with Courbet in 1866 (see Chapter 1, p. 7 and note 6).

8. See Chapter 2, pp. 16–17.

9. For Monet's *esquisses*, works complete in their own terms but insufficiently worked for the art market, see p. 159; *Lilacs in Sunlight*, sold to Durand-Ruel early in 1873, is unusually freely handled for a canvas sold into the dealer market; these were normally more precisely and meticulously executed (see also p. 167).

10. None of Whistler's Nocturnes was exhibited while Monet was in London in 1870–1; for a discussion of the possibility that the two men met in London during this time, see House, 'New Material', 1978, pp. 641–2.

11. See note 9.

12. Letter to Duret, 13 August 1887, W letter 794.

13. The figures in *The Boulevard des Capucines* (pl. 262) are rather more clearly indicated than in the vertical version of the subject painted at the same time (W 293); this latter version is left in the state of an *esquisse*, whereas the other (very probably the one exhibited in the first group exhibition in 1874) was worked up to the degree of finish of Monet's more highly worked *tableaux* of this date.

14. Tucker 1982, pp. 181ff, sees in these last Argenteuil canvases Monet's alienation from his physical subject – from the place itself – without recognising that their treatment ties in closely with this more general change in Monet's handling at this date.

15. See pp. 159–61, 206.

16. Letter from Martelli to Fattori, 10 April 1879, in Martelli 1979, p. 41; Burty 1883.

17. W. Eaton, 'Jean-François Millet', in Van Dyke 1896, p. 183; Pissarro, quoted in Sheldon 1889, p. 160; for a discussion of the viewing distances demanded by the perspectival organisation of old master paintings, see E. Thénot, *Traité de perspective pratique pour dessiner d'après nature*, 4th edn. Paris 1872, p. 52.

18. Letters from Bazille to his parents, 25 February 1864, in Daulte 1952, p. 92, and [1864], in Chicago, Art Institute, 1978, letter 26; since at this time Monet was one of Bazille's closest comrades in Gleyre's studio, it is most likely that he, too, saw the exhibition.

19. Letter to Boudin, 3 June 1859, W letter 2.

20. For Delacroix's ideas about finish, see Chapter 9, p. 165; for Monet's view of the *Journal*, see p. 13 and note 60 there.

21. See Duret 1880 (reprinted in Duret 1885, pp. 97–8); letter from Pissarro to Lucien, 16 May 1887, in Pissarro 1950, p. 150. For the interest of young artists in Delacroix, see also Zola, *L'Oeuvre*, 1886 (*Les Rougon-Macquart*, IV, Paris 1966, edn. la Pléiade, p. 45), in which Lantier comments of Delacroix: 'What a decorator, who made his colour blaze out!'

22. Baudot 1949, p. 108; Monet's friend Duret pointed out that the Japanese did not use pens, in an essay published in 1885 (Duret 1885, p. 166) in which he paralleled Japanese and Impressionist techniques; Monet owned a copy of Duret's book (M. Kahn 1904).

23. See Pissarro and Venturi 1939, no. 349 (1876, *The Garden of the Mathurins, Pontoise*), no. 44 in London, Arts Council, *Pissarro*, 1980–1.

24. For Cézanne's 'constructive stroke', and the suggestion that it originated in his imaginative paintings, see Reff 1962; for the suggestion that it evolved simultaneously in landscapes and figure subjects, see my brief argument in London, Royal Academy of Arts, 1979–80, no. 40, pp. 53–4.

25. Sisley's problems with *The Seine at Suresnes* can be seen in the traces of an overpainted signature, also dated '77', to the right of the present one.

26. Lecomte, *L'Art impressionniste*, 1892, p. 92.

27. Lecomte, *L'Art impressionniste*, 1982, p. 94.

28. Quoted in Phoenix Art Museum 1982, p. 75.

29. Herbert 1979.

30. I was able to examine these paintings under a binocular microscope in the Conservation Department of the Museum of Fine Arts, Boston. I am extremely grateful to Alain Goldrach and Brigitte Smith, of the Conservation Department, and to Alexandra Murphy and John Walsh, both formerly of the Department of Paintings, for allowing me the opportunity to examine the paintings under ideal conditions, and for giving me the benefit of their great experience when we examined them together. This examination led me to the following conclusions, which I will present in the order in which the points are discussed in Herbert 1979.

A. *Meadow with Haystacks near Giverny* (pl. 132)
Herbert p. 94 col. 2: the orange-red 'touch' where quadrants J and F of fig. 2 meet; this is part of a layer beneath the thin surface blue around it, revealed along this ridge by abrasion of the paint surface. Herbert p. 94 col. 3 para. 1: the blue strokes, which Herbert sees as drawn in separately, appear to be the result of very delicate 'skip strokes' brushed across the surface ridges. Herbert p. 94 col. 3 para. 2: the green spot in the belly of the yellow lozenge is part of a layer which lies below the yellow, revealed by the pressure of the centre of the brush as it applied the yellow stroke; the tiny hairlines of red which cross this green (not mentioned by Herbert) probably were on Monet's brush with the yellow paint and were applied with the same stroke as the yellow, but the slight surface flattening in this area leaves this not wholly clear. Elsewhere in the picture, notably on the trees, some of the highlights are suggested by very fine paint strokes, some of them virtually hairlines, but these are briskly flicked across the surface, not painstakingly 'drawn' on.
B. *Stone Pine at Antibes* (pl. 133)
Herbert p. 95 col. 3 top: the elongated ridge about an inch long is a group of three bristles from Monet's paint brush, one more prominent than the others, with its actual colour revealed in the middle of its length because of very small paint losses. Herbert p. 95 cols. 1–2: the individual colours enumerated by Herbert do not seem all to have been applied separately; some appear to have been together in single brushstrokes, while other small accents are part of lightly applied surface colour, often skip strokes, which cross larger areas of the canvas. Some very small strokes

may have been applied separately, for instance the little red-orange touch to the lower left of the dome-shaped greeny area, and a tiny blue touch just right of this orange-red; but each of these is very closely related to neighbouring colours. Herbert's isolation of individual minute areas of colour detaches these colours from the sequences of delicate surface colours of which they are part, and from the role these play in the broader effect of the painting.

C. *Ravine of the Creuse* (pl.134)

Herbert p.95 col.3 bottom: the orange and yellow stroke in quadrant B of fig.7 could not be identified; a very similar stroke in the lower parts of quadrants E and F of the same detail is a genuine wet, two-colour stroke, rather than an imitation of one. Herbert p.97 col.1 top: these orange touches belong to delicate skip strokes; the slender ridge in the centre of the detail is built up of orange paint mixed with yellow, rather than merely covered with orange. Herbert p.97 col.1 lines 8ff: the colours here are parts of longer strokes, and the green stroke in the middle of the area described was added over the orangey and reddy hues in the area. Herbert p.97 col.1 para.2: the tiny touches of coral red are part of one or two very fine skip strokes about an inch long; in the area with blue and orange just below this, some of the blue which appears to 'shadow' the orange stroke was clearly applied before the orange; the later blue dab, just to the right of this, overrides the orange but does not read as its shadow. In this picture the nearest thing to single hairline strokes to have been located is in the water at bottom right, where several thread-like deep blue strokes, applied with a flick of the brush, express the gentle ripples on this area of the water.

31. For further discussion of these late-added accents, see Chapter 9, pp.179–81.
32. Letter to Berthe Morisot, 10 March 1888, W letter 852.
33. Robinson, Diary, 23 May 1892; Daudet 1927, p.145.
34. Letter to Alice Monet, 2 April 1893, W letter 1207.
35. Guillemot 1898, p.[2].
36. Herbert 1979, p.98.
37. See House 1983, pp.154, 162–4.
38. [Anon.], *The Standard*, 1908.
39. Sickert 1947, pp.59, 144, reprinting articles from *The New Age*, 2 June 1910, and *The Evening News*, 30 May 1927; the rehabilitation of the Decorations was pioneered by critics such as Greenberg (see 'The Crisis of the Easel Picture', 1948, reprinted in Greenberg 1961).

NOTES TO CHAPTER 6

1. Clément 1878, p.176.
2. For a salutary warning about the problems of discussing colour in paintings, see Gage 1969, p.9. I am indebted to Robert Ratcliffe for emphasising, over the years, the need to take all these factors into account in examining paintings.
3. The first Impressionist group exhibition in 1874 was hung on walls covered with red-brown material (Burty, *La République française*, 16 April 1874, reprinted in Paris, Grand Palais, 1974, p.256); the walls of Durand-Ruel's galleries, where Monet most frequently exhibited, were likewise hung with deep red fabric. A few recent exhibitions of painters of the Impressionist circle have hung their earlier paintings on quite dark walls, for instance the first half of *Manet* in Paris in 1983 and the first small part of *Renoir* in Boston in 1985, but in each case lighter walls were adopted for the lighter-toned later canvases, thus undermining the intended effect of this lighter palette, which would have stood out so much more strongly against the dark walls on which the painters expected their paintings to be seen. In only one permanent collection have I seen Monet's work hanging on dark walls, at the University of Michigan Museum of Art, Ann Arbor, where the deep brown walls emphasise the dramatic difference of tonality between Monet's *The Thaw* of 1880 (W 565) and the landscapes of the Barbizon generation hanging in the same space.

4. This is dramatically illustrated by the photographs of half-cleaned paintings in Boston, Museum of Fine Arts, 1977, pp.8–9, and see p.10.
5. Gimpel 1963, p.156.
6. Trévise 1927, pp.49–50; Gimpel 1963, p.68.
7. Perry 1927, p.120; Gimpel 1963, pp.67, 89; Elder 1924, pp.51–2; Trévise 1927, p.50.
8. For Renoir's endless preoccupation with the stability of his colours, see e.g. Baudot 1949, p.12 and Vollard 1938, pp.216–17.
9. On the problems of colour terminology as described by an associate of the Impressionists, see Bracquemond 1885, pp.54–6.
10. Only five lists of the colours in Monet's palette seem to have survived, and these are not all specific or complete: (i) Letter to Bazille, 11 January 1869, W letter 46: 'Blanc d'argent, noir d'ivoire, bleu de cobalt, laque fine, ocre jaune, brun rouge, jaune brillant, jaune de Naples, terre de Sienne brûlée'; the letter shows that the list is not complete. (ii) Rashdall 1888, p.196: 'Viridian, emerald green, cobalt, white, laque de garance, cadmium pale and dark, burnt sienna'. (iii) Letter to Durand-Ruel, 3 June 1905: 'Blanc d'argent, jaune cadmium, vermillon, garance foncée, bleu de cobalt, vert émeraude, et c'est tout': the tetchy tone of this letter raises doubts about whether this list is complete, since use of a very restricted palette was a cherished part of the Impressionists' mythology. (iv) Tabarant 1923, pp.289–90, from the recollections of the colour-merchant Moisse, probably referring to Monet's late years: blanc d'argent, violet de cobalt clair, vert émeraude, outremer extra-fin, vermillon (rarely), jaune de cadmium clair, jaune de cadmium foncé, jaune de cadmium citron, outremer jaune citron. Moisse emphasised how different Monet's palette was from Renoir's. (v) Gimpel 1963, p.89, based on Gimpel's own observations in 1918: 'Cobalt, bleu d'outremer, violet, vermillon, ocre, orange, vert foncé, un autre vert pas très clair, jaune d'ocre, jaune d'outremer, blanc'. For the results of modern pigment analysis on two of Monet's canvases, pl.145 and W 441 (of 1877), see Roy in Wilson, Wyld and Roy 1981, and Roy 1985.
11. Lostalot 1883, p.343; letter from Pissarro to Lucien, 23 February 1887, in Pissarro 1950, pp.134–5; letter from Seurat to Fénéon, 20 June 1890, in Fénéon 1970, I, p.508.
12. For Monet's reaction to Pissarro's preaching in 1886–8, see Chapter 1 note 12; for the non-theoretical nature of his colour, see Clemenceau 1928, p.111 and Barbier 1952, p.10.
13. Mirbeau 1889, p.5; around 1882 Monet had refused to teach Paul Signac; see Geffroy 1924, I, pp.175–6, for Signac's letter requesting advice, and Rey 1931, p.132, for Monet's refusal.
14. Letter from Cézanne to Bernard, 26 May 1904, in Cézanne 1978, p.302; Perry 1927, p.120.
15. On this problem, see Gombrich 1960, 1962 edn, pp.40–5.
16. Letters from Cézanne to Pissarro, 24 June 1874 and 2 July 1876, in Cézanne 1978, pp.147, 152.
17. Rashdall 1888, p.196.
18. Shiff 1984, pp.199ff.
19. The contrast between *peinture claire* and chiaroscuro among 'realist' painters of the 1850s was brought home to me by the exhibition *The Realist Tradition*, Cleveland Museum of Art etc., 1980–2.
20. Letter to Geffroy, 8 May 1920, W letter 2348.
21. A. Piron, *Eugène Delacroix, sa vie et ses oeuvres*, Paris 1865; E. Chesneau, *Peintres et statuaires romantiques*, Paris 1880, p.201, points out that because of Piron's death his book was not distributed until 1868, and then only to Delacroix's friends; the planned ordinary edition was never produced, and Piron's material was only reprinted in Delacroix 1923.
22. T. Silvestre, *Documents nouveaux sur Eugène Delacroix*, Paris 1864 (reprinted in Silvestre 1926, I, pp.46–8); on Silvestre's account, see Johnson 1963, p.70.
23. On Bazille's enthusiasm for Delacroix, see Daulte 1952, pp.92–3; on Renoir's, see e.g. Vollard 1938, p.276. For Monet's love of Delacroix, see Elder 1924, p.51, and Fels 1929, p.198.

24. See Chapter 5 and note 21 there.
25. Thiébault-Sisson 1900; Thiébault-Sisson 1920; Elder 1924, p.39.
26. Delacroix 1980, p.881 (Journal for 23 September 1846); for a similar verdict on Constable, see W. Bürger (T. Thoré), *Trésors d'art*, Paris 1857, pp.412–13; there is no visible evidence of the influence of Constable on Monet's paintings.
27. Duret 1880 (reprinted in Duret 1885, p.97–8).
28. See Aitken and Delafond 1983, nos.112–61, for the fifty prints by Hiroshige that Monet owned; see above, Chapter 3 and note 19 there, for the question of the dates of Monet's acquisition of his Japanese prints.
29. Silvestre 1873, p.23; Gonse 1898, p.112; the story about the first Impressionist exhibition was recorded in Muther 1896, II, p.717.
30. Duret 1878 and 1880 (reprinted in Duret 1885, pp.65–8, 98–100); Duret doubtless played an important part in encouraging the Impressionists' interest in Japan, since he had travelled there in 1871–2 with Cernuschi; see his *Voyage en Asie*, Paris 1873, letter from Pissarro to Duret, 2 February 1873, in Pissarro 1980, p.78, and letter from Pissarro to de Bellio, ? c.1873, saying that he has seen Japanese *dessins chez* Duret (extract in London, Arts Council, *Hokusai*, exhibition catalogue, 1954, p.14).
31. Koechlin 1927, p.33; Gimpel 1963, p.88.
32. See L. Mancino, *L'Art*, 1875 (1), pp.335ff, quoted in Venturi 1939, II, p.301, and E. Blémont, *Le Rappel*, 9 April 1876, quoted in Geffroy 1924, I, p.83.
33. Rashdall 1888, p.196; Robinson, Diary, 5 September 1892, this extract quoted in Lewison 1963, p.211.
34. Geffroy, 'J.-B. Jongkind', in Geffroy 1892, p.64; Geffroy 1894, p.16; Pissarro, quoted in Gsell 1892, p.404; for Pissarro's later reservations about Turner, see Dewhurst 1903, p.94, Dewhurst 1904, p.61, and Pissarro 1950, pp.500–1.
35. For Monet's admiration for Corot in the later 1890s, see Chapter 2 and notes 73–4 there.
36. Crucy 1904.
37. Very small traces of ivory black have been found in one of the Gare Saint-Lazare paintings of 1877 (W 441; see Roy 1985); these serve slightly to darken the dark areas of the canvas, but their effect remains emphatically coloured, predominantly coloured with deep purples and blues. Roy's analysis shows what complex mixing of colours Monet used to achieve his effects in this canvas. A story from Monet's visit to the Creuse in 1889 illustrates his later attitude to black; Geffroy, who was with him, had left his coat somewhere in the landscape, and to his friends' amazement, Monet spotted it from afar, from a hilltop, insisting 'there's no black like that in nature' (Jourdain 1956, p.22). Pissarro and Sisley seem to have abandoned black at around the same time; Renoir still used it in *La Loge* (Courtauld Institute Galleries, London), completed early in 1874, but seems to have abandoned it soon after, using it only for a few more 'official' canvases (such as his *Portrait of Madame Charpentier and her Children* of 1878), until he took it up again regularly in the early 1890s.
38. For a discussion of the Impressionists' use of green, and for a definitive refutation of the idea that Impressionists colour involved 'optical fusion', with green suggested by juxtaposed blue and yellow touches, see Webster 1944; by far the most important colour in Monet's treatment of green foliage, throughout his career, was green of various hues; habitually he gave his foliage its vivacity by introducing gradations of green, as in Constable's precepts quoted above (p.111 and note 26), with the addition of nuances of yellow and blue to suggest the play of light and shade.
39. This canvas provides an example of the subjectivity of all descriptions of colour; my own analysis of the importance of the colour in it should be contrasted with Seitz's description of it as 'almost monochromatic' (*Monet*, 1960, p.110); on such contrasting interpretations of colour in a single painting, see also Gage 1969, p.9.
40. See pp.153–5.

41. Letters to Durand-Ruel, 11 March 1884, and Alice Hoschedé, 10 March 1884, W letters 442, 441.

42. Letters to Duret, 2 February 1884, and Alice Hoschedé, 7 February 1884 (noting the importance of blue) and 5 March 1884 ('an extraordinary, untranslatable rose-coloured tone reigns here'), W letters 403, 410, 438.

43. Letters to Alice Hoschedé, 3 February 1888, and Helleu, 10 March 1888, W letters 827, 853.

44. Thiébault-Sisson 1900; Le Roux 1889; Geffroy 1891 (reprinted in Geffroy 1892, p. 23).

45. Elder 1924, p. 71; Robinson, Diary, 23 May 1892.

46. For Delacroix and the colour of the Orient, see Johnson 1963, pp. 61ff; Fromentin, *Une Année dans le Sahel*, 1907 edn, pp. 220–34, is his most important statement about the problems of painting the Orient; though we have no evidence that Monet read Fromentin, the appearance of this book shortly before Monet's own experience of Algeria in 1861–2 may well have attracted his attention; Fromentin reached the height of his fame with his exhibits at the 1859 Salon, which Monet saw.

47. Letter from Cézanne to Pissarro, 2 July 1876, in Cézanne 1978, p. 152; Denis 1912, 1920 edn, p. 253.

48. Renoir's *Mountains of the Esterel* (Corcoran Gallery of Art, Washington, D.C.) shows a site very like that in Monet's undated *Monte Carlo seen from Roquebrune* (W 892); of the two canvases that W dates to Monet's trip with Renoir, one is dated '84', not '83' as W says (W 850); thus W 851, which is dated '83', is the only canvas that can be securely dated to this trip.

49. Rivière 1921, p. 190; Renoir 1962, p. 228.

50. See London, Arts Council, 1985, no. 56, p. 226.

51. Letter to Alice Hoschedé, 23 October 1886, W letter 721.

52. Rashdall 1888, p. 196; Blanc 1876, p. 70.

53. Bullet 1901.

54. Letter to Geffroy, 6 July 1912, W letter 2019; Fels 1929, pp. 190–1.

55. See Chapters 12 and 13.

56. Lecomte, *Revue indépendante*, 1892, pp. 4–5; on this, see above, Chapter 3, p. 46, Herbert 1984, and Levine 1976, passim.

57. Rewald, 'Signac', 1949, p. 101 (Journal for 23 August 1894).

58. Letter to Geffroy, 7 June 1912, W letter 2015.

59. Robinson, Diary, 25 April 1894, noting a story he has heard from Hamlin Garland; it appears, too, in Low 1908, p. 450.

NOTES TO CHAPTER 7

1. Vollard 1937, pp. 304–5.

2. For a discussion of the sizes of Monet's canvases, see below, note 16.

3. Thiébault-Sisson 1900; letter to Geffroy, 8 May 1920, W letter 2348.

4. Baudelaire 1965, pp. 199–200; Boudin's often-quoted comments about the value of outdoor painting, from his notebooks as quoted in Cahen 1900, must be set alongside other remarks in the same notebooks: 'Elaborate your studies, elaborate them! In front of nature or *sous l'impression*.' 'One can count as direct paintings both things done on the spot and those done when the impression is fresh' (Cahen 1900, p. 183). The existence of many small studies from these years, in watercolour, pencil and pastel, suggests that the composition of Boudin's more highly finished oils must have been a composite process, perhaps undertaken entirely in the studio from a variety of 'documents'.

5. Jongkind's letters show that he painted some small oils out of doors in the 1860s; see letters from Jongkind to Martin, 25 September 1863, 20 August 1864 and 28 August 1865, in Hefting 1969, pp. 141, 147, 158.

6. Letter to Bazille, 14 October 1864, W letter 11; it remains uncertain whether the type of work that Monet described as a 'simple *étude*' was small, rapidly brushed canvases such as W 25 and 36, or more elaborate scenes like W 28 and 35.

7. Trévise 1927, p. 126.

8. Vernet's letter to a pupil in Lhote 1946, pp. 105–7; Valenciennes's oil studies are in the Louvre; for further discussion of Valenciennes's studies, see Chapter 12, p. 193.

9. The main collection of Constable's oil sketches only entered the Victoria and Albert Museum in 1888; Allemand 1877, pp. 38–9, mentions Constable's studies of skies, of which Allemand had seen several in England..

10. Corot exhibited *The Colisseum from the Farnese Gardens* of 1826 (30 × 48cm; Musée du Louvre, Paris) at the 1849 Salon, but he probably added or altered the bank of trees on the right at this date in order to make the canvas conform more closely to Salon expectations (see Paris, Orangerie, *Corot*, 1975, pp. 20–2, no. 5).

11. Monet described his methods in painting his *Déjeuner* to Trévise (1927, pp. 121–2); see Isaacson 1972.

12. Trévise 1927, p. 122; Thiébault-Sisson 1900.

13. Letter from Dubourg to Boudin, 2 February 1867, W I, p. 444, shows that Monet was at that time finishing the canvas at Honfleur.

14. Rousseau, *An Avenue, Forêt de l'Isle-Adam*, exhibited 1894 (Musée du Louvre; see Paris, Musée du Louvre, *Théodore Rousseau*, 1967–8, p. 61, no. 40); Corot, *Volterra, looking towards the Municipio*, exhibited 1838 (Musée du Louvre; see Paris, Orangerie, *Corot*, 1975, p. 41, no. 31), and *Port of la Rochelle*, exhibited 1852 (Yale University Art Gallery).

15. Henriet 1875, p. 43; the canvas (100 × 200cm; Mesdag Museum, The Hague) now bears the date '1872', which suggests that it was reworked after its exhibition. Couture 1869, p. 40, commented that the ruse of painting out of doors in grey weather bypassed the point of landscape painting, which was to show the effects of sunlight.

16. By large paintings, I mean canvases larger than size 50 (116cm for their longer side); until he began the Water Lily Decorations in 1914, large paintings were quite exceptional for Monet, and undertaken for special reasons – for the Salon, as decorations, or as a pivot for an exhibition (on these, see Chapters 8 and 13, pp. 153–5, 206). However, the sizes of his standard-sized canvases gradually increased during his career. Until *c*.1880 most of his outdoor canvases were between 55 and 73cm for their longer side (sizes 10 to 20), with occasional more ambitious canvases of 81 to 100cm (sizes 25 to 40); in early 1882 he classed two size 40 canvases (100 × 81cm) as 'large' (letter to Durand-Ruel, 6 February 1882, W letter 234; pl. 189 was one of them), but the next month he used the term 'large' for much bigger pictures, of size 80 (150cm; letter to Durand-Ruel, 23 February 1882, W letter 249; these were pls. 186, 187 and 270). We cannot tell whether the large canvases he planned but failed to paint at Etretat in 1883 would have been size 40 or size 80 (see Chapter 13, p. 211), but in 1884 at Bordighera he made no such plans, explaining to Durand-Ruel: 'I've done no large canvases, but I have done around ten of size 30, which is a respectable size' (letter of 11 March 1884, W letter 442). Thereafter until around 1890 his landscapes generally ranged between sizes 20 and 30 (73 to 92cm for their longer side), and whole groups of paintings were of similar sizes. After 1890 he worked rather more often on size 40 canvases (100cm) and occasionally on size 50 (116cm), but only when he began his outdoor studies for the Water Lily Decorations in 1914 did he start to work out of doors regularly on a larger scale than this.

17. For his methods in these figure paintings, see Chapter 2, pp. 36–8.

18. See Chapter 8, p. 147 and note 4 there.

19. Billot 1868.

20. Le Roux 1889.

21. Geffroy 1924, II, p. 109.

22. Thiébault-Sisson, *Le Temps*, 1927.

23. On Daubigny's boat and its launching, see Henriet 1866, pp. 55ff, and Moreau-Nélaton 1925, pp. 73–8; on Monet's relations with Daubigny, see letter to Moreau-Nélaton, 14 January 1925, W letter 2587, and House, 'New Material', 1978, pp. 636–41.

24. Corot's painting of Daubigny's boat is reproduced in

25. Lanes 1964, p. 359; Manet's painting seems closer to Daubigny's etching *The Botin at Conflans (The Landscapist in his Boat)*, published in Henriet 1866.

26. Letter to Caillebotte, 14 September 1891, W letter 1432.

27. For the Argenteuil boat, see Thiébault-Sisson, *Le Temps*, 1927; for the boat of the 1890s, see Perry 1927, p. 120, Elder 1924, p. 35, Guillemot 1898, p. [1]; for Monet's boats at Giverny, see also Hoschedé 1960, I, pp. 46, 77–8.

28. For instance, Duret 1878 (reprinted in Duret 1885).

29. Duret 1880 (reprinted in Duret 1885, p. 96); Taboureux 1880.

30. Fuller 1891, p. 5; Guillemot 1898, p. [2]; Dewhurst, *Pall Mall Magazine*, 1900, p. 216; for Monet's use of the studio, see here, Chapter 8.

31. Mirbeau 1889, pp. 14, 26.

32. Fuller 1891, p. 9.

33. Geffroy 1897, p. 261 (reprinted in Geffroy 1924, I, p. 185); letters to Alice Monet, 1 April 1896, and to Alice Hoschedé, 26 April 1888, W letters 1343, 880.

34. Elder 1924, p. 35 (this story may instead refer to the freeze of 1879–80); letters to Geffroy, 26 February 1895, and to Blanche Hoschedé, 1 March 1895, W letters 1274, 1276.

35. Letters to Alice Hoschedé, 17 February 1882, and to Alice Monet, 1 April 1896 and 6 February 1897, W letters 243, 1343, 1367.

36. Maupassant 1886; for the various windows, see letter to Alice Hoschedé, 15 October 1885, W letter 590. He also painted two canvases of rain from his window on Belle-Isle in 1886, W 1120–1; see letters to Alice Hoschedé, 9 and 12 October 1886, W letters 707, 710.

37. Letter to Alice Hoschedé, 27 November 1885, W letter 631; this story is also recounted in Thiébault-Sisson, *Le Temps*, 1927 (see Chapter 2, p. 26 and note 52 there).

38. See Chapter 2, pp. 17, 25–6.

39. The tunnel which today gives access to this beach at low tide was cut after Monet's visits; the path up the cliff was derelict in 1972.

40. Valenciennes 1800, pp. 406–7; Laforgue 1903, pp. 139–40; on the Poplars, see Perry 1927, p. 121; Gimpel 1963, p. 67.

41. Haircuts, see Hoschedé 1960, I, p. 161; Vollard, see above, note 1; Blanche Hoschedé-Monet told Gerald Kelly about the canvases inscribed with the time of day (Hudson 1975, p. 14).

42. On their lighting, see Perry 1927, p. 120; on early rising, see Guillemot 1898, p. [1]; on other occasions Monet painted effects which necessitated a very early start, working from 5a.m. at Antibes in April 1888, and from 4a.m. at Giverny in May 1894 (see letters to Alice Hoschedé, 24 April 1888, and to Helleu, 10 May 1894, W letters 879, 1242). However, getting up early can have been little hardship to him, for apparently he so enjoyed the feeling of rising from bed that sometimes he went back to bed again, in order to enjoy it twice over (Joyes 1975, p. 20).

43. Letters to Alice Monet, 8 March 1896, and to Alice Hoschedé, 11 March 1889 and 19 March 1884, W letters 1331, 915, 450.

44. Letters to Alice Hoschedé, 7 April 1882 and 13 March 1884, W letters 266, 445.

45. Letters to Alice Hoschedé, 12 May 1889, and to Alice Monet, 29 March 1893, W letters 977, 1203.

46. Letters to Alice Hoschedé, 19 and 23 November 1885, W letters 624, 627.

47. Mirbeau 1889, p. 14; Trévise 1927, p. 126.

48. Letter to Alice Hoschedé, 6 April 1882, W letter 264.

49. Letters to Alice Hoschedé, 29 January, 15 February and 27 March 1884 and 14 November 1886, W letters 398, 419, 464, 746.

50. Letter to Durand-Ruel, 3 September 1886, W letter 683.

51. Perry 1927, p. 119.

52. Le Roux 1889; see also Maupassant 1886, and Mirbeau 1889, pp. 14–15.

53. Perry 1927, p. 120; letter to Alice Hoschedé, 19 November 1886, W letter 752.

54. On the wind, at Antibes, see letter to Alice Hoschedé, 12 March 1888, W letter 857; on the clouds, see Hudson 1975, p. 14.

55. Letters to Durand-Ruel, 10 December 1885 and 24 January 1893, to Alice Hoschedé, 24 February 1888, and to Blanche Hoschedé, 1 March 1895, W letters 638, 1174, 842, 1276; on the thaw, see W I, pp. 106–7, and reports in *La République française*, 1–7 January 1880.

56. Letters to Durand-Ruel, 25 November 1885, and to Alice Monet, c. 20 February 1897, W letters 630, 1372.

57. Letters to Alice Hoschedé, 18 September 1886, and to Geffroy, 24 April 1889, W letters 688, 963.

58. Letters to Alice Hoschedé, 8 December 1885, 10 November 1886, 10 February and 2 March 1888, W letters 636, 742, 842, 848.

59. Letters to Durand-Ruel, 26 April 1894, and to Alice Monet, 25 March 1896 and 30 March 1897, W letters 1239, 1340, 1387.

60. Letters to Alice Hoschedé, 8 and 9 May 1889, W letters 975–6; letter from Rollinat to Monet, 25 May 1889, in Geffroy 1924, I, pp. 202–3.

61. On the orchard, see letter to Duret, 3 October 1880, W letter 200; boats, letter to Alice Hoschedé, 10 February 1883, and to Pissarro, 27 October 1885, W letters 321, 599; logs, letter to Alice Hoschedé, 3 May 1889, W letter 971; reeds, letter from Mirbeau to Monet, ? summer 1890, in Mirbeau, *Cahiers d'aujourd'hui*, 1922, p. 167 (the painting referred to is probably *The Boat*, pl. 50, on which, see p. 37 and note 95 there); shooting range, letter to Alice Hoschedé, 6 February 1897, W letter 1367.

62. Geffroy 25 May 1887, p. 2.

63. Mirbeau 1889, p. 15; Perry 1927, p. 121.

64. Letter to Alice Hoschedé, 10 November 1886, W letter 742; see also W letter 752.

65. Letters to Alice Monet, 20 March 1895 and 29 March 1897, W letters 1286, 1386.

66. Trévise 1927, p. 126.

67. See Chapter 11.

68. Letter to Charteris, 21 June 1926, in Charteris 1927, p. 131 (not in W).

69. Letters to Murer, 28 November 1878, and to Duret, 3 October 1880, W letters 141, 197.

70. Letters to Alice Hoschedé, 13 February 1882, and to Durand-Ruel, 25 March 1882, W letters 240, 260.

71. Letters to Durand-Ruel, 31 January, 12 and 18 February 1883, W letters 311, 325, 332; Monet delivered one painting of Etretat on 27 February, but this was returned to him on 2 March, the day after the opening of the exhibition, presumably because he, or Durand-Ruel, felt that it was unsuitable for inclusion; it cannot be identified.

72. Letter to Alice Hoschedé, 26 March 1884, W letter 462.

73. See letters to Alice Hoschedé, 21 November 1885 (from Etretat), 23 and 31 October 1886 (from Belle-Isle), 27 April 1889 (from the Creuse), W letters 626, 721, 731, 965.

74. Letter to Durand-Ruel, 9 November 1886, W letter 741.

Notes to Chapter 8

1. Taboureux 1880.

2. W 52, shown at the 1865 Salon, is closely based on W 40, with a few additions; W 51, shown the same year, involved a more elaborate recreation of W 38; W 77, rejected in 1867, incorporated elements from both W 75 and W 76, and probably involved other studies as well; W 109, rejected in 1868, used elements from W 88.

3. Letters to Bazille, 14 and 16 October 1864, W letters 11, 12. Four pairs of canvases, each of a single subject and similar in size, are catalogued by W: W 26–7, 29–30, 31–2, 33–4; of these, W 26 is perhaps most likely to be one of the *études*, but I am not convinced that all the canvases in this group are rightly attributed to Monet's hand.

4. Monet's letter was quoted by Roger Marx in his notes on *Fishing Boats at Sea* in La Farge and Jaccaci 1907, p. 341. The Ville d'Avray episode must have taken place in 1866,

when Monet was living there, but it remains uncertain that *Fishing Boats at Sea* was one of this group of studio paintings, particularly since (as La Farge and Jaccaci note) it was not worked with a palette knife. In the same volume, Duret placed the picture to 1868, but agreed that it was painted in the studio. Of the three known paintings by Monet where the knife was used (see above, p. 75), *Marine, Storm* (W 86, Sterling and Francine Clark Art Institute, Williamstown) is perhaps the best candidate to be one of the 1866 memory paintings, while the rather more delicate working of *Fishing Boats at Sea* perhaps supports Duret's dating of 1868.

5. See e.g. P. Courthion (ed.), *Courbet raconté par lui-même et par ses amis*, Geneva 1948, I, pp. 165–6.

6. Fels 1929, pp. 190–1, quotes Monet's disillusion at trying to finish his 1908 Venice paintings from memory.

7. Letter to de Bellio, 25 July 1876, W letter 95; see W I, p. 57, for the Rue d'Isly; W I, p. 58, for the first Argenteuil house, with details from Thiébault-Sisson, *Le Temps*, 1927 (on the reliability of this source, see above, Chapter 7, note 37, and W I, p. 58, note 414); W I, pp. 71–2, for the second Argenteuil house.

8. Letters to Gachet, 15 February 1878, and to Charpentier, 17 January 1877, W letters 122, 101; also W I, pp. 83, 89.

9. W I, p. 94, and letter to Charpentier, 9 December 1878, W letter 142 (the first known reference to the Rue Vintimille studio); the description, first published in 1921, in Fénéon 1970, I, p. 392. On Monet's paintings for the 1880 Salon, see here, p. 153–5, 208.

10. The canvases which he spoke of finishing in a letter from Poissy to Durand-Ruel, 17 December 1881, W letter 227, did not represent subjects of Poissy, and must thus have been finished indoors; for the studio he was lent in Dieppe, see letter to Alice Hoschedé, 14 February 1882, W letter 241.

11. Letter to Durand-Ruel, 23 June 1883, W letter 361, mentions retouching canvases soon after he moved to Giverny; for description of the first studio, see Hoschedé 1960, I, pp. 52, 55; for the enlargements and alterations, see letter to Durand-Ruel, 24 December 1885, W letter 644, and letter from Robinson to Perry, 9 June 1891 (MS Museum of Fine Arts, Boston).

12. The date of the second studio, see W IV, p. 9 and note 54; for a description, see Hoschedé 1960, I, pp. 55–6; on the Water Lilies studio, see W IV, p. 84, and Hoschedé 1960, I, pp. 134–5; on the studios, see also Trévise 1927, pp. 121ff, and Geffroy 1924, II, p. 186.

13. Letters to Durand-Ruel, 2 October and 17 December 1881, W letters 224, 227. Details, here and throughout this chapter, about Monet's sales to Durand-Ruel come from the Archives Durand-Ruel, from the stock-books and the *brouillard* (day-book) of the firm.

14. No such savage conditions occurred in winter 1880–1. W includes a fourth painting of ice floes dated 1881 (W 570) and one dated 1882 (W 571), but I am not convinced that these were painted by Monet; similar doubts arise over other paintings of the frozen river and ice floes.

15. For the signature, see pp. 150–1, and Chapter 10, pp. 177–9. The great majority of apparent misdatings in Monet's work were paintings that he signed and dated many years after their execution; paintings signed late in his life can readily be identified by the handwriting of their signature, smaller and more informal than in earlier years. Few paintings that were signed and dated at or near the time of their execution can be proved to be misdated; W (I, p. 449) seems too ready to redate dated canvases without explanation. A few early paintings seem to be misdated: the finished sketch of *Déjeuner sur l'herbe* is dated 1866 though it almost certainly preceded the large version of winter 1865–6; *The Turkeys* was begun in summer 1876, and presumably dated 1877 on its inclusion in the 1877 group exhibition; and *The Tuileries, esquisse*, presumably painted in 1876, was misdated 1875 in error many years later (since it was part of Caillebotte's collection, the most likely occasion for its signing and misdating was at its acceptance for the Musée de Luxembourg in 1894–7).

16. Letter to de Bellio, 24 December 1877, W letter 112; for the suggestion that retouching was something new in 1881, see Mount 1966, p. 320.

17. Le Roux 1889; on the care with which Monet structured the Gare Saint-Lazare paintings, see also here pp. 67–8, 184. Other densely reworked canvases of the 1870s include *The Basin at Argenteuil* (pl. 143)

18. Letters to Durand-Ruel, 22, 27 and 29 July 1883, W letters 366–8; on his failure to complete any Etretat paintings for his March 1883 exhibition, see above, p. 146 and note 71 there.

19. Of the five Etretats dated '84', only one, W 907, was in circulation by the 1890s; on the rain picture, see Maupassant 1886, and above, pp. 140–1.

20. Letters to Durand-Ruel, 11 and 27 August, c. 12 September and 29 December 1886, W letters 678, 681, 684, 766; on the reworking of pl. 130, see here, p. 184.

21. On his plans to revisit Etretat, see p. 144.

22. Letter to Durand-Ruel, 27 April 1884, W letter 489.

23. Letter to Alice Hoschedé, 9 April 1884, W letter 479; letter to Durand-Ruel, 24 May 1884, W letter 497, makes it clear that he had not yet resumed outdoor work, over a month after returning home.

24. Letters to Durand-Ruel, 8 December and 9 November 1886, W letters 762, 741.

25. Details of Monet's sales to Boussod & Valadon in Rewald, *Gazette des Beaux-Arts*, 1973; Petit's records have, it seems, not survived.

26. W 1085, dated '86', and 1089, dated '87', resemble each other most closely.

27. Letter to Alice Hoschedé, 29 April 1888, W letter 882.

28. Letters to Durand-Ruel, 9, 11 and 27 October 1890, W letters 1077–9; these included W 1243 and 1245, both spring or early summer subjects.

29. Although Boussod & Valadon are not listed in the catalogue as lenders, several canvases appeared in the show which were in their hands at the time – presumably lent anonymously, since a rival dealer was mounting the exhibition: Rewald, *Gazette des Beaux-Arts*, 1973, p. 42, implies that Boussod & Valadon did not lend.

30. Letter to Durand-Ruel, 22 March 1892, W letter 1141.

31. For still life, see Chapter 2, pp. 40–3; letter to Durand-Ruel, 5 June 1883, W letter 356; see also letters to Durand-Ruel, 22 July, 26 August, 6 September, 18 October, 1 December 1883, W letters 366, 371, 373, 377, 383.

32. Letters to Durand-Ruel, 9 and 11 October 1890, W letters 1077–8.

33. See above, note 23.

34. Letter to Durand-Ruel, 19 December 1892, W letter 1173; see letter to Durand-Ruel, 22 March 1892, cited in note 30. Matters had clearly come to a head in 1891: on 22 July Durand-Ruel bought ten canvases from Monet, but only received six at once, two more following on 21 October and the last two only on 27 January 1892.

35. Letters to Alice Monet, 10 March 1901, and to Geffroy, 15 April 1901 and 15 April 1903, W letters 1616, 1632, 1692.

36. Letter to Durand-Ruel, 28 January 1909, W letter 1875; for his problems in completing this series, see House 1983.

37. M. Kahn 1904; Fitzgerald, *Brush and Pencil*, 1905, p. 187; Alexandre 1904, and Alexandre 1930, p. 29.

38. Fels 1929, pp. 190–1; letters to Bernheim-Jeune, 25 October 1908, and to Geffroy, 7 December 1908, W letters 1863a, 1869; for his regrets in 1912, see letter to Geffroy, 6 July 1912, W letter 2019; Blanche, in Hoschedé 1960, I, p. 162.

39. Letter to Durand-Ruel, 12 February 1905, W letter 1764, in reply to letter from Durand-Ruel, 11 February 1905, W IV, p. 428; one of the photographs he owned of Rouen Cathedral is reproduced in Gordon and Forge 1983, p. 173.

40. On the Grain Stacks series, see Chapter 12, pp. 197–201.

41. See House 1983.

42. Alexandre 1930, p. 29; see Alexandre 1921, pp. 104–5.

43. Letter to Durand-Ruel, 23 March 1903, W letter 1690; see also letters to Durand-Ruel, 9 February 1901, 26

October 1905 (for the Londons), 27 April 1907 (for the Water Lilies), W letters 1600, 1787, 1832.

44. Seiberling 1981, pp. 90, 205; Guillemot 1898, pp. [1], [2].

45. Letter to Durand-Ruel, 26 October 1905, W letter 1787.

46. Fitzgerald, *Brush and Pencil*, 1905, p. 185; Manet 1979, p. 23. Details of the series from W.

47. We do not know the original purpose of *Luncheon*, but Monet indicated the way he envisaged it by exhibiting it in 1876 as *Panneau décoratif*; of the Hoschedé decorations, W 432 may well have served as a study for *The Hunt*, while W 417 was clearly the study for W 418, and W 419 for W 420.

48. Letter to Duret, 8 March 1880, W letter 173.

49. The elements of *Lavacourt* all appear in either W 475 or W 539.

50. Letter to Durand-Ruel, 23 February 1882, W letter 249.

51. Durand-Ruel's records show that pl. 189 and W 684 were the two 'large canvases' which Monet sent Durand-Ruel in February 1882 (see letter to Durand-Ruel, 6 February 1882, W letter 234); for discussion of what Monet meant by 'large canvases', see Chapter 7, note 16.

52. Letters to Alice Hoschedé, 2, 7, 8 and 12 February 1883, W letters 313, 318–19, 324.

53. Letter to Berthe Morisot, 30 March 1884, for his initial promise to Morisot, see Rouart 1950, pp. 117, 119; for the fact that the original plan involved a L'Estaque subject, see letter to Alice Hoschedé, 26 March 1884, W letter 462.

54. Letters to Durand-Ruel, 17 and 24 December 1885, W letters 642, 644.

55. On the figure paintings and the questions about their execution, see Chapter 2, pp. 36–8.

56. A photograph of 1915 (W IV, p. 71) shows him at work out of doors on W 1795, a canvas of 160 × 180 cm. For discussion of the execution of the Water Lily Decorations, see W IV, Gordon and Stuckey 1979, and Stuckey 1979; however, no thorough study has yet been made of the likely role of the smaller canvases in the execution of the Decorations.

57. Letter from Renoir to Madame Charpentier, January/February 1882, in M. Florisoone, 'Renoir et la famille Charpentier', *L'Amour de l'art*, February 1938, p. 36; letter from Renoir to Durand-Ruel, 27 September 1883, in Venturi 1939, I, p. 125.

58. Letters from Renoir to Durand-Ruel, 25 March 1891 and ?1890, in Venturi 1939, I, pp. 145, 130 (the latter, dated by Venturi to 1884, probably belongs to 1890, the only year in which Renoir can be proved to have visited La Rochelle; on this, see London, Arts Council, 1985, p. 304).

59. Gsell 1892, p. 404.

60. R. de la Villehervé, 'Choses du Havre, les dernières semaines du peintre Camille Pissarro', *Havre Éclair*, 25 September 1904.

NOTES TO CHAPTER 9

1. Letter to Geffroy, 28 March 1893, W letter 1201.

2. This subject has been discussed at length in Boime 1971. This pioneering study treats many problems which are vital for an understanding of the period, but it is marred by a tendency to over-interpret evidence, and to force its material into over-rigid frameworks – for instance in discussion of the relationships between Impressionist painting and academic practice. Moreover, Boime's visual arguments are much damaged by his failure to mention the sizes of any of the paintings he discusses – a crucial issue in any discussion of this sort. On Monet, see especially Boime 1971, pp. 62–4, 75–6, 156.

3. Paillot de Montabert 1829, I, pp. 157, 201, 258.

4. Valenciennes 1800, p. 404; Paillot de Montabert 1829, I, pp. 158–9.

5. See Chapter 4, pp. 65–9.

6. Adéline 1884, p. 193; Hareux 1908, p. 38.

7. [Anon.], *Dictionnaire*, V, p. 311, s.v. *étude* (this issue published 1896).

8. Couture, undated letter, in Couture 1932, p. 89.

9. Arsenne 1833, pp. 155–6; Allemand 1877, p. 32.

10. Adéline 1884, pp. 189–90.

11. [Anon.], *Dictionnaire*, V, p. 306, s.v. *esquisse*.

12. Burnet 1835, p. 72 (quoted here in my translation from the French edition); for the fact that Delacroix read this, see Johnson 1963, p. 72.

13. Henriet 1875, p. 46; D.W. Tryon, 'Daubigny', in Van Dyke 1896, p. 161.

14. Allemand 1877, p. 31.

15. Robert 1878, p. 81; see Robert 1891, p. 145.

16. Moreau-Nélaton 1925, p. 81, quotes Gautier's comments; the full critical history of the term *impression* has still to be written; see particularly Brunius 1972, pp. 100–3, and Shiff 1984, pp. 14–20.

17. Letter to Bazille, 15 July 1864, W letter 8; Monet reported Troyon's advice in a letter to Boudin, 19 May 1859, W letter 1.

18. Monet described his early procedure to Trévise (1927, p. 122); he wrote of completing his *études* for sale to Bazille, 16 October 1864, W letter 12, but without making it clear how much reworking would be needed to make them saleable; see also W letter 11.

19. Letters to Alice Hoschedé, 6 April 1882 and 13 March 1884, W letters 264, 445; see also letter to de Bellio, 23 September 1878, W letter 139.

20. Clemenceau 1928, p. 49; on the *études* for the Decorations, see also Howard-Johnson 1969, p. 31.

21. The only Creuse painting which Clemenceau can be proved to have owned is W 1228, the celebrated *Bloc*; Monet gave him this in 1899 (see W IV, p. 11 and note 72 there); there is no obvious candidate for identification as the painting Clemenceau lent for the 1891 exhibition.

22. Gimpel 1963, p. 348 (Diary for 23 September 1927).

23. Letter to Durand-Ruel, 27 April 1907, W letter 1832; on Monet's problems with this series, see House 1983.

24. Of the two canvases of Rouen Cathedral seen from virtually due west, W 1320 is not fully finished, while W 1319 reached its present form after much revision (see p. 191); for his omission of Cleopatra's Needle from all except pl. 92 and W 1543 in the Charing Cross Bridge series, see pp. 60–1.

25. Letters to May, 10 December 1878, and to Durand-Ruel, 4 March 1910 (the painting referred to here is pl. 91) and 27 March 1920, W letters 143, 1915, 2341.

26. Trévise 1927, p. 50.

27. Letters to Durand-Ruel, 30 June 1891 and 22 January 1886, W letters 1116, 650.

28. Duranty 1876 (reprinted in Duranty 1946, p. 50); Paillet, quoted in Wilhelm 1962, p. 520.

29. Monet's *carnets* are preserved in the Musée Marmottan, Paris; details in this chapter are taken from the original MS, which, though used by W, has not been fully published; Zola 1880 (reprinted in Zola 1970, p. 341).

30. Rivière 1877, p. 5.

31. The two *esquisses*, W 447 and 448, were both among the canvases which the French state did not retain from the Caillebotte collection, unlike the *tableau*. The account of Caillebotte's collection in *L'Art français*, 24 March 1894, mentions two other *esquisses* by Monet which Caillebotte owned, 'trees in flower, trees in winter', which may perhaps be identified as W 519 and 437. The comparatively large proportion of *esquisses* in Caillebotte's collection, though typical of an artist's collection, may have contributed to the state's reluctance to accept it in its entirety after Caillebotte's death in 1894 (on the bequest, see Vaisse 1983, and Berhaut 1983).

32. The Vernon *esquisse* was either W 842 or W 1060; the sketchy quality of W 1060 perhaps makes it more likely to be the painting in question. Other possible examples of *esquisses* owned by fellow artists are W 713, owned by J.-E. Blanche, and W 715, owned by Helleu.

33. Letters to Durand-Ruel, 11 April 1884 and 29 November 1885, W letters 481, 633.

34. Letters to Alice Hoschedé, 26 March 1884, W letter 461.

35. W letters 650, 2341 (see above, notes 27, 25).

36. Geffroy 1924, II, p. 185; it was, though, presumably the same type of canvases that Gimpel saw in Monet's studio

37. Letters to Durand-Ruel, 9 February 1883, and to Alice Hoschedé, 17 November 1886, W letters 320, 750; the portrait of Paul is W 744.

38. Letter to Bazille, 25 September 1869, W letter 53; from a photograph of the lost version hanging alongside other paintings in the Arnhold Collection (Gordon and Forge 1983, p. 45), its size can be measured as 60 × 100 cm – no larger than the surviving pictures; however, its brushwork does seem to have been rather more refined, its surface more densely worked, though (if indeed it was submitted to the Salon jury in 1870) it must have seemed startlingly abbreviated for a finished painting at the time of its execution.

39. *Pochade Argenteuil* (pl. 142, W 233); *Pochade marine* (W 72, Ordrupgaardsamlingen, Copenhagen); *View of the Plain of Argenteuil* (W 220, Musée d'Orsay, Paris).

40. Robinson, Diary, 30 November 1892; Boussod & Valadon at this date had five snow scenes by Monet in stock, W 254, 255, 349, 351 and 352; the sketchy quality of pl. 202 (W 349) makes it the most likely candidate to be the *pochade*.

41. Letters to Alice Hoschedé, 12 February 1883 and 6 May 1889, W letters 324, 974; neither of these can be identified with confidence.

42. Letters to Alice Hoschedé, 13 October 1886, and to Durand-Ruel, 17 October 1886, W letters 711, 715; on his need for fresh canvases for his *pochades*, see letters 708, 730.

43. Letters to Alice Hoschedé, 14, 17 and 30 October 1886, W letters 712, 714, 730.

44. The most obvious candidates to be the *pochades*, W 1112, 1117 (pl. 108) and 1119, are all on canvases of size 20 (60 × 73 cm), whereas most of the Belle-Isle canvases measure 65 × 81 (size 25).

45. Noirmoutier, see letter to Alice Hoschedé, 28 November 1886, W letter 760; Menton *pochades*, see letter to Alice Hoschedé, 26 March 1884, W letter 461; see letter to Alice Hoschedé, 12 April 1884, W letter 484, for his decision to try to finish something at Menton.

46. We have no evidence of when Mirbeau acquired pl. 108, but Monet may well have left it with him on Noirmoutier; for Mallarmé's *pochade*, see letter to Mallarmé, 12 October 1889, W letter 1007; the painting he gave Mallarmé, W 912, an 1884 view of the Seine, is less highly worked than W 909–11 or 913, each of which shows a very similar subject.

47. Guillemot 1898, p. [1].

48. Charteris 1927, pp. 129, 131.

49. *Marine (impression)*, shown in 1886, cannot be identified.

50. Letters to Alice Monet, 15 March 1895 and 10 March 1901, W letters 1283, 1616.

51. For the *ébauche*, see Chapter 4, pp. 65–9; for critics' comments that the Impressionists' paintings were nothing more than *ébauches*, see for instance reviews of the 1874 group exhibition by Cardon, Castagnary and Chesneau (all reprinted in Paris, Grand Palais, 1974, pp. 262–9).

52. Letters to Nadar, 2 January 1900, and to Burty, 22 March 1883, W letters 1489, 342. The picture given to Burty cannot be identified.

53. Letter to Alice Hoschedé, 27 March 1884, W letter 464; Trévise 1927, p. 50; Hoschedé 1960, I, p. 113.

54. Le Roux 1889.

55. The fullest version of the story, though with impossible dates, is in Clemenceau 1928, pp. 64–5; see also Gimpel 1963, p. 155 (Diary for 1 February 1920), for the 'all white' comment, and Arnyvelde 1914, p. 38.

56. Robinson, Diary, 14 September 1892.

57. Letters to Durand-Ruel, 16 September 1885, and to Alice Hoschedé, 19 November 1886, W letters 585, 752; Perry 1927, p. 121.

58. New York, American Art Association, Fitzgerald Sale, 21–2 April 1927, lot 97, entry in catalogue; Fitzgerald, *Brush and Pencil*, 1905, p. 181, speaks of a day spent at Giverny in 1900, and the painting (W 1028) may have been bought then.

in 1918 and adjudged 'flat and colourless . . . preparatory work' (Gimpel 1963, p. 67; see above, p. 68).

59. See note 1 above.
60. Robinson, Diary, 10 August 1892; Fuller 1899, p. 23; letter to Geffroy, 7 October 1890, W letter 1076.
61. Letter to Durand-Ruel, 26 September 1882, W letter 290.
62. Letter to Durand-Ruel, 1 December 1883, W letter 383; see also Arnyvelde 1914, p. 37, and Trévise 1927, p.134.
63. Letters to Durand-Ruel, 24 October and 3 November 1884, W letters 526–7; Adéline 1884, p. 264.
64. Letters to Durand-Ruel, 9 November 1886, and to Alice Hoschedé, 16 March 1888, W letters 741, 858.
65. Letter to Durand-Ruel, 22 March 1892, W letter 1141 (see above, pp.150–1); Bullet 1901.
66. See Chapter 5, p. 102, and Chapter 10, p. 170.
67. Couture 1932, p.107; Delacroix 1980, pp.137, 327 (Journal for 1 March 1847, 13 April 1853; see also 20 April 1853); letter from Pissarro to Lucien, 4 December 1895, in Pissarro 1950, p. 391.
68. Robinson, Diary, 3 June 1892; this account is discussed further in Chapters 12 and 14, pp. 200–1, 220ff.
69. See p. 158 and note 16 above.
70. Letter to Duret, 8 March 1880, W letter 173; on this, see pp.153–4, 208.
71. Zola 1880 (reprinted in Zola 1970, p. 341).
72. Huysmans 1883, pp. 268–9; Burty 1883; letter to Alice Hoschedé, 12 March 1884, W letter 444; characteristic discussions of Huysmans's 'change of heart' are in Rewald 1973, p. 473, and Reuterswärd 1950.
73. Letter to de Bellio, 8 January 1880, W letter 170; details of Monet's sales from his *carnets*; his prices reached their nadir in December 1877, when in a single transaction he sold Murer five *pochades* for 125 francs in all, and four *toiles* for 200 francs in all.
74. Trévise 1927, p.134; see also Arnyvelde 1914, p. 37, and Bullet 1901.

NOTES TO CHAPTER 10

1. Geffroy 2 June 1887, p. 2; see above, Chapter 4, p.69.
2. See pp. 102, 191.
3. Hoschedé, 1960, I, p.76; Geffroy 1924, II, p.186; Fels 1929, pp.197–8.
4. Goulinat 1927, p. 28.
5. Hoschedé 1960, I, pp.56, 113; the canvas which he is retouching in this photograph, pl. 212 here, is W 1779.
6. Clemenceau 1928, p.49; Geffroy 1924, II, pp.185–6.
7. Letter to Durand-Ruel, 27 April 1884, W letter 489.
8. Fels 1929, p.192; the existence of many Norway canvases which Monet left unfinished at his death (e.g. pl. 87, 100) suggests that he retained the hope that he might be able to make something of them after his return to France.
9. See Vollard 1938, pp. 213, 267.
10. On the wind, see letters to Alice Hoschedé, 10, 12 and 16 March 1888, W letters 856–8; on his attempts to rework his paintings at the end of his stay, after the wind dropped, see letters to Alice Hoschedé, 11, 13, 14, 16 and 18 April 1888, W letters 769–74.
11. Perry 1927, p. 120; on this, see above, p. 143.
12. Letter to Duret, 30 April 1886. W letter 671; on the consistent weather, see Trévise 1927, pp. 126–7.
13. See pp. 90, 125.
14. Letter to Geffroy, 7 October 1890, W letter 1076; on the Grain Stacks, see also pp.197–201.
15. See Chapter 8, pp.151–3.
16. See Chapter 11, pp.190–1.
17. Hoschedé 1960, I, p.113, and Fuller 1891, p.9, describe his normal practice; for retouches added when signing, see above, p.148 (this regularly happened in later years, too).
18. For signing earlier paintings late in his life, see e.g. letters to Durand-Ruel, 26 March 1917 and 20 November 1923, W letters 2220, 2543. One of the few examples of paintings sold without signatures was the pair of paintings of girls in boats bought by Gimpel in 1926 (pl.191 and W 1249); Gimpel refused to leave them with Monet for signing, for fear that he would change his mind about the sale, since, Gimpel was told, 'he finds it more difficult to sign than to paint' (Gimpel 1963, pp. 318–19).

19. Two of the elongated canvases of flowers which he executed for Durand-Ruel in the mid-1880s are signed vertically (W 919, 950), and one landscape, a southern canvas of 1884 (W 894) which Monet only signed in 1920: in an 1878 still life (W 492) signature and date are placed separately, at either side of the wall above the table top on which the vase of flowers is placed.
20. This effect was wholly deliberate, for the paint of the crossing of the 't' was applied in two separate strokes.
21. Gsell 1927, p. 80.
22. On his use of carmine, see pp.115–17, 124.
23. The other two canvases are W 565 and 609; the delicacy of these effects suggests that they were deliberate, rather than merely the result of chance colours left on the brush.
24. W 1680, 1687.
25. Of the paintings dating from 1876 onwards, very approximately one quarter of those examined seem to have been retouched at a late stage in their execution with the same colour as that used for the signature, but far more often the colour of the signature was decided independently of the retouches.
26. Fénéon, *Signac*, 1890 (reprinted in Fénéon 1970, I, p.177); Pissarro's two-coloured signature can be seen in an 1886 canvas (Pissarro and Venturi 1939, no.696), and in certain earlier paintings which seem to have been signed at around this period (e.g. Pissarro and Venturi 1939, no.285).
27. In this sense, the absorption of the signature into the overall harmony can be compared with the suppression of the brand name in advertisements for particularly famous products (such as Schweppes, Guinness, Benson and Hedges).
28. 1868, see letter from Martin to Boudin, 1 March 1868, W I, p. 444; letter to Durand-Ruel, 12 February 1883, W letter 325; the frames at Giverny can be seen in film taken there by John Read in summer 1975. Presumably Monet sent his canvases to Paris unframed, and they were reframed there for exhibition or sale.
29. Quoted in Paris, Grand Palais, *Millet*, 1975–6, p.123, s.v. no.82, from the account of Edward Wheelwright.
30. See Chapter 5, p.102.
31. In some of the monumental canvases that Monet did not complete, the animated brushmarks do disrupt the overall coherence of the effect and the legibility of the space depicted (for instance, up the centre of W 1978, in the National Gallery, London).
32. Delacroix 1980, pp.611, 626 (Journal for 13 and 25 January 1857).
33. See note 1 above.
34. Letter to Geffroy, 7 June 1912, W letter 2015.

NOTES TO CHAPTER 11

1. In Ratcliffe 1961.
2. X-ray analysis has so far largely been confined to Monet's earlier paintings; see Adhémar 1958, Isaacson 1972, Hours 1974, and Sapego 1969. The evidence provided by pl. 208 suggests how much might be learned from X-ray examination of his later paintings.
3. On several occasions Monet mentioned in his letters that he had scraped out paintings; see letters to Durand-Ruel, 18 September 1882, and to Alice Hoschedé, 7 March 1882, 20 October 1886 and 25 January 1888, W letters 288, 253, 718, 817. Scraped areas that have not been repainted appear in *Autumn Effect at Argenteuil* (pl.72), in the foliage of the tree on the right and, less visibly, in the bank of autumnal trees on the left, and in *Entrance to the Village of Vétheuil in Winter* (W 509; Museum of Fine Arts, Boston), on the verge to the right of the road near the centre of the picture.
4. Trévise 1927, p. 50.
5. The following are clear examples of reused canvases: W 51 (originally a still life with a pitcher), 134 (pl. 71), 151, 152, 233 (pl.142), 263 (pl.199, discussed here), 330, 447 (pl.197, discussed here), 469 (pl.120), 477, 506 (pl. 22), 533, 553, 565, 881 (from Bordighera in 1884, originally a

scene with lavish palm trees), 1099 (from Belle-Isle, 1886) and 1190 (from Antibes).
6. For instance, pl. 206, where the lines of the mountains were originally quite different, and W 1221, from the Creuse.
7. Its original arrangement was similar to W 1174; for his fears of repeating himself, see letter to Alice Hoschedé, 17 January 1888, W letter 808, and here, p.196.
8. Letter to Alice Monet, 29 February 1896, W letter 1328.
9. Other Pourville cliff scenes, e.g. W 751 and 752, show comparable changes.
10. This second version, pl. 233, is only lightly and rapidly worked, whereas pl. 232 is fully and elaborately finished.
11. Described in Chapter 4, pp.65ff.
12. See Chapter 7.
13. See p.145 and note 61 there, for his problems with moving boats.
14. See p.145 and note 57 there.
15. Letters to Durand-Ruel, 3, 5, 21 December 1890, and 21 January 1891, W letters 1083–4, 1088, 1096; on the Grain Stacks, see pp.197–201.
16. The underlying position can be clearly detected when the canvas is viewed in raking light, but its exact angle would presumably appear more clearly in X-ray.
17. W III, p. 46; for the implications of the exhibition of *The Portal, Front View*, see here, p. 216.
18. The placing of Charing Cross Bridge was moved in W 1530, of Waterloo Bridge in W 1588 and 1589, and of the Houses of Parliament in W 1614.
19. [Anon.], *The Standard*, 1908; the Japanese Bridge canvas with the moved bridge is W 1516 (National Gallery, London).
20. The original colour scheme of the canvas in the National Gallery, London (W 1978), was originally in greens and blues, as can be seen around its bottom right corner.
21. Le Bail, quoted in Rewald, *Impressionism*, 1973, p.479, note 31; Perry 1927, p.121.

NOTES TO CHAPTER 12

1. Letter to de Bellio, 20 June 1876, W letter 90; before this, critics had used the term to describe Monet's work: Zola in 1868 mentioned his 'series of canvases painted in gardens' (Zola 1970, p.154), and Pothey in 1876 described his submission to the second Impressionist group exhibition as 'a series of landscapes painted from nature at Petit-Gennevilliers or in the surroundings of Argenteuil' (*La Presse*, 31 March 1876, reprinted in Geffroy 1924, I, p. 80).
2. Letters to Duret, 3 October 1880, to Durand-Ruel, 12 January 1884, and to Alice Hoschedé, 4 February 1884, W letters 200, 388, 405.
3. Letters to Durand-Ruel, 20 January 1885 and c.25 April 1885, W letters 543, 563; the winter scenes in question are presumably W 961–8 (the last four of these show the identical scene), the spring scenes W 980–8.
4. On Turner's Norham Castle, see London, Royal Academy of Arts, *Turner*, 1974–5, pp.172–4.
5. Valenciennes 1800, p.409.
6. London, Heim Gallery, *Paul Huet*, 1969, nos.97 A–I, showing the Bay of the Trépassés, apparently all executed during sunset on a single evening; for Turner's Rigi, see London, Royal Academy of Arts, *Turner*, 1974–5, pp.164–7, and Ruskin's account quoted there; it is uncertain which (if any) of the Turners were executed out of doors; even the most summary of them (nos. 594, 597–8) may be improvisations based on notes or memory.
7. It is unclear whether the Rigis were shown together as such (see Ruskin, cited in note 6); on Tabley House, see London, Royal Academy of Arts, *Turner*, 1974–5, pp.70–3.
8. For the Fontainebleau forest views, see Paris, Musée du Louvre, *Théodore Rousseau*, p. 59; They were not painted out of doors, and there are discrepancies between their backgrounds; for Rousseau's demonstration, see Burty, quoted in Véron 1878, p. 304, note 1.

9. On the problems of the status of Daubigny's replicas and repeats, see Lanes 1964, p. 458 and especially note 10 there; Daubigny's working methods need detailed examination.

10. On Jongkind's outdoor work, see Chapter 7 and note 5 there; on his Notre Dame views, and the liberties he was willing to take with his subject, see letter from Jongkind to Bascle, 13 July 1864, in Hefting 1969, p. 144. For his three Notre Dame views, see Hefting 1975, nos. 263 (1863), 292–3 (1864); in 1864–6 he painted at least six oils of the view out of Honfleur Harbour, with only slight variations of viewpoint (Hefting 1975, nos. 295, 341–3, 346, 384), but discussion of groups of paintings like these is complicated by the existence of related drawings and watercolours (e.g. Hefting 1975, nos. 275 [1863], 352–4, 365). Jongkind's working methods also need detailed examination.

11. In an autobiographical note of the 1860s, Courbet stated that he produced 'by series' when he tackled a subject relating to modern society, and Proudhon spoke of Courbet's fascination with series (quoted in P. Courthion (ed.), *Courbet raconté par lui-même et par ses amis*, I, Geneva 1948, pp. 30–1, 177); I am grateful to Alan Bowness for emphasising the relevance of Courbet's 1867 exhibition.

12. For Monet's Japanese collection, see Aitken and Delafond 1983; he owned nine of Hokusai's *36 Views of Mount Fuji*, and the three volumes of his *100 Views of Mount Fuji*; the two versions of Hiroshige's *The Isle of Tsukuda* are Aitken and Delafond 1983, nos. 125–6; we do not know when he acquired them, and he may have bought them late in his life, in recognition of their similarity to his own methods.

13. For the studies and related paintings, see Chapter 8, p. 147 and note 3 there.

14. The most unequivocal such pairs from the later 1860s and early 1870s are W 91–2, 156–7 and 296–7 (pl. 200); few of the Argenteuil paintings can be so closely paired, because of uncertainties about dates, minor variations of viewpoint, and discrepancies in their treatment, but e.g. W 318–19 (pls. 241, 242) are clearly one such pair.

15. At the 1870 Salon, Sisley showed a pair of views of the Canal Saint-Martin, though not seen from identical viewpoints (Daulte 1959, nos. 16–17); like Monet's, his paintings of the early 1870s are hard to date precisely, but a few clear pairs emerge, such as Daulte 1959, nos. 22–3, 71–2.

16. E.g. W 426–7, 429 (W 428 shows the same scene, but I am unconvinced by its attribution to Monet); W 450–3; W 459–61.

17. These are W 552–74; I am not convinced of the attribution to Monet of certain paintings in this group; see p. 148 for the problems raised by those dated 1881.

18. W's reasons for dividing these paintings between Monet's two visits to Pourville in 1882 are often unclear; the views of the beach looking west are W 709–13, 776–86; of the church, W 725–7; of the cottage, W 730–43, 803–5.

19. Maupassant 1886; Le Roux 1889.

20. Letters to Alice Hoschedé, 24 October 1885, and to Pissarro, 27 October 1885, W letters 597, 599.

21. See p. 193 and note 2 there.

22. Geffroy 2 June 1887, p. 2; Geffroy 1894, p. 75.

23. Letters to Alice Hoschedé, 22 and 29 September 1886, W letters 691, 699.

24. Letter to Alice Hoschedé, 30 October 1886, W letter 730.

25. He painted the view of the old town of Antibes at least six times (W 1158–62 and canvas in Museum of Fine Arts, Boston, no. 1978.634; W 1163 shows the same view, but I am unconvinced by its attribution to Monet).

26. Letters to Alice Hoschedé, 19 and 17 January 1888, W letters 810, 808.

27. Mirbeau 1889, p. 15.

28. Letter to Geffroy, 26 February 1895, W letter 1274; for the variety of sites he painted in Norway, see letter to Blanche Hoschedé, 1 March 1895, W letter 1276.

29. The Canal du Loing, Daulte 1959, nos. 518, 533, 609–16; of the Moret views of the late 1880s, Daulte 1959, nos.

656–60 are the most closely integrated, being distinguished by variations of weather alone.

30. *La Cravache*, 15 December 1888, reprinted in Fénéon 1970, I, p. 133.

31. The principal accounts of the genesis of the Grain Stacks series are: Geffroy 1891 (reprinted in Geffroy 1892; not very explicit in its details, but presumably based on conversations with Monet); Alexandre 1921, p. 95; Trévise 1927, p. 126; Thiébault-Sisson, *Le Temps*, 1927; Fels 1929, pp. 179–80; Barotte 1942. It seems likely that all of these accounts are independent of each other, and each based on conversations with Monet or Blanche Hoschedé. Alexandre speaks of the summer, Thiébault-Sisson of the autumn; de Fels of a single stack, Trévise of 'stacks which made a magnificent group'; Trévise suggests that Monet was already painting stacks, while Alexandre and de Fels suggest that the experience took place on his first day of work on the subject.

32. On the significance of the subject, see p. 28; Pissarro's grain stacks paintings include London, Sotheby, 30 April 1969, lot 24 (1878 painting), and Pissarro and Venturi 1939, no. 589 (1883 painting).

33. Pl. 247 was either no. 126 or 127 in the 1889 exhibition; in his review of this exhibition, Verhaeren mentions nos. 126 and 127 being of identical subjects (reprinted in Verhaeren 1927, p. 186); the second canvas shown was W 1213 or 1214. Their titles in the exhibition catalogue (*Hoar Frost, Sunrise*, and *Before Sunrise: Hoar Frost*) do not mention the grain stacks, which suggests that Monet attributed no great significance to their presence.

34. Letter to Geffroy, 22 June 1890, W letter 1060; on these figure paintings, see pp. 36–8.

35. See p. 98.

36. Clemenceau 1895 (reprinted in Clemenceau 1928, p. 85); for the four easels, see Clemenceau 1928, pp. 77, 79.

37. Hoschedé 1960, II, p. 53; on the remarkable circumstances of Jean-Pierre Hoschedé's birth, on an express train from Paris to Biarritz on 20 August 1878, see W I, p. 83 and note 595 there.

38. Letter to Geffroy, 7 October 1890, W letter 1076. Geffroy 1924, II, pp. 186–7, publishes a letter from Mallarmé dated to 9 July 1890, in which the poet praises the Grain Stacks; this should presumably be redated to 1891, and is probably a belated response to the exhibition of the paintings (see Mallarmé 1973, IV (1), p. 119 and notes 1–2 there); Monet's letter to Mallarmé of 28 July 1891 (W letter 1121) would then be a reply to this letter.

39. Alexandre 1921, p. 95.

40. On *Vétheuil in the Fog*, see pp. 162–4, 221–2. The time-sequence of Thiébault-Sisson's account (*Le Temps*, 1927) is: (a) the painting of Vernon Church; (b) the Grain Stacks, 'ten or twelve years afterwards, . . . having settled at Giverny, after a spell of around ten years at Vétheuil'. The true sequence was: (a) 1878–81, living at Vétheuil; *Vétheuil in the Fog* painted in 1879; (b) 1883, move to Giverny, and first paintings of nearby Vernon Church, in clear weather (pl. 40 and W 844); (c) 1890–1, series of Grain Stacks; (d) 1893–4, series of Vernon Church in the fog (including pl. 41). Presumably Thiébault-Sisson mis-recorded the single, crucial canvas as a view of Vernon, not Vétheuil, by confusion with this later series.

41. Letter from Rollinat to Monet, January 1891, in Rollinat 1919, pp. 279–80; Geffroy 1891 (reprinted in Geffroy 1892, pp. 23–4).

42. It happened before his letter to Geffroy of 7 October (W letter 1076), quoted above, and presumably after his letters to Mallarmé and Morisot of 22 September (W letters 1073–4), in which he described the recent set of interruptions to his work.

43. Letters to Durand-Ruel, 5 December 1890 and 21 January 1891, W letters 1083, 1096.

44. For Boussod & Valadon's purchases, see Rewald, *Gazette des Beaux-Arts*, 1973; the late summer canvas is W 1267, the snow scenes W 1276 and ?1275.

45. The drawing (reprinted Mirbeau 1891, p. 183) had not been begun on 4 January 1891 (W letter 1093), and was presumably finished before Monet sold the canvas to

Boussod & Valadon on 5 February: on Monet's drawings, see below, Appendix A.

46. Letters from Pissarro to Lucien, 3 and 9 April 1891, in Pissarro 1950, pp. 230–1; on the contents of the exhibition, see here, p. 215.

47. Three of those dated '89' belong to the first small group of canvases of which two were exhibited in summer 1889 (W 1213–15); the fourth dated '89' (W 1216) was only signed and dated very late in Monet's life; this, and the closely related undated W 1217, may well belong to the main group begun in 1890, rather than to 1889 where W places them.

48. Kandinsky, *Rückblicke*, 1913 (reprinted in R. L. Herbert (ed.), *Modern Artists on Art*, Englewood Cliffs, N.J., 1964, p. 26).

49. Guillemot 1898, p. [1].

50. Letter to Durand-Ruel, 9 November 1886, W letter 741; on this see Chapters 8 and 9.

51. Bijvanck 1892, p. 177.

52. On the final state of the paintings, see pp. 98–100, 127–8; on their exhibition, see pp. 213–15; for retouching after the exhibition, see letters to Durand-Ruel, 19, 30 June and 6 July 1891, W letters 1114, 1116–17.

53. Robinson, Diary, 3 June 1892: for further discussion of these 'more serious qualities', see Chapter 14.

54. The story of the Poplars is recorded by Elder 1924, p. 12, and Gimpel 1963, pp. 318–19 (Diary for 17 July 1926); historical details in W III, p. 43 and note 1047: the public sale of the trees was decided on 18 June 1891, and took place on 2 August; Monet clearly paid for them to remain standing for several months after this, but it is unclear whether he began to paint the trees before 18 June; the fact that one of the canvases (W 1304) was exhibited in 1892 as *The Three Trees, Spring* may suggest that he did.

55. Letters to Mallarmé, 28 July 1891, and to Durand-Ruel, 20 October 1891, W letters 1121, 1123.

56. In both the Norway and Pourville series, Monet painted several different types of view, and of the Venice paintings he wrote to the Bernheim Jeune brothers (8 April 1912, W letter 2001d): 'There is no series among my views of Venice, but only different motifs repeated once, twice or thrice.'

57. Letters to Blanche Hoschedé, 1 March 1895, and to Alice Monet, 8 March 1896, W letters 1276, 1331.

58. Letter to Blanche Hoschedé, 4 March 1900, W letter 1522; Trévise 1927, p. 126, recorded that he had a hundred of a single motif. Around a hundred in all exist today, but Monet may have destroyed others which did not satisfy him (see Cortissoz 1925, p. 262); however, the survival of many London canvases in a quite scrappy state (notably pl. 98) suggests that he may have destroyed fewer of this series than of some others, such as the 1903–9 Water Lilies (on which see above, p. 159).

59. Guillemot 1898, p. [1], pointed out the distinction between summer and winter series; the summer sequence is: Early Mornings on the Seine, Giverny pond and garden, Vétheuil and Water Lilies; the winter sequence: Norway, Pourville, London and Venice.

60. Letter to Alice Monet, 20 March 1895, W letter 1286; Perry 1927, p. 120, described his reasons for choosing a dawn effect, because it changed less quickly, and thus he could take his paintings further (see above, p. 143).

61. Letter from Pissarro to Mirbeau, ? early April 1892, in Kunstler 1930, p. 226; letter from Pissarro to Lucien, 1 June 1895, in Pissarro 1950, p. 382.

62. See Chapter 14, pp. 220ff, for further discussion of the *enveloppe* and 'more serious qualities'.

Notes to Chapter 13

1. Monet's contributions to the Impressionist group exhibitions are listed in Venturi 1939, II; the whole catalogues of these exhibitions have been republished in Reff 1981 and San Francisco, Fine Art Museums, 1986. W I–IV includes abbreviated details of the paintings which Monet

exhibited during his lifetime, though some of W's identifications of exhibited paintings are questionable.

2. Letter to Gustav Pauli, 7 May 1906, W letter 1803.

3. *The Port of Honfleur* (W 77) was rejected in 1867, along with *Women in the Garden*; in 1868 *Boats leaving the Port of Le Havre* (W 89; picture lost) was accepted, *The Jetty of Le Havre* (pl. 259, W 109) rejected; it is uncertain which were the two paintings rejected in 1869: W's assertion that they were *Fishing Boats at Sea* (pl. 182, W 126) and *The Magpie* (pl. 168, W 133) remains unproven.

4. On Monet's reputation as a painter of modern subjects in the late 1860s, see pp. 15–16; the evidence about the display of Monet's work in dealer's windows is summarised in W I, p. 36 and note 253 there, and Rewald, *Impressionism*, 1973, p. 193, note 20. Few dealers at this date had exhibition space within their premises; the displays in their windows, Gautier wrote in 1858, made the rue Lafitte into 'a sort of permanent Salon' (quoted in Lethève 1972, p. 144).

5. Letters from Bazille to his parents, spring 1867, in Chicago, Art Institute, 1978, letter nos. 76–7 (misdated to 1869).

6. See p. 161 and note 38 there; details of Monet's rejection from the 1870 Salon from *Revue internationale de l'art et de la curiosité*, III, April 1870, p. 323.

7. Durand-Ruel's own stock at the time provides the clearest evidence. In 1873–5 he published *Galérie Durand-Ruel, Recueil d'estampes*, a set of 300 etchings of paintings in his current stock, issued in 30 parts; this contains many canvases of sizes 10, 12 and 15 (between 55 and 65 cm for their longer side), and some even smaller, alongside certain much larger pictures, on the scale more usually shown at the Salon, from size 50 (116 cm for their longer side) upwards. The date of Durand-Ruel's publication is generally given as 1873; however, the individual parts are separately dated, 12 to 1873, 12 to 1874 and 6 to 1875, and the preface by Armand Silvestre is dated January 1873; thus it was presumably issued in monthly parts from January 1873 to June 1875.

8. It remains unclear how far Durand-Ruel's inability to continue buying their work precipitated their decision to mount an independent exhibition; the dealer's financial problems, aggravated by a financial slump, led him to stop buying from Monet after the purchase of a group of paintings in mid-December 1873, but he continued to make payments to Pissarro until May 1874; the formal charter of the exhibiting group is dated 27 December 1873.

9. See Castagnary, *Le Siècle*, 29 April 1874, and Burty, *La République française*, 16 April 1874 (both reprinted in Paris, Grand Palais, 1974, pp. 256ff).

10. The clearest indications of the hanging of the 1876 exhibition are in Burty's review (*La République française*, 1 April 1876); see also A. Pothey, *La Presse*, 31 March 1876 (quoted in Venturi 1939, II, p. 302); for 1877, see Rivière, 'L'Exposition des impressionnistes', *L'Impressionniste*, 6 April 1877 (quoted in Venturi 1939, II, p. 308). It has been argued that *The Turkeys* was reworked after the 1877 show; however, its handling, sketchier and more open than the other decorations which Monet did for Hoschedé, is wholly consistent with the title *décoration non terminée* (see Paris, Grand Palais, 1980, p. 176, and San Francisco, Fine Art Museums, 1986, p. 225).

11. See pp. 159–61.

12. Reviews cited by W (I, p. 308, s.v. W 448) suggest that pl. 266, the exceptionally sketchy *The Signal*, was among those shown; though only seven Gare Saint-Lazare paintings are listed in the catalogue, press reports show that an eighth was included (see W I., p. 84, note 602).

13. See letter to Murer, 25 March 1879, W letter 156, and letters from Caillebotte to Monet, in Geffroy 1924, II, pp. 38–41. The catalogue of the exhibition lists six canvases without indication of their ownership, which were presumably still owned by Monet; thus he still had some say in its contents, albeit he was unable, or unwilling, to participate in its organisation.

14. Monet described his plans in a letter to Duret, 8 March 1880, W letter 173; for the methods used in the execution of these paintings, see pp. 153–5.

15. For Sisley's Salon plans in 1879, see letter from Sisley to Duret, 14 March 1879, in Paris, Braun, *Sisley*, 1933, p. 5. Duret was a regular advocate of exhibiting at the Salon; early in 1874 he had urged Pissarro to show there, and to 'select pictures which have a subject, something resembling a composition, pictures that are not too freshly painted' (quoted in Rewald, *Impressionism*, 1973, p. 310). Zola made his advocacy of the Salon clear in his review of the 1880 Salon (reprinted in Zola 1970, pp. 331ff).

16. Letter to Duret, 8 March 1880, W letter 173.

17. Principal evidence of the group's exhibiting plans in the 1880s is in the letters of Monet, Pissarro and Renoir to Durand-Ruel (in Venturi 1939), of Pissarro to Lucien (in Pissarro 1950), and of Berthe Morisot (in Rouart 1950). For the exhibitions of 1879–82, see Ann Arbor, University of Michigan Museum of Art, 1979–80.

18. Letter to Durand-Ruel, 23 February 1882, W letter 249.

19. Letter to Durand-Ruel, 24 February 1882, W letter 250, makes it likely that Monet went to Paris to finalise the selection of his canvases; the details in the Durand-Ruel *brouillard* (Day-book) do not allow precise identification of the paintings which were finally shown.

20. Letter to Durand-Ruel, 25 March 1882, W letter 260.

21. Letter to Durand-Ruel, 10 November 1882, W letter 300.

22. In 1879–81 Georges Charpentier had mounted at the offices of *La Vie moderne* small displays of de Nittis, Renoir, Manet, Sisley and Redon, besides the June 1880 Monet show (on the idea behind these shows, see the announcement quoted in Rewald, *Impressionism*, 1973, p. 430); more ambitious, but quite exceptional, had been the personal shows organised by Courbet in 1855 and 1867, and by Manet in 1867.

23. See p. 146 and note 71 there.

24. From 1882 onwards Durand-Ruel began to organise small shows of Impressionist paintings in London, Berlin and the United States, but the 1886 exhibition was on a far larger scale; for Monet's disquiet when Durand-Ruel decided to ship much of his stock to New York, see letters to Durand-Ruel, 28 July 1885, 22, 23 and 24 January 1886, W letters 578, 650–2; for Durand-Ruel's own account of his American venture, see Venturi 1939, II, pp. 214ff.

25. For Cazin's suggestion, see W II, p. 38 and note 389 there; letter from Gauguin to Pissarro, n.d., quoted in Rewald, *Impressionism*, 1973, p. 493.

26. Letter from Monet to Pissarro, 9 November 1885, W letter 616.

27. Letter from Mary Cassatt to Aleck Cassatt, quoted in Sweet 1966, p. 104.

28. Letter to Morisot, July/August 1886, W letter 676.

29. For Les Vingt, see letters to Maus, 5 November 1885 and 11 January 1886, W letters 611, 646.

30. Letters to Petit, 23 April 1887, to de Bellio, 29 April 1887, W letters 784, 786, and letter to Hemman, 29 April 1887, Archives Durand-Ruel (not in W). Geffroy's review (Geffroy 2 June 1887) shows that pl. 101 was shown, though it does not appear in the catalogue.

31. The Boussod & Valadon stock-books, insofar as they deal with the Impressionists, have been published in Rewald, *Gazette des Beaux-Arts*, 1973; Geffroy's review (Geffroy 1888) is largely reprinted in Geffroy 1924, I, pp. 191–3. The ten paintings, in the order that Geffroy described them, are: W 1158?, 1171, 1167 (pl. 231 here), 1175, 1192 (pl. 207 here) or 1193, 1187, 1191, 1190, 1181 and 1179.

32. Letter to Morisot, June 1888, W letter 895, shows that the ten pictures bought by Boussod & Valadon were the ten exhibited; however, they already owned other paintings by Monet (including several of Belle-Isle), and thus their decision to exhibit Antibes views alone was a calculated one.

33. Verhaeren's review of the exhibition (reprinted in Verhaeren 1927, pp. 185–6) comments on these groups of paintings of single motifs, giving their catalogue numbers: 128, 132, 133, 134, 137 all showed the Ravine of the Creuse, 129, 138 and 141 the Barrage de Vervit.

34. G. Kahn, in *La Vogue*, August 1889, p. 133, reviewing the Exposition Universelle.

35. Letter to Durand-Ruel, 14 December 1890, W letter 1085.

36. Letter from Pissarro to Lucien, 9 April 1891, in Pissarro 1950, pp. 230–1.

37. Bijvanck 1892, p. 177; on this, see also above, pp. 152 and 200–1.

38. Letters from Pissarro to Lucien, 26 May and 1 June 1895, in Pissarro 1950, pp. 381–2.

39. Temporary exhibitions have given some idea of this original impact, notably *The Impressionists in London* (London, Arts Council, 1973), *Monet's Years at Giverny* (New York, Metropolitan Museum of Art, 1978), and *Claude Monet au temps de Giverny* (Paris, Centre Culturel du Marais, 1983). The largest groups in permanent collections are the Grain Stacks in the Art Institute of Chicago and the Rouen Cathedrals in the Musée d'Orsay, Paris.

40. Letter to Durand-Ruel, 21 May 1894, W letter 1243; see also letter to Durand-Ruel, 9 March 1895, W letter 1280, for his decision to include his recent paintings of Norway.

41. On the well-spaced hanging in 1874, see de Lora, *Le Gaulois*, 18 April 1874, and Burty, *La République française*, 25 April 1874 (both reprinted in Paris, Grand Palais, 1974, pp. 257, 261); see also above, p. 206 and note 9 there; in 1883 Pissarro described Monet's one-man show at Durand-Ruel's as 'very well organised, not too many pictures, forty at the most, well spaced' (letter from Pissarro to Lucien, 3 March 1883, in Pissarro 1950, p. 34).

42. Geffroy 21 June 1889; letter to Petit, 21 June 1889, W letter 996, and see also W III, p. 21 and note 831 there, for Edmond de Goncourt's description of Rodin's egotism over this installation.

43. Letter from Pissarro to Lucien, 28 February 1883, in Pissarro 1950, p. 32; it is possible that Pissarro did not know of Whistler's earlier experiments in the mounting of his exhibitions.

44. Letter to Durand-Ruel, 5 March 1883, W letter 336, reveals Monet's concern with lighting conditions, urging the dealer to install blinds in Monet's one-man show, in order to prevent direct sunlight falling on the canvases.

45. Letters to Durand-Ruel, 13 April 1891 and 9 March 1892, W letters 1104, 1138, mention white frames; Rewald 1953, p. 44, quotes Signac's Journal of 15 March 1899; on the 1897 frames, see letter to Maus, 18 January 1897, W letter 1359. On the Impressionists' experiments with framing, see Laforgue, 'Les Cadres en rapport avec l'oeuvre', a section of his 1883 essay, in Laforgue 1903, p. 145; Huysmans 1883, pp. 91 (on the 1880 exhibition), 250f (on the 1881 exhibition); Rouart 1950, pp. 104–5, 109–10; Fénéon 1922.

46. Bijvanck 1892, p. 177.

47. See letter to Durand-Ruel, 23 February 1892, W letter 1135: Monet was not planning to come to Durand-Ruel's gallery to hang the Poplars exhibition until the morning of 29 February, for the opening that same evening.

48. C.F[rémine], 'Les on-dit', *Le Rappel*, 2 March 1892; A. Brisson, 'Claude Monet', *La République française*, 28 May 1895.

49. Clemenceau 1895 (reprinted in Clemenceau 1928, p. 88).

50. See p. 191.

51. Letter to Maus, 18 January 1897, W letter 1359.

52. On Cleopatra's Needle, see pp. 50–1; the two Charing Cross Bridge paintings are W 1533–4.

53. On the series exhibited in 1909, see House 1983.

54. On the installation plans for the Decorations, see W IV, Gordon and Stuckey 1979, and Stuckey 1979.

55. See pp. 151–2.

56. Letters to Durand-Ruel, 2, 21 May and 10 September 1895, W letters 1240, 1243, 1251; though Durand-Ruel mounted the exhibition of the Rouen Cathedral series, he only bought two of the canvases at that point, and these apparently for particular buyers, not for stock (w 1325, 1354).

57. Quoted in House 1983, p. 154.

58. For a detailed account of the development of the Davies collection, see Ingamells 1967.

59. See letters to Durand-Ruel, 9 October 1890, 3 February, 30 June 1891, 22 March and 12 December 1892, W letters 1077, 1097, 1116, 1141, 1172; see also pp. 11, 150–1.

NOTES TO CHAPTER 14

1. Letters to Bazille, December 1868, and Geffroy, 7 June 1912, W letters 44, 2015.
2. The following are characteristic: he seeks to '*rendre ce que je sens*' (letter to Geffroy, 28 March 1893, W letter 1201); 'I have only the merit of having painted directly before nature, seeking to render my impressions in front of the most fugitive effects' (letter to Charteris, 21 June 1926, in Charteris 1927, p.131 – not in W); 'I paint what I experience (*éprouve*) in front of nature . . . I seek to fix *sensations*' (Howard-Johnson 1969, p.30).
3. Quoted in Cézanne 1978, p.135 note.
4. Bullet 1901.
5. Letter from Lucien Pissarro to Monet, 21 June 1919, in Meadmore 1962, p.165; letter from Cézanne to Monet, 6 July 1895, in Cézanne 1978, p.246.
6. Letter from Camille Pissarro to Lucien, 22 November 1895, in Pissarro 1950, p.391.
7. Letter to Alice Hoschedé, 1 February 1884, W letter 401; Bijvanck 1892, p.177.
8. Shiff 1978, pp.347ff; Shiff 1984, pp.17–20.
9. Quoted in P. Courthion (ed.) *Manet raconté par lui-même et par ses amis*, Geneva 1953, I, pp.134–6.
10. Zola 1868 (reprinted in Zola 1970, p.160).
11. See Chapters 2, 5 and 6 for discussion of Monet's subject matter, brushwork and colour.
12. Monet's letters to Bazille during the 1860s are the one significant sequence of informal statements about his painting from these years; the earliest formal interview is Taboureux 1880, published to coincide with Monet's first one-man show, at the offices of *La Vie moderne*.
13. Zola 1868 (reprinted in Zola 1970, pp.152–5); Zola 1880 (reprinted in Zola 1970, pp.340, 351).
14. Huysmans 1883, p.270.
15. Shiff 1978; Shiff 1984, part I.
16. Kahn, 'Réponse aux symbolistes', *L'Evénement*, 28 September 1886; Aurier, 'La Symbolisme en peinture – Paul Gauguin', *Mercure de France*, March 1891 (reprinted in Aurier 1893).
17. Robinson, Diary, 3 June 1892.
18. Letter to Geffroy, 7 October 1890, W letter 1076.
19. See Chapter 7.
20. Levine 1981.
21. Letter from Degas to Frölich, 27 November 1872, in M. Guérin (ed.), *Lettres de Degas*, Paris 1945, p.23; in this letter Degas distinguishes clearly between his own need to study his subjects intensively, and the instantaneity of photography; on Impressionism and photography, see Varnedoe 1980 (an important rebuttal of Scharf 1968).
22. Levine 1981, pp.119–20, cites Fénéon (in Fénéon 1970, I, pp.41, 51 note); Mirbeau 1889; letter to Geffroy, 8 May 1920, W letter 2348.
23. Adéline 1884, p.182, s.v. *envelopper*; as early as 1818 Deperthes had used the verb when describing natural effects, mentioning 'the sort of mysterious veil with which nature envelops herself' at sunrise (Deperthes 1818, p.35); at least by the 1870s an artist could be said to *envelopper* his subjects by giving them an atmospheric unity (Duranty 1876, describing Jongkind, reprinted in Duranty 1946, p.33).
24. Corot, from a notebook: never forget to give a scene 'that *enveloppe* which has struck us' (P. Courthion (ed.), *Corot raconté par lui-même et par ses amis*, Geneva 1946, I,

p.89); Boudin, from a notebook: 'More *enveloppe*, treat it more softly; the touch of the brush looks too harsh' (Cahen 1900, p.182); there is no way of dating either of these passages from their published form.
25. Fourcaud, *Le Gaulois*, 12 March 1883; letter to Alice Hoschedé, 3 February 1888, W letter 827.
26. Le Roux 1889; Mirbeau 1889, p.17.
27. Letter to Geffroy, 21 July 1890, W letter 1066; Bijvanck 1892, p.177.
28. H. Johsen and H. Bang, quoted in Hoschedé 1960, II, pp.110, 112; Geffroy, 'Salon de 1890' (reprinted in Geffroy 1892, p.186).
29. Butor 1963, p.285.
30. Thiébault-Sisson, *Revue de l'art*, 1927, pp.44–5; the context of this quotation in Thiébault-Sisson's account suggests that it referred to the Water Lilies series of 1903–9.
31. Letter to Charteris, cited in note 2 above; Grappe 1926, p.443.
32. See pp.198–9 and note 40 there.
33. Le Roux 1889; see above, pp.162–4.
34. On Monet's memories of fog in London from 1870 to 1871, see Fitzgerald, *Brush and Pencil*, 1905, p.186; letter to Duret, 25 October 1887, W letter 797.
35. Letters to Alice Hoschedé, 5 March 1884 and 3 February 1888, W letters 438, 827.
36. For this exhibition, see also p.213.
37. *Mr Whistler's 'Ten O'Clock'*, London 1888, p.15; on Monet introducing Whistler to Mallarmé, and the '*Ten O'Clock*' translation, see Barbier 1964, pp.6ff; Mallarmé III, 1969, pp.176, 187, 194–5, 207.
38. For Monet's interest in Turner c.1890, see p.113 and notes 33–4 there.
39. Silvestre 1856 (reprinted in Silvestre 1926, II, p.83); on Monet's admiration for Corot, see above, pp.29–30 and notes 73–4 there.
40. Bullet 1901; Gimpel 1963, pp.88, 156; Gimpel's accounts are probably among the most trustworthy records of Monet's comments, since, like Theodore Robinson, he wrote them down regularly in his diary, instead of recalling long-past meetings. The Clean Air Acts of the past thirty years have deprived the London of today of the only beauty Monet found in it.
41. Bijvanck 1892, p.177.
42. Robinson, Diary, 19 June 1892 (Robinson's comments on a painting by Raffaëlli: 'It has a good deal of Monet's *desideratum*, mystery'), 29 July 1892 ('A good criticism by Monet on a canvas of Deconchy's – sunlight and shadow – little spots of sunlight on ground were too much spots of paint – not observed closely enough – too little mystery').
43. Deperthes 1818, p.35; Henriet 1866, p.47.
44. Huret 1891, p.60.
45. Mirbeau 1889, p.17; Mirbeau 1891, pp.183–5; for Mirbeau's visit to Monet before writing the latter article, see letter to Durand-Ruel, 14 December 1890, W letter 1085.
46. Letter from Mirbeau to Monet, ? September 1886, in Geffroy 1924, I, p.218 ('The beginning of autumn gives this rather harsh landscape an incomparable and poignant mystery', describing Noirmoutiers); letter from Rollinat to Monet, January 1891, in Rollinat 1919, p.291 (urging Monet to revisit 'the most mysterious retreats of my solitude' in the Creuse).

47. Lecomte, *L'Art impressionniste*, 1892, pp.259–63.
48. Goldwater 1963, p.116. The only general treatment of Impressionism within the broad context of Symbolist ideas is Francastel 1937, a major interpretive essay whose ideas have still not been fully explored. Hamilton 1960 is an important attempt to locate Monet's work of the 1890s, and particularly the Rouen Cathedrals, within this framework of ideas. See also Shiff 1984.
49. Mallarmé's distinction between *reportage* and literature, in 'Crise de vers', from *Divagations*, Paris 1896 (reprinted in *Oeuvres complètes*, Paris 1945, p.368; this passage was originally published as a preface to R. Ghil, *Traité du verbe*, Paris 1886); for Mallarmé on Zola, see Huret 1891, pp.63–4.
50. C. Janin, *L'Estafette*, 10 March 1892.
51. See p.220 and note 17 there.
52. See Hamilton 1960, especially pp.23ff, who cites Huysmans, *La Cathédrale*, 1898, and a contemporary discussion of the differences between Monet's and Huysmans's attitudes to the cathedral. L. Bazalgette's essay in Bazalgette 1898; on this, see also Herbert 1984. The subject of the Symbolist cathedral is touched on in J. Dakyns, *The Middle Ages in French Literature, 1851–1900*, Oxford 1973. The mysterious cathedral is also a key element in the Breton legend of the Kingdom of Ys, turned by Lalo in 1888 into the highly successful opera *Le Roi d'Ys*. Most relevant for Monet, though, was probably the use of the cathedral in Zola's novel *La Rêve* of 1888, discussed here.
53. H. Fiérens-Gevaert, *L'Indépendance belge*, 20 June 1895: 'The great sculpted portals of the church must open on to the unknown. No-one enters them, they are obstinately closed. The artist himself halts on the threshold, incapable of deciphering the enigma that haunts him.'
54. Howard-Johnson 1969, p.30.
55. Hamilton 1960, pp.24–5, discusses the possible significance of the omission of the cross.
56. Blanche 1928, p.35; Monet's fascination with the idea of painting cathedrals before he began to paint Rouen is shown in Geffroy 1891 (reprinted in Geffroy 1892, p.23), where 'the cathedrals of France' are included in a clearly authentic list of subjects which Monet hoped to tackle. In 1892 Rouen Cathedral became a subject for his nightmares: 'The cathedral was falling on top of me, it looked either blue or pink or yellow' (letter to Alice Hoschedé, 3 April 1892, W letter 1146).
57. Zola, *La Rêve*, 1888 (*Les Rougon-Macquart*, IV, Paris 1966, edn La Pléiade, p.863).
58. Eon, *La Plume*, 1 June 1895, p.259; letter from Pissarro to Lucien, 24 March 1896, in Pissarro 1950, p.403.
59. For his pantheism, see Geffroy 1891 (reprinted in Geffroy 1892, p.29); Mirbeau 1891, p.184; for his atheism, see Blanche 1928, p.30.
60. Clemenceau 1928, p.101; that Monet was not a theorist, see p.111; for Clemenceau's aims in this book, see letter from Clemenceau's secretary Perremond to Blanche Hoschedé-Monet, 28 June 1928, in Hoschedé 1961, p.72.
61. Daudet 1927, pp.147, 151–2, 154; the van Gogh was presumably *Irises* (Joan Whitney Payson Gallery of Art, Westbrook College, Portland), which was exhibited at the Indépendants in 1889.
62. Lecomte, *Revue indépendante*, 1892, p.10.
63. Aurier 1892, p.223; Kahn, cited above, note 16.
64. Robinson, Diary, 10 August 1892.

BIBLIOGRAPHY

THIS makes no claim to be a complete bibliography of Monet. It includes sources that have been of use for the present study, as primary material about Monet, or to enrich understanding of his context, or to help me crystallise my ideas. I have included as full a listing as possible of sources that include a witness account of Monet or first-hand evidence about his activities, in the form of reminiscences or letters from other people; these are indicated by an asterisk. Virtually all of Monet's letters are included in the relevant volume of Daniel Wildenstein's catalogue raisonné.

Adeline, J. *Lexique des termes d'art*. Paris 1884

Adhémar, H., and G. Sarraute. 'Contributions à l'étude du *Déjeuner sur l'herbe* de Monet', *Bulletin du Laboratoire du Louvre*, June 1958

Aitken, G., and M. Delafond. *La Collection d'estampes japonaises de Claude Monet à Giverny*. Paris 1983

*Alexandre, A. 'Le Jardin de Monet', *Le Figaro*, 9 August 1901 (translated in Stuckey 1985)

*Alexandre, A. 'Un jardinier', *Le Courrier de l'Aisne* (Laon), 9 June 1904 (translated in Stuckey 1985)

*Alexandre, A. 'Claude Monet', *The Studio* 43, March 1908

*Alexandre, A. 'Un paysagiste d'aujourd'hui', *Comoedia*, 8 May 1909

*Alexandre, A. 'L'Epopée des Nymphéas', *Le Figaro*, 21 October 1920

*Alexandre, A. *Claude Monet*. Paris 1921

*Alexandre, A. 'Claude Monet', *La Renaissance de l'art français*, January 1927

*Alexandre, A. *La Collection Canonne, Une histoire en action de l'impressionnisme et de ses suites*. Paris 1930

Allemand, H. *Causeries sur le paysage*. Lyons 1877

Ann Arbor, University of Michigan Museum of Art. *The Crisis of Impressionism, 1878–1882*, exhibition catalogue by J. Isaacson and others. 1979

*[Anon.] 'La Journée parisienne, Impression d'un impressionniste', *Le Gaulois*, 24 January 1880

[Anon.] 'Le Gaulois à la Galérie Georges Petit', *Le Gaulois*, 16 June 1898

*[Anon.] 'The Conscientious Artist', *The Standard*, 20 May 1908 (reprinted in Stuckey 1985)

[Anon.] 'Des lettres inédites de Claude Monet', *Arts-Documents*, February and March 1953 (the latter omitted in W)

*Arnyvelde, A. 'Chez le peintre de la lumière', *Je sais tout*, 15 January 1914 (translated in Stuckey 1985)

Arsenne, L.C. *Manuel du peintre et du sculpteur*. Paris 1833

Arsenne, L.C., and F. Denis. *Nouveau manuel complet du peintre et du sculpteur*. Paris 1858

Auckland City Art Gallery. *Claude Monet, Painter of Light*, exhibition catalogue by J. House. 1985

Aurier, A. 'Monet', March 1892, in *Oeuvres posthumes*. Paris 1893

*Bang, H. 'Feuille de mon journal – Claude Monet', 6 March 1895 (translated from Norwegian in Hoschedé 1960, II, pp.111–15)

*Barbier, A. 'Monet, c'est le peintre', *Arts*, 31 July 1952

Barbier, C.P. (ed.) *Correspondance Mallarmé–Whistler*. Paris 1964

*Barotte, R. 'Blanche Hoschedé nous parle de Monet', *Comoedia*, 24 October 1942

Baudelaire, C. *The Painter of Modern Life and other essays*, translated by J. Mayne. London 1964

Baudelaire, C. *Art in Paris, 1845–1862*, translated by J. Mayne. London 1965

*Baudot, J. *Renoir, ses amis, ses modèles*. Paris 1949

*Baur, J. *Theodore Robinson*. Brooklyn 1946

Bazalgette, L. 'Les Deux Cathédrales, Claude Monet et J.-K. Huysmans', in *L'Esprit nouveau dans la vie artistique, sociale et réligieuse*. Paris 1898

Bazin, G., M. Florisoone and J. Leymarie. 'L'Impressionnisme', *L'Amour de l'art*, 1947

Bell, Mrs A. *Representative Painters of the XIXth Century*. London 1899

Belloncle, M. 'Les Peintres d'Etretat', *Jardin des arts*, March 1967

Berger, K. 'Monet's Crisis', *Register of the Museum of Art, University of Kansas*, May 1963

*Berhaut, M. *Caillebotte, sa vie et son oeuvre*. Paris 1978

Berhaut, M. 'Le Legs Caillebotte, Vérités et contre-vérités', *Bulletin de la Société de l'Histoire de l'Art Français*, 1983 (published 1985)

Bernac, J. 'The Caillebotte Bequest to the Luxembourg', *Art Journal*, 1895

Bernard, E. *Souvenirs sur Paul Cézanne*, 4th edition, Paris 1924

*Bernheim de Villers, G. *Little Tales of Great Artists*. New York 1949

*Bernier, R. 'Dans la lumière impressionniste', *L'Oeil*, May 1959

*Bijvanck. W.G.C. 'Une impression (Claude Monet)', in *Un hollandais à Paris en 1891*. Paris 1892 (translated in Stuckey 1985)

*Billot, L. 'Exposition des Beaux-Arts', *Journal du Havre*, 9 October 1868 (translated in Stuckey 1985)

Blanc, C. *Grammaire des arts du dessin*. Paris 1867

Blanc, C. *Les Artistes de mon temps*. Paris 1876

*Blanche, J.E. 'Dans l'atelier de Claude Monet', *L'Art vivant*, 1 January 1927

*Blanche, J.E. *Propos de peintre, III, De Gauguin à la Revue nègre*. Paris 1928

*Blanche, J.E. *Les Arts plastiques*. Paris 1931

Blanche, J.E. *Portraits of a Lifetime*. London 1937

Blanche, J.E. *La Pêche aux souvenirs*. Paris 1949

Bodelsen, M. 'Early Impressionist Sales 1874–94 in the light of some unpublished "procès-verbaux"', *Burlington Magazine*, June 1968

Boime, A. *The Academy and French Painting in the Nineteenth Century*. London 1971

*Borchardt, F. 'Besuch bei Claude Monet', *Künstwanderer*, October 1920

Borély, J. 'Cézanne à Aix', *L'Art vivant*, July 1926

Boston, Museum of Fine Arts. *Barbizon Revisited*, exhibition catalogue by R.L. Herbert. 1962

Boston, Museum of Fine Arts. *Monet Unveiled: A New Look at Boston's Paintings*, exhibition catalogue by E.H. Jones, A. Murphy and L.H. Giese. 1977

Bouvier, P.L. *Manuel des jeunes artistes et amateurs en peinture*, 3rd edition. Paris 1844

Bracquemond, F. *Du dessin et de la couleur*. Paris 1885

*Breeskin, A. *The Graphic Work of Mary Cassatt*. New York 1948

Brettell, R. 'Monet's Haystacks Reconsidered', *Art Institute of Chicago Museum Studies*, Fall 1984

*Breuil, F. 'Les Iris aux bords de l'eau', *Jardinage*, October 1913

Brown, R.F. 'Impressionist Technique: Pissarro's Optical Mixture', *Magazine of Art*, January 1950

Brownell, W.C. *Modern French Painting*. London 1892

Brunius, T. *Mutual Aid in the Arts, from the Second Empire to Fin de Siècle*. Uppsala 1972

*Bullet, E. 'Macmonnies, the sculptor, working hard as a painter', *The Eagle* (Brooklyn), 8 September 1901

Burnet, J. *Notations pratiques sur l'art de la peinture*. Paris 1835

Burty, P. *Grave imprudence*. Paris 1880

*Burty, P. 'Les Paysages de M. Claude Monet', *La République française*, 27 March 1883 (translated in Stuckey 1985)

Butor, M. 'Claude Monet, ou le monde renversé', *Art de France* III, 1960

*Cahen, G. *Eugène Boudin, sa vie et son oeuvre*. Paris 1900

Callen, A. *Techniques of the Impressionists*. London 1982

*Cézanne, P. *Correspondance*, ed. J. Rewald. Paris 1978

Champa, K.S. *Studies in Early Impressionism*. New Haven and London 1973

Champfleury. *Le Réalisme*, ed. G. and J. Lacambre. Paris 1973

*Charteris, E. *John Sargent*. London 1927

Chavange, R. 'Claude Monet', *Le Figaro artistique*, 16 December 1926

Chesneau, E. 'Le Japon à Paris', *Gazette des Beaux-Arts* 18, 1878

Chesneau, E. *L'Education de l'artiste*. Paris 1886

Chevreul, E. *De la loi du contraste simultané des couleurs*. Paris 1839

Chicago, Art Institute. *Paintings by Monet*, exhibition catalogue. 1975

Chicago, Art Institute. *Frédéric Bazille and Early Impressionism*, exhibition catalogue. 1978

Chisaburō, Y. (ed.) *Japonisme in Art: An International Symposium*. Tokyo 1980

★Ciolkowska, M. 'Monet, his Garden, his World', *International Studio*, February 1923

★Ciolkowska, M. 'Memories of Monet', *Canadian Forum*, March 1927

Clark, T.J. *The Painting of Modern Life: Paris in the Art of Manet and his Followers*. London 1985

Clay, J., and R. Huyghe, *L'Impressionnisme*. Paris 1971

Clemenceau, G. 'Révolution des cathédrales', *La Justice*, 20 May 1895 (reprinted in Clemenceau 1928; translated in Stuckey 1985)

★Clemenceau, G. *Claude Monet, les nymphéas*. Paris 1928

Clément, C. *Gleyre*. Paris 1878

Cleveland, Museum of Art. *Japonisme: Japanese Influence on French Art, 1854–1910*, exhibition catalogue by G. Weisberg and others. 1975

Cooper, D. *The Courtauld Collection*. London 1954

Cooper, D. 'The Monets in the Metropolitan Museum', *Metropolitan Museum Journal 3*, 1970

★Coquiot, G. 'Des Monet, des Renoir pour cinquante francs', *Excelsior*, 28 November 1910

★Cortissoz, R. 'Monet', in *Personalities in Art*. New York 1925

★Cortissoz, R. 'The Field of Art, Claude Monet and Impressionism in Landscape Painting', *Scribner's Magazine*, March 1927

Couture, T. *Méthode et entretiens d'atelier*, Paris 1867

Couture, T. *Paysage, entretiens d'atelier*. Paris 1869

Couture, T. *Couture, par lui-même et par son petit-fils*. Paris 1932

★Craft, R. *Conversations with Igor Stravinsky*. London 1959

Crouzet, M. *Duranty*. Paris 1964

★Crucy, F. 'Le Peintre de l'air', *L'Aurore*, 12 June 1904

★Dashiell, S. 'Claude Monet and Georges Clemenceau', *Arts and Decoration*, November 1923

★Dauberville, H. *La Bataille de l'impressionnisme*. Paris 1967

★Daudet, L. *Souvenirs des milieux littéraires, politiques, artistiques et médicaux*. Paris 1913–22

★Daudet, L. 'Claude Monet', in *Ecrivains et artistes*, I. Paris 1927

★Daulte, F. *Frédéric Bazille et son temps*. Geneva 1952

Daulte, F. *Alfred Sisley*. Lausanne 1959

Daulte, F. *Auguste Renoir, I, Figures, 1860–1890*. Lausanne 1971

Delacroix, E. *Oeuvres littéraires*. Paris 1923

Delacroix, E. *Journal d'Eugène Delacroix*, ed. A. Joubin. Paris 1980

Delage, R. 'Chabrier et ses amis impressionnistes', *L'Oeil*, December 1963

★Delange, R. 'Claude Monet', *L'illustration*, 15 January 1927

★Denis, M. *Journal*. Paris 1957–9

Denis, M. *Théories, 1890–1910*. Paris 1912

Deperthes, J.B. *Théorie du paysage*. Paris 1818

★Descaves, L. 'Chez Claude Monet', *Paris Magazine*, 25 August 1920 (translated in Stuckey 1985)

★Descaves, L. *Souvenirs d'un ours*. Paris 1946

★Dewhurst, W. 'Claude Monet, Impressionist', *Pall Mall Magazine*, June 1900

★Dewhurst, W. 'A great French Landscapist', *The Artist*, October 1900

★Dewhurst, W. 'Impressionist Painting, its Genesis and Development', *The Studio*, April and July 1903

★Dewhurst, W. *Impressionist Painting, its Genesis and Development*. London 1904

★Dewhurst, W. 'What is Impressionism?', *Contemporary Review*, March 1911

Doran, P.M. (ed.) *Conversations avec Cézanne*, Paris 1978

Dorbec, P. *L'Art du paysage en France*, Paris 1925

Dufwa, J. *Winds from the East: A Study in the Art of Manet, Degas, Monet and Whistler, 1856–86*. Stockholm 1981

Dunlop, I. *The Shock of the New*. London 1972

Duranty, E. *La Nouvelle Peinture*, Paris 1876 (ed. M. Guérin. Paris 1946; reprinted and translated in San Francisco, Fine Art Museums, 1986)

Duranty, E. 'Le Peintre Louis Martin', in *Le Pays des arts*. Paris 1881

Duret, T. *Les Peintres impressionistes*. Paris 1878 (part translated in Stuckey 1985)

★Duret, T. 'Claude Monet', preface to catalogue of exhibition at *La Vie moderne*. Paris 1880 (translated in Stuckey 1985)

Duret, T. *Critique d'avant-garde*. Paris 1885 (includes Duret 1878 and 1880)

★Duret, T. *Manet and the French Impressionists*. London 1910

★Duret, T. *Histoire des peintres impressionnistes*. Paris 1922

Eidelberg, M. 'Bracquemond, Delâtre and the Discovery of Japanese Prints', *Burlington Magazine*, April 1981

★Elder, M. 'Une visite à Giverny', *Bulletin de la vie artistique*, 1 May 1920

★Elder, M. *Chez Claude Monet à Giverny*. Paris 1924

★Eugen of Sweden, Prince. 'Monet och hans maleri', *Ord och Bild*, December 1947

★Fels, F. *Claude Monet*. Paris 1925 (reprinted in *Propos d'artistes*. Paris 1925)

★Fels, F. 'Claude Monet au Musée de Zürich', *Arts-Documents*, June 1952

★Fels, M. de. *La Vie de Claude Monet*. Paris 1929

★Fénéon, F. *Oeuvres plus que complètes*, ed. J.U. Halperin. Paris 1970

Fénéon, F. 'Les Cadres', *Bulletin de la vie artistique*, 1 February 1922 (not in Fénéon 1970)

Fernier, R. *La Vie et l'oeuvre de Gustave Courbet*. Lausanne and Paris, 1977–8

Finke, U. (ed.) *French 19th Century Painting and Literature*. Manchester 1972

★Fitzgerald, D. 'Claude Monet', preface to catalogue of exhibition at Chase's Gallery. Boston 1891

★Fitzgerald, D. 'Claude Monet', preface to catalogue of exhibition at Copley Hall. Boston 1905

★Fitzgerald, D. 'Claude Monet, Master of Impressionism', *Brush and Pencil*, 1905

Flint, K. *Impressionists in England: The Critical Reception*. London 1984

Fosca, F. *Claude Monet*. Paris 1927

★Fourcaud. 'Pour deux maîtres impressionnistes', *Le Gaulois*, 30 June 1908

Franc, H.M. *Claude Monet, Water Lilies*. New York, Museum of Modern Art, n.d.

Francastel, P. *L'Impressionnisme*, Paris 1937 (reprinted Paris 1974)

★Fuller, W.H. *Monet*. no location [1891]

★Fuller, W.H. *Claude Monet and his Paintings*. New York 1899 (reprinted in Stuckey 1985)

Gachet, P. *Deux amis des impressionnistes, le docteur Gachet et Murer*. Paris 1956

Gachet, P. *Lettres impressionnistes au Dr Gachet et à Murer*. Paris 1957

Gage, J. *Colour in Turner, Poetry and Truth*. London 1969

Gassier, P. 'Monet et Rodin photographiés chez eux en couleur', *Connaissance des Arts*, April 1975

Gauguin, P. *Lettres à sa femme et à ses amis*, ed. M. Malingue. Paris 1946

★Geffroy, G. 'Salon de 1887, V & VI, Hors du Salon – Claude Monet, I & II', *La Justice*, 25 May and 2 June 1887

Geffroy, G. 'Dix tableaux de Claude Monet', *La Justice*, 17 June 1888

Geffroy, G. 'Paysages et figures', *La Justice*, 28 February 1889

Geffroy, G. 'L'Exposition Monet – Rodin', *La Justice*, 21 June 1889

★Geffroy, G. 'Les Meules de Claude Monet', preface to catalogue of exhibition, Durand-Ruel. Paris 1891 (reprinted in *La Vie artistique*, I. Paris 1892; translated in Stuckey 1985)

★Geffroy, G. 'L'Impressionnisme', *Revue encyclopédique*, 15 December 1893

★Geffroy, G. 'Histoire de l'impressionnisme', in *La Vie artistique*, III. Paris 1894

★Geffroy, G. *Pays d'ouest*. Paris 1897 (extract translated in Stuckey 1985)

★Geffroy, G. 'Claude Monet', *Le Journal*, 7 June 1898 (reprinted in *La Vie artistique*, VI. Paris 1900)

Geffroy, G. *La Bretagne*. Paris 1905

★Geffroy, G. 'Claude Monet', *L'Art et les artistes*, November 1920

★Geffroy, G. *Claude Monet, sa vie, son oeuvre*, Paris 1922 (revised edition Paris 1924)

★Georges-Michel, M. *De Renoir à Picasso*. Paris 1954 (extract translated in Stuckey 1985)

Gillet, L. *Trois variations sur Claude Monet*. Paris 1927

★Gimpel, R. 'At Giverny with Claude Monet', *Art in America*, June 1927

★Gimpel, R. *Journal d'un collectionneur, marchand de tableaux*. Paris 1963

Goldwater, R. 'Symbolic Form: Symbolic Content', in 'The Reaction against Impressionism in the 1880s: Its Nature and Causes', in *Problems of the 19th and 20th Centuries*, Acts of the 20th International Congress of the History of Art, IV. Princeton 1963

Gombrich, E. *Art and Illusion*. London 1960

★Goncourt, E. and J. de. *Journal, Mémoires de la vie littéraire*, ed. R. Ricatte. Paris 1956

Gonse, L. 'L'Art japonais et son influence sur le goût européen', *Revue des arts décoratifs*, 1898

Gordon, R. 'The Lily Pond at Giverny: The Changing Inspiration of Monet', *Connoisseur*, November 1973

Gordon, R., and A. Forge. *Monet*. New York 1983

Gordon. R., and C.F. Stuckey. 'Blossoms and Blunders: Monet and the State', I, *Art in America*, January–February 1979

★Goulinat, J.G. 'La Technique de Monet', *L'Art vivant*, 1 January 1927

Gourmont, R. de. 'Claude Monet', in *Promenades philosophiques*. Paris 1905

Grappe, G. *Monet*. Paris 1912

★Grappe, G. 'Chez Claude Monet', *L'Opinion*, 15 October 1926

★Grappe, G. *Monet*. Paris 1941

Greenberg, C. 'The Later Monet', *Art News Annual*, 1957 (reprinted in *Art and Culture*. Boston 1961)

★Gsell, P. 'La Tradition artistique française, I, L'Impressionnisme', *Revue bleue*, 26 March 1892

Gsell, P. 'Un adorateur de la lumière, Claude Monet', *La Renaissance de l'art*, February 1927

*Guillemot, M. 'Claude Monet', *La Revue illustrée*, 15 March 1898 (translated in Stuckey 1985)

*Guitry, S. *Si j'ai bonne mémoire*. Paris 1934

Gwynn, S. *Claude Monet and his Garden*. London 1934

Hamerton, P.G. *The Present State of the Fine Arts in France*. London 1892

Hamilton, G.H. *Claude Monet's Paintings of Rouen Cathedral*. Oxford 1960

Hamilton, G.H. *Painting and Sculpture in Europe, 1880–1940*. London 1967

Hareux, E. *La Peinture à l'huile en plein air*. Paris [c.1908]

Haskell, F. *Rediscoveries in Art*, London 1976

Hefting, V. *Jongind d'après sa correspondance*. Utrecht 1969

Hefting, V. *Jongkind, sa vie, son oeuvre, son époque*. Paris 1975

Henriet, F. *Le Paysagiste aux champs*. Paris 1866, and enlarged edition 1876

Henriet, F. *C. Daubigny et son oeuvre gravé*. Paris 1875

Herbert, R.L. 'Method and Meaning in Monet', *Art in America*, September 1979

Herbert, R.L. 'Industry and the Changing Landscape from Daubigny to Monet', in J.M. Merriman (ed.), *French Cities in the Nineteenth Century*. London 1982

Herbert, R.L. 'The Decorative and the Natural in Monet's Cathedrals', in Rewald and Weitzenhoffer 1984

Hoog, M. *Les Nymphéas de Claude Monet au Musée de l'Orangerie*. Paris 1984

Hoopes, D.F. 'John S. Sargent: The Worcestershire Interlude', *Brooklyn Museum Annual*, 1966

*Hoppe, R. 'Ett besök his Claude Monet i Giverny', in *Städer och Konstnärer*. Stockholm 1931.

*Hoschedé, J.P. *Claude Monet, ce mal connu*. Geneva 1960

*Hoschedé, J.P. *Blanche Hoschedé-Monet, peintre impressionniste*. Rouen 1961

Hours, M., and others. 'Manière et matière des impressionnistes', *Annales*, Laboratoire de recherche des Musées de France, 1974

House, J. *Monet*. Oxford 1977, and enlarged edition 1981

House, J. 'New Material on Monet and Pissarro in London in 1870–71', *Burlington Magazine*, October 1978

House, J. 'The New Monet Catalogue', *Burlington Magazine*, October 1978

House, J. 'The Impressionist Vision of London', in I.B. Nadel and F.S. Schwarzbach (eds.), *Victorian Artists and the City*. New York and Oxford 1980

House, J. 'Monet: le jardin d'eau et la 2e série des Nymphéas (1903–9)', in Paris, Centre Culturel du Marais, 1983

House, J. 'Monet in 1890', in Rewald and Weitzenhoffer 1984

House, J. 'Impressionism and History: The Rewald Legacy', *Art History*, September 1986

Houston, Museum of Fine Arts. *Gustave Caillebotte*, exhibition catalogue by J.K.T. Varnedoe and T.P. Lee. 1976

*Howard-Johnson, P. 'Une visite à Giverny en 1924', *L'Oeil*, March 1969

*Hudson, D. *For Love of Painting: The Life of Sir Gerald Kelly*. London 1975

Huret, J. *Enquête sur l'évolution littéraire*. Paris 1891

Huysmans, J.K. *L'Art moderne*. Paris 1883

Huysmans, J.K. *Certains*. Paris 1889

Ingamells, J. *The Davies Collection of French Art*. Cardiff 1967

Isaacson, J. 'Monet's Views of the Thames', *Art Association of Indianapolis Bulletin*, 1965

Isaacson, J. 'Monet's Views of Paris', *Allen Memorial Art Museum Bulletin* (Oberlin), Fall 1966

Isaacson, J. *Monet: Le Déjeuner sur l'herbe*. London 1972

Isaacson, J. *Claude Monet: Observation and Reflection*. Oxford 1978

Isaacson, J. '*La Débâcle* by Claude Monet', *Bulletin*, Museums of Art and Archaeology, University of Michigan, 1978

Isaacson, J. 'Impressionism and Journalistic Illustration', *Arts Magazine*, June 1982

James, H. *Parisian Sketches*. London 1958

*Jean-Aubry, G. 'Une visite à Giverny: Eugène Boudin et Claude Monet', *Havre-Eclair*, 1 August 1911

*Jean-Aubry, G. *Eugène Boudin*. Paris 1922

*J[eanniot], G. 'Notes sur l'art, Claude Monet', *La Cravache parisienne*, 23 June 1888

Joëts, J. 'Lettres inédites: les Impressionnistes et Chocquet', *L'Amour de l'art*, April 1935

*Joëts, J. 'Lettres inédites de Pissarro à Claude Monet', *L'Amour de l'art*, 1946

Johnson, L. *Delacroix*. London 1963

*Johsen, H. press cutting of April 1895, translated from Norwegian in Hoschedé 1960, II, pp.109–10

Jourdain, F. 'Claude Monet, exposition du Boulevard Montmartre', *Revue indépendante*, March 1889

Jourdain, F. *Les Décorés, ceux qui no le sont pas*. Paris 1895

*Jourdain, F. *Sans remords ni rancune, souvenirs épars d'un vieil homme "Né en '76"*. Paris 1953

*Jourdain, F. 'J'ai connu Lautrec, Cézanne, Monet', *L'Oeil*, September 1956

*Joyes, C., and others. *Monet at Giverny*. London 1975, and new edition 1985

Kahn, G. 'L'Exposition Claude Monet', *Gazette des Beaux-Arts*, July 1904 (translated in Stuckey 1985)

*Kahn, M. 'Le Jardin de Claude Monet', *Le Temps*, 7 June 1904 (translated in Stuckey 1985)

Kasanof, N. 'Monet and Etretat', *North Carolina Museum of Art Bulletin*, May 1968

Kemp, G. van der. *Une visite à Giverny*. Giverny 1980

*Koechlin, R. 'Claude Monet', *Art et décoration*, February 1927

*Kunstler, C. 'Des lettres inédites de Camille Pissarro', *La Revue de l'art*, March and April 1930

Kuroe, M. 'Claude Monet dans les collections japonaises', *Bulletin annual du Musée National de l'Art Occidental, Tokyo*, 1968

*La Farge, J., and A.F. Jaccaci (eds.) *Noteworthy Paintings in American Private Collections*. New York 1907

Laforgue, J. 'L'impressionnisme', 1883, in *Mélanges posthumes*. Paris 1903

Lanes, J. 'Daubigny Revisited', *Burlington Magazine*, October 1964

Lanoé, G. *Histoire de l'école française du paysage*. Nantes 1905

*Le Braz, A. *Iles Bretonnes (Belle-Ile – Sein)*. Paris 1935

*Lecomte, G. *L'Art impressionniste*. Paris 1892

Lecomte, G. 'L'Art contemporain', *Revue indépendante*, April 1892

Lecomte, G. 'Claude Monet', in *Catalogue des tableaux composant la Collection de M. E. Blot*, Bernheim-Jeune, Paris, 9–10 May 1900

*Lecomte, G. 'Claude Monet ou le vieux chêne de Giverny', *La Renaissance de l'art*, October 1920

*Lecomte, G. 'Un Fondateur de l'impressionnisme', *La Revue de l'art*, March 1930

Léger, C. *Claude Monet*. Paris 1930

*Le Roux, H. 'Silhouettes parisiennes, l'exposition Claude Monet', *Gil Blas*, 3 March 1889

Lethève, J. *Impressionnistes et symbolistes devant la presse*. Paris 1959

Lethève, J. *Daily Life of French Artists in the Nineteenth Century*. London 1972

Levine, S.Z. 'Monet's Pairs', *Arts Magazine*, June 1975

Levine, S.Z. *Monet and his Critics*. New York 1976

Levine, S.Z. 'Décor/Decorative/Decoration in Monet's Art', *Arts Magazine*, February 1977

Levine, S.Z. 'Monet, Lumière, and Cinematic Time', *Journal of Aesthetics and Art Criticism*, Summer 1978

Levine, S.Z. 'The Window Metaphor and Monet's Windows', *Arts Magazine*, November 1979

Levine, S.Z. 'The "Instant" of Criticism and Monet's Critical Instant', *Arts Magazine*, March 1981

*Lewison, F. 'Theodore Robinson and Claude Monet', *Apollo*, September 1963

Leymarie, J. *Impressionism*, Geneva 1955

*Liberman, A. *The Artist in his Studio*. London 1960

Lhote, A. *De la palette à l'écritoire*. Paris 1946

Lindon, R. 'Etretat et les peintres', *Gazette des Beaux-Arts*, May–June 1958

Lindon, R. '"Falaise à Etretat" par Claude Monet', *Gazette des Beaux-Arts*, March 1960

London, Arts Council of Great Britain. *Claude Monet*, exhibition catalogue by D. Cooper and J. Richardson. 1957

London, Arts Council of Great Britain. *The Impressionists in London*, exhibition catalogue by A. Bowness and A. Callen. 1973

London, Arts Council of Great Britain. *Pissarro*, exhibition catalogue by C. Lloyd and others. 1980

London, Arts Council of Great Britain. *Painting from Nature: The Tradition of Open-Air Oil Sketching from the 17th to 19th Centuries*, exhibition catalogue by L. Gowing and P. Conisbee. 1980

London, Arts Council of Great Britain. *Renoir*, exhibition catalogue by J. House and A. Distel. 1985

London, Royal Academy of Arts. *Impressionism*, exhibition catalogue by J. House. 1974

London, Royal Academy of Arts. *Post-Impressionism*, exhibition catalogue by J. House, M.A. Stevens and others. 1979

Los Angeles County Museum of Art. *A Day in the Country: Impressionism and the French Landscape*, exhibition catalogue by R. Brettell, S. Schaefer and S. Gache-Patin. 1984

Lostalot, A. de. 'Exposition des oeuvres de M. Claude Monet', *Gazette des Beaux-Arts*, April 1883

*Low, W.H. *A Chronicle of Friendships, 1873–1900*. London 1908

*Lucas, E.V. *French Leaves*. London 1931

*Ludovici, A. *An Artist's Life in London and Paris, 1870–1925*. London 1926

MacColl, D.S. *Nineteenth Century Art*. Glasgow 1902

Malingue, M. *Claude Monet*. Monaco 1943

Mallarmé, S. 'The Impressionists and Edouard Manet', *Art Monthly Review*, 30 September 1876 (reprinted in San Francisco, Fine Arts Museums, 1986)

Mallarmé, S. *Correspondance*, III–VII, ed. H. Mondor and L.J. Austin. Paris 1969–82

Manet, J. *Journal (1893–1899)*. Paris 1979

Marcel, H. *La Peinture français au XIXe siècle*. Paris 1905

Martelli, D. *Les Impressionnistes et l'art moderne*, ed. F. Errico. Paris 1979

*Martet, J. *Clemenceau peint par lui-même*. Paris 1929

*Marx, R. 'Les "Nymphéas" de M. Claude Monet', *Gazette des Beaux-Arts*, June 1909 (translated in Stuckey 1985)

Masson, A. 'Monet le fondateur', *Verve*, 27 August 1952

M[auclair], C. 'Exposition Claude Monet', *Revue indépendante*, March 1892

Mauclair, C. *The French Impressionists*. London 1903

Mauclair, C. *Claude Monet*. Paris 1924

Maupassant, G. de. 'La Vie d'un paysagiste', *Gil Blas*, 28 September 1886 (translated in Stuckey 1985)

Maus, M.O. *Trente années de lutte pour l'art*. Brussels 1926

*Meadmore, W.S. *Lucien Pissarro*. London 1962

*Meier-Graefe, J. *Modern Art*. London 1908

Mellerio, A. *L'Exposition de 1900 et l'impressionnisme*. Paris 1900

Memphis, Dixon Gallery and Gardens. *Impressionists in 1877*, exhibition catalogue. 1977

Mirbeau, O. 'Notes sur l'art, Claude Monet', *La France*, 21 November 1884

*Mirbeau, O. 'Claude Monet', preface to catalogue of *Claude Monet, Auguste Rodin*, exhibition at Galerie Georges Petit. Paris 1889

*Mirbeau, O. 'Claude Monet', *L'Art dans les deux mondes*, 7 March 1891 (translated in Stuckey 1985)

*Mirbeau, O. *La 628–E8*. Paris 1907

*Mirbeau, O. *Claude Monet, "Venise"*. Paris 1912

*Mirbeau, O. *Des artistes*, I and II. Paris 1922, 1924

*Mirbeau, O. 'Lettres à Claude Monet', *Cahiers d'aujourd'hui*, 29 November 1922

*Moore, G. *Confessions of a Young Man*. London 1888

Moore, G. *Impressions and Opinions*. London 1891

Moore, G. *Modern Painting*. London 1893, and enlarged edition 1896

*Moore, G. *Reminiscences of the Impressionist Painters*. Dublin 1906

Moreau-Nélaton, E. *Jongkind raconté par lui-même*. Paris 1918

*Moreau-Nélaton, E. *Daubigny raconté par lui-même*. Paris 1925

*Moreau-Nélaton, E. *Manet raconté par lui-même*. Paris 1926

*Morgan, J. 'Causeries chez quelques maîtres, M. Claude Monet', *Le Gaulois*, 5 May 1909

Mount, C.M. 'New Materials on Claude Monet: The Discovery of a Heroine', *Art Quarterly*, Winter 1962

Mount, C.M. *Monet: A Biography*. New York 1967

Muther, R. *The History of Modern Painting*. London 1896, and enlarged edition 1907

*Natanson, T. *Peints à leur tour*. Paris 1948

New York, Acquavella Galleries. *Claude Monet*, exhibition catalogue. 1976

*New York, American Art Association. Catalogue of Sale of Desmond Fitzgerald Collection, 21–2 April 1927

New York, Guggenheim Museum. *Neo-Impressionism*, exhibition catalogue by R.L. Herbert. 1968

New York, Metropolitan Museum of Art. *French Paintings*, II and III, catalogues by C. Sterling and M. Salinger. 1966, 1967

New York, Metropolitan Museum of Art. *Monet's Years at Giverny: Beyond Impressionism*, exhibition catalogue. 1978

New York, Museum of Modern Art. *Claude Monet: Seasons and Moments*, exhibition catalogue by W.C. Seitz. 1960

New York, Museum of Modern Art. *Before Photography: Painting and the Invention of Photography*, exhibition catalogue by P. Galassi. 1981

Niculescu, R., 'Georges de Bellio, l'ami des impressionnistes', *Paragone*, nos. 247 and 249, 1970

Niess, R.J. *Zola, Cézanne and Manet*. Ann Arbor 1968

Nochlin, L. (ed.) *Impressionism and Post-Impressionism, 1874–1904: Sources and Documents*. Englewood Cliffs, N.J., 1966

Nochlin, L. *Realism*. Harmondsworth 1971

Ormond, R. *John Singer Sargent*. London 1970

*Pach, W. 'Interview with Monet', *Scribner's Magazine*, June 1908 (reprinted in *Queer Thing, Painting*. New York 1938; and in Stuckey 1985)

Paillot de Montabert. *Traité complet de la peinture*. Paris 1829

Paradise, JA. C. 'Three Letters from Claude Monet to Gustave Geffroy', *The Stanford Museum* XII–XIII, 1982–3

*Paris, Centre Culturel du Marais. *Claude Monet au temps de Giverny*, exhibition catalogue. 1983

Paris, Durand-Ruel. *Claude Monet*, exhibition catalogue. 1970

Paris, Galerie d'Art Braun. *L'Impressionnisme et quelques précurseurs, Bulletin des expositions* III, 1932

*Paris, Galerie d'Art Braun. *Sisley, Bulletin des expositions, 2me année* II, 1933

Paris, Grand Palais. *Centenaire de l'impressionnisme*, exhibition catalogue by H. Adhémar and others. 1974

Paris, Grand Palais. *Hommage à Claude Monet*, exhibition catalogue by H. Adhémar, A. Distel and S. Gache. 1980

Paris, Grand Palais. *Manet*, exhibition catalogue by F. Cachin, C.S. Moffett, J.W. Bareau. 1984

*Paris, Hôtel Drouot. *Archives de Camille Pissarro*, sale catalogue. 21 November 1975

*Pays, M. 'Une visite à Claude Monet dans son ermitage de Giverny', *Excelsior*, 26 January 1921

*Pays, M. '"Les Nymphéas" de Claude Monet attendant un emplacement', *Excelsior*, 16 May 1921

*Perry, L.C. 'Reminiscences of Claude Monet, 1889–1909', *American Magazine of Art*, March 1927 (reprinted in Stuckey 1985)

*Phoenix Art Museum. *Americans in Brittany and Normandy, 1860–1910*, exhibition catalogue by D. Sellin. 1982

Philadelphia Museum of Art. *The Second Empire: Art in France under Napoleon III*, exhibition catalogue by J. Rishel and others. 1978

Philadelphia Museum of Art. *Cézanne in Philadelphia Collections*, exhibition catalogue by J. Rishel. 1983

Pickvance, R. 'Monet and Renoir in the mid-1870s', in Chisaburō 1980.

*Pissarro, C. *Lettres à son fils Lucien*, ed. J. Rewald. Paris 1950

*Pissarro, C. *Correspondance, I, 1865–1885*, ed. J. Bailly-Herzberg. Paris 1980

Pool, P. *Impressionism*. London 1967

*Poulain, G. *Bazille et ses amis*. Paris 1932

Poulain, G. 'L'Origine des Femmes au jardin du Claude Monet', *L'Amour de l'art*, March 1937

Proust, M. 'Monet', in *Contre Sainte-Beuve*. Paris 1954

*Rashdall, E.M. 'Claude Monet,' *The Artist*, 2 July 1888 (reprinted in Flint 1984)

Ratcliffe, R.W. 'Cézanne's Working Methods and their Theoretical Background', PhD thesis, University of London, 1961

Reff, T. 'Cézanne's Constructive Stroke', *Art Quarterly*, Autumn 1962

Reff, T. (ed.) *Modern Art in Paris, 1855–1900*. New York and London 1981

*Régamey, R. 'La Formation de Claude Monet', *Gazette des Beaux-Arts*, February 1927

Reidemeister, L. *Auf den Spuren der Maler der Ile de France*. Berlin 1963

*Renoir, J. *Renoir*. Paris 1962

*Reuterswärd, O. *Monet*. Stockholm 1948

Reuterswärd, O. 'Duranty and his "Nouvelle Peinture"', *Konsthistorisk Tidskrift*, 1949

Reuterswärd, O. 'The "Violettomania" of the Impressionists', *Journal of Aesthetics and Art Criticism*, December 1950

Reuterswärd, O. 'The Accentuated Brushstroke of the Impressionists', *Journal of Aesthetics and Art Criticism*, March 1952

Reuterswärd, O. *Impressionisterna infor publik och kritik*. Stockholm 1952

Rewald, J. 'Extraits du Journal inédit de Paul Signac', *Gazette des Beaux-Arts*, vol.36, 1949; vol.39, 1951; vol.42, 1953

Rewald, J. *Paul Cézanne*. London 1950

Rewald, J. 'Notes sur deux tableaux de Claude Monet', *Gazette des Beaux-Arts*, October 1967

Rewald, J. 'Chocquet et Cézanne', *Gazette des Beaux-Arts*, July–August 1969

Rewald, J. *The History of Impressionism*, 4th edn. New York and London 1973

*Rewald, J. 'Van Gogh, Goupil and the Impressionists', *Gazette des Beaux-Arts*, January–February 1973

Rewald, J. *Studies in Impressionism*. London 1985

Rewald, J., and F. Weitzenhoffer (eds.) *Aspects of Monet: A Symposium on the Artist's Life and Times*. New York 1984

*Rey, R. *La Renaissance du sentiment classique*. Paris 1931

Riat, G. *Gustave Courbet*. Paris 1906

Rivière, G. 'L'Exposition des Impressionnistes', *L'Impressionniste*, 6 May 1877

*Rivière, G. *Renoir et ses amis*. Paris 1921

*Rivière, G. 'Claude Monet aux expositions des impressionnistes', *L'Art vivant*, 1 January 1927 (translated in Stuckey 1985)

Robert, K. *Traité pratique de la peinture à l'huile (paysage)*. Paris 1878, and enlarged edition 1891

Robida, M. *Le Salon Charpentier et les impressionnistes*. Paris 1958

*Robinson, T. 'Diary', MS in Frick Art Reference Library, New York (fragments published in Lewison 1963 and Chicago, Art Institute, 1975)

*Robinson, T. 'Claude Monet', *Century Magazine*, September 1892 (reprinted in Van Dyke 1896 and Stuckey 1985)

Rodenbach, G. 'Quelques peintres: Claude Monet', *Figaro, supplément littéraire*, 26 January 1895

Roger-Marx, C. *Monet*. Lausanne 1949

*Rollinat, M. *Fin d'oeuvre*. Paris 1919

Roskill, M. *Van Gogh, Gauguin and the Impressionist Circle*, London 1970

Roskill, M. 'Early Impressionism and the Fashion Print', *Burlington Magazine*, June 1970

Ross, M. *Robert Ross, Friend of Friends*. London 1952

Rostrup, H. *Claude Monet et ses tableaux dans les collections danoises*. Copenhagen 1950

★Rouart, D. *Correspondance de Berthe Morisot*. Paris 1950

Rouart, D., and L. Degand. *Claude Monet*. Geneva 1958

Rouart, D. 'A propos des oeuvres datées de Claude Monet', *Bulletin du Laboratoire du Louvre*, September 1959

Rouart, D., J.D. Rey and R. Maillard. *Monet Nymphéas*. Paris 1972

Rouart, D., and D. Wildenstein. *Edouard Manet, catalogue raisonné*. Lausanne and Paris 1975

Roy, A. 'The Palettes of Three Impressionist Paintings', *National Gallery Technical Bulletin*, 1985

Sabbrin, C. *Science and Philosophy in Art*. Philadelphia 1886

Saint Louis, City Art Museum. *Claude Monet*, exhibition catalogue, with preface by W.C. Seitz. 1957

★Salomon, J. 'Giverny 14 juin 1926, déjeuner chez les Monet', *Arts*, 14 December 1951

★Salomon, J. 'Chez Monet, avec Vuillard et Roussel', *L'Oeil*, May 1971

San Francisco, Fine Arts Museums. *The New Painting, Impressionism, 1874–1886*, exhibition catalogue by C.S. Moffett and others. 1986

★Sapego, I. *Claude Monet*. Leningrad 1969

Sarraute, G. 'Deux dessins inédits de Claude Monet', *Revue du Louvre*, 1962

Scharf, A. *Art and Photography*, London 1968

Scheyer, E. 'Far Eastern Art and Impressionism', *Art Quarterly*, Spring 1943

Schlee, N. 'Monet – His Approach to Painting, 1890–1900', *The Artist*, December 1972

Seiberling, G. *Monet's Series*. New York and London 1981

Seitz, W.C. 'Monet and Abstract Painting', *College Art Journal*, Fall 1956 (reprinted in Stuckey 1985)

Seitz, W.C. *Monet*. London 1960

Seitz, W.C. 'Meadow at Giverny', *Princeton Record*, 1960

Seitz, W.C. 'The Relevance of Impressionism', *Art News*, January 1969

Shattuck, R. 'Approaching the Abyss: Monet's Era', *Artforum*, March 1982

Sheon, A. 'French Art and Science in the Mid-Nineteenth Century: Some Points of Contact', *Art Quarterly*, Winter 1971

Sheldon, G.W. *Recent Ideals of American Art*. New York [1889?]

Shiff, R. 'The End of Impressionism', *Art Quarterly*, Autumn 1978

Shiff, R. *Cézanne and the End of Impressionism*. Chicago and London 1984

Sickert, W. *A Free House! or the Artist as Craftsman*. London 1947

Signac, P. *D'Eugène Delacroix au néo-impressionnisme*, Paris 1899 (ed. F. Cachin. Paris 1964)

Silvestre, A. Preface to *Galerie Durand-Ruel, Recueil d'estampes*. Paris 1873

Silvestre, T. *Les Artistes français*. Paris 1856, and enlarged edition 1926

Sloane, J.C. *French Painting between the Past and the Present*. Princeton 1951

Spate, V. 'Transcending the Moment: Monet's *Water Lilies*', in Auckland City Art Gallery 1985

★Speed, H. *Oil Painting*. London 1924

Steinberg, L. 'Monet's Water-Lilies', *Arts*, February 1956 (reprinted in *Other Criteria*. New York 1972)

Stevens, A. *Impressions sur la peinture*. Paris 1886

Stokes, A. *Monet*. London 1958

Stuart, E. 'Claude Monet's Art', *The Studio* (New York), November 1889

Stuckey, C.F. 'Blossoms and Blunders: Monet and the State', II, *Art in America*, September 1979

Stuckey, C.F. (ed.) *Monet: A Retrospective*. New York 1985

★Suarez, A. *La Vie orgueilleuse de Clemenceau*. Paris 1930

Sweet, F.A. *Miss Mary Cassatt, Impressionist from Pennsylvania*. Norman, Okla. 1966

Tabarant, A. 'Le Peintre Caillebotte et sa collection', *Bulletin de la vie artistique*, 1 August 1921

Tabarant, A. 'La Collection Matsukata', *Bulletin de la vie artistique*, 15 December 1922

★Tabarant, A. 'Couleurs', *Bulletin de la vie artistique*, 15 July 1923

★Tabarant, A. *Pissarro*. Paris 1924

Tabarant, A. 'Autour de Manet', *L'Art vivant*, 4 May 1928

Tabarant, A. *La Vie artistique au temps de Baudelaire*. Paris 1942

★Taboureux, E. 'Claude Monet', *La Vie moderne*, 12 June 1880 (translated in Stuckey 1985)

Tavernier, A. 'Sisley', *L'Art français*, 18 March 1893

Thiébault-Sisson. 'Une histoire de l'impressionnisme', *Le Temps*, 17 April 1899

★Thiébault-Sisson. 'Claude Monet, les années des épreuves', *Le Temps*, 26 November 1900 (translated in Stuckey 1985)

★Thiébault-Sisson. 'Claude Monet', *Le Temps*, 6 April 1920 (translated in Stuckey 1985)

★Thiébault-Sisson. 'Un don de M. Claude Monet à l'Etat', *Le Temps*, 14 October 1920 (translated in Stuckey 1985)

★[Thiébault-Sisson]. 'Achats des Musées nationaux', *Le Temps*, 9 February 1921

★Thiébault-Sisson. 'Autour de Claude Monet, anecdotes et souvenirs', I and II, *Le Temps*, 29 December 1926 and 8 January 1927 (translated in Stuckey 1985)

★Thiébault-Sisson. 'Les Nymphéas de Claude Monet', *Revue de l'art*, July 1927 (translated in Stuckey 1985)

Thoré, T. *Salons de W. Bürger*. Paris 1870

Thornley, W. *20 Lithographies d'après Claude Monet*. Paris [c.1890]

★Toulgouat, P. 'Peintres américains à Giverny', *Rapports France–Etats-Unis*, May 1952

★Trévise, Duc de, 'Le Pèlerinage de Giverny', *La Revue de l'art*, January–February 1927 (translated in Stuckey 1985)

★Truffaut, G. 'Le Jardin de Claude Monet', *Jardinage*, November 1924 (translated in Stuckey 1985)

Tucker, P.H. *Monet at Argenteuil*. New Haven and London 1982

Tucker, P.H. 'The First Impressionist Exhibition and Monet's *Impression, Sunrise*: A Tale of Timing, Commerce and Patriotism', *Art History*, December 1984

Vaisse, P. 'Le Legs Caillebotte d'après les documents', *Bulletin de la Société de l'Histoire de l'Art Français*, 1983 (published 1985)

Valenciennes, P.H. *Elémens de perspective pratique*. Paris 1800

★Valéry, P. *Cahiers*, II. Paris 1974

Van Dyke, J.C. (ed.) *Modern French Masters*. New York 1896

Varnedoe, K. 'The Artifice of Candor: Impressionism and Photography Reconsidered', *Art in America*, January 1980

★Vauxcelles, L. 'Un après-midi chez Claude Monet', *L'Art et les artistes*, December 1905 (translated in Stuckey 1985)

★[Vauxcelles, L.] Pinturicchio. 'Souvenir de Giverny', *Le Carnet de la semaine*, 3 October 1926

Vauxcelles, L. 'La Rétrospective Claude Monet', *Le Monde Illustré*, 7 December 1935

Venturi, L. *Cézanne, son art, son oeuvre*. Paris 1936

Venturi, L. *Les Archives de l'impressionnisme*. Paris 1939

Verhaeren, E. *Sensations*. Paris 1927

Véron, E. *L'Esthétique*. Paris 1878

Villhervé, R. de la. 'Choses du Havre, les dernières semaines du peintre Camille Pissarro', *Havre-Eclair*, 25 September 1904

★Vollard, A. *Paul Cézanne*. Paris 1914; *Renoir*. Paris 1920; *Degas*. Paris 1924 (all reprinted in *En écoutant Cézanne, Degas, Renoir*. Paris 1938)

★Vollard, A. *Souvenirs d'un marchand de tableaux*. Paris 1937

Walter, R. 'Emile Zola et Claude Monet', *Cahiers naturalistes*, 1964

Walter, R. 'Les Maisons de Claude Monet à Argenteuil', *Gazette des Beaux-Arts*, December 1966

Walter, R. 'Saint-Lazare l'impressionniste', *L'Oeil*, November 1979

Walter, R., and G.E. Bessone. 'Charles Garnier et Claude Monet à Bordighera', *L'Oeil*, January–February 1977

Webster, J.C. 'The Technique of Impressionism', *College Art Journal*, November 1944

Werth, L. *Claude Monet*. Paris 1928

Whistler, J. *Mr Whistler's "Ten O'Clock"*. London 1888

White, H.C. and C.A. *Canvases and Careers: Institutional Change in the French Painting World*. New York 1965

Wildenstein, D. *Monet, impressions*. Paris 1967

Wildenstein, D. *Monet, biographie et catalogue raisonné*, I (1840–1881), II (1882–1887), III (1888–1898), IV (1899–1926). Lausanne and Paris 1974, 1979, 1979, 1985

Wilhelm, J. 'The Sketch in Eighteenth Century French Painting', *Apollo*, September 1962

Williamstown, Clark Art Institute. *Jongkind and the Pre-Impressionists*, exhibition catalogue by C.C. Cunningham and others. 1976

Wilson, M., M. Wyld and A. Roy. 'Monet's "Bathers at la Grenouillère"', *National Gallery Technical Bulletin*, 1981

★Zola, E. 'Mon Salon, les actualistes', *L'Evénement illustré*, 24 May 1868 (reprinted in Zola 1959 and Zola 1970)

★Zola, E. 'Le Naturalisme au Salon', *Le Voltaire*, 18–22 June 1880 (reprinted in Zola 1959 and Zola 1970)

Zola, E. *Salons*, ed. F.W.J. Hemmings and R.J. Niess. Geneva 1959

Zola, E. *Mon Salon, Manet, Ecrits sur l'art*, ed. A. Ehrard. Paris 1970

Zola, E. *Le Bon Combat, de Courbet aux impressionnistes*, ed. G. Picon and J.P. Bouillon. Paris 1974

★Zürich, Kunsthaus. *Claude Monet*, exhibition catalogue with introduction by G. Besson. 1952

INDEX

The key topics in the book, which form the subjects of separate chapters, do not appear in the index. References in the footnotes have been indexed only when they add substantial information which is not cited in the text. Works of art are listed under the name of the artist who made them; under the heading Monet, Claude, only the titles of paintings are listed.

Académie Suisse, 7
Adéline, Jules, 67, 158, 165, 221
Alexandre, Arsène, 151, 152, 198
Algeria, 5, 12, 22, 124, 125
Antibes, 23, 25, 100, 124, 140, 144, 150, 168, 184, 195, 196, 211, 222
Argenteuil, 5, 12, 17, 18, 30, 34, 81, 147
Astruc, Zacharie, 7, 147, 233 note 7, 234 note 32
Aurier, Albert, 220

Barbizon School, 12, 15, 111
Baudelaire, Charles, 7, 16–17, 47, 110, 135, 235 note 9
 Le Peintre de la vie moderne, 16, 76
Bazille, Frédéric, 7, 8, 111, 135, 205, 233 note 6
 Studio in the rue de la Condamine, 7, pl.7
 Studio in the rue Furstenberg, 7, pl.6
Beaux, Cecilia, 92
Belle-Isle, 9, 12, 13, 22, 24, 25, 26, 125, 144, 150, 162, 164, 195, 196, 200
Berard, Paul, 234 note 44
Bergerat, Emile, 46
Bernheim Jeune, 11
black, use of, 115, 239 note 37
Blanc, Charles, 110, 127
Blanche, Jacques-Emile, 13
Bonnard, Pierre, 10
Bordighera, 23, 24, 25, 39, 46, 142, 144, 150, 155, 175, 176, 193, 195, 222
Boudin, Eugène, 6–7, 16, 46, 47, 110, 135, 218, 240 note 4
 Beach at Trouville, 16, 46, pl.62
Bougival, 7
Boussod & Valadon, 11, 150, 151, 162, 199, 211
Brasserie des Martyrs, 7
Bruyas, Alfred, 10
Burnet, John, 158
Burty, Phillipe, 69, 75, 116, 166

Cadart, 10
Café de la Nouvelle-Athènes, 8
Café Guerbois, 7, 8
Café Riche, 9, 13
Caillebotte, Gustave, 8, 10, 43, 54, 58, 112, 115, 138, 159, 161, 162, 211, 233 note 31
 Chrysanthemums, 43, pl.61
calligraphy, 85, 98, 102, 106
carnets, 11, 159, 161, 234 notes 28–9
Carolus-Duran (Charles Auguste Durand), 8
 Portrait of Claude Monet, 8, pl.1
Cézanne, Paul, 9, 11, 12, 13, 46, 58, 65, 68, 85, 110, 125, 133, 182, 233 note 15, 238 note 24 (Ch.5)
Champfleury, 46
Chardin, Jean Baptiste Siméon, 40, 42
Charpentier, Georges, 11, 54, 208, 211
Chasseurs d'Afrique, 5
Chesneau, Ernest, 47, 166

Chevreul, Eugène, 64
chiaroscuro, 110, 117, 125
Clemenceau, Georges, 9, 158, 171, 198, 216, 225, 237 note 14
collection, Monet's private, 13, 23, 43, 47, 51, 58, 83, 234 note 57, 236 note 119, 237 notes 18–20, 24, 244 note 12
collectors, 5, 10–12, 159, 164, 206
Constable, John, 1, 111, 135, 240 note 9
Corot, Jean-Baptiste-Camille, 28, 29–30, 47, 50, 51, 75, 110, 113, 135, 222, 223, 240 note 10
 Landscape at Coubron, pl.31
 Souvenir of Mortefontaine, 113, 222, pl.34
Courbet, Gustave, 7, 23, 40, 42, 46, 63, 75, 109, 135, 233 note 60, 235 note 58, 237 note 3, 244 note 11
Couture, Thomas, 135, 157, 165
Creuse Valley, 12, 23, 25, 66, 144, 145, 165, 195, 196, 200
crisis of Impressionism, 2
croquis, 157

Daubigny, Charles-François, 15, 23, 28, 47, 51, 53, 63, 75, 135, 137–8, 158, 171, 238 note 13 (Ch.4), 244 note 9
 The Banks of the Seine, 53, pl.73
 Gulping it Down, 137–8, pl.171
 The Studio Boat, 47, pl.63
 The Tow Path, 68, pl.103
 Villerville-sur-Mer, 135–6, pl.167
Daudet, Léon, 9, 225
dealers, 8, 10–12, 20, 40, 150, 151, 166, 199, 208, 213, 245 note 4 (see also specific dealers, e.g. Durand-Ruel, Petit)
de Bellio, Georges, 10, 20, 148
decorative works, 5, 41, 60, 61, 133, 151, 153, 155, 206
Degas, Edgar, 46, 58, 197
Delacroix, Eugène, 23, 75, 83, 85, 109, 110–11, 113, 124, 125, 127
 Journal, 13, 72, 85, 158, 182
 Jacob wrestling with the Angel, 85, pl.123
 Saint-Sulpice murals, 85, 111, pl.123
Delius, Frédéric, 40
Dieppe, 22, 23, 26, 147
Doncieux, Camille (later Monet) 5, 20, 21, 35, 36, 40, 147
drawing, 45, 66, 238 note 22 (Ch.4), Appendix A
Dreyfus, Alfred, 9
Durand-Ruel, Joseph, 36
Durand-Ruel, Paul, 5, 8, 9, 11, 12, 25, 39, 40, 41, 60, 109, 123, 146, 147, 148, 150–1, 152, 158–9, 161, 164, 166, 183, 206, 208, 211, 213, 234 notes 28, 34, 245 notes 7–8
Duranty, Edmond, 64, 159
Duret, Théodore, 18, 36, 45, 58, 69, 111–12, 140, 218, 239 note 30

ébauche, 65–9, 83, 147, 157, 162
enveloppe, 15, 28, 29, 98, 113, 127, 133, 181, 198, 204, 220–5, 242 notes 31–2
esquisse, 69, 77, 83, 92, 157–66, 167–9
d'Estournelles de Constant, Baron, 12

Etretat, 5, 7, 23, 26, 140, 141, 144, 145, 146, 150, 155, 161, 195, 200, 211
étude, 75, 150, 157–61, 165, 167, 170–3, 195, 198

Fantin-Latour, Henri, 7, 40
 A Studio in the Batignolles Quarter, 7
fashion plates, 47, 54, 205
Faure, Jean-Baptiste, 10, 163
Fels, Marthe de, 151
Ferme Saint-Siméon, 7
Fitzgerald, Desmond, 153, 164
flowerpots, 12, pls.3, 188, 189
Forest of Fontainebleau, 12, 15, 205, pl.258
formats, 59–60
framing, 180–1, 215
Franco-Prussian War, 5, 8, 10, 12, 17
Fromentin, Eugène
 Une Année dans le Sahel, 125
Fuller, W. H., 66, 165

gardening, 9, 12–13, 28, 30–1, 236 note 75
Garnier, Charles, 24, 235 note 40
Gaudibert, Louis-Joachim, 5, 10
Gauguin, Paul, 9, 12, 58, 61, 87, 234 note 35
 Le Gaulois, 8
Gautier, Amand, 7, 110, 147
Gautier, Théophile, 75, 158
Geffroy, Gustave, 9, 12, 13, 21, 24, 29, 36, 45, 46, 69, 71, 124, 140, 145, 167, 170, 171, 195
Gimpel, René, 38, 47, 68, 109, 159, 234 note 40
Giron, Charles, 11
Giverny, 5, 6, 9, 10, 12–13, 20–1, 25, 27, 28, 30–1, 41, 54, 58, 125, 133, 140, 147, 151, 174, 176, 197, 198, 222
Gleyre, Charles, 5, 7, 109
Godwin, E. W., 13
Goncourt, Edmond de, 9
Gonse, Louis, 112
Goulinat, J. G., 171
Greenberg, Clement, 46, 239 note 39 (Ch.5)
La Grenouillère, 7, 161, 205
guidebooks, 23–5
Guillaumin, Armand, 9
Guillemet, Antoine, 219
 The Old Quai de Bercy, 219, pl.271
Guillemot, Maurice, 152, 200

hanging, 109, 206, 215–16, 239 note 3, 245 note 41
Harpignies, Henri, 23
Hayem, Charles, 11
Helleu, Paul, 9
Henriet, Frédéric, 23, 45, 135–6, 229
Herbert, Robert, 46, 92, 94, 96, 102–5, 106
Hiroshige, Ando, 54, 112
 Fifty-Three Stations on the Tokaido, 58
 The Isle of Tsukuda, 194

Seashore at Izu, 57, pl.84
Tea-Water Canal, 58
Twin Sword Rocks, Bō no ura, Satsuma Province, 57, pl.86
Wisteria at Drum Bridge, 59
Hokusai, Katsushika, 43, 54
　Chrysanthemums, 43, 59, pl.60
　Large Flowers (series), 43, 194, pl.60
　Mount Fuji in Fine Weather, 58, 194, pl.88
　The Sazaidō of the Gohyaku Rakan-ji Temple, 51, 194, pl.66
　Women gathering Water Lilies, 59
Holland, 12, 144, 157
Honfleur, 7, 137
Hoschedé, Alice (later Monet), 5–6, 8, 9, 12, 20, 21, 36
Hoschedé, Blanche (later Monet), 6, 151
Hoschedé, Ernest, 5–6, 10
Hoschedé, Jean-Pierre, 31, 45, 171, 198
Houssaye, Arsène, 10
Huet, Paul, 193, 235 note 58, 243 note 6 (Ch.12)
Huysmans, Joris-Karl, 9, 166

images d'Epinal, 46, 47
impression, 158, 162, 166, 218, 242 note 16
Impressionist group exhibitions, 8, 10, 18, 64, 83, 112, 137, 155, 158, 166, 206, 208, 218, 220, 244 note 1
instantanéité, 220–1

Japanese art, 12, 13, 35, 37, 39, 45, 46, 47, 53, 54, 56, 57, 58, 59, 75, 85, 87, 112, 237 notes 14, 15, 19
Jeanniot, Georges, 66
Jongkind, Johan Barthold, 7, 47, 75, 83, 110, 135, 193, 240 note 5, 244 note 10
　Boat on a Canal in Holland, 83, pl.121
　The Coast of Sainte-Adresse, 11, 75, 83, 205, pl.112
Joyant, Maurice, 43

Kahn, Gustave, 213, 220, 225
Kandinsky, Wassily, 200
Kuniyoshi
　Priest in the Snow, 57, pl.82

Le Havre, 5, 6, 12
Le Sénéchal de Kerdréoret, G. E., 56
　Fishing Ground at Veules-en-Caux, 56, pl.80
Lecadre, Marie-Jeane, 5
Lecomte, Georges, 46, 85, 87, 133, 223
London, 5, 8, 10, 12, 22, 29, 39, 144, 145, 204, 222
Lostalot, Alfred de, 110
Louveciennes, 7

Macmillan, Hugh
　The Riviera, 25, pl.29
Madrid, 12
Mallarmé, Stéphane, 9, 13, 39, 222, 223–4, 234 note 19
Manet, Edouard, 7, 8, 16–17, 34, 39, 40, 43, 47, 75, 76, 77, 85, 178, 218
　Claude Monet in his Studio, 137, pl.170
　Déjeuner sur l'herbe, 135, 205
　Music in the Tuileries Gardens, 17, 46, 76, 77, 178, pl.16
　Olympia, 9, 39
　The Street Singer, 47
Manet, Julie, 13, 153
Marquet, Albert, 124
Martelli, Diego, 83
Matsukata, Tajiro, 11
Mauspassant, Guy de, 9, 26, 141, 195, 234 note 21
Mediterranean, 12, 23, 25, 28, 38–9, 123–5, 222
Meier-Graefe, Julius, 13
Menton, 144, 150, 161, 162, 175
Millet, Jean François, 28, 57, 181
　Autumn, the Grain Stacks, 28, 197, pl.32
　The End of the Village of Gréville, 51
　Shepherdess seated on a Rock, 181
Mirbeau, Octave, 9, 12, 46, 110, 140, 142, 144–5, 162, 196, 199, 221, 223–4
models, 36
modernism, 3, 15, 46, 220
Monet, Adolphe, 5
Monet, Alice, *see* Hoschedé, Alice
Monet, Camille, *see* Doncieux, Camille
Monet, Claude
　Antibes, 168, 173, 187, 189, pls.207, 208
　Antibes seen from the Jardins de la Salis, 184, pls.226, 227
　Antibes seen from the Salis (W 1167), 60, 185–6, pl.231
　Antibes seen from the Salis (W 1168), 60, 185–6, pl.229
　Antibes seen from the Salis (W 1170), 60, 185–6, pl.230
　Argenteuil, the Bank in Flower, 81, pl.21
　Autumn Effect at Argenteuil, 18, 53, 79, 115, 180, 243 note 3 (Ch.11), pl.72

The Baie des Anges, seen from the Cap d'Antibes, 66, 167, 168, pl.205
The Banks of the Seine near Vétheuil, 54, 86, 187, pl.127 (detail pp.88–9)
The Basin at Argenteuil, 54, 79, 81, 83, 115, 148, 167, pl.143
Basket of Fruit, Apples and Grapes, 40, 42, pl.56
Bathers at La Grenouillère, 115, 136, 147, 161, 205, pl.45
The Bathing Place at La Grenouillère, 147, 205, pl.260
The Bench, 34, pl.43
A Bend on the River Epte, 27, 71, 90, 100, 125, pl.131 (detail p.93)
The Blue Boat, 36–7, 155, pl.191
The Blue Boat (drawing), 155, 229, pl.280
The Boat, 37, 145, 197, 229, pl.50
Boats on the Beach at Etretat, 188, pl.236
Bordighera, 23, 25, 46, 56, 193, 195, pl.245
The Boulevard des Capucines, 18, 54, 81, 238 note 13 (Ch.5), pl.262
Cabin at Sainte-Adresse, 51, pl.69
Camille, 33, 54, 205, pl.257
Camille on her Death Bed, 35, pl.46
Cap d'Antibes, Mistral, 168, 173, 181, 188, 189, pl.206
Cap Martin, 64, 66, 71, 72, 124, 175, pl.155
The Castle at Dolce Acqua, 25, 67, 176, pl.99
Charing Cross Bridge (W 1533), 68, 102, 153, 170, 191, 216, 222, pl.268
Charing Cross Bridge (W 1535), 61, 170, pl.91
Charing Cross Bridge, London, 67, 98, 170, pl.98
Chrysanthemums, 42, 59, pl.59 (detail p.ii)
The Church at Vernon, 11
Cleopatra's Needle and Charing Cross Bridge, 61, 68, 159, 170, pl.90
The Cliff at Fécamp, 54, 120, 185, pl.77
The Cliff Walk, Pourville, 27, 35, 55, 94, 185, pl.228
Cliffs near Dieppe, 120, pl.152
The Cliffs of Petites-Dalles, 23, 68, 86, pl.128
The Clouds, 159, pl.194
The Coastguard's Cottage at Pourville, 120, 125, 129, 195, pl.151
The Coastguard's Cottage at Pourville, Full Sunlight, 58, 129, 185, pl.165
A Corner of the Apartment, 12, 35, 115, pl.13
The Corniche de Monaco (W 890), 23, 25, 155, 175, 179, pl.28
The Corniche de Monaco (W 891), 155, pl.190
Déjeuner sur l'herbe (study), 15, 33, 47, 135, 205, 241 note 15, pl.14
Early Mornings on the Seine (series), 30, 58, 92, 102, 106, 113, 129, 133, 140, 152, 170, 173, 182, 200, 203, 204, pls.35, 139, 211
Early Morning on the Seine (W 1479), 30, 58, 113, 129, 200, pl.35
Early Morning on the Seine (W 1482), 129, 170, 173, 182, 200, pl.211
Early Morning on the Seine, Morning Mists, 92, 102, 129, 182, 200, pl.139
Etretat, Rainy Weather, 140–1, 150, 162, pl.174
Etretat, the Cliff and Port d'Aval in Stormy Weather, 176, pl.198
Etude de rochers, Creuse, 159
Field of Iris at Giverny, 60, 87, pl.93
Field of Oats, 28, 197, pl.250
Field of Poppies (series), 60, 98, 100, pls.135, 251
Field of Poppies (W 1252), 27, 60, 98, 100, 150, 197, 198, pl.135 (detail p.101)
Field of Poppies (W 1253), 98, 197, 198, pl.251
Fishing Boats at Sea, 137, 147, 241 note 4, 245 note 3, pl.182
Fishing Nets at Pourville, 56, 190, pl.79
The Flood, 170, 173, pl.210
Flower Beds at Vétheuil, 86, 179, pl.154
Forest of Fontainebleau, 15, 47, 114, 135, 205, 235 note 3, pl.258
Gare Saint-Lazare (series), 18, 64, 67, 80, 81, 83, 100, 118, 148, 161, 194, 206, 213, pls.101, 119, 196, 224, 265, 266
The Gare Saint-Lazare, 80, 83, 85, 100, 115, 161, 184, 207, pls.119, 224
The Gare Saint-Lazare, Exterior View, 161, 183, pl.196
The Gare Saint-Lazare, the Normandy Train, 67, 148, 184, pl.101
The Gare Saint-Lazare, the Signal, 63, 161, 184, 207, 245 note 12, pl.266
Gladioli, 18, 30, 35, 80, 115, 117, pl.118
The Golfe Juan, 66, 67, 70, pl.107
Grain Stacks (series), 21, 25, 28, 36, 40, 45, 58, 66, 98, 100, 127, 128, 133, 151, 165, 176, 178, 189, 190, 197–204, 213, 215–16, 220, 221, 223, 225, 244 note 31, pls.33, 136, 161, 162, 252, 253, 254
Grain Stack at Sunset, 28, 98, 128, 176, 178, 197, 199, pl.162

Grain Stack at Sunset, Winter, 58, 66, 98, 128, 176, 178, 189, 191, 199, pl.136 (detail p.226)
Grain Stack in Sunlight, 199, 200, pl.253
Grain Stacks, Effect of Hoar Frost, 197, pl.247
Grain Stacks, End of Summer, 127, 178, 199, pl.252 (detail p.192)
Grain Stacks, Snow Effect, Morning, 28, 98, 128, 178, 182, 191, 199, pl.161
Grain Stacks, Snow Effect, Sunlight, 191, 199, pl.254
The Grand Quai at Le Havre, 159
La Grenouillère, 15, 51, 53, 59, 77, 136, 161, 205, pl.71
Houses of Parliament, Fog Effect, 58, 178, pl.89
The Hunt, 83, 153, 242 note 47 (Ch.8), pl.4
The Ice-Floes (W 567), 20, 59, 155, 195, pl.185
The Ice-Floes (W 568), 20, 59, 153, 155, 195, 208, 211, pl.186
The Ice-Floes (W 1335), 27, 65, 69, 100, 128, 148, 174, pl.213
Ice-Floes on the Seine at Bougival, 17, 51, 76–7, 115, pl.115
Impression, Sunrise, 69, 79, 83, 115, 155, 158, 162, 167, 183, 206, 211, 222, 225, pl.199
La Japonaise (Japonnerie), 35, 54, 206, 236 note 88, pl.264
The Jardin de l'Infante, 47, 51, 81, pl.15
Jean on his Mechanical Horse, 34, pl.44
Jeanne-Marguerite Lecadre in the Garden, 75, pl.114
The Jetty of Le Havre, 147, 205, 245 note 3, pl.259
The Jetty of Le Havre in Stormy Weather, 17, 147, pl.17
Juan-les-Pins (W 1188), 60, 186, pl.235
Juan-les-Pins (W 1189), 60, 125, 186, pl.234
Landscape at Giverny, 68, pl.102
Landscape at Vétheuil, 59, 167, 176, 187, pl.204
Lavacourt, 19, 153–5, 166, 208, 218–20, pl.270
Le Havre, Fishing Boats leaving the Port, 162, pl.200
Lilacs in Sunlight, 79, 238 note 9, pl.116
London (series), 66–7, 68, 102, 129, 151–3, 159, 170, 176, 190–1, 203, 216, 222, 244 note 58, pls.89, 90, 91, 98, 223, 268
Low Tide at Pourville (W 712), 195, pl.243
Low Tide at Pourville (W 716), 195, pl.239
Low Tide at Pourville, Hazy Weather, 195, pl.244
Luncheon, 5, 34, 153, 205, 206, 242 note 47 (ch.8), pl.2
Luncheon (Panneau décoratif), 153, 206, pl.263
Madame Gaudibert, 34
The Magpie, 136, 245 note 3, pl.168 (detail p.134)
The Manneporte, Etretat (W 832), 59, 66, 71, 86, 167, 179, 184, 195, pl.129
The Manneporte, Etretat (W 1036), 57, 125, 167, 195, pl.83
The Manneporte, Etretat (W 1052), 59, 67, 86, 125, 150, 184, 195, pls.130, 225
Marine, Storm, 241 note 4
Meadow with Figures, 36, pl.48
Meadow with Haystacks near Giverny, 94, 96, 238 note 30 (Ch.5), pl.132 (detail p.95)
Meditation, 34, 237 note 30
Monet's Garden at Vétheuil (W 683), 155, pl.189
Monet's Garden at Vétheuil (W 685), 30, 155, pl.188
Monet's House at Argenteuil, 18, 30, 34, 80, 115, pl.3
Moored Boat at Fécamp, 64, 180, pl.221
Morning Haze, 98, 125, 190, pl.160
Mount Kolsaas, Norway, 58, 171, 204, pl.87
Oarsmen at Argenteuil, 18, 188–9, pl.237
Old Tree at Fresselines, 145, 178, 200, pl.179
Palm Trees at Bordighera, 72–4, 87, 124, 150, pl.110 (detail pp.vi–vii)
The Palms, Bordighera, 25, 124, 195, pl.156
Path in the Ile Saint-Martin, Vétheuil, 19, 59, 67, 117, 167, pl.149
Pears and Grapes, 40, 42, pl.57
The Pheasants, 40, 178, pl.219
The Pink Boat, 37, 213, pl.49
The Plaine de Colombes, Hoar Frost, 17, 115, pl.146
The Pointe de la Hève, 47, 114, 194, 211, pl.111
The Pointe de la Hève at Low Tide (W 40), 147, 194, pl.180
The Pointe de la Hève at Low Tide (W 52), 15, 75, 147, 205, pl.181
Poly, Fisherman at Kervillaouen, 26, 31, 161, pl.45
The Pont de l'Europe, 67, 80, 83, 85, 135, 207, pl.265
Poplars (series), 25, 45, 58, 67, 100, 128, 140, 142, 178, 189, 201–3, 204, 215, 244 note 54, pls.137, 209, 214, 232, 233, 255, 256
Poplars, 186, pl.233
The Poplars, Autumn, 25, 189, 201, pl.255
Poplars, Overcast Weather, 67, 168, pl.209
The Poplars, the Four Trees, 25, 128, 178, pl.256
The Poplars, the Three Trees, Autumn, 58, 100, 128, pl.137
Poplars near Argenteuil, 18, 115, pl.147
Poplars on the Banks of the Epte, 67, 69, 168, 174, 189, pl.214
Poplars on the Banks of the Epte, seen from the Marshes, 186, 189, pl.232

253

The Poppies at Giverny, 27, 54, 90, pl. 76
Poppy Field near Giverny, 27, 54, 68, 71, 87, pl. 109 (detail p. 73)
The Porte d'Amont, Etretat, 141, pl. 175
Portrait of Suzanne Hoschedé with Sunflowers, 223, pl. 273
The Promenade, 31, pl. 39
Promenade at Argenteuil, 17, pl. 18
Promenade, Grey Weather, 36, pl. 47
The Pyramides at Port-Coton, 20, 57, 60, 195, pl. 85
The Pyramides at Port-Coton, Belle-Isle, 60, 189, 195, pl. 246
The Quai du Louvre, 15, 47, 51, 81, 115, pl. 68
The Railway Bridge, Argenteuil (W 318), 194, pl. 242
The Railway Bridge, Argenteuil (W 319), 194, pl. 241
Ravine of the Creuse, 23, 96, 98, 189, 200, 213, 239 note 30 (Ch. 5), pl. 134 (detail p. 99)
The Red Boats, Argenteuil, 18, 83, pl. 20
The Reeds, 53, 85, pl. 124
Regatta at Argenteuil, 59, 77–9, 83, 92, 112, 115, 162, 167, pl. 142
Rising Tide at Pourville, 55, 64, 179, 195, pl. 220
The Road in Front of the Ferme Saint-Siméon, Winter, 17, 51, 137, pl. 169
The Rocks at Pourville, Low Tide, 27, 56, 64, 67, 70, 86, 141, 179, pl. 177
Rouen Cathedral (series) 28, 58, 100, 102, 109, 124, 128, 151, 153, 176, 190–1, 203, 204, 213, 215, 216, 224, pls. 138, 163, 164, 240, 267
Rouen Cathedral, the Cour d'Albane, 216, pl. 267
Rouen Cathedral, the Portal, Front View, 191, 216, pl. 240
Rouen Cathedral, the Portal, Sunlight, 128, 181, 224, pl. 163
Rouen Cathedral, the Portal and the Tour d'Albane, Dawn, 128, 181, 224, pl. 164
Rouen Cathedral, the Portal and the Tour d'Albane, Grey Weather, 100, 191, 224, pl. 138
Rough Sea, Etretat, 20, 188, pl. 25
The Rue Montorgueil, Fête nationale, 18, 81, 83, pl. 120
The Ruisseau de Robec, 64, 66, pl. 94
Sandviken, 58, 67, 171, pl. 100
Seascape, Storm, 75, 100, pl. 113
The Seine at Bougival, 51, 189, pl. 238
The Sein at Port-Villez, 66, pl. 97
The Sheltered Path, 54, 79–80, 115, 180, pl. 117
Snow at Argenteuil (W 348), 167, pl. 203
Snow at Argenteuil (W 349), 167, pl. 202
Snow Effect at Falaise, 27, 64, 90, 125, 176, pl. 157
Snow Effect at Lavacourt, 121, 128, pl. 153
Spring at Giverny, 176, 178, pl. 158
Spring Effect at Giverny, 98, 125, 126, 189, pl. 159
Still Life, Pears and Grapes, 40, pl. 54
Stone Pine at Antibes, 94, 96, 98, 100, 238 note 30 (Ch. 5), pl. 133 (detail p. 97)
Storm, Coast of Belle-Isle, 25, 27, 125, 181, pl. 30
Storm on Belle-Isle, 25, 27, 70, 86, 92, 162, 179, 189, pl. 108 (detail p. 62)
The Studio Boat, 137, pl. 172
Study of the Sea from the Cliff Tops, 158–9, pl. 193
Sunset on the Seine, Winter, 19, 121, 153, 155, 211, pl. 187
The Tea Service, 40, pl. 55
Terrace at Sainte-Adresse, 15, 16, 47, 51, 114, 136, 188, pl. 67
The Thames and the Houses of Parliament, 64, 79, 115, 222, pl. 144
The Thaw, 26, 54, 195, pl. 124
The Train in the Snow, 54, pl. 75
Trouville Beach, 64, 140, pl. 96
The Tuileries, 18, 83, 117, 178, pl. 218
The Tuileries, esquisse, 83, 159, pl. 195
The Tuileries Gardens, 83, 159, 161, 206, pl. 197
Tulip Field in Holland, 68, 69, pl. 105
Tulip Fields in Holland, 144, 175, pl. 216
The Turkeys, 153, 206, 241 note 15, 245 note 10, pl. 5
Two Grain Stacks, Close of Day, Autumn, 21, 25, 27, 28, 58, 98, 127, 178, 179, pl. 33
Unloading Coal, 18, 80, 117, pl. 148
The Vallée de Sasso, 23, 195, pl. 27
Valley of the Creuse, Evening Effect, 66, 69, 206, pl. 104
Varengeville Church, 55, 59, 60, 121, 125, 181, 190, 195, pl. 222
Varengeville Church, Sunset, 56, 57, 60, 195, pl. 81
Vase of Flowers, 42, 178, 185, pl. 217
Venice, the Ducal Palace, 219, 151, pl. 166
Vernon Church (series), 31, 215, pls. 40, 41
Vernon Church, 27, 31, pl. 40
Vernon Church, Fog, 31, pl. 41

Vétheuil at Sunset, 31, pl. 42
Vétheuil Church, 67, 69, 87, pl. 106
Vétheuil Church, Snow, 19, 117, 178, pl. 22
Vétheuil in the Fog, 121, 164, 199, 221, 222, 225, 244 note 40, pl. 201
The Village of Roche-Blond at Sunset, 68, 175, 200, pl. 215
Water Lilies (series), 31, 59, 102, 105, 133, 151, 159, 178, 190–1, 203, 216, pls. 37, 140, 141
Water Lily Decorations (series), 11, 31, 59, 60, 102, 106–8, 133, 147, 155, 158, 182, 191, 205, 216, pls. 92, 269
Water Lily Decorations, Green Reflections, 31, 59, 102, 106, 133, 155, 182, 213, pl. 269 (detail p. 214)
Water Lily Decorations, Morning with Willows, 31, 59, 102, 106, 133, 155, 182, 213, pl. 92 (detail p. 44)
The Water Lily Pond, 31, 59, 133, 178, pl. 36
Waterloo Bridge, Overcast Weather, 129, 182, 222, pl. 223
The Wheat Field, 54, 180, pl. 23
Winter Sun, Lavacourt, 64, pl. 95
Woman seated under the Willows, 19, 35, 64, 86, 120, pl. 150
Woman with a Parasol, 31, 36, 81, 215, pls. 38, 275
Women in the Garden, 34, 47, 111, 114, 135–6, 147, 178, 205, pl. 64
The Wooden Bridge, Argenteuil, 17, 53, 80, pl. 19
Monet, Jean, 5–6, 35, 36
Monet, Léon, 11, 12
Monet, Michel, 5, 12, 234 note 57
Mont Saint-Michel, 12, 22
Montgeron, 5
Moreno, 24, 193, 195
Morisot, Berthe, 9, 36, 39, 153, 155
motor car, 12, 135, 234 note 47, pl. 11
Murer, Eugène, 11
mystery, 223–4, 246 notes 42, 46

Nabis, 58, 133
Neo-Impressionism, 9, 90, 110, 133
Norway, 12, 22, 26, 58, 67, 144, 145, 151, 173, 176, 196, 203, 204, 215, 243 note 8 (Ch. 10)

Paillot de Montabert, 157, 159
palette, 109, 128, 239 note 10
palette knife, 75, 238 note 7
pantheism, 75
Paris, 5, 6, 7, 12, 18, 54, 147, 208, 217
patrons, *see* collectors
pattern, 46, 58
peinture claire, 110, 114, 115
Perry, Lilla Cabot, 9, 30, 66, 69, 75, 109, 110, 144, 145, 164
Petit, Georges, 9, 11, 40, 150, 151, 166, 197, 211
photography, 54, 151, 220, 237 note 21, 246 note 21
Piron, Achille, 9
Pissarro, Camille, 7, 8, 9, 28, 39, 58, 68, 69, 83, 85, 90, 110, 113, 123, 133, 156, 165, 218, 224, 233 note 11
Drawings from letter, 39, pl. 51
The Gleaners, 156, pl. 192
Sunset, Côtes des Grouettes, Pontoise, 85, pl. 125
Pissarro, Lucien, 218
pochade, 25, 69, 157–62, 166, 167
Poe, Edgar Allan, 13
pointillism, 9, 90
Poissy, 5, 147
Poly, Père, 26, 35, 147, 148, 150, pl. 45
popular art, 46, 47
Positivism, 2, 140, 218, 220
Pourville, 22, 26, 143, 145, 146, 150, 165, 184, 195, 203, 211
priming, 63–5, 67
Puvis de Chavannes, Pierre, 9, 234 note 19
Puys, 22

Raffaëlli, Jean-François, 8
Rashdall, E. M., 66, 67
reflections, 46, 51, 53, 59, 111, 145, 182, 221
Rembrandt van Rijn, 109, 193
Renoir, Pierre-Auguste, 7, 8, 12, 13, 23, 38–9, 40, 43, 53, 58, 63, 65, 109, 111, 125, 133, 156, 233 note 11
Algerian paintings, 87
Argenteuil, 53, pl. 74
Bather, 38
Bather with a Griffon, 206, pl. 261
The Bathers, 39
Monet painting in his Garden at Argenteuil, 137, pl. 8
The Mosque, Arab Festival, 125
Mountains of the Esterel, 235 note 35

Portrait of Madame Charpentier and her Children, 54, 208
retouching, 147–52, 156, 167–82
Rivière, Georges, 159, 161
Robert, Karl, 65, 67, 68, 158
Robinson, Theodore, 9, 27, 46, 58, 72, 124, 133, 162, 164, 201, 223, 227, 229
Scene at Giverny, 197, pl. 248
Rodin, Auguste, 9
Rollinat, Maurice, 12
Rouen, 144, 151
Rousseau, Théodore, 193, 238 note 13 (Ch. 4)
Roussel, Ker-Xavier, 10, pl. 10

Saint-Michel, 5
Salon, 8, 10, 11, 15, 33, 40, 47, 56, 75, 83, 135, 166, 205–8
Sargent, John Singer, 9, 233 note 16
By The River, 39, pl. 53
Carnation, Lily, Lily, Rose, 39, pl. 52
Claude Monet painting at the Edge of a Wood, 9, pl. 9
Claude Monet painting in his Bateau-Atelier, 138, pl. 173
sensation, 45, 90, 133, 165, 182, 218
Seurat, Georges, 9, 12, 110, 178
A Sunday at the Grande-Jatte, 39
Shiff, Richard, 110, 218, 220
Sickert, Walter, 46, 108
Signac, Paul, 45, 133, 178
Silvestre, Armand, 112
Silvestre, Théophile, 110–11, 113
Sisley, Alfred, 7, 8, 9, 42, 58, 85, 117, 133, 194, 196, 204, 208, 244 note 15
The Seine at Suresnes, 85, pl. 126
sketch, *see* esquisse
sketchbooks, 25, 37, 45, Appendix A
the South, 10, 23, 25, 39, 124–5, 150, 173
spontaneity, 1–2, 92–6, 162–5
Stevens, Alfred, 54
studio boat, 137–40, pls. 170, 172
study, *see* étude
Switzerland, 12, 22
symbolism, 220, 223, 224, 225

tableau, 56, 65, 157–66, 167–71, 238 note 6
tache, 75, 77, 79, 85, 86
Theulier, 40
Thiébault-Sisson, 21, 198
Thoré, Théophile, 17, 75, 235 note 10
Tissot, James, 54
Tolstoy, Leo, 13
topographical prints, 51, 54, pl. 70
travel guides, 23–5
Trévise, Duc de, 46, 65, 109, 135, 159, pl. 184
Trouville, 5, 16, 26
Troyon, Constant, 7
Turner, Joseph Mallord William, 29, 110, 113, 141, 193, 243 notes 6–7 (Ch. 12)

Uzanne, Octave, 9

Valenciennes, Pierre-Henri, 56, 135, 142, 193
Van Gogh, Theo, 11, 150, 211, 213
Van Gogh, Vincent, 12, 225
Varangeville, 140
varnish, 109
Vauxcelles, Louis, 13
Velásquez, Diego, 12
Venice, 12, 129, 151, 203, 204
Vernet, Joseph, 135, 141, 235 note 58
Veronese, Paolo, 110, 125
Vétheuil, 5, 8, 19–20, 27, 28, 30, 54, 81, 83, 147, 194–5, 222
Vignon, Victor, 9
Ville d'Avray, 147
Les Vingt, 211
Viollet le Duc, Eugène, 55–6, pl. 78
Vlaminck, Maurice, 10
Vuillard, Edouard, 10, pl. 10

Whistler, James Abbott McNeil, 9, 12, 13, 47, 54, 79, 100, 222
Nocturne in Blue and Silver, Chelsea, 79, 222, pl. 272
The Music Room, 47

Ziem, Félix, 129
Zola, Emile, 7, 15, 16, 75, 159, 166, 218, 220, 224, 233 note 7

PHOTOGRAPHIC ACKNOWLEDGMENTS

Aberdeen Art Gallery and Museum: 77

Amsterdam, Stedelijk Museum: 28

Birmingham, Barber Institute of Fine Arts, University of Birmingham: 222

Boston, Museum of Fine Arts: 132, bequest of Arthur Tracy Cabot; 109, 133, 155, 162, Juliana Cheney Edwards Collection; 128, 134, Denman Waldo Ross Collection; 135, deposited by the Trustees of the White Fund, Lawrence, Massachusetts; 140, gift of Edward Jackson Holmes; 147, bequest of David P. Kimball in memory of his wife, Clara Bertram Kimball; 151, 203, bequest of Anna Perkins Rogers; 154, John Pickering Lyman Collection; 161, gift of Misses Aimee and Rosamond Lamb in memory of Mr and Mrs Horation A. Lamb; 164, Tompkins Collection; 206, bequest of Arthur Tracy Cabot; 264, 1951 Purchase Fund

Brooklyn Museum: 166, gift of A. August Healy; 220, gift of Mrs Horace Havemeyer

Cambridge, courtesy of the Syndics of the Fitzwilliam Museum: 233

Cambridge, Mass., Harvard University, Fogg Art Museum: 20, bequest-collection of Maurice Wertheim, Class of 1906; 175, gift of Mr and Mrs Joseph Pulitzer, Jr.

Cardiff, National Museum of Wales: 91

Chicago, © The Art Institute of Chicago, All Rights Reserved: 3, collection of Mr and Mrs Martin A. Ryerson; 33, 228, Mr and Mrs Lewis Larned Coburn Collection; 101, Mr and Mrs Martin Ryerson Collection; 236, Charles H. and Mary F. S. Worcester Collection, 1947. 95; 245, Potter Palmer Collection; 251, W. W. Kimball Collection

Cleveland Museum of Art: 23, 239, gift of Mrs Henry White Cannon

Dallas Museum of Fine Arts: 270; 141, gift of the Meadows Foundation Inc.

Detroit Institute of Arts: 118, City of Detroit Purchase; 248, gift of Mrs Christian H. Hecker

Edinburgh, National Gallery of Scotland: 31, 254

Enschede, Rijksmuseum Twenthe: 112

Farmington, Conn., Hill-Stead Museum; 182, 247

Fort Worth, Kimball Art Museum: 181

Frankfurt, Städelsches Kunstinstitut: 2

Glasgow Art Gallery and Museum: 204

The Hague, Gemeentemuseum: 68, 79, Escher Foundation

The Hague, Mesdag Museum: 103, 167

Hamburg, Kunsthalle: 57, 223

Hartford, Conn., Wadsworth Atheneum: 8, bequest of Anne Parrish Titzell

Le Havre, Musée des Beaux-Arts: 95, Legs Charles Auguste Marande, 1936; 165, Achat de la Ville du Havre en 1911

Leningrad, Hermitage Museum: 114, 262

London, by courtesy of the Trustees of the British Museum: 66, 82

London, courtesy Courtauld Institute Galleries: 72, 207

London, reproduced by courtesy of the Trustees, The National Gallery: 16, 96, 144, 145, 153, 210

London, courtesy of the Board of Trustees of the Tate Gallery: 9, 52, 214, 272

London, Victoria and Albert Museum (Crown Copyright): 60, 84, 86, 88

Lyons, Musée des Beaux-Arts: 25

Munich, Bayerische Staatsgemäldesammlungen: 170

New York, Metropolitan Museum of Art: 32, bequest of Lilian S. Timken, 1959; 56, gift of Henry R. Luce, 1957; 67, purchased with special contributions and purchase funds given or bequeathed by friends of the Museum, 1967; 71, 213, 256, bequest of Mrs H. O. Havemeyer, 1929. The H. O. Havemeyer Collection; 110, bequest of Miss Adelaide Milton de Groot (1876–1967), 1967; 129, bequest of William Church Osborn, 1951; 89, 149, 211, bequest of Julia W. Emmons, 1956; 130, gift of Lizzie P. Bliss, 1931

Northampton, Mass., Smith College Museum of Art: 267, gift of Caroline R. Wing '96 and Adeline F. Wing '98, 1956

Oberlin, Ohio, Allen Memorial Art Museum: 15, R. T. Miller Jr. Fund

Oslo, Nasjonalgalleriet: 174

Oxford, Ashmolean Museum: 51

Philadelphia, John G. Johnson Collection: 242

Philadelphia Museum of Art: 117, given by Mr and Mrs Hughes Norment in honor of William H. Donner; 131, William L. Elkins Collection; 137, bequest of Anne Thomson as a memorial to her father, Frank Thomson, and her mother, Mary Elizabeth Clarke Thomson; 230, bequest of Charlotte Dorrance Wright; 255, given by Chester Dale

Pittsburgh, Carnegie Institute: 152, acquired through the generosity of the Sarah Mellon Scaife family

Raleigh, North Carolina Museum of Art: 139

Rochester (N. Y.) Memorial Art Gallery: 177, gift of Mrs James Sibley Watson

São Paulo, Museu de Arte: 261

Shelburne (Vt) Museum: 41, 186

Toledo (Ohio) Museum of Art: 229, gift of Edward Drummond Libbey

Washington, D.C., National Gallery of Art: 18, 62, 188, Ailsa Mellon Bruce Collection; 39, collection of Mr and Mrs Paul Mellon; 127, 150, 160, 163, 217, Chester Dale Collection

Williamstown, Mass., Sterling and Francine Clark Art Institute: 113, 274

Zurich, Kunsthaus: 253

Photo Routhier: 1, 37, 45, 50, 61, 75, 93, 97, 98, 99, 104, 105, 122, 199, 201, 218, 265

Cliché des Musées Nationaux, Paris: 5, 7, 10, 13, 22, 26, 30, 34, 36, 38, 42, 46, 64, 92, 94, 115, 119, 120, 126, 142, 143, 148, 168, 169, 184, 185, 195, 212, 216, 240, 241, 252, 263, 269

Photo Claude O'Sughrue: 6

Photo Editions d'Art Lys: 12

Photo courtesy of Christie, Manson & Woods, London: 19, 87, 100, 189, 209, 226, 273

Photo Durand-Ruel: 24, 47, 58, 81, 156, 193, 219, 237, 258, 266, 268

Photograph courtesy of the Museum of Fine Arts, Boston: 44

Photo Luiz Hossaka: 49

Photo Hanz Hinz: 59, 192

Photograph courtesy of Fondation Wildenstein: 69, 108, 260

Courtesy of the Trustees of the British Library: 70

Photo Patrick Jean: 73

Photo Marie de Paris: 123

Lauros-Giraudon: 138

Photo Bridgeman Art Library: 158

Photo copyright Barnes Foundation: 172

Photo courtesy of the National Gallery of Art, Washington, D.C.: 173

Photo Bulloz: 187

Photo Artothek: 200

Photo A.C. Cooper: 235